LEONARDO DA VINCI, MICHELANGELO, AND THE RENAISSANCE IN FLORENCE

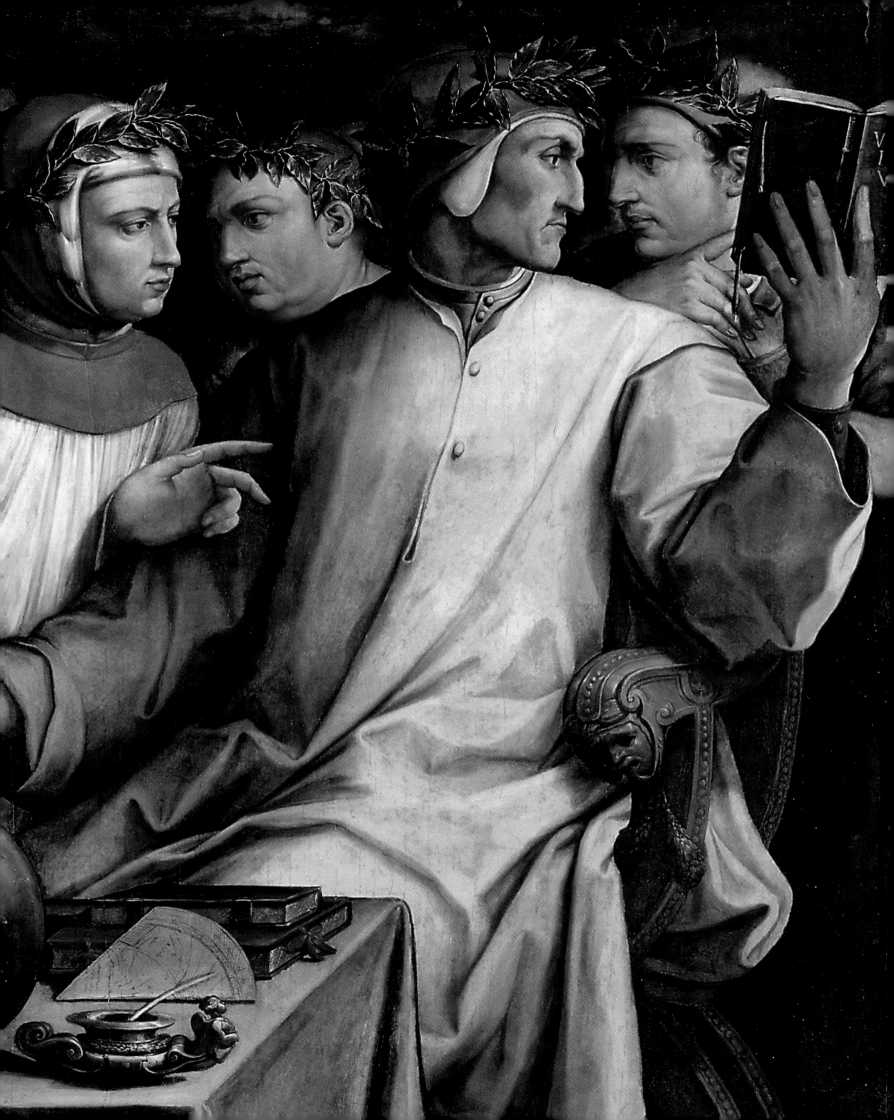

GENERAL EDITOR, DAVID FRANKLIN

**WITH ESSAYS BY DAVID FRANKLIN,
LOUIS A. WALDMAN,
AND ANDREW BUTTERFIELD**

LEONARDO DA VINCI, MICHELANGELO, AND THE RENAISSANCE IN FLORENCE

National Gallery of Canada
in association with Yale University Press

Ottawa, 2005

The exhibition *Leonardo da Vinci, Michelangelo, and the Renaissance in Florence* was organized by the National Gallery of Canada and presented in Ottawa from 29 May to 5 September 2005.

Catalogue produced by the Publications Division of the National Gallery of Canada, Ottawa.
Chief of Publications: Serge Thériault
English Editors: Usher Caplan, Susan McMaster
French Editor: Denise Sirois
Picture Editor: Colleen Evans
Freelance editors: Douglas Campbell, Marcia Rodriguez, Edward Tingley, Jennifer Wilson
Freelance translators: Marcia Couëlle, Antonia Reiner

Design and typesetting: Fugazi, Montreal
Printing: Tri-Graphic Printing (Ottawa) Limited

Printed in Canada.

ISBN 0-88884-804-8
Aussi disponible en français : ISBN 0-88884-805-6

Front cover: Andrea del Sarto, *Portrait of a Man* (detail), c. 1517–1520 (cat. 38)
Back cover: Raphael, *Leda and the Swan, after Leonardo da Vinci* (detail), c. 1507 (cat. 3)
Frontispiece: Giorgio Vasari, *Disputa between Dante and the Tuscan Love Poets* (detail), 1544 (cat. 113)

National Gallery of Canada, Ottawa
www.national.gallery.ca

Yale University Press, New Haven and London
www.yalepress.yale.edu/yupbooks/contact.asp
www.yalebooks.co.uk/yale/default.asp

The year 2005 is a remarkable one for the National Gallery of Canada, as it proudly celebrates its 125th birthday, and presents the most important Renaissance exhibition ever held in North America: *Leonardo da Vinci, Michelangelo and the Renaissance in Florence*. As our contribution to the celebrations, the National Gallery of Canada Foundation has organized our first national fundraising event, the Renaissance Ball. ¶ With funds raised through the Ball from patrons of art from across the country, the Gallery has been able to acquire a marvellous pen-and-ink drawing from the exhibition, Francesco Salviati's *David* (see cat. no. 117). These funds will also support permanent-collection outreach and travelling exhibitions, and educational art programs for children – projects that enhance appreciation of our national treasure by all Canadians. ¶ The Renaissance Ball is one of many endeavours by the Foundation since 1997 to promote private gifts to the Gallery while encouraging new associations and partnerships. The support we receive provides financial resources that help ensure the long-term success of the Gallery as a leader among cultural institutions at home and abroad. ¶ In 2005, we particularly salute the outstanding generosity of numerous patrons of the arts, including our many partners from the artistic, voluntary, business, and political communities, who are contributing to the Gallery's 125th anniversary celebrations. Deserving of special recognition is Bell Canada, the presenting sponsor of the exhibition, without whom this adventure would not have been possible. ¶ It is with great pride that we at the Foundation invite you to enjoy this magnificent catalogue. For years to come, it will recall the splendours of *Leonardo da Vinci, Michelangelo, and the Renaissance in Florence* at the National Gallery of Canada.

THOMAS P. D'AQUINO
Chairman, Board of Directors
National Gallery of Canada Foundation

"The true work of art is but a shadow of the divine perfection," Michelangelo once said. But if any masters of any era, in any place, came close to reflecting the divine, these masters were Michelangelo, Leonardo da Vinci, and their Florentine contemporaries. ¶ The Renaissance marked the passage from the dark ages to modern times. It brought new importance to individual expression and worldly experience. It was a brilliant time, illuminated by accomplishment in scholarship, literature, architecture, science, and the arts. Florence was its home and its inspiration. ¶ As we celebrate our 125th anniversary, Bell Canada is proud to support this first major exhibition in North America of more than a hundred paintings, sculptures, drawings, and prints celebrating the Florentine Renaissance. This impressive collection of rare and influential works, assembled from some of the world's greatest art institutions, has never before been seen together in one place. We applaud the National Gallery of Canada for its vision and leadership in bringing this unique experience to Canadians. ¶ This exhibition will give the National Gallery's visitors a new appreciation for the vital role the Renaissance played in shaping artistic form and expression today. It promises insight. It will provoke discussion. It will surprise, delight, and inform. And it will give visitors Leonardo da Vinci's "noblest pleasure" – the "joy of understanding" one of the greatest of times in the history of art.

MICHAEL SABIA
President and CEO
Bell Canada Enterprises

LENDERS TO THE EXHIBITION

Agnes Etherington Art Centre, Queen's University, Kingston 24
Albertina, Vienna 4, 11, 64, 91, 93, 97, 100, 111
Ashmolean Museum, Oxford 54, 79
Biblioteca Nazionale Centrale, Florence 26
Bob Jones University Museum and Gallery, Greenville,
 South Carolina 82
British Museum, London 12, 33, 74, 89, 94
Christ Church Picture Gallery, Christ Church College,
 Oxford 66, 72, 80
Courtauld Institute of Art Gallery, Gambier-Parry Collection,
 London 20
Devonshire Collection, Chatsworth 2, 35, 77
École Nationale Supérieure des Beaux-Arts, Paris 34
Frick Art and Historical Center, Pittsburgh 88
Galerie Sarti, Paris 116
Galleria Corsini, Florence 51
Galleria degli Uffizi, Florence 30, 31, 45, 58, 62, 81, 92
Galleria Estense, Modena 27
Galleria Palatina, Palazzo Pitti, Florence 22, 46
Her Majesty Queen Elizabeth II 1, 3, 16, 17
Istituto Nazionale per la Grafica, Villa Farnesina, Rome 67, 69, 70
Kunsthalle, Hamburg 63, 75
Los Angeles County Museum of Art 112
Memorial Art Gallery of the University of Rochester 15
Moretti, Florence–London 55
Musée des Beaux-Arts, Orléans 95
Musée des Beaux-Arts, Strasbourg 10
Musée du Louvre, Paris 90, 101, 108
Musée Jacquemart-André, Paris 44
Museo Civico e Diocesano d'Arte Sacra, Montalcino 29
Museo di San Salvi, Florence 48
Museo Diocesano, Arezzo 114
Museo Nacional del Prado, Madrid 41
Museo Nazionale del Bargello, Florence 96, 104
Museo Thyssen-Bornemisza, Madrid 83
Museum of Fine Arts, Boston 8, 36
National Gallery, London 38
National Gallery of Art, Washington 42, 59, 102

National Gallery of Canada, Ottawa 19, 25, 37, 39, 50, 73, 85, 98,
 110, 117, 120
National Gallery of Scotland, Edinburgh 115
New Orleans Museum of Art 28, 86
Philadelphia Museum of Art 56, 84
Pinacoteca di Brera, Milan 65
Princeton University Art Museum 47
Private collections 9, 53
Private collection, Chicago 119
Private collection, London 61
Private collections, Milan 52, 121
Private collections, Montreal 109, 118
Private collections, New York City 60, 76, 78, 123
Private collection, Paris 105
Szépművészeti Múzeum, Budapest 7, 18, 49
The Art Institute of Chicago 21, 71
The Cleveland Museum of Art 40
The Earl of Leicester and Trustees of the Holkham Estate,
 Norfolk 13
The Fitzwilliam Museum, University of Cambridge 6
The J. Paul Getty Museum, Los Angeles 32, 68, 87
The Metropolitan Museum of Art, New York City 23, 43
The Minneapolis Institute of Arts 99, 113
The Saint Louis Art Museum 122
Vatican Museums, Vatican City 106
Victoria and Albert Museum, London 5, 14, 57
Wadsworth Atheneum, Hartford 107

CONTRIBUTING AUTHORS

AUSTRIA

Achim Gnann, External collaborator, Albertina, Vienna **4, 11**

BRITAIN

Martin Clayton, Deputy Curator of the Print Room, Windsor Castle **1, 2, 3, 16**

Florian Härb, P. and D. Colnaghi and Co., London **107, 108, 109, 110, 111, 119**

Peta Motture, Chief Curator, Medieval and Renaissance Galleries, Victoria and Albert Museum, London **5, 57**

Rick Scorza, The Warburg Institute, University of London **113, 115**

Ben Thomas, Lecturer in History and Theory of Art, University of Kent, Canterbury **100**

Catherine Whistler, Senior Assistant Keeper, Department of Western Art, Ashmolean Museum, Oxford **31, 54**

CANADA

David Franklin, Deputy Director and Chief Curator, National Gallery of Canada, Ottawa **13, 14, 19, 20, 21, 28, 30, 32, 33, 35, 36, 38, 40, 41, 45, 55, 58, 59, 60, 62, 63, 64, 65, 66, 67, 68, 69, 70, 72, 73, 74, 75, 76, 82, 83, 98, 114, 117, 120**

David McTavish, Professor of Art History, Department of Art, Queen's University, Kingston **23, 24, 112, 118**

Catherine Johnston, Curator, European Art, National Gallery of Canada, Ottawa **37, 85**

DENMARK

Chris Fischer, Head of Centre for Advanced Studies in Master Drawings, Statens Museum for Kunst, Copenhagen **17, 18**

FRANCE

Philippe Costamagna, Art Historian, Paris **34, 61, 77, 116, 121, 122**

ITALY

Victoria Avery, Rush H. Kress Fellow (2004–2005), Villa I Tatti, The Harvard University Center for Italian Renaissance Studies, Florence **6**

Elena Capretti, Art Historian, Florence **46, 48, 49, 50, 51, 52**

Carlo Falciani, Art Historian, Florence **53**

Serena Padovani, Director of the Galleria Palatina, Palazzo Pitti, Florence **22, 25**

Francesca Petrucci, Professor, History of Art, The Albertina Academy of Fine Arts, Turin **26, 29**

Antonio Natali, Art Historian, Galleria degli Uffizi, Florence **27, 39**

UNITED STATES

Denise Allen, Associate Curator, The Frick Collection, New York City **102, 103**

Andrew Butterfield, Senior Vice President, Salander-O'Reilly Galleries, New York City **9, 123**

Marietta Cambareri, Assistant Curator of Decorative Arts and Sculpture, Art of Europe, Museum of Fine Arts, Boston **8**

Stephen J. Campbell, Professor, History of Art, The Johns Hopkins University, Baltimore **79, 80**

Elizabeth Cropper, Dean, Center for Advanced Study in the Visual Arts, National Gallery of Art, Washington **81**

Dennis Geronimus, Assistant Professor, Department of Fine Arts, New York University **10**

Laura M. Giles, Curator of Prints and Drawings, Princeton University Art Museum **71**

Robert G. La France, Research Associate, Center for Advanced Study in the Visual Arts, National Gallery of Art, Washington **15, 86, 87, 88**

Eike D. Schmidt, Research Curator, Department of Sculpture, National Gallery of Art, Washington **104**

Carl Brandon Strehlke, Adjunct Curator of the John G. Johnson Collection at the Philadelphia Museum of Art **56, 84**

Louis A. Waldman, Assistant Professor, Department of Art and Art History, The University of Texas at Austin **7, 12, 42, 43, 44, 47, 78, 89, 90, 91, 92, 93, 94, 95, 96, 97, 99, 101, 105, 106**

CONTENTS

Florence – the capital of Tuscany – sometimes seems more myth than real place. Celebrated as the cradle of the Renaissance, many exhibitions have been held in Florence glorifying its art. Rarely, however, has the period that found Leonardo da Vinci and Michelangelo both active in the city at the same time, and both working on their famous battle frescoes for the Palazzo della Signoria, been so featured. Beyond Florence itself, exhibitions on this subject are yet more rare, and in Canada an event of this type is entirely unprecedented. ¶ *Leonardo, Michelangelo, and the Renaissance in Florence* presents 123 paintings, sculptures, prints, and drawings from Renaissance Florence created during a turbulent, dynamic period of cultural history that continues to fascinate scholars and the public alike. This was a period featuring clashing systems of government and patronage – one side Republican and the other dominated by the Medici supported by popes from their own family – and some of the most celebrated names in the history of art. It was also the period described by Giorgio Vasari, the author of the first comprehensive biographies of artists ever written, as the "modern" age in Italian art, often now referred to as the High Renaissance or Mannerist period.

¶ The exhibition sets out to explore the innovations in the art of Leonardo and Michelangelo in Florence after 1500, as well as their impact on a great many other talented, highly intriguing artists, including Raphael, Andrea del Sarto, Pontormo, Fra Bartolommeo, and some forty of their peers; works on paper naturally receive special emphasis because of the fundamental significance in Florentine art practice of developing original ideas through drawing. It goes on to examine how the vibrant tradition these artists initiated was betrayed and terminated around 1550 at the time of publication of the first *Lives of Artists* by Vasari himself, who, despite his admiration for them, would promote a different agenda and alter the history of art in Europe forever.

¶ The majority of these works have never before travelled to North America, or been seen together in one place. Several are being shown for the first time ever. Given the rarity and value of the objects considered for loan, it was clear early on in the planning of the exhibition that only one venue would be possible, and we are proud that it is the National Gallery of Canada. But we could not have mounted an exhibition in Canada of this unique nature without the extraordinary generosity and vision of individual lenders. Particular thanks are due to the Superintendent of Works in Florence and the various museum directors and curators in that city who were the initial supporters of this project, especially Antonio Paolucci, Soperintendente regionale Regione

Tonscana, Serena Padovani at the Palazzo Pitti, and Annamaria Petroli Tofani and Antonio Natali at the Uffizi. ¶ I should like to thank David Franklin, our Deputy Director and Chief Curator, for undertaking the singular challenge of organizing this exhibition. He has been superbly aided at every turn by two prominent scholars of the period, Andrew Butterfield and Louis A. Waldman, who have acted as the other members of his curatorial committee. ¶ Special thanks are due to the dedicated team at the National Gallery of Canada for their excellent work and aid of every kind, and to the Board of Trustees of the National Gallery of Canada for supporting the more recent acquisition for the nation of some of the newly discovered works featured in this show. ¶ The opening of *Leonardo da Vinci, Michelangelo, and the Renaissance in Florence* began a year of celebration for the National Gallery of Canada, as we reached our 125th birthday on 6 March 2005. Another venerable national institution, Bell Canada, is also celebrating its 125th anniversary in 2005. We are particularly grateful that Bell has chosen to mark this significant year in its history by supporting the exhibition in a most generous fashion.

PIERRE THÉBERGE, O.C., C.Q.
Director
National Gallery of Canada

Traditionally, for Florentine artists, life drawing and the representation of expressive human form were the basis of good art. This predilection crystallized around 1500 in the work of Leonardo and Michelangelo during the period often called the High Renaissance. In the art theory of the time, the Italian term for drawing, *disegno*, encapsulated the core of their art. Literally, the word meant the skill of sound drawing, but it equally signified the talent to design in a more spiritual sense, through the invention of beautiful objects of all descriptions. Among the works chosen for this exhibition, therefore, those which best illustrate the concept of *disegno* were favoured, namely objects in which the active and expressive figure is paramount, especially in the context of strong narrative content. ¶ On a more general level, through a judicious selection of paintings, sculptures, drawings, and prints never before seen together, Andrew Butterfield, Louis A. Waldman, and I have attempted to discredit conventional assumptions about the evolution of art in Renaissance Florence from 1500 to 1550. By demonstrating the consistency of a type of experimental creativity shared by such artists as Piero di Cosimo and Michelangelo, and passed on to Rosso, Pontormo, Rustici, Cellini, Bronzino, and many others, the exhibition questions the relevance of terms like "High Renaissance and "Mannerism" in analyzing the finest art of the period, not least because such terms are usually and quite improperly defined in opposition to one another. In fact, there was no obvious stylistic break in the art produced in Florence before and after the death of Raphael in 1520, and innovation in Florentine art was not so much linear as lateral, established through many years of effort and refinement. Even conservative artists like Ridolfo Ghirlandaio were fully engaged with the developments of Leonardo, Raphael, and Michelangelo. ¶ At the same time, the art of the Ancients was not such a unifying force as might be assumed from the term Renaissance, because these artists regarded antique art more as an acceptable challenge to surpass than as a model to be slavishly followed. By emphasizing the extraordinary invention in some of the most-loved works ever produced in Florence, this exhibition exposes the limitations of our inherited style terms High Renaissance and Mannerism as critical tools. ¶ Within the period from about 1500 to 1550, it is also possible to follow a rival line, laid down by Giorgio Vasari, the so-called founder of Art History. Vasari promoted a more decorative and superficial style of painting than that of the Florentine masters, developed through an appreciation of Raphael's later work in Rome. The final part of the exhibition explores Vasari's radical rewriting of Florentine

art history; it looks closely at the manner in which he gave visual expression to his views through both his art and his famous *Lives of the Artists*. Vasari's principal allies in his opposition to Florentine innovation were artists born in Florence but trained in Rome, like Perino del Vaga and Francesco Salviati; their work is represented here by carefully chosen, major examples. The success of the efforts of Vasari and his followers marks the end of the Renaissance in Florence.

DAVID FRANKLIN
Deputy Director and Chief Curator
National Gallery of Canada

ACKNOWLEDGEMENTS

The members of the curatorial committee and I wish to express our gratitude to all those from some sixty private and public collections and institutions who contributed to the exhibition and catalogue, including but not only: Bruce Anderson, Stephen Borys, Marjorie Bronfman, David Alan Brown, Sheila Coutts, Ronni Baer, Colin Bailey, Alessandro Bagnoli, Sylvain Bellenger, Katrin Bellinger, Sidney Bregman, Janet Brooke, Julian Brooks, Christopher Brown, Emmanuelle Brugerolles, Paul and Julia Butterfield, Marco Calafati, Salvatore Carrubba, Stefano Casciu, Carlo Cavalleri, Mimi Cazort, Alessandro Cecchi, Hugo Chapman, Alan Chong, Roberto Ciabattini, Timothy Clifford, Amedeo Cocchi, Fabio Comanducci, Victoria Cooke, Alessandro Cortese, Gino Corti, Janet Cox-Rearick, Michael Daley, Kate Davis, Peter Day, David DeWitt, Hester Diamond, Douglas Druick, Caroline Elam, Marzia Faetti, Everett Fahy, Richard Feigen, Larry Feinberg, Gabriele Finaldi, Liugi Fiorani, Fanny Fioravanti, Maria Teresa Fiorio, Suzanne Folds McCullagh, Daniele Francioni, Thomas and Roman Franklin, Giancarlo Gentilini, Alessandra Giovannetti, Edward Goldberg, Jean Goldman, Jan Gontarczyk, Meg Grasselli, Marco Grassi, Alessandra Gregori, Antony Griffiths, William Griswold, Anne Guite, Nadine Gut, Nicholas Hall, Lee Hendrix, Michael Hirst, Antonia Ida Fontana, Dominique Jacquot, David Jaffé, Ian Kennedy, Luigi Koelliker, David Lachenmann, David Landau, Terry Lignelli, Catherine Loisel, Antonella Longo-Turri, Henri Loyrette, Gillian Malpass, Judith Mann, J. Patrice Marandel, Louis Marchesano, Patrick Matthiesen, Alain Moatti, Catherine Monbeig-Goguel, Jennifer Montagu, Fabrizio Moretti, John Morton Morris, Stanley Moss, Jonathan Nelson, Larry Nichols, Diane Nixon, John Nolan, Patrick Noon, Annick Notter, Flavia Ormond, Carlo Orsi, Beatrice Paolozzi Strozzi, Antonio Paolucci, Serenita Papaldo, Peter Parshall, Annamaria Petrioli Tofani, Ivan Phillips, Serena Pini, Massimo Pivetti, Carol Plazzotta, Antonia Reiner, Joseph Rishel, Jane Roberts, William Robinson, Betsy Rosasco, Giudo Rossi, Patricia Rubin, Antonio Quattrone, Bruno Santi, Giovanni Sarti, Scott Schaefer, David Scrase, Alan Shestack, Richard Shone, Barb Sicko, Jeanette Sisk, Tom Smart, Enrica Spantigati, David Steel, Andreas Stolzenburg, Dora Thornton, Filippo Trevisani, David Tunick, Claire Van Cleave, Ernst Vegelin, Charles Venable, Francoise Viatte, Katalin Waldman, Kathleen Weil-Garris Brandt, Sue Welsh Reed, Aidan Weston-Lewis, Heinz Widauer, Thomas Williams, Martin Wyld, and Lorand Zentai. ¶ At the National Gallery, I would like to single out a few talented individuals without whom this catalogue would never have been

realized to such an impeccable standard, starting with the Chief of Publications, Serge Thériault, who pulled together a consummate team, notably the principal English editors, Usher Caplan and Susan McMaster, and the principal French editor, Denise Sirois, who were sensitive and valuable to me in the production of the book. Picture editor Colleen Evans brought her usual fine eye to the visuals, aided by Lucille Banville and Nelda Damiano in photo acquisition. I would like to thank the project manager, Christine LaSalle, for her support and attention to every possible detail affecting this exhibition. François Martin has done an outstanding design and layout for this beautiful book. Above all, it gives me great pleasure to acknowledge the work of the chief research assistant for this project, Nelda Damiano, who was unfailingly diligent (and optimistic) throughout the entire process. ¶ As always, I am grateful for the excellent contributions of all Gallery staff to the exhibition and catalogue, including especially Daniel Amadei, Monique Baker-Wishart, Claire Berthiaume, Delphine Bishop, Shawn Boisvert, Joanne Charette, Karen Colby-Stothart, Doris Couture-Rigert, Jean-Charles D'Amours, Pamela Delworth, Erika Dolphin, Christine Dufresne, Christine Fagan, Louise Filiatrault, Stephen Gritt, Suzanne Haddad, Suzanne Lacasse, Irene Lillico, Paul Leduc, Ceridwen Maycock, Marie Claire Morin, Geoff Morrow, Michael Pantazzi, Barbara Rottenberg, Greg Spurgeon, Yves Théoret, Alan Todd, Anne Tessier, Ellen Treciokas, Murray Waddington, and Karen Wyatt. Their efforts were well supported by freelance contributors Douglas Campbell, Danielle Chaput, Marcia Couëlle, Carine De Paux, Jane Jackel, Antonia Reiner, Marcia Rodriguez, Edward Tingley, and Jennifer Wilson.

DAVID FRANKLIN

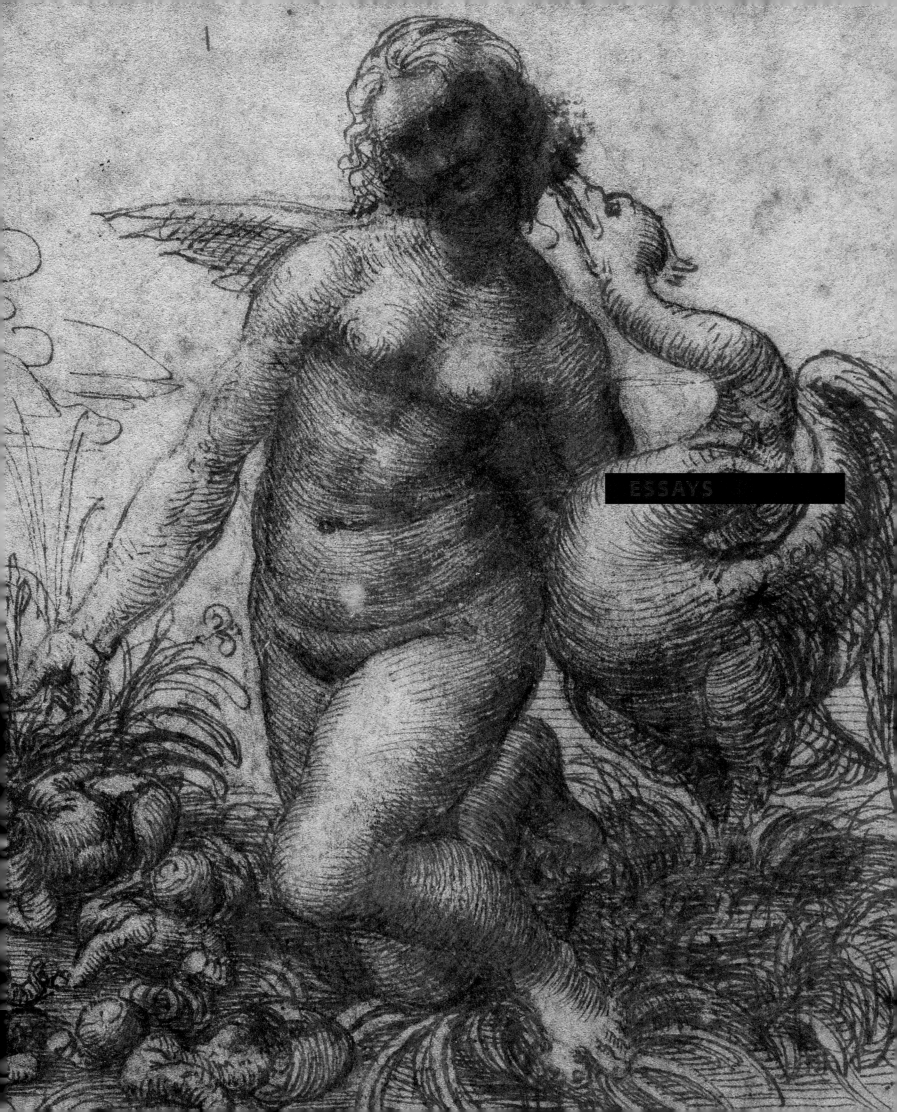

"REVEALING MAGNIFICENCE AND GRANDEUR" FLORENTINE DRAWING IN THE FIRST HALF OF THE SIXTEENTH CENTURY

DAVID FRANKLIN

seriously.[4] The cartoons for the battle frescoes were soon torn into fragments, the paper itself seized by artists and collectors for yet closer study, admiration, and the prestige of ownership. Indeed, the veneration of these drawings almost as sacred relics also constitutes a decisive moment in the history of the collection of works on paper. To reconstruct these major projects, it is now necessary to examine both artists' preparatory drawings for the cartoons and various copies of them (see cat. nos. 1, 11–15).

¶ Although it is impossible to document thoroughly, it seems that the examples of Leonardo and Michelangelo stimulated the appetite of artists for seeking out and copying the drawings of other masters, as opposed to completed paintings and sculptures, in Florence after 1500. Copying such works was already a traditional feature of local graphic practice. Cennino Cennini, in the previous century, had even recommended copying select works of art *prior* to drawing after nature.[5] Copies and derivations after Michelangelo's "ideal head" (*testa divina*) studies serve as the clearest example, after that of the two battle cartoons, of this phenomenon of drawings as a source of influence (figs. 1 and 2). The surviving works of Raphael, Vasari, and Francesco Salviati

Fig. 1 Michelangelo, *Ideal Heads (Venus, Mars, and Cupid)*, c. 1526, black chalk, 35.6 x 25.7 cm. Galleria degli Uffizi, Florence (598E recto)

Fig. 2 Rosso Fiorentino, *Ideal Head*, c. 1525, black chalk, squared with stylus, 17.9 x 14.7 cm. Fogg Art Museum, Harvard University Art Museums, Cambridge, Mass. (1979.67)

19

provide other instances of the direct copying of drawings (see cat. nos. 3, 62, 120).[6] Such copies should not be perceived as mere reproductions or records, however, as they could be made in a spirit of criticism as much as of admiration, or even with a desire to improve on the original. ¶ Florentine artists could also be generous in the distribution of drawings, even whole compositions, as gifts to others, to be transformed into commissioned paintings. Rosso Fiorentino's provision of designs for Domenico Alfani in Perugia, and Giovanni Antonio Lappoli's for the young Vasari in Arezzo provide securely attested examples of this sort of exchange, which went far beyond simple tokens of friendship.[7] Michelangelo occasionally made drawings for his artist friends to assist them with major commissioned works in Florence. He provided such drawings for Francesco Granacci, who was working on an altarpiece for the church of Sant'Apollonia, and for Giuliano Bugiardini for an altarpiece in Santa Maria Novella, as well as cartoons that Jacopo da Pontormo transformed into finished paintings.[8] Vasari himself provides later examples of the same practice, as in the instance of the use of his designs by the Bolognese artist Prospero Fontana.[9] The dependence in this period on prints as a source, including those by northern European artists, has also been recognized, and the printed line's attraction for Florentines as material to be translated into a drawn line should be stressed. ¶ With this form of sophisticated interchange in mind, it seems reasonable to view the approach of Florentine artists to drawing as one of coherence and common purpose within a shared heritage. Before considering further examples of the practice, however, it will be useful to examine how "drawing" was defined in Florence in written texts that would now be termed "art theory," starting with Vasari's *Lives of the Artists*, which was first published in 1550. For Vasari, *disegno* (the Italian word for drawing) had two related but distinct meanings.[10] It meant drawing well in the sense of manual competence developed through lengthy study, but it also denoted design or invention in more abstract or conceptual terms, thereby expanding the compass of the term beyond the preparatory and technical to the analysis and appreciation of an object. Drawing originated from the intellect as much as from the intuitive hand; it was, for the artist, a means of thinking. Yet the component of the definition of *disegno* that denoted the actual craft of drawing also needs to be stressed, as it was the practical, mechanical basis for the creativity of Florentine artists, and was part of the workshop domain from which scholars were excluded for reasons of social decorum. ¶ The additions in the second, expanded edition of Vasari's *Lives of the Artists*, published in 1568, directly reveal the ambitions of a new body founded in Florence in 1563 under the patronage of Duke Cosimo I de' Medici – the Accademia del Disegno.[11] The Accademia was created in part as an attempt to raise the intellectual and social stature of Florentine architects, painters, and sculptors, and it was their ambitions that provided the catalyst for the codification of *disegno* in written expositions. The Accademia del Disegno augmented the activities of the Compagnia di San Luca, a religious confraternity founded in the mid-fourteenth century that was largely composed of artists and continued to carry out such practical functions as the burial of the dead. The Accademia del Disegno expanded in 1571 when many artists renounced their membership in the traditional guilds, and it survived until the founding of the Accademia di Belle Arti by the Grand Duke of Tuscany in 1784. The Accademia had rooms in Florence, and it appears to have supported formal lectures, as well as life drawing sessions and the study of anatomy. It cannot be assumed, however, that attitudes toward drawing promoted by the Accademia and published by Vasari precisely reflected past practice, as the Accademia del Disegno had its own agenda to promote with regard to practical and consistent teaching methods, as well as to the intellectual and social ambitions of its members. Any reference to a coherent and unified history of Florentine drawing prior to 1550 must make allowance for the vagaries of individual

approaches and examples. ¶ What types of drawings did artists in Florence produce in a period dominated by the examples of Leonardo and Michelangelo? Given their sophisticated use of the medium, it might be assumed that the practice of drawing was deliberate and methodical, although the result was certainly not programmatic. However, even Vasari's *Lives of the Artists*, which provides so much source material for art history as a written discipline, lacks a technical language flexible enough to provide consistent definitions.[12] It is, nonetheless, possible to identify some categories of drawing, although the order and procedure they imply are illusory. ¶ The *primo pensiero*, the initial and most elementary sketch in the design process, was typically executed on a small scale. Generally produced in pen and ink, although chalk was also used (see cat. no. 33), drawings of this type were distinguished by their loose and free handling, as the artist sought to

explore different solutions for a design without concerning himself with detail. Even these drawings, however, were often executed with an underdrawing and so were not necessarily truly spontaneous. All artists must have made numerous drawings of this type, but because they were more freely discarded they do not often survive. Their lack of finish also made them less desirable to the earliest collectors, which further explains their low survival rate. Those executed by Leonardo (fig. 3) are an exception to this rule, as they were, fortunately, considered worth preserving. ¶ These initial sketches were refined through studies of individual figures in a composition. The figure study, which may be regarded as the definitive type of Florentine drawing, could encompass a considerable range, from the anatomical study of a figure to the nude study to the drawing of a fully clothed figure in a complex pose. Heads and facial expressions might also be studied on separate sheets. Many of these drawings were produced in workshops, with studio assistants as models. Florentine artists also used aids other than live models in their production of the figure study, with its implications for contour line, dimensionality, and movement. Such aids included mannequins or sculptural models, made of wax or terracotta, all of which had a constancy and availability often lacking in a living model. In Florentine practice, it was traditional for figures that would be clothed in the final work to be represented initially as nudes, so that the anatomy and underlying structure of the body would be thoroughly understood from the start. The drapery study, which was usually concerned with the elaboration of the drapery folds on a single figure, was a subcategory of the figure study. Not all figure drawings produced in Florence were made from posed models, however. Some artists, such as Michelangelo and, later, Pontormo and Rosso, undoubtedly had the image of an ideal figure in mind and could elaborate a study purely from their imagination (figs. 4 and 5). One of the main purposes of a successful figure drawing was to communicate human

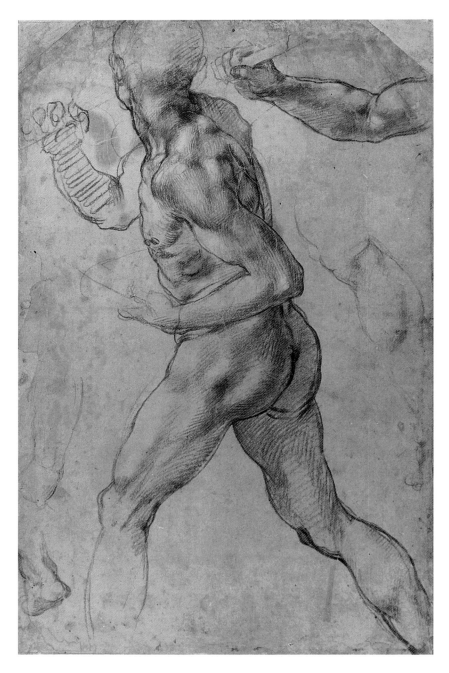

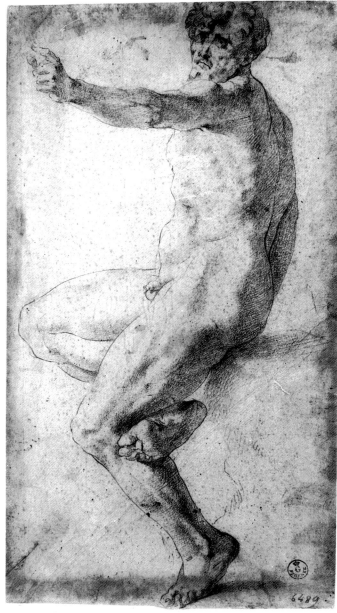

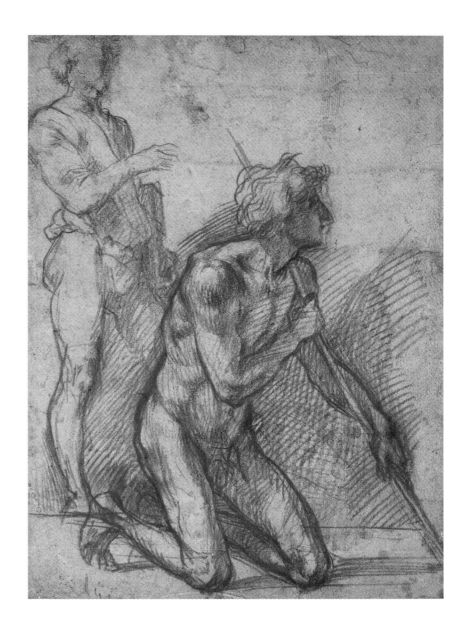

movement and gesture, as Michelangelo indicated in his critique of Albrecht Dürer's study of proportions, which he found overly restrictive and, in the end, almost without purpose.[13] In the figure drawings of Michelangelo, Pontormo, and Rosso, the scale of the figure in relation to the sheet on which it is represented is often unconventional. Compared to some of their exaggerated creations, the figure drawings of Fra Bartolommeo and especially those of Andrea del Sarto (fig. 6) seem more humane, even disarmingly modest and traditional. ¶ The compositional drawing was one in which a group of posed figures was arranged in a coherent and emotionally charged design. Technically, drawings of this type would be produced in chalk alone, but some might be executed in a more elaborate range of materials, as the artist began with an underdrawing to block in the composition, but went on to use wash or white heightening to approximate more fully the light and shade depicted in the final work. Compositional drawings could be constructed logically in an aggregate manner from individual life studies, but generally they had little connection with the studio model and were based more on the artist's purely creative imagination. Again, there was a considerable range: it was

Fig. 4 Michelangelo, *Study of a Male Nude for the Battle of Cascina*, c. 1504, black chalk, 40.4 x 26 cm. Teylers Museum, Haarlem (A19)

Fig. 5 Rosso Fiorentino, *Seated Male Nude*, c. 1523, red chalk, 39.6 x 21.6 cm Galleria degli Uffizi, Florence (6489F)

Fig. 6 Andrea del Sarto, *Study of Kneeling and Standing Figures*, c. 1528, red chalk, 28 x 20.2 cm. British Museum, London (1896-11-18-1)

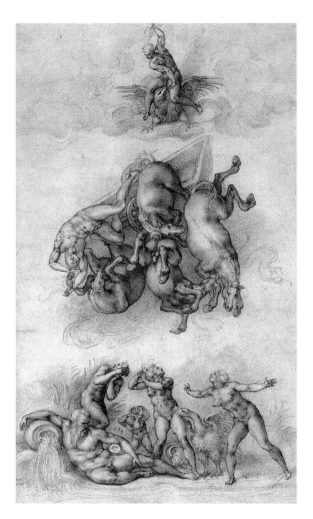

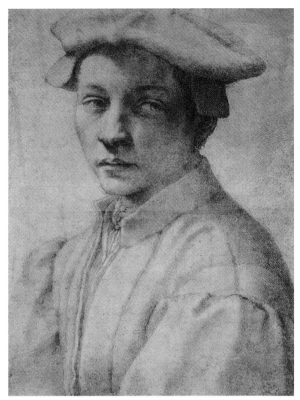

possible for Sarto to compose a design smoothly and logically from the aggregation of separate life drawings, whereas Pontormo preferred to generate somewhat elaborate designs, in which rhythm and the interlocking of bodies took precedence, from his imagination. ¶ The *modello*, a drawing made for the approval of a patron, was the ultimate redaction of the compositional drawing. For the sake of legibility and clarity, drawings of this type were generally more polished, which is why they belong in a category of their own. They were usually produced with the fullest possible range of available materials, including prepared or coloured papers (see cat. no. 54). There are many instances, however, of artists completely altering a design between the *modello* stage and the finished piece. Bronzino's study (now in Frankfurt) for the ceiling of the Eleonora chapel in the Palazzo Vecchio provides a well-documented example.[14] Thus the *modello* did not necessarily signify the end of the production of a particular design, and an artist might return to all of the previous stages – the *primo pensiero*, the figure study, and the compositional drawing – even this late in the process. ¶ The cartoon – a full-size preparatory drawing, concentrated on the outline of the image, which could

be transferred from paper to the requisite support, such as the wall to be covered – was the final stage in the design process. Typically, cartoons were executed in charcoal or black chalk, handled in a relatively broad manner. Because they had a practical use, cartoons were often destroyed during the final act of creation, and therefore very few survive. Those that do are often little more than damaged fragments (fig. 7). At this late stage in the development of a design, particularly in Florence, a master might not feel the need to participate further in the production of the finished work, except as a supervisor. With the design fully resolved, his work might be considered complete. The fact that Florentine artists (in contrast to the Venetians) did not, as a rule, create or significantly revise their compositions directly on the support shows how vital the cartoon was in the design process: it was essentially the finished work of art. ¶ It is apparent from this survey of the types of drawings produced in Florence during the first half of the sixteenth century that most of them were entirely functional – a means to an end during the preparatory process. Some drawings have survived, however, that were clearly intended as fully realized works in their own right, and these are now commonly referred to as presentation drawings. They emerged in part as a means by which patrons could obtain some type of finished work from artists who were much in demand but who had notoriously slow working methods. Leonardo and Michelangelo – the latter especially toward the end of his career (fig. 8) – each produced influential works in this category. Presentation drawings might feature relatively erudite subject matter, but many portrait drawings also belong in this category. Michelangelo's *Portrait of Andrea Quaratesi* (fig. 9) is one of the better-documented examples of these, although finished head studies also appear in the work of Fra Bartolommeo. Some of Sarto's head studies (see cat. no. 34) give the impression of being private, informal works with a deeply personal meaning, and they are among the most evocative sketches of the entire period. ¶ Outstanding drawings of landscapes and animals and even genre studies by Florentine artists, in particular Leonardo and Fra Bartolommeo, do survive, but few informal drawings of this type by such central figures as Sarto, Rosso, and Pontormo are known. This may simply be chance, although certainly the general loss of sketchbooks would partly account for such an imbalance. Two sets of the finest examples of landscape drawings from the period, by Fra Bartolommeo and Antonio di Donnino del Mazziere (fig. 10), may once have been in sketchbooks, and some were likely produced in front of the motifs themselves.[15] Yet it is clear that there was a traditional Florentine prejudice, shared by Michelangelo, against the depiction of landscape, which would help to account for the general absence of objective nature studies. More to the point, the treatment of the human figure, and in particular the male nude, was so fundamental to Florentine art practice that it is not surprising that the majority of drawings to survive from the period depict figures and were produced with a particular composition in mind. Indeed, compared to artists in the fifteenth century, those active in the first half of the sixteenth century seemed more limited in their selection of themes and materials, with the notable but telling exception of Leonardo. In this context, the significance of the two cartoons made for the battle frescoes in the Palazzo della Signoria must be stressed, as the cartoons communicated directly to artists the primary concern of both Michelangelo and Leonardo to represent figures in motion, even if their approaches differed. Michelangelo established a new canon for the powerful three-dimensional treatment of the male nude in action, whereas Leonardo set a new standard for vigour and variety in the emotional description of figures. While the influence of these two geniuses was universal, their effect on particular artists varied considerably. Pontormo's compositional drawing for the *Baptism and Victory of the Nine Thousand* (cat. no. 63) betrays, for example, an ambitious desire to combine the two not entirely compatible approaches of Michelangelo and Leonardo in one design.

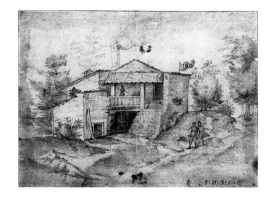

Fig. 7 Andrea del Sarto, *Head of Saint Joseph*, c. 1525–1528, black chalk with traces of white chalk, 11.7 x 23.5 cm MacKenzie Art Gallery, Regina (35-3)

Fig. 8 Michelangelo, *The Fall of Phaeton*, 1533, black chalk, 41.3 x 23.4 cm. Royal Library, Windsor Castle (12766 recto)

Fig. 9 Michelangelo, *Portrait of Andrea Quaratesi*, c. 1532, black chalk, 41.1 x 29.2 cm. British Museum, London (1895-9-15-519)

Fig. 10 Antonio di Donnino del Mazziere, *Landscape*, c. 1527, red chalk, 21.2 x 27.8 cm. Musée Bonnat, Bayonne (1293)

¶ What types of materials and tools did Florentine artists in the period after 1500 like to use? It is possible to identify some very general trends. In the overwhelming majority of instances, they preferred plain cream paper for their drawings. In special circumstances, they would prepare the paper using coloured washes made with chalk, as in Pontormo's "Corsini sketchbook" (see cat. no. 68), and on this paper they would use both chalk and pen and ink. Coloured surfaces were also used in the production of *modelli* drawings, when the artist wanted to replicate a finished work in the fullest possible range in order to gain approval from a patron (see cat. no. 54). The use of natural blue paper of the type favoured by Venetian artists does not appear to have been common in Florence – presumably in part because of its relative lack of availability – except, again, for *modelli*. Following a trip to Venice around 1540, Vasari and Salviati became more intrigued by the expressive possibilities of blue paper, and later artists such as Maso da San Friano (fig. 11) followed their example. ¶ With regard to the selection of drawing tools, two surprisingly distinct approaches are evident, one based on the use of pen and brown ink, and the other on red or black chalk, each inspired in its own way by the examples of Leonardo and Michelangelo. By 1500, these media had gradually replaced the use of metalpoint on carefully prepared surfaces. Indeed, by far the majority of drawings produced in this period in Florence were executed in one of these two media, often in conjunction with washes and white heightening for added tone. This technical shift reflects a search for greater monumentality and a more emotionally intense presentation of the human form. The use of metalpoint did not disappear entirely, but it became almost a curiosity, or perhaps an instance of simple nostalgia.

¶ The most consistent and innovative use of pen and brown ink is traceable, above all, through the sculptors, especially Baccio Bandinelli, Tribolo, and Cellini. As far as can be established from what survives, Bandinelli in particular among the Florentine sculptors explored the enormous potential of pen and ink to produce a broad, dramatic effect in drawings with a whole range of purposes (see cat. nos. 90, 92–94), although he might still depend on chalk for figure studies (fig. 12). Though not a sculptor, Jacone used pen and ink in a yet more aggressive, almost careless manner and produced some of the most unusual sketches of the entire period (see cat. nos. 66, 67). ¶ Vasari and Salviati, while still depending on a variety of media at different stages in the design process, made a particular contribution to the history of drawing in Florence in their reliance on pen and brown ink. Vasari's commission from the newly installed Duke Cosimo I de' Medici to decorate a large number of vast rooms in the Palazzo Vecchio altered his attitude toward drawing and how it would be defined in the period (see cat. no. 110). Vasari employed talented and prolific younger artists, including Giovanni Battista Naldini, Jacopo Zucchi, and Johannes Stradanus, and he was motivated by the need for a codified drawing procedure and style that would be easily comprehensible to and repeatable by different artists. Better than any other drawing tool, pen and ink suited his need for brevity and clarity, qualities that were especially important in the preparation of finished designs. The style pioneered in the Palazzo Vecchio by Vasari (fig. 13) and his workshop was used for other types of commissions, from temporary decorations to altarpieces. ¶ In comparison to pen and ink, chalk had been a less commonly used medium in Florentine drawing, and so its implementation in the early sixteenth century was a somewhat more radical departure from tradition. It was the dominant drawing tool for Sarto and, through his example, for the young Rosso, Franciabigio, Pontormo, and Pier Francesco Foschi, among others. Sarto was an especially accomplished master of red chalk (see cat. nos. 30–35), probably inspired by the example of Leonardo, who was the first to use red chalk so intensively. Red chalk inherently tends to be harder and more linear than black chalk, with less of a graduated range, and it was well suited to the dramatic figure studies in the work of these

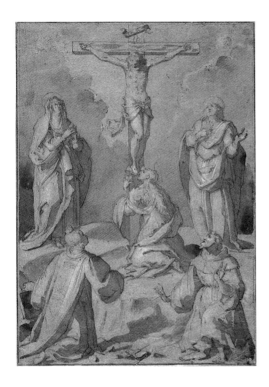

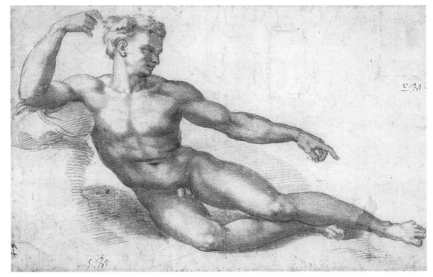

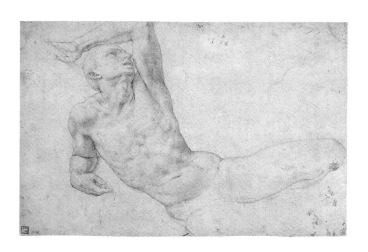

Fig. 14 Agnolo Bronzino, *Figure Study*, 1552, black chalk, 27.2 x 40.1 cm Isabella Stewart Gardner Museum, Boston (IV1966)

Florentine masters. Rosso, also in Florence in the earlier part of his career, used red chalk almost exclusively, partly as a result of his contact with Sarto's workshop. ¶ Pontormo was dominant in Florence in the period following Sarto's death in 1530, and the purity and discipline of his approach to drawing are remarkable. While he continued to use red chalk, his most innovative later drawings are those executed in black chalk and occasionally in charcoal (see cat. no. 73). Black chalk had earlier been used to miraculous effect by Michelangelo in his drawings of male nudes for the Cascina cartoon, and these directly inspired Pontormo. Through Pontormo's influence on Bronzino, who preferred a relatively tighter finish (fig. 14), the traditional use of black chalk in Florentine art would be sustained through yet another generation, to Alessandro Allori. ¶ Broadly speaking, Sarto's and Pontormo's emphasis on chalk and Vasari's on pen and ink were the result of two different needs – one for the uncluttered representation of the human body in motion, and the other for the treatment of narrative, as influenced by the grace and fluidity of Raphael's work in Rome. The impact of Vasari's workshop, powerfully reinforced for artists and patrons alike by the writing contained in his *Lives of the Artists*, effectively ended the emphasis on the figure in Florentine art practice, whose lineage can be traced from Giotto through Michelangelo to Pontormo, in favour of a more socially aware art that concentrated on transmitting expressive and literary content.

¶ Given that Florence was a place where drawing as a discipline was central to the creative process, it is not surprising that it was also the city where the collection of works on paper began to have a documented history. This is an important subject in its own right, as the types of drawings collected have a significant effect on the perspective of modern scholarship. The respect that collectors had for the drawings of certain artists often helps to account directly for their survival. For example, the Medici family identified Pontormo's drawings as desirable early on, and now about four hundred survive, almost all in the Uffizi. However, the general absence of drawings by Bronzino indicates that fame and important patronage were no guarantee in this regard. Some workshops played a role in the preservation of drawings, valuing them as designs to be used in future projects and so treating them as irreplaceable. This was the case with Sarto's drawings, but the best-documented example is provided by Fra Bartolommeo, whose assistants, following his death in 1517, kept together more than one thousand drawings that were in his workshop; almost all of them still survive, the majority in Rotterdam.[16] Although Fra Bartolommeo's range as a painter was somewhat limited, his surviving corpus of drawings illustrates better than any other the array of techniques and subjects available to a sixteenth-century Florentine artist, with the exception of the unorthodox Leonardo. Franciabigio provides a counter-example to Fra Bartolommeo:

only about a dozen of his drawings survive, indicating a low reputation at the time of his death and the complete loss of his studio effects. Domenico Puligo is another example of an artist who was not succeeded by any important pupils and whose drawings do not appear to have been particularly valued. A few Puligo drawings, mostly in red chalk and in a style derived from Sarto, still exist, but none of them can be linked to a surviving work.[17] (It is difficult to understand, however, why almost no drawings have been securely attributed to Ridolfo Ghirlandaio, an artist who had perhaps the largest workshop in Florence in the sixteenth century and successful artistic heirs.) One additional factor that could influence the chances of survival of an artist's drawings was the determination of his family, after his death, to build up his reputation so that, as descendants of a great and distinguished forebear, they might be admitted into the nobility. The family of Baccio Bandinelli safeguarded a large number of his drawings for just such a reason, which helps to account for the fact that as many as five hundred of them have come down to us.[18] ¶ Vasari is the main source of information on private collectors of drawings in this period, and he cites a number of cases of particular collectors owning individual drawings, some of which can now be connected with surviving sketches. But it was his own collection of drawings – the *Libro de' Disegni* – that represents the most telling and novel instance of this new type of systematic cataloguing.[19] Vasari's establishment of an ambitious model for later collections of drawings was a truly original and pioneering achievement, and in its emphasis on the Florentine artists it codified an entire tradition – a tradition at the heart of one of the most significant schools the history of art has ever seen.

Notes

1 Surprisingly, considering the importance of drawing in Florentine art history, there have been very few attempts to survey the subject. One major exception, to which this essay is much indebted, is C. Monbeig Goguel's article "Il disegno fiorentino del Cinquecento: Uso e funzione," in *Storia delle Arti in Toscana: Il Cinquecento*, ed. R.P. Ciardi and A. Natali (Florence, 2000), pp. 255–275. See also A. Forlani Tempesti, *Capolavori del rinascimento: Il primo cinquecento toscano* (Milan, 1983), pp. 4–11.

2 B. Cellini, *The Treatises of Benvenuto Cellini on Goldsmithing and Sculpture*, trans. C.R. Ashbee (New York, 1967), p. 2. For the original Italian see *Benvenuto Cellini: Opere*, ed. B. Maier (Milan, 1968), pp. 625–626.

3 Vasari 1986, p. 889. On the reaction to these cartoons see, among others, C.C. Bambach, *Drawing and Painting in the Italian Renaissance Workshop* (Cambridge, 1999), pp. 251–252.

4 *Michelangelo: Life, Letters, and Poetry*, ed. G. Bull (Oxford and New York, 1987), p. 64. For the original Italian see *Il Carteggio di Michelangelo*, ed. P. Barocchi and R. Ristori (Florence, 1973), vol. 3, p. 7.

5 C. Cennini, *The Craftsman's Handbook*, trans. D. Thompson, Jr. (New York, 1960), pp. 14–15.

6 On copying in general and its place in art training in Florence see P. Costamagna, "L'étude d'après les maîtres et le rôle de la copia dans la formation des artistes à Florence au XVIᵉ siècle," in *Disegno: Actes du colloque* (Rennes, 1991), pp. 51–62.

7 See Franklin 1994, pp. 105–106, 157–161.

8 Franklin 2001, p. 75.

9 See F. Härb, "Prospero Fontana alias Giorgio Vasari: Collaboration and the Limits of Authorship," in Monbeig Goguel et al. 2001, pp. 577–608.

10 For the definitions see Barzman 2000, pp. 144–151. L.J. Feinberg, *From Studio to Studiolo*, exh. cat. (Oberlin, 1991–1992), defines drawing specifically under Duke Cosimo I de' Medici.

11 Ważbiński 1987. There is an extensive bibliography on the Accademia del Disegno.

12 On this point see P. Rubin, "Answering to Names: The Case of Raphael's Drawings," *Word and Image* 7 (1991), p. 39.

13 *Michelangelo: Life, Letters, and Poetry*, p. 64. For the original Italian see A. Condivi, *Vita di Michelangelo Buonarroti*, ed. G. Nencioni (Florence, 1998), p. 57.

14 Smyth 1971, p. 11.

15 On this subject see Fischer 1990b, pp. 375–400. For del Mazziere see the entries of M. Sframeli in Florence 1996, no. 92–93.

16 Fischer 1990b, pp. 12–13.

17 A. Forlani Tempesti, "Sul Puligo disegnatore," in Florence 2002, pp. 55–64.

18 Vasari-Milanesi 1878–1885, vol. 6, p. 190.

19 Ragghianti Collobi 1974 remains fundamental.

The quotation in the essay title is from M. Poccianti, *Vite de' Setti Beati*, Fiorentini Fondatori del Sacro Ordine de' Servi (Florence, 1589), p. 29.

"INGENIOUS AND SUBTLE SPIRITS"
FLORENTINE PAINTING IN THE FIRST HALF
OF THE SIXTEENTH CENTURY

LOUIS A. WALDMAN

(as it was for later Venetian artists and the Carracci), the painting of early-Cinquecento Florence exerted an inescapable influence on the future course of Western art.

¶ Scholarship in the last decade or so has seen a growing appreciation of the diverse strands inherent in Florentine sixteenth-century painting – in which a wealth of differing styles coexisted, serving the tastes of a variety of patrons and audiences. The history of Florentine painting looks less tidy than it did a generation ago – but it is its very complexity that has enabled us to appreciate the works of long-forgotten artists, and even the diversity of styles practised by individual masters. ¶ Since the early decades of the Quattrocento, Florence's government – nominally a constitutional republic – had been under the de facto domination of the Medici. Beginning with Cosimo the Elder, this family of bankers had used art patronage – in their own commissions and in the public art projects they influenced – both to glorify the city and to legitimate their own role in the political life of the state. At a time when *magnificenza* (civic-minded philanthropy) was viewed as a quality befitting a monarch, the Medici justified their quasi-monarchical rule by means of artistic embellishments of the city and its buildings. Cosimo's leadership role, and his conspicuous support of the arts and learning, were carried on by his son Piero the Gouty and by Piero's son Lorenzo, himself a learned poet and humanist, whose support of humanistic scholarship and the arts won him the epithet *il Magnifico*. The rule of the early Medici, though it would come to be described as a golden age by later panegyrists, was marked by constant conflict with pro-republican factions, rival families, and hostile foreign powers.

¶ The most decisive blow to Florence's *Pax Medicea* came in 1494, in the wake of the military campaign waged by the French king Charles VIII to conquer the kingdom of Naples. Lorenzo's son, known to history as Piero the Unfortunate, took sides against France (Florence's traditional ally), and the outraged citizenry of Florence exiled him, establishing a new republican government that would endure, in changing forms, until 1512. The terror unleashed by the French invasion led to the political ascendancy of the Dominican preacher Girolamo Savonarola, who had predicted a similar disaster as punishment for the Florentines' sinful, materialistic ways. Claiming to be a divinely inspired prophet, Savonarola came to exercise almost dictatorial powers over the Florentines, until a series of reversals led to his execution at the stake in 1498. Many artists joined the ranks of the *piagnoni*, or "weepers," as Savonarola's followers were called; in 1500 the painter Baccio della Porta heeded the call, taking the cloth as Fra Bartolommeo. Others, like the painter Lorenzo di Credi, modified the elegance of their earlier styles in favour of a chaste, simple manner, as prescribed by Savonarola, whose sermons reveal an intense interest in art. ¶ The trend toward an unadorned, somewhat archaizing "Savonarolan" manner can be seen nowhere more clearly than in the works painted after 1500 by Sandro Botticelli, who adhered to the movement for years after the prophet's death. The inscription, in Greek, on his *Mystic Nativity* of 1501 (fig. 15) records the painter's belief in Savonarola's claim that the Florentines were living through the last days of the world, foretold by Saint John in the Apocalypse – after which Christ would return to earth and usher in a millennial reign of peace and harmony.[4] Botticelli was one of a number of important older masters who kept alive the stylistic preoccupations of an earlier era during the opening years of the Cinquecento. His pupil, Filippino Lippi, until his death in 1504, continued the graceful classicism that had animated his master's works of two decades earlier, and Lippi's fifteenth-century manner was sustained for

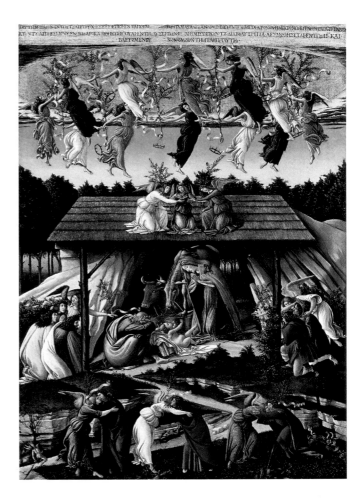

Fig. 15 Sandro Botticelli, *Mystic Nativity*, 1501, oil on panel, 108.6 x 74.9 cm National Gallery, London

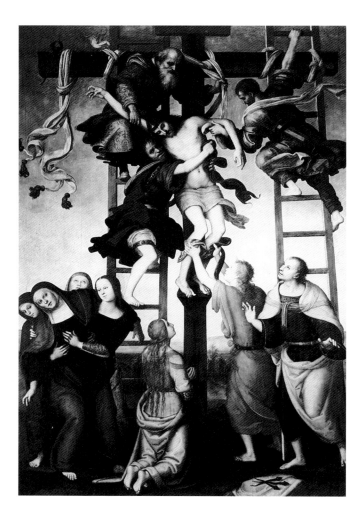

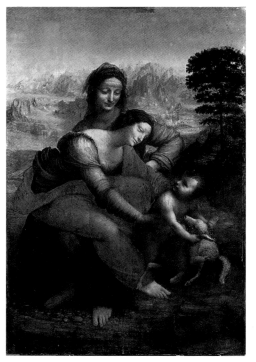

Fig. 16 Filippino Lippi and Pietro Perugino, *The Deposition from the Cross*, c. 1506, oil on panel, 333 x 218 cm Galleria dell'Accademia, Florence

Fig. 17 Leonardo da Vinci, *The Virgin and Child with Saint Anne*, c. 1508–1513 (?), oil on panel, 168 x 130 cm. Musée du Louvre, Paris

Fig. 18 Leonardo da Vinci, *Mona Lisa*, begun 1503, oil on panel, 77 x 53 cm Musée du Louvre, Paris

years by pupils such as the mysterious Master of Memphis.[5] ¶ A poignant view of the generation of painters active at the beginning of the sixteenth century emerges in Vasari's account of the Umbrian painter Pietro Perugino, who worked extensively in Florence during his later years. Though the biographer praises Perugino for introducing a "new and more vivid beauty" into painting, he reports that the high altarpiece for the church of Santissima Annunziata, begun earlier by Lippi and completed by Perugino around 1506 (fig. 16), was criticized because it repeated motifs from earlier works. The story of Perugino's utter inability to understand how figures that had pleased before could suddenly have lost their appeal suggests the increasing importance accorded by the younger generation of artists (and the public) to the idea of *invenzione*, or originality, as an aesthetic criterion. When *invenzione* became a privileged element in artistic thought, art came to be characterized as an intellectual pursuit rather than as workmanlike production, and as a result the status of the artist was elevated.[6] ¶ The most articulate representative of the new conception of painting as an intellectual activity was Leonardo da Vinci. This great Renaissance polymath – painter, sculptor, inventor,

and student of nature – defined painting in his notebooks as nothing less than a process of investigating the natural world. Rather than a trade that produced altarpieces and portraits for the public, Leonardo called painting "the granddaughter of nature and the kin of God," deserving to be numbered among the sciences.[7] This emphasis on painting as a process of investigation rather than the making of a tangible product explains why Leonardo's oeuvre contains so few finished paintings. Contemporaries lamented this as a loss for art; on another level, however, it marked a radical new conception of what art could be. ¶ Leonardo had been in Milan during most of the last two decades of the Quattrocento, but his renewed presence in Florence during the first half-dozen years of the new century coincided with a seminal period in his work as a painter. In 1501 he exhibited a cartoon for a planned altarpiece in Santissima Annunziata, which was described by Fra Pietro da Novellara, an agent of Isabella d'Este:

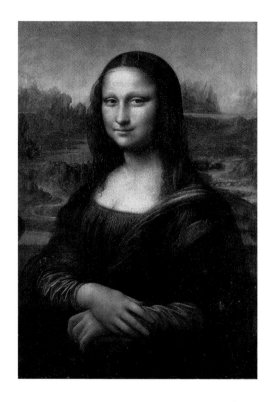

It depicts a Christ child about one year old, who, almost slipping from his mother's arms, grasps a lamb and seems to hug it. The mother, almost rising from the lap of Saint Anne, takes the child as though to separate him from the lamb ... Saint Anne, rising somewhat from a sitting position, seems to wish to keep her daughter from separating the child and the lamb ... And these figures are life-size, but they are in a small cartoon, because they are all either seated or bending over, and one is placed somewhat in front of another as they move from left to right.[8]

The Santissima Annunziata altarpiece was never executed, and only a sketch for the cartoon itself survives; a few years later, though, Leonardo painted a picture deriving from it, the *Virgin and Child with Saint Anne* now in the Louvre (fig. 17). Much of the novelty of Leonardo's painting resides in its unorthodox, compact composition, which had so impressed Pietro da Novellara. Nested within one another, the figures curve like coiled springs; their opposing movements create a dynamic counterpoise of visual axes, conveying a sense of restrained energy. Leonardo's emphasis on chiaroscuro, the contrast of light and shadow, infuses the painting with a powerful sense of atmosphere and unites the figures with the carefully observed landscape that surrounds them. His fascination with effects of shadow, and with the soft, hazy modelling made possible by the technique of oil painting, is most powerfully demonstrated in the *Mona Lisa* (fig. 18), which Leonardo probably began in 1503. If the portrayal of a woman in full frontal view, rather than the more traditional profile, was anomalous for the time, even more so was the complex and ambiguous expression with which Leonardo brought to life Lisa del Giocondo, the wife of a Florentine merchant. Although *Mona Lisa* stayed with Leonardo on his travels throughout his life, it must have been available for study during his Florentine sojourns, as its mysterious, evocative characterization inspired painters such as Andrea del Sarto and Raphael. ¶ Following the Florentines' burning of their "prophet" Savonarola in 1498, the city's republican government elected Piero Soderini

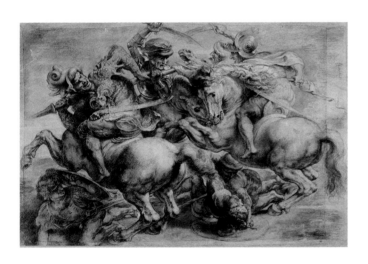

as its chief magistrate (*gonfaloniere*) for life. In 1503–1504 Soderini commissioned Leonardo and Michelangelo to decorate the newly built Sala del Gran Consiglio of the Palazzo della Signoria, the centre of the city's government, with mural paintings narrating Florentine military victories. Leon Battista Alberti, in his 1435 treatise *De pictura*, had characterized history painting as a painter's highest challenge, and the competing *Battles* designed by Leonardo and Michelangelo represent sixteenth-century Florence's most cogent and influential conceptions of painted *istoria*. Leonardo's contribution, the *Battle of Anghiari*, was only partially painted on the wall, and Michelangelo's design for the *Battle of Cascina* never went beyond a full-scale cartoon; both works are known to us today only through literary accounts, preparatory sketches, and partial copies. Nevertheless, in different ways they cast a long shadow over the course of Florentine painting. Leonardo's *Battle of Anghiari* (see fig. 19) focused on the violent clash of men and horses locked in desperate combat; their writhing forms and furious expressions lend a sense of immediacy to the battle and recall Leonardo's dictum that the painter and the poet share the goal of rendering visible the movements of the mind of man.[9] His composition – at the same time tightly interwoven and dynamically whirling – profoundly influenced the painting and sculpture of artists such as Giovanni Francesco Rustici (see cat. nos. 7 and 14). Michelangelo's *Battle of Cascina* cartoon could hardly be more different. Michelangelo chose to depict not the battle itself, but rather an earlier incident, in which the Florentine militiamen were surprised by a call to arms while bathing in the Arno. That unorthodox iconography allowed him to focus all his attention on the theme of the heroic male nude. Vasari relates how the *Cascina* cartoon became something like a school for the younger generation of Florentine artists, who studied its statue-like figures in order to learn the secrets of portraying the human body in all its possible movements; many of the poses in the *Battle* would later reappear, transformed, in their works. Michelangelo's approach to colour, unlike Leonardo's, remained rooted in the fifteenth-century practice of his teacher, Domenico Ghirlandaio; in the *Doni Tondo*, painted around 1503 for the Florentine merchant Agnolo Doni (fig. 20), clear local colours modelled from dark to light, or *cangiante* (which, like Joseph's golden mantle, change hue as well as value in the shadows), adhere within each figure's linear contours. *Disegno* – drawing and linear design – reigns supreme. Uninterested in Leonardesque *sfumato*, Michelangelo predominantly used the old-fashioned technique of tempera for his panel paintings (although the *Doni Tondo* also has layers of glazing in oil, its application is very similar to the traditional manner of applying tempera). ¶ At the time when Leonardo and Michelangelo were at work on their murals for the Palazzo

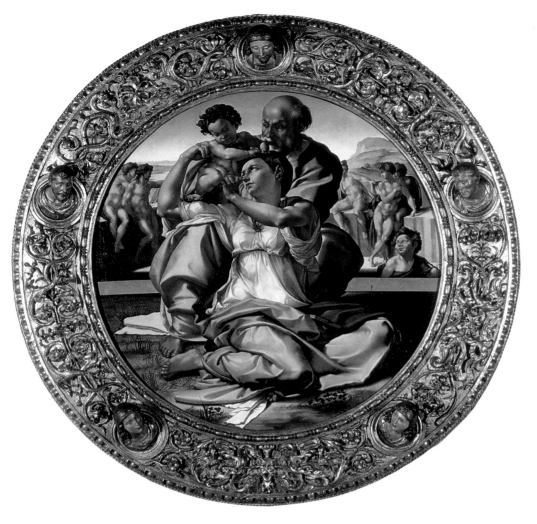

Vecchio, the teenaged Raphael settled in Florence, following in the footsteps of his teacher, Perugino. Raphael's brief sojourn in Florence (c. 1504–1508) marked a period of intense productivity. In at least seventeen surviving paintings of the Virgin and Child or the Holy Family, and a variety of other major works, Raphael transformed the graceful Peruginesque style of his earlier works into a new, monumental, and essentially modern idiom. A work like the *Madonna of the Meadows* (fig. 21), with its compact pyramidal composition and its integration of figures with landscape, demonstrates how earnestly the young painter had risen to the challenges posed by Leonardo's recent painting in Florence. Two portraits painted during this period, representing Agnolo Doni and his wife Maddalena (fig. 22), recall something of the mystery – and even the compositional design – of the *Mona Lisa*, which Leonardo had begun just a few years earlier. Despite their fresh, clear colour, these portraits are imbued with an intensity of observation and a breadth of design that simultaneously exalts their sitters and renders them palpably real. ¶ If Leonardo, Michelangelo, and Raphael represented innovative trends that appeared in Florence during the first decade of the sixteenth century, a more

conservative strand of artistic inspiration flourished alongside them in the work of artists like the prolific Fra Bartolommeo. Together with Mariotto Albertinelli, with whom he frequently collaborated before becoming a Dominican friar at San Marco – Savonarola's own monastery – Fra Bartolommeo developed a remarkably popular style of painting, marked by formal restraint, a graceful, smooth, idealized draftsmanship, and meticulous handling of light. The many large altarpieces and innumerable small devotional pictures by Fra Bartolommeo and his followers – collectively known as the School of San Marco – offered the public an accessible and sincere devotional art, intimately tied to earlier traditions of Florentine religious art and characterized by a chaste, dignified simplicity. In Fra Bartolommeo's final works this style becomes coarser, tinged with a cumbersome Michelangelesque monumentality and less closely tied to observation of nature; this late, reductivist phase of the blandly pious San Marco idiom was continued in the work of two followers, Fra Paolino and Suor Plautilla Nelli. ¶ Another prolific artist who helped to generate a "school" of conservative painting was Ridolfo Ghirlandaio, the son of Michelangelo's teacher Domenico Ghirlandaio. Ridolfo too was greatly in demand as a painter of altarpieces, and patrons like Leonardo Buonafede, who commissioned many paintings from him on behalf of monastic foundations and benefactors of his hospital, were undoubtedly attracted to his pleasantly idealizing style, animated by a beguiling attention to nature. After about 1525, Ridolfo began collaborating with his adopted son, Michele Tosini, and the workshop's style drifted increasingly toward a coolly ideal style, influenced by Michelangelo and by the graceful elegance of younger artists like Rosso and Salviati. Judging from its surviving output, the workshop of Ghirlandaio and Tosini must have employed a great number of assistants; Vasari states that some of these artists – Bartolomeo Ghetti, for example – specialized in painting pictures for export to France or England. ¶ The commercial success of prolific artists such as Fra Bartolommeo and Ridolfo Ghirlandaio contrasts with the much more limited, but far more personal and original, oeuvre of Piero di Cosimo. As a young man Piero had painted alongside Botticelli and Perugino in the Sistine Chapel, but unlike the work of those older masters, Piero's never lost its technical brilliance and inventiveness. Although Vasari's portrait of Piero as an anti-social creature (living on eggs boiled fifty at a time in his glue-pot, refusing on principle to weed his garden, and beset by innumerable phobias and quirks) has been questioned by recent scholarship, there can be little doubt that for the author of the *Lives*, Piero was the antithesis of the ideal courtier-artist.[10] But Piero's elegant flights of imagination and exquisitely refined technique were appreciated by such cultivated and wealthy patrons as Francesco del Pugliese. Piero also remained engaged with the work of up-and-coming artists; his *Battle of Lapiths and Centaurs* (National Gallery, London) derives from the marble relief of the same subject carved a few years earlier by the young Michelangelo (c. 1490–1492, Casa Buonarroti, Florence), and his late works, such as the dramatic *Liberation of Andromeda* (fig. 23), suggest the influence of Leonardo's atmospheric handling of paint and use of light. The drama and poignancy of Piero's unconventional paintings, with their animated figures and expressive landscapes, suggest that he was a more compelling personality than the reclusive, misanthropic artist created by the pen of Vasari. ¶ The treatment that Piero di Cosimo has received in the historiography reflects one way in which art history remains bound up with the personal viewpoints and opinions expressed in Vasari's *Lives*. But other artists, many of them working for a more popular audience or specializing in minor commissions (such as small devotional pictures), were condemned to complete exclusion from the biographical collection, and as a result their works remained almost unknown for centuries. In the early 1960s, Federico Zeri coined the term Florentine Eccentrics to describe these painters – many of them still anonymous, and others known to us only as

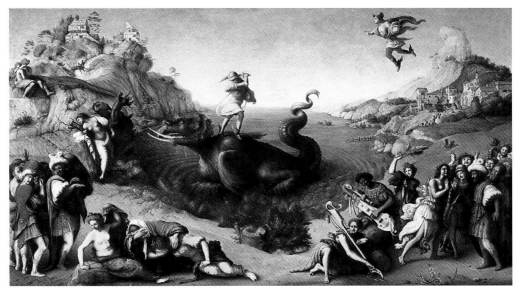

Fig. 22 Raphael, *Portraits of Agnolo and Maddalena Doni*, c. 1505–1506, oil on panel, 65 x 47.7 and 65 × 45.8 cm Galleria Palatina, Palazzo Pitti, Florence

Fig. 23 Piero di Cosimo, *The Liberation of Andromeda*, c. 1510–1513, oil on panel, 71 x 123 cm. Galleria degli Uffizi, Florence

Fig. 24 Andrea del Sarto, *The Madonna of the Harpies*, 1517, oil on panel, 207 x 178 cm. Galleria degli Uffizi, Florence

Fig. 25 Rosso Fiorentino, *The Virgin and Child with Saints John the Baptist, Anthony Abbot, Stephen, and Jerome*, 1518, oil on panel, 172 x 141 cm. Galleria degli Uffizi, Florence

documented names, with no known works.[11] Interest in the Eccentrics, fuelled by the publication of new works and by identification of long-anonymous masters, has opened a view to a long-neglected side of the Florentine art scene. Although many of them were uneven or even awkward as artists, rank-and-file painters like Giovanni Larciani, Giovambattista del Verrocchio, Bartolomeo Ghetti, Antonio di Donnino del Mazziere (see cat. nos. 51–53), and the Master of Serumido (possibly Mariotto Dolzemele; see cat. no. 25) reflect a significant but poorly understood segment of the art market. Their work is notable for the way it adapts ideas and models by more prominent artists to the tastes of a less affluent public.[12] ¶ An artist who worked throughout his life on both humble and upscale commissions was Andrea del Sarto, whose first public commission, begun in 1509, was a series of frescoes depicting the life of Beato Filippo Benizzi, for the Chiostrino dei Voti in the Florentine church of Santissima Annunziata (see cat. no. 42). The recent discovery of a contract has revealed that the friars intended Sarto to paint all the vacant spaces in the Chiostrino, but after completing the Filippo Benizzi cycle and beginning a new cycle of the life of the Virgin, he ceased work there. Of the

three remaining scenes in the Marian cycle, one was supplied by Sarto's contemporary, Franciabigio, and the other two were painted by Pontormo and Rosso, who were pupils of Sarto. ¶ The famous epithet now inscribed on Sarto's house in Via Gino Capponi, the "painter without errors," derives from the faint praise with which his own pupil, Giorgio Vasari, damned him in the *Lives*. In Vasari's account, Sarto's career became a cautionary tale of opportunities wasted, from his refusal of a generously paid position at the court of Francis I to his failure to spend an extended time in Rome, where he might have fully assimilated the ancients and the mature work of Michelangelo and Raphael.[13] ¶ In twentieth-century historiography, Sarto often appears as the exponent of a "classical" style, against which artists like his pupils Rosso and Pontormo rebelled with a more lively, experimental, "Mannerist" mode. But the notion of Mannerism as a style is now coming to be recognized as an anachronistic construct with few direct connections to sixteenth-century art theory; today it seems much less useful to repeat the paradigm of Cinquecento painting as a dialectical struggle between "classical" and "anti-classical" styles than to submit the works themselves to a fresh examination.[14] A recent reappraisal of Sarto's career by David Franklin has offered a challenge to the idea that he was a purely "classical" painter, pointing out that any of the characteristics found in the work of Rosso and Pontormo – intense emotional drama, for example, or unorthodox open compositions – were present already in Sarto's early work.[15] Sarto gradually moved away from the softer, lyrical manner of the 1510s toward a style of great structural rigour and monumentality. A painting such as the *Madonna of the Harpies* of 1517 (fig. 24) demonstrates an intense concern with the picture's underlying compositional geometry. The lighting is softly shaded, in a manner recalling Leonardo, and envelops the whole composition in a warm, atmospheric glow. In his later paintings Sarto's brushwork grows more precise and controlled, and his treatment of drapery takes on an almost abstract, faceted quality that profoundly influenced Rosso Fiorentino. ¶ Like Sarto, Francesco di Cristofano, known as Franciabigio, was content to spend his entire career working for Florentine patrons. In 1505 he formed a partnership with Sarto, and over the next few years they collaborated on several commissions. Not surprisingly, Franciabigio's early style is closely related to Sarto's, with traces of the conservative mode of Ridolfo Ghirlandaio. His later work, though displaying little of the compositional formality found in Sarto's painting, shares with it a profound interest in dramatic effects of light, often rendered through bold use of thick impasto brushwork. An ineffable sense of drama pervades many of his final works, such as the frescoed *Noli me tangere* (cat. no. 48), painted during the last months of his life. Franciabigio's portraits stand out as among the most remarkable Renaissance works in their genre. Apparently influenced by Leonardo (and perhaps also by Venetian painting), a picture like his atmospheric *Portrait of a Jeweller* (cat. no. 47) evokes a compelling sense of harmony between the sitter and his surroundings. ¶ Rosso Fiorentino, who got his start in the workshop of Andrea del Sarto, was a relentless formal experimenter. His early Florentine works are so original in conception, and so freely executed, that it hardly comes as a surprise that they baffled contemporaries. The patron of Rosso's *Assumption of the Virgin* fresco in Santissima Annunziata (1513–1514) even planned to destroy it. And Rosso's first altarpiece (fig. 25), with its unconventional figure types and free brushwork, was originally refused by its patron, Leonardo Buonafede; finally forced to pay, the patron packed it off to a remote country church and commissioned a replacement from his favourite artist, Ridolfo Ghirlandaio. Non-ecclesiastical patrons seem to have responded more favourably to the vivid style of Rosso's Florentine years. In the *Moses Defending the Daughters of Jethro* (cat. no. 58) commissioned by the violent whoremonger Giovanni Bandini, Rosso echoed the ferocity of Leonardo's *Battle of Anghiari*; his vortex of whirling figures, pressed close to the

Fig. 26 Jacopo da Pontormo, *The Lamentation*, 1524–1525, detached fresco, 300 x 290 cm. Certosa del Galluzzo, Florence

Fig. 27 Agnolo Bronzino, *Portrait of Eleonora di Toledo and Francesco de' Medici*, 1545, oil on panel, 115 x 96 cm. Galleria degli Uffizi, Florence

picture plane, seems ready to burst out of the confines of the frame. Rosso's portraits are among the most powerful Florentine works in the genre; each one hints at psychological complexities that lie beneath his elegant sitters' dandified composure (cat. no. 59).

¶ Rosso's companion in the workshop of Sarto, Jacopo da Pontormo, is equally remarkable for the protean transformations of his style; throughout Pontormo's career he seems to have been driven by a constant impulse to discover new expressive possibilities in composition, draftsmanship, and colour. But if Rosso's style mutated by fits and starts, Pontormo's oeuvre evolved gradually along a more consistent – though no less radical – trajectory. His earliest works, like the San Michele Visdomini altarpiece of about 1518 (fig. 68.1), recall the complex architectonic design of Sarto's work, but with a new sense of nervous energy created by its off-centre composition of figures glancing and gesturing in a variety of directions. The fresco cycle from the Certosa del Galluzzo (fig. 26, and see cat. no. 71) presents many of the features of Pontormo's mature style that modern historiography has tended to classify under the somewhat ahistorical term "Mannerist": the flattened or ambiguous treatment of space, an open or unbalanced composition marked by dynamic or "difficult" poses, a cool and intense palette, and distortion of the human figure for expressive effect. In his lifelong experimentation with the nude, Pontormo was fascinated by various stylistic models, from Dürer's prints, with their gangly, homespun naturalism (imitated, to Vasari's disgust, in the Certosa frescoes), to Michelangelo's idealized masterworks (a constant inspiration for him from the 1530s up to his death in 1557). From the time of Alessandro de' Medici's installation as the first duke of Florence in 1532, Pontormo enjoyed a position as a Medici court artist. Alessandro's successor, Duke Cosimo I, commissioned the iconographically unorthodox fresco cycle in the church of San Lorenzo in Florence that occupied Pontormo for the last ten years of his life. These paintings of Old Testament scenes, combined with imagery of the Last Judgement, were completed after his death by his pupil Bronzino, only to be destroyed in the eighteenth century. Studies and surviving documents reveal the strange majesty of Pontormo's conception. Many of the bodies recall the preternatural giants of Michelangelo's *Last Judgement*, but in Pontormo's hands the painted figure takes on the malleability of clay (it is known that he often drew from specially created clay models rather than from life). In this ballet of sinuous bodies, the last traces of coherent spatial illusion dissolve, leaving the viewer in an unreal, mystic realm that, like his unusual figural distortions, often puzzled and amazed those who saw them. ¶ The career of Agnolo Bronzino, though completely bound up with that of his teacher and lifelong friend Pontormo, was of a more courtly, upwardly mobile character. His inspirations led him naturally toward a cool, controlled virtuosity – well suited to princely commissions – rather than the fervid formal experimentation that drove his master's oeuvre. After working with Pontormo in the latter half of the 1520s, Bronzino left for the service of the Duke of Urbino at Pesaro; after his

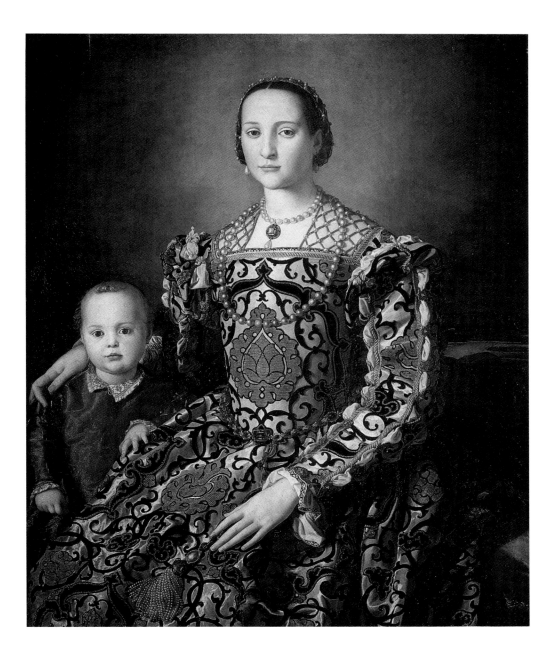

return he accepted a position as court painter to the recently elected Duke Cosimo I. The emblematic *Portrait of Duke Cosimo I de' Medici as Orpheus* (cat. no. 84), possibly commissioned as a wedding present for the duke's Spanish bride, Eleonora di Toledo, shows Bronzino at a crossroads both in his career and in his style. Cosimo's sinuous outlines and twisting pose, with his body flattened against the picture plane, recall Pontormo; but in the muscular, classicizing nude figure – inspired by the antique *Belvedere Torso* – his art began moving toward a new ideality, inspired by classical sculpture and the post-Sistine style of Michelangelo. Other Bronzino portraits of Cosimo, Eleonora, and their children (see fig. 27), which were copied by assistants and sent abroad to all the courts of Europe, authoritatively shaped the public face of the Medici dynasty throughout Cosimo's thirty-seven-year reign (1537–1574). ¶ The establishment of the Medici court in Florence had profound consequences for Florentine painting. It meant, among other things, that large numbers of important commissions were concentrated in the hands of the duke and his courtiers. Vasari acrimoniously condemned the favouritism of the ducal major-domo, Pier Francesco Riccio, complaining that it effectively hindered

artists like his friend, Francesco Salviati, from obtaining important Medicean commissions.[16] Salviati spent the early years of the Medici principate working in Rome, where he achieved considerable success with his fluidly elegant style, characterized by sinuosity of outline, spontaneous brushwork, and rich displays of ornamental detail *all'antica*. All these qualities are evident in Salviati's most important commission in ducal Florence, his frescoes of the *Life of Furius Camillus* in the Sala dell'Udienza of the Palazzo Vecchio (fig. 28). The *Camillus* cycle's complex iconographic program, designed by Paolo Giovio, points toward the dense and pedantic inventions that Cosimo would favour during the later decades of his reign (for example, in Vasari's later decorations for the palace), and seems perfectly suited to Salviati's fertile imagination; hundreds of figures – some in fictive bronze, marble, or stucco – are united in tumultuous celebration of Rome's "second father" (who was meant to evoke clear parallels with Cosimo). The sheer visual complexity of Salviati's work, like its profusion of classical ornament (carefully researched among the remains of ancient Rome), has no precedent in Florentine monumental painting, unless one looks all the way back to Filippino Lippi's work at the end of the fifteenth century. The rhetorical grandeur of Salviati's work was poorly received; after running into financial disputes with his ducal host, and losing out to Pontormo in a bid for the San Lorenzo fresco commission, he returned to Rome, where his copiously ornate style found a more enthusiastic reception. ¶ The career of Giorgio Vasari is difficult to define within the parameters of any single art form. His many-faceted pursuits – painter, architect, and writer – were all subsumed under the image, eloquently promoted in the *Lives*, of the artist as courtier, and few if any other Florentine artists enjoyed the degree of material and social success he attained. Vasari possessed exceptional social skills, which enabled him to manoeuvre the patronage networks of the ducal court (especially after the demise of his nemesis, Pier Francesco Riccio). He was unusually cultured for an artist (his family had given him a classical education), and keenly aware of the importance of courtly comportment and protocol in dealing with powerful and influential patrons. Moreover, his seemingly infinite store of energy made it possible for him to carry out an unprecedented quantity of work, with consistent results. On at least one occasion Vasari himself admitted that because of the intense pressure of his schedule his work did not always turn out as well as it could have. In contrast to artists like Leonardo, Michelangelo, or Pontormo, Vasari approached his art as a pragmatic entrepreneur who could not afford to compromise his productivity by wilful indulgence in flights of creative fancy. In the preface to the third part of the *Lives*, Vasari boasts that whereas prior to the sixteenth century it might have taken an artist six years to paint a picture, he and his contemporaries could paint six pictures a year; Vasari bore out the truth of this adage with an output whose volume is unrivalled in earlier Florentine painting. His workmanlike approach, combined with his ability to mobilize large teams of assistants (who went on to diffuse his stylistic principles in their own works), made Vasari the ideal man to carry out such ambitious schemes as the decoration of the ducal apartments in the Palazzo Vecchio (fig. 29). ¶ Vasari's paintings themselves, long viewed unfavourably or completely ignored by art historians, have only recently begun to receive a fresh assessment.[17] Vasari's pictorial conceptions are often bold and original, but his style remained somewhat ossified after the early 1530s, when he perfected a manner based largely upon the imitation of Michelangelo, whom

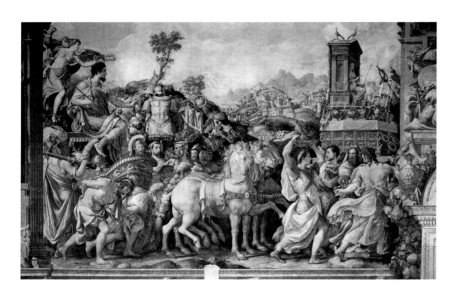

Fig. 28 Francesco Salviati, *The Triumph of Furius Camillus*, c. 1543–1545, fresco. Sala dell'Udienza, Palazzo Vecchio, Florence

Fig. 29 Giorgio Vasari and workshop, Salone dei Cinquecento, 1563–1571 Palazzo Vecchio, Florence

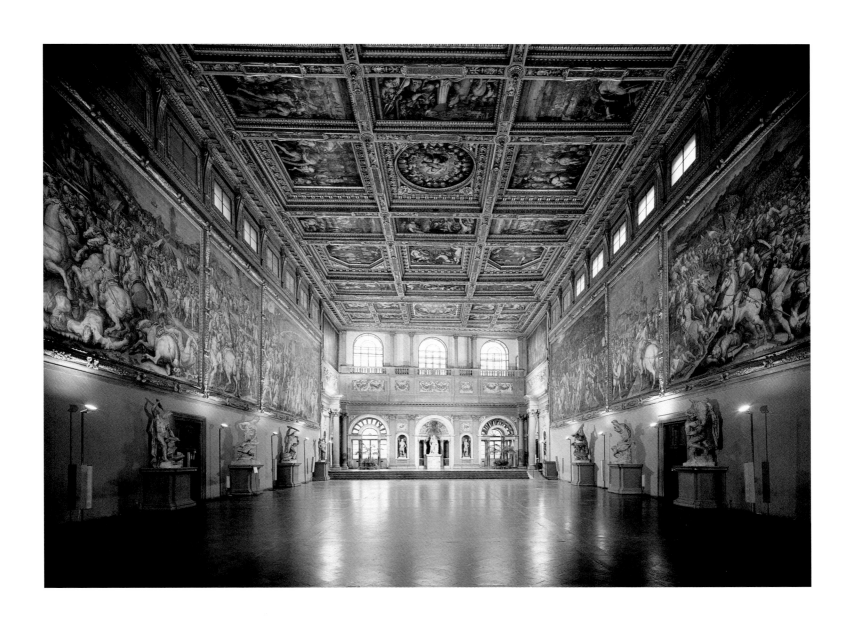

he declared in the *Lives* to represent the consummation of artistic perfection. However much it expedited his vast output, Vasari's remarkable facility as a draftsman tempted him to work a great deal from memory; he often repeated stock figures and facial types, and his painting is often marked by a perfunctory approach to detail, which betrays its origins in the artist's mind rather than in studies from life. ¶ Like Vasari's work, much of the painting of the mid-sixteenth century in Florence is marked by qualities that the seventeenth-century art theorist Giovanni Pietro Bellori and many later writers have condemned. In Bellori's view, the painters who flourished after Raphael's death in 1520 had erred in privileging their own artistic ideas over naturalistic observation; "abandoning the study of nature, [they] corrupted art with *la maniera*, or, if you prefer, a fantastic idea based on practice [*pratica*], and not on imitation [of nature]."[18] This is an image of Cinquecento painting viewed retrospectively through the optic of Baroque naturalist painting, like that of Caravaggio and the Carracci, and it can easily distract us from the reality that all painting exists as a dialectic between naturalism and invention. Echoing through the centuries, Bellori's view of Cinquecento painting has induced generations of students to lump artists as stylistically diverse as Pontormo and Vasari, Rosso and Salviati, into the same category of Mannerism. In recent years, however, scholars and the viewing public have become increasingly interested in exploring the unprecedented diversity that for so long was hidden beneath stylistic terms like "*maniera*" and "Mannerist." ¶ It would be difficult, in fact, to point to any half-century in Italian art that was more keenly invested in formal experimentation – or "fantastic ideas," to use Bellorian terminology. Not only did artists strive to make themselves stand out in the market with distinctive "trademark" styles; for many of the artists included in this exhibition, individual style was itself fluid and subject to an astonishing range of transformations. The remarkable diversity presented by the painters working in early-Cinquecento Florence can be linked to factors like competition for patronage, a growing consciousness of the artist's place in history fuelled by the burgeoning literature on art, and the idea of painting as a process that privileged the intellectual over the manual aspects of creation. In an important sense, the surviving works are the most eloquent evidence with which we can reconstruct the artistic ideals of the Florentine Cinquecento. Sympathetic examination of the works themselves, in their historical and aesthetic context, remains one of the most important agendas of Florentine art history today. By surveying the tremendous diversity of styles and iconography that evolved during this period – both in its surviving monuments and in the legacy of designs, models, and replicas of works that have been lost – this exhibition offers a fresh look at those "ingenious and subtle spirits" and their imaginative conceptions of what painting could become. The eloquence of those visions is undiminished by time, and limited only by our willingness to explore.

Notes

1 Vasari-Milanesi 1878–1885, vol. 1, pp. 1–7. All translations from Renaissance texts are the present writer's own.
2 See the Life of Donatello (Vasari-Milanesi 1878–1885, vol. 2, p. 413): "[His works] being considered miraculous there [in Padua], and praised by every knowledgeable person, he decided to return to Florence, saying that if he remained there [in Padua] any longer he would have forgotten everything he knew, being so greatly praised by everyone; and that he willingly returned to his native city so that he might be continually criticized there, which motivated him to study, and consequently to greater glory."
3 In the biography of the fourteenth-century painter Gaddo Gaddi: Vasari-Milanesi 1878–1885, vol. 1, p. 345.
4 The most detailed study of the apocalyptic imagery of Botticelli's *Mystic Nativity* and its relation to Savonarola's predictions about the Last Days is R. Hatfield, "Botticelli's Mystic Nativity, Savonarola and the Millennium," *Journal of the Warburg and Courtauld Institutes* 58 (1995), pp. 88–114.
5 See Nelson and Waldman 2004.
6 On the role of *invenzione* in Renaissance art theory see especially M. Kemp, "From 'Mimesis' to 'Fantasia': The Quattrocento Vocabulary of Creation, Inspiration and Genius in the Visual Arts," *Viator* 8 (1977), pp. 347–398.
7 Kemp 1989, pp. 13–20.
8 Marani 2000, p. 349, no. 36.
9 Kemp 1989, pp. 144–146.
10 For Vasari's treatment of Piero see Franklin 2001, pp. 41–61; L.A. Waldman, "Fact, Fiction, Hearsay: Notes on Vasari's Life of Piero di Cosimo," *The Art Bulletin* 82:1 (2000), pp. 171–179.
11 Zeri 1962.
12 See the bibliographies in the relevant works in this catalogue. Additionally, on Larciani and the Master of Serumido/Dolzemele, see Natali 1995; Franklin 2001, pp. 57–58, 174–177; Waldman 2001 (with bibliography).

13 Vasari-Milanesi 1878–1885, vol. 5, pp. 54–55: "Nor is there doubt that if Andrea had remained some time at Rome when he went there to see the works of Raphael and of Michelangelo, and likewise the ruins of that city, he would have much enriched his style, and would eventually have given his figures more refinement [*finezza*] and greater power."
14 See, for example, the critique of the historicity of the modern art-historical notion of "Mannerism" in J. Stumpel, *The Province of Painting: Theories of Italian Renaissance Art* (Utrecht, 1990), pp. 97–172, and in Franklin 2001. Useful overviews of approaches to the problem include E. Cropper, "Introduction" to C.H. Smyth, *Mannerism and Maniera* (Vienna, 1992), pp. 12–21, and G.A. Bailey, *Between Renaissance and Baroque: Jesuit Art in Rome, 1565–1610* (Toronto, 2003), pp. 22–26.
15 Franklin 2001, pp. 127–151.
16 Vasari reports in the Life of Salviati that the latter believed Riccio had secretly withheld his design for the San Lorenzo fresco commission from the duke's eyes, in order to favour Pontormo, who received the commission (Vasari-Milanesi 1878–1885, vol. 7, p. 30).
17 The most important recent assessments of Vasari's achievement as a painter are Rubin 1995; Franklin 2001, pp. 229–249; see also Baldini 1994.
18 For Bellori's criticism see C.H. Smyth, *Mannerism and Maniera* (Vienna, 1992), especially pp. 22–23 (with bibliography).

"EQUAL TO THE ANCIENTS"
FLORENTINE SCULPTURE IN THE FIRST HALF
OF THE SIXTEENTH CENTURY

ANDREW BUTTERFIELD

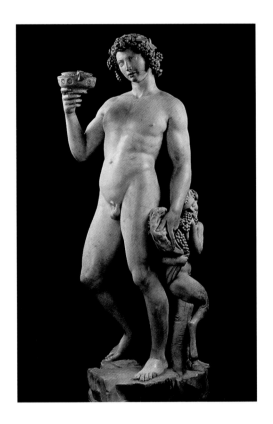

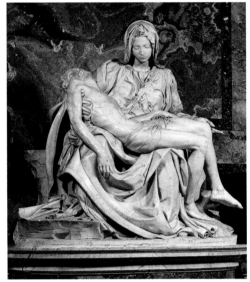

fifteen, he was on intimate terms with Giovanni and Giulio de' Medici, who in later years, as popes Leo X and Clement VII, would be two of his most important patrons.

¶ It was during his residency at the Palazzo Medici that Michelangelo made his first surviving works, the *Madonna of the Steps* and the *Battle of the Centaurs*. Remarkably, given his young age, at this time Michelangelo also carved a colossal marble statue of *Hercules* (lost) on his own initiative and without a commission. However, fearing the political turmoil attendant on the fall of the Medici as the rulers of Florence, in October 1494 he left for Venice, and ultimately settled in Bologna for a year. Michelango's visit to Venice was crucial for his development. The sculptures of the Venetian artist Tullio Lombardo were infinitely superior, both in their sophisticated classicism and in the technical wizardry of their carving and polishing, to anything that he had seen before, and they acted as an enormous, catalytic stimulus on his work. ¶ In 1496, after a short period back in Florence, Michelangelo moved to Rome, where he lived until 1501. During this time he carved his first works of supreme importance, the *Bacchus* and the *Pietà* (figs. 30 and 31). From 1501 to 1505 he again lived in Florence, and in these years, in

Fig. 30 Michelangelo, *Bacchus*, 1496–1497, marble, 184 cm high. Museo Nazionale del Bargello, Florence

Fig. 31 Michelangelo, *Pietà*, 1497–1499, marble, 174 cm high. Saint Peter's Basilica, Vatican City

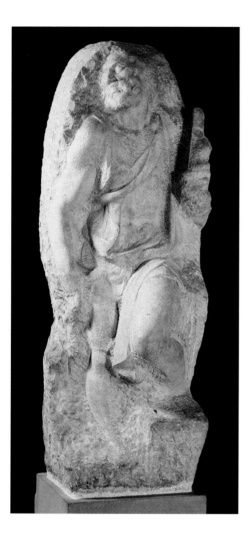

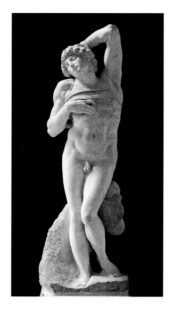

Fig. 32 Michelangelo, *Saint Matthew*, c. 1506, marble, 216 cm high. Galleria dell'Accademia, Florence

Fig. 33 Michelangelo, *The Dying Slave*, 1513–1516, marble, 228 cm high. Musée du Louvre, Paris

Fig. 34 Michelangelo, *Prisoner* (called *Atlas*), 1520–1530, marble, 277 cm high Galleria dell'Accademia, Florence

Fig. 35 Michelangelo, *Tomb of Lorenzo II de' Medici*, 1521–1534, marble, 178 cm high. New Sacristy, Church of San Lorenzo, Florence

a burst of unequalled creativity, he produced the *David*, the *Bruges Madonna*, the *Pitti Tondo*, the *Taddei Tondo*, the statues for the *Piccolomini Altar*, and, in 1506, the *Saint Matthew* (fig. 32). In this period, too, he painted the *Doni Tondo* and made the cartoons for the *Battle of Cascina* fresco in the Palazzo della Signoria. Additionally, in 1505 he received the commission for the tomb of Pope Julius II, a project that ultimately was to occupy the artist until 1545, when, in much reduced form, it was finally completed. This monument was to inspire some of Michelangelo's greatest sculptures, produced chiefly in two periods of intense labour and fertility. Around 1513–1516 he carved the *Moses*, the *Dying Slave* (fig. 33), and the *Rebellious Slave*; in the 1520s he produced *Victory* and began four massive statues of *Prisoners* (see fig. 34), all for the tomb. ¶ The same span of years saw several other projects of breathtaking originality and unprecedented ambition. Between 1508 and 1512, he frescoed the Sistine Chapel ceiling, perhaps the most celebrated painting in all of Christendom. From 1516 to 1520 he concentrated on plans for the facade of the church of San Lorenzo in Florence, and although Michelangelo never realized these plans, they helped initiate a new era in architecture, one that would lead ultimately to the Baroque style of facade design. Moreover, beginning in 1521 and continuing until 1534, he was engaged in creating the New Sacristy in San Lorenzo (see fig. 35). Built as a memorial chapel for members of the Medici family, it is possibly the greatest expression of his ideals of sculpture and architecture. ¶ With the death of Clement VII in 1534, Michelangelo considered himself free of further obligations to the Medici family. He suspended work on the New Sacristy, moved to Rome, and entered the service of Pope Paul III Farnese. The artist never returned to Florence, and in subsequent years sculpture no longer occupied the same pre-eminent place in his artistic production. ¶ In Rome Michelangelo initially concentrated on painting. Between 1536 and 1541 he made the monumental fresco of the *Last Judgement* in the Sistine Chapel. He then made the frescoes of the *Crucifixion of Saint Peter* and the *Conversion of Saint Paul* for the Pauline Chapel (1542–1550). In 1547 he was appointed

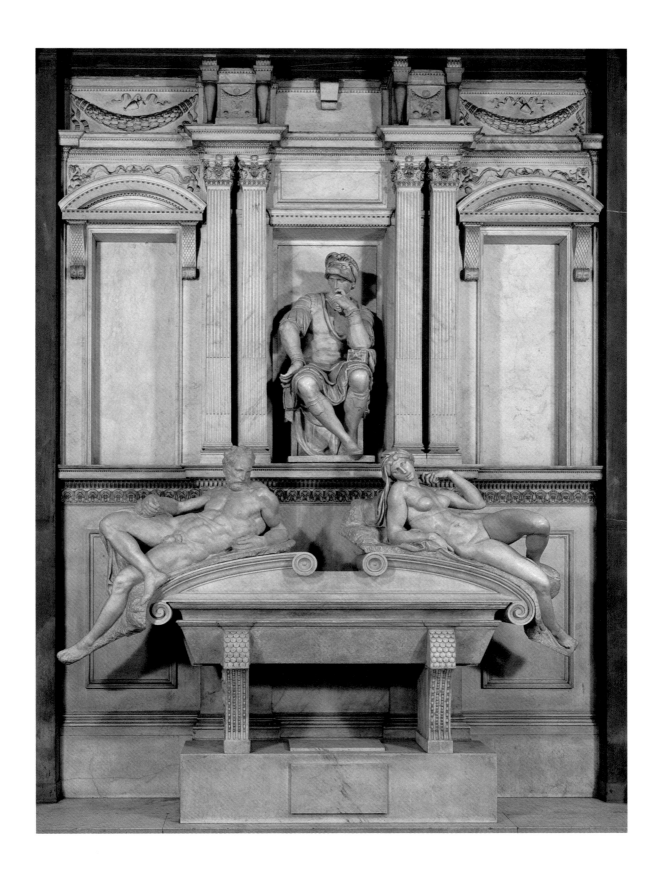

chief architect of Saint Peter's, and thereafter he dedicated himself primarily to architecture. Only two sculptures are known from the last decades of his life. One is the great *Deposition* group in the Museo dell'Opera del Duomo in Florence. Michelangelo seems to have worked on it intermittently until about 1554, when he finally abandoned the statue. The second is the so-called Rondanini *Pietà*, now in the Castello Sforzesco in Milan. Michelangelo desperately hacked away at this statue during the last months of his life, giving up on the piece only a few days before he died on 18 February 1564.

¶ One good way to begin study of Michelangelo's achievement is by considering his technique. This subject is usually discussed only in passing, if at all. Yet Michelangelo's technical mastery was the foundation of his innovations as a sculptor. There is little documentary evidence or contemporary written commentary concerning this aspect of his work. The proof is in the sculptures themselves; they are significantly different from the statuary of previous generations in a vast number of ways. Michelangelo used the same tools and the same materials as the artists of the past, but he was fortunate to come to maturity just as a small vanguard of sculptors – chiefly Tullio Lombardo and Cristoforo Solari – began to understand better the potential capacities of carving marble. Michelangelo soon surpassed all others in this regard. ¶ Michelangelo's technical mastery affected every aspect and stage of his creation of sculpture, from the conception and planning of pose and composition to the final polishing of a statue's surface. One major difference was that earlier artists had been uncertain of the material strength of marble, and therefore tended to make their sculptures massive and blocky to ensure that they would not collapse under their own weight or fail at some critical juncture. As a result, the limbs are typically held close to the body and the legs are enrobed in drapery that acts as a stabilizing support. So great was the fear that the marble block might collapse that few artists dared to excavate or drill through the block around the legs, and when they did so, it was always in a limited and restricted way.

¶ Michelangelo was not encumbered by such fears. Equipped with a more exact understanding of the structural tolerances of marble, he could work the stone close to its inherent limits. For example, *Dawn* raises her left hand to her shoulder and bends her arm sharply at the elbow (fig. 36). Unsupported except at one point, cantilevered over space, the massive weight of the arm creates tremendous force where it joins the main block of the sculpture at the shoulder. No previous artist had ever risked such a potentially precarious pose. As a result of such passages, his statues have a freedom of stance and bearing that was inconceivable before. ¶ Michelangelo's work represents a significant advance over earlier Renaissance sculpture in another way as well. The precision of his control over the shaping, finishing, and polishing of the surfaces of marble was without precedent. This capacity was essential to his artistry in the most fundamental way: it enabled him to make the nude the focus of his efforts as a sculptor. Most earlier Renaissance artists had avoided making nude statuary, not only for reasons of taste and decorum, but also because of the technical difficulties such sculptures entail. Marble is a relatively intractable material, but the forms of the human body are supple, undulating, and irregular. It requires tremendous technical skill to carve such intricate surfaces in anything approaching a naturalistic manner. There are only a handful of nude, or almost nude, statues from the fifteenth century, and their forms are somewhat crude and approximate. By comparison, in works such as the *Pietà* and the *Dying Slave* Michelangelo exhibits perfect control of his material. ¶ Another important aspect of Michelangelo's technique was his ability to render movements of the human body that are complex and multidirectional. For earlier Renaissance sculptors it was extremely difficult to represent motion, especially in marble. Their statues tend to stand stiffly; the movements of the figures' arms and legs are limited, and the torso is more or less in plane with the front of the block. Michelangelo changed all this. His

figures are usually shown in motion: their arms and legs are flexed, and bent at the joints, and the torso is almost always turned, often dramatically. Moreover, whereas earlier sculptors avoided the depiction of motion, Michelangelo typically showed the body moving in more than one direction at the same time. Often, as in figures such as *Dawn* and the *Dying Slave*, every muscle seems to be engaged in motion. Even the downward pull of gravity on the body appears visible: *Dawn*, for example, seems to struggle to raise herself up, fighting against an all-but-inescapable force that drags her back down to earth.
¶ To achieve effects of such complexity, to show so many different vectors of movement on the surface of a volume, Michelangelo had to carve and finish marble with unparalleled precision and subtlety. Not since antiquity had any artist demonstrated control over material equal to Michelangelo's; no one would approach his level of practical command again until Bernini a century later. ¶ Technical supremacy was at the root of another aspect of his art as well. Michelangelo carved marble more quickly, and on a larger scale, than anyone had before. His rate of production was superhuman.

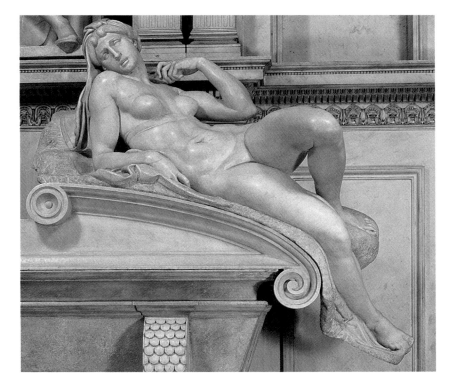

Fig. 36 Michelangelo, *Dawn*, 1521–1534, marble, 203 cm wide. New Sacristy, Church of San Lorenzo, Florence

He carved the *David*, the *Bruges Madonna*, the *Pitti* and *Taddei Tondi*, and the four sculptures for the *Piccolomini Altar* virtually simultaneously. At one point, he planned to execute twelve giant marble sculptures for Florence Cathedral and at the same time all forty of the statuary figures for the tomb of Julius II – a total of more than fifty works. By comparison, Donatello carved only ten or so full-scale marble statues in his whole career. Moreover, Michelangelo's work was typically much larger in dimension than earlier sculptures. For example, only two of Donatello's marble sculptures are over two metres tall. Michelangelo made over a dozen works that tall or taller, including the *David*, which is over 4 metres in height. His capacity was unprecedented, and it was this facility that allowed him to conceive, and at least partially execute, projects of monumental ambition and colossal scale, such as the tomb of Julius II and the New Sacristy and facade of San Lorenzo. ¶ Earlier Renaissance sculptors were incapable of the perfect imitation of nature. Michelangelo was capable of it, but chose to make idealized images, by transforming the natural proportions and details of the body. This wilful idealization and regularization of form is an outstanding characteristic of his art, and one that was to affect every artist in Italy for the next century. Beginning with the *David* and through the remainder of his career, Michelangelo changed the canon of the

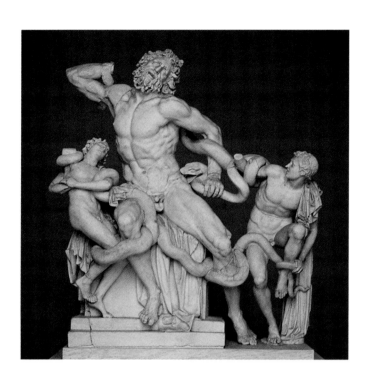

Fig. 37 Hagesandros, Athenodoros, and Polydoros of Rhodes, *Laocoön*, late Hellenistic, marble, 210 cm high Museo Pio-Clementino, Vatican Museums, Vatican City

face and body in accordance with a personal vision that initially was his alone. He introduced a geometric clarity and order to the representation of the face. In his allegories of *Dawn*, *Day*, *Twilight*, and *Night* adorning the Medici tombs in the New Sacristy, he smoothed out all the curves and planes of the face and greatly increased the linearity of the features: the lips, the noses, and the eye-sockets are all made up of predominantly straight lines. In the second half of the fifteenth century, Florentine sculptors had reached a high point in the naturalistic representation of the lineaments of the face. But Michelangelo was wholly uninterested in the depiction of distinctive descriptive details; he preferred the representation of an imaginary and otherworldly ideal.

¶ Likewise, Michelangelo altered the canon of the human body: he lengthened the proportions of the forms and added muscle and bulk, especially to the torso and arms. His starting point for this transformation of the canon was, no doubt, the series of rediscovered masterpieces of Hellenistic statuary: the *Apollo Belvedere*, the *Torso Belvedere*, and the *Laocoön* (fig. 37). These seem to have provided a model, but, perhaps more importantly, they helped to liberate his imagination and his creative fantasy. It is in part this transformation of nature and antiquity that Vasari had in mind when he famously remarked,

This master surpasses and excels not only all those moderns who have almost vanquished nature, but even those most famous ancients who without a doubt did so gloriously surpass her; and in his own self he triumphs over moderns, ancients, and nature, who could scarcely conceive anything so strange and so difficult that he would not be able, by the force of his most divine intellect and by means of his industry, draftsmanship, art, judgement, and grace, to excel it by a great measure.[1]

The making of marble statuary is typically a group enterprise. During the Renaissance, as before, marble statues were usually made for display in public locations. They were generally commissioned by large bodies of men (such as a guild or the governors of a church), often as part of a decorative program of an important building; they were made by workshops that either collaborated on the project or competed to outdo one another in making parts of the decorative program; and they were meant to be seen by the entire civic community. This situation inevitably placed a premium on the expression of group beliefs and ideals. There was relatively little room for personal interpretation of

the subject matter by the artist. The one possible exception to this in fifteenth-century sculpture is Donatello, although Donatello's vision of his subject matter was never so innovative or private as to disturb or mystify the public. ¶ Michelangelo did not feel restricted by such expectations. His artistic imagination was both intensely personal and deeply mythopoeic, so much so that it subsumed and overwhelmed any subject at hand. No matter what he was supposed to depict, no matter what the patron wanted, what Michelangelo created was to a very large degree a manifestation of his own inner vision of life and death, of the fate and fears of the human soul. As many critics have noted, this is especially true of his sculpture after 1506, when he made the *Saint Matthew*. From that point forward, two interrelated motifs – struggle and captivity – become paramount in Michelangelo's work; almost all his figures seem painfully bound and desperate to be free. Sometimes, as in the *Dying Slave* and *Dawn*, they look almost like dreamers fighting to awaken from a nightmare; in other works, such as the *Rebellious Slave* and the four *Prisoners*, the emphasis is more on brute physical force, and the figures consequently look more wilful and defiant, more Promethean. The *terribilità* of Michelangelo's work – both feared and admired by his contemporaries – is nowhere clearer than in these works. ¶ The reasons for Michelangelo's obsession with these motifs are not clear; nor is anyone exactly sure how these works should be understood. Yet many viewers have been struck by the apparent plausibility of two lines of interpretation. One is artistic and applies best to the unfinished sculptures. In these a primary struggle seems to be that of the figure straining to burst free from the fetters of the surrounding block; the viewer watches as the statue itself, still inchoate and unformed, strives to take shape and come alive. The second line of interpretation is religious: the essential struggle is that of the soul trying to escape the bonds of the material and corruptible body. Rodin said of these works, "The soul turned in upon itself; suffering; distaste for life; struggle against the dominance of matter – such are the elements of his inspiration."[2] This is, of course, a nineteenth-century reaction, but one that responds appropriately to the spiritual fervour of Michelangelo's art. ¶ Whatever the origins of Michelangelo's vision of strife, he was certainly encouraged in this direction by the rediscovery of the *Laocoön* in Rome in January 1506, just two months before he began work on the *Saint Matthew*. The most famous sculpture of antiquity, and perhaps the greatest masterpiece of Hellenistic classicism, the *Laocoön* depicts a man and his sons ensnared by and struggling against a pair of monstrous snakes. A description of the sculpture written in 1506 stresses its awful and tragic power: "The mute image strikes the heart with a pity joined with no small terror."[3] As Michelangelo studied the grandeur of its forms and the perfection of its carving, he may also have been struck by how one of the most celebrated sculptures of antiquity anticipated his own inner ideal of *terribilità* in art. ¶ As we have already seen, for nearly a generation, from Michelangelo's return to Florence in 1501 until his final departure for Rome in 1534, his dominance of the production of marble sculpture in Florence was nearly absolute. Both in conception and execution his work vastly outstripped anything made before. Moreover, there were relatively few commissions, and Michelangelo was typically everyone's first choice. Some other artists slowly and irregularly received important sculpture projects, but the demand was never strong, and many artists elected to leave Florence and seek their fortunes elsewhere. Indeed, of the major Florentine sculptors born between 1470 and 1510, only Francesco da Sangallo, Baccio Bandinelli, and Giovanni Francesco Rustici stayed throughout the years of Michelangelo's dominance. Among the important artists who left, either permanently or for extended periods, were Andrea Sansovino, Jacopo Sansovino, Pietro Torrigiano, Benvenuto Cellini, Lorenzetto, and Niccolò Tribolo. Formerly a magnet for genius, in this period Florence became an exporter of talent. The sculptors who went forth took with them a new set of standards

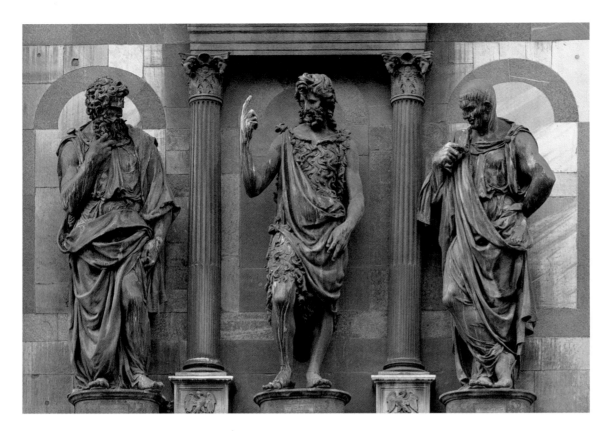

and ideals, learned chiefly from the art of Michelangelo. Their exodus helped to establish what is now referred to as the High Renaissance style in sculpture throughout Italy and Europe. ¶ One artist who was relatively free of Michelangelo's influence was Giovanni Francesco Rustici. Only a few months older than Michelangelo, Rustici is said by Vasari to have studied under Verrocchio. Certainly he was deeply influenced by Verrocchio's most famous pupil, Leonardo da Vinci. Indeed, Leonardo lived with Rustici in 1508, when Rustici was working on the large bronze group of *Saint John the Baptist Preaching* above the north portal of the Baptistery (fig. 38). This group shows the direct influence of Leonardo, who seems to have supplied ideas and drawings for the sculpture and may even have participated in the modelling. Rustici occasionally made sculpture in glazed terracotta, and one example, closely related to the Baptistery sculpture, is included in this exhibition (cat. no. 8). Recently found in the storerooms of the Museum of Fine Arts, Boston, by Marietta Cambareri, this piece is a major rediscovery, presented here to the public for the first time. Another of Rustici's most famous works was a bronze figure for a fountain in the Palazzo Medici (cat. no. 6). According to Vasari, water spurted from its lips and spun a device like a toy windmill held in its right hand. Commissioned by Giulio de' Medici, it was one of the few bronze sculptures made in Florence in the early sixteenth century. ¶ Next to Michelangelo, Jacopo Sansovino was perhaps the greatest sculptor to emerge in Florence in the early sixteenth century. Trained by Andrea Sansovino, whose surname he adopted, Jacopo won a commission in 1511 for a statue of *Saint James the Great* for Florence Cathedral; he finished it in 1518. Between 1510 and 1512 he also carved a marble statue of *Bacchus* for Giovanni Bartolini (fig. 39). Clearly inspired by Michelangelo's statue of the same subject, it shows the figure walking forward and lifting a drinking bowl up high. It was the first Florentine sculpture to rival the freedom of pose and movement in Michelangelo's work, and it was deeply admired by other artists, among them Vasari, who wrote that "it was held to be the most beautiful work that had ever been executed by a modern master."[4]

Jacopo Sansovino was also an outstanding modeller in clay, and some of his models were used by Andrea del Sarto and other painters as the basis for their compositions. The model of the *Saint Paul*, an astonishingly beautiful work made around 1511–1513, reveals his excellence in this medium (cat. no. 44). Frustrated by the lack of adequate opportunities in Florence, in 1518 he left for Rome, where he worked until the Sack of Rome in 1527. His most important piece from this period is the *Madonna del Parto* in the church of Sant'Agostino. In 1527 he moved to Venice, where he became the pre-eminent sculptor of the city, as well as one of its most highly regarded architects. Among Sansovino's major sculptures in Venice are the bronze statues for the Loggetta and the colossal marbles of *Mars* and *Neptune* in the courtyard of the Palazzo Ducale. ¶ Baccio Bandinelli, a vain and irascible person, was an erratic artist with grand theoretical pretensions but insufficient technical abilities. Nevertheless, the Medici, especially Pope Clement VII and Duke Cosimo I, supported him, making him their unofficial court sculptor. Bandinelli was originally trained by his father, a goldsmith, and later received instruction from Rustici. Leonardo also encouraged him as a youth. He won the commission for the statue of *Saint Peter* for the Florence Cathedral (1515–1517), and made a large marble figure of *Orpheus* (fig. 40) for the central court of the Palazzo Medici (c. 1519), perhaps his most satisfying work. Between 1525 and 1534 he carved a monumental marble group of *Hercules and Cacus*, which was erected in front of the Palazzo della Signoria. It was carved from a prized block of marble originally intended for Michelangelo. Upon its unveiling in 1534, it was harshly criticized; Cellini said that the body of Hercules looked like a "sack of melons." ¶ This exhibition presents several aspects of Bandinelli's oeuvre. He was one of the few Florentine artists to make bronze statuettes between the death of Verrocchio in 1488 and the arrival of Giambologna in 1553. In Florence this genre was almost exclusively bound up with the collecting interests of the Medici, and the statuette of *Jason*, too, was made for the family (cat. no. 96). Bandinelli was an idiosyncratic and compelling draftsman, often employing a system of vigorous cross-hatching to generate energetic and wiry figures in strong relief. ¶ Following the return of the Medici in 1530, the situation for sculptors in Florence changed in two ways. First, Michelangelo's move to Rome in 1534 created a vacuum in which other artists could flourish. Second, the Medici formed an explicit court around themselves. They resumed their role as the dominant art patrons in the city, but their needs, now, were primarily of a decorative kind. One artist who prospered in this era was Niccolò Tribolo. Gifted with both imagination and facility, he readily adapted to changing conditions. He had trained with Jacopo Sansovino, and assisted in the execution of both the *Bacchus* and the *Saint James*. He subsequently worked in Rome for several years, before returning to Florence at the end of the 1520s. He helped Michelangelo with work on the New Sacristy, and ultimately, in 1546, supervised the installation of Michelangelo's sculptures and the completion of the sacristy.

For the Medici family, he directed all manner of decorative projects, including the fountains at their villa at Castello and the gardens at Castello and Poggio a Caiano, as well as the Boboli garden behind the Palazzo Pitti in Florence. In the exhibition he is represented by a drawing for a wall fountain intended for the villa at Castello (cat. no. 101).

¶ Tribolo's most brilliant assistant was Pierino da Vinci, a nephew of Leonardo. A dazzling, precocious artist, he was one of the finest carvers of marble of the Renaissance, and was especially distinguished as a sculptor of reliefs. Praised by Vasari and Borghini, the *Pisa Restored* (cat. no. 106) is perhaps his most celebrated marble relief. According to John Pope-Hennessy, this relief was inspired by the Sistine Chapel ceiling, which supplied Pierino "with a vision of the beauty and coherence of the human figure that he retranslated into sculpture."[5] ¶ Without question the most important sculptor in Florence from about the middle of the century was Benvenuto Cellini. In the first twenty years of his career, Cellini worked chiefly in Rome, and exclusively as a jeweller and medallist. It was only after he moved to France in 1540 to enter the service of Francis I that he began to make sculpture. Upon returning from France in 1545, he settled in Florence, and thereafter large-scale sculpture was the primary focus of his artistic production. Between 1545 and 1554 he made the colossal bronze statue of *Perseus*, technically and artistically the most innovative sculpture produced in Florence during that time (fig. 41). Among other celebrated works are the bronze busts of *Duke Cosimo I de' Medici* (Bargello, Florence) and *Bindo Altoviti* (Isabella Stewart Gardner Museum, Boston), and the marble statue of the *Crucified Christ* (Escorial, Spain). In the exhibition Cellini is represented by two related works, a drawing and a bronze model for a large-scale sculpture of a satyr, intended for the Porte Dorée of the French royal château at Fontainebleau (cat. nos. 102 and 103). ¶ In every general account of sixteenth-century Florentine sculpture, the emphasis is almost exclusively on works of art in bronze and marble. Sculpture in other media, such as wood and terracotta, is typically given very little attention. But such an account profoundly misrepresents the nature of the market and the taste for sculpture at the time. Measured by the number of commissions, terracotta sculpture – specifically glazed and painted terracotta – was the most popular form of statuary in Florence and Tuscany at the end of the fifteenth century and the beginning of the sixteenth. While the Medici and a few other patrons fought over marble statues by Michelangelo, almost every other client sought the sculpture of the della Robbia and Buglioni workshops; while Torrigiano, Rustici, Sangallo, and Sansovino struggled to find work and make ends meet, the della Robbia and Buglioni workshops produced hundreds of altarpieces and perhaps thousands of statues, which decorated chapels and palaces throughout the city and region. Because they did not appeal to later taste, these artists have been comparatively little regarded in the modern era; for much of the Renaissance, however, they were the height of fashion. ¶ The making of glazed, painted terracotta sculpture was pioneered in the

Fig. 41 Benvenuto Cellini, *Perseus with the Head of Medusa*, 1545–1554, bronze, 320 cm high (without base) Loggia dei Lanzi, Florence

fifteenth century and popularized by Luca della Robbia, who died in 1482. His nephew, Andrea, took over direction of the workshop around 1470 and ran it for several decades, eventually handing over its management to his five sons, who remained active in the business into the middle of the sixteenth century. The chemistry and the firing of the glazes were closely guarded secrets, and few artists ever succeeded in imitating the work of the della Robbia. One who did was Benedetto Buglioni. He worked for Andrea della Robbia before setting up his own workshop, probably in the 1480s; in the sixteenth century, Benedetto eventually handed over his workshop to his nephew, Santi Buglioni. Initially, the della Robbia workshop was clearly the more sophisticated of the two, in the quality of its techniques as well as in the naturalism and classicism of its forms. However, in the 1520s Girolamo and Luca the Younger, the two most successful of Andrea's sons, left Florence for France, where they entered the employ of Francis I, and from that point forward the Buglioni workshop dominated the production of glazed terracotta. ¶ Since the eighteenth century, it has been widely assumed that sculpture is achromatic in its essence. This assumption was not shared in the Renaissance, when sculpture was most often coloured in some way. Sculptures in marble and bronze were regularly decorated with gold or silver foil, at least in highlights, and sometimes were even fully painted. Sculptures in other media, such as wax, terracotta, stucco, and wood, were always completely painted, and often in a highly naturalistic manner. The statuary of the della Robbia and the Buglioni thus fulfilled a common expectation of the Florentine public in the early sixteenth century. ¶ It is important to address another misconception as well. Modern viewers have often presumed that terracotta

statuary chiefly appealed to patrons of modest status and taste, to people who could not afford, or did not want, sculpture in marble and bronze. While this may have been true in some instances, it was certainly not the general rule, and it would be very wrong to think of it as such. On the contrary, many of the wealthiest and most discerning collectors in Europe commissioned works from the della Robbia and the Buglioni, sometimes in great number. To name only a few of these collectors – Bindo Altoviti, Leonardo Buonafede, Francis I – is to suggest how central glazed terracotta was to the making of art in the early sixteenth century ¶ One intention in selecting sculptures for the present exhibition has been to give an idea of the immense contribution of the della Robbia and the Buglioni to the visual culture of the early sixteenth century. While they did not choose to work in the putatively "noble" media of bronze and marble, they made sculptures of the very highest artistry, and fully represent some of the most progressive ideals of the art of their day. For example, Andrea della Robbia's statue of *Saint Sebastian* is a magnificent work, animated by close, detailed study of both classical art and human anatomy (cat. no. 29). The all-white painting of the figure, typical of much of Andrea's work, was probably intended to indicate the spiritual purity of the figure, as well as to suggest the appearance of ancient statuary ¶ Equally beautiful and sophisticated is the bust of an angel by Andrea's son, Luca the Younger (cat. no. 9). With its poignant gaze and its ravishingly beautiful hair arranged in long curling locks, the sculpture reveals a large debt to Leonardo. In terms of style alone the sculpture is unmistakably a work of the High Renaissance, but it is in a medium, glazed terracotta, that we do not usually associate with that movement. Looking at this sculpture, it is obvious why Raphael would have hired Luca to work for him in the decoration of the Vatican Loggie, and why Francis I would have hired him along with other major Italian artists, such as Rosso and Primaticcio. ¶ Santi Buglioni represents the culmination of the tradition of glazed terracotta in Florence. The statue of *San Giovanni di Capistrano* in the exhibition (cat. no. 123) may give us some idea why his art was in constant demand for nearly half a century. The colour is sufficiently naturalistic that the work has a certain immediacy and credibility, yet the pigments are deeply saturated and the glaze adds an unearthly lustre to the sculpture. The modelling is of the utmost vigour and intensity. The work is a forceful image of religious passion. In its Counter-Reformation fervour and its astonishingly direct appeal to the viewer, it is a harbinger of the Baroque. ¶ Florentine Renaissance sculpture has long been considered one of the defining achievements of the visual culture of Europe. A reason for this may be that the Renaissance is not only a period in European history, it is also a recurrent ideal: the ideal of cultural reform inspired and guided by exempla from classical antiquity. This ideal finds especially clear and full expression in the sculpture of the early sixteenth century, when artists turned directly to the masterpieces of Greek and Roman statuary as models for their own works, and in so doing helped to create a new

period of extraordinary artistic flowering. To be sure, some artists of earlier periods had also turned to the glories of the past (one thinks of the sculptors in Rheims in the early thirteenth century, for example), but the results of such efforts were comparatively limited and ephemeral. In contrast, Florentine sculptors of the Renaissance established a new paradigm that was to hold true until the early twentieth century, and that remains relevant and important even today. Michelangelo's role in this achievement was unique. In sculptural technique, knowledge of anatomy, and understanding of classical sources, he surpassed every sculptor who had come before. More important still, he wedded the epic vocabulary of antique statuary to the lyric expression of personal religious pathos. This was a new departure, one that was to resonate with artists from Bernini to Rodin.

Notes

1 Vasari 1996, vol. 1, pp. 621–622.
2 A. Rodin, *L'Art : Entretiens réunis par Paul Gsell* (Paris, 1961), p. 283 as quoted in H. von Einem, *Michelangelo*, trans. R. Taylor (London, 1973), p. 5.
3 J. Sadoleto, *De Laocoontis statua*, quoted in M. Baxandall, *Words for Pictures* (New Haven and London, 2003), p. 99.
4 Vasari 1996, vol. 2, p. 808.
5 Pope-Hennessy 1996, p. 206.

The quotation in the essay title is from G.B. Adriani, *Istoria de' suoi tempi* (Florence, 1583), col. 719b.

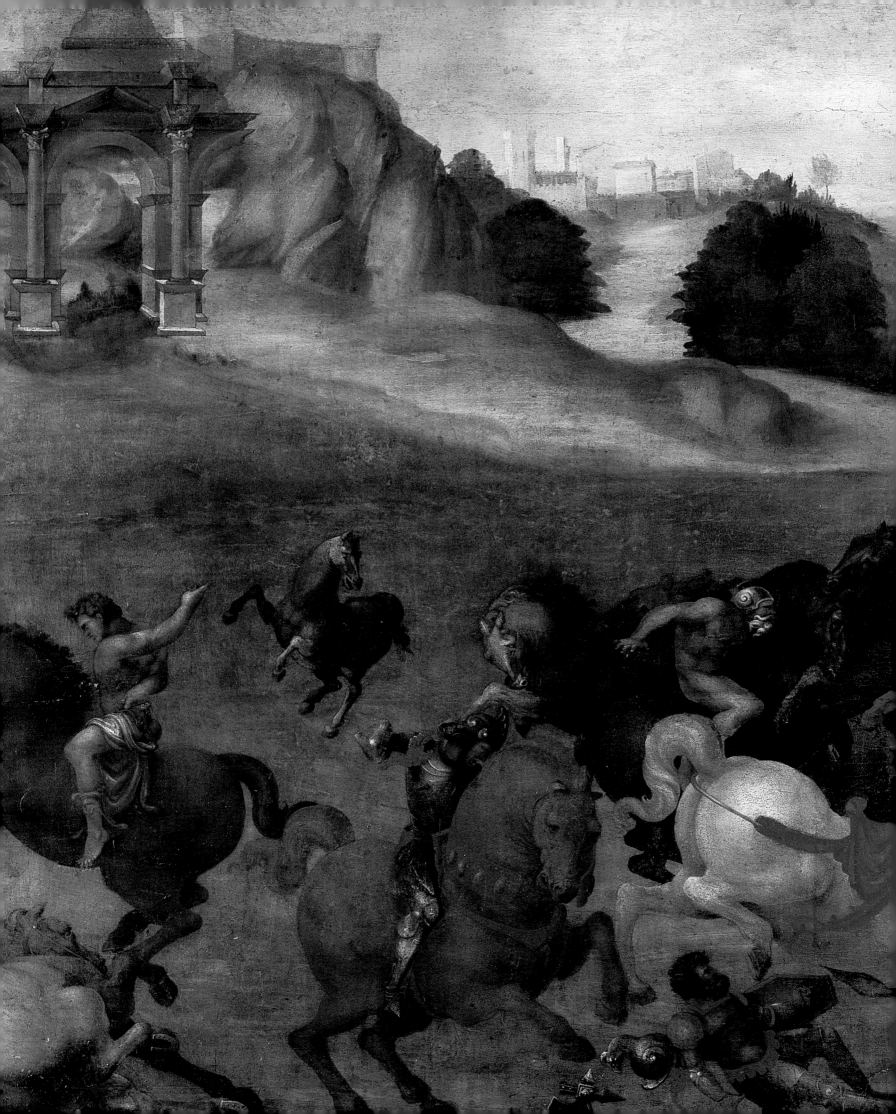

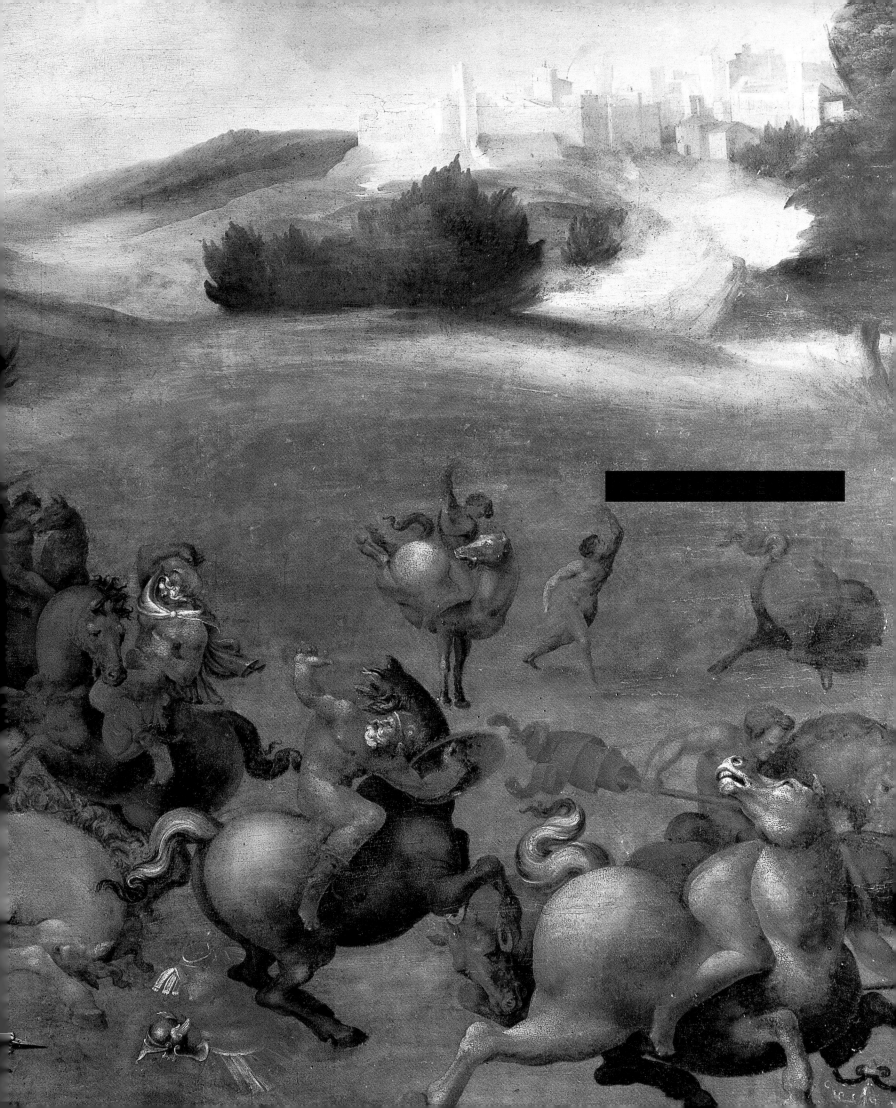

In 1500 Leonardo da Vinci returned to Florence, the city of his youth, after two decades in Milan. For the first couple of years he seems to have accomplished little, but a spell as an itinerant military engineer and mapmaker to Cesare Borgia in 1502–1503 was followed by a burst of artistic activity during which he was possibly busier than at any other time in his life. This sheet of miscellaneous studies reflects several of his projects around 1504. ¶ The first drawing to be made on the sheet was most probably the large Angel of the Annunciation on the right. The weak black chalk is shaded with the right hand and must be the work of a pupil, although Leonardo corrected the too-thin right arm in ink, using curved lines to follow the form, a feature of his draftsmanship in the first decade of the century. Two drawings of the left hand of the angel, apparently tracings, again by a pupil, are to be found on a sheet of geometrical studies of the same date in the Codex Atlanticus (Biblioteca Ambrosiana, Milan, fol. 395i). Another drawing of the same hand and forearm, in the Accademia in Venice (inv. 138), is attributed to Cesare da Sesto, a Lombard associate of Leonardo who may have been in contact with the master on several occasions after 1500. ¶ A painting of the *Angel of the Annunciation* reputedly by Leonardo was recorded by Vasari in the collection of Duke Cosimo I de' Medici; no original is now known, although several early versions have survived, such as those in the Kunstmuseum, Basel (fig. 1.1), the Hermitage, Saint Petersburg, and the Ashmolean Museum, Oxford. The angel, looming out of a dark, featureless background, is depicted in the act of making the salutation to the Virgin. Leonardo puts the viewer in the place of the Virgin Annunciate, and the angel does not gaze passively out of the picture but engages the viewer directly with his stare, a psychologically and devotionally powerful device that Leonardo was to use again, less successfully, in his *Saint John the Baptist* of the following decade, now in the Louvre. ¶ Most of the other small sketches on the sheet – apart from the mechanical and geometrical studies – are connected with the mural of the *Battle of Anghiari* that Leonardo agreed to paint in the Palazzo della Signoria in Florence, probably around the middle of 1503. The following year, a pendant, the *Battle of Cascina*, was commissioned from his young rival, Michelangelo. The two huge paintings, perhaps 20 metres wide, were to have been the dominant decorations of the Sala del Gran Consiglio, the centre of government of the Florentine republic, conceived after the expulsion of the Medici in 1494 and constructed by the finest Florentine artists and craftsmen of the day. Each painting was intended to represent a celebrated Florentine military victory; the *Battle of Anghiari* was to commemorate an action against Milanese forces in 1440 in which the Florentine army held a strategic bridge over the Tiber at Anghiari, in eastern Tuscany. ¶ On 24 October 1503 Leonardo was given the keys to the Sala del Papa of Santa Maria Novella, a chamber big enough to accommodate the full-scale cartoon for the painting. He made preparations during the following summer, including the construction of a mobile scaffold, although work on the mural apparently did not begin until 1505. In September 1506 Leonardo left for Milan, supposedly temporarily. Much to the chagrin of the government of Florence, he never resumed work on the project. Only a portion of the centre of the *Battle* was completed; known as the *Fight for the Standard*, it showed a furious cavalry engagement. This was widely copied before being replaced after 1563 by Vasari's extant frescoes. ¶ It is likely that no final design was determined for the episodes flanking the *Fight for the Standard*, as the contract allowed Leonardo to begin the painting without completing the entire cartoon. Other preparatory drawings suggest that Leonardo intended the right side of the mural to show a group of cavalry on a low hill, waiting to cross a bridge and join the battle. The small sketches near the centre of the sheet here, showing men pole-vaulting across a ditch, are probably first thoughts for the foreground joining the central and right-hand sections. Most of the other sketches of horses and warrior-like figures on the sheet must also have been drawn with the *Battle of Anghiari* in mind, although it is clear that Leonardo was at this stage casting around for motifs rather than finalizing his ideas. The short note at lower centre reads, in translation, "make a little one in wax, one finger long," which may be taken as evidence that Leonardo intended to study the complex forms of horses in action by means of small wax models. The standing nude at the middle left of the sheet is strongly reminiscent of Michelangelo's huge marble sculpture of *David* – Leonardo was a member of the committee that met on 25 January 1504 to decide where the sculpture, then almost complete, ought to be placed. The rearing horse to the right of lower centre is a copy after an antique coin, a sestertius of Nero, with the profile of the emperor, drawn from the obverse of the same coin, immediately to the right.

Martin Clayton

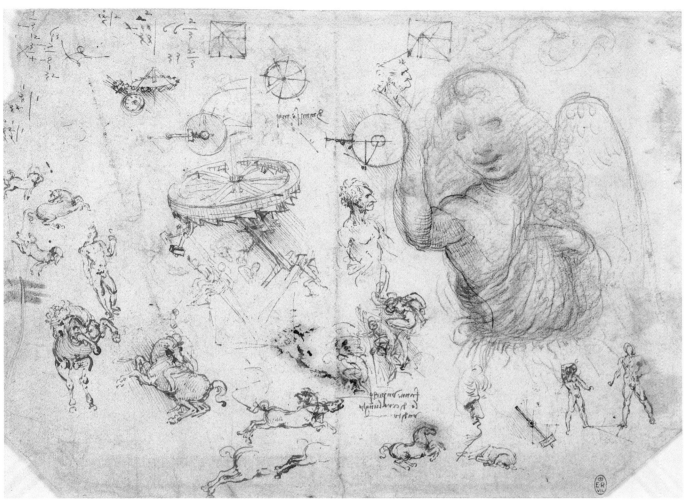

Fig. 1.1 Follower of Leonardo da Vinci, *The Angel of the Annunciation*, tempera on panel, 71 x 52 cm. Öffentliche Kunstsammlung Basel, Kunstmuseum

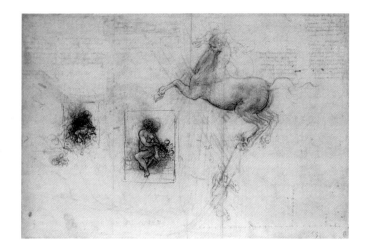

In Greek mythology, Leda, the wife of Tyndareus, king of Sparta, was seduced by Zeus in the form of a swan and bore two eggs, from which hatched Helen of Troy, Clytemnestra, and Castor and Pollux. During the first two decades of the sixteenth century Leonardo da Vinci worked on two variants of a composition of Leda with the swan, one in which the woman kneels, and the other in which she stands. There is no record of a commission, but the kneeling version was under consideration by about 1504, when Leonardo sketched Leda's twisting figure three times on a sheet at Windsor Castle (fig. 2.1) that also contains a study for the *Battle of Anghiari* (see cat. no. 1). The most heavily worked of those three sketches (to the left) is hard to read fully, but it is clear that Leonardo did not at this stage intend that Leda should be shown with the transformed god. Instead she twists to reach her right arm fully across her body, embracing what appears to be one of her offspring almost behind her back. ¶ That flat, diagonal pose, stretched out from near left to far right of the pictorial space, was opened out by Leonardo in the next (and final) two studies of the kneeling Leda, the present sheet from Chatsworth and a smaller but equally careful study in Rotterdam (fig. 2.2). Zeus in the guise of the swan has now been introduced. Most treatments of the subject of Leda, both ancient and contemporary with Leonardo, showed her in sexual union with the transformed god, and in depicting the princess both embracing the swan and gesturing toward their children, Leonardo rejected a narrative approach to the subject in favour of a mythological "family portrait." ¶ Leda's legs in the Chatsworth and Rotterdam drawings retain the pose of the Windsor sketches, but her right arm has been brought down to her side, where she gestures to her infants sprawling on the ground. In each of these two drawings Leda has essentially the same sinuous pose, probably inspired, as has often been pointed out, by an antique sculpture of the crouching Venus, known during the Renaissance in several Roman marble variants of a Hellenistic bronze original. Leonardo did not, however, follow that model slavishly; he was a subtle classicist, and he adopted the compact sensuousness of the ancient sculpture without copying its pose. Only the angle of Leda's head differs between the two drawings, although the changes to the swan and to the setting give the two drawings a very different feel – the Rotterdam version is intimate, whereas here Leda's upright stance is both more statuesque, emphasizing the instability of the kneeling pose, and more exposed, with a watery landscape sketched in to the left. ¶ Together, the Chatsworth and Rotterdam drawings are a unique example in Leonardo's oeuvre of equally cogitated alternative solutions to a compositional problem. Each is worked up to the same degree of finish, and it is impossible to be certain which was the later solution. Leonardo apparently did not make a full-size cartoon or painting of either composition, although painted versions by associates are known, which implies that the drawings were freely accessible in Leonardo's studio. Instead he turned to a standing pose for Leda, which was to occupy him over the next decade (see cat. no. 3). ¶ Alongside his studies of the figure of Leda, Leonardo prepared a series of botanical drawings as incidental details for the composition. In the present study we can see the leaves of the Star of Bethlehem at the lower right (studied in the well-known drawing at Windsor Castle, RL 12424), a flowering plant behind the children, and the tall leaves of a rush beyond. Some of the botanical studies are among the most objective of Leonardo's "scientific" drawings; others are more stylized, and approach the artificiality of the studies of Leda herself. Swirling plants can also be seen in the foreground of the Rotterdam drawing, and are found in some of the variant paintings of the standing *Leda*. These twisting forms endow all the components of the image – woman, swan, children, plants – with the same sense of vitality: the composition was worked on at a time when Leonardo was increasingly fascinated by the processes of life, leading to his campaign of human and animal dissection in the years around 1507 to 1513.

Martin Clayton

Fig. 2.1 Leonardo da Vinci, *Studies of Leda and the Swan, and a Mounted Soldier*, c. 1504, black chalk and pen and brown ink, 28.7 x 40.5 cm. Royal Library, Windsor Castle (12337r)

Fig. 2.2 Leonardo da Vinci, *Leda and the Swan*, c. 1505, pen and brown ink over black chalk, 12.6 x 10.9 cm. Museum Boymans-van Beuningen, Rotterdam (I-466)

3 RAPHAEL (1483–1520) · Leda and the Swan, after Leonardo da Vinci · c. 1507 · Pen and
brown ink over black chalk · 31 x 19.2 cm · Royal Library, Windsor Castle

3

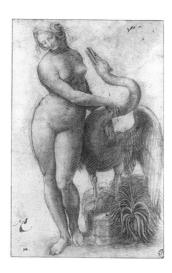

Fig. 3.1 Leonardo da Vinci, *Leda* (detail), c. 1506–1508, pen and brown ink, 26.8 x 19.5 cm overall. Royal Library, Windsor Castle (12642v)

Fig. 3.2 Anonymous Florentine, *Leda and the Swan, after Leonardo da Vinci*, red chalk, 27.2 x 16.8 cm. Musée du Louvre, Paris (2563)

Having developed a composition of a kneeling Leda (see cat. no. 2), Leonardo da Vinci abandoned that format and worked instead on a composition in which Leda stands, reaching across her body to embrace the swan by her side. The earliest sight of the composition in Leonardo's drawings is an effaced small pen sketch, part of a sheet of miscellaneous sketches of about 1506–1508 (fig. 3.1). A smaller pen sketch of the figure (Windsor Castle, RL 12642A), formerly set into figure 3.1, is impossible to date; an even tinier sketch of the figure on a sheet of geometrical studies of about 1515 in the Codex Atlanticus (Biblioteca Ambrosiana, Milan, fol. 423) is probably a doodle of an extant composition rather than a developmental drawing. ¶ Over the last decade or so of his life Leonardo completed a full-scale panel painting of the subject, which was the most highly valued item in an inventory of the estate of his assistant Salaì after the latter's death in 1524. The painting was recorded in the possession of Louis XIII at Fontainebleau in 1625, but it was destroyed sometime between 1694 and 1775. Several painted copies of Leonardo's composition are known, agreeing generally in the forms of Leda and the swan but differing greatly in the backgrounds, suggesting that some of the copies were made from a cartoon in which the background was barely indicated, rather than from the finished panel. ¶ The present drawing is a copy by Raphael after some version of Leonardo's composition. Although Raphael could have seen Leonardo's designs for the *Leda* during the period that both artists were resident in Rome, from 1513 to 1516, the style of the drawing indicates that it was executed before Raphael left Florence in late 1508. The number and variety of Raphael's borrowings from Leonardo – specific motifs and more general aesthetic ideas – strongly suggest that Raphael had access to Leonardo's studio at this time and could study his drawings as well as the few "public" works available to other artists. Both men were gregarious and highly receptive to the works of others, and even though Leonardo was thirty-one years older than Raphael, each had much to learn from the other. ¶ Raphael's model was almost certainly a drawing, probably of the same nature as the surviving drawings for the kneeling *Leda* (see cat. no. 2), rather than a full-size cartoon or a painting. The lines curving around the forms of the woman

are conspicuously different from Raphael's usual straight hatching and emulate the "bracelet" modelling developed by Leonardo during the first decade of the century (as in the corrected arm of the Angel of the Annunciation in cat. no. 1). Leonardo himself must have reduced the extreme *contrapposto* seen in the first extant sketch of the standing Leda (fig. 3.1), but another copy (fig. 3.2), apparently after the same original as the present drawing, shows that Raphael played down the torsions of the figure still further. Leda's left knee does not cross over her right, her right hip juts out less, her right shoulder does not drop so far, and her head is held at a less coy angle. The swan too is desensualized, its somewhat sinister serpentine neck rendered as a solid column. The ambivalence of Leonardo's design, with Leda both embracing and squirming away from the swan, is replaced by classical balance, and Leda's gaze calmly meets our own rather than disappearing under fluttering eyelids. ¶ Leonardo's designs for the *Leda* served as a rich source for Raphael. Her pose from the waist down was the model for Eve in the *Temptation*, painted by Raphael about three years later on the ceiling of the Stanza della Segnatura in the Vatican. The controlled twisting of the figure was the basis of designs such as the *Saint Catherine* (National Gallery, London), to be intensified a few years later in the *Galatea* (Villa Farnesina, Rome) and in a drawing in the British Museum of *Venus*, who might almost be Galatea's twin sister.[1] Also in the British Museum is a sheet of studies for Raphael's Borghese *Entombment* of 1507,[2] which includes studies of elaborate hairstyles clearly drawn in emulation of Leonardo's fantastic drawings of Leda's coiffure (Windsor Castle, RL 12515-8). The rhythms found in the present drawing recur throughout Raphael's studies for the *Entombment*, but in all of these adaptations Raphael imposed his own rationalism on Leonardo's dark eroticism: his supreme talent was to take what he needed from his models, absorbing their lessons without ever being in thrall to the vision of another.

Martin Clayton

On the recto of this sheet in Vienna (fig. 4.1), Raphael made a metalpoint drawing of the Mother of God with the Christ child seated diagonally across her lap. In a second phase, he elaborated the body of the child in pen and ink. The drawing is a preliminary sketch for the so-called *Bridgewater Madonna* in Edinburgh (fig. 4.2); another study for it has survived in a drawing that was once part of the sheet in Vienna but was separated from it and is now in the British Museum.[1] The motif of the Christ child leaning far over to the side and supporting himself on his mother's arm and hand is clearly derived from Michelangelo's marble tondo (Royal Academy of Arts, London), which the artist had been able to study at his friend Taddeo Taddei's house. A drawing by Raphael in the Louvre captures this relief with minor changes, omitting the young Saint John, who is also absent in the studies for the *Bridgewater Madonna*. Besides the influence of Michelangelo, that of Leonardo can also clearly be sensed in the delicate facial features of the Madonna and in the movement of the child, whose turning away recalls the Christ child in the cartoon for the *Virgin and Child with Saints Anne and John the Baptist* in the National Gallery in London. While the drawing in Vienna shows the Christ child's legs wrapped around Mary's thigh, nothing in the completed painting recalls this seated pose. Instead, the child takes on a sliding, spiralling position that no longer seems to require any hold or support. While the drawing depicts the upper body of the Mother of God almost frontally, the painting shows her leaning forward, thereby creating an oblique line that provides an effective counterpoint to the child's dynamic movement. The artist thus heightens the tension between the figures while allowing the viewer's gaze to slip past them into the background. ¶ In the drawings on the verso (cat. no. 4) we see the master at a unique creative moment, producing design studies in rapid succession for various Madonna compositions, all of which he would develop into paintings during his Florentine period. Only two vertical lines at the bottom of the sheet separate these studies, in which variations in the positions generate a wealth of different motifs of movement. To begin with, Raphael took red chalk and drew a large figure of Mary in the middle, her head tilted to one side as she grasps the body of the child. The Christ child, presumably seated, stretches upward to press his cheek affectionately to his mother's head and wrap his arms around her neck. This motif, which is known as the "Madonna Eleusa" and anticipates the artist's *Tempi Madonna* in the Alte Pinakothek in Munich, is repeated in another sketch above. Over it, he draws a second Christ child with his back to Mary, toward whom he must now turn his head, looking at her over his shoulder. The drawing in the upper-left corner is an early

idea for the *Colonna Madonna* in the Gemäldegalerie in Berlin. The artist then takes his pen and with a spontaneous, fluid handling cursorily outlines the figures below anew and gradually enhances the lines that determine the ultimate movements. Here art historians have noted the influence of Leonardo's drawings, which Raphael must have seen in the latter's workshop. Even in terms of composition, the study for a Madonna Lactans on the right is reminiscent of a preliminary drawing by Leonardo for the *Benois Madonna* in the Hermitage in Saint Petersburg.[2] The motif reappears in a similar form in the *Madonna of the Pinks* in the National Gallery in London, although there the Christ child is not nursing at his mother's breast but holding a carnation. ¶ In the drawing at the lower right Raphael repeatedly corrects the position of Mary's head and arm and incorporates the pose of the Christ child turning back that he had essayed in red chalk above, except that here the infant appears to catch hold of flowers and a book. This later evolved into the *Holy Family with a Palm Tree* in the National Gallery of Scotland in Edinburgh. A drawing at the middle left depicts Mary in a similar position, while the Christ child looks at the viewer as in the *Large Cowper Madonna* in the National Gallery of Art in Washington, dated 1508. The drawing below it is related to Raphael's *Orléans Madonna* in the Musée Condé in Chantilly. All of these studies wonderfully express the intimate and loving relationship between mother and child through their organically fused positions. Nevertheless, they all differ from each other in the liveliness and intensity of the mutual affection shown. In style they are quite reminiscent of the preliminary drawings for the *Madonna of the Meadows* in the Kunsthistorisches Museum in Vienna, which is dated 1505 or 1506 (fig. 21), the *Madonna of the Goldfinch* in the Uffizi, probably also from the same period, and the *Belle Jardinière* in the Louvre, dated 1507 (fig. 26.1). One can reasonably assume that the drawings on this sheet in Vienna belong to the same general period.

Achim Gnann

Fig. 4.1 Raphael, *Study for the Bridgewater Madonna*, c. 1506–1507, pen and brown ink over metalpoint on brown prepared paper (recto of cat. no. 4)

Fig. 4.2 Raphael, *The Bridgewater Madonna*, c. 1506–1507, oil on panel, 87 x 61.3 cm. Duke of Sutherland Collection, on loan to the National Gallery of Scotland, Edinburgh

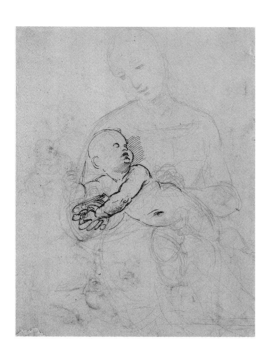

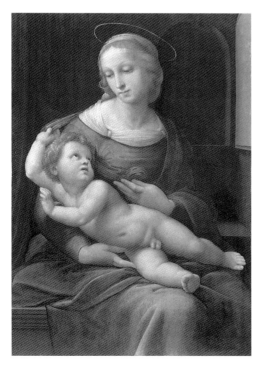

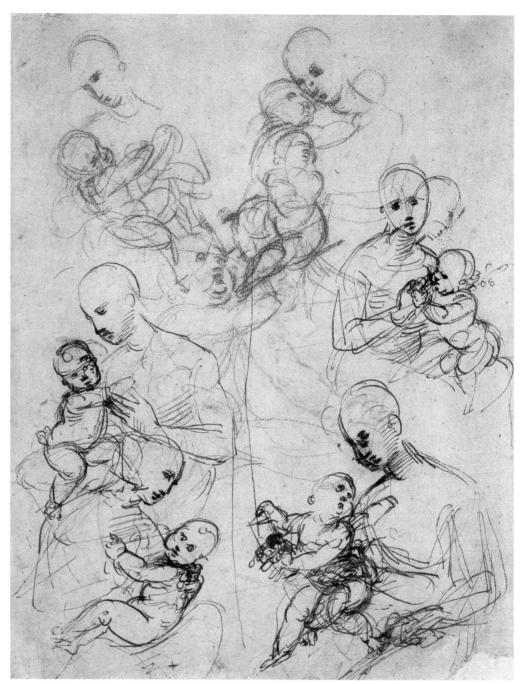

4

This is one of three busts in the Victoria and Albert Museum now identified as Saint Jerome that were purchased in Florence in the mid- to late nineteenth century (see fig. 5.1).[1] Jerome was one of the four doctors of the Christian Church. A learned man who translated the Bible into Latin, he lived for four years as a hermit in the Syrian desert. He is often portrayed in that setting, penitent and beating himself to alleviate the powerful sexual hallucinations and fevers that he suffered. The emaciated appearance of the stucco bust, with its bony chest and sunken cheeks, together with the distracted, upward glance are characteristic representations of the penitent saint, who is more usually depicted with a long beard. ¶ The form relates to the Florentine portrait busts, inspired primarily by antique precedents, that were developed and produced in the fifteenth century by artists such as Antonio Rossellino, Benedetto da Maiano, Andrea del Verrocchio, and Pietro Torrigiano.[2] Contemporary portraits in this form are occasionally based on casts taken from life or after death, providing a true likeness of the sitter, while other subjects include idealized representations of antique philosophers or religious figures. Such busts were often set above doorways and in other domestic and religious settings. This stucco bust appears largely to have been cast from moulds made from an original model; some fine moulding lines are visible where stucco had squeezed through the gaps in the piece mould and were not completely smoothed away. The bust would probably have been painted, and the paint layer would have obscured any lines. The term "stucco" is used loosely, often being interchangeable with plaster. The composition of stucco varies, being based on gypsum and/or lime, with the addition of an aggregate of stone powder or similar material and sometimes a binding medium. Analysis of this bust shows it to be made of finely ground gypsum with pigment particles.[3] The image of Saint Jerome, while having the character of a likeness, is over life-size and therefore cannot have been made from moulds taken from life. The prominent ears are distinctive but there is also an element of idealization. The image had to be universally recognizable as the saint if it were to fulfill a potential role as intercessor – representing the worshipper in heaven and acting as an agent for the transmission of his or her prayers. In the absence of an attribute, identification was probably achieved, at least in part, through the figure's resemblance to other well-known images of Saint Jerome. ¶ This bust was traditionally attributed to Torrigiano, but in more recent scholarship it has been variously connected with three generations of artists: Verrocchio, his pupil Leonardo da Vinci, and Giovanni Francesco Rustici, who was Leonardo's assistant. Despite Rustici's relationship with Leonardo and his ability to convey a sometimes exaggerated

realism, the bust is not sufficiently close to Rustici's autograph sculptures to uphold the attribution. The evident relationship of the *Saint Jerome* to Verrocchio's work was recognized by Maclagan and Longhurst, who thought the bust might reflect a lost model by the artist, an idea based on a remark in Vasari's biography stating that Verrocchio excelled at making "certain things of clay," including a "Saint Jerome, which is held to be marvellous."[4] Images of Jerome associated with Verrocchio or his circle – including a painted head in the Palazzo Pitti and a terracotta bust at the Liebieghaus in Frankfurt am Main – are clearly quite close, although their expression is more restrained.[5] ¶ Parallels can equally be found in Leonardo's works. Several examples of this type of idealized head are notable in his drawings, including the extraordinary sheet at Windsor Castle (fig. 5.2) exploring the bone and muscle structure of an elderly, emaciated man (who is nonetheless idealized), a knowledge Leonardo had obtained through the dissection of cadavers.[6] A closer comparison, first remarked by Suida, is Leonardo's unfinished painting of the saint in the Vatican, in which the intensity of the expression, with the upward gaze and open mouth, as well as the pose and treatment of the anatomy parallel those in the bust.[7] It has been suggested that contemporary busts generally thought to represent Seneca provided a common source for both that painting and the related terracotta and stucco sculptures.[8] Despite the work's evident relationships with painted images of the unbearded saint, such as the aforementioned works associated with Verrocchio and Leonardo, it remains difficult to assign the bust to a particular hand. The reproduction of variants based on or inspired by a known original of such sculpted images was no doubt undertaken by a number of workshops, some of which remain unidentified.

Peta Motture

5

Fig. 5.1 Follower of Andrea del Verrocchio, *Saint Jerome*, c. 1500–1520, terracotta, 47.9 cm high. Victoria and Albert Museum, London

Fig. 5.2 Leonardo da Vinci, *The Superficial Muscles of the Neck, Thorax, Right Arm, and Shoulder*, c. 1510–1511, pen and ink with wash over traces of black chalk, 28.9 x 19.8 cm. Royal Library, Windsor Castle (19001v)

6 GIOVANNI FRANCESCO RUSTICI (1474–1554) · **Mercury Taking Flight** · c. 1515 · Copper alloy, probably bronze, on a weathered green and red breccia marble ball · 47.9 cm high · The Fitzwilliam Museum, University of Cambridge

Mercury stands balanced on a marble ball, his left leg thrust out behind him, his left hand resting on his hip, and his right arm raised, the hand shaped to grasp a (lost) rod-like attribute.[1] He is shown with head thrown back, cheeks puffed out, lips pursed, and mouth formed as a nozzle pierced with a round hole (6 mm in diameter). ¶ The figure is cast in one piece (except for the right leg, which is joined at the centre of the thigh by a visible sleeve joint) in a pale brassy alloy that is now covered with a modern, dark-brown patina. The sculpture is hollow except for the arms (which are solid to just above the biceps), the forepart of the left foot, and the right foot (solid to just above the ankle). The right foot is a later replacement. A large, irregular, rabbeted oval aperture (7.8 x 3.7 cm) designed to receive a (lost) closely fitted cover was cast into the centre of the back, and a near-circular hole (12 mm in diameter) was cut into the outer flank of the right thigh, just below the sleeve joint, by a rather inexpert hand. There are several repaired casting flaws (for example, in the left forearm) as well as areas of both corrosion (in particular the abdomen and feet) and damage (especially in the right leg, which has lost the definition of its modelling due to successive repairs). Radiographs reveal the remains of a thick metal pipe in the extended left leg, running from the bottom of the foot up into the left buttock, the bore of the pipe being consistent with that of the mouth aperture. ¶ It was Henry Harris in 1926[2] who first identified the bronze with the fountain figure of *Mercury* that, according to Vasari, had been commissioned from Giovanni Francesco Rustici in 1515 by Cardinal Giulio de' Medici for the second courtyard of the Palazzo Medici in Florence:

When Pope Leo came to Florence in 1515, he [Rustici] made some statues at the request of his great friend Andrea del Sarto, which were considered very beautiful. These, because they pleased Cardinal Giulio de' Medici, were the cause of his having him make, for the top of the fountain which is in the great court of the Medici palace, the *Mercury* of bronze about one braccio high, which stands on a ball in the act of taking flight. In the hands of this he put an instrument that is made to turn by the water which it spouts up. For, one leg being pierced, a pipe passes through this and through the torso, whereby, when the water reaches the mouth of the figure, it strikes this instrument balanced with four thin blades soldered to it in the manner of a butterfly and makes it spin. This figure, I say, was much praised for a small thing.[3]

Given that the present bronze fits Vasari's description in terms of pose, physical characteristics, and mounting, and is only 10 centimetres short of a braccio fiorentino (which could well have been the height of the lost whirligig), most critics have accepted Harris's identification.[4] However, the absence of any of the traditional attributes of Mercury – caduceus, petasus (the winged hat), and talaria (the wings attached to the ankles) – and the distinctly Pollaiuolesque character of the figure, with its angular pose and heavily emphasized musculature, have encouraged the suggestion that the present bronze is actually an unrecorded work by Antonio Pollaiuolo that may have provided a model for the (lost) *Mercury* by Rustici that was recorded by Vasari.[5] ¶ Anthony Radcliffe has argued that the figure was indeed intended for a Mercury, noting that when it was catalogued by Arthur Skinner in 1904 it had "four small wings [presumably attached in pairs to the ankles] and a caduceus with a windmill,"[6] which he believes were original. However, Skinner, who actually saw these attributes, was of the opinion that they were later additions designed to convert the figure from a "herald" into a Mercury. That opinion was repeated in the 1925 Cook sale catalogue,[7] which appears to have prompted Henry Harris's regrettable decision in late 1925 to remove (and discard) those attributes. Without seeing them, it is impossible to judge their authenticity, yet it seems likely that they were later additions; as Jo Dillon has pointed out, the fact that Harris was able to remove them suggests that they were not integrally cast.[8]
¶ As regards the question of authorship, the strongly Pollaiuolesque character of the bronze is undeniable. Were it the *Mercury* that Rustici made for Giulio de' Medici in 1515, it would be distinctly "old-fashioned" for a figure of that date.[9] This has led some critics to question Vasari's date of 1515, with Maria Grazia Ciardi Dupré, for example, dating the *Mercury* to before 1500.[10] However, other critics have argued that the retrospective style of the bronze accords well with other works that Rustici made in the mid-1510s and represents a deliberate decision on his part to return to Quattrocento realism. Ulrich Middeldorf and John Pope-Hennessy, for example, pointed to stylistic affinities with certain figures in Rustici's terracotta roundels for the courtyard of Villa Salviati, which can be dated to these years given that they form part of the same decorative scheme as the *sgraffito* frieze by Andrea di Cosimo Feltrini, which is datable to between late 1512 and late 1517.[11] ¶ Radcliffe has plausibly suggested that the *Mercury* may have been commissioned by Giulio de' Medici as part of his larger project to replace the sculptures that had been removed from the palace by the Signoria in the mid-1490s following the expulsion of the Medici from Florence on 9 November 1494. He further proposed that it was probably designed to crown the large granite fountain-basin in the second courtyard, left bare when Donatello's bronze group of *Judith and Holofernes* (fig. 6.1)

was removed in October 1495. The precise location of that fountain in the courtyard is not known, but it seems likely, as Radcliffe has argued, that it occupied the site of the large sandstone basin now in the middle of the southern half of the courtyard, centred on the Michelozzian loggia. ¶ If so, it is rather curious that the *Mercury* was designed with one dominant viewpoint rather than in a fully circular form. The only effective viewpoint is from the figure's left side (as illustrated), since from this position the unsightly external water pipe (entering the figure through the round hole just above the right knee) would have been hidden and the action of the water wheel mounted on the caduceus would have been seen to maximum effect. This particular infelicity, together with the work's rather old-fashioned appearance, may explain why the figure was removed from the fountain less than a century after it had been installed: by 1609 it was in storage in the Guardaroba of the palace.[12] Nothing is known of its fortunes after that date until its appearance in the collection of Sir Francis Cook in the late nineteenth century.

Victoria Avery

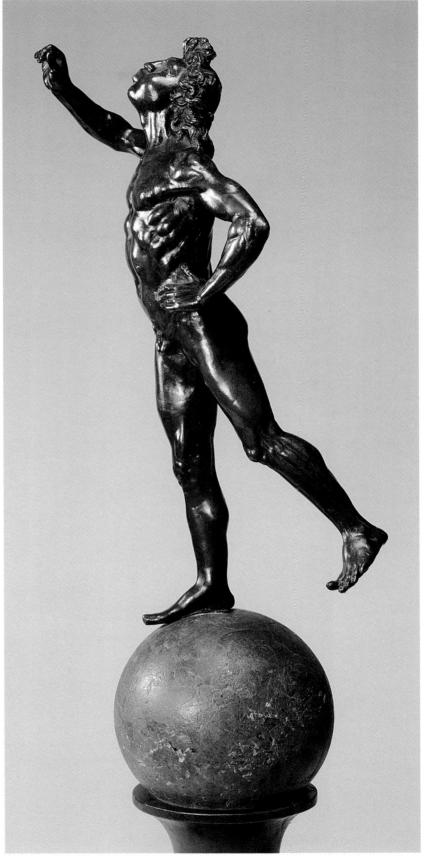

Fig. 6.1 Donatello, *Judith and Holofernes*, c. 1453–1457, bronze, 236 cm high (with base). Palazzo Vecchio, Florence

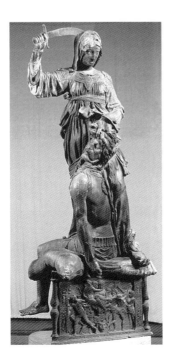

7 **GIOVANNI FRANCESCO RUSTICI (1474–1554)** · **Saint George and the Dragon** · c. 1520–1528 (?)
Marble relief · 29 x 48 cm · Szépmüvészeti Múzeum, Budapest

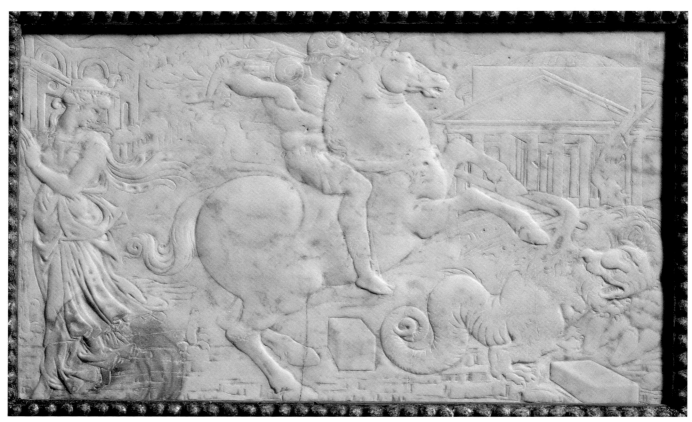

Fig. 7.1 Donatello, *Saint George and the Dragon*, c. 1417, marble, 39 x 120 cm Museo Nazionale del Bargello, Florence

In his 1504 treatise *De sculptura*, Pomponius Gauricus mentions Giovanni Francesco Rustici as one of the most famous marble sculptors of his time;[1] yet Vasari, writing two generations later, says little about Rustici as a marble carver, and modern scholars have dismissed Gauricus's praises as a mere rhetorical flourish. Be that as it may, Rustici's few surviving works in marble demonstrate that he was indeed one of the period's most remarkable practitioners of marble carving. His *Saint George and the Dragon*, now in Budapest, synthesizes motifs drawn from classical antiquity, Donatello, and Leonardo da Vinci into a vigorous, eloquent exploration of the possibilities of relief sculpture. ¶ In its general outlines, Rustici's *Saint George* repeats – in reverse – the composition of Donatello's famous relief of the same subject, carved a century earlier, which formed part of the niche of Donatello's statue of *Saint George* on the exterior of Orsanmichele in Florence (fig. 7.1). Rustici's imitation can be seen as both in homage to and in competition with the venerable patriarch of Florentine sculpture, who furnished an inexhaustible reservoir of visual motifs and served as a model of emotional expressiveness, or *terribilità*.[2]

¶ Donatello's *Saint George* relief marked the first appearance of the revolutionary technique of *rilievo schiacchiato* ("squashed relief"). Combining extremely shallow modelling with incision, this manner of carving made it possible for relief sculpture to achieve a panoply of pictorial effects – including linear perspective. Rustici employed elements of *rilievo schiacchiato* in many of his reliefs in terracotta, but it is in his marble carvings – particularly the *Saint George* and the Villa Salviati *Annunciation* – that he pushed the technique to its most extreme form.[3] These works employ incision so extensively that the scene appears to have been etched or drawn into, rather than carved out of, its stony matrix. Although, in a famous letter of 1549, Rustici's contemporary Michelangelo condemned *rilievo schiacchiato* for its similarity to painting,[4] it was the only kind of sculpture that overcame the medium's inability to portray effects of landscape and perspective – a defect that, for Leonardo, represented an argument for sculpture's inferiority to painting. The Budapest *Saint George* thus represents a nodal point between the sixteenth-century revival of interest in Donatello's work and the ideas of Rustici's close friend and mentor,

Leonardo. ¶ According to Vasari, Rustici "learned many things from Leonardo, but particularly how to make horses."[5] Rustici's spirited horse – its body a coiled spring of muscular energy and its small head taut with furious intensity – clearly derives from Leonardo's animated and anatomically particularized studies of equine movement.[6] The writhing, serpentine dragon also has close analogies in Leonardo's work.[7] The fluttering draperies of the princess, a motif ultimately derived from Roman sculpture, can be found, for instance, in a drawing by Leonardo at Windsor Castle (RL 12581),[8] as well as in the work of such late-Quattrocento masters as Sandro Botticelli and Filippino Lippi. The rocky landscape on the left side of the relief recalls Leonardo's lifelong fascination with craggy outcroppings of stone, and the gradually softening outlines of the trees and hills in the distance are evidently an attempt to translate Leonardo's aerial perspective into the medium of sculpture. ¶ In contrast to the sparse setting of Donatello's relief, the background of Rustici's *Saint George* is replete with detail, almost a sculptural equivalent of the complex unity between figures and background that Leonardo achieved in his paintings. On the left side, surrounded by trees, stands a massive, irregular facade, evidently inspired by the Septizodium at Rome. The right side, behind the dragon, is dominated by the imposing outlines of the Pantheon. Such *all'antica* stage dressing suggests the possibility – not attested by documents – that Rustici may have visited Rome. ¶ The flowing draperies and the treatment of the horse in Rustici's *Saint George* have close parallels in a series of relief sculptures produced by the artist for the Villa Salviati, outside Florence, between 1522 and 1526,[9] and as a result most recent scholarship has dated the Budapest relief to the 1520s. Its many Florentine influences certainly imply that the *Saint George* was carved prior to Rustici's departure for France in 1528, but beyond such generalities it is hard to be overly fastidious about its precise place in Rustici's oeuvre. Because of the freedom with which Rustici altered his *maniera*, the dating of his works on the basis of style alone is a perilous, even invidious undertaking, as recent documentary research has emphasized.[10]

Louis A. Waldman

8 GIOVANNI FRANCESCO RUSTICI (1474–1554) · *Saint John the Baptist* · c. 1510–1520 · Glazed terracotta · 100.3 x 33 x 26.7 cm · Museum of Fine Arts, Boston · Gift of Mrs. Solomon R. Guggenheim

This white-glazed terracotta sculpture of *Saint John the Baptist* was given to the Museum of Fine Arts, Boston, in 1950 by Mrs. Solomon R. (Irene) Guggenheim, who believed it to be by Andrea della Robbia.[1] Upon acquisition, it was attributed by the museum "to the della Robbia family" and dated to about 1550. While its relationship to the central figure in Giovanni Francesco Rustici's bronze group of *Saint John the Baptist Preaching, between a Levite and a Pharisee* (1506–1511, Baptistery, Florence; fig. 38) was noted and its quality recognized, condition problems seem to have led to its being placed in storage and never exhibited. Careful examination of its style and facture suggest that it is a work by Rustici reflecting the influence of Leonardo da Vinci, whose impact on Rustici's Baptistery group is attested to by both Vasari and the group itself.[2] Rustici was a brilliant modeller, known to create works that were then glazed and fired by the della Robbia workshop.[3] ¶ With a base and support that suggest a rocky landscape setting, the sculpture represents Saint John in the wilderness, the "voice of one crying in the wilderness" (Mark 1:3). The back of the sculpture is complete but not fully modelled, indicating placement in a niche or against a wall. A pair of holes in the top of the figure's head suggests that a halo may once have been attached. No other attributes seem to have been employed. Though the sharp turn of the head might imply that the sculpture was once part of a group, it seems more likely that the work was created as a single figure in the tradition of Donatello's figures of *Saint John* in wood and bronze; the influence of Donatello on this work is apparent. ¶ The torsion of the figure's stance and the intensity of its expression suggest a comparison with Rustici's Baptistery group, the only contemporary figural sculpture to display a similarly strong interest in qualities of light and shadow, texture and atmosphere.[4] The irises, the outlines of the eyes, and the eyebrows are emphasized through the application of purple glaze (fig. 8.1). All other effects of light and shade are conveyed through the vigorous modelling of the clay, the remarkable working of the surface, and the glaze that reflects light in the high areas and traps it in the recesses. The Boston sculpture may record ideas explored by Rustici in the form of clay models for the figure of Saint John in the Baptistery group, made, as Vasari tells us, in consultation with Leonardo.[5] Alternatively, it

may have been commissioned after the installation of the Baptistery group, as a reflection of that group. ¶ Many aspects of the *Saint John* relate to the works and ideas of Leonardo, especially the way in which, through its pose and gaze, the figure engages the space around it.[6] The directed gaze and open, speaking mouth recall Leonardo's head studies, especially the heads in the Uffizi *Adoration of the Magi*, while the hands, with their long, carefully articulated fingers, recall studies by Verrocchio and Leonardo and their followers.[7] Further reflecting working practices established in Verrocchio's workshop and carried forward by Leonardo, the folds of the outer cloak create an almost autonomous rhythmic passage across the front of the figure, recalling the drapery studies common among these very artists.[8] ¶ Technical aspects of the piece support the dating and attribution.[9] Thermoluminescence testing indicates that the sculpture was last fired between 1499 and 1601. The white-bodied clay is typical of Florentine terracotta sculpture. Areas that broke either in firing or through subsequent jolts to the object may reveal methods of making. For example, the once-detached right hand snapped off cleanly, revealing a luted join that would have remained weak; this suggests that the sculptor reworked the gestures of the clay hands, detaching and reattaching them, a process that recalls descriptions of plaster models of hands and feet used for study purposes in the Verrocchio and Leonardo workshops. A similar process of refinement likely characterized the artist's approach to the head. This evidence accords well with Vasari's description of Rustici's commitment to rethinking and reworking before arriving at a final solution, an approach he shared with Leonardo.[10] Finally, the glaze is not the brilliant white of many della Robbia works but has a creamy cast that further enhances the colouristic effects of the monochrome sculpture. The results can be compared to Andrea del Sarto's manipulation of chiaroscuro in his contemporary frescoes in the Chiostro dello Scalzo.[11] This kind of experimentation with medium, typical of Leonardo, helps to make the *Saint John* one of the most daring and expressive terracotta sculptures of the early sixteenth century.

Marietta Cambareri

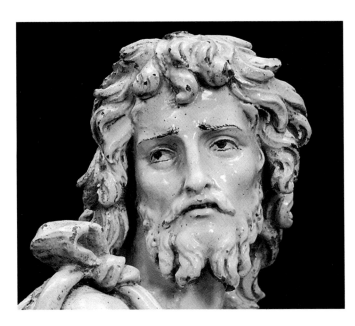

Fig. 8.1 *Saint John the Baptist* (detail)

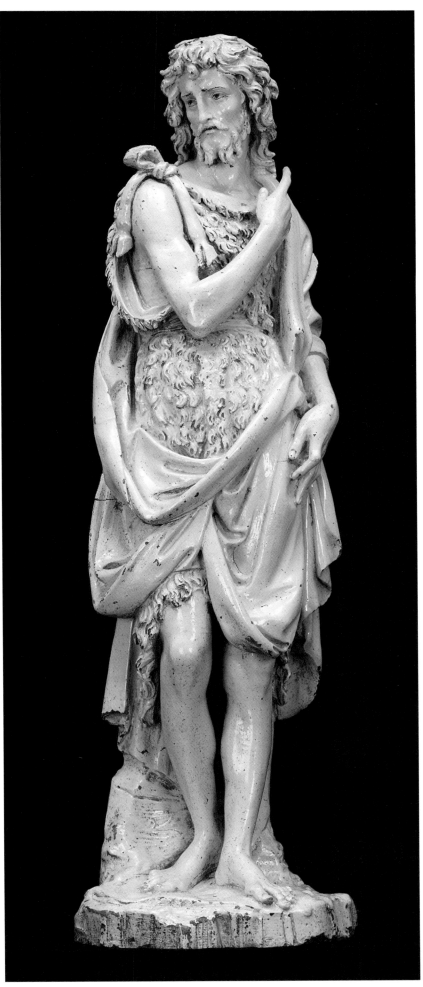

8

This deeply moving angel is one of the most beautiful terracotta sculptures of the early sixteenth century. Made as the upper portion of a full-length or nearly full-length standing figure, it shows the angel with his hands crossed over his chest in a gesture of adoration. The rich locks of his hair cascade in wave patterns down over his shoulders, his drapery is agitated as if blown by the wind, and an expression of poignant tenderness traverses his face. The terracotta is only partially glazed; the unglazed passages were originally painted after firing, so that the whole figure was polychromed. ¶ Since its discovery in 1990, this sculpture has been recognized as the work of Luca della Robbia the Younger, one of the sons of Andrea della Robbia. Along with his brothers Giovanni and Girolamo, Luca the Younger was a leading exponent of the della Robbia tradition in the sixteenth century. Luca won considerable fame for his work. He was praised by Vasari for the quality of his glazing, he collaborated with Raphael on the decoration of the Vatican Loggie, and he worked almost exclusively for Francis I for the last twenty years of his life. However, the destruction of so much of his work at the Château de Madrid and other royal residences during the French Revolution has made it difficult to know much about his oeuvre, and it is only during the last decade that scholars have begun to reconstruct his career and grasp his significance. ¶ In earlier publications of this sculpture, it was suggested that it was part of a decorative ensemble that also included

a pair of angels now in the Museo Thyssen-Bornemisza in Madrid. Direct examination of those angels, however, reveals that this hypothesis is incorrect. Each of the Thyssen angels was fired as an integral unit; they do not have joins at the waist. Thus they differ technically from the present sculpture. Moreover, the Thyssen angels are flatter and in lower relief than the present sculpture. ¶ This sculpture manifests an unmistakable affinity with the work of Leonardo. The beautiful masses of elegant curls, the rounded and perfected forms of the face, the emphasis on gesture as the indicator of expression, the sensitive melancholy of the eyes and mouth, and the gently rippling drapery all reveal the sculptor's close attention to the painter's work. This piece thus provides an interesting parallel to the work of Giovanni Francesco Rustici, another contemporary follower of Leonardo, who also worked in glazed terracotta.

Andrew Butterfield

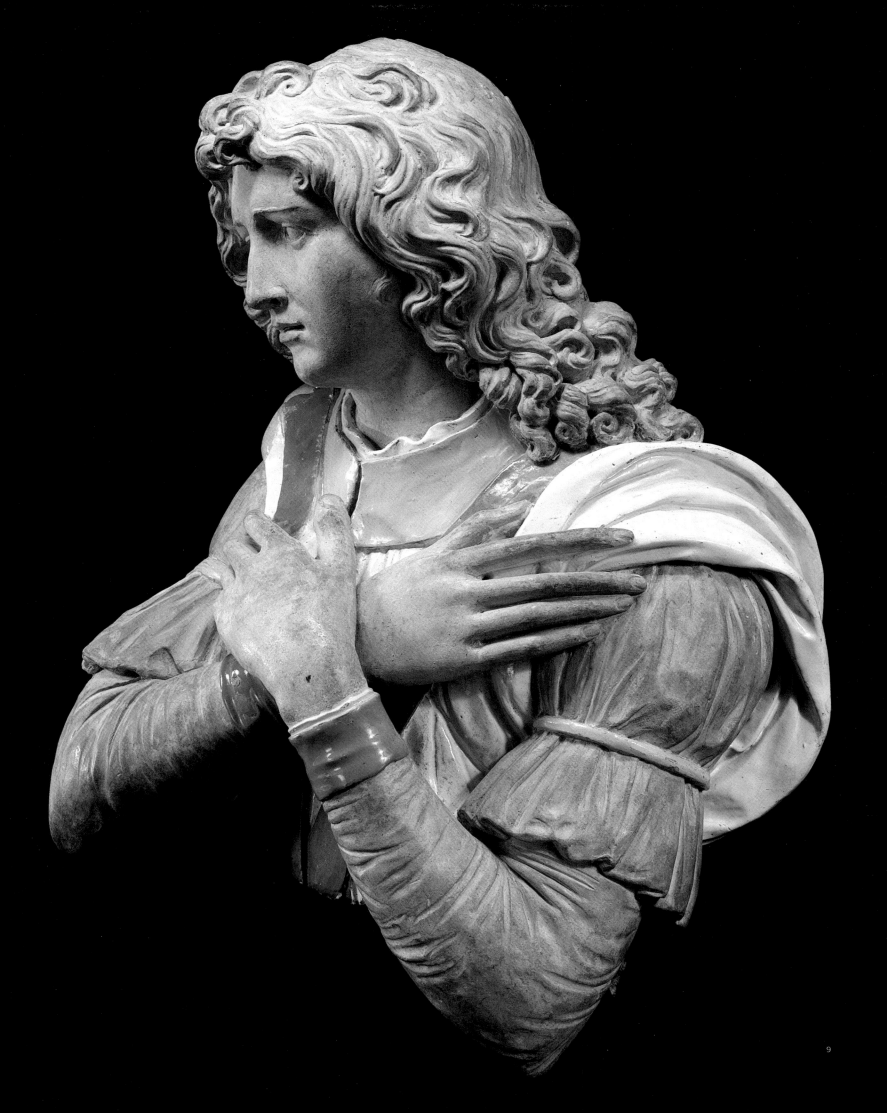

9

Well documented for his exuberant flights of fantasy, Piero di Cosimo again plays the master storyteller in *Prometheus Stealing the Celestial Fire*. This painted fable, now in Strasbourg, originally joined a slightly larger pendant panel, now in Munich, representing the beginning of the Greek creation myth: *Prometheus Fashioning the First Man* (fig. 10.1).[1] The companion scenes were intended to function as *spalliera* panels (from *spalla*, shoulder), decorated backrests on large pieces of furniture such as chests and benches, or, more plausibly in this instance, boards inset at shoulder height into the panelled wainscoting of a room.[2] While the original provenance remains unknown, the works' destined location can be traced with some confidence to a *camera* (bedroom) or *anticamera* in a patrician palace, where they would have served as alluring windows opening onto a whimsical world far beyond the clamour of urban Florence. Sharing the visual vocabulary of another secular panel from Piero's late oeuvre – the gem-like *Liberation of Andromeda* (fig. 23) – the Prometheus fantasies likely survive as Piero's final *spalliera* commission, stylistically datable to about 1515. ¶ While attesting to Piero's distinctive interest in indeterminate yet strangely suggestive landscape and cloud formations (also apparent in the *Liberation*), the Prometheus narratives appear distinctly understated in their tawny palette. Piero's dimming of the glowing luminosity of his earlier myths in favour of subdued earth tones is accompanied by a distillation of compositional complexity. Looking ahead, the elliptical simplicity of his increasingly muted landscapes, enlivened by local bursts of vivid reds and blues, was significantly to shape the *sfumato*-shrouded visions of his one-time pupil Andrea del Sarto at the beginning of his career. ¶ Berenson was the first to connect the Munich and Strasbourg panels.[3] Although they were intended to be installed separately, their initial paired state is confirmed by the exactitude of the landscape contours, which seem to match at an imaginary central joint. Beginning at the far left of the Munich composition, we find the Christ-like figure of Zeus, distinguished by a red robe and ultramarine mantle, annihilating a *Spinario*-inspired seated clay effigy of the first man. On his knees, trembling before the fearsome Olympian sovereign and surrounded by tools of the sculptor's trade is Epimetheus ("Afterthought"), the Titan brother of Prometheus and creator of the doomed clay model. The aftermath of Zeus's fit of temper materializes behind this iconoclasm in the form of a tree-climbing monkey, its quasi-human identity betrayed by the fact that it wears Epimetheus's ominously familiar red sash. This simian symbol of folly refers to the Titan's transformation in punishment for his audacity, a mockery of the sculptor's (and more profanely, the ape's) uncanny powers of

imitation. ¶ Man's genesis must await a craftier conjuror in Prometheus ("Forethought", see fig. 10.1).[4] Glorious proof of his inspired skill, a second and far nobler statue of man, akin to a classical bronze ephebe, stands remade at the centre.[5] Towering above its altar-like pedestal, the new archetype resonates with Ovid's triumphant verse in the *Metamorphoses* (1.76–88): "Man was made to hold his head erect in majesty and see the sky, and raise his eyes to the bright stars above. Thus earth, once crude and featureless, now changed, put on the unknown form of humankind." In the right foreground, richly attired in contrast to Prometheus's hairshirt, we find wise Athena, worshipped as the patroness of the arts and thus a natural choice as the inspiration for Prometheus's artful cunning. Gesturing at the skyward-pointing statue in admiring approval, she instructs that a life-giving spark from the celestial fire be added to animate the exalted creation. ¶ The narrative concludes at the upper right, as the goddess takes to the skies with Prometheus at her side.[6] Shown soaring toward the source of divine fire, the pair – like Perseus descending with winged sandals from the skies in Piero's *Liberation* – finds a striking visual parallel in the designs of popular contemporary spectacles, work for which Piero himself received the highest accolades from Vasari. Reminiscent, in their theatricality, of mythologically inspired themes for public festivals (as well as enacted religious dramas), Piero's floating figures appear suspended in much the same way that mythical deities and heavenly angels alike were represented in mock flight on the Renaissance stage. ¶ Further scrutiny of the skyscape reveals two chariots punctuating Piero's curious cloud formations. In the left cloud bank, Cupid accompanies his mother Aphrodite, who plucks a love-tipped arrow from her quiver, while a second chariot is pulled by two dragons, signifying the ownership of Cronus, father of Zeus. Discernible below the airborne figures of Prometheus and Athena is the panel's most obscure passage: a man struggling under a giant stone. This mysterious figure is accompanied by an overturned basket of mushrooms – a decidedly odd detail most likely intended to be read as a veiled allusion to foolish ignorance and, more precisely, man's mentally inhibited state before the dawn of Promethean enlightenment.[7] ¶ The Strasbourg panel presents the tragi-heroic conclusion of Prometheus's costly triumph. While lacking its companion's profusion of itemized foreground detail, the Strasbourg fantasy is similarly evocative of stage design. Reflecting Piero's experimentation with varying planes of action, the Strasbourg narrative unfolds in a less linear pattern, beginning amid the clouds with Prometheus's daring theft of fire from the chariot of the Sun. The action then shifts diagonally to the left

Fig. 10.1 Piero di Cosimo, *Prometheus Fashioning the First Man*, c. 1515, oil on panel, 68 x 120 cm. Bayerische Staatsgemäldesammlungen, Munich

foreground before progressing regularly from left to right. Brandishing his smouldering fennel stalk at the left, Prometheus activates the inanimate colossus by applying the life-giving flame to its breast. Prometheus's trickery and defiance of Zeus's will carries an infinitely more terrible price than his unlucky sibling's, however, as he is sentenced to hang for all eternity from the face of Mount Caucasus – here represented by a craggy tree that mimics Prometheus's tortured frame in its twisting limbs. Ironically, the lot of carrying out Zeus's vengeance falls upon the god of tricksters, the herald Hermes, here shown readying his captive for the giant eagle that will daily devour the immortal's liver. ¶ Still unappeased, the thunder-god proceeded to punish the entire human race for Prometheus's impieties with the cursed gift of Pandora. According to classical sources, it was hapless Epimetheus – unsuspecting of the afflictions that were soon unleashed upon mankind from Pandora's jar – who took the irresistible seductress as his wife. It is this malediction that may explain a pair of mysterious landscape motifs in these panels that perhaps foretell the evils to befall the earth: a youth fends off a snake that has coiled itself around his leg in the left background of the Strasbourg work, while the attempted rescue of a drowning woman occupies the far meadow of the Munich narrative. ¶ Although it is subject to alternative readings, the council of six figures detectable in the middle ground of the Strasbourg panel may allude to the kind of scornful sentiment expressed in the verses of classical authors like Hesiod (*Theogony* 509–620; *Works and Days* 58–128), who condemned Pandora as the bitter root of a "deadly race and population of women, a great infestation among mortal men."[8] Piero's triad may present Zeus (again robed in red and blue) and venerable Hephaestus, responsible for fashioning Pandora, as the first seated pair; followed by armoured Hermes, who endowed Pandora with a cheating heart, accompanied by the elegantly gowned figure of the alluring temptress herself (or possibly Venus, who infected Pandora with "painful desire and knee-weakening anguish"); and finally, at the right, a mortal couple, suffering the pains of love. The final pair's tortured pleadings resonate not only with the cautionary tales of ancient authors but also with the most popular mediator of those tales in the Renaissance, Giovanni Boccaccio's *Genealogie deorum gentilium*, first printed in Venice in 1472. Boccaccio cited "famine, fever (assuming its libidinous form), and women" as the scourges accompanying Pandora's arrival. Taking his lead from Hesiod, Juvenal, and Plutarch, the Trecento poet exhorted man to lead a quiet, solitary life. "As you flee quarrels, flee women!" he pleaded, comparing the opposite sex, armed with untold wiles, to the mythical basilisk, capable of killing with a glance. Either way, Hesiod lamented, man was destined to come off the worse, since "whoever escapes marriage and women's harm, comes to deadly old age without any son to support him." Could Piero be alluding to this equally unappealing fate in the left pair of aged figures in the Strasbourg panel's central group? ¶ Prometheus won unmatched popularity in ancient Greece as not only the begetter of the human race but the high-minded champion of all human civilization. The most important of the many commentaries celebrating this greatest of culture heroes – from Hesiod, Plato, and Aeschylus to the mythographer Hyginus – were readily available in the Renaissance, although the myth gained a manifestly moralizing or Christian dimension in the age of Boccaccio and the humanists Marsilio Ficino and Celio Calcagnini of Ferrara who came after. Yet, attesting once more to his poetically quixotic sensibility, Piero's visual narratives are more illustrative than overtly allegorical or didactic. In fact, despite drawing freely upon ancient literary prototypes, Piero's panels owe nothing to earlier Renaissance visual sources. Highly descriptive yet unmistakably personal, his reworkings bear the hallmarks of this painter's insatiable inventiveness, as ancient descriptions of the gods are given breath through the artist's imaginative understanding. An implied kinship with the creation myth's protagonist seems impossible to ignore. Taking pride in his singular originality, Piero relied upon a game Renaissance viewer to recognize in the visual metaphor an implicit declaration of his own limitless, Daedalean creative potential. For just as Prometheus garnered eternal fame as man's teacher of the arts and the titular deity of all craftsmen, so too does the ambitious Piero – Renaissance craftsman and inventor – align himself with the tireless labours of the arch-artificer.

Dennis Geronimus

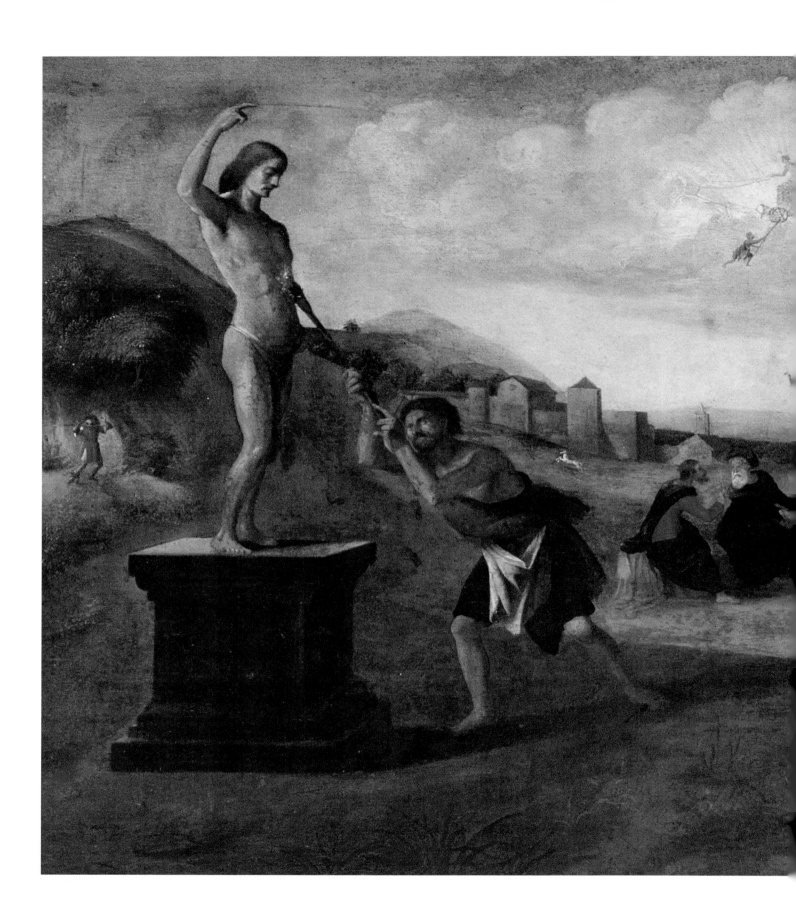

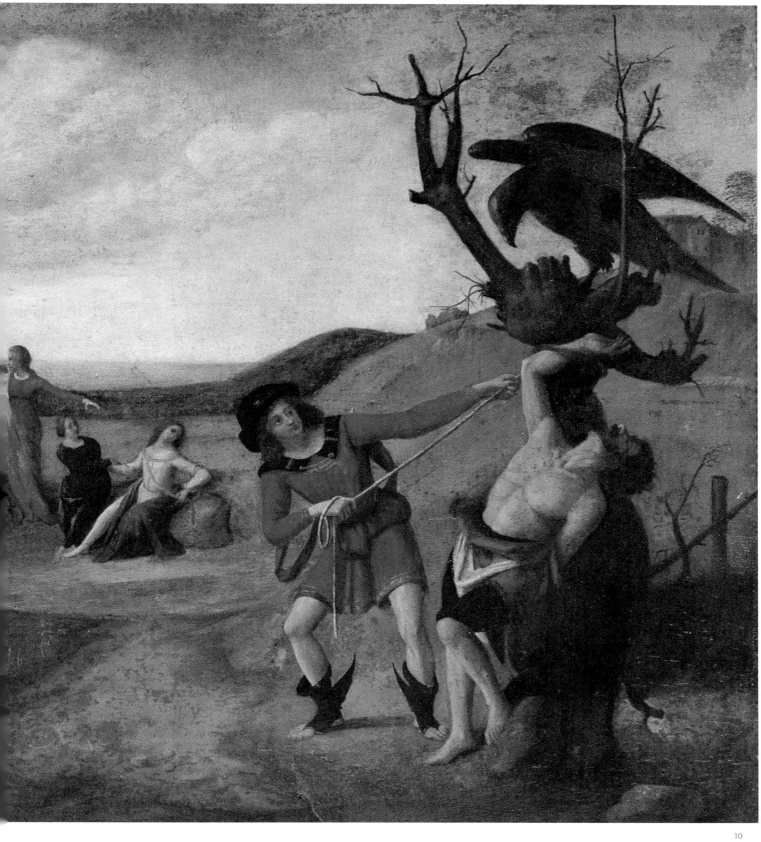

The nude studies on both sides of this sheet, which was once owned by Rubens, are preliminary drawings for the famous *Battle of Cascina* that Michelangelo was to execute as a monumental wall painting in the Sala del Gran Consiglio of the Palazzo della Signoria in Florence to compete with Leonardo's *Battle of Anghiari*. These are the two most famous depictions of battles in the history of art, even though Michelangelo only partially completed his composition, in the form of a cartoon, and Leonardo's painting remained unfinished and eventually fell victim to subsequent alterations to the hall. ¶ The subject of Michelangelo's planned fresco was the glorious victory of Florence's army over Pisa's troops on 29 July 1364. The cartoon is now lost but has come down to us in the form of a grisaille copy attributed to Bastiano da Sangallo now in Holkham Hall (cat. no. 13).[1] It shows the Florentines, bathing in the Arno near Cascina because of the great heat, suddenly attacked by the Pisans and rushing to dress and seize their arms. The Florentines withstood the onslaught of their enemies and were able to repulse them. The cartoon with the bathers, however, does not record the entire scheme of the project. There were to be other scenes, including a cavalry encounter on one side. Only preliminary drawings for these have survived. ¶ The nude seen from the back on the verso of the sheet, whose lower half has unfortunately been cut off, served as a study for the soldier carrying a lance in the middle of the last row of the bathers. The artist had originally placed the face more to the right, but with a bold black-chalk line he narrowed it and lowered the head. The position is almost identical with that of the figure in the cartoon, whose back, however, bends sideways more markedly, giving the movement greater impetus. In the drawing in the Albertina the body acquires a powerful, relief-like sculptural effect through the strongly contrasting alternation between the dark areas of closely spaced chalk lines and the white highlights. It is animated by strong pulsating movements of the muscles, in which the drawing technique makes the transitions between the individual parts softer and more fluid than in pen drawings. These closely spaced rippling muscles create an almost autonomous rhythm, which resonates with the strikingly curvaceous contour that at the same time restrains it. It is one of the artist's most beautiful nude studies in black chalk. Furthermore, it provides an idea of the appearance of the cartoon, in which "there were also many figures in groups…some outlined with charcoal, some drawn with strokes, others stumped in and heightened with lead-white."[2] Two other studies for the lance bearer, belonging to an earlier design stage, are in the Louvre.[3] ¶ On the recto of the drawing (fig. 11.1), the nude on the left is a study for the bearded warrior rushing forward at the centre of the bathers. He is often identified as Manno Donati, who was the first to realize the danger and sounded the battle cry. The other figure, seen from the side, is the soldier in the cartoon who is putting armour on his comrade. However, in the cartoon and in a final study for this figure in the Teyler Museum in Haarlem, he is seen slightly from above and with a spatially more effective rotation of the torso.[4] In addition, on the sheet in the Albertina he has his right hand in front of his face as if holding a wind instrument, although that is unlikely, as his cheeks are not puffed out. ¶ Michelangelo started by establishing the contours of the two soldiers in black chalk and using sketchy hatching to give substance to the individual shapes. For the detailed elaboration of the bodies, with the exception of the heads, he then used pen. At this stage he studied nude models in order to clarify the organic sequence of the movements, with the difficult foreshortenings, and to depict the muscle groups in detail. On each of the two soldiers he provided the same muscles around the collarbone, shoulder blade, and hip area, with individual characteristics. The anatomically correct rendering and powerfully muscular detailing of the bodies, together with the daring of their positions, have particularly fascinated artists. According to Vasari, they came in throngs to see the exhibited cartoon and to learn from it. ¶ It is not known exactly when Michelangelo received the commission for the fresco, but bookbinders were paid on 31 October 1504 for delivering the paper and gluing the cartoon together,[5] which suggests that the composition was ready at that time. Since the nudes on the sheet in the Albertina largely correspond to those in the executed cartoon (with a few variations – for example, Manno Donati looks to his right on the Albertina sheet but straight ahead in the cartoon), they can confidently be dated to about 1504.

Achim Gnann

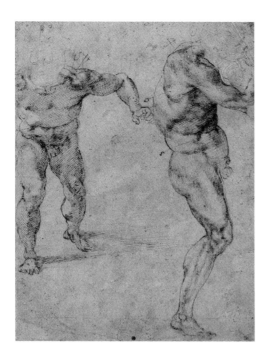

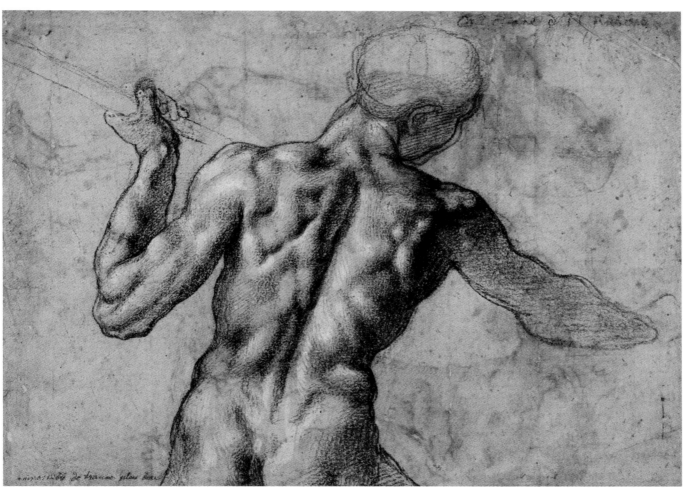

Fig. 11.1 Michelangelo, *Two Male Nudes*, pen and brown ink over black chalk (recto of cat. no. 11)

11

MARCANTONIO RAIMONDI (c. 1470/1482–1527/1534) · **Copy after the Cartoon for the Battle of Cascina by Michelangelo (The Climbers)** · 1510 · Engraving · 28.4 x 22.8 cm · British Museum, London

This engraving – known since Bartsch by the nickname *The Climbers* – is one of the few surviving documents of Michelangelo's lost cartoon for the *Battle of Cascina* (see cat. nos. 11 and 13). In 1504, when Leonardo da Vinci was painting the *Battle of Anghiari* in the Sala del Gran Consiglio of the Palazzo della Signoria, the republican government of Piero Soderini awarded Michelangelo the commission for a companion mural depicting the Florentine victory over the Pisan army at Cascina in 1364. Michelangelo worked on the cartoon for some ten months before he was called away to Rome to undertake the tomb of Pope Julius II; he resumed work on it briefly in November 1506 before returning to the service of the pope. ¶ The moment Michelangelo chose to depict was not the battle proper, but an incident that took place the previous day. According to the Florentine historian Matteo Villani, the Florentine soldiers were complacently bathing in the Arno when one of their leaders, Manno Donati, raised a false alarm that the Pisans were attacking. Making a mad dash for their clothes, the Florentines prepared to meet the enemy – but found themselves admonished for their lack of preparedness. Galvanized by Donati's trick, the Florentines decisively routed the Pisan army the following day. ¶ The choice of the bathing scene afforded Michelangelo a pretext for portraying a large group of nude figures in a variety of intricate poses. He never began the painting itself, but his full-size cartoon survived for about a decade in Florence, where, according to Vasari, it became the "school" for a generation of young draftsmen eager to master the depiction of the nude figure in movement. Raimondi probably saw Michelangelo's cartoon during a brief stay in Florence around 1508, on his way from Venice to Rome. ¶ Comparison with the most complete surviving copy of Michelangelo's cartoon, the panel at Holkham Hall attributed to Bastiano da Sangallo (cat. no. 13), reveals that Raimondi copied the work quite faithfully, presumably in the presence of the original. Yet unlike some contemporary artists, who aimed to "document" the appearance of the original work, Raimondi in his engravings after the *Battle of Cascina* attempted to distill a single motif from the whole and to develop it into an expressive new creation that unites figures and landscape. The landscape behind the three figures is copied, with various minor changes, from a 1508 engraving of *Mohammed and the Monk Sergius* by Lucas van Leyden (fig. 12.1). By transforming the group of standing figures in the middle ground of Lucas's print into an approaching band of soldiers, Raimondi was able to create a logical motivation for the foreground figures' glances and gestures. He seems to have also transformed the bank of the Arno into the summit of a cliff, with a grassy ledge in place of the flowing waters.

Yet the semi-deshabille of the pointing figure with his breeches not fully drawn up around his waist, in contrast to the fully dressed soldiers in the background, suggests that Raimondi did indeed mean us to see the foreground figures as bathers; thus one is evidently meant to infer the presence of the river just below the engraving's lower border. Raimondi's insertion, at the bottom of the sheet, of three fingers and the thumb of a fourth climber still in the unseen stream (not visible in the Holkham Hall copy of Michelangelo's cartoon) lends the print an air of mystery, hinting at the possible presence of other companions outside the frame.

¶ Shortly before creating the present work in Rome in 1510, Raimondi produced a smaller engraving that depicts only one of the three figures shown here, the left-hand climber, seen from behind (fig. 12.2). Though undated, this smaller print seems to represent an earlier stage in Raimondi's study of Michelangelo. In the smaller engraving, his treatment of anatomy is schematic, and individual muscles are too starkly defined by light and shadow, giving the figure something of the appearance of an *écorché*. The 1510 three-figure group, in contrast, displays a softer modelling of the figures and a more atmospheric treatment of landscape, achieved through the greater range of tonal modulations from dark to light Raimondi was now able to employ. Close examination of the earlier and later prints reveals that he obtained this new richness of shading in part through extensive use of short strokes of the burin, alternating with dots, to modulate his shadows and soften their transitions into the highlights. This change in Raimondi's style reveals the extent to which he was assimilating the burin technique of Albrecht Dürer – some of whose prints he had copied during his stay in Venice – and particularly of Lucas van Leyden, whose delicately luminous works Raimondi pillaged for the backgrounds of other engravings during his early Roman years.

Louis A. Waldman

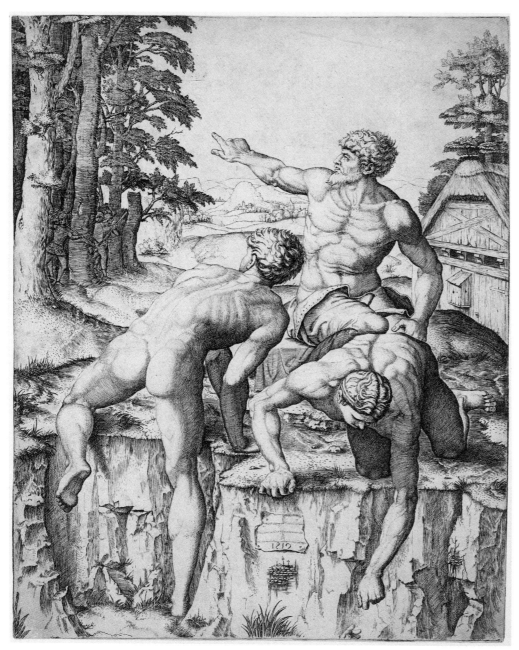

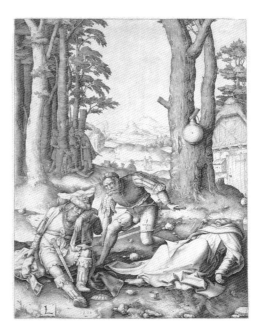

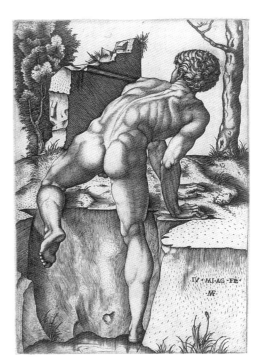

Fig. 12.1 Lucas van Leyden,
Mohammed and the Monk Sergius, 1508,
engraving, 29.2 x 21.8 cm. Spencer
Museum of Art, The University of Kansas,
Lawrence (1969.0109)

Fig. 12.2 Marcantonio Raimondi,
*Copy after the Cartoon for the Battle of
Cascina by Michelangelo* (*The Climbers*),
c. 1509, engraving (Bartsch 63.488),
20.1 x 13.4 cm. British Museum, London
(1868-8-22-55)

13 BASTIANO DA SANGALLO (1481–1551) · Copy after the Cartoon for the Battle of Cascina by Michelangelo (The Climbers) · c. 1542 · Oil on panel · 78.7 x 129 cm · The Earl of Leicester and Trustees of the Holkham Estate, Norfolk

Michelangelo's first prominent painting commission in Florence was to produce a fresco of a Florentine victory over the Pisans on the feast day of Saint Victor in 1364 in the Battle of Cascina.[1] The republican government commissioned the fresco in the late summer of 1504, following its request to Leonardo in October 1503 for a large painting to commemorate the Battle of Anghiari. Both were intended for a wall of the Sala del Gran Consiglio in the Palazzo della Signoria. On 22 September 1504, while Leonardo was preparing his cartoon in a room in Santa Maria Novella, Michelangelo was given space to work in the hospital of the Tintori at Sant'Onofrio, not far from Santa Croce, and on 31 October 1504 he was provided with paper for his cartoon.[2] By March 1505, however, Michelangelo had left Florence for Rome to begin work on the tomb of Pope Julius II. So, unlike Leonardo, who would make a start, if an entirely disastrous one, on his part of the commission, Michelangelo did not have time to begin painting. ¶ This copy in monochrome paint on panel after part of Michelangelo's preparatory cartoon for the mural survives at Holkham Hall, Norfolk. Done at Vasari's personal urging by Bastiano da Sangallo in Rome around 1542, it was composed from drawn copies made after Michelangelo's original cartoon by the young Sangallo himself in Florence.[3] It appears, then, that the picture was produced by Sangallo not with a particular patron in mind, but as a way of preserving a venerable image for posterity, in the period, not coincidentally, leading up to the appearance of Vasari's first meticulous biographies of artists. Though it is the most faithful surviving replica of the lost design, no mention of it appears again until the eighteenth century, and so it is difficult to know how many other artists might actually have studied it. Sangallo certainly was not a talented painter, and in any comparison with the autograph drawings his copy demonstrates a clear loss of characterization and a simplification of details. Further, the artist miniaturized the figures in Michelangelo's work, which were apparently intended to be larger than life-size. It is what the panel records rather than its intrinsic quality that made it such a valued object. No less a person than Paolo Giovio, according to Vasari, arranged to have it presented to Francis I, an enthusiastic collector of Italian art of this period. ¶ The painted copy, which includes all that Michelangelo brought to the completed cartoon stage, depicts not the battle proper, but an emergency call to arms sounded by the captain, Manno Donati, on the day preceding it, which was meant to test the soldiers' readiness for battle. If it was intended for the central section, this would explain why the figures look laterally out of the field in both directions. It is an unusual choice for a pivotal scene in a large-scale historical painting.

However, it is entirely consistent with Michelangelo's singular artistic tastes, prejudiced toward the active male nude in motion, which contrasted with Leonardo's emphasis on the representation of a plausible narrative. The figures' general lack of armour seems to emphasize their raw courage, accentuating again how it was, above all, form rather than exterior attributes that generated meaning for Michelangelo. Nonetheless, as indicated by some of the extant drawings, he did plan to depict more than just these soldiers bathing in the Arno and rushing to prepare for battle. There are drawings that show other military activity behind the central figures (see fig. 13.1) and even a cavalry skirmish – Michelangelo's main concession to Leonardo's more spirited design. ¶ The primary and most influential part of the Battle of Cascina fresco design is found in a group of male nudes who, isolated from each other, are balanced and pivoting like free-standing sculptures on individual pedestals on a flat inclined plane. Following this principle, Michelangelo organized the figures as if they were climbing up the picture space in sculpted low relief – a stacking device completely at odds with Leonardo's method in the Battle of Anghiari, where the figures were intended to interact and to be set more in depth. ¶ The impact of the whole design, while immediate and profound in Florence, was not long sustained except through copies, for within a decade of its creation, while stored at the Palazzo Medici, the cartoon was torn apart on more than one occasion and the fragments dispersed.[4] None now survive. Drawn and printed copies after the cartoon generally contain just one or two, or occasionally three, figures. Indeed, the grisaille copy at Holkham, created rather late in the context of the destruction of Michelangelo's cartoon, is of unique interest precisely because it records more than just the individual figures that other artists tended to study.

David Franklin

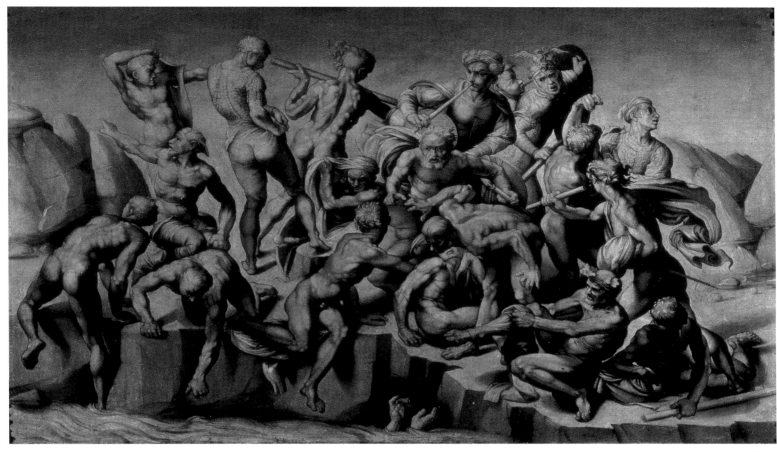

13

Fig. 13.1 Anonymous, *Copy after the Cartoon for the Battle of Cascina by Michelangelo* (*The Climbers*), pen and brown ink over black chalk, 45.8 x 89 cm British Museum, London (1946-7-13-593)

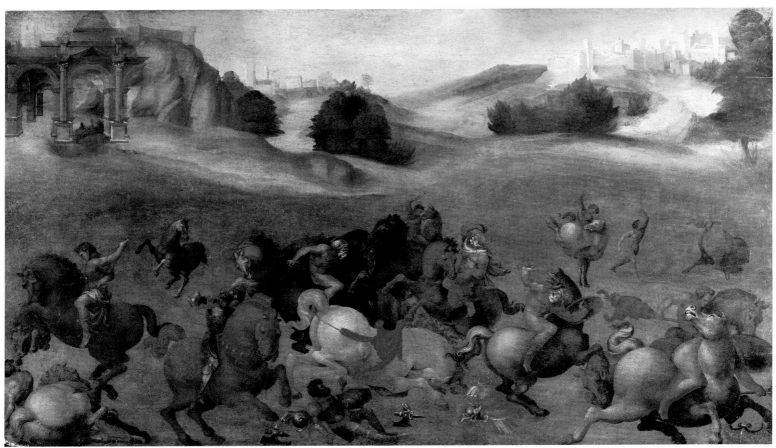

14

Leonardo's commission to decorate part of the Sala del Gran Consiglio in the Palazzo della Signoria in Florence was perhaps the most significant and ambitious to open the sixteenth century. The subject of the fresco was the military conflict on the plain before Anghiari in 1440, when the Florentine coalition led by Pier Giampaolo Orsini defeated the Milanese, under the command of Niccolò Piccinino. The section generally recorded in copies (see fig. 14.1) is that of the so-called "battle for the standard," which formed the central part of the image. With this project the artist brought to narrative painting a level of expressive violence and passion never seen before. In 1503 Leonardo was provided with a room in Santa Maria Novella in which he began his drawings, although there is documentary evidence that his cartoons were not completed until February 1505.[1] He was ready to paint by about April 1505. Work was interrupted on 30 May 1506, when he was given permission by the patron to go to Milan, and it was never resumed. In this commission, Leonardo had continued to experiment with a fresco medium modified by oil, but with disastrous results, and he could not complete any part of the painting. It seems that, overall, Leonardo spent about a year on the fresco and probably started only a relatively small central section, featuring the symbolic struggle for possession of the cavalry flag. There was nothing left to save when, in 1563, Vasari obliterated any remaining fresco in preparation for his own large-scale decorations in the hall. ¶ A painting attributed to Leonardo's close follower and collaborator Giovanni Francesco Rustici indicates how his designs for the *Battle of Anghiari* were perceived in the period immediately following his death. Dating from about 1525, or perhaps slightly earlier, this remarkable work is the only painting by Rustici cited by Vasari that can be identified with some certainty.[2] The panel was formerly attributed to Beccafumi by Bernard Berenson, to Bachiacca by Donato Sanminiatelli, and to the Master of the Kress Landscapes (Giovanni Larciani) by Federico Zeri, but it was Anthony Radcliffe who first associated Vasari's description of a Rustici painting of this subject with the picture in the Victoria and Albert Museum.[3] The nominal subject of this large horizontal panel, which was offered as a gift by the artist to the prominent Florentine diplomat Piero di Braccio Martelli, is the conversion of Saint Paul, although no halo is visible on the main figure who has fallen beneath a horse; there is, however, a yellow glow in the sky, indicating a divine appearance.[4] As Vasari worked for the Martelli family, it is likely that he knew the original, and his testimony in this case must be respected. Vasari also mentions the painting in his Life of Bandinelli, where he describes how the sculptor, in observing Rustici working on this particular panel, was inspired to try his hand at painting too.[5] ¶ Rustici's painting is obviously derived from Leonardo's design for the *Battle of Anghiari*. Indeed, it must closely reflect Leonardo's general intentions for his art in this period, given Rustici's unparalleled proximity in Florence to the older master, with whom he sometimes collaborated. Rustici changed the unusual patriotic subject of Leonardo's commission to a more common religious theme, acceptable for private devotion, although the aggression of the figures in the painting suggests that they are still engaged in battle, but without an enemy. The clear debt in the portrayal of certain of the horses to Paolo Uccello's equally famous battle paintings, in Rustici's time in the Palazzo Medici, has also been repeatedly noted in the literature. ¶ In Rustici's version, the principal event of the religious narrative is subsumed by the spirited, almost distracting formalism of interpretation that owes so much to Leonardo's battle cartoon. The sweeping landscape, including the superimposed ruin of a temple at the left, is attractive, but the main interest of the painting is the bracing activity displayed for maximum effect at the first plane. Here, the horses and soldiers appear as if detached from the ground, and it would seem reasonable to suspect that the landscape might even be by the hand of a different painter. Not surprisingly, Rustici simplified Leonardo's figural groups, and this results in a more staccato overall impression. As with Bastiano da Sangallo's version of Michelangelo's cartoon for the *Battle of Cascina* (see cat. no. 13), the copyist was able to imitate only part of his prototype. But even while sacrificing some of its intense emotionality, his work captures the rich activity and full sculptural potential of the design for the *Battle of Anghiari* better than any other surviving painting of the period.

David Franklin

Fig. 14.1 Anonymous sixteenth-century artist, *The Battle of Anghiari, after Leonardo da Vinci*, oil on panel, 86 x 106 cm. Palazzo Vecchio, Florence

15 FRANCESCO D'UBERTINO VERDI, CALLED BACHIACCA (1494–1557) · The Conversion of Saint Paul · c. 1540 · Oil on panel · 96.5 x 78.7 cm · Memorial Art Gallery, University of Rochester

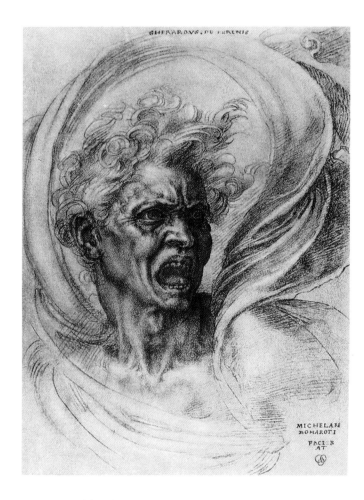

Fig. 15.1 Michelangelo, *"Furia," or the Damned Soul,* c. 1520s, black chalk, 29.7 x 20. 6 cm. Galleria degli Uffizi, Florence (601E)

In its present state of preservation, the *Conversion of Saint Paul* only hints at its former splendour. The poplar panel support has been thinned and cradled to prevent warping, and the painted surface has been heavily abraded by old cleanings that have marred a once luxurious finish. The loss of the upper layers of translucent oil glazing reveals the luminous underpainting and the unmitigated, abrupt chiaroscuro – reducing most hues to mid-tones and resulting in what Nikolenko considered harsh, unpleasant colours. ¶ Despite this, the *Conversion of Saint Paul* still offers a kaleidoscopic display of more than twenty active and elaborately costumed figures, rearing warhorses, and rugged terrain – all within less than a square metre of surface area. Bachiacca achieved this remarkable effect by combining and elaborating upon famous works by Michelangelo, Leonardo, Lucas van Leyden, and Albrecht Dürer – a collage-like method that evinces his artistic heritage and gift for composition. ¶ One important source for the *Conversion of Saint Paul* is Michelangelo's lost cartoon for the *Battle of Cascina*. Michelangelo's composition is partly recorded in a grisaille panel at Holkham Hall (cat. no. 13) painted by Bachiacca's friend and associate Bastiano da Sangallo.[1] Bachiacca's quotations from Michelangelo's design include the bearded head visible between the two white horses to the right of Saint Paul, derived from the figure of Manno Donati sounding the cry to battle in the *Battle of Cascina*. At the centre of Bachiacca's painting, the little trumpeter with a drum standing behind the hill directly above Saint Paul borrows from a figure just above Donati in the *Battle of Cascina*. The body of the soldier on the rearing horse to the right reverses the soldier pulling on his hose at the upper left of the Holkham Hall grisaille. Bachiacca also cited Michelangelo's drawing of *Furia* (fig. 15.1), one of the renowned *teste divine*, which appears in a somewhat calmer state as the face of the shouting and gesticulating soldier near the left edge of the *Conversion of Saint Paul*. As well, the tiny God the Father in the upper-right corner of Bachiacca's painting hails from Michelangelo's *Separation of the Earth from the Waters* on the Sistine Chapel ceiling. ¶ In addition to the quotations from Michelangelo's *Battle of Cascina*, Bachiacca included elements of Leonardo's rival Florentine commission, the *Battle of Anghiari*. The battle-like fray of charging and rearing cavalry, the close engagement of men and horses, the fallen warriors, and especially the partly obscured soldier with the dragon helmet on the right side of the *Conversion of Saint Paul* reflect Leonardo's *Fight for the Standard*, the central portion of the *Battle of Anghiari*, as transcribed in later copies. In addition, Bachiacca borrowed a scowling face (next to the dragon helm) from one of Leonardo's tiny drawings of grotesque faces, possibly the *Head of an Old Man*

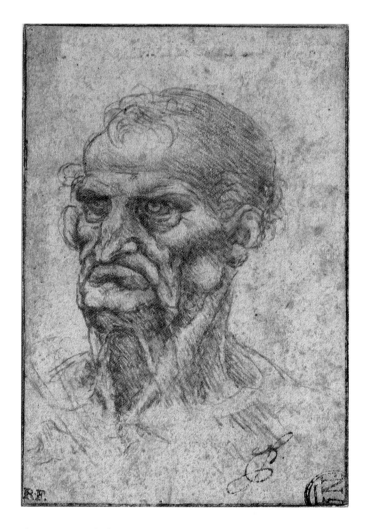

Fig. 15.2 Leonardo da Vinci,
Head of an Old Man, c. 1505, red chalk,
9.4 x 6.1 cm. Musée du Louvre, Paris
(2249)

in the Louvre (fig. 15.2).[2] ¶ As Merritt (1958) observed, Bachiacca turned to Lucas van Leyden's enormous engraving of the *Conversion of Saint Paul* (Bartsch 107) for iconographic and topographic inspiration. Like Lucas, Bachiacca relied on the traditionally northern European representation of Saint Paul struck blind while remaining stubbornly in the saddle of the fallen horse. Bachiacca moved this scene from the left background of Lucas's composition to the centre foreground of his own, yet retained much of the engraving's terrain, including the rocky bluff, distant vistas, stony soil, and tree stump. Bachiacca also used Lucas's print to supply other details for the painting, such as the motif of riders partly obscured by hillocks and the left-hand figure of the central pair of drummers, borrowed from the figure near the tree stump at the left. The city gate and tower in the distance at the right come from the background of Albrecht Dürer's engraving of the *Virgin with the Pear* (Bartsch 41). ¶ Thus the *Conversion of Saint Paul*, like many of Bachiacca's panel paintings, functions on at least two levels. At first glance his works impress by their saturated colours, high polish, and variety of both familiar and exotic imagery. On another level, their many references, allusions, and quotations invited the cognoscenti of the Medici court to test their knowledge of fifteenth- and sixteenth-century art. During Bachiacca's seventeen years at court, Duke Cosimo I de' Medici redecorated the ducal palace, collected art, naturalia, and exotica in a series of curiosity cabinets (Kunstkammern), and sponsored the printing of the 1550 edition of Vasari's *Lives of the Artists*.[3] Bachiacca's paintings are best understood within this cultural context as colourful, highly decorative luxury objects and fascinating collections of citations drawn from the history of European art.
¶ That practice of citation and assemblage, which lies at the heart of Bachiacca's creative method, may also reveal a possible meaning of the artist's nickname. In the sixteenth century, the Italian verb *bacchiare* described the picking of fruit, nuts, or olives by beating the branches of the tree with a pole (*bacchetta*).[4] In the *Conversion of Saint Paul*, the artist nicknamed Bachiacca[5] figuratively harvested the choicest fruit of Florentine and northern European art.

Robert G. La France

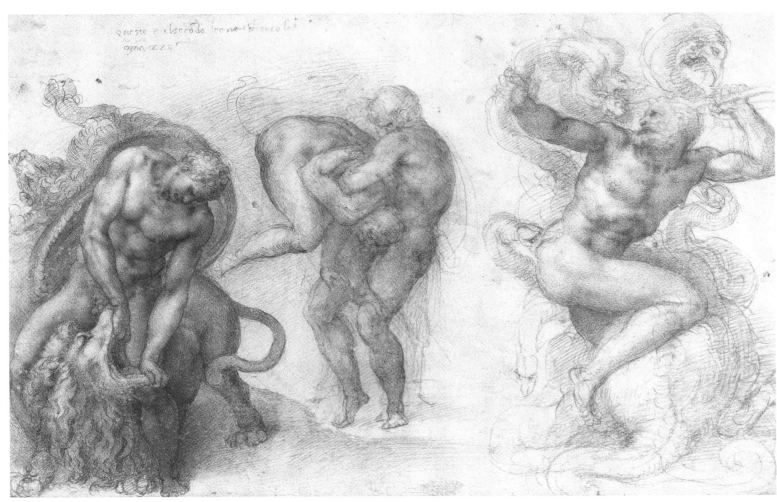

16

In the years around 1530 Michelangelo executed a number of chalk drawings of a richness and finish unequalled in Western art. Several are documented as having been made as gifts for friends, and while others can be associated with larger-scale projects that the artist was working on at the time (most notably a composition of the *Resurrection*), it seems clear that Michelangelo conceived the majority as independent works of art without any preparatory function. ¶ The present drawing shows three of the legendary deeds of Hercules, including two of the twelve Labours undertaken while in the service of Eurystheus, king of Mycenae, as penance for having slain his own children in a fit of madness. His first mission was to kill the lion that terrorized the city of Nemea. The beast was invulnerable to Hercules's club, so he had to kill it by strangulation; here, interestingly, Michelangelo adopted from the Old Testament story of Samson the motif of the hero rending the lion's jaws. Further, he showed Hercules already wearing a lion's pelt, explaining this apparent anomaly in the short note above that reads "questo e il seco[n]do leone ch[e] ercole am[m]azzo" ("this is the second lion that Hercules killed"), referring to the Cithaeronian lion that, in some versions of the legend, Hercules slaughtered in his youth. ¶ The second episode shown, *Hercules and Antaeus*, was not in itself one of the canonical Labours, but was among the most familiar episodes from his life because it afforded artists an opportunity to depict two human figures wrestling together. Having gathered the golden apples from the garden of the Hesperides, Hercules was challenged by the giant Antaeus; but Antaeus derived his strength from the earth, and when Hercules lifted him into the air he weakened and could be crushed to death. Hercules was usually shown with his arms around the waist of Antaeus, simply lifting him from the ground (despite being a giant, Antaeus was always presented as no bigger than Hercules). Michelangelo chose instead a peculiarly contorted posture for Antaeus – Hercules has reached over the back of Antaeus and is turning him upside down, as the giant curls his left foot over Hercules's left knee. ¶ On the right is the second of the Labours, the killing of the Lernean hydra, a seven-headed serpent here given a gross dragon-like body. Michelangelo shows Hercules struggling with the hydra, brandishing his club ineffectually – the actual killing of the beast by cauterizing its decapitated necks with a burning torch was rarely illustrated. ¶ The story of Hercules, in various forms, was one of the most popular tales of classical antiquity and enjoyed a particular vogue in Renaissance Florence, whose heroic self-image was consciously promoted within the city. Michelangelo had been commissioned in 1508 to execute a monumental sculpture of *Hercules and Antaeus* as a pendant to his *David*, the comparable hero of the Old Testament, at the entrance to the Palazzo della Signoria, Florence's centre of government. The project was revived by Pope Clement VII (Giulio de' Medici) in 1524, at which time the marble block for the sculpture was assigned instead to the Medici protégé Baccio Bandinelli. Michelangelo regained control of the worked marble during the Florentine republic of the end of the 1520s, intending

to change the subject to *Samson Slaying Two Philistines*, but the reinstatement of the Medici in 1530 saw Bandinelli take final control of the project to produce his *Hercules and Cacus*, unveiled in 1534 to widespread (and partly politically motivated) derision. ¶ It is thus clear that the subject of Hercules would have been very much on Michelangelo's mind around 1530. But a work of an earlier generation may have provided an additional impetus for the present drawing – the set of three large canvases by the brothers Piero and Antonio Pollaiuolo, recorded in the Palazzo Medici in 1492 in the quarters of Lorenzo the Magnificent, and probably known to the young Michelangelo. Those paintings depicted *Hercules and the Nemean Lion*, *Hercules and Antaeus*, and *Hercules and the Lernean Hydra*, exactly the three episodes shown here. The Pollaiuolo canvases are lost, but two small panels of the latter two subjects by Antonio (now in the Uffizi) presumably give a good indication of their appearance, and show that even if Michelangelo took the subjects from the Pollaiuolo brothers, his treatment was entirely different. Their characteristically wiry figures are replaced by heavily muscled bodies indebted to the two most celebrated antique sculptures known to Michelangelo. The hunched-over pose of the first two studies is essentially that of the *Torso Belvedere*, believed during the Renaissance to be the remains of a sculpture of Hercules, and probably the single most influential work of art in the development of Michelangelo's aesthetic ideal. The more sinuous pose of Hercules in the *Hydra* episode is constructed in emulation of the *Laocoön*, discovered in 1506 and studied in detail by Michelangelo while he was in Rome to begin work on the tomb of Julius II. ¶ The intended recipient of Michelangelo's drawing is not known, and it is thus impossible to discern the precise reasons for his choice of subject. The presence of the inscription suggests that the drawing was made for someone who could not be expected to be entirely familiar with the various versions of the Hercules legend. The arrangement of the episodes on the sheet is oddly disunited – there is little continuity of space or scale – and the degree of finish of the three studies is modulated to give each a markedly different effect, from the strongly plastic modelling of the *Nemean Lion* to the surface patterning of the *Antaeus*. It would thus seem probable that the drawing was made to serve as an exemplar for an artist friend, such as Sebastiano del Piombo, Daniele da Volterra, or Marcello Venusti, for each of whom Michelangelo is known to have produced model drawings.

Martin Clayton

This double-sided sheet holds a key position in our understanding of Fra Bartolommeo's early career, before he entered the Dominican order in 1500 in consequence of his ardent sympathy with the ideas and preaching of Savonarola. We do not know much about this period in the Frate's life. Our main source is Vasari, whose chief informant on Fra Bartolommeo's career was Fra Eustachio, an eighty-year-old Dominican friar who would not have known much about Fra Bartolommeo's life before he became a friar.[1] Fra Bartolommeo had been apprenticed to Cosimo Rosselli. It was in Rosselli's studio that he became friends with Mariotto Albertinelli, with whom he shared a workshop after completing his education. That collaboration lasted until Fra Bartolommeo took his vows as a Dominican friar and entered the monastery of San Marco in Florence, leaving his companion to finish their most ambitious work to date, a fresco of the *Last Judgement* that had been commissioned for the hospital of Santa Maria Nuova in January 1499 (now in the Museo di San Marco).[2] The sheet exhibited here is apparently from the same time, as the running mother with a child on the verso (fig. 17.1) seems to be an unused study for one of the women in the right background of the *Last Judgement*. As well, the temptress in the composition on the recto was used by the Frate in a painting for which there exists another drawing that, on its verso, bears a further study connected with the *Last Judgement*.[3] ¶ The meticulous drawing of the Roman horseman on the verso (fig. 17.1) is not characteristic of the Frate. It was made in a lighter ink than the other drawings on the sheet, probably at another moment. Its heavy-handedness can be explained by the fact that it is a copy of a drawing in the Codex Escurialensis reproducing an antique relief now in the Palazzo Ducale in Mantua.[4] The Codex Escurialensis was executed by an artist from Domenico Ghirlandaio's workshop, who probably copied one or more of his master's sketchbooks. If the drawing of the Roman horseman is indeed by Fra Bartolommeo, this would suggest that he had access to material from the Ghirlandaio workshop, which held a leading position in Florence in the 1490s. A connection with that workshop is also suggested by other drawings in a similarly constrained style, leading some scholars to believe Fra Bartolommeo once worked as an assistant in Ghirlandaio's workshop.[5] But if he did, why did Vasari not mention it? He would certainly have known of it, as one of his main informants about the art scene in Florence at the end of the Quattrocento was Domenico Ghirlandaio's son Ridolfo.[6] ¶ Saint Anthony, founder of monasticism and eventual patron of the Order of the Hospitallers, was a third-century hermit who lived in the Egyptian desert, where he was disturbed by devilish temptations in the form of evil thoughts, lust, and desires of all kinds. At one time devils carried him into the air, beat him, and let him fall back to earth; at another time a devil assumed the most seductive feminine form, yet again failed to corrupt him. Fra Bartolommeo must have suffered comparable afflictions during the witch trial that led to Savonarola's execution in 1498, and the theme might well reflect the painter's own spiritual trials prior to his decision to become a Dominican friar two years later. ¶ Although Saint Anthony was popular in art and devotion, depictions of his temptations are rarely found in Florentine art. The theme might have been suggested to the young painter by Domenico Ghirlandaio's most talented pupil at this time, Michelangelo. He too was a follower of Savonarola, and the drawings of the two artists from this period suggest that they exchanged ideas for compositions and themes. Vasari, Varchi, and Condivi recount that Michelangelo in his youth made a small painted copy of Martin Schongauer's etching of the temptation of Saint Anthony and went to the fishmongers to study the colours of fish for this purpose.[7] Although Schongauer's print is a depiction of Saint Anthony's dramatic elevation, not his temptation by the devil disguised as a woman, characteristically preferred by the more classically minded Fra Bartolommeo, Michelangelo's treatment of an episode from Anthony's temptations might nonetheless have influenced his choice of subject. ¶ In any case, the selected theme must have presented a challenge to the young painter, who was evidently left to his own imagination for lack of models, as confirmed by the large number of extant preparatory drawings. These allow us to follow his struggle with the subject step by step, and they show that he arrived at his final design only after an unusually large number of hesitant trials. Perhaps he never found a satisfying solution, as there is no painted version of the subject that is known to us. ¶ The highly finished drawing exhibited here must be the final compositional study. Saint Anthony is sitting on a knoll in a rocky landscape, recognizable by his distinguishing attributes, the bell and the tau-shaped staff. The temptress addresses him from a mound on which he sits, and at the sight of her he raises his right hand in a gesture of repudiation. The atmospheric landscape, with a town in the background to the right – comparable to Florence but probably meant to represent the depraved Alexandria, where Saint Anthony had refuted the Arians – is rendered with quick and sketchy strokes, while the figures and the rocks in the foreground are more finished and show the application of wash in two different shades of brown ink. The result is the rich graphic variety that is characteristic of Fra Bartolommeo's early drawing style. In his youth it was his habit to use for compositional sketches the strongly linear pen-and-ink medium, so well adapted for the rendering of pattern and movement, and to execute the final studies of individual figures and details in the more responsive black-chalk medium, better suited to the rendering of volume and plasticity. The Windsor composition is evidently the final one, since the Frate made two elaborate figure studies of Saint Anthony in black chalk (now in the Museum Boymans-van Beuningen in Rotterdam) that are based upon this version.[8] ¶ The drawings leading up to this solution suggest that Fra Bartolommeo started out with a depiction of the afflicted saint kneeling toward the right, tempted by one or more nude women before him who indicate their genitals.[9] The next stage, represented by a drawing in the Pierpont Morgan Library, shows a seated Saint Anthony in profile and facing right about to be disturbed in his studies by an

agitated woman in fluttering robes.[10] The relief-like manner in which the figures move parallel to the picture plane reflects Fra Bartolommeo's interest in Donatello's *rilievo schiacciato*. After an attempt to reverse the composition,[11] the Frate presumably made the very finished study in Dresden (fig. 17.2)[12] showing the temptress as a siren-like creature with bird's legs. This eccentric idea was abandoned in the final version, in which she has retained her fluttering robes and deep décolletage. Fra Bartolommeo was apparently very satisfied with her, as he used her again as the midwife Salome in a small and charming painting of the *Flight into Egypt*, though her provocative dress is somewhat inappropriate for a nanny employed by the Holy Family.[13]

Chris Fischer

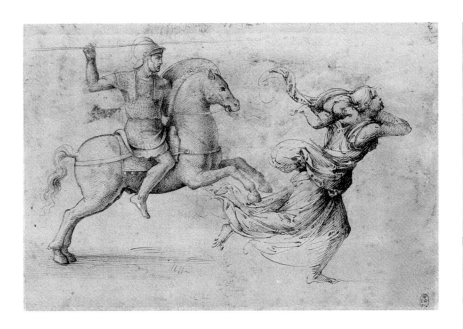

Fig. 17.1 Fra Bartolommeo, *A Woman Carrying a Child on Her Shoulder in Flight to the Right and a Roman Horseman with a Spear Galloping in the Same Direction*, pen and brown ink and brown wash (verso of cat. no. 17)

Fig. 17.2 Fra Bartolommeo, *The Temptation of Saint Anthony*, c. 1500, pen and brown ink, heightened with white, 23.9 x 17.2 cm. Kupferstich-Kabinett, Staatliche Kunstsammlungen, Dresden (C96)

17

18 FRA BARTOLOMMEO (1472–1517) · **Three Studies for Dominican Friars** · c. 1504–1508
Black chalk, heightened with white chalk, on brown prepared paper · 26.2 x 27 cm · Szépmüvészeti
Múzeum, Budapest

18

A careful examination of this beautifully mounted drawing reveals that it is in fact an assemblage of two finely joined pieces of paper. The fragment to the left carries two drawings for a kneeling monk embracing the lower part of a board (a preliminary small sketch in the upper-left corner and a more finished larger variation below), whereas the right-hand fragment depicts a kneeling monk with hands stretched forward in a gesture of prayer. The assemblage that brings these two originally unconnected figures together in a psychologically efficient composition was no doubt made by the collector Pierre Jean Mariette (1694–1774), himself a trained and talented draftsman who often made additions to the fragmented drawings in his collection in order to present them in a more pleasing and picture-like way. Here he reconstructed the trimmed halo of the kneeling monk, extending it right across the divide.

¶ Both drawings are executed in black and white chalks, which increasingly became Fra Bartolommeo's preferred media during his first period as a painter at San Marco, from about 1504 to 1508. Before the execution of the actual drawing, the paper was prepared with a relatively heavy layer of brown coating, which gave it a rough surface on which the grainy black chalk would easily bite. The colouring provided the artist with a third tonal value midway between the black chalk and the white highlights. Both drawings are executed in a relatively soft and vaporous drawing style, with few accentuated outlines. This handling is comparable to drawings from Fra Bartolommeo's first years as a painter at San Marco, and the subjects of the drawings corroborate this dating. ¶ On the fragment to the left, the Dominican friar is probably embracing the stem of a cross, a subject that Fra Angelico, Fra Bartolommeo's predecessor as a painter-friar at San Marco, had depicted in several murals in the monastery. These crucifixions had been painted to heighten the religious fervour and devotion of the praying friars. A drawing in Berlin, presumably executed much later, as well as two copies in private collections made from lost Fra Bartolommeo drawings testify to the friar-painter's continuous absorption in the subject.[1] ¶ On the right-hand fragment, the orans (arms outstretched) gesture of the friar was probably also modelled on pictures in the monastery. It is the fifth of nine poses that Saint Dominic himself assumed when he prayed, according to an illustrated thirteenth-century Dominican prayer treatise, *De modo orandi*, which propagates the Dominican idea that the soul might be elevated to higher states through the proper disposition of the body.[2] A copy of this treatise in the library of San Marco was no doubt available to Fra Angelico,[3] and it is very likely that Fra Bartolommeo was also familiar with it. The drawing is probably a study for the figure of Saint Peter Martyr, who kneels behind the sarcophagus in Fra Bartolommeo's first monumental altarpiece, the *Assumption* executed for the Florentine Compagnia dei Contemplanti (it eventually went to the Kaiser-Friedrich Museum in Berlin, but was destroyed in 1945). We do not know when the painting was commissioned, but the earliest preparatory drawings for it are datable to about 1504 and the work was paid for in 1508.[4] A sketchy version of the figure is included in a compositional drawing in the Museum Boymans-van Beuningen in Rotterdam,[5] which also owns a somewhat less developed figure study that seems to have preceded this one from Budapest.[6] ¶ Fra Bartolommeo's drawings were inherited by his pupil Fra Paolino, who left them to the Dominican painter-nun Suor Plautilla Nelli.[7] None of these painters was especially talented, and they made up for their lack of inventiveness by recycling in their own paintings figures lifted from Fra Bartolommeo's drawings. In the 1530s Fra Paolino inserted a reversed version of the left-hand figure, in the role of Saint Thomas Aquinas embracing the cross, into one of his altarpieces for the church of San Domenico in Pistoia (fig. 18.1).

Chris Fischer

Fig. 18.1 Fra Paolino, *The Crucifixion with the Virgin and Saints Thomas Aquinas and John the Evangelist*, c. 1533, oil on panel, 325 x 213 cm. Church of San Domenico, Pistoia

19 **GIOVANNI ANTONIO SOGLIANI (1492–1544)** · **Young Woman Kneeling** · c. 1520 · Black and
white chalks and pen and black ink · 30.6 x 21.5 cm · National Gallery of Canada, Ottawa

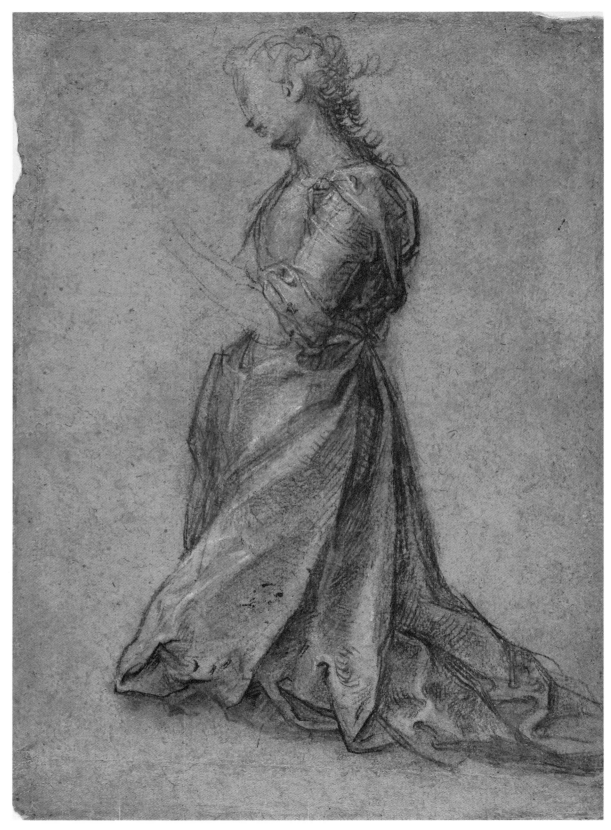

The attribution of this hitherto unpublished drawing to Sogliani was proposed on stylistic grounds by Catherine Monbeig Goguel at the time of its sale at Sotheby's in 1979, and has since been supported by Chris Fischer (written communication). In this figure study, the influence of the drawings of Fra Bartolommeo, which Sogliani knew first-hand, is detectable in the crisp, regular, parallel hatching and in the convincing sense of geometry apparent in the treatment of the voluminous draperies. The elegance of the drawing, evident in the attenuated figural proportions and the handling of the cascading curls, also reveals an artist attempting to remain up to date in a Florence dominated, after the death of Fra Bartolommeo in 1517, by the more refined and emotionally varied style of Andrea del Sarto. At the same time, drawings of this clarity and refinement served as an inspiration to Florentine artists of the Baroque period, especially Jacopo Confortini. ¶ Sogliani was a pupil of Lorenzo di Credi, with whom he remained for twenty-four years, presumably more as an equal partner than as an assistant, according to Vasari.[1] The major determining influence on his style was, however, Fra Bartolommeo and the School of San Marco, to which Credi was also sympathetic. This was a group of predominantly Dominican friar-painters centred in San Marco, who developed from their master a style based on a simple, austere elegance and grace.[2] ¶ The purpose of this drawing is mysterious. It is a working study of some type of kneeling figure with spreading draperies, presumably intended for a *Virgin Annunciate* (oriented, as was the convention, to the viewer's left), a female saint, or possibly a donor in a devotional image such as an altarpiece or tabernacle fresco. The unusual addition of some pen and ink in the lower part of the drapery, perhaps intended to clarify the folds in that part of the sketch, further indicates a practical drawing of some kind. Given that Sogliani produced almost exclusively religious compositions on standard themes such as the Annunciation, it is not surprising that the work to which this drawing relates might be as yet unidentified or indeed lost. On the basis of style, the drawing appears to be close to the period of Sogliani's *Martyrdom* altarpiece of 1521, now in the church of San Lorenzo in Florence, although it is difficult to suggest a date for it with much confidence, not least because the artist was so consistent.

David Franklin

Two painted panels by Mariotto Albertinelli of similar height and style – the present one from the Courtauld Institute of Art Gallery in London and the other from the Strossmayer collection in Zagreb (fig. 20.1) – illustrate episodes described in the opening chapters of Genesis. As the subject of the Strossmayer painting is the Expulsion from the Garden, a later episode in the narrative, we can assume that it was cut from the right-hand side of the Courtauld work.[1] These panels can be associated with a passage in Vasari's biography of Albertinelli that mentions three small narrative paintings ("tre storiette") executed for the banker Giovanmaria di Lorenzo Benintendi in Florence sometime after the election of the Medici pope Leo X in 1513.[2] They were apparently among the last works that Albertinelli completed prior to his death in November 1515. It is possible, in fact, to be even more specific about their dating, as they must have been started after the artist's visit to Rome in 1514, when he saw certain works, principally the ancient sculpture of the *Falling Gaul*, that he used for the figure of Adam in the scene depicting his creation.[3] The painting was, therefore, definitely executed after the collapse of the long-standing partnership between Albertinelli and the Dominican painter Fra Bartolommeo. Nevertheless, it is painted in the artist's elegant but subdued and delicate manner, familiar from the San Marco workshop. Benintendi's taste for this style is also evident from his acquisition of an altarpiece by Fra Bartolommeo directly from the friars of San Marco. ¶ The marked horizontality of the painting suggests that it had a particular location, installed in a piece of furniture or a wall. The relatively good condition of the surface indicates that it was never used in a wedding chest, or *cassone*, which was another common setting for panels of this shape and degree of finish. Albertinelli's picture is an especially outstanding later example of a venerable type of painting featuring different episodes in a narrative sequence in a continuous field, for which Florentine artists had a particular talent. Piero di Cosimo, although elderly, remained one of the masters of this genre, and he supplied specific models for Albertinelli's picture (see cat. no. 10). In the Courtauld painting the story from Genesis is revealed in four distinct scenes, to which the fragment in Zagreb adds a fifth. Moving from left to right, the narrative sequence begins with the Creation of the Animals; this is followed by the Creation of Adam with God physically lifting him off the ground as he brings him to life; next is the Creation of Eve from Adam's side; and concluding the sequence, at the right edge, is the Temptation and Fall of Man. ¶ As for so many narrative scenes in Florentine art of the Renaissance period, Lorenzo Ghiberti's bronze doors on the Baptistery, the so-called *Gates of Paradise*, provided a starting point for the representation of the subject matter, in this case for the two central scenes featuring the Creation of Adam and of Eve. In more contemporary terms, Leonardo's designs for the *Battle of Anghiari* provided the inspiration for the rearing horse in the left background. Similarly, it is not difficult to imagine that some fantastical creation of Leonardo or of Piero di Cosimo inspired Albertinelli's fabulous rendition of the serpent with a beautiful face, entwined around the tree in the scene of the Temptation and Fall of Man. The attention to detail and the luminosity of Albertinelli's work also betray a general awareness of northern European painting. ¶ Vasari suggests that the patron of Albertinelli's work was Giovanmaria Benintendi, but Benintendi, who was born in 1491, was probably too young to have commissioned this painting (which, it should be recalled, is not directly documented). That the painting was ordered by the Benintendi family is not, however, in doubt. The allusion to the installation of the new Medici pope in Vasari's text may not be merely incidental, as the Benintendi were traditionally loyal to Florence's de facto ruling family and would have been inspired to commission these panels from a leading Florentine painter in order to emulate the Medici family's illustrious patronage. Giovanmaria Benintendi married Bartolomea di Bivigliano d'Alamanno, of a collateral branch of the Medici family, in 1517.[4] He is better known for having ordered what was apparently a second decorative project for the family palace in Florence, a major cycle of paintings commissioned after Albertinelli's death, of which only one – Franciabigio's *Bathsheba and David*, surviving in Dresden – is dated (1523).[5] This rather heterogeneous series included at least four other panels: Jacopo da Pontormo's *Adoration of the Magi* now in the Palazzo Pitti, Bachiacca's so-called *Legend of the King's Sons* in Dresden and *Baptism of Christ* in Berlin, and Andrea del Sarto's solitary *John the*

Baptist also in the Palazzo Pitti. Albertinelli's contribution was probably intended for a different room than the one occupied by this later group, but its quality and beauty would certainly have ensured it a special place in Benintendi's remarkably complete and outstanding collection of modern Florentine painting.

David Franklin

Fig. 20.1 Mariotto Albertinelli,
The Expulsion of Adam and Eve,
c. 1514–1515, oil on panel, 56.8 x 55 cm
Strossmayer's Gallery of Old Masters,
Zagreb

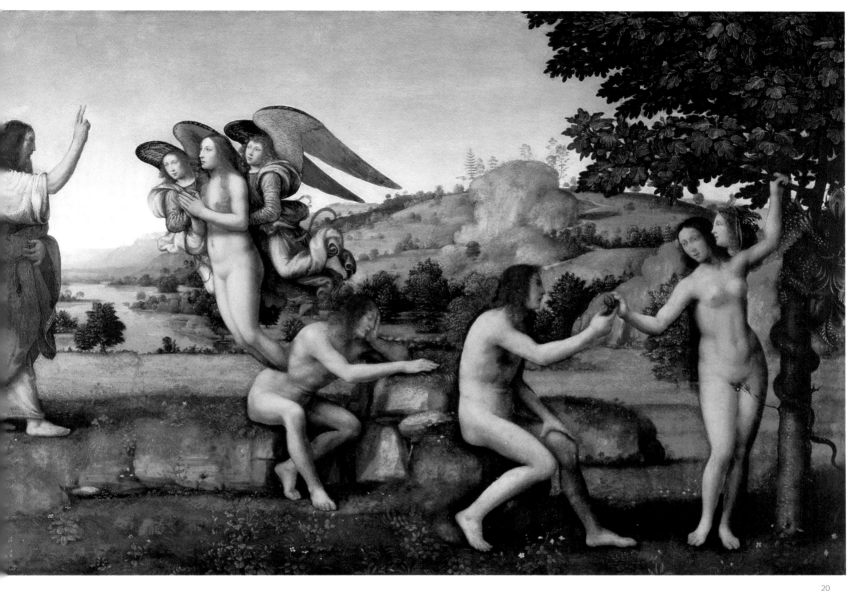

Ridolfo di Domenico Ghirlandaio, who had a highly successful career, has only recently been rehabilitated as an artist.[1] This reassessment, acknowledging a style other than the more up-to-date ones of Leonardo and Michelangelo, was long overdue, given Ridolfo's close link with the young Raphael in Florence in the earlier 1500s. The Chicago painting, which was attributed to Raphael until about 1900, when Wilhelm Bode recognized that it was by Ridolfo (it was then still in a private collection in Rome), is one of the finest examples of his work as a portraitist.[2] It is a relatively early picture by the artist, and can be dated on stylistic grounds to the first decade of the sixteenth century by comparing it with altarpieces by Ridolfo such as the *Virgin and Child with Saints Francis and Mary Magdalen*, dated 1503, in the Galleria dell'Accademia in Florence, and the *Adoration of the Shepherds*, signed and dated 1510, in the Szépmüvészeti Múzeum in Budapest.
¶ The sitter is crisply rendered in a dignified manner, with a suggestion of intensity in the facial expression reinforced by the composed gesture of the right hand. The contact initiated by the sitter, who turns to address the viewer from behind a stone ledge, indicates that Ridolfo was aware of Leonardo's contemporary advances in portraiture in Florence, and especially his development of a greater interaction between subject and viewer. The work has a lively surface, with its directed lighting, some well-observed textures (such as the stubble of the beard), and broad rhythms initiated by the opening of the cloak. Ridolfo's painting, as in this example, has a noble and restrained clarity and balance, as well as an emotional sincerity, on a monumental scale that represents his contribution to the most orthodox branch of Florentine art at the start of the sixteenth century. Such was Ridolfo's popularity that he was able to train portrait specialists, and more portraits emanated from his workshop than from any other in Florence in the sixteenth century. ¶ The sitter has not been securely identified, but the likeness matches a woodcut portrait (fig. 21.1) supposedly of the Florentine poet Domenico di Giovanni, called il Burchiello (1404–1449), used for a book published by Anton Francesco Doni in Venice in 1547 and again in 1553.[3] Indeed, the two works are close enough to allow for the speculation that the Chicago portrait itself was the direct source for the print. However, on the basis of another portrait (once in the collection of Paolo Giovio) that is claimed, with more authority, to represent Burchiello, there is good reason to believe that the man in the Chicago portrait is in fact not Burchiello and that the Venetian publisher may have been misled in this regard – a not uncommon occurrence in a period when the standards of proof were less stringent than they are today. Indeed, the sitter may be wearing

the hat and costume of a member of government, who would have been permitted, as here, to wear fur and to display the red lining of his coat.[4] ¶ Patronage of Ridolfo's work inevitably had an intensely political dimension, as his style was intrinsically associated with the prestige of his own distinguished Florentine ancestry. In the Chicago portrait, the use of the ledge to truncate the length of the figure and the inclusion of an open, unarticulated window with a landscape view, in this case of a working farm, are traditional devices, and it is in such references to the past, both Florentine and northern European, that Ridolfo made his career as a portraitist in Florence, developing stylistic qualities taken from his father, Domenico Ghirlandaio, who had died in 1494. Also from his father, Ridolfo inherited stylistic tendencies toward a precise and linear style. Gamba's comment that the image in the Chicago picture seems to be copied from some fresco of the artist's father is relevant here.[5] This example serves as proof, if any were needed, that Renaissance patrons looked as eagerly to the past as to the future.

David Franklin

Fig. 21.1 Anonymous, *Portrait of Domenico di Giovanni, called il Burchiello*, woodcut, from *Rime del Burchiello commentate dal Doni* (Venice, 1553), p. 16

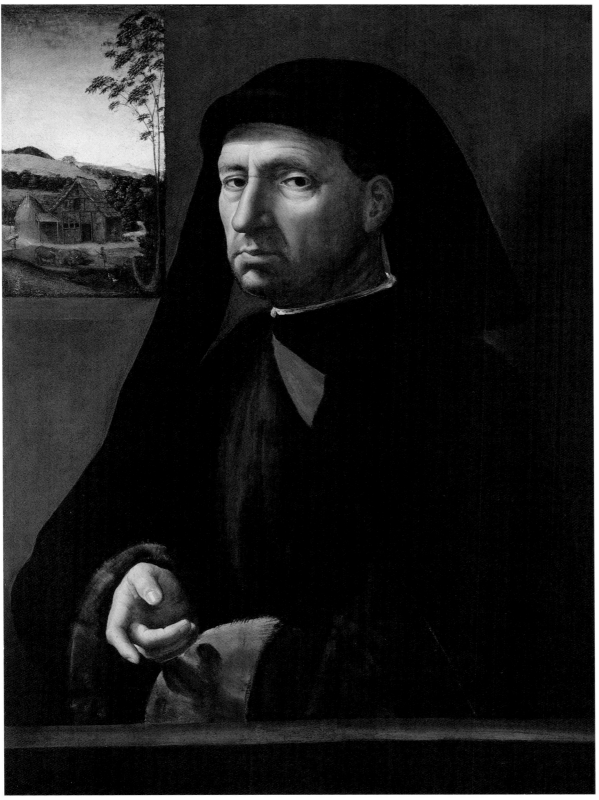

The traditional interpretation of this painting as a portrait of a goldsmith is justified by the emphasis placed upon the jewel the youth contemplates with such melancholy intensity. However, the young man's expression of fixed concentration, and the fact that he holds the jewel so that the viewer can see only its back, suggest that the object may have had a sentimental value, rather than functioning as an allusion to the sitter's trade. ¶ Paolo del Sera's letters from Venice to Cardinal Leopoldo de' Medici in 1668 shed light on the events surrounding the purchase of this portrait.[1] According to del Sera, the painting, believed at the time to be a work by Leonardo da Vinci, belonged to a friend of his, a Venetian nobleman; del Sera had previously sent the painting to Cardinal Leopoldo requesting his opinion on the question of its attribution, which was confirmed by the cardinal, who had consulted other painters as well and had been assured that it was indeed by Leonardo. When the portrait's owner died, in 1668, his heirs, wishing to sell it, consulted del Sera, who suggested to Cardinal Leopoldo that he should purchase it for a hundred silver scudi. The painting, meticulously packaged, was sent from Venice to the Palazzo Pitti, and after Leopoldo's death in 1675 it was recorded in the inventory of his collection. ¶ Thanks to the prestigious attribution to Leonardo, the small painting was subsequently displayed in the Tribuna, in the centre of the Galleria degli Uffizi, where the most important works from the Medici collections were gathered; in fact, it appears that the painting may be identified with the "Portrait of a Youth Wearing a Beret" recorded under the name of Leonardo in the inventory of the Tribuna that was compiled in 1704.[2] But shortly after this date, following the reorganization of the collections ordered by Duke Cosimo III de' Medici, documented in the 1716–1723 inventory of the valuable objects of the palace, it was moved back to the Palazzo Pitti, where it remained. It is also documented in the inventory compiled in 1761 in preparation for the arrival of the new Grand Duke Pietro Leopoldo of Hapsburg-Lorraine. According to the *inventario parlante* of 1782, the painting was kept at that time in the Sala di Apollo.[3] In all the Galleria's early nineteenth-century catalogues it is mentioned as a work by Leonardo.[4] ¶ Giovanni Morelli, writing under the pseudonym Ivan Lermolieff, was the first to doubt the attribution to Leonardo, suggesting instead that the portrait, while influenced by both Leonardo and Piero di Cosimo, was an early work by Ridolfo Ghirlandaio.[5] Apart from Adolfo Venturi, who reinstated the ascription to Leonardo, and Wilhelm Suida, who suggested that it was based on a drawing by Leonardo but executed by Franciabigio, scholars have accepted the attribution to Ridolfo.[6] An exception to this unanimity is the suggestion by Costamagna and Fabre favouring Piero di Cosimo, a hypothesis buttressed by arguments that serve to deepen our appreciation of this fine work.[7] ¶ The portrait has an immediate appeal, thanks to its powerful expressiveness, its informal depiction of the sitter, its sophisticated choice of colours, and the fine execution of its details, elements that could justifiably appear to be the product of Piero di Cosimo's exuberant genius, rather than of the rational, more moderate genius of Ridolfo. However, now that its restoration has not only revealed its richer, more luminous chromatic variety, but also highlighted the abrasions that occurred during the previous cleanings (in the landscape, the hair, and the character's complexion), I feel the portrait should be attributed to Ridolfo. ¶ The half-length figure, outlined against a luminous outdoor landscape, reflects not only the undeniable influence of Leonardo and, to a greater extent, that of Piero di Cosimo, but also the legacy of Fra Bartolommeo and of Raphael's Florentine works, the other two essential elements of Ridolfo's pictorial idiom. However, these prototypes of the first decade of the Cinquecento, imitated almost literally in Ridolfo's beautiful *Portrait of a Woman* of 1509 (fig. 22.1), are here reworked and indeed surpassed, with far richer results: in the softness of the flesh colouring, *Portrait a Man* more closely echoes paintings by Piero di Cosimo. In the context of Ridolfo's chronology, which has been given a more precise outline thanks to new documentary evidence,[8] the dating of this portrait to the middle of the second decade of the Cinquecento, suggested by Costamagna and Fabre, means that it coincides with the period of his execution of the two beautiful panel paintings of the *Miracles of Saint Zenobius* of 1516–1517 (Galleria dell'Accademia, Florence), which are populated by a crowd of portraits in many ways similar to the present one.[9]

Serena Padovani

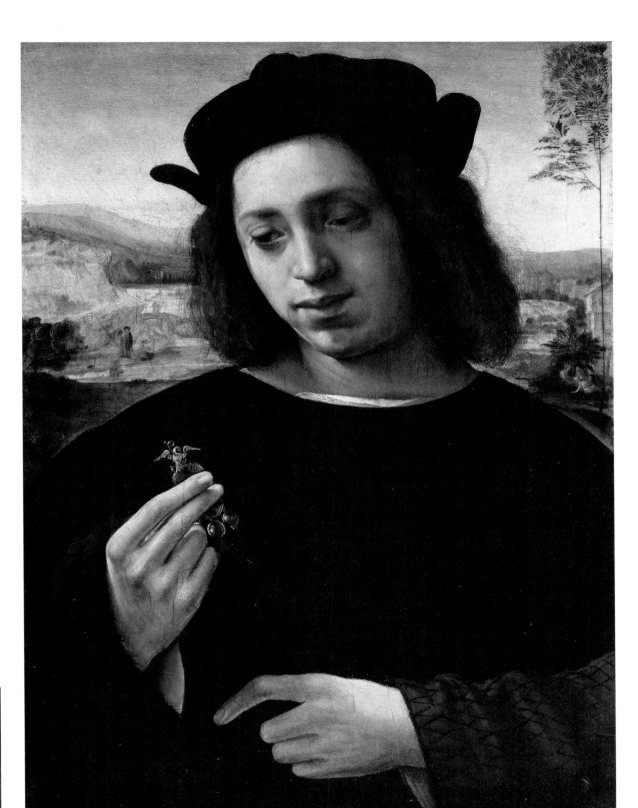

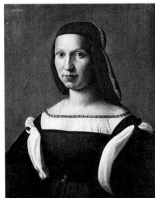

Fig. 22.1 Ridolfo Ghirlandaio, *Portrait of a Woman*, 1509, oil on panel, 61 x 47 cm Galleria Palatina, Palazzo Pitti, Florence

23 RIDOLFO GHIRLANDAIO (1483–1561) · **The Nativity, with Saints** (portable tabernacle)
c. 1509–1515 Tempera (?) and oil with gold on panel · 35.6 x 22.9 cm (central panel), 31 x 10 cm (left wing), 31 x 9.9 cm (right wing) · The Metropolitan Museum of Art, New York · The Michael Friedsam Collection, Bequest of Michael Friedsam, 1931

This small tabernacle, which includes wings (on hinges) that originally closed to cover the central panel, is typical of the restrained and gently meditative style of Ridolfo Ghirlandaio. Although the painting was ascribed to Mariotto Albertinelli when it was in the Cristoforo Benigno Crespi collection in Milan, Berenson's attribution to Ridolfo Ghirlandaio, first published in 1909 in *The Florentine Painters of the Renaissance*, has won support ever since.[1]

In the central panel, Mary and a black-robed monk reverently kneel and meekly press their hands together in adoration of the newborn Christ child, while Joseph, under a ruined arch in the right background, accepts a lamb from a well-dressed figure who does not appear to be a conventional shepherd. Typically, Ridolfo completed several variations on the theme, including evidently his only surviving signed and dated painting (1510), now in the Szépművészeti Múzeum, Budapest, and a panel formerly in the Henry Harris collection, London, and now in the Snite Museum of Art, University of Notre Dame, Indiana.[2] In each, Mary is the central figure, kneeling over the naked Christ child on the ground in front of her, while overhead a trio of angels hovers in the sky and in the left distance a bleached and partly rocky landscape stretches back to a misty horizon.

In the wings of the New York tabernacle, two standing male saints and one kneeling female saint flank the principal scene and in pose, gesture, and facial expression augment its contemplative tenor. All four of the male saints (Benedict, Peter, Paul, and John the Evangelist) carry books, and at the left Saint Christine (identified by the arrow illusionistically projecting from the ground below), with tubular fingers, piously holds her hands, just as the monk does in the central panel, and as Mary does in the grisaille panel that once no doubt occupied the exterior of the right wing (see cat. no. 24). At the right, Saint Dorothy balances Saint Christine, and likewise appears kneeling and in profile, with flowers overflowing from her apron onto the ground. The presence of Saint Benedict at the extreme left, bearded and wearing a black habit, and, in the central panel, what seems to be a Benedictine monk, also in a black habit, suggests that a member of that order may have commissioned the tabernacle, but specific details have yet to be discovered.

The New York tabernacle has consistently been dated between 1512 and 1515,[3] but it may be somewhat earlier, given the similarities of figure type and meditative introspection in Ridolfo's *Enthroned Virgin and Child with Four Saints* of 1509–1510 in the Museo Diocesano in San Miniato in Pisa.[4]

Small portable tabernacles had long been a popular type of intimate devotional image both in Italy and north of the Alps, but it seems that the format – frequently with a grisaille *Annunciation* on the exterior of the wings – may have enjoyed a specific vogue in conservative circles in Florence around 1500. In the late 1490s, Fra Bartolommeo had painted wings (now in the Uffizi), including a monochrome *Annunciation* on the exterior side – still a novelty in Italian art – to flank a marble relief of the *Virgin and Child* by Donatello for Piero del Pugliese.[5] In addition, in 1503 the will of Piero's nephew, Francesco del Pugliese, who was one of Savonarola's staunchest supporters, made mention of a small triptych composed of a painted head of Christ or a *Veronica's Veil* by a Flemish artist (the Master of the Legend of Saint Ursula) in the middle, and wings by Filippino Lippi (now in the Seminario Patriarcale in Venice),[6] as well as a *Last Judgement* by Fra Angelico with wings by Botticelli (possibly now in the Hermitage, Saint Petersburg).[7] These paintings were evidently kept in del Pugliese's palace in Florence, but if he died without male issue he wanted them to be placed in the chapel of his villa outside Florence at Sommaia, to be administered by the Observant Dominicans of San Marco, Florence (for whom Savonarola had been prior). Lastly, Mariotto Albertinelli also executed a small triptych with, on the inside, a seated Virgin and Child and a flanking saint, and on the exterior side a grisaille *Annunciation*, inscribed "MD," which could be read as the date (1500) or an abbreviation of Mater Domini (now in the Poldi-Pezzoli Museum, Milan).[8]

David McTavish

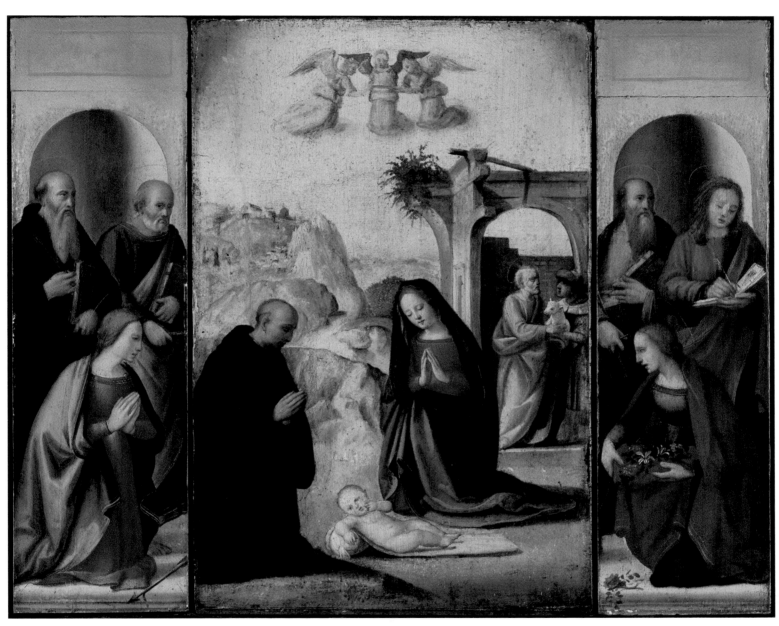

23

24 RIDOLFO GHIRLANDAIO (1483–1561) · **The Annunciation** · c. 1509–1515 · Tempera (?) and oil with gold on panel · 31.1 x 10 cm each · Agnes Etherington Art Centre, Queen's University, Kingston Purchased with the assistance of the Government of Canada through the Cultural Property Export and Import Act, 1984

These grisaille panels are presented here as the covers of the wings of Ridolfo Ghirlandaio's triptych in the Metropolitan Museum of Art in New York (see cat. 23).[1] In addition to stylistic similarities, the New York and Kingston panels share comparable measurements and an analogous use of medium and support. In both cases the wings are painted on poplar, thinned to a thickness of 3 to 3.5 millimetres and adhered to an auxiliary oak panel. In all four of these panels the semicircular arch of the alcove is inscribed by a compass with a radius of about 3.9 centimetres and in each the central pinprick is still visible to the naked eye. Perhaps most telling of all, both of the left-hand panels contain a similar vertical crack stretching from top to bottom. The connection between the two parts of the triptych was made only recently, and the current exhibition is the first time that the various elements have been reunited since they were separated at some unknown date, probably in the nineteenth century. ¶ When acquired by the Agnes Etherington Art Centre in 1984 the panels were mounted in a cardboard mat inscribed "Mariotto Albertinelli/1474–1515." The mount appears to be late nineteenth-century English, since newspaper clippings dated London, 18 March 1893, are glued to its back, as well as to the back of the auxiliary support of the panels themselves. Otherwise, all that is known about the provenance of the panels is that their previous owner, A. Roy Thomas of Ottawa, inherited them from a family member in Britain and brought them to Canada when he immigrated sometime after the Second World War. ¶ Since the Metropolitan Museum's triptych was also attributed to Albertinelli when it was formerly in the Crespi collection in Milan, the entire triptych was most likely known under that name when the wings were divided into two. But whereas the Kingston panels retained an attribution to Albertinelli until recently, Berenson convincingly assigned the New York triptych to Ridolfo Ghirlandaio almost a century ago.[2] ¶ Ridolfo Ghirlandaio was the son of Domenico Ghirlandaio, who had operated one of the most efficient workshops in Florence, but since Ridolfo was only eleven when his father died, his uncle Davide (also an artist) assumed responsibility for his training. Ridolfo copied Michelangelo's cartoon for the *Battle of Cascina*, and also spent some time with and was trained by Fra Bartolommeo.[3]

¶ The *Annunciation*, with its conspicuous ties to the work of Ridolfo's immediate family and its circle, fully reflects his artistic background. In particular, his archangel Gabriel adopts a traditional pose – in profile, kneeling humbly on his nearer (right) knee, and extending his right arm toward the Virgin, with two fingers emphatically raised, and the lily held upright in his left hand. In 1482 Ridolfo's father's workshop had employed a similar pose and drapery for the angel (in turn indebted to Leonardo) in a frescoed *Annunciation* in San Gimignano. The Virgin Mary in the fresco also offers several points of comparison with the Kingston painting, especially with respect to her general attitude. More conspicuously, in 1490 Domenico Ghirlandaio repeated the archangel's pose in a mosaic *Annunciation* on the exterior of Florence Cathedral above the Porta della Mandorla. Fra Bartolommeo also used this authoritative pose in his 1497 altarpiece in Volterra Cathedral, and his longtime collaborator, Albertinelli, employed it in his large 1510 altarpiece for the chapel of the Confraternity of Saint Zenobius (now in the Galleria dell'Accademia, Florence), which Ridolfo Ghirlandaio certainly knew, because he, Pietro Perugino, and Francesco Granacci did an evaluation of it.[4] ¶ Ridolfo Ghirlandaio himself painted the *Annunciation* on a number of occasions, most notably in a lunette fresco, completed around 1515, in the Cappella dei Priori of the Palazzo della Signoria, and in an altarpiece of approximately the same date at Pitiana.[5] In the altarpiece, the angel is depicted in the conventional pose. Mary kneels at a lectern at the extreme right and, with hands outstretched, turns her head in demure acknowledgement of Gabriel. Her pose is related to that in the Palazzo della Signoria fresco and in the Kingston grisaille, but in the latter Mary assumes an even more meditative stance, with her hands pressed meekly together. ¶ What distinguishes the present *Annunciation* from the others is the gentle austerity of the interpretation – not just the rendering in grisaille (which was dictated by the original function of the panels) but the widespread elimination of distracting detail and gratuitous decoration. Indeed, the figures in the Metropolitan Museum's triptych are only somewhat less affected by the same aesthetic embargo. However, the commission should not necessarily be considered poorly funded, because where linear highlights do occur, as on the haloes, they are often picked out in shell (powdered) gold. Instead, the conservative and backward-looking traits are typical of Ridolfo Ghirlandaio's distinctive style, which is partly akin to Fra Bartolommeo's contemplative manner, and which evidently found a sympathetic response from at least a significant segment of contemporary Florentines.[6] ¶ This *Annunciation* was originally designed to play an effective role in prompting religious devotions. Of exceptional theological significance, in that it is the beginning of the incarnation of God, the Annunciation is recounted in the Gospel of Luke, 1:28–31: "And the angel came in unto her, and said, Hail, thou that art highly favoured, the Lord is with thee: blessed art thou among women … Fear not, Mary: for thou hast found favour with God. And, behold, thou shalt conceive in thy womb, and bring forth a

son, and shalt call his name JESUS." Since the Annunciation is taken to be the conception of Jesus Christ, its feast day is celebrated on 25 March, nine months before his birth at Christmas. Such was the importance attached to this pivotal date that Florentines designated 25 March as the first day of their calendar year. ¶ During Lent it was customary to cover religious images, and to close winged triptychs. Sombre grisaille is especially appropriate for this penitential season, and the Annunciation is a subject equally fitting for the liturgical calendar, because although Easter is a movable feast, 25 March always falls within Lent.[7] Flemish fifteenth-century artists such as Jan van Eyck had perfected the grisaille *Annunciation* as an effective combination of form and content for the exterior side of a hinged altarpiece, but Florentines fully apprehended this usage from at least 1483, when Hugo van der Goes's magnificent Portinari altarpiece, with its grisaille *Annunciation* on the outer wings, was installed on the high altar of the church of San Egidio of the hospital of Santa Maria Nuova. Ridolfo's father, for one, immediately succumbed to the great altarpiece's spell, as is demonstrated by his well-known emulation of van der Goes's shepherds in his own 1485 *Adoration of the Shepherds* in the church of Santa Trinita in Florence.

David McTavish

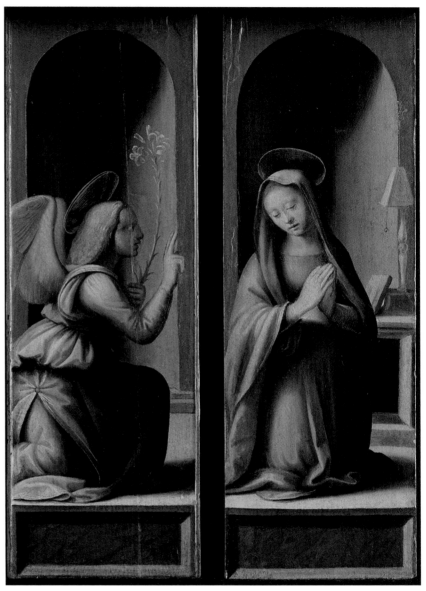

24

MASTER OF SERUMIDO (ACTIVE C. 1505–1540) · **The Annunciation** · c. 1505–1510 · Tempera (?) and oil on panel · 50.5 x 65.5 cm · National Gallery of Canada, Ottawa · Bequest of Mrs. Jeanne Taschereau Perry, Montreal, 1965

This painting is first recorded only in 1929, when it was owned by Annesley Gore in London and attributed to Mariotto Albertinelli. It was then that it became the property of Frederick J. Perry of Montreal, and in 1965 Jeanne Taschereau Perry bequeathed it to the National Gallery of Canada.[1] Its dimensions – probably too large for a predella – suggest that this was an autonomous work, initially destined for a private collection and then released to the art market. On the whole, the paint appears to be well preserved, apart from some light abrasions on the angel's face and, especially, in the blue nuances of the landscape. ¶ Long unknown to scholars,[2] the small panel was recognized by Fredericksen and Zeri in 1972 to be the work of an anonymous Florentine master active during the early part of the sixteenth century, whose career had been reconstructed by Zeri; Zeri named him the Master of Serumido in reference to his most important painting, the altarpiece of the *Virgin and Child Enthroned with Four Saints* in the church of Serumido in Florence.[3] On stylistic grounds, based on the group of paintings thus attributed, Zeri himself proposed identifying the anonymous artist with Bastiano da Sangallo, whom Vasari describes as associated through friendship and collaboration with Raphael and Michelangelo. Antonio Natali later suggested a possible identification with Ruberto Lippi, the son of Filippino, and it must be conceded at least that Filippino provided the inspiration for some of the works by the anonymous painter.[4] Louis A. Waldman has recently maintained that the artist may be identified with the craftsman and gilder Mariotto Dolzemele, documented in relation to Giovanni da Larciano, whose works are sometimes confused with those of our anonymous painter.[5] But while the search continues for firm documentation, this eclectic painter, whose pictorial language is so distinctive, will have to remain the Master of Serumido, a designation originating from the name of the Florentine man of humble origins who, shortly after 1530, collected enough money through begging to pay for the reconstruction of the church where the touchstone work by this artist is located. ¶ In the Ottawa *Annunciation*, the elongated structure and the physiognomy of the two figures, the distinctive curling of the borders of the angel's robe, and the monumental, classicizing architecture of Mary's home are recognizable as the Master's particular idioms and mannerisms. The bright, iridescent tonalities, the purplish brown shades of the architectural elements, and the harmonizing of pale or bright pink with green or blue create the same unstable, vibrant chromatic balance that characterizes all his production. Particularly convincing is the comparison of this *Annunciation* with the paintings that he executed between about 1505 and 1515, which are close both in style and iconography to those of the most prestigious painters of the time, including Fra Bartolommeo and his partner Mariotto Albertinelli, Andrea del Sarto, Franciabigio, Giovanni da Larciano, and Raphael, with whom the Master of Serumido very likely collaborated. The similarity of this *Annunciation* to Albertinelli's *Annunciation* for the predella of his *Visitation* of 1503 (now in the Uffizi) justifies the traditional attribution of the Ottawa panel to Mariotto, and offers a useful clue to its context and chronology; it is clear that the anonymous artist was familiar with Fra Bartolommeo's workshop in the monastery of San Marco, to which Albertinelli was always linked, even when he was not working in partnership with the friar-painter. ¶ The close link – in proportions, physiognomies, gestures, and drapery – between this painting and the two monochrome scenes apparently by the same artist on the backs of Raphael's portraits of Agnolo and Maddalena Doni, painted probably shortly after their marriage on 31 January 1504 (see fig. 25.1) offers a further clue to the chronology of its execution. The date of Raphael's commission from Agnolo Doni can now be established as 1505, thanks to the discovery of a new document.[6] And since it is probable that the portraits of the Doni couple originally formed a diptych, Raphael must have entrusted the Master of Serumido with the two paintings on the back immediately after he completed the two portraits.[7] (The verso paintings represented two episodes from the story of Deucalion and Pyrrha in Ovid's *Metamorphoses*, expressing a wish for fertility for the couple.) ¶ A date of about 1505–1510 for the *Annunciation* therefore seems convincing, rather than twenty years later, as has been proposed until now.[8]

Serena Padovani

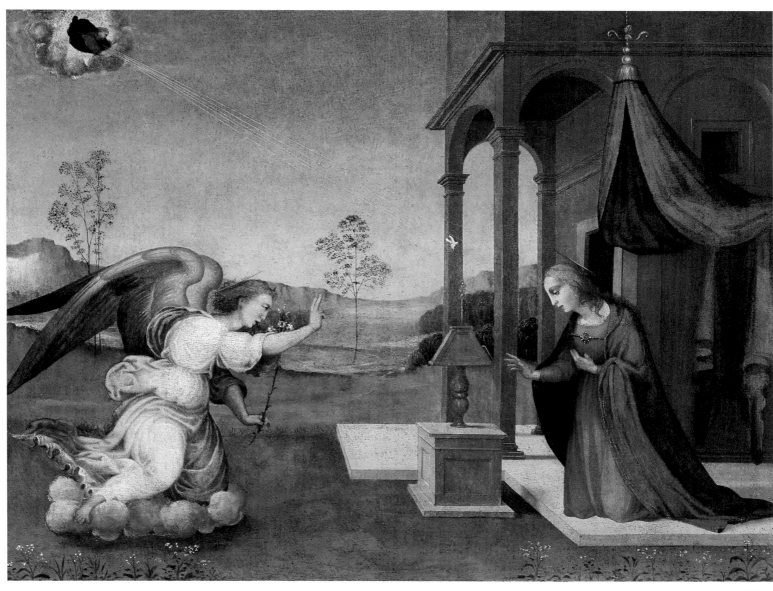

Fig. 25.1 Master of Serumido,
Deucalion and Pyrrha, c. 1505–1506,
oil on panel, 65 x 45.8 cm, painted on the
back of the *Portrait of Maddalena Doni*
by Raphael (see fig. 22). Galleria Palatina,
Palazzo Pitti, Florence

In 1919 Marquand published this relief, then in the Florentine palace of Vieri Giugni Canigiani, complete with a glazed-terracotta predella with three panels: the larger, central one with a medallion of a half-figure of Saint Peter, and the lateral ones with the emblems of the Strozzi and del Benino families. The relief and the predella were inserted within a wood frame decorated with three acroteria with corollas and small palmettes, and with a corbel in the shape of a shell. After the death of its owner in 1922, the work came into the possession of Jenny Finaly, a niece of the bibliophile and art collector Orazio Landau, who had left his estate to her in 1903. The art collection and extensive library were subsequently handed down to her five children, among them her son Horace, who died in New York in 1945 having bequeathed his share to the City of Florence. On 17 July 1947, after the inevitable bureaucratic hurdles had been overcome, the city council entrusted the "six closed boxes of books" to the Biblioteca Nazionale, where they were deposited permanently along with some works of art, including the present relief.¹ The delivery records of the City of Florence, dated 5 May 1949, describe the object succinctly as "a majolica by Giovanni della Robbia depicting a Virgin, known as the Canigiani Madonna, from Palazzo Strozzi."² After the flooding of the Arno on 4 November 1966 the *Virgin* and the predella, which had been seriously damaged, were removed from their frame. The restoration of the objects in 1997 by the Opificio delle Pietre Dure in Florence revealed that the lateral panels with emblems had been intended for a different location than the *Saint Peter* panel, and that the three had been integrated only later, probably in the nineteenth century, when the Renaissance-style wooden frame was made. ¶ This work is an interesting three-dimensional translation of the painting by Raphael known as *La Belle Jardinière* (fig. 26.1), executed in 1507, when the artist was in Florence, and acquired by Francis I for his private collection (now in the Louvre). The relief presents the same composition: the Virgin, at the centre and seated on a rock, supports a standing, naked Christ child, who gazes trustingly into his mother's serene face as she smiles gently back at him, while in the foreground the infant Saint John, in a kneeling posture, looks at the Christ child with reverence. The saint's right hand would once have held his attribute (now lost) – a staff in the shape of a cross, probably made of gilded metal. A comparison with Raphael's original reveals differences in the Virgin's dress (which in the relief contains the head of a cherub as a decoration at her breast) and in the way the figures are turned somewhat more fully toward Christ, the privileged object of their thoughts and actions. Another difference is the presence of a crown of ivy in the curls of Saint John, which probably possesses

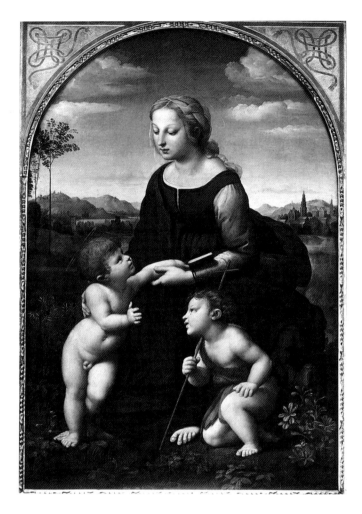

Fig. 26.1 Raphael, *La Belle Jardinière*, 1507, oil on panel, 122 x 80 cm. Musée du Louvre, Paris

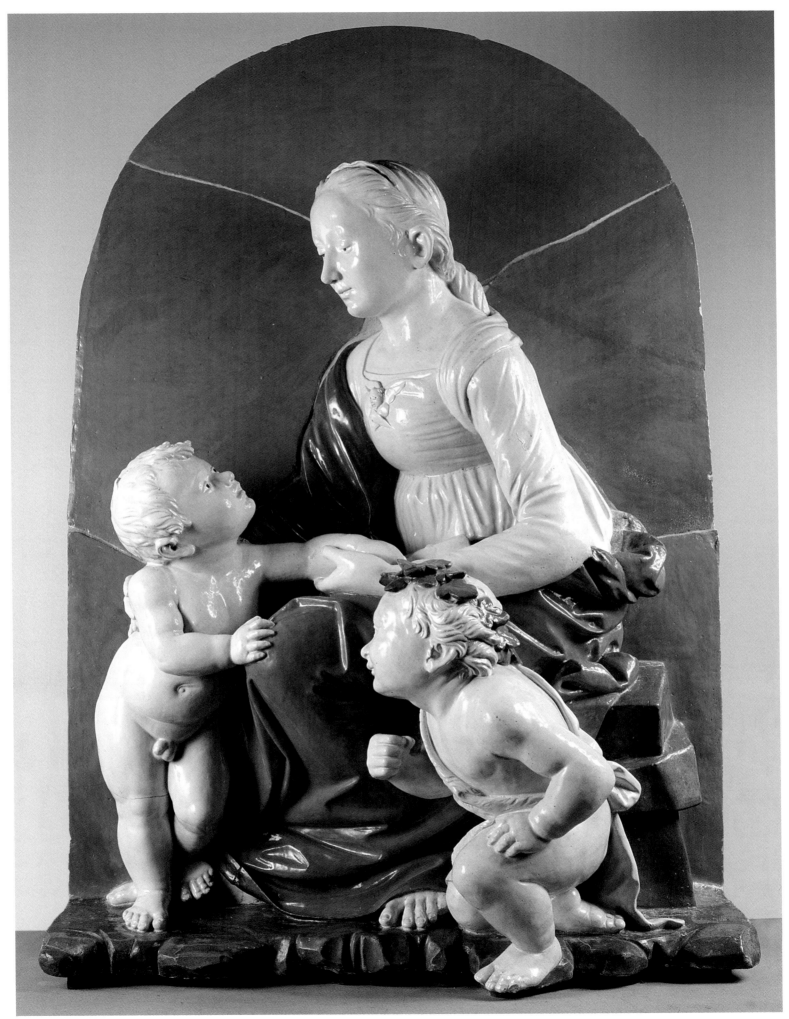

a particular significance of a devotional nature. In antiquity, ivy was sacred to Bacchus, who had entwined his first garland with it: given its similarity to the vine, ivy alluded to deep wine-induced sleep, similar to the sleep of death. In the present relief, the crown on the head of the infant Saint John may symbolize the Passion and the human death of Christ as well as the certainty of his resurrection.[3] It may also refer to the personal, loving bond between the Baptist and Christ. The originality of the sculpture owes much to the use of white, green, and light blue (so different from the warm tones of Raphael's painting) as well as to the complete omission of the landscape background. The three-dimensional nature of the figures is enhanced as they emerge vividly from the uniform, abstract sky behind them. They reveal their ideal, symbolic value precisely through the elements that distance them from the narrative naturalism of the painted version. ¶ Gentilini has rightly attributed this work to Girolamo della Robbia, the youngest of Andrea's twelve children, who was active in his father's workshop under the guidance of his brother Luca. According to Vasari, Girolamo "devoted himself to working in marble, in clay, and in bronze," competing with Jacopo Sansovino and Baccio Bandinelli.[4] He was a best friend ("amicissimo") of Andrea del Sarto, who portrayed him in the fresco of the *Exequies of Beato Filippo Benizzi* in the Chiostrino dei Voti in the church of Santissima Annunziata in Florence. Girolamo thus joined in the new trend of Florentine art, maintaining a close relationship with the most celebrated painter of the period. His sensitive perception of the innovations of contemporary art together with his unquestionable talent led him to forsake the traditional prototypes of the della Robbia workshop and modernize his compositional repertoire, often inspired by contemporary paintings. ¶ In one of the earliest autonomous works attributed to Girolamo della Robbia, the *Saint Francis Receiving the Stigmata* in the church of San Francesco in Barga (c. 1510), the landscape in the background recalls Sarto's frescoes for the church of the Annunziata. The modern classicism of the altarpiece of the *Virgin and Saints* in San Jacopo a Gallicano, near Lucca (c. 1516), was likewise inspired by Sarto. Here, as in other sculptures of the second decade of the sixteenth century, we see animated figures, wrapped in exuberant drapery, that are at times characterized by disproportionate dimensions and complex, artificial poses typical of early Mannerism. ¶ The present relief belongs to the same period as these works. Its derivation from Raphael may have accommodated the request of its patron, Raphael being one of the greatest representatives of the modern style. The painting selected was exemplary of the new grace and naturalness of the period; adapting it to the format of

the della Robbia tradition created an eclectic hybrid of idioms and cultural references replete with the typical elements of the nascent "modern manner." ¶ Having reached his artistic maturity, Girolamo moved to France in 1517 to work in the court of Francis I. He was joined there by other Florentine artists, among them Andrea del Sarto (1518), Giovanni Francesco Rustici (1528), his brother Luca (1529), Rosso Fiorentino (1530), and Benvenuto Cellini (1540). He executed important works for the sumptuous palace in the Bois de Boulogne and for several châteaux (de Cognac, de Sansac, d'Assier), of which only fragments remain – too few to reconstruct an artistic career that was so successful it earned Girolamo the title of "valet de chambre du Roi" (1557). According to Vasari, after the death of Luca in 1548, the old Girolamo, "alone and without any of his kin ... resolved to return, in order to enjoy in his own country the riches that his labour and sweat had brought him," and was confident that there he would be able to work for Duke Cosimo I de' Medici. Cosimo, however, was preoccupied with political conflicts, including a harsh war with Siena, and failed to offer Girolamo a task of any significance. This drove the artist to return again to France, where he died – the last of the della Robbia dynasty – and "art was deprived of the true method of making glazed work."[5]

Francesca Petrucci

In 1512 Giuliano Bugiardini signed and dated a panel depicting the birth of Saint John the Baptist.[1] On that panel, now in Stockholm (fig. 27.1), he wrote the name of the patron, "D. VINCENTIUS SACHRISTA S. PETRONI F.F." – thereby revealing that it was executed in Bologna.[2] The panel that concerns us here, from the Galleria Estense in Modena, is identical in subject and similar in composition, and is generally considered to be later than the Stockholm painting. While we have no documentary evidence as to its date or even its authorship, it is manifestly the work of Bugiardini. ¶ When compared with the Modena panel, the one in Stockholm looks as if it must have been cut down on its left side, but it was not. It is in their narrative aspect that the most substantial differences between the two works can be seen. The tall silhouette of the mantelpiece that we find in the Modena panel, the beautiful ceramic jug that rests on it, and most notably the two ecstatic figures standing at the foot of the bed are absent in the Stockholm painting. The Swedish panel is more focused on the image of the bed and its canopy, with mouldings that bear inscriptions about the newborn child. Because some confusion has arisen regarding the source of these inscriptions, it should be pointed out that one ("NO SUR[R]EXIT MAIOR IOA. BA") is from Matthew 11:11, while the other ("ET TU PUER P[RO]PHETA ALTISSIMI") is from the hymn sung by Zacharias and quoted by the evangelist Luke (1:76). ¶ It has been observed that the figure of Mary as she appears in the 1512 panel, acting as an assistant to her cousin Elizabeth, who has recently given birth, was inspired not by the episode from Luke, but by the *Golden Legend*,[3] according to which the Virgin visits the pregnant Elizabeth, stays with her for three months, and at the time of the birth takes on the role of caring nurse. In the Stockholm painting, in fact, Mary sits on the step at the foot of the mother's bed. She is absent-mindedly caressing the child and looking toward Elizabeth and her husband, who are discussing the name to be given the child; her cousin's husband is writing the word that his lack of faith prevents him from pronouncing aloud. Beyond the canopy a maidservant looks on with curiosity, holding a tray. While the Modena panel shows the same figures, two additional characters are standing on the left, and the crouching woman, depicted as Mary in the Stockholm panel, is now merely an assistant; the halo is placed instead on the head of the woman standing behind her (a sign that she is the new Mary), who is accompanied by a youth wearing a hat. The identity of this latter figure is uncertain, as he does not have a halo: he may be a secondary figure included simply to fill out the gathering, or he may even be the patron himself. As a result, whereas the narrative of the Stockholm panel is as simplified

as the image of an *ex-voto*, here it is more animated – indeed almost theatrical. ¶ Not only does the Modena panel have a more intense dramatic quality, it is also marked by different stylistic elements. The Swedish panel is reminiscent of the work of Domenico Ghirlandaio, Bugiardini's teacher, in the composition of the scene (it almost literally imitates – although in reverse – Ghirlandaio's fresco of the *Birth of Saint John the Baptist* in Santa Maria Novella), as well as in the expression on some of the faces, such as that of the servant behind the bed. However, the impact of Ghirlandaio on Bugiardini is compounded by the influence of the artists of the School of San Marco – for example, Fra Bartolommeo, and to an even greater extent Mariotto Albertinelli, both of whom were highly influential models for artists working in Florence in the early sixteenth century. But the year 1512, the date that appears in the inscription of the Stockholm panel, is precisely the very latest date at which the School of San Marco could be considered an artistic driving force. After that time, that is to say after the return to Florence of the Medici (not well disposed toward the monastery of San Marco, formerly the residence of Girolamo Savonarola), the attention of Florentine artists turned toward the church of the Annunziata. At the end of the first decade of the century and in the decade that followed, in the Chiostrino dei Voti of the venerated church, a group of painters, led by Andrea del Sarto, created images that had strong repercussions on the future of representational art, and not only in Florence. Sarto frescoed the *Stories of Beato Filippo Benizzi* (1509–1510), the *Journey of the Magi* (1511), and finally the *Birth of Mary* (1514). In this monumental work, which, incidentally, also reveals the influence of Ghirlandaio, we find the precedent for the more articulate composition and new pictorial idioms of the Modena panel. It should be remembered that Sarto's fresco made explicit reference to a yet more obvious model for Bugiardini's painting, Dürer's engraving of the *Birth of Mary* – in the placement of the figures, whether standing or sitting, in their dynamic gestures, and in the northern-European-looking objects placed on the mantelpiece and on the furniture. ¶ The formal differences between the Stockholm and the Modena panel cannot be explained without an awareness of Bugiardini's personal reworking of the style of Andrea del Sarto and, perhaps even more profoundly, that of Franciabigio. The latter artist, deeply influenced by Sarto, with whom he collaborated extensively, offered his own version of Sarto's figurative style, which, while not as delicate as Sarto's, was more vigorous with respect to colour and graphic quality (an example can be found in the Chiostrino dei Voti, where in 1513 Franciabigio produced a fresco of the *Marriage of the Virgin*). It is not surprising,

therefore, that the Modena panel was at one time authoritatively attributed to Franciabigio himself.[4] On the other hand, the *Birth of Saint John the Baptist* is not the only one of Bugiardini's paintings to echo the work of Franciabigio; suffice it to mention the *Virgin and Child with Saints Mary Magdalen and John the Baptist* in the Metropolitan Museum in New York, which is but one notable example of a whole group of works dating to the second decade of the Cinquecento in which Franciabigio's influence is present.[5]

Antonio Natali

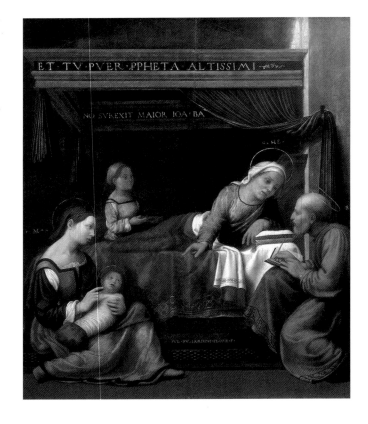

Fig. 27.1 Giuliano Bugiardini, *The Birth of Saint John the Baptist*, 1512, tempera on panel, 122 x 100 cm Stockholm University Art Collection

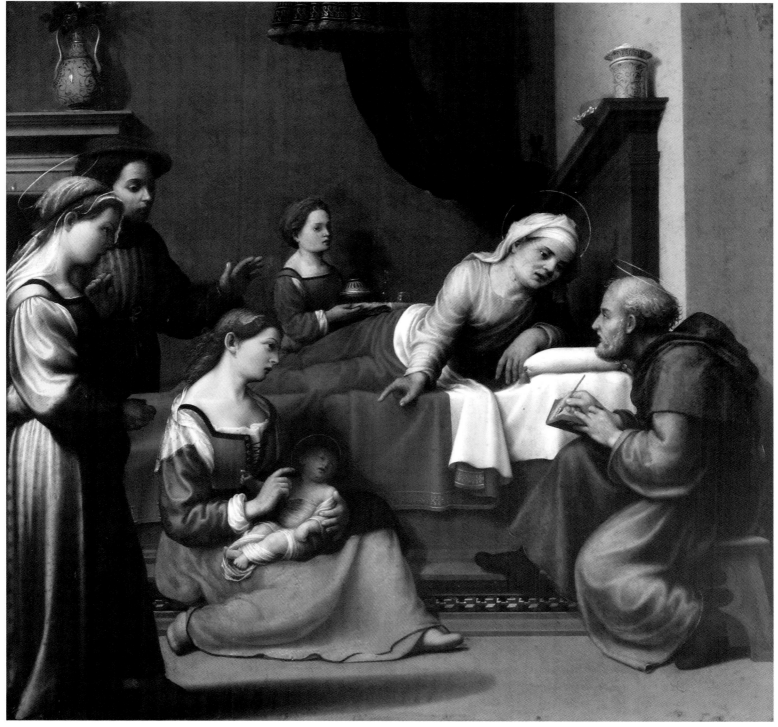

Giuliano Bugiardini was born in the same year as Michelangelo. Given his modest level of skill, it is somewhat surprising that he was one of Michelangelo's most faithful friends (they had trained together in the workshop of Domenico Ghirlandaio and at the San Marco sculpture garden). In 1568 Vasari devoted one Life in his biographies to this minor painter, although he chastised him for being too enamoured of his own creations – a quintessential example of pride and arrogance divorced from genuine talent and supported by a belief in the unique importance of the Florentine tradition.[1] ¶ The New Orleans painting is not mentioned by Vasari, but the attribution to Bugiardini made by Berenson in 1896 remains uncontested. The only other recorded attribution (made at the time of its sale in 1924), to an anonymous painter in the circle of Perugino, is instructive in terms of the serene control of the image but is altogether implausible. The work is closely derived from Fra Bartolommeo's painting of the same subject (including an angel with a palm of martyrdom) executed around 1515 for the church of San Marco in Florence and later destroyed.[2] Fra Bartolommeo's altarpiece was removed from the choir wall of the church following the painter's death in October 1517 because its nudity was judged to be shocking and indecorous, according to Vasari's elaborate account, and it was moved to a more private location in the chapter house of the Dominican monastery. It was subsequently acquired in 1529 by Tommaso Sartini, a Florentine merchant in Lyons, and was in turn sold to Francis I to join three other paintings by Fra Bartolommeo already in the royal collection.[3] The most faithful copy is an anonymous one that survives in the church of San Francesco in Fiesole (fig. 28.1). Yet, because of its higher quality, Bugiardini's picture is the most important record of Fra Bartolommeo's painting, a landmark in Florentine art, with which the Frate had deliberately attempted to counter those critics who complained about the general absence of monumental, sculptural nudes in his work following the eclipse of Perugino and the rise of Leonardo and Michelangelo after 1500.[4] Even if it was a demonstration piece, the claim of the Anonimo Magliabechiano that the *Saint Sebastian* was Fra Bartolommeo's best work can be read as an implicit criticism of this conservative artist, since it highlights how uncharacteristic of his oeuvre the painting was – one more in keeping, in fact, with Florentine artistic tradition of a more secularized nature. ¶ In revising Fra Bartolommeo's invention, Bugiardini produced a more elegant, calm, and restrained image, with a less contorted and revealing pose that is flatter to the picture plane, thus intentionally bringing what had been a controversial image more in line with conventional religious taste. He also eliminated the architecture and placed the saint in a verdant landscape, which relieves the intensity of the original. For all its studious confidence and rather arid elegance the painting is entirely typical of Bugiardini's rather than Fra Bartolommeo's style. The stylistic dating of Bugiardini's replica has traditionally fluctuated within the 1510s, but Laura Pagnotta, who has studied the artist most thoroughly, has proposed a date of about 1518, making the work an almost immediate

response to the original. Given that Fra Bartolommeo died in 1517, this would suggest that Bugiardini and his patron wished to pay homage to the work of a venerated master. The patron who commissioned Bugiardini's painting is unknown, but the fact that the work is on canvas – more portable than panel – suggests that it may have been intended for a market outside Florence.

David Franklin

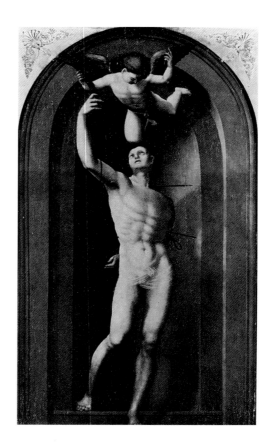

Fig. 28.1 Anonymous, *Saint Sebastian, after Fra Bartolommeo*, oil on panel, 147 x 86 cm. Church of San Francesco, Fiesole

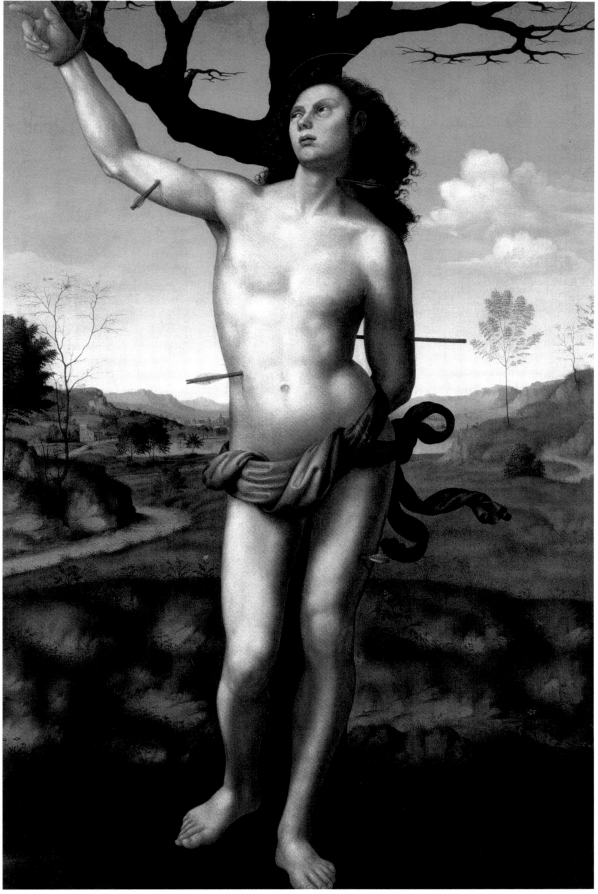

29 ANDREA DELLA ROBBIA (1435–1525) · *Saint Sebastian* · c. 1500–1510 · Glazed terracotta
130 cm high · Museo Civico e Diocesano d'Arte Sacra, Montalcino

This sculpture, formerly in the church of San Francesco in Montalcino, was catalogued by Marquand as a product of the workshop of Andrea della Robbia dating to the last decade of the fifteenth century; Gentilini proposed an alternative date in the first decade of the sixteenth century, drawing a comparison between this figure and the *Penitent Magdalen* in San Jacopo a Borgo in Mozzano, the *Virgin Annunciate* in the church of Santa Maria di Vitaleta in San Quirico d'Orcia (Bagni di Lucca), and another *Virgin Annunciate* in San Pietro in Radicofani. Supporting the argument put forward by Carli, Gentilini regards the sculpture as "probably autograph," and later scholars have confirmed that the execution was indeed by Andrea, pointing out the high quality of the modelling and the intense expression of the figure.

¶ This glazed terracotta statue represents a vigorous Saint Sebastian tied to the tree-trunk at which he has endured his torment; the arrows piercing his body are lost, but their traces remain in the evident holes on his chest and arms. Covered only by the lowered robe tied on his hips, the youth's body has handsome, classical proportions; the saint is poised in the resting position of Polycletus's *Doriphoros* – as if the pain inflicted by the wounds (notably free of any trace of blood) were not even perceived, the mind and soul of the young man wholly focused on a transcendent vision toward which he turns his head. His face is turned upward, while his eyes, enlivened by the darkness of the irises and pupils, are rapt in dialogue with an invisible interlocutor. The brilliance of the white glaze is enhanced by the halo of soft curls, once gilded, that surround the youth's head and fall heavily on his shoulders like the impetuous ripples of a mountain torrent.

¶ Supported by faith and certain of God's deliverance, the saint faces his test stoically. According to legend, Sebastian's mother Irene treated his wounds and saved his life, so that the saint's eventual martyrdom took a different form. Because of that victory over death Saint Sebastian became the patron saint of victims of the plague, an affliction that pierced the flesh with painful, fatal ulcers. Saint Sebastian often appears in that miraculous role in Tuscan art from the end of the fifteenth to early in the sixteenth century, when terrible epidemics of the invincible disease swept the area. Sebastian's miraculous survival, furthermore, suggested an important parallel with Christ: both were generally depicted as handsome, semi-naked young men with their arms tied, martyred and wounded but undefeated, soon to be resurrected from death, indicating the infinite mercy and omnipotence of God.[1] In confirmation of this symbolic significance of the saint, we find on the border of his rolled-up robe the golden traces of a holly-leaf pattern: owing to their similarity with the crown of thorns, the stinging leaves of this evergreen were often taken to allude to the Passion of Christ.[2] ¶ In the production of Andrea's workshop several representations of Saint Sebastian appeared during the years bridging the two centuries: sometimes, as in the altarpiece for the collegiate church of San Lorenzo in Montevarchi (c. 1495–1500), the saint is represented as a delicate adolescent with a spiritual face framed by wavy hair, a depiction inspired by the work of Verrocchio. Because of its more mature physique, however, the Montalcino *Saint Sebastian* bears a closer comparison to the distinctly classical modelling of other treatments of the saint in the altarpiece of the chapel of Saint Anthony in Camaldoli and in the altar frontal with the *Nativity* in the church of San Lorenzo at Bibbiena, works dated to 1513–1520. The Hellenistic beauty in the mature and stern features of the saint is intended to convey the eternal, absolute values of sincere Christian faith and virtue. The figure's composure and beauty thus appear to mirror the soul's perfection, and the saint's calm endurance of suffering is offered as an exemplary model to all Christians, who are encouraged to face their personal afflictions with a strength equal to that of the ancient Christian martyrs. Completely glazed in white, and enriched by the gilded details added *a freddo*, the figure displays the same rigorous choice of colours that had characterized the sculpture of the della Robbia family since the days of Andrea's uncle Luca early in the fifteenth century: the *Angels Holding Candelabra* for Florence Cathedral (1448) and the *Visitation* in San Giovanni Fuorcivitas in Pistoia (c. 1445) were the first examples of monumental sculpture in glazed terracotta and were both decorated in the same two-colour scheme of white and gold. The glazing technique employed in the *Saint Sebastian* ensured the work's eternal, unchanging splendour, while the white colour was symbolic of purity and perfection and evocative of divine light. ¶ Adopted by his uncle Luca after the death of his father Marco in 1448, Andrea apprenticed to Luca and would until his later production preserve a personal and artistic bond with his uncle, the genial inventor of glazed clay sculpture – the "new art" that brought him and his successors wealth and eternal fame. During his early years Andrea imitated his uncle's style, even copying Luca's work at the request of patrons. Starting in the 1470s, however, his production displayed distinctive personal elements that furnished the workshop with new typologies, enriching its repertory. Andrea's style was more emotional and narrative than his uncle's and contributed significant variants to Luca's subjects: the drapery of the figures was executed in a pictorial manner, the clothes (embellished with ribbons and jewels) reflected contemporary fashion, and settings became naturalistic. ¶ The expressive,

engaging tone of Andrea's sculptures, aimed at evoking an emotional response in the viewer, made his works especially suited to the Franciscan reformed notions of spirituality, which sought to bring the faithful closer to the mysteries of religion by translating those notions into a simple, everyday language. In the last decade of the fifteenth century the faith of Andrea and his sons was profoundly affected by the preaching of Girolamo Savonarola, the Dominican friar from Ferrara whose large following included Florentine intellectuals and artists impressed by his eloquence, moral rigour, and doctrines. Savonarola fiercely opposed the Roman papacy, declaring Florence to be the "New Jerusalem," seat of the religious renaissance of humanity. Starting in these years, Andrea modified his expressive, lively language, simplifying his compositions and employing sober, imposing figures draped in austere robes, as in the paintings of the School of San Marco under Fra Bartolommeo. The Montalcino *Saint Sebastian* is a work from this period and a representative example of the earnest religious feeling that inspired Andrea until the end of his long and prolific career. According to Vasari, Andrea realized "many, nay, innumerable other works"[3] regaling even the most uninviting setting with the beauty of glazed terracotta figures, which were impervious to the elements, unchanging in colour, and wonderfully luminous even in the darkness of churches.

Francesca Petrucci

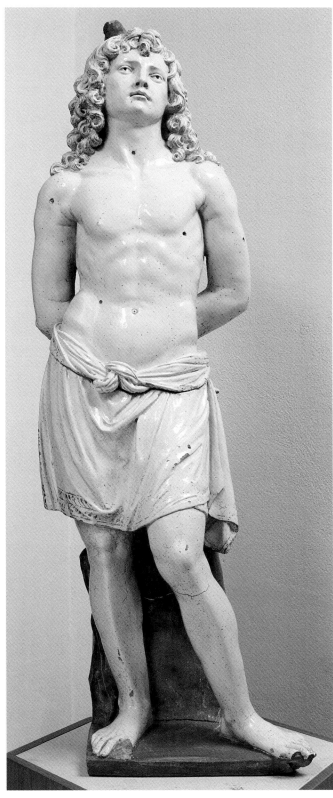

As was first recognized by Alfred von Reumont in 1835, this figure study represents the archangel Gabriel in the *Annunciation* altarpiece signed by Andrea del Sarto that is now in the Palazzo Pitti (fig. 30.1).[1] The painting was executed for the chapel of Taddeo di Dante Castiglione in the Augustinian church of San Gallo, located outside the walls of Florence and destroyed in 1529 as part of a scorched earth policy during the siege of the city at the time of the last republic.[2] ¶ The San Gallo *Annunciation* was a work of extreme significance in the development of sixteenth-century painting in Florence, for according to Vasari, two talented youths, Jacopo da Pontormo and Rosso Fiorentino, collaborated on a now lost predella for the altarpiece.[3] Vasari mentions that this information was supplied by Bronzino, who had been Pontormo's pupil, so there is no reason to doubt its veracity. The work is described as a Dead Christ with angels holding torches, and with prophets appearing in tondi flanking the image; it was probably ruined in the flood of 1557 that devastated the church of San Jacopo tra' Fossi, where it was installed at the time.[4] Sarto's altarpiece can be dated to about 1513 on stylistic grounds, in relation to the *Tobias* altarpiece in the Kunsthistorisches Museum in Vienna – a securely documented work of 1512 that seems less mature.[5] Thus, the contact that Pontormo and Rosso had with Sarto on this project would have been one of the most formative influences on them on the eve of their independent careers, and they must have studied the

surviving drawings for the altarpiece especially carefully. A recently discovered drawing in Rotterdam of another *Angel of the Annunciation* (fig. 30.2), attributable to Pontormo and of relatively early date, provides an intriguing response to Sarto's sketch in the Uffizi.[6] ¶ The figure in the Uffizi drawing is portrayed as turned three-quarters to his right, with his right arm extended and his left hand supporting a lily. The drawing has been oddly trimmed so that the right hand extends beyond the original sheet.[7] The figure is almost completely drawn, and the pose is extremely close to that in the finished painting. This would suggest that the artist could move from a finished study of this nature to the final cartoon stage just prior to painting. The angel in the altarpiece has been given a thinner and more attenuated shape, idealizing him further, and some areas of the drapery fold in different ways in comparison with the drawing, but otherwise the two works are closely related. ¶ Using red chalk alone and a variety of hatching lines, Sarto was able to create a powerful tonality, almost equalling what he was able to achieve in the painting with more elaborate technical means. The chalk is treated so densely in some of the shadowed areas that it resembles a coloured wash. Although it was for a relatively early work, this drawing is of astonishing refinement and maturity.

David Franklin

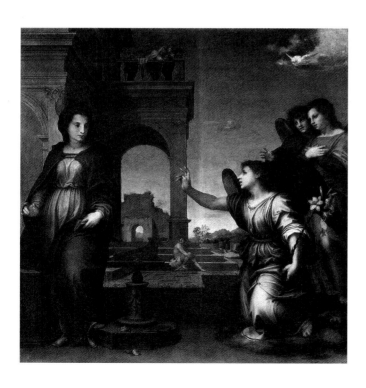

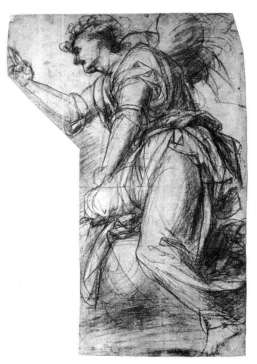

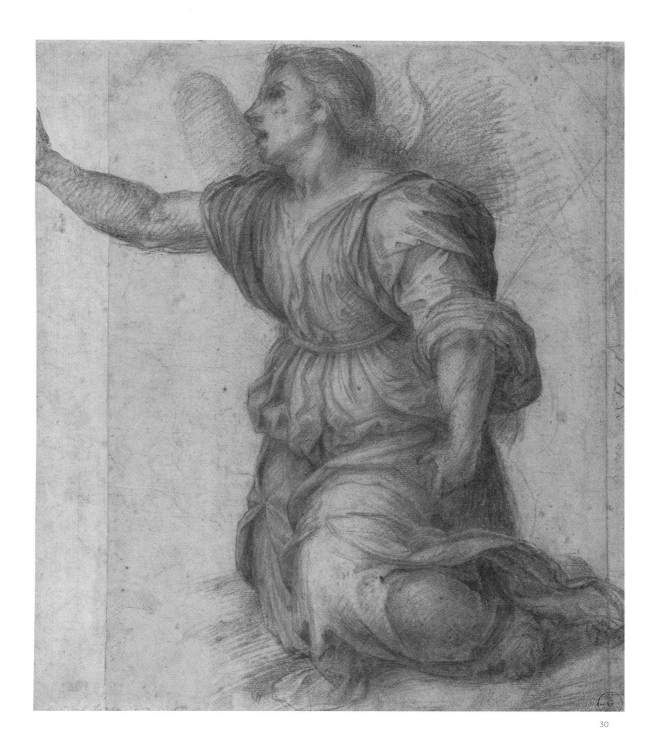

30

Fig. 30.1 Andrea del Sarto,
The Annunciation, c. 1513, oil on panel,
185 x 174.5 cm. Galleria Palatina, Palazzo
Pitti, Florence

Fig. 30.2 Jacopo da Pontormo,
The Angel of the Annunciation, c. 1519,
red chalk, pricked for transfer,
38.4 x 25.7 cm. Museum Boymans-van
Beuningen, Rotterdam (7.I265 PK)

In this vigorous preparatory drawing now in the Ashmolean Museum, Sarto studied the same model from the life twice over, concentrating on the musculature and tension of a near-nude figure in a difficult pose. Initially he indicated the head schematically, subsequently adding abbreviated features and reinforcing the contours of the arm and torso. The full tonal range of the red chalk is exploited, from quick, light hatching to sharper, more decisive strokes; tonal modulation is achieved by softly rubbing the chalk while stronger pressure was used to create the velvety pools of shadow in the darkest areas. In the lower study the figure wears contemporary dress, and Sarto's attention appears focused on the modelling of the arm as it emerges from the sleeve and on the articulation of the hand, while the position of the load, identifiable as a vase, has changed slightly. By now the artist was considering that the figure might look outward at the viewer, although the angle of the head is simply indicated. ¶ The sheet is preparatory for the vase-carrying figure (lower left, in purple) in the *Tribute to Caesar* painted about 1520 in the Medici villa at Poggio a Caiano, a work to which later additions were made by Alessandro Allori (fig. 31.1). For this large-scale fresco, one of a series commissioned by Pope Leo X from leading artists in Florence, Sarto made a considerable number of drawings. He conceived of a boldly asymmetrical composition of monumental architecture with complex figure groupings and a variety of animals. Notionally a classical subject celebrating the triumph of the Roman leader in Egypt, the *Tribute to Caesar* in fact alludes to the history of the Medici family, referring particularly to the gifts of exotic animals sent to Lorenzo de' Medici and the Signoria by the sultan of Egypt in 1487. An allusion to a similar tribute sent by the king of Portugal to Lorenzo's son, Leo X, in 1514 would also have been understood. Sarto's preparatory drawings include studies of figures, drapery, expressive heads, and animals, as in an attractive sheet with monkeys and a dog now at Darmstadt (A.E.1373). The vividly portrayed animals and birds in the fresco recall the interests of Piero di Cosimo, one of Sarto's teachers. ¶ A large and highly worked compositional study in the Louvre (inv. 1673), made at an early stage in the preparatory process, does not include the figure of the man with the vase.[1] After working up this motif on the Ashmolean sheet, Sarto made a beautiful life drawing in red chalk (Uffizi, 648E) of the man's head, with a second, partial study on the same sheet showing him beardless, as he would appear in the fresco. On the verso of that sheet are further studies for his raised right arm, with greater attention paid to the hand.[2] ¶ Parker observed that the motif of a vase-carrying figure was taken from the antique, as it resembles a sculpture on a fountain in the Giardino Cesi, but although the pose is similar the young figure of a putto carrying an amphora is unlikely to be Sarto's prototype. Parker also pointed to a similar motif in a drawing by Michelangelo in the Louvre (688R).[3] There, a muscular male figure, his raised right arm curving over his head, supports a heavy object on his left shoulder. Although Michelangelo's drawing is in pen and ink there are affinities with Sarto's nude study in the treatment of tensed muscles and in the massive form of the man's back and shoulder. Intriguingly, Sarto had already incorporated a reference to Michelangelo in the large Louvre study: as Shearman was first to note, a figure beneath the giraffe is very similar to one in the *Battle of Cascina*, although in the final fresco the man with the vase replaced this motif. ¶ The rapid sketch on the verso of the Ashmolean sheet shows a sword or dirk attached to a fold of drapery. Shearman identified it as a study for the dirk fastened to the belt of the servant in the *Dance of Salome* in the Chiostro dello Scalzo, completed in early 1522. Forlani Tempesti remarked that drawings for Poggio a Caiano and for the Chiostro often appear on the same sheets – work from an extraordinarily creative moment in Sarto's career.

Catherine Whistler

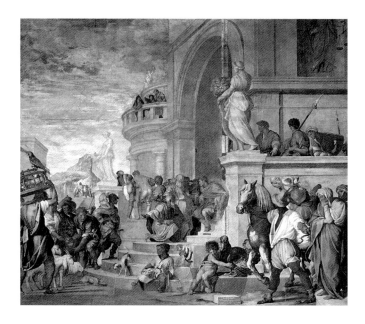

Fig. 31.1 Andrea del Sarto with additions by Alessandro Allori, *Tribute to Caesar*, c. 1520, fresco. Poggio a Caiano

31 (verso)

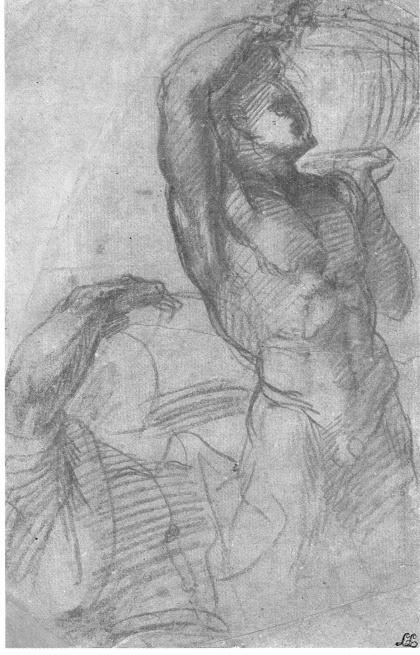

31 (recto)

The principal drawing on the recto is a figure study for the kneeling apostle on the left in the Panciatichi *Assumption of the Virgin*, now in the Palazzo Pitti (fig. 32.1), begun around 1522.[1] The painting was commissioned by Bartolomeo Panciatichi, a Florentine merchant living in France, for a chapel in the church of Notre-Dame-de-Confort in Lyons, but it was never dispatched because the panel began to split even while Andrea del Sarto was painting. The work was eventually acquired by the son of the original patron, and it remained in Florence.[2] ¶ The pose depicted in this drawing derives from that of Saint Sebastian, located in the lower-left foreground of the earlier *Disputa on the Trinity* altarpiece (fig. 38.1), also in the Palazzo Pitti, to which the artist returned when conceiving this yet more ambitious altarpiece perhaps four years later. The arrows held by Saint Sebastian as an attribute are replaced in the later work by a book, which appears in the sketch, but the position of the head and the more upright nature of the pose in the drawing are in fact still closer to the prototype than the completed work. In the context of Sarto's continuing dependence on this stock pose in paintings with the same subject matter, it is appropriate that he used it again for the figure of Saint Nicholas of Bari in the Passerini *Assumption of the Virgin*, executed just after the Panciatichi *Assumption* for the Passerini family for a church in their native Cortona. ¶ Typically, Sarto selected the red chalk he preferred for nude studies, thus concentrating more on the patterns of the muscles created by the underlying anatomy of the figure and less on the characterization of the face. As was conventional in Florentine graphic practice, the artist produced a figure study without clothing for a character that would be dressed in the finished picture. Other drawings would focus on details of the clothing as well as the placement of the figure in a broader setting. The indication of a cap and even breeches suggests that this was a study done directly from life. ¶ The recto was first published in 1959, together with the other known drawings for the painting, by Shearman, who did not then know the whereabouts of the sheet; the verso was revealed only after the purchase of the sheet by the Getty Museum in 1984. The verso contains another figure study, possibly of the same rather thin studio model, in this instance for the figure of Saint Thomas in the same altarpiece, standing on the step on which the sepulchre rests. The sketch was presumably executed at the same time as the recto, although it is much less finished and reinforced. Rather, Sarto focused on establishing a lively rhythmic contour. The drawing is useful for revealing how the artist began these figure studies before overlaying the form with the type of flexible hatching lines visible on the recto. The pose was also reused for the same figure in the Passerini *Assumption*, but with some modifications, such as the higher position of the left arm, derived from this drawing. Sarto clearly returned to his old drawings as stock material when starting a new work with related subject matter. The verso also contains two relatively finished head studies that the artist himself struck out.

David Franklin

Fig. 32.1 Andrea del Sarto, *The Panciatichi Assumption of the Virgin*, c. 1522, oil on panel, 362 x 209 cm Galleria Palatina, Palazzo Pitti, Florence

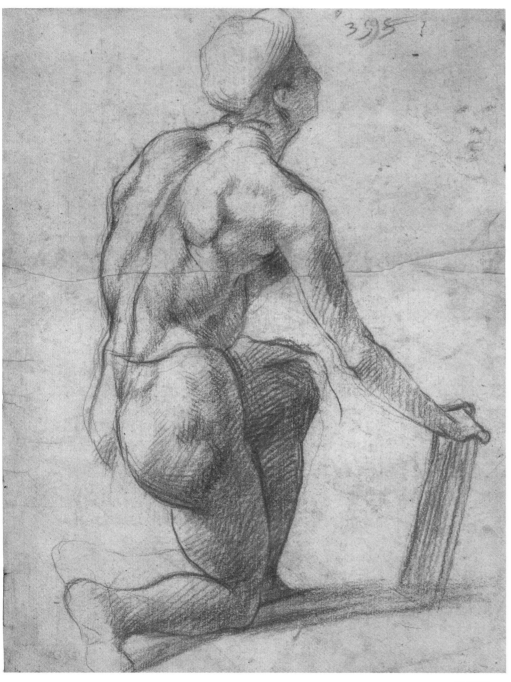

32 (recto)

32 (verso)

Fig. 33.1 Andrea del Sarto,
The Madonna del Sacco, 1525, fresco,
191 x 403 cm. Church of Santissima
Annunziata, Florence

Berenson was the first to relate this drawing to Andrea del Sarto's *Madonna del Sacco* fresco (fig. 33.1), signed and dated 1525, in the Chiostro dei Morti of Santissima Annunziata in Florence.[1] One of the most celebrated of all Sarto's paintings, it was described by Francesco Bocchi in a treatise of 1571 as among the two or three greatest works ever produced in Florence, while it had earlier been called the sister of Michelangelo's *David* by Anton Francesco Doni in a letter of 1549.[2] The monumental fresco takes its popular title from the sack on which Joseph leans, although, ironically, to judge by these preparatory sketches, this figure was almost certainly unintended at the outset. ¶ The drawing contains separate studies for the lunette in varying degrees of finish. The sheet is a quintessential example of the *primo pensiero* type, featuring rapid, semi-illegible sketches. However, the sketches are executed in chalk (without any apparent underdrawing) rather than in the more conventional pen and ink, and they are also on a relatively large scale. Intended as the artist's personal exploration of the subject as the design became increasingly resolved, the drawings are handled with a rough, superficial touch, and there is little treatment of the forms in depth. They are notable as the finest surviving examples by Sarto of a category of drawing that must have existed in a far greater number. ¶ The artist explored five different approaches to the subject in this instance, attesting to his lively imagination and his ability to convey complex thoughts with red chalk.[3] The light sketch at the upper right with a single figure that is reminiscent of one of Michelangelo's *ignudi* from the Sistine Chapel ceiling is the least realized. The image at the upper left features the Virgin, possibly on one knee and supporting the Christ child on the other, in front of a baldachin, while the central study depicts her apparently kneeling in the clouds with the standing Christ child vigorously blessing the viewer. In the even

more lightly rendered drawing at the lower right, Sarto appears to have considered depicting the mother breast-feeding her child. While not at all representing what was eventually painted, the study at the lower left comes closest to the fresco and is the most concentrated and resolved of the group on this sheet. The Virgin rests on the ground, which corresponds to the lower plane of the actual architecture in the cloister of the church, while controlling the active Christ child within a pyramidal plane defined by her body. The vertical elements of the internal architecture are also indicated in this sketch. However, all of the attendant angels and other details of the setting that appear in the drawing were eventually eliminated from the final work and were replaced by Joseph, who calmly reads an open book. Unlike the drawings, which focus on the rapport between the Virgin and the Christ child, the fresco presents a more iconic treatment of the subject, in an architectural setting. This change is significant in demonstrating how artists in this period might take the subject referred to in a formal contract merely as a starting point, much to the dismay of their patrons. ¶ The finished painting is produced in Sarto's mature style of the 1520s, distinguished by a quiet dignity and sculptural restraint, but the drawings reveal how the artist arrived at the final image through a process of lively, intense drawing, which produced entirely distinct studies that had, nonetheless, to be abandoned.

David Franklin

This drawing is a preparatory study for Andrea del Sarto's painting of the *Woman Holding a Volume of Petrarch* (fig. 34.2). On the recto of the sheet are two studies of the bust, one a foreground view in which the artist concentrates solely on the facial expression, and the other a smaller version, from further back, in which he develops the collar of the garment. On the verso (fig. 34.1) he concentrates more on perfecting the sitter's pose. In order to stress the naturalness of the subject's appearance Sarto used repeated strokes to model her features, an expressive technique inherited from Leonardo and Michelangelo. Such pulsating lines are found throughout his graphic works, most notably in those that post-date his decorating of the *Salone* in the Medici villa at Poggio a Caiano. The sheet recalls the style of the artist's drawings for the *Pietà* at Luco di Mugello (Palazzo Pitti), painted during the plague of 1524. The likeness is most evident in the study of a young girl's head for Mary Magdalen (Uffizi, 644E), in which the sitter is the same as in the portrait and appears to be about the same age. This would support the date of about 1525 for both the drawing and the (still *sfumato*-style) portrait. Although often dated late in Andrea's career,[1] the Uffizi portrait bears stylistic similarities to the copy of Raphael's *Portrait of Pope Leo X with Two Cardinals* (Galleria Nazionale di Capodimonte, Naples) made in late 1524 or early 1525; the pose is taken directly from the Raphael, as is the handling of the fabrics, particularly the white sleeve. ¶ On the basis of the commonplace initiated by Vasari to the effect that every female portrait by Andrea del Sarto reflects one of the women of his household, there have been efforts to identify the model of the drawing and the painting as Lucrezia del Fede, the artist's wife, or Lucrezia's daughter, Maria del Berrettaio. Lucrezia, however, was too old to have lent her features to this girl of about fifteen, while Maria del Berrettaio, born in 1513, was too young. For the latter to have been the model, the portrait would have to be dated later, not before 1528. In that case, though, the resemblance to Mary Magdalen in the *Pietà* would be inexplicable, whereas it is clearly the same person, just slightly older. The features of the young girl in the portrait appear frequently in Andrea's work after 1524. She is recognizable in numerous preliminary drawings for various paintings, notably in sheets in Paris (Louvre, 1716 and 1716 bis) and

in Florence (Uffizi, 644E, mentioned above, and also 653E, 306F, and 15789F).[2] Although one of these may be considered preparatory to the Luco *Pietà* or the Barberini *Holy Family* and another to the female figures of the Pisa and Berlin altarpieces,[3] it is not impossible that the artist used the same feminine prototype, someone close to him, at different periods. If so, the model for these drawings, and thus for the École des Beaux-Arts sheet and the Uffizi portrait, may have been Maria del Fede, Lucrezia's young sister, who, according to Vasari,[4] fled with the painter's family to the Mugello region to escape the plague.[5] ¶ The presence of Petrarch's *Canzoniere* in the portrait suggests that the painting was designed to exhibit the sitter's beauty and virtue on the occasion of her marriage.[6] It is clear from the preliminary drawing – which indicates the colours to be used – that Sarto took great pains with this piece, particularly in rendering the facial expression so as to achieve the Petrarchan ideal of beauty. The archetype of this portrait is Leonardo da Vinci's *Mona Lisa*, in which, thanks to the smile, the artist manages to suggest that his model is capable of speech – something Simone Martini was unable to achieve when he drew his mythical portrait of Laura. Sarto, like Leonardo, is able to reveal the sitter's character with his brush, just as Petrarch depicts Laura with his words. Paintings of this sort were commonly commissioned by the fiancée's family, and if this one was done for Lucrezia's sister's marriage[7] it is not surprising that the artist, who knew the young woman well, was able to capture her mischievous expression perfectly.

Philippe Costamagna

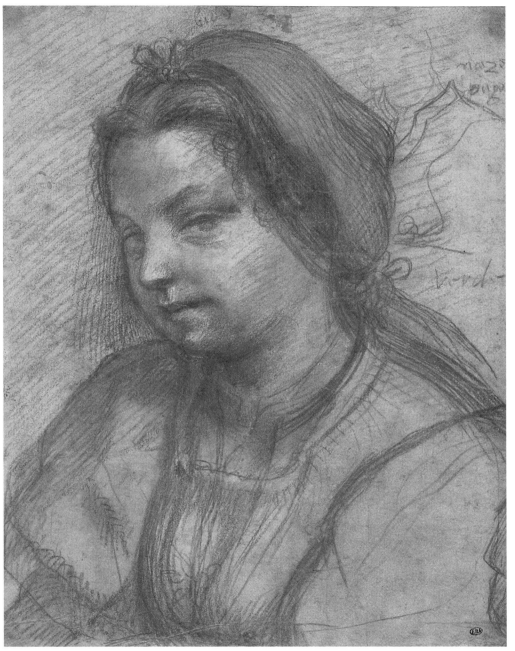

34

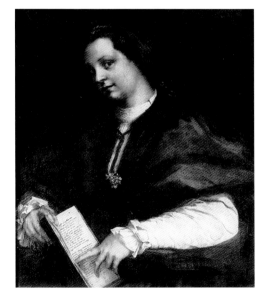

Fig. 34.1 Andrea del Sarto, *Study for a Portrait of a Young Woman*, red chalk over black chalk (verso of cat. no. 34)

Fig. 34.2 Andrea del Sarto, *Portrait of a Woman Holding a Volume of Petrarch*, c. 1525, oil on panel, 84 x 69 cm. Galleria degli Uffizi, Florence

This red-chalk drawing by Andrea del Sarto was a preparatory study for a painting of one of the three captains who had deserted Florence during the siege of 1529–1530, on the eve of what would prove to be the end of the last republic, soon to be brought down by those loyal to the Medici. Sarto was ordered by officials of the republican government to paint effigies of the traitorous captains on the facade of the palace of the Mercanzia Vecchia facing the east end of the Piazza della Signoria, as well as effigies of three citizen-traitors on the Palazzo Vecchio in the civic heart of Florence.[1] The representation of the traitors hanging upside down by one leg, as if in the throes of a horrible death, reflects an especially brutal Florentine custom. In addition to taking revenge on those traitors who had abandoned the republic and providing a warning to other citizens, the purpose of these propagandistic frescoes was to shame any friends or family members left in the city.[2] ¶ Sarto here continued a tradition established by other illustrious Florentine artists, including Sandro Botticelli and Andrea del Castagno, who had produced similar paintings in the fifteenth century. According to Vasari, Sarto claimed that the work had been carried out by an otherwise obscure assistant, Bernardo del Buda (to whom payments were made from February to April 1530), but this appears to have been a deception, as the artist could hardly have defied such an important patron.[3] In Benedetto Varchi's account, Sarto presumably created this subterfuge because he hoped to protect his already elevated reputation by distancing himself from this project, so as to avoid the fate of Castagno, who had been dubbed "Andrea degli impiccati" ("Andrea of the hanged ones").[4] Sarto's wish to dissociate himself from this distasteful public commission in no way indicates that he was more loyal to the Medici than to the republic – like most artists, he accepted commissions from patrons on both sides.

¶ This exceptional drawing and four other equally powerful and vigorous ones of the same type, all in the Uffizi, leave no doubt that Sarto was the artist. He chose red chalk, the better to render the dramatic effects of full sunlight illuminating the bodies, whose agitation and terror he has striven to imagine. Vasari also relates that the sculptor Tribolo made mannequins out of wax for Sarto, just as Jacopo Sansovino had done earlier in his career, to help him visualize the three-dimensional quality of the dangling figures. It is likely that the figures on this sheet were based on such a model, given that the facial features are not differentiated. It is probable that the artist added real clothes to the models to make them as lifelike as possible. This drawing also provides a general idea of the appearance of the realistic effigies of prominent citizens that were commonly donated for votive purposes to important cultic locations like Santissima Annunziata. ¶ The painting for which this drawing was a study – one of the final works of Sarto's career – had been deliberately obliterated by the time Vasari wrote his first biography of the artist in 1550, no doubt by supporters loyal to the Medici and Pope Clement VII.

David Franklin

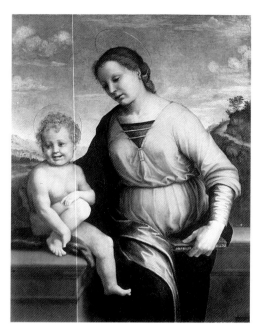

Fig. 36.1 Franciabigio, *The Virgin and Child*, 1509, oil on panel, 86 x 66 cm Galleria Nazionale d'Arte Antica, Palazzo Corsini, Rome

The attribution of this *Virgin and Child* to Andrea del Sarto was proposed by both Shearman and Freedberg, each the author of a monograph on the painter, in separate private communications dated 1990.[1] With the exception of one catalogue entry, however, the painting has not been discussed in the scholarly literature. The surest evidence for the autograph status of this painting is the free and vigorous brushwork, creating in places an effect of remarkably delicate transparency. There are also several very significant pentimenti evident, as in the left foot of the Christ child, where the incisions defining an extra toe, cancelled in the act of painting, are now detectable. ¶ The panel has been dated to about 1509–1510, at the time of Sarto's frescoes illustrating events in the life of Beato Filippo Benizzi in the Chiostrino dei Voti of Santissima Annunziata in Florence. However, it may well be slightly later. It seems closest in date to the *Noli me tangere* formerly in the church of San Gallo and now in the Museo di San Salvi in Florence, and to the *Tobias* altarpiece in the Kunsthistorisches Museum in Vienna, a securely documented work of 1512.[2] Both these altarpieces were painted for the Morelli family, and although the patron of the Boston painting remains a mystery, the Morelli family would be a candidate, given its obvious admiration for the artist's early work. It is not difficult to imagine the family ordering a private devotional picture from Sarto to complement the public altarpieces. A reading of the first part of Vasari's biography of

Sarto yields several other potential candidates worthy of further investigation, including the Spini, Borghini, and Giocondo families, for which hitherto unidentified paintings, presumably featuring the Virgin and Child, were executed.[3] ¶ The Boston painting is larger and more monumental in scale than other early Sarto pictures of the Virgin and Child, and in this regard and in other details it was likely inspired, in reverse, by Franciabigio's work on almost exactly the same scale in the Palazzo Corsini in Rome, which is dated 1509 (fig. 36.1).[4] The paintings share, for example, the use of a prominent ledge, symbolic in this context of the stone of unction. Both works reveal a more up-to-date influence from Leonardo, specifically seen here in the benign expression of the Virgin with her shrouded eyes and slightly parted lips. Sarto's figures nonetheless retain a particular daintiness that the artist would struggle to discard. The quizzical, rather cloying expression of the teething Christ child is further evidence of Sarto's relative immaturity. Youthful paintings of this elegant type by Sarto are not to be dismissed, however, as mere juvenilia; they were certainly known to other artists. A work of this type would have had a significant influence on painters entering his workshop at a much later date, such as Antonio di Donnino del Mazziere.

David Franklin

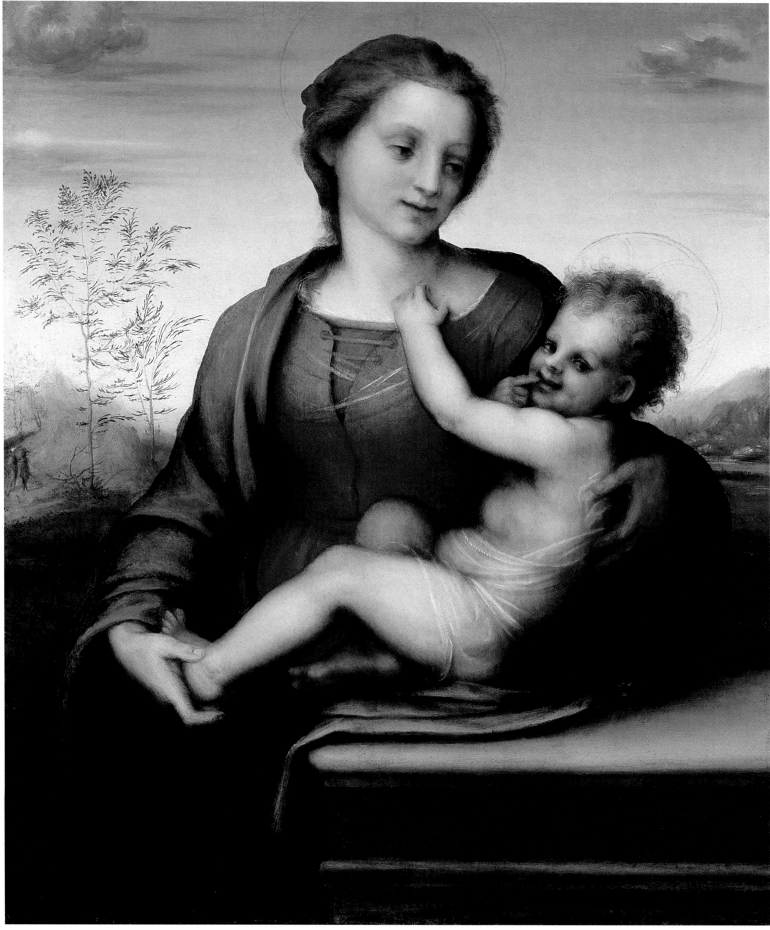

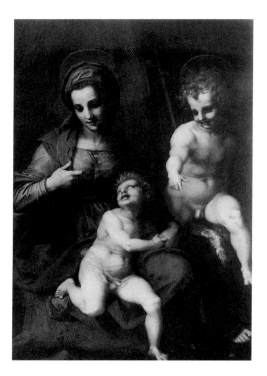

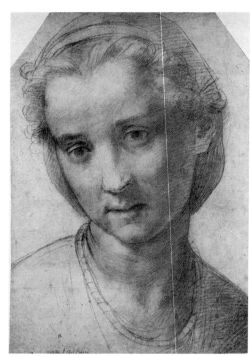

Fig. 37.1 Andrea del Sarto, *The Virgin and Child with the Young Saint John the Baptist*, c. 1516–1517, oil on panel, 154 x 101 cm. Galleria Borghese, Rome

Fig. 37.2 Andrea del Sarto, *Head of a Woman*, c. 1515, black chalk, 33 x 22.4 cm National Gallery of Art, Washington, The Armand Hammer Collection (1991.217.5)

This work, one of a number of small, intimate paintings by the artist, likely served as a devotional picture for a chapel or a bedroom in a Florentine palace. Although its early history is unknown, the presence of at least six wax seals[1] attests that the picture was a prized possession, which is further borne out by the existence of copies, some of them with the addition of the child Baptist.[2] In the nineteenth century the painting belonged to the Barons Wenlock, who frequented Florence, and conceivably the picture was purchased there.[3] Initially it did not find full acceptance in modern literature, but cleaning, technical analysis, and first-hand examination of the work by specialists have now allowed it to be placed within the artist's oeuvre.[4] Moreover, Raffaelle Monti commented on the originality of the iconography. Instead of the more typical landscape setting, the Virgin is represented within a niche, in half figure, with the Christ child standing on a ledge in front of her; at the back, vivid green curtains hang as if suspended from an unseen baldachin. As well, the use of plum and teal blue to create subtle colour variations on the traditional red and blue of the Virgin's robes, and the iridescent creamy yellow head scarf shot with plum, are characteristic of Andrea del Sarto's own heightened chromatic sensibility. ¶ That the picture dates from the artist's early maturity is evident from its relation to two independent commissions executed before his brief trip to France in 1518. The Virgin resembles the larger Borghese *Madonna* (fig. 37.1)[5] with

respect to the angle of her head and the description of her bodice, and indeed the two heads depend upon a drawing in Washington (fig. 37.2), seemingly made from life, in which the eyes look out at the viewer, as in the painting in Ottawa, rather than downward, as in the Borghese composition.[6] In addition, the figure of the Christ child is identical to the curly-haired angel standing to the right of the pedestal in the altarpiece of the *Madonna of the Harpies*, commissioned in May 1515 by the nuns of San Francesco in Via Pentolini, where it was delivered in 1517.[7] There the downward gaze is directed at the eagle attending Saint John the Evangelist immediately to his right, while his left arm crosses over his chest to lend support to the Virgin, who stands on a pedestal, which argues for this angel's having preceded the Ottawa Christ child. Andrea del Sarto had already used this *contrapposto* gesture in the grisaille fresco *Charity*, executed for the Chiostro dello Scalzo in 1513, and he repeated it more emphatically in the pose of the angel at the upper left of the *Birth of the Virgin* fresco of 1514 in the Chiostrino dei Voti in Santissima Annunziata, where the pointed nose and tousled red-gold hair clearly announce the Uffizi angel and the Ottawa Christ child. Such obvious repetition of heads and limbs in compositions of similar date indicates that the artist reused drawings preserved in his studio. ¶ A superlative draftsman in the Florentine tradition, Andrea del Sarto not only made preparatory studies for his paintings but worked these up into cartoons

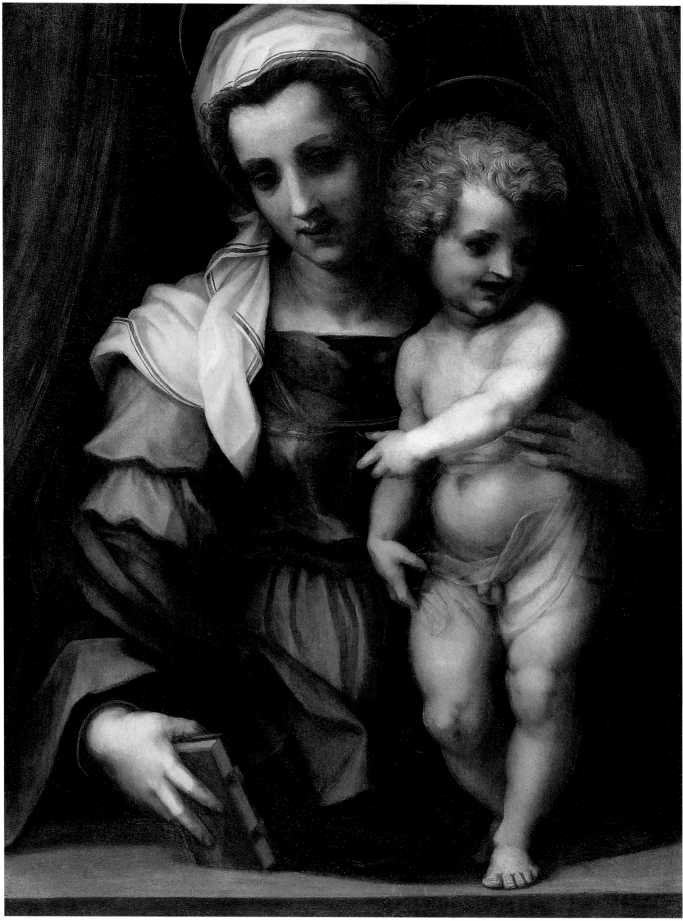

that were employed in the transfer of the image to the painting's surface, especially in instances where he may have intended more than one version of the composition, such as with smaller devotional works.[8] In this process the back of the paper or an interleaf was blackened and laid down on the panel surface; then a stylus was employed to retrace the lines of the enlarged drawing, leaving a black outline on the prepared panel. Infrared reflectography revealing such underdrawing in a number of the smaller devotional paintings often shows both mechanically transferred lines and more animated passages gone over several times, as if the artist were improving, even at this stage, upon the initial drawing.[9] This implies that the artist himself collaborated in the transfer process instead of entrusting the task to an assistant. Frequently visible in his paintings are incised lines from the pressure of the stylus on the still soft gesso layer or *imprimatura*, such as here in the outline of the Christ child's forearm. Underdrawing in the same arm can be seen with the naked eye, but it is even more obvious with infrared reflectography, which reveals that the arm was originally placed slightly higher, as with the other examples just mentioned. Further changes are detectable in the outlines of the Christ child's legs, there are lively freehand strokes in his hair, and characteristically abbreviated indications occur in the Virgin's nostrils and upper lip. As on more than one occasion, the artist also struggled with the placement of eyes, both in the painting and the drawing.[10]

¶ The recent discovery of a nearly identical version of the painting now on the London market confirms the artist's practice of working in conjunction with his assistants on several versions of the same composition simultaneously. The quality of the underdrawing in that work is evidence of the master's participation in the transfer. Some of it is typically mechanical, as is to be expected with the transfer of a cartoon, but other passages, especially at the lower left, show Sarto seeking a satisfactory solution for the Virgin's hand – her thumb is placed in the middle of the prayer book – and vigorous drawing can be seen in the book's binding and the folds of her mantle.[11] In the painting itself, however, the thumb appears as it is rendered in both the Ottawa painting and its underdrawing, as if the artist made the cartoon for the London picture first and then moved to the second panel, perhaps with the intervention of a second cartoon. He then proceeded with the painting of the Ottawa panel, whereas it appears he may have left the London one for his assistants to complete.[12]

Catherine Johnston

144

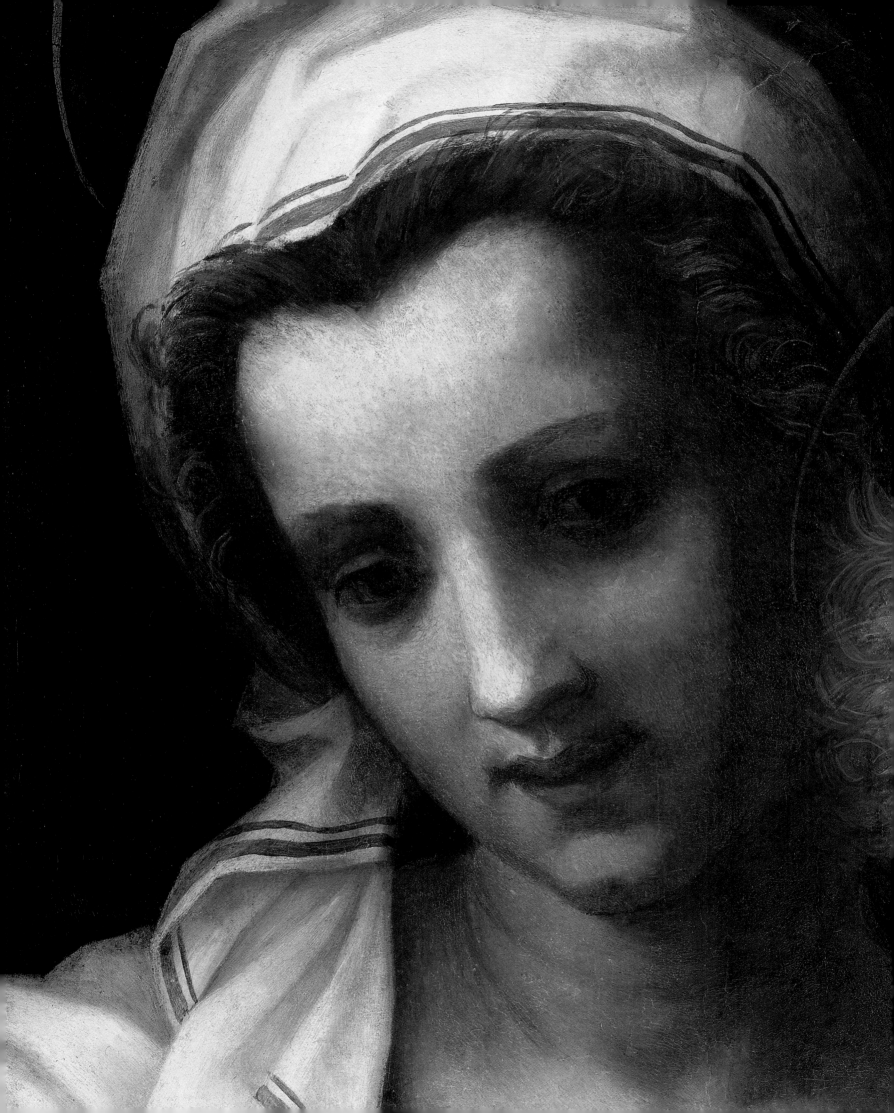

This portrait by Andrea del Sarto is among the strongest and liveliest he ever produced. It belongs to the most important transitional stage of his career, when he painted his remarkable *Disputa on the Trinity* altarpiece (fig. 38.1). The portrait is signed with the artist's monogram at the upper left near the head of the sitter, and so its attribution to Sarto is secure. Its provenance can be traced back to the Puccini family in Pistoia, and since there is evidence that the family commissioned two paintings from Sarto, it is possible that the sitter was a Puccini.[1] The competing theory that this is a portrait of the brickmaker Paolo da Terrarossa, documented as a Sarto patron later in the 1520s, cannot be confirmed.[2] When the work was still in the Puccini collection it was said to be a self-portrait, but our knowledge of the artist's appearance makes that claim implausible. ¶ The half-length figure is shown seated in a chair against a wall – a format that was to have an influence on later Florentine portraiture (see, for example, cat. no. 56). The viewing angle is rather daring, with the sitter's back partly turned to the viewer. The man's dramatic sidelong glance creates a sense of engagement that betrays the general influence of Leonardo's innovations. With its seemingly spontaneous narrative, it is the most intense and pictorial of any of Sarto's portraits. One can imagine the sitter has been interrupted while reading the book that he holds open in front of him (sometimes interpreted, less plausibly, as a block of stone). The portrait has an almost irresistible magnetic force, arising from and yet curiously at odds with the sitter's disdainful ease of comportment. This is the work of an artist at the height of his powers. ¶ The broad sleeve in the portrait is treated in one of Sarto's preferred colours, a steely lavender, and establishes a prominent, dramatic diagonal at the picture plane. The amplitude of the shirt emerging from under the tightly fitting black vest is an observed detail that produces another striking formal element in the design. The sharply delineated, angular folds captured in a broken light are familiar from the *Disputa*. Particularly noteworthy throughout is the treatment of paint, ranging from the hard polish of the sleeve to the broken, virtuoso brushwork of the hands. ¶ The portrait is on a fine canvas, which is somewhat unusual in that Florentine paintings were most often on panel. There is no evidence that it was ever transferred from panel to canvas. The unusual support may indicate that the portrait was painted for export, or perhaps for a country villa.

David Franklin

Fig. 38.1 Andrea del Sarto, *Disputa on the Trinity*, c. 1517, oil on panel, 232 x 193 cm. Galleria Palatina, Palazzo Pitti, Florence

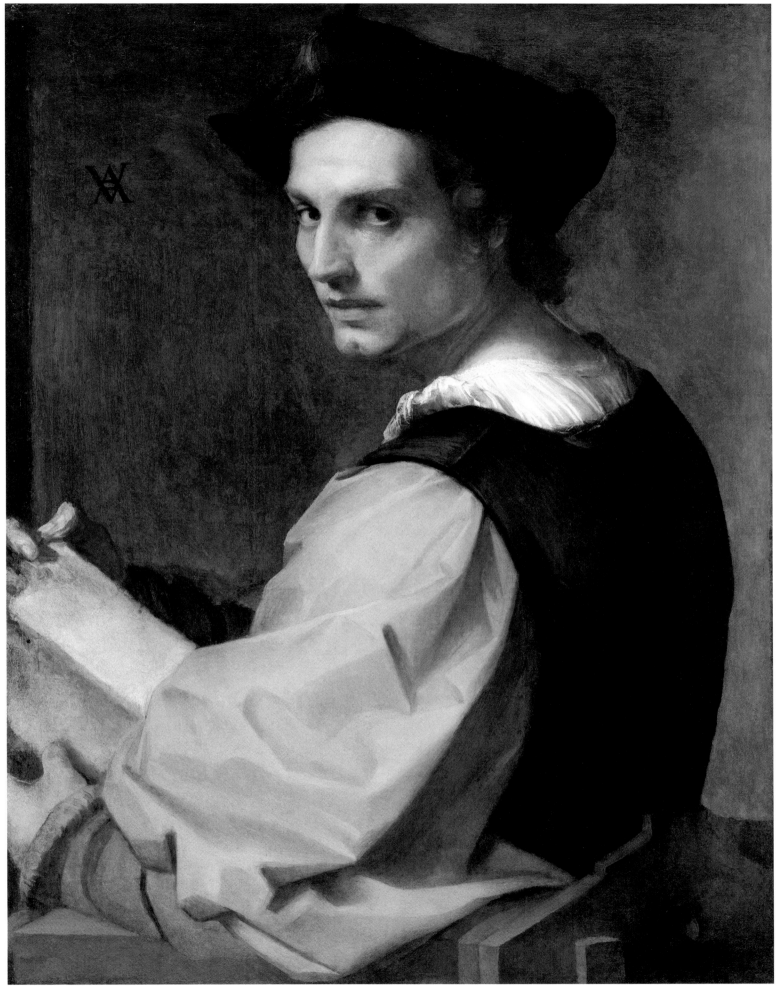

Andrea del Sarto's talent as a portraitist became apparent early in his career. By the end of the first decade of the fifteenth century, when he executed the Beato Filippo Benizzi frescoes for the Chiostrino dei Voti in the church of the Annunziata, he had already demonstrated a great ability to render realistically the physiognomies of protagonists and secondary figures. In his biography of the painter, Vasari identified some Florentine personages – members of the della Robbia family – that appear in the large lunettes.[1] A little later, in 1512, in the panel with the archangel Raphael between Tobias and Saint Leonard, Andrea del Sarto executed a profile portrait of Leonardo di Lorenzo Morelli, the patron of the painting. His portrait also appears in a powerful preparatory drawing, now at the Fondation Custodia in Paris. But Sarto, who relied on friends and assistants as his models, succeeded also in producing entirely credible saints and Madonnas – such as the four standing saints in the *Dispute on the Trinity* of about 1517, or the emaciated figure of Saint Francis and the handsome, red-headed John the Evangelist in the *Madonna of the Harpies*, also of the same period – and numerous Madonnas in which the features are believed to have been inspired by his beloved Lucrezia del Fede. ¶ Andrea del Sarto is universally considered one of the finest, most lyrical masters of the "modern manner." The characteristic elements of his style (his graphic skill, his vibrant and yet balanced use of colour, the clear composition of his scenes, the tranquil bearing of his figures) became the principal model for artists who, in the second half of the Cinquecento, had to comply with the ideological parameters dictated by the Council of Trent. His most celebrated works were later copied, not only to satisfy the wishes of learned collectors, but also, even more frequently, for the purpose of artistic study. No painter in Florence would neglect studying Sarto's works, and every art connoisseur would recommend him as a model to be imitated. His portraits, too, became exemplary. That of Becuccio the glassmaker ("bicchieraio") likely figured among his most important, if only for the "Counter-Reformation" still life in the foreground: resting near the edge of a table are three pieces of fruit and a bowl made of clear glass, its outline softened by gleams of light; luminous streaks are also reflected on the lip of a jug the sitter is holding. The discreet, chromatically felicitous rendition of these objects would not be out of place in one of the crowded pantries painted by Jacopo da Empoli (which, however, were executed only well into the first years of the following century); the clear, delicate, familiar appearance of these objects would have pleased even the Lombard Fede Galizia. ¶ That the sitter of the Edinburgh portrait was Becuccio the glassmaker was first pointed out by Alessandro Conti, after his discovery that two small tondi in the Art Institute of Chicago (fig. 39.1), formerly believed to portray Sarto and his beloved, Lucrezia del Fede, were in fact a double portrait of the same Becuccio and his wife. These profoundly expressive images, painted by Sarto with extreme finesse and scrupulous attention to detail, were incorporated at the ends of the predella for the Gambassi altarpiece,[2] a fact recorded by Vasari himself, who

rightly describes the two small clypeate portraits as "most life-like."[3] Vasari informs us that the Gambassi altarpiece was commissioned from Sarto by Becuccio, "who was very much his friend," when the painter returned from Luco di Mugello, where he had found shelter from the plague that afflicted Florence in 1523. Conti's identification of the characters is undoubtedly confirmed by the similarities between the facial features in the Chicago tondo and those of the half-figure in the National Gallery of Scotland in Edinburgh, which was formerly thought to be a self-portrait (based, understandably enough, on a comparison with the frescoed tile in the Uffizi).[4] In the article in which he presented his theory, Conti also included a biographical note on Becuccio.[5] His real name was Domenico di Jacopo di Matteo, and he was probably a relatively wealthy man, thanks to his small glass business (to which the fruit bowl and the carafe undoubtedly allude); he belonged, therefore, to the artisan class (usually individuals of little education), with which Sarto – in spite of his familiarity with high-ranking intellectuals and aristocratic patrons – was always pleased to maintain contact. Indeed, until the end of his life he was never less than generous in producing paintings for them. However, Becuccio too must have been on familiar terms with men who were knowledgeable about humanist culture, if it is true that at the time of the plague or shortly thereafter Pontormo included a prominently displayed page of Cicero's *De amicitia* (6.22) in his portrayal of the glassmaker's son-in-law and a friend. Again, this is recorded by Vasari: "Pontormo also portrayed in one and the same picture two of his dearest friends – one the son-in-law of Becuccio Bicchieraio, and another, whose name likewise I do not know."[6] Regardless of the identity of the two sitters, the fact remains that the double portrait (now in the Cini collection in Venice), painted in the "German manner," celebrates the friendship between the two men, evoking the author who was deemed at that time to be not only the greatest orator of all antiquity, but, more especially, the noblest model of ethical behaviour. This leads one to reflect on the humanist culture of both the painter and his models, of whom one was related to our Becuccio. The portraits of the glassmaker and of the two friends date to the third decade of the Cinquecento, but whereas Pontormo executed his painting around 1523 (as is proved by Jacopo's assimilation of northern models, which indicates the period of his stay in the Certosa del Galluzzo), the artist most likely painted the corpulent, pacific Becuccio in the second half of the decade: the dating suggested for the Edinburgh panel in fact wavers between 1524 and 1528. The majority of scholars, however, tend to propose a date closer to the end of the decade, which, as is well known, concludes with Andre del Sarto's death.

Antonio Natali

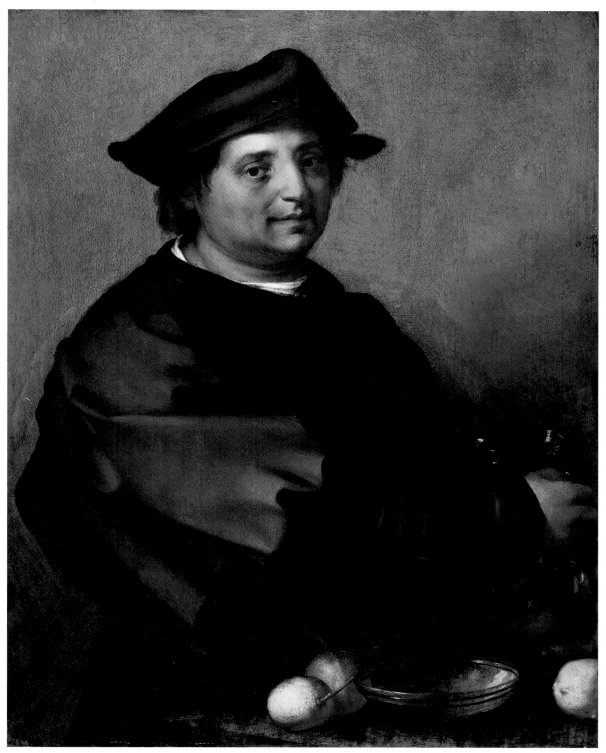

39

Fig. 39.1 Andrea del Sarto, *Portrait of Becuccio Bicchieraio*, c. 1525–1528, oil on panel, roundel (*tondo*) 11 cm in diam. The Art Institute of Chicago, Gift of Mrs. Murray S. Danforth

40 ANDREA DEL SARTO (1486–1530) · **The Sacrifice of Isaac** · c. 1528–1529 · Oil on panel 178.2 x 138.1 cm · The Cleveland Museum of Art, Delia E. and L.E. Holden Funds

41 ANDREA DEL SARTO (1486–1530) · **The Sacrifice of Isaac** · c. 1529 · Oil on panel · 98 x 69 cm Museo Nacional del Prado, Madrid

Andrea del Sarto's *Sacrifice of Isaac* exists today in three versions, two of which, from Cleveland and Madrid, are presented here; the third is in Dresden (fig. 40.1).[1] The paintings are executed in the powerful, aggrandizing style of the artist's mature period in the late 1520s. The commission likely originated with Battista della Palla, a fervent republican returning to Florence from exile in 1527, who attempted to acquire Florentine art for Francis I, in part to ingratiate himself with the monarch, so as to induce him to remain steadfast in his activities against the Medici family.[2] During the period of the last Florentine republic (1527–1530), della Palla commissioned a *Sacrifice of Isaac* explicitly for Francis I, along with the painting of *Charity* now in Washington. These commissions attest to the high reputation Sarto enjoyed in France, in spite of his sudden departure from the French court a decade earlier. Della Palla, who also sent Rosso's *Moses Defending the Daughters of Jethro* (cat. no. 58) to France, died in a Medici prison in 1532, probably from poisoning. ¶ The composition in all three versions of Sarto's *Sacrifice of Isaac* is dominated by the dramatic phalanx of figures whose movement flows from the angel at the top of the panel through the contorted figure of Abraham to the agitated Isaac, who now appears aware of his terrible fate and looks out at the viewer as if for assistance. Sarto was clearly aiming for maximum sculptural relief in the treatment of these figures, with the flesh tones of the boy set off by the rich, polychromatic treatment of his father's clothing. Both of the main protagonists kneel on an articulated pedestal and have the appearance of living statues. The subject was a venerable one in Florentine art, having served as the theme for the competition for the bronze doors of the Baptistery at the start of the fifteenth century. The subject, with its message of divine deliverance, was doubtless chosen not only for its metaphorical overtones, intended to flatter Francis I, but also because of its suitability for a virtuoso treatment.[3] Sarto was attentive to details of the story told in Genesis 22:1–14, which relates how Abraham, the first patriarch of Israel, followed God's instructions and travelled for three days to a mountain where he was to sacrifice his only son, Isaac, as a test of faith. The two servants and the donkey specifically mentioned in the story are included by Sarto, as is the ram that would be offered for sacrifice instead of the boy. ¶ Because of its unfinished state, it is assumed that the Cleveland painting preceded the other two versions and was begun first for della Palla but for some reason proved inadequate, either formally or technically, and was abandoned. Perhaps the artist was dissatisfied with the compressed nature of the design, because in the definitive Dresden version the figures are given slightly more space in which

Fig. 40.1 Andrea del Sarto, *The Sacrifice of Isaac*, c. 1528–1529, oil on panel, 213 x 159 cm. Gemäldegalerie Alte Meister, Staatliche Kunstsammlungen, Dresden

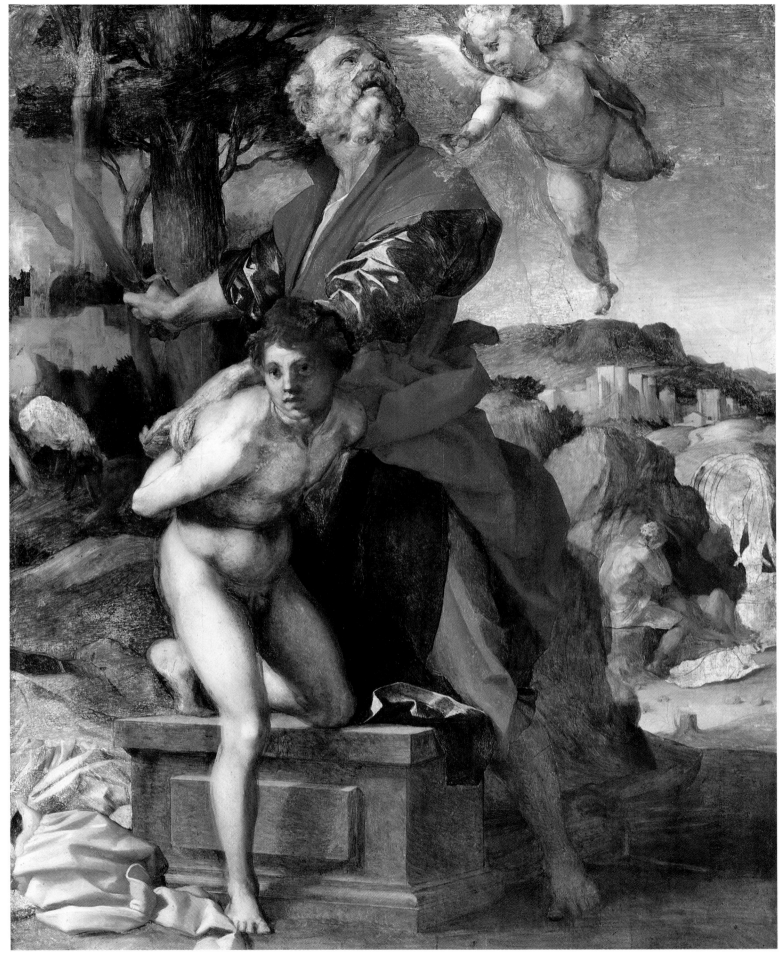

to move. Some areas of the Cleveland painting reveal little more than underdrawing, clearly legible on the priming layer, which is a golden-brown colour. The painting's unusual state of preservation allows the viewer to appreciate not only the sheer vigour and freedom of Sarto's brushwork, but also some of the changes he made in the process of execution. Both the changes made with charcoal underdrawing and those done later with paint have become more visible over time due to the transparency of the paint layer. For example, the angel was originally more upright and was less severely foreshortened. The pose of Isaac also gave the artist particular problems. The two attendant figures and the donkey in the middle ground appeared in different positions, as did the sacrificial ram and details of the trees at the left. The Cleveland version appears to have remained in Florence and eventually to have been acquired – ironically, considering the original purpose of the commission – by the Medici.[4] ¶ The Dresden version of the *Sacrifice of Isaac* is even larger than the Cleveland painting, and is fully completed. It was likely the primary "finished" painting of the subject – the one explicitly praised by Vasari for its diligent execution – and therefore the one intended for dispatch to France by della Palla, although this never occurred because of the events of the siege of Florence in 1529–1530. It is the only one of the three paintings signed with the artist's monogram – on a rock in the right foreground – which also indicates its status as the definitive version. ¶ The Madrid version is reduced in scale in comparison with the other two paintings. From what Vasari tells us, it appears to have been painted for a friend of the painter – Paolo da Terrarossa – about whom nothing else is known.[5] Given its smaller size and its incorporation of details from both the Cleveland and the Dresden pictures, it was probably painted last in the sequence of three. It is closer to the Dresden painting than to the one in Cleveland, again reinforcing the view that the latter picture represents the original, more experimental treatment, which was eventually somewhat tempered. It has the hard, crystalline surface typical of all Sarto's later finished paintings, which were also the works of his that had the greatest influence on Florentine artists right up to the Baroque period. That Vasari was familiar with Sarto's image is proven by the fact that, as a young artist in 1533, he made a copy after the work. Pier Francesco Foschi also produced a copy around the same period (now in the villa at Poggio Imperiale in Florence), which is closest to the Cleveland version, thus supporting the belief that Vasari knew that version too, or at least that he regarded it as the primary one.[6] ¶ As has been much discussed in the literature on the three paintings, the design was based on a variety of source materials, attesting to Sarto's desire to produce a particularly effective image, both formally and emotionally. The pose of Isaac owes much to the ancient sculptures of the *Laocoön*, discovered in Rome in 1506, and the figure of Abraham to the so-called *Pasquino*, also in Rome. The prominent tree at the left of the image is borrowed from Lucas van Leyden's print of the *Return of the Prodigal Son*. But despite the heterogeneous nature of his sources, Sarto was able to create one of the most articulate, tensely harmonized images of the entire Florentine Renaissance.

David Franklin

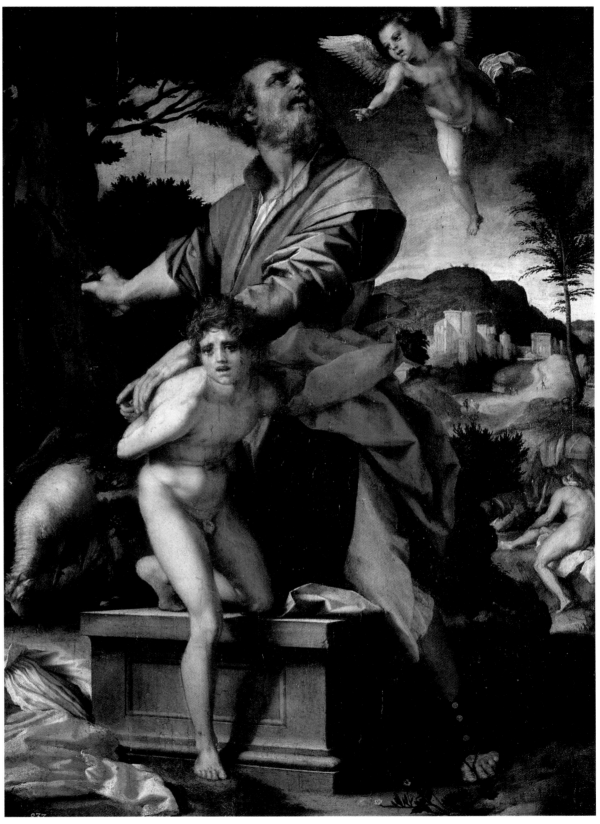

This engraving, relatively large for its time, reproduces one of the five frescoes depicting the life and miracles of Beato Filippo Benizzi (1233–1285), prior-general of the Servite Order, painted by Andrea del Sarto in the Chiostrino dei Voti in the Florentine Servite church of Santissima Annunziata in 1509–1510. The present scene is the earliest of the five scenes in the narrative of Filippo's life entrusted to Sarto, and was almost certainly the first one he painted (fig. 42.1).[1] ¶ The print, and Sarto's fresco, relate an event that took place in 1268, as Filippo journeyed to the papal court at Viterbo in order to renounce his generalship of the Servites. He travelled with three fellow friars, from among whom Pope Clement IV was to choose his successor. (In Sarto's rendition, and in the print, the companions are reduced to two.) While on the road, between Buonconvento and San Quirico, he met a crippled, naked beggar from Camigliano. Filippo gave the beggar his short white tunic, quoting to him the words of Acts 3:6: "Silver and gold have I none; but such as I have I give to thee." When the beggar put on the clothing, he was cured of his disability and revitalized.[2] ¶ This engraving is among the earliest known examples of a print designed specifically as a reproduction of a particular painting. It compresses Sarto's composition into a narrower compass in relation to its height, and eliminates some of the expanse of empty sky at the top of the fresco. The engraver's awkward technique reduces Sarto's deep stage, on which the story unfolds from foreground to background, to a flat, rather two-dimensional screen. Yet in other respects it faithfully reproduces the fresco, from the arched top of the picture field to the details of its intricate landscape and numerous figures. Such relative fidelity suggests that rather than working from the artist's preparatory drawings – a much more common practice for "reproductive" printmakers before the middle of the sixteenth century – he based his design on the actual fresco. ¶ The engraving differs from many prints of the period in that it scrupulously preserves the original left/right orientation of its prototype design. Since intaglio prints are reversed right to left in respect to their plates, there must have been some special justification for the extra effort involved in reversing the composition on the copperplate. It could be that the engraver wanted to ensure that the figure of Filippo in the foreground would point with his right hand (since antiquity, the right hand was traditionally privileged over the left, or "sinister," hand). But this can hardly have been a very compelling motivation, since the fresco is full of figures who point, promiscuously, with either their right or left hands. A more plausible explanation is that the engraver and his patron wanted to reflect Sarto's painting as closely as possible, either because of its importance as a cultic image or because of its value as a work of art. ¶ This raises the question: who commissioned the engraving? Santissima Annunziata was one of the most venerated shrines in Tuscany, and it is possible that this engraving was made to be sold to pilgrims there, and perhaps was commissioned by the Servites themselves. The choice of this particular scene from the cycle may have been intended to inspire visitors to emulate Filippo's generosity while visiting the shrine.[3] Prints depicting the lives and miracles of saints and other religious figures had been popular since the earliest years of Italian engraving. Like the *Beato Filippo Benizzi*, most of these works were executed in a crude popular style, presumably by goldsmiths. Often these prints were separated into multiple panels, making the narratives easy to follow and remember (fig. 42.2).[4] Sarto's design, by contrast, combines no fewer than four incidents in a single, coherent landscape and imposes visual unity upon a number of discrete scenes while maintaining the overall legibility of the narrative. ¶ It is equally possible that Sarto ordered this print himself, to publicize his work soon after its completion – just as, in 1516, he commissioned an engraved copy of his newly finished *Pietà with Angels* from the engraver Agostino Veneziano (cat. no. 43). If it was indeed Sarto who conceived the idea of reproducing his paintings in the Chiostrino dei Voti, one can hardly doubt that this rough, awkward translation of his design dissatisfied him at least as much as, according to Vasari, Veneziano's more skilful print did.[5] But even if the maladroit outlines and heavy-handed shading of the anonymous print did little to convey the delicacy and grace of Sarto's emerging style, this "reproductive engraving" may have been important in the diffusion of his figural inventions. A year or two after Sarto's fresco was painted, Michelangelo himself may have been inspired by the inward-pointing hands of Filippo and the beggar in the foreground of Sarto's design (and quite possibly by this engraved copy) when he invented the famous coupling of hands in the *Creation of Adam* on the Sistine Chapel ceiling.[6]

Louis A. Waldman

42

Fig. 42.1 Andrea del Sarto, *Beato Filippo Benizzi Healing a Beggar*, 1509–1510, fresco. Church of Santissima Annunziata, Florence

Fig. 42.2 Anonymous Florentine, *Beato Filippo Benizzi, with Twelve Scenes from His Life*, c. 1460–1480, engraving, 25.4 x 18 cm. British Museum, London (1879-7-12-287)

Agostino Veneziano's engraving of 1516 after Andrea del Sarto's lost *Pietà with Angels* is an important document in the story of Sarto's ill-fated relationship with Francis I, an avid collector of Florentine, Roman, and northern Italian paintings. Around 1515 the king's Florentine agent, Giovanni Battista Puccini, commissioned Sarto to paint a *Virgin and Child* for Francis, but in the end decided that he could not part with it. He subsequently ordered a *Pietà with Angels*, which was actually delivered to the French court. According to the Life of Sarto written by his pupil Giorgio Vasari, the picture pleased everyone so much that before sending it to France, "implored by many," the artist "had it engraved in Rome by Agostino Veneziano; but when it did not turn out very well for him, [Sarto] never again desired to give anything to the press."[1] In Vasari's Life of Marcantonio Raimondi, however, the story is told differently, with the initiative for the print coming from Veneziano, who purportedly travelled from Rome to Florence in order to convince Sarto that he should let him reproduce his pictures in engraving.[2] ¶ Sarto's *Pietà with Angels* so pleased Francis that several other royal commissions followed. Finally, in May 1518, Sarto himself moved to the French court, where, showered with money and honours, he painted several pictures over the course of a year and a half (of which the Louvre *Charity* is the only known survivor). Vasari blames a stream of manipulative letters from Sarto's wife Lucrezia for the painter's abrupt decision to return home in October 1519, leaving France on the pretense of an art-buying trip for his royal patron. With the proceeds of his sojourn at the French court Sarto built a large house in Florence, where he remained for the rest of his life. The king was so offended when he learned of the artist's deception that, in Vasari's words, "for a long time [Francis] never wanted to see or hear anything about Florentine painters; and I swear that if Andrea had fallen into his hands, he would have done some rather unpleasant things to him."[3] ¶ Sarto's lost *Pietà*, with its heroic figures, expressive pathos, and innovative composition, was an intriguing choice for the artist's only documented foray into self-promotion through the medium of engraving. As was customary, the Roman printmaker would have worked from a drawn copy or a preparatory study, which perhaps explains the print's heavy-handed outlines and harsh shading – the antithesis of Sarto's painterly and atmospheric style. But even in Veneziano's inept reproduction, Sarto's Puccini *Pietà* makes an unforgettable impression through its fusion of traditional religious imagery and the high drama and idealization of ancient art. The gestures of the figures ("sad and full of piety," in Vasari's words) expressively convey the emotion of the scene. The limbs and wings of the angels are interwoven in a dynamic arrangement of diagonals that creates a powerful sense of rotating movement around the inert but muscular and graceful body of Christ. The Saviour's limp arm and sagging head recall Michelangelo's Saint Peter's *Pietà*, which was only some seventeen years old at the time this print was made. ¶ Iconographically, Sarto's *Pietà with Angels* is a profound meditation on one of the central mysteries of the Catholic Church – the Real Presence of Christ in the consecrated bread of the Mass. The elevated body of the Dead Christ – the so-called "Man of Sorrows" – had been a popular devotional image since the Middle Ages;[4] in 1330, Pope John XXII had officially urged all Catholics to visualize such images in their mind's eye while participating in the Mass.[5] Sarto's *Pietà* makes the doctrine of the Real Presence powerfully evident through the arrangement of the angels around an altar-like hillock – in a way that might have reminded contemporary viewers of the familiar sight of a priest with acolytes performing the Elevation of the Host.

Louis A. Waldman

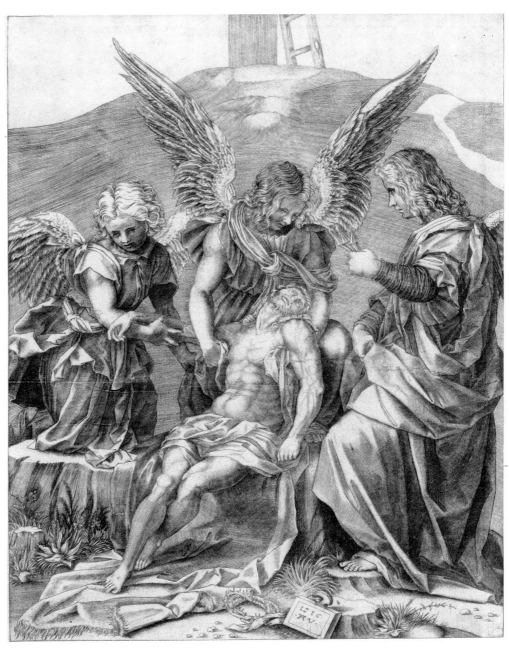

43

This terracotta was acquired by Madame Edouard André in 1886 as Baccio da Montelupo's model for his bronze statue of *Saint John the Evangelist* for Orsanmichele, and it was catalogued as such until Weihrauch convincingly argued that the similarities to Baccio's art were superficial and that the sculpture was the work of Jacopo Sansovino – an attribution that all later students have accepted without question. ¶ Despite its small size, Sansovino's *Saint Paul* is a work of remarkable intensity and characterization. Its poised yet dynamic *contrapposto*, with its interplay of opposing diagonals, reveals the young Sansovino's careful study of the work of contemporaries like Andrea del Sarto and Michelangelo, as well as the venerable godfather of Florentine Quattrocento sculpture, Donatello. Although the extended right arm is a modern replacement, there can be little doubt that it closely replicates the design of the original, creating an open, angular profile that contrasts with the sinuous, closed outline of the opposite side of the saint's body. The twisting movement of the left arm around the body was a favourite motif of Sansovino's during his early years in Florence, as in his model for the *Saint John the Evangelist* of Orsanmichele (c. 1510–1512, lost, but known to us from its adaptation for the figure of the same saint in Andrea del Sarto's 1517 *Madonna of the Harpies*) and his *Saint James* for Florence Cathedral (begun in 1511), which nearly replicates the pose of the Jacquemart-André statue, but in reverse.[1] Given its stylistic similarity to these works, Boucher's dating of the Paris sculpture to about 1511–1513 appears highly plausible, although a dating from Sansovino's early years in Rome (c. 1506–1508) cannot be definitively ruled out. ¶ It was Middeldorf who discovered that the sculpture served as the model for a larger-than-life wooden statue of the saint that was carved, along with its companion figure of *Saint Peter*, around 1602 by Andrea di Michelangelo Ferrucci. Both statues are still preserved

in the Badia di Passignano, in the Chianti region south of Florence (figs. 44.1 and 44.2).[2] ¶ As suggested by Boucher, it is likely that the patron of Sansovino's model for the *Saint Paul* was the abbot of Passignano, Biagio Milanesi, who also commissioned the tomb of Saint Giovanni Gualberto, begun by the sculptor Benedetto da Rovezzano (in progress 1507–1513). When Milanesi was removed from office in 1513, work on the statue commission was presumably suspended, just as in the case of Benedetto's tomb project. Sansovino's model may have been preserved at Passignano until the start of the Seicento, when Ferrucci's statues were carved as part of a renovation campaign. There is, however, good reason to accept a different hypothesis, recently proposed, according to which the Jacquemart-André terracotta would have been part of the collection of Niccolò Gaddi in Florence during the second half of the sixteenth century.[3] ¶ Ferrucci's use of a model created much earlier is certainly not without precedent; in the later sixteenth century Giovanni Bandini had carved a pair of marble reliefs after models by Sansovino (Gaddi chapel, Santa Maria Novella), and in 1600 Antonio Susini created a bronze replica of Bandinelli's *Deposition* relief (now in the Louvre). By the close of the sixteenth century – with the rise of the Accademia del Disegno and the dissemination of books like Vasari's *Lives*, Borghini's *Riposo*, and Bocchi's *Bellezze della città di Firenze* – the sculptors of the early part of the century had taken on something of a mythic status, and artists of Ferrucci's generation came to look upon those masters in much the same way that Sansovino and his peers, two generations earlier, had venerated Donatello and the seminal early works of Michelangelo.

Louis A. Waldman

44

Fig. 44.1 Andrea di Michelangelo Ferrucci, *Saint Paul, after Jacopo Sansovino,* c. 1601, wood and gesso, covered with paint and whitewash, 180 cm high. Badia di Passignano, Greve

Fig. 44.2 Andrea di Michelangelo Ferrucci, *Saint Peter,* c. 1601, wood and gesso, covered with paint and whitewash, 180 cm high. Badia di Passignano, Greve

45 · FRANCIABIGIO (1484–1525) · Male Nude · c. 1516 · Red chalk over black chalk · 38.8 x 14.6 cm
Galleria degli Uffizi, Florence

On account of the nineteenth-century annotation on the verso, this drawing was related initially to Andrea del Sarto's *Beato Filippo Benizzi Healing a Beggar*, a fresco in the Chiostrino dei Voti of Santissima Annunziata in Florence. It is in fact a study for the figure of Saint Job in Franciabigio's altarpiece for the church of San Giobbe, now in the Museo di San Salvi in Florence (fig. 45.1).[1] The connection was pointed out by di Pietro in 1910, and since that time the identification and attribution of the sketch have never been doubted.[2] The altarpiece, featuring the Virgin and Child with Saints Job and John the Baptist, is signed and dated 1516, which provides an approximate date for the preparatory drawing. It is known that by 1509 Franciabigio had joined the Confraternity of Saint Job, which commissioned this painting for the high altar of its church, located behind Santissima Annunziata.[3] So closely associated was the artist with the confraternity that his alias, "Franciabigio," was derived from the colour of the confraternity's robes (*bigio*, or grey). Vasari claimed that Franciabigio had even used his own features for the face of Saint John the Baptist in the altarpiece.[4] ¶ The drawing is of a nude model, probably one of the artist's workshop assistants, in the devout posture of the pilgrim Saint Job. The pose of this stiff upright figure was suggested to Franciabigio by a venerable precedent – one of the spectators in Masaccio's *Baptism* fresco in the church of Santa Maria del Carmine in Florence. True to Florentine graphic tradition, by treating the figure in this way the artist was able to articulate the underlying structure of the body before considering any costume or drapery, or even facial features. Although in the painting the saint is portrayed as a considerably older man with a beard, perhaps based on an ancient prototype, in other respects the drawing and painting are similar. Some of the saint's cloak and staff are sketched in here, but almost as an afterthought. ¶ Franciabigio

started with a loose sketch in black chalk. The freedom of this initial drawing is emphasized by the fact that the red chalk was added between these guiding lines as the artist tightened rather than amplified his original conception. The strokes have been applied in long parallel lines with little cross-hatching, giving the figure its curious hirsute appearance. Shadows have been created by the application of yet more lines rather than by the addition of wash. Indeed, in some areas the chalk has been applied so densely and with such pressure that it has created an enamelled effect. ¶ This remarkable sketch has the crude majesty that distinguishes the artist's drawings from those of his contemporary and occasional early collaborator, Sarto. Given the general difficulty of identifying drawings by Franciabigio, the fact that this sheet is connected to a securely attributed and dated painting makes it one of the touchstone drawings by the artist, of which only about a dozen have emerged. The almost monolithic strength, powerful discipline, and humility that characterize the artist's approach to nature in this sketch are consistent features of his style, but it is only through his drawing that the directness of his attitude can be appreciated.

David Franklin

Fig. 45.1 Franciabigio, *The Virgin and Child Enthroned with Saints Job and John the Baptist*, 1516, oil on panel, 209 x 172 cm. Museo di San Salvi, Florence

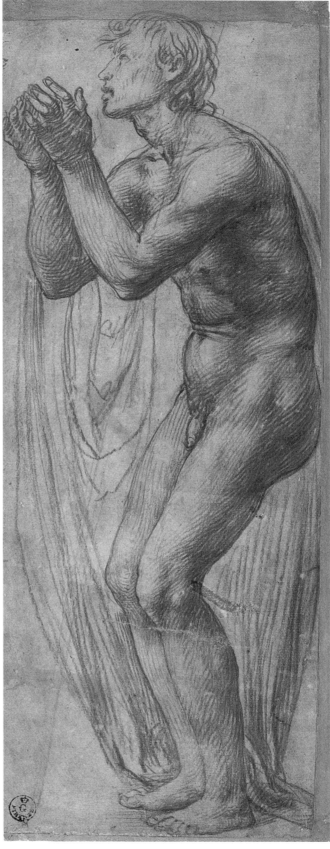

On the pedestal of the left-hand column in this painting Franciabigio's customary signature, the monogram "FBC," is visible, while the lower portion of the painting bears the inscription: "CLAUDITE QUI REGITIS POPULOS HIS VOCIBUS AURES / SIC MANIBUS LAPSUS NOSTRIS PINXIT APELLES." As this inscription tells us, the work recreates the celebrated painting by Apelles described by Lucian in the *De Calumnia*. At the centre of the composition the king, who has ass's ears like Midas, is seated on his throne between Suspicion and Ignorance, looking upon the arrival of Calumny, who holds in her hand a lighted torch and drags her screaming and innocent victim by the hair. Deceit and Treachery draw Calumny forward while Envy, the male figure seen from behind, presents her to the sovereign. The scene also includes a second episode at the right, in which the king has now stepped down from the throne to question the nude figure of Truth, seen as a maiden who holds up a mirror (Knowledge) in which the king examines his reflection while clutching at his cloak as though feeling the cold. ¶ This small panel has been attributed to Franciabigio since 1588, when it was first recorded in the inventories of the Medici collections.[1] That attribution has never been questioned by scholars, who usually date the work to 1515 at the latest. It has been pointed out that the painting is close in style to the *Marriage of the Virgin* of 1513 in Santissima Annunziata and the *Last Supper* of 1514 in the convent of the Calza,[2] but even more noteworthy is its resemblance to the *Saint Nicholas of Tolentino* panels that originally formed the predella of the *Saint Nicholas* altarpiece in Santo Spirito, dated to 1513–1515 (now dispersed among various private and public collections).[3] ¶ Of particular interest is the work's subject,[4] taken from a text by Lucian that had been cited since the early fifteenth century. In his *De Pictura* (1435), Leon Battista Alberti invoked Lucian's description of Calumny when urging painters to seek inspiration for their "inventions" in literary sources. It was during the second half of the fifteenth century, however, that the Greek poem was increasingly introduced into humanist circles via manuscripts, with the appearance of a Latin translation as well as an Italian version by Bartolomeo Fonzio, dating to 1472 and dedicated to Ercole d'Este. In 1494 a selection from Lucian's *Dialogues*, translated into Latin by Benedetto Bordon, was printed in Venice by Simone Bevilacqua, several editions following within a short span of time. In 1496 the *editio princeps* of the Greek text of Luciano's *Dialogues* was printed in Florence by Janus Lascaris, followed by Aldus's Venetian edition of 1503. ¶ The literary popularization of the classical source stimulated the growth of a figurative tradition that was initiated in the 1470s with the illuminations for the

manuscript translation by Fonzio.[5] In Florence the subject of the Calumny of Apelles was especially popular, as proved by the number of works it inspired: for instance, the poem dedicated to the *Triumph of Calumny* written by Bernardo Rucellai around 1493;[6] a rare fifteenth-century manuscript with a Latin translation by Francesco Griffolini from Arezzo, recorded in the collection of Francesco Sassetti (a financial consultant to the Medici but also an erudite bibliophile who was on friendly terms with Fonzio himself);[7] and lastly a canvas painted "in the French manner" with a "Story of Calumny" recorded in the inventory of the Palazzo Medici that was compiled in 1492.[8] The most illustrious figurative precedent for Franciabigio's *Calumny* to have survived, however, is Botticelli's, a panel given by the painter to Antonio Segni (now in the Uffizi).[9] Vasari noted that Segni's son Fabio added an inscription to that painting that celebrated Apelles's work as an appropriate cautionary tale for sovereigns. The same message was conveyed by the inscription that accompanied the lost *Calumny* by Signorelli in the fresco cycle for the Palazzo Petrucci in Siena, completed by 1509. ¶ The Latin inscription on Franciabigio's panel was thus rooted in an older tradition, and reads: "Close your ears to the sound of these words, you who govern peoples! / Thus, escaped from my hands, Apelles painted." In compositional terms, however, the version by Franciabigio possesses an originality that shows no dependence upon any known version of the subject, with its divergent perspective and its two lateral groups linking the allegory of Calumny with the theme of royal judgement. The episode on the right, moreover – placing the contrite king, turned to listen to the figure of Truth, in the role of Repentance – is unprecedented. As has been noted, Franciabigio has translated the erudite allegory into more colloquial narrative terms at the expense of the spatio-temporal dimension, among other things.[10]

¶ The painting could have been conceived in the climate of outrage and distrust that followed the return of the Medici to Florence on 1 September 1512. In fact, the darkness of the scene, with the feeble light filtered through the windows, producing sombre effects of shadow and light, seems deliberately intended to create an ambience of gloom. The name of the patron for this work, however, remains unknown; the two coats of arms on the bases of the columns beside the throne are very damaged. The three arms above the throne are likewise illegible, with the exception of the central one: an emblem of the Medici, with whom the artist had had contact at several times during his career. McKillop links Franciabigio's design with the foiled anti-Medici conspiracy organized by the Boscoli family in 1513, which provoked a violent retaliation in which innocent individuals were also targeted. That

theory is not shared by Massing, for lack of documentary evidence, but the political significance of the work is undeniable.

❡ A comparison of this small panel, which was certainly conceived for a rich domestic setting, with the fresco of the *Noli me tangere* (cat. no. 48) painted by Franciabigio for the terrace of a humble weaver, shows that the artist knew how to adapt his lively narrative language to different registers. He adopted a subtle, introspective tone for works intended either for private collections (the *Calumny*, as well as devotional paintings and portraits) or for enclosed, intimate spaces (the predella for the *Saint Nicholas* altarpiece in Santo Spirito). For his larger paintings, mainly frescoes, he employed a rather direct and expressive pictorial language, leaning to a colloquial, synthetic style in the more modest commissions (like the *Noli me tangere*), and favouring grandiose, resounding images in the largest of spaces (for example, the *Tribute to Caesar* at Poggio a Caiano).

Elena Capretti

Portraiture played a major role in Franciabigio's career, and his work in this medium includes some of the most intensely characterized of all Renaissance likenesses. In this panel, a work of Franciabigio's maturity, we see the artist adopting a more restrained format than in his earlier work, but with undiminished psychological conviction. ¶ The sitter leans over a parapet – a motif borrowed from Flemish or Venetian portraiture – inscribed with the superimposed letters "FRC" (the artist's monogram) and the date, "A.[NNO] S.[ALUTIS] M.DXVI" ("in the year of salvation 1516"). The diagonal placement of the sitter's shoulders establishes a compositional link with the narrow, winding road leading into the background. He displays several rings, one of which he is testing by rubbing it against the black touchstone (*pietra di paragone*) that he holds in his left hand; the colour of the streaks left on the stone would indicate the purity of the gold.[1] A diffuse half-light models the sitter's face, at the same time integrating his figure with the hilly landscape. Despite its somewhat abraded condition, this dramatic work vividly testifies to the impact exerted on Franciabigio by Leonardo da Vinci's chiaroscuro. ¶ A doubtful tradition (undocumented before the mid-nineteenth century, when Waagen reported it, hesitantly) holds that the Princeton portrait represents the Milanese goldsmith Cristoforo Foppa, called Caradosso (c. 1452–1526/1527), who worked for the papacy in Rome from the time of Julius II to that of Clement VII.[2] This identification is still repeated in recent scholarship[3] but has no basis in reality. The only documented portrait of Caradosso – a posthumous one – occurs in Vasari's fresco depicting Leo X's 1515 triumphal entry into Florence, painted in the Sala di Leone X in the apartments of Duke Cosimo I de' Medici in the Palazzo Vecchio. Even though Vasari was too young to have known Caradosso (the same was true for many of the sitters he included in his historical tableaux), the Aretine painter scrupulously sought out earlier effigies of his *dramatis personae*, and those likenesses that can be verified tend to be quite reliable. The explication of the fresco provided by Vasari in his *Ragionamenti* identifies Caradosso as the left-hand mace-bearer, whose head is visible immediately to the left of the papal tiara carried by the papal datary Baldassarre Turini.[4] Vasari's Caradosso is a lean-faced figure with deep-set eyes, jutting cheekbones, a shock of flaming russet hair, and a long red beard – strikingly different from the pasty features of Franciabigio's beardless, white-haired, and somewhat elderly-looking sitter. A more recent claim that Franciabigio's sitter is the anonymous individual depicted in Lorenzo Lotto's *Portrait of a Jeweller* in the Getty Museum appears highly doubtful.[5] ¶ The Princeton portrait may instead represent a contemporary of Caradosso, the Florentine jeweller Michelangelo di Viviano (1455–1526), the father of the sculptor Baccio Bandinelli.[6] Michelangelo di Viviano, who would have been about sixty-one at the time Franciabigio painted this work, was the household jeweller to the Medici family and the most celebrated Florentine goldsmith of his time. In his *Treatise on Goldsmithing* and in his autobiography, Michelangelo di Viviano's erstwhile pupil Benvenuto Cellini praises him highly, noting with particular admiration his skill at setting gemstones.[7] A leading figure in the artistic life of Florence, he was among those consulted on the placement of Michelangelo's *David* in 1504.[8] ¶ Like the sitter in another Franciabigio portrait, the so-called *Portrait of a Medici Steward* at Hampton Court (fig. 47.1) – which echoes the composition of the Princeton portrait – Michelangelo di Viviano was a dedicated Medici servant from the 1490s, when

he appears in Lorenzo the Magnificent's correspondence, until his death.[9] In the year of Franciabigio's portrait, for example, he produced several daggers and a gorget (*pettorale*) for Lorenzo de' Medici, Duke of Urbino.[10] His great financial success is attested by the extensive land holdings he acquired, beginning in 1496, at Pizzidimonte, a hilltop just outside Prato. The steep hill rising behind the sitter, connected to the foreground by a winding road, may thus be an allusion to the tangible rewards he had obtained through his skill as a setter of jewels and a maker of precious objects for the ruling Medici family.

Louis A. Waldman

Fig. 47.1 Franciabigio, *Portrait of a Medici Steward*, 1523, oil on panel, 65 x 48.9 cm. Royal Collection, Hampton Court

Fig. 48.1 Andrea del Sarto, *Noli me tangere*, c. 1509, oil on panel, 176 x 155 cm. Museo di San Salvi, Florence

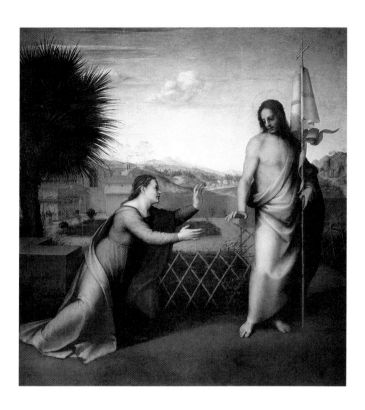

This painting is identifiable with the fresco that, according to Vasari, Franciabigio executed at the end of his life for "the cloth-weaver Arcangelo, at the top of a tower that serves as a terrace, in Porta Rossa."[1] Vasari's description, coming from an ambitious court artist at the height of his career, betrays some disappointment with respect to Franciabigio. Himself the son of a cloth-weaver, Franciabigio was an artist of lowly origins who was known for his humility and compliance; he would readily accept "any assignment that was given to him," including "unworthy things" such as the Porta Rossa fresco. Nevertheless, the biographer was forced to admit that this particular painting was "most beautiful," like other works by Franciabigio, whose abilities came, Vasari wrote, more from the artist's dedication to his work and his long study of the representation of reality than from an innate "boldness of invention." ¶ The tower of Arcangelo the cloth-weaver, known as the Torre dei Ciacchi, was destroyed around 1890 when the area of the Mercato Vecchio was demolished. The fresco, however, was detached and saved from destruction, as were other works and decorations from that quarter. In 1894 it was acquired by the Gallerie Fiorentine. ¶ In the foreground of the composition we see Christ resurrected, appearing to the Magdalen and forbidding her to touch him (John 20:11–18). She kneels before him, genuflecting as though suddenly witnessing a holy vision. Jesus, who appears more monumental as a result of the lowered

viewpoint, pulls away from Mary's touch and with a gesture of his right hand commands her to stop. His semi-naked body, outlined with sculptural precision, shows his wounds, from which blood still flows; he carries a hoe on his shoulder, an allusion to the gardener that, according to the Gospel, Mary had mistaken him for. Behind the two figures in an outdoor landscape there is a dilapidated wall, to the left of which we see a different episode in the narrative: the women approaching the sepulchre with ointment discover the angel who announces to them that the Resurrection has already occurred. Golgotha and its three crosses appear in the distance. The scene is depicted with bright and intense colours, with the warm, pink-hued glow of dawn casting elongated shadows on the ground and creating dramatic outlines against the light, as on Christ's hand. The composition is characterized by intense, spontaneous pathos, fully intended to evoke an emotional response in the viewer. ¶ A significant precedent for Franciabigio's fresco was the altarpiece with the *Noli me tangere* originally in the Morelli chapel in the Augustinian church of San Gallo (now in the Museo San Salvi), a work painted by Andrea del Sarto around 1509, when the two young painters shared a workshop in the Piazza del Grano (fig. 48.1). In addition to that painting, whose composition is undoubtedly reflected in Franciabigio's own, another influential model was a fresco of this subject painted in 1517 by Fra Bartolommeo in the hospice of Santa Maria Maddalena at

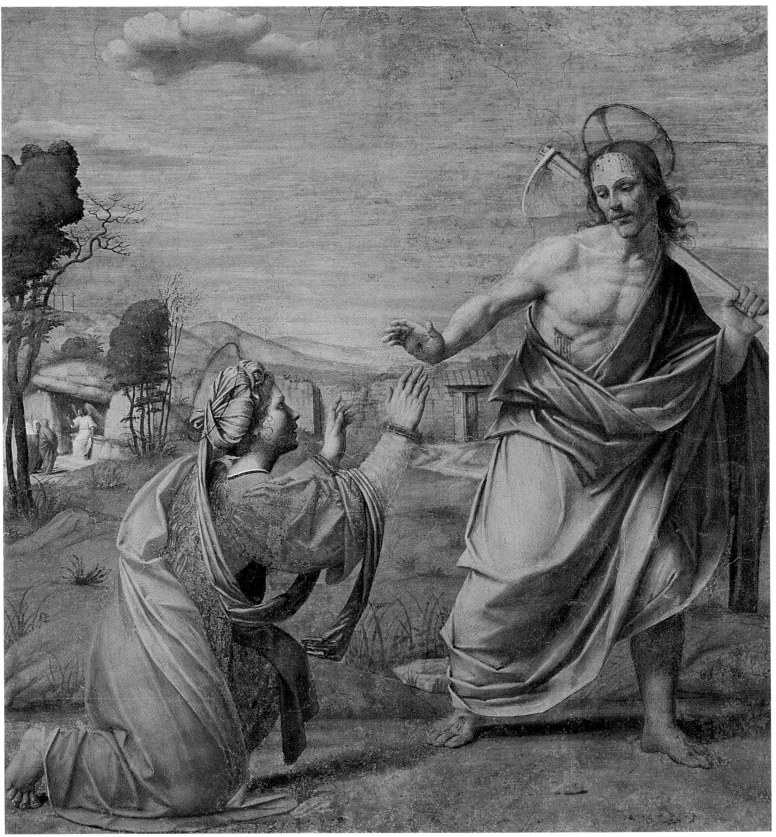

Caldine. The most evident similarities are the dynamic posture of the two figures, the pose of Christ (who carries a hoe in both paintings), and the scene with the three Marys at the sepulchre on the left-hand side. Franciabigio, however, has infused this episode with a more explicit emotional and dramatic quality than either of the others, employing a more naturalistic approach in the representation of the figures, who are depicted as distinct individuals. Christ's body, marked by suffering, is solidly sculpted but out of proportion in relation to the other figure. The Magdalen's dress is heavy and abundant. Her lively personality is portrayed through the features of her rounded profile; the intensity of her emotion unsettles her, so that even her hair is in disarray, with curls falling down her cheek and locks down her back. The two figures occupy the foreground of the scene conducting a dialogue in the manner of two actors on a stage, characterized not by elegance and heroism but rather by a vivacious spontaneity. Here the gentle, elegant figures of Andrea del Sarto and the mystical, abstract personages of Fra Bartolommeo are replaced by Franciabigio's own interpretation of reality, illustrated through protagonists whose inner nobility remains undiminished despite their unpolished appearance.

¶ The late dating of this work – generally accepted by scholars – is supported by the appearance of similar motifs in works by Sarto datable to the early 1520s. The figure of the Magdalen, for example, can be compared with some of the apostles in the Panciatichi *Assumption* in the Palazzo Pitti; Christ's gesture recalls that of Saint Paul in the Luco *Pietà*, also in the Palazzo Pitti, and also that of the youth at the centre of the *Presentation of the Head of John the Baptist* in the Chiostro dello Scalzo. Although certain motifs were the common stock of artists active in Florence in the early 1520s, in the case of Franciabigio and Sarto these probably were the direct result of their continuing working relationship, one that remained fruitful and long-lasting even after their early partnership had ended. The projects on which they both worked included the cycle of *Stories of Saint John the Baptist* in the Scalzo (which Sarto entrusted to Franciabigio when he departed for France in 1518), the frescoes for Poggio a Caiano in 1520–1521, and the panels for the Benintendi palace (Gemäldegalerie, Dresden) completed in 1523, a date recorded on Franciabigio's *Letter of Uriah*. ¶ In addition, the *Noli me tangere* reveals the artist's interest in prints from northern Europe, a common influence on the work of many artists in this period, whether from Florence or elsewhere.[2] In Franciabigio's painting we find that influence in the jagged drapery, the individualized faces and hairstyles, the bare, synthetic landscape cut horizontally by the dilapidated wall with the gate open to the orchard, the monolithic rocks near the sepulchre, and the trees, partly desiccated and twisted and partly luxuriant, with compact and leafy crowns – a probable allusion to death and resurrection. Prints by Lucas van Leyden may have provided inspiration for the more imaginative elements of the composition aimed to convey a direct emotional response, a result that Franciabigio especially sought to achieve in the relatively larger fresco format.

Elena Capretti

In the Hungarian museum since 1971 and formerly in the Lederer collection, this panel was attributed to Puligo by Berenson,[1] an identification supported by Tátrai[2] and the general consensus of scholars. The composition reveals close stylistic and formal affinities with the female figures in Puligo's Anghiari altarpiece, probably executed in 1515. The *Cleopatra* can be dated to the same decade, together with the *Magdalen* in the Royal Apartments of the Palazzo Pitti, the *Holy Family* in the Columbus Museum of Art in Ohio, and the *Virgin* in the Museo Nationale in Pisa.[3] These paintings reveal the impact of Leonardo's influence on Puligo, who, like his predecessor, made extensive use of soft modelling, thus obtaining an effect of emotional lyricism in his figures. Puligo's work of this period also shows clear affinities with that of certain artists from Siena, particularly Sodoma, Beccafumi, and Brescianino, the latter sometimes being regarded as Puligo's Sienese "alter ego." The *Cleopatra*, for example, finds a suitable parallel with paintings of Lucretia by both Sodoma (Niedersächsische Landesgalerie, Hannover, Galleria Sabauda, Turin, and others) and Brescianino (Pinacoteca Nazionale, Siena), which suggests that they all originated from the same prototype. ¶ Initially limited to a formal, traditional approach to composition, around 1515 Puligo began to explore stylistic innovations based on the exaggeration of established models and the use of languorous poses, troubled expressions, and compressed compositions. During this phase the artist participated in the growing Florentine taste for the explicit expression of pathos, a feature that had been derived from Hellenistic art and had filtered through the images of Leonardo and Michelangelo as well as sculptures by Jacopo Sansovino and possibly the prints produced in Raphael's circle.[4] These influences were further reinforced by the strong impact of Rosso's "anti-classical" early works, such as the fresco of the *Assumption of the Virgin* in the Chiostrino dei Voti in the church of Santissima Annunziata in Florence, completed by 1514. Another source was the work of foreign artists such as Alonso Berruguete, who was in Florence until 1518. ¶ According to Vasari, Puligo mainly produced paintings destined for domestic settings rather than large, ambitious public works.[5] A survey of the artist's corpus in fact reveals a special concentration on the painting of "pictures of Our Lady, portraits, and other heads."[6] In the latter category "may be seen the half-length figure of Cleopatra, causing an asp to bite her on the breast" and other paintings with "the Roman matron Lucretia killing herself with a dagger."[7] Two recently published documents of 1524 specifically mention this kind of painting, making reference to two "heads" painted by the artist for a "brickmaker" named Jacopo di Filippo, works that were examined by the painters Raffaello di Domenico and Franciabigio for the purpose of establishing their value.[8] In the nineteenth century, in his manuscript notes to Vasari's *Lives*, Puccini mentions a *Cleopatra* by Puligo in the Bartolommei palace and a *Lucretia* in the Aldobrandini collection.[9] Today we know of several paintings similar to the Budapest *Cleopatra*, some of which are attributable to Puligo himself or to an artist who worked closely with him,

including one work recently on the art market in Florence,[10] another in the Musée de l'Assistance Publique in Paris, and a *Cleopatra* in the Palazzo Bianco in Genoa that was transformed into a *Magdalen* by the addition of a vase. There are also some modest copies of Puligo's works.[11] The other secular "heads" that are securely attributed to Puligo reveal a composition similar to that of the *Cleopatra*, with half-figures viewed against a neutral background and seemingly pushed to the foreground by the soft brightness of the interior setting. Among these, the *Lucretia* formerly in the Irvin Singer collection in Cincinnati lends credibility to Vasari's comment that many of the artist's works were intended for domestic settings.[12] In addition, there is the *Venus and Cupid* in a private collection in Basel published by La Porta and the *Female Figure* in the hospital of the Misericordia in Florence.[13] ¶ In the Budapest painting, Cleopatra is presented as a half-length figure seen taking her own life by holding an asp to her bare breast. Based on classical sources, the story of Cleopatra and other stories of the heroines of antiquity (such as Lucretia, Virginia, Portia, and Sophonisba) were translated in fourteenth- and fifteenth-century literature into exemplary paradigms of virtues or vices. Viewed as a lustful "regina meretrix" after Boccaccio's description in the *De claris mulieribus*, but also as a model of perseverance and loyalty,[14] Cleopatra gained popularity as a pictorial subject much later than did other virtuous heroines such as Lucretia and Virginia. Cleopatra's iconographic fortune, in fact, began only in the sixteenth century, possibly owing to the revival of interest in Egyptian history and art at the end of that century in Rome and other areas in central-north Italy.[15] Nevertheless, some images of the Egyptian queen with an asp in her hand had already appeared in Siena at the end of the fifteenth century, usually in conjunction with other heroines of antiquity or the Old Testament. Such paintings were usually intended for domestic settings, as in the case of the three panels of *Judith*, *Sophonisba*, and *Cleopatra* in the Chigi Saraceni collection in Siena.[16] ¶ Domenico Puligo appears to have introduced a comparatively new iconographic formulation to Florence, one that soon became popular and widely diffused, as demonstrated by the fact that the composition of his secular "heads," showing heroines in languorous poses and with melancholy, introverted expressions, was one that he was also able to employ in single-figure devotional paintings, such as the *Magdalen* in the Royal Palace in Stockholm, the *Magdalen* in the Pinacoteca Capitolina in Rome, and the *Saint John the Baptist* recently sold on the art market in Milan.[17] Just as he did in his depictions of the Virgin, but especially in the field of portraiture, Puligo employed a pre-conceived compositional formula that he adapted to individual commissions by modifying the attributes and details.

Elena Capretti

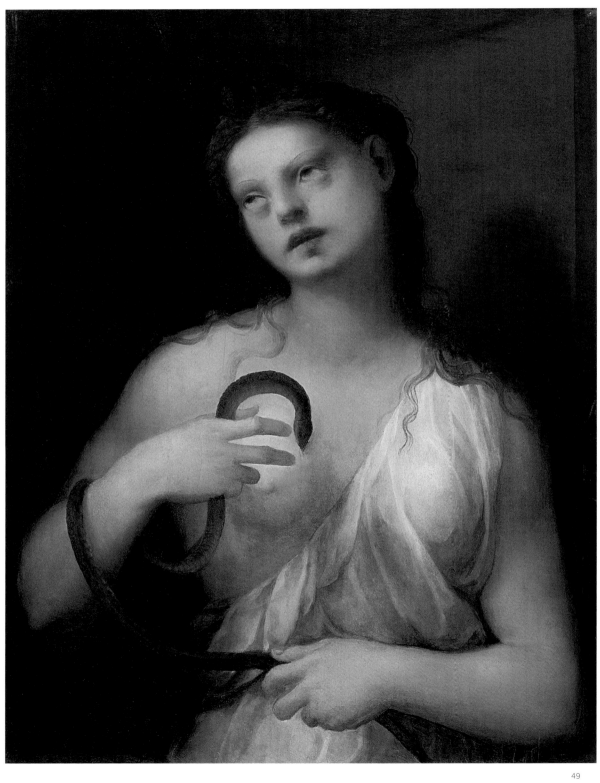

50 DOMENICO PULIGO (1492–1527) · **Portrait of a Woman as the Magdalen** · c. 1520–1525 · Oil on panel, transferred to canvas · 91 x 68.5 cm · National Gallery of Canada, Ottawa

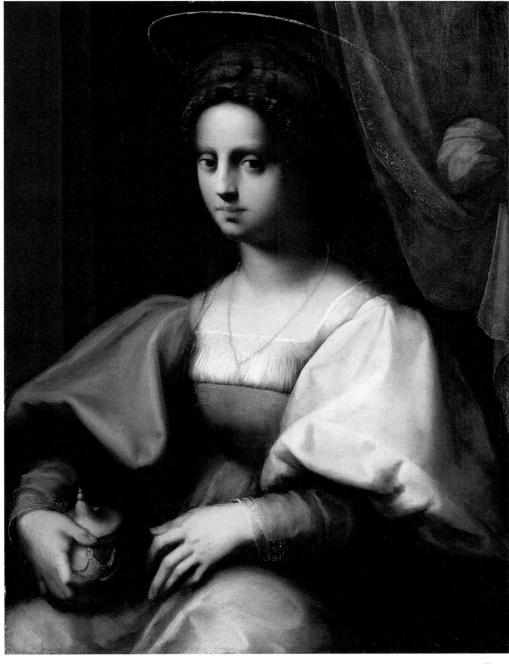

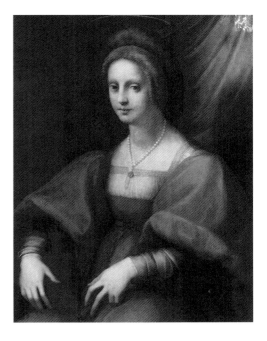

Fig. 50.1 Domenico Puligo, *Portrait of a Woman as Saint Barbara*, c. 1525, oil on canvas, 92 x 69 cm. State Hermitage Museum, Saint Petersburg

This painting came from the nineteenth-century collection of the Duke of Hamilton in Glasgow and was acquired by the National Gallery of Canada in 1912. Crowe and Cavalcaselle rejected the attribution to Andrea del Sarto made by Waagen, believing the panel to be "a slovenly thing" by Bachiacca. Ffoulkes was the first to propose the attribution to Puligo, a suggestion supported by Berenson and now generally accepted, except by Freedberg, who considered it a product of the artist's workshop. ¶ The composition features a three-quarter-length figure of a woman seated indoors beside a curtain, lifted and tied on the right. She wears a dress and a turban that were in style around the 1530s, has a halo, and holds a jar of myrrh, the attribute of the Magdalen – an object considered the "guardian of the spiritual life, from which emanates the perfume of knowledge."[1] Together with gold and incense, myrrh was a gift to the Christ child from the Magi, and was used by the pious women who anointed the body of Christ before he was placed in the sepulchre after the deposition from the cross. Myrrh possesses a complex significance, as it symbolizes the mortal nature of the Messiah, the Passion, and prayer, as well as Christ's thaumaturgic and salvific qualities.[2] ¶ In Florentine and Tuscan art between the fifteenth and sixteenth centuries, the portrayal of a woman as the Magdalen carrying myrrh was a common pictorial formulation, as can be seen from works by Piero di Cosimo (Galleria Nazionale, Palazzo Barberini, Rome), Pontormo,[3] Bachiacca (Palazzo Pitti, Florence), and Poppi (private collection, Florence).[4] In the early decades of the sixteenth century, the same design appeared also in Flemish painting, with female half-figures in an interior setting, carrying a vase (sometimes with an open lid) as an attribute of the saint – see, for example, the Quinten Metsys *Magdalen* in the Royal Museum of Fine Arts in Antwerp.[5] ¶ Puligo explored this theme several times – for example, in two paintings formerly in the Kisters collection in Kreuzlinger and in the Royal Apartments of the Palazzo Pitti.[6] The distinctively secular tone of these images contrasts with the more thoroughly devotional nature of other compositions with the Magdalen made by the same artist, such as those in the Royal Collections in Stockholm, the Pinacoteca Capitolina in Rome, the Galleria Borghese in Rome, and the Accademia Albertina in Turin. ¶ The Ottawa painting should be dated to the early 1520s, alongside the 1523 *Portrait of a Man Writing* in Firle Place, England. The scheme of the Ottawa painting is analogous to that of the *Portrait of a Woman* in Ball State University, Muncie,[7] and the *Portrait of a Woman as Saint Barbara* in the Hermitage in Saint Petersburg (fig. 50.1). In composition, the work is also very close to other devotional paintings by Puligo, such as the *Virgin and Child with Saint John the Baptist* in the Palazzo Pitti; as Stefano Casciu has pointed out, the physiognomy, pose, framing of the image, and elongated and amplified proportions there are identical to those in the Ottawa painting.[8] It is therefore reasonable to assume that the painter used the same model for the female figure in both works – and probably even the same cartoon, at least for some parts. The Saint Petersburg portrait also seems to be derived from the same design, though it features different accessories, such as a tower instead of the jar, to identify the figure as Saint Barbara. The Ottawa portrait undoubtedly preceded the Hermitage one, as the image there is more fully resolved. ¶ The sensitive and original handling Puligo employed in his portraits has attracted the attention of scholars since the early twentieth century.[9] In the past, these qualities were even considered indications that the works were not by Puligo but rather by Andrea del Sarto (as in the case of the Ottawa *Magdalen*) or by Pontormo (as with the so-called *Fattore di San Marco* in Firle Place). ¶ The protagonists in Puligo's portraits are typically either sensitive and introverted young men or self-possessed, even austere young women with fine (albeit not individualized) features and melancholy expressions. The softening of the outlines of the figures by means of blending is a characteristic feature of the artist's portraiture. A soft light is concentrated on the figure, enveloping the facial planes, the hollows of the eyes, the small lips, and the tapering fingers; the light picks out the wide folds of the neat drapery and the rigid pleats of the curtains before fading into the darkness of the room. In such intimate settings, which create an aura of nobility by framing the figure in darkness, the protagonists seem to distance themselves from the harsh reality of daily life, as if forced to conceal their true emotions and maintain an air of composure. Their faces, devoid of distinctive features, seem caught in a moment of time and fixed in the idealizing harmony of Puligo's portraiture. ¶ As in the Ottawa and Saint Petersburg paintings, Puligo often repeated the pose of his sitters, employing a preconceived composition that the artist could adapt to his patrons' requirements by varying the attributes and the details of setting. The male portraits of standing subjects viewed partly in profile, their right hands resting at their sides, are usually set in a room with an indistinct wall, so that the shadow of the protagonist can almost be viewed as a projection of this introspective individual. The female portraits, on the other hand, show the model seated in a three-quarters pose before a simplified architectural background, sometimes framed by a curtain on the right, with the space opening up to a landscape on the left. In compositional terms these images recall Raphael's portraits (for example, the *Lorenzo de' Medici*, which came to Florence in 1518, and the *Joanna of Aragon* now in the Louvre), though translated into a pictorial language rooted in the artistic culture of Florence in the 1520s and 1530s (as demonstrated by the evident similarities with Andrea del Sarto and Franciabigio). Puligo's clearly conceived, consistent style of portraiture, so appreciated by his contemporaries,[10] later became one of the main points of reference for artists like Bronzino and Alessandro Allori.[11]

Elena Capretti

51 ANTONIO DI DONNINO DEL MAZZIERE (1497–1547) · **The Myth of Apollo and Daphne and the Myth of Narcissus** · early 1520s · Oil on panel · 30 x 44.5 cm · Galleria Corsini, Florence

52 WORKSHOP OF ANTONIO DI DONNINO DEL MAZZIERE · **The Myth of Narcissus** · early 1520s (?)
Oil on panel · 30 x 41.5 cm · Private collection, Milan

These two small panels have very similar compositions. The subject of the Corsini painting has traditionally been interpreted as an episode from the myth of Apollo and Daphne on the left with two episodes from the myth of Narcissus on the right. On the left, Apollo chases the wood nymph Daphne, who to escape him is already turning into a laurel tree, beginning with her left leg; at the centre of the composition Narcissus gazes at his reflection in the spring, while to the right, enamoured of his reflection, he lies dead, his head resting among the flowers that would be named after him. The hunting scene in the background on the left presents an activity enjoyed by both Apollo and Narcissus. Though this is the most convincing interpretation yet presented, a few perplexing details might yet prompt alternative readings of the images. For example, behind the expired body of the youth we see a broken bow that is not mentioned in any of the literary sources for the story of Narcissus. Furthermore, the protagonist of all three episodes, who is identical in physiognomy and dress, appears to be the same person. The same is true of the painting in the private collection in Milan. In my view, the Milan work depicts only the story of Narcissus, based on Ovid's *Metamorphoses* (3.356-510), which was one of the main literary sources of inspiration for secular Florentine painting in the fifteenth and sixteenth centuries – an interpretation already suggested by the title in the 1914 sale catalogue, when the painting was still in the Benson collection. ¶ In the foreground of the composition in Milan, Narcissus gestures at Echo to leave him, while the nymph, viewed from the back, runs into the wood as she dissolves into mere sound. The figure of the girl seems partly transparent, as if she were gradually losing solidity, starting with her feet and legs. Here her legs are not turning into a laurel tree as in the Corsini panel. In the middle ground at the centre, Narcissus appears again before a shrub-covered rock, gazing at his own reflection in a pool of water, while on the right he falls to the ground, broken-hearted and exhausted as the nymphs gather around him in mourning and Echo embraces him for the last time. ¶ In both panels, which were destined for a domestic setting, the central theme is the passion of love that makes appearances deceiving. The two narratives are set outdoors and share a common theme in the hunt, illustrated by both the background scene and the bows and arrows in both compositions. ¶ The painting in Florence entered the Corsini collection in the first half of the eighteenth century with an attribution to Andrea del Sarto; despite the initial support of Berenson, that attribution later gave way to tentative attributions to Bachiacca (Sinibaldi, Venturi), Puligo (Freedberg), and Franciabigio (Forlani, Shearman).[1] The Milan painting, which was attributed to both Franciabigio (Crowe and Cavalcaselle) and Puligo (Berenson, Freedberg), was in the Benson collection in London until the early twentieth century, having earlier moved from the Casa Rosini in Pisa to the Pollen collection in Norton Hall, Gloucestershire. A decisive turning point in the critical history of the two panels was reached in 1962 by Federico Zeri, who in his authoritative article on the Florentine Eccentrics associated the works with other small narrative paintings traditionally ascribed to Puligo, but gave them a new attribution to Antonio di Donnino del Mazziere and a date in the 1530s. ¶ A pupil of Franciabigio, Antonio di Donnino is mentioned in 1520 in the so-called *Libro Rosso* of the debtors and creditors of the painters' Compagnia di San Luca. In 1538 he executed an altarpiece of the *Nativity* for the church of San Giuseppe in Castiglion Fiorentino (now in the local Pinacoteca), while in 1539 he participated in the realization of the festive apparati for the marriage of Duke Cosimo I to Eleonora di Toledo and painted the stage sets for a play by Antonio Landi. According to Vasari, Antonio completed several works in the Aretine region, though these are no longer identifiable. He also painted a *Martyrdom of the Ten Thousand* in fresco for the Giocondo chapel in the church of Santissima Annunziata in Florence, a work whose composition was inspired by the small panel on an analogous subject recently discovered in the Accademia delle Arti del Disegno and originally in the monastery of Vallombrosa.[2] Finally, in 1543 he painted the altarpiece with Saint Anne and other saints for the Giacomini Tebalducci chapel in the tribune of the church of the Annunziata. ¶ Vasari recounts that Antonio's monumental works, such as the fresco for the Annunziata, were not well received by his contemporaries, but that he "was a bold draftsman and showed much invention in making horses and landscapes."[3] Such qualities are indeed present

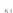

51

in these two paintings with stories of Narcissus and in the other panels that Zeri grouped with them. However, even with the similarity of its style and composition, the Milan panel reveals a somewhat weaker, more rigid execution, and may very well have been developed by the artist's workshop from one of Antonio's designs. The scene in the Corsini panel displays the graceful, slightly exaggerated qualities typical of contemporary theatrical representations, in which costumes of the time are freely mixed with ancient attire (notice Apollo's modern hunting dress and classical-looking footwear). The landscape, with its bizarre bushes and shrubs and luminous valleys, villages, and turreted castles serves as a stage set for the unfolding of the story's episodes. The lively and loose narrative structure of the panel is probably indebted to the artist's personal experience in painting theatrical sets. ¶ The bluish landscapes are a recurrent element in the panels executed early in Antonio's career, and, in their eccentric and playful details – knotted, contorted shrubs and trees with few

or no leaves; slim, upward-turning leaves and compact-looking bushes; and improbable rocky protuberances with soft, moss-covered surfaces – seem inspired by the backgrounds created by Franciabigio and Andrea del Sarto, not to mention later works by Piero di Cosimo. That same extravagant touch can be found also in the human figures, who resemble actors gracefully clad in bright, fluttering garments, their faces all of a type, with rough and sketchy features.

Elena Capretti

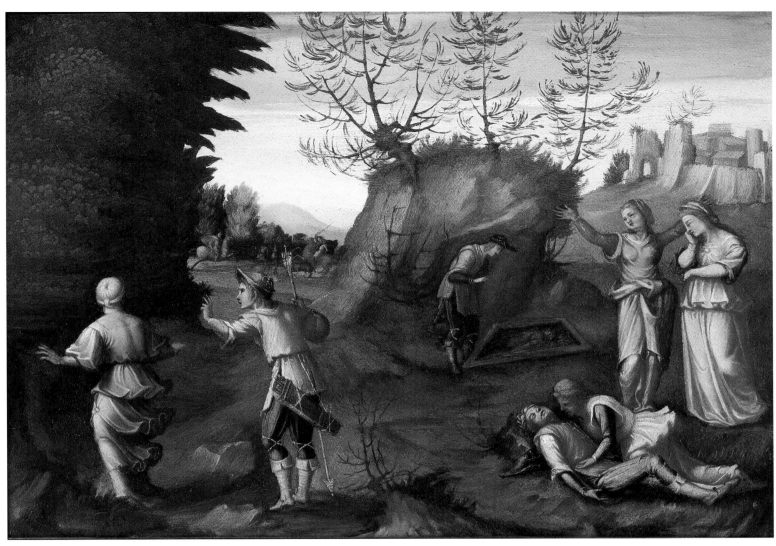

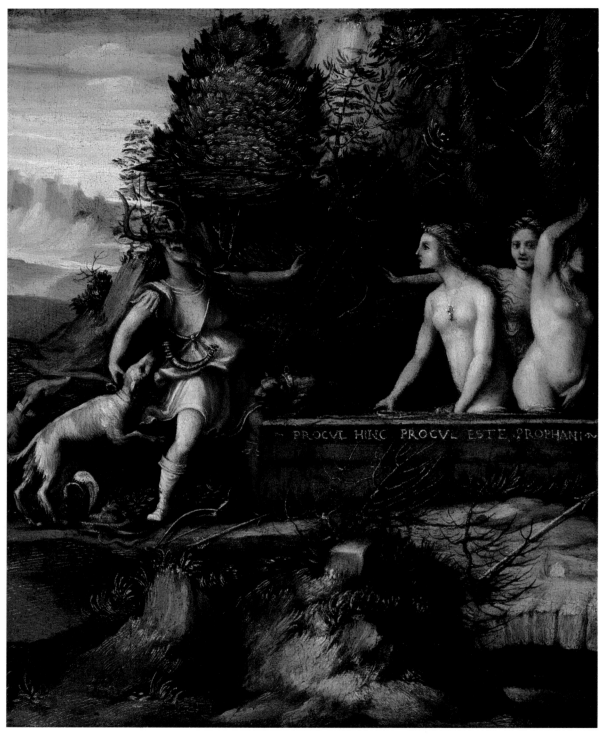

PROCVL HINC PROCVL ESTE PROPHANI

This small painting featuring the myth of Diana and Actaeon is a remarkable, newly discovered addition to the slight corpus of work by Antonio di Donnino del Mazziere assembled by Federico Zeri.[1] The work displays undeniable affinities with two other small panels also representing narratives from Ovid, one in the Corsini collection in Florence featuring the myths of Narcissus and of Apollo and Daphne (cat. no. 51) and another in a private collection in Milan depicting just Narcissus (cat. no. 52). The present panel illustrates the ill-fated encounter between Diana and Actaeon, showing both the surprise and rage of the goddess, who tries to hide her naked body behind the nymphs,[2] and the punishment of the young hunter, who is turned into a stag and is thus set upon by his own dogs.[3] In contrast to the other two panels, however, the exquisiteness of the figures in this work is enriched by a finely rendered and almost perfectly preserved gold decoration, which highlights the trunks and foliage of the trees, the dry branches of the bushes, the shrubs and grass in the foreground, the arms lying on the ground, and also the hair and delicately shaped jewels of Diana and the two nymphs. The effect of the whole is an almost nervous, quivering motion – as though these details had been executed with the tip of an engraver's burin or by an experienced miniaturist.[4] Around the middle of the 1520s, when northern European art provided Pontormo a model for his frescoes in the Certosa del Galluzzo, such brilliant graphic elements may have been created to vie with German prints[5] and compete with northern painting by subtle analogy. ¶ The formal features of this newly discovered panel reflect elements that are typical of Antonio di Donnino's production, including the obvious indebtedness to Franciabigio (his teacher, according to Vasari), as seen in the rosy female nudes – and provide confirmation, if any were needed, of the correct attribution to Antonio di Donnino of a series of drawings in the Uffizi.[6] The path that climbs up toward the hill behind the women has the same rhythm as the path that leads up to a castle in a sheet in the Uffizi (1356E), while the lively chalk strokes on the leaves of the trees are comparable to the gold touches in the present painting. ¶ Beyond its formal features, the *Diana and Actaeon* panel displays other similarities with the Corsini painting that suggest that both pictures belonged to a small cycle dedicated to Ovid's *Metamorphoses*. The paintings are almost identical in height, and though the width of the Corsini panel is almost twice that of the present picture, the two might have belonged to a *spalliera* (a panel decoration set into the wainscotting of a room) in which scenes of the same height but of different widths were alternated, as in the *spalliera* of the Camera Borgherini (several panels of which survive in the National Gallery in London). Another element of correspondence between the two works is the unusual feathered hat sported by all the male figures in the two scenes: in the Corsini panel it is worn by Apollo chasing Daphne as well as by Narcissus, and is seen on the ground next to the latter when he expires. A similar hat appears at the feet of Actaeon, decorated with three feathers in the same colours: red, white, and a saturated green.[7] The feathered hat, however, does not appear in the panel from the Milanese private collection. In the early 1520s, just after the end of the papacy of Leo X, when this painting was presumably made, three feathers in these colours were still used in Florence as a distinctive element of the Medicean livery. They were clearly recognizable as such before the rise to power (with Duke Cosimo I) of Lorenzo di Pierfrancesco's branch of the Medici family, which never adopted the "brevi medicei" (Medicean devices) that had been so prized by the descendants of Cosimo the Elder.[8] ¶ It is worth pointing out that one of the few known documents relating to Antonio di Donnino concerns his work on the festive decorations produced for the wedding of Cosimo. These two Ovidian panels may also have been commissioned by a member of the highest ranks of the Florentine aristocracy, if not the Medici themselves then a family connected with them. The same patron probably also owned a small painting of the *Preaching of Saint John the Baptist* attributable to Antonio di Donnino and formerly in a private collection in Venice; this features, on the right, a knight wearing the same tricolour hat of red, white, and green feathers – according to Paolo Giovio, a symbol of faith, hope, and charity.[9] Elevated patronage would certainly justify the unusually exquisite execution, with its rich detailing in gold, as well as the presence in both paintings of the same feathered headgear and the subtle literary reference that we find in the inscription, seen along the edge of the basin in which Diana and her nymphs are bathing: "procul hinc procul este prophani" – "remove yourselves far from here, O desecrators." These words do not correspond to those actually pronounced by Diana to Actaeon: "nunc tibi me posito visam velamine narres, si poteris narrare, licet" ("Now you are free to tell that you have seen me undressed, if you can tell").[10] They are akin, rather, to the words spoken to Aeneas by the Cumaean Sibyl in book 6 of the *Aeneid*: "procul o procul este, prophani" ("go far, far away, O desecrators"), creating a subtle parallel between Actaeon and Aeneas.[11] The exhortation to intruders to leave the altar where Aeneas had offered his sacrifices before his descent into Hades is similar to Diana's own injunction to trespassers. Furthermore, the words in the painting's inscription are taken from the line in the *Aeneid* that immediately precedes a description of the menacing howling of dogs, in words that are almost identical to "resonat latratibus aether" ("the air resounds with their howling"), which in the *Metamorphoses* announces the death of Actaeon, about to be torn to pieces by his own hounds.[12] ¶ On the assumption that the painting with *Diana and Actaeon* is linked with the Corsini panel, the two works can be identified as part of a cycle dedicated to the *Metamorphoses*, though that work remains too fragmentary to be thoroughly understood. The images may have been cautionary tales warning against the unhappy or fatal consequences of unrequited love, in an exaltation of love's spiritual over its physical aspect. Further information could presumably be gathered through the comparison of other works of art, executed for the Medici circle, in which the figure of Actaeon is linked with the symbol of the feathers.

Carlo Falciani

c. 1525 · Black chalk, pen and brown ink, and brown wash, heightened with white, on greyish-blue
prepared paper, some auxiliary lines incised with stylus · 30.9 x 26.8 cm · Ashmolean Museum, Oxford

Owing to the fact that Vasari had little to say about Pier Francesco Foschi, the artist remained underrated, and his work was neglected in the critical literature until relatively recently.[1] In fact he had a successful career marked by commissions from leading Florentine mercantile families; his conservative but distinctive manner clearly appealed to sophisticated patrons. Trained first by his father Jacopo (who had been a pupil of Botticelli), Foschi moved to the studio of Andrea del Sarto, whose paintings were to leave an indelible impression on his art. By the early 1520s he was apparently established as an independent master. ¶ This attractive sheet, a preparatory study for an unknown commission, presents some iconographical problems. The enthroned figures of the Virgin and Child in an architectural setting are flanked by pairs of saints. The saint next to the Virgin on the right carries a builder's square and is identifiable as the apostle Thomas. The "T" marked beside this figure suggests that the initials added to the sheet (which are contemporary with the drawing) refer to the names of the saints. The archangel Michael appears on the far right, characterized by his wings, sword, and armour. He holds a pair of scales: the weights are seen in his left hand, and two thin white lines descend from this hand to conclude in a rapidly indicated curved object below his left knee that is probably one of the scales. The saint at the far left, marked with the letter "S," carries a staff or cudgel and supports a book on his thigh. He may be the apostle Simon, who, as a missionary, is sometimes shown with a staff, although he generally carries a saw or a cross in reference to his martyrdom. The bearded saint beside him, who also holds a book, is marked with a "B" and bears as his main attribute an object that could be a large-bladed knife, in which case he might be Saint Bartholomew, who suffered death by flaying. However, he appears to wear the habit of a religious order, with a high-necked cowl, and the object could also be a martyr's palm.[2] ¶ On stylistic grounds, the drawing is datable to about 1525: the design, the figure types, and the softness of the handling find resonance in Foschi's work of that period, notably the *Virgin and Child with Saints Benedict and Bernard* (the Lotti altarpiece) in the church of San Barnaba in Florence, of about 1523–1526. The convoluted figure of Saint Michael is adapted from that of Saint Francis in

Sarto's *Madonna of the Harpies* of 1517 (now in the Uffizi), although Saint Michael glances away to his left rather than engaging with the viewer. Interestingly, in Foschi's composition only the apostle Thomas has a direct outward gaze. ¶ Foschi had planned to include a seated figure on the steps of the throne, probably an angel musician as in the Lotti altarpiece, but may have decided that the composition was becoming too crowded or that the architectural setting deserved more emphasis. Black-chalk outlines of this figure remain visible, though they are partly obscured by the shadows cast on the steps, rendered in chalk and wash, and by the modelling of the lower part of the Virgin's drapery. The technique of drawing with chalk on paper prepared with a layer of colour (which provides a middle tone) was common in Florence, deriving ultimately from the practice of metalpoint drawing. A few of Sarto's drawings display this technique, while Fra Bartolommeo often used a grey preparation for his black-chalk drawings. Foschi's compositional drawing, with its delicate pale-blue preparation and ink washes, has a painterly, sensuous quality. ¶ The old annotation on the drawing led to its identification as a work by Timoteo Viti until sold from the Pembroke collection. Parker found an attribution to Domenico Puligo reasonably convincing, although he noted that an alternative attribution to Foschi proposed by Frederick Antal deserved consideration. It was only after the publication of Parker's catalogue in 1956 that Foschi's work began to be more thoroughly studied.

Catherine Whistler

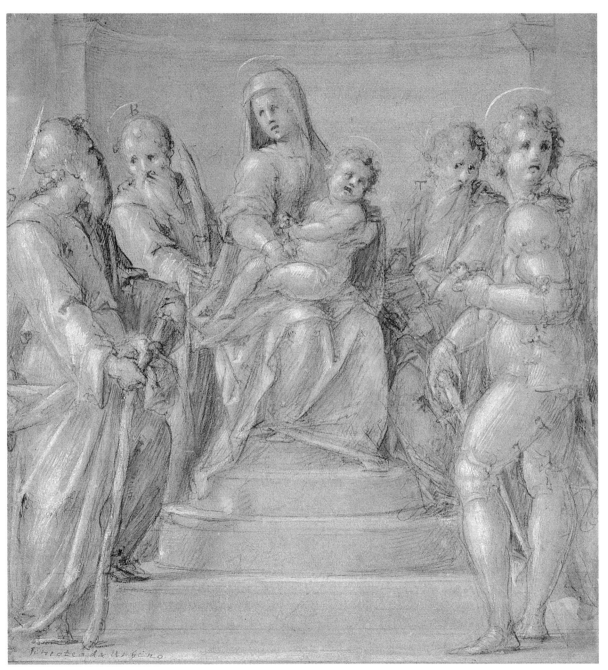

54

Pier Francesco Foschi was one of a number of significant talents who passed through Andrea del Sarto's workshop toward the end of the master's life. Others included Francesco Salviati, Giorgio Vasari, and Jacopino del Conte, all of whom had independent careers. Foschi has only recently received some deserved attention.[1] Even Vasari disregarded his life and work, and this affected the perceived worth of the artist in the past, just as it handicaps the biographer today. Yet Foschi was not a marginal figure during Vasari's own lifetime. In fact, he executed more public altarpieces in Florence during the 1540s than any other painter, except for those active in the workshop of Ridolfo Ghirlandaio, who would have provided his main competition among more conservative patrons. A member of the Accademia del Disegno, Foschi was also a fine portraitist. In the period of his full maturity, he satisfied a local market increasingly nostalgic for paintings reflecting the styles of Rosso Fiorentino, the increasingly reclusive Jacopo da Pontormo, and the deceased Sarto. ¶ The attribution of this previously unpublished painting to Foschi was first made by Nicholas Hall and has been supported by Everett Fahy (verbal communication). The artist's distinctive style can be recognized in the calm and simplified presentation of the subject, as well as in the heavily moulded, spiky, and elongated forms. It is a relatively large painting intended for private devotion, but its provenance is mysterious. The Virgin's gesture of embracing the two children evokes the popular image of the Madonna of Mercy. Foschi's painting contains links to Sarto's workshop, in particular to the cooler and more restrained style of the 1520s, although the arrangement of the Virgin standing by the Christ child who is situated on a ledge was introduced by Sarto in pictures dating to the very start of his career, around 1510. In this example, the head of Saint John the Baptist has been modelled specifically on that of the Christ child in Sarto's *Holy Family* painted for Zanobi Bracci, now in the Palazzo Pitti – a work that influenced Foschi's style in general and which he at one time copied entirely (fig. 55.1).[2]

¶ Establishing the date of Foschi's *Virgin and Child with the Young Saint John the Baptist* on the basis of style is a matter of guesswork, but in relation to the dated fresco of the *Crucifixion* in the Rosselli del Turco villa at Poggio alla Noce (Ponte a Ema), a date of about 1545 would seem acceptable.[3] In stylistic terms, the work is also close to the *Immaculate Conception* in the Torrigiani chapel in the church of Santo Spirito in Florence – a signed altarpiece datable to 1544–1546.[4]

David Franklin

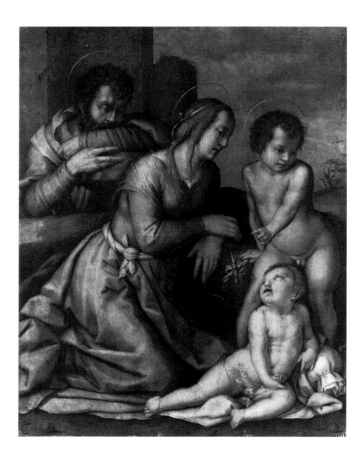

Fig. 55.1 Pier Francesco Foschi, *The Holy Family, after Andrea del Sarto,* oil on panel, 132.5 x 104 cm Szépmüvészeti Múzeum, Budapest

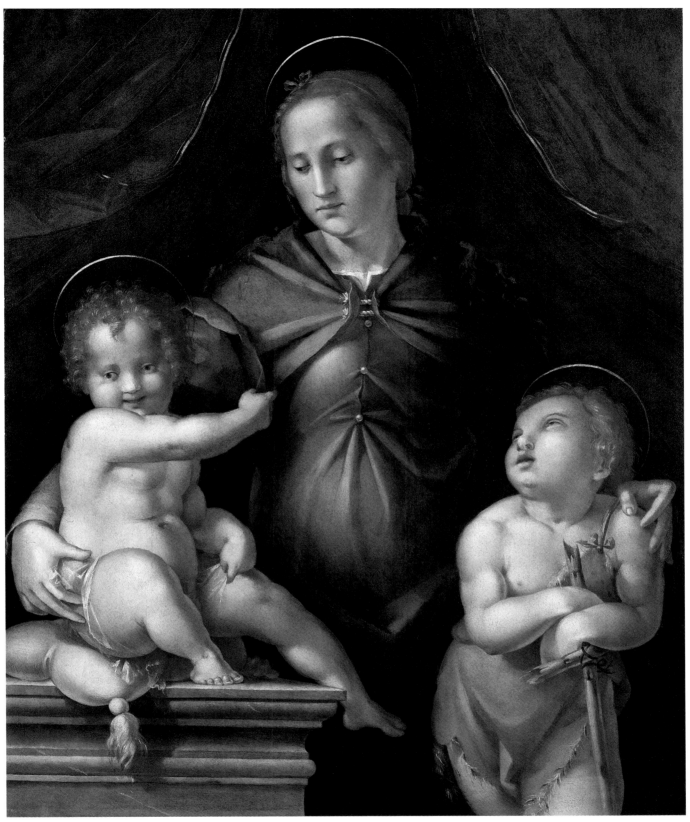

55

Bernard Berenson obtained this painting of a young man seated in a Savonarola chair for the Philadelphia collector John G. Johnson. Before its sale Berenson wrote to Johnson that "the portrait is beyond all question an authentic work by Andrea del Sarto himself, and in no impossible state."[1] Adolfo Venturi, who knew the painting from the photograph in Berenson's 1913 catalogue of the Johnson collection, argued instead that it was a youthful work of Pontormo, whose early portraits have much in common with Sarto's. Two scholars of Sarto, Sydney Freedberg and John Shearman, have also rejected Berenson's attribution. Shearman first proposed that it was by Jacopino del Conte, an opinion later taken up by Federico Zeri and most other scholars. Jacopino's earliest known works are versions of paintings by Andrea del Sarto of the Virgin and Child, confirming Vasari's indication that del Conte was Sarto's pupil.
¶ The connection of the Philadelphia painting with the portraiture of Sarto, who died in 1530, is also obvious. The lively expression of the young man turning around in his chair recalls in particular Sarto's portrait of a man, sometimes identified as Paolo da Terrarossa, in the National Gallery in London (cat. no. 38). Similar portraits of young Florentine men dressed in sober though perfectly tailored clothes became popular in the 1520s and early 1530s. As in this painting, many of these men have no attribute to recommend them other than their cool self-confidence. Here the self-certainty might be attributed to the cockiness of youth or aristocratic hauteur, traits that marked the period of the dissolute rule of Duke Alessandro de' Medici from 1530 to 1537, during which time, Zeri noted, the Philadelphia portrait was painted. Shortly thereafter Jacopino left Florence for Rome, where he is first documented in 1538. ¶ Vasari comments on Jacopino's talent as a portrait painter, writing that from his youth he had often painted portraits from life ("al naturale") and had expressed the desire to dedicate himself totally to portraiture. Vasari considered this a strange ambition, given that Jacopino had already proven himself, both on panel and in fresco, in other, more important subjects. Vasari does not mention any portraits from del Conte's early Florentine period, listing only some of his Roman sitters, whose commissions made the artist rich. The sitters included members of the Colonna, Orsini, and Strozzi families as well as many ecclesiastics and other *signori*. The portraits of Francesco de' Pisis (Fitzwilliam Museum, Cambridge), Marcello Cervini (Galleria Borghese, Rome), Giannetto Doria (Galleria Doria, Rome), Bindo Altoviti (Montreal Museum of Fine Arts), and Michelangelo (Metropolitan Museum of Art, New York), among others, have all been identified as works from Jacopino's Roman period. His early Florentine period of portraiture, when he painted "al naturale," still remains problematic and as yet includes only the Johnson painting, the recently attributed *Portrait of a Young Lute Player* in the Musée Jacquemart-André in Paris,[2] and two pictures attributed to him by Zeri: one in the Palazzo Bianco in Genoa and the other a work last recorded in a London private collection. While many Italian artists painted portraits, it would seem from a reading of Vasari that Jacopino tried to establish portrait painting as a specific professional category. This might explain why in the Roman portraits each sitter is shown in a context in which his or her position in society is easily identified. The absence of any such references in the Philadelphia portrait dates it to a period in which both the painter and the sitter were willing to ignore outward signs of status. It sufficed to portray the subject as alert and lively, in the manner of this unidentified youth.

Carl Brandon Strehlke

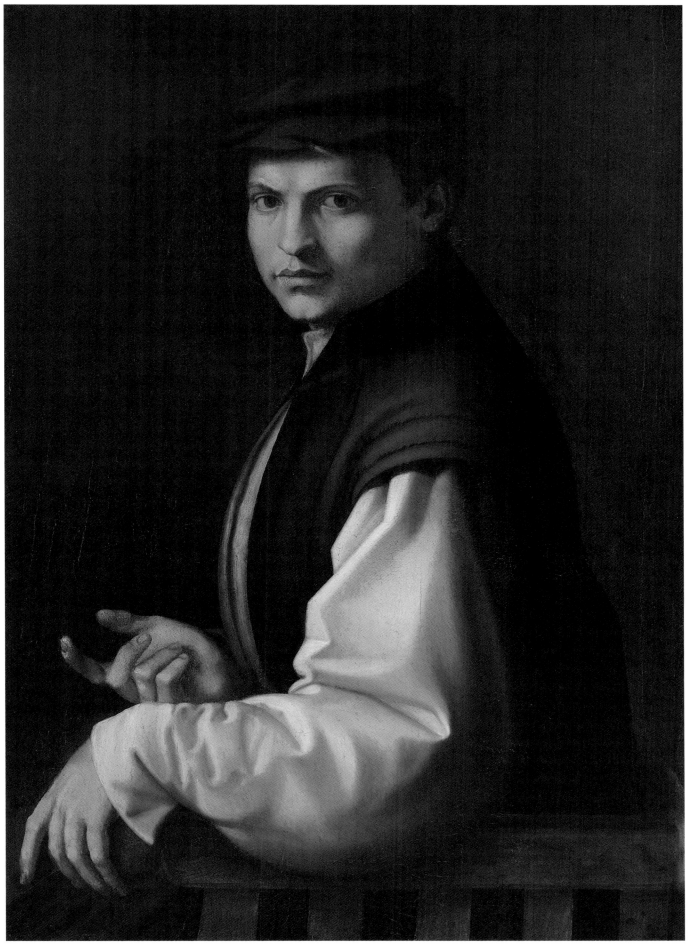

This terracotta group is one of a number of variants first attributed by Wilhelm Bode to an unknown fifteenth-century Florentine sculptor he characterized as the Master of the Unruly Children.[1] This apt pseudonym relates to the lively, often mischievous children that appear in this and related pieces, including groups of two fighting youngsters in the Victoria and Albert Museum (fig. 57.1) and in Berlin (since destroyed). The Master has subsequently been associated with several leading sculptors from the fifteenth and sixteenth centuries, including Donatello, Verrocchio, Torrigiano, Rustici, and Sansovino, and has even been identified as Leonardo da Vinci.[2] Other small genre pieces attributed to the equally elusive Master of the David and Saint John Statuettes may be related, and there are parallels with glazed terracottas produced in the della Robbia workshop. More recently, Ferretti proposed that the artist responsible could be Zaccaria Zacchi (1473–1544), noting a comparison to a Virgin and Child of about 1516, in Santa Maria della Salute at Buggiano, that he attributed to Zacchi.[3] Bellandi rejected this suggestion, supporting instead a possible attribution to the obscure Florentine "sculptor of statuary" Sandro di Lorenzo di Sinibaldo, previously put forward by Avery, who added further works with different subjects to the oeuvre of the Master of the Unruly Children.[4] ¶ The figure of Charity is accompanied by three naked boys: the one on her knee is smiling, that to her left is grimacing or crying, and the thoughtful child on her right is clutching a poppy head. Some of the related groups, including a *Charity* formerly in Berlin (destroyed), comprise only the woman and one child, who in each case exposes the woman's right breast. The two-figure groups are generally interpreted as the Madonna Lactans. The female figure is sometimes also portrayed reading a book, possibly representing the Virgin as the Mother of Wisdom, as seen in a version in Amsterdam (fig. 57.2). Like that piece, the London group would originally have been painted, and traces of the gesso ground remain. The flexible medium of clay allows variants of a model to be made comparatively easily. Such variations on a theme are commonly found in reliefs of the Virgin and Child that were often designed for replication in terracotta or stucco by the use of plaster moulds taken from the original model.[5] Surprisingly, this *Charity* was apparently modelled and is thus a unique work, although the heads were possibly cast. The clay walls have been roughly hollowed out to reduce the risk of cracking during firing, with the figure left open at the back. In contrast, the backs of the figures in related groups were worked in the round. ¶ The iconography of the *Charity* – combining the bare breast (alluding to mother's milk), the poppy heads (a symbol of fertility), and the wriggling, naked children – is consistent with traditional marriage imagery of the period. Images of naked boys, often playing, making music, fighting, or urinating, carried talismanic associations, encouraging women to bear healthy sons. Such metaphors were commonly found on the painted wood *deschi da parto*, or birth-trays, that were used to bring sweetmeats to expectant or new mothers.[6] The iconography that this *Charity* shares with such an exemplar of ideal motherhood as the Virgin would have made it an even more potent symbol in the context of marriage and the prevailing predilection for a male heir. Indeed, a terracotta *Charity* was one of the wedding gifts presented by the Florentine Andrea Minerbetti to his son in 1521.[7] The variation in expression of the children seen here may also bear significance. The cheerful Christ child, for example, was common in mid- to late fifteenth-century Florence – notably visible in the small terracotta *Virgin with the Laughing Child* in the Victoria and Albert Museum, usually attributed to Antonio Rossellino and possibly intended for a similar domestic setting.[8] ¶ The attribution of the *Charity* and other pieces to Sandro di Lorenzo di Sinibaldo is based largely on its perceived relationship with four small-scale *terra cruda* (unfired clay) sculptures documented in 1523. These sculptures are yet to be identified, but include works after Desiderio da Settignano and Andrea del Verrocchio, indicating a continued interest in the earlier masters and providing a possible explanation for the differing stylistic elements in the variants. Sinibaldo had connections with the sculptor Antonio Solosmeo, whose only known painting, of 1527, shows the seated Virgin in a twisting pose reminiscent of the figure of Charity here. Parallels can also be seen in the work of Solosmeo's master Andrea del Sarto and his circle, and Bellandi noted stylistic comparisons with sculptures by Rustici, who has a documented link with Sinibaldo.[9] These connections indicate that the terracottas were made in Florence probably about 1515–1530. The theoretical arguments for an attribution to Sinibaldo are appealing if not definitive. The treatment of the boys in the two London groups is virtually identical, leaving no doubt that they were made in the same workshop. However, it seems likely that such pieces were produced by several workshops to serve the growing market for small domestic and devotional sculptures. The inconsistencies in style, composition, facture, and quality may be due to the involvement of different hands within the same workshop, but the widespread production of variants of a common model could equally explain why it is so difficult to identify the Florentine genre masters with any certainty.

Peta Motture

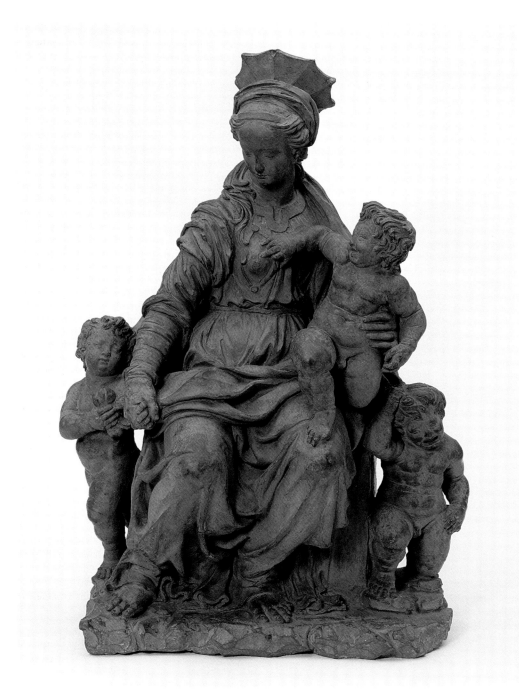

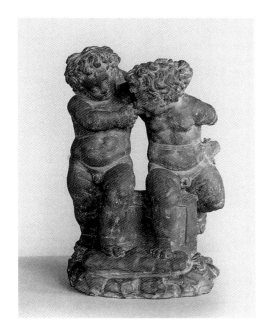

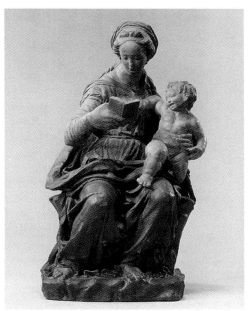

Fig. 57.1 Master of the Unruly Children, *Two Boys Quarrelling*, c. 1515–1530, terracotta, 27.9 cm high. Victoria and Albert Museum, London

Fig. 57.2 Master of the Unruly Children, *The Virgin and Child*, c. 1515–1530, painted and gilded terracotta, 54.5 cm high Rijksmuseum, Amsterdam

Moses Defending the Daughters of Jethro is an extraordinary painting even by Rosso Fiorentino's standards. Vasari refers to the picture in his Life of Rosso as one that was commissioned by Giovanni Bandini in Florence but was shortly afterward sent to France.[1] As has been recognized since Milanesi's edition of Vasari, Rosso's canvas does not depict the subject matter described by Vasari of Moses killing an Egyptian for attacking one of his kinsmen, as told in Exodus 2:11–12. Rather, it portrays a subsequent story, related in Exodus 2:16–18, in which Moses intervened on behalf of the seven daughters of Jethro, who were prevented from watering their father's flock by some shepherds who came to the well. Moses is identifiable as the man at the centre of the painting, pummelling some shepherds to the ground. The daughter separated from the group may represent Zipporah, whom Moses later married and who bore his sons. In the same passage of Rosso's biography, Vasari also misinterprets the subject of *Rebecca and Eliezer at the Well* (see cat. no. 62), which was related to the Uffizi painting in style and conception but was never a true pendant. ¶ The work and its patron, Giovanni Bandini, have been studied in depth by Elam.[2] A loyal Medicean, Bandini was a notorious figure who was involved in maintaining a brothel outside the San Gallo gate, fought duels, and killed several men. How Bandini encountered the painter is unknown, but he was also friendly with other artists, including Andrea del Sarto, Giovanni Francesco Rustici, and Giuliano Bugiardini, in addition to Carlo Ginori, who was another important patron of Rosso's in this period. The unavoidable inference is that the virile and sensual nature of the *Moses* was at least partially the result of Rosso's desire to create a painting to suit Bandini's personality. ¶ Elam discovered evidence that a picture whose description ("a painting of nudes") might point to this work was procured by the well-known exporter of Florentine art, Battista della Palla, and dispatched to Francis I around 1530, which lends support to Vasari's statement about the painting's early departure for France.[3] Rosso's canvas would thus have been part of della Palla's campaign to encourage Francis I to continue to play a part in the propaganda war against the Medici. This particular painting is next recorded, however, in 1587 in the gallery of the Palazzo del Casino of Don Antonio de' Medici (it was later donated to the Uffizi by his heirs).[4] Assuming, therefore, that a painting of this subject matter did indeed go to France, as seems likely, the question arises as to how the painting surviving in the Uffizi, first noted in Florence in 1587, could have returned from France so quickly. Is it possible that the Florence painting remained in the city and a copy, now lost, was made to send to France? Although the autograph status of the painting in the Uffizi has sometimes been questioned,[5] traces of the artist's characteristic paint hatching are evident all over the canvas – a clear sign that it is an autograph work, for Rosso's copyists do not seem to have been able to reproduce this highly personal aspect of his technique. As several commentators since the nineteenth century have pointed out, the painting is somewhat unfinished, which reinforces the view that it is an autograph work, since a copyist would have been inclined to complete the picture. The informal circumstances of the original commission must account for the use of canvas and the general lack of finish, as well as for the restricted number of pigments applied to produce a bright, schematic effect that is characteristic of Rosso. ¶ There have been attempts to discover an underlying meaning in Rosso's painting, but such theories are unverifiable and undervalue the visual power of the work.[6] Doubtless, the main attraction of the subject was that it was unprecedented, and Rosso was free to interpret it with as much licence as he chose, in the process creating a unique image with an emphasis on nude men in spirited action and ideally beautiful figures. The freedoms offered by the obscure subject matter and the fact that the painting was destined for a private collection allowed the painter to draw upon his knowledge of antiquity, while also making unabashed reference to the recent designs for the cartoons for the battles of Cascina and Anghiari by Michelangelo and Leonardo. Considering Rosso's sensuous, violent, and rather non-anecdotal presentation of the subject matter, it is not surprising that the work was listed simply as a painting "con più figure che fanno forzze" ("with numerous figures engaged in fighting") in the Medici inventory of 1587, while in a later inventory of 1798 it was described remarkably as "Ercole che uccide il Minotauro e distrugge le mura di Troia" ("Hercules murdering the Minotaur and destroying the walls of Troy").[7] ¶ Rosso's use of canvas links the picture to a traditional type of private domestic painting. The most celebrated works in this category are by Sandro Botticelli and Piero di Cosimo, artists maturing in the later Quattrocento who generally favoured secular subjects, though Old Testament stories were occasionally used for such canvases. The often intricate and dramatic narratives of the Old Testament were attractive to artists searching for the kind of action and variety rarely found in the traditional repertoire of Christian subjects. Rosso's *Moses* updates this type of painting for the sixteenth century, as does Perino del Vaga's *Crossing of the Red Sea*, which provided the most immediate model for the picture (see cat. no. 65). ¶ It is reasonably certain that the *Moses*, along with the *Rebecca and Eliezer*, was completed after October 1523 because Vasari relates that while painting it Rosso lived in the Borgo de' Tintori by Santa Croce, and an extant rental agreement indicates that the artist was residing in another part of Florence for one year from 2 October 1522.[8] It was perhaps the last painting that Rosso produced in his native city, before his move to Rome in the spring of 1524.

David Franklin

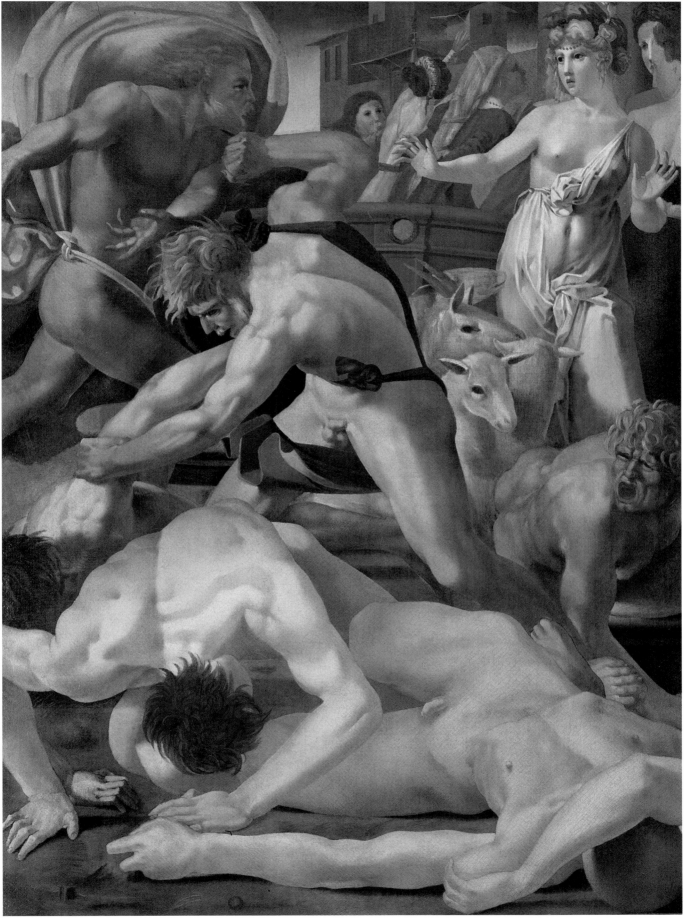

According to the earliest reference to it at Beechwood, home of owner Thomas Sebright, Andrea del Sarto painted this portrait – even though G.F. Waagen had attributed it to Franciabigio in 1838.[1] Roberto Longhi may have been the first to ascribe it to Rosso Fiorentino,[2] probably just before it was purchased by the Kress Foundation. The artist's typical hatching in strokes of paint is found all over the surface – a certain indicator of the work's autograph status. In the more recent literature, the portrait is universally attributed to Rosso, with just two exceptions.[3] ¶ The dating of the portrait has fluctuated within the first half of the 1520s, but the work seems more specifically to straddle the end of Rosso's final Florentine period of about 1522 to 1524 (exemplified by the San Lorenzo *Betrothal of the Virgin*) and his Roman period of 1524 to 1527 (typified by the Boston *Dead Christ*). Béguin recently published a radiograph of the painting that reveals a female profile and costume underneath the paint layer, indicating that Rosso executed the portrait over an abandoned work.[4] Stylistically, the head of the discarded figure resembles the young females in the San Lorenzo altarpiece of 1522–1523 and in the background of *Moses Defending the Daughters of Jethro* of about 1523–1524 (cat. no. 58). ¶ The portrait is composed in a half-length format, with the man angled into depth diagonally before a plain olive background. The compressed design is typical of Rosso: the top of the hat as well as the sitter's left arm and the drapery falling behind the right arm are almost cut off by the edge. The most dramatic area of the portrait is the elbow breaking the front plane at a sharp angle, while the other arm falls weakly with a more fluid contour. The portraits that Raphael executed in Rome may have provided Rosso with general prototypes for the bold and authoritative placement of the hand on the hip. However, Rosso's interpretation creates one of the most exciting portraits of the early sixteenth century in Florence, its originality emphasized by its execution just prior to Pontormo's introduction of the same arrangement. Indeed, the stark format of the portrait and the absence of any props or attributes are also notable and deceptively novel. It may be the greatest surviving portrait by Rosso, not only because of the convincing treatment of the dramatic pose but also because of the handling of the light, which comes almost from behind the figure to throw him into sharp relief. The roughened background contributes to the overall sense of spontaneity. ¶ The sitter in this portrait almost appears to speak to the viewer and, as a result, he exudes accessibility and a certain urgency. By adding vitality to the face, presenting the figure as if engaged in conversation – and thus breaking the stillness of the pose – Rosso, with his typical disrespect for tradition, undermined the very purpose of most Renaissance portraits, which was to offer a fixed record of the sitter. Yet, despite all the conscious artistic flourish in this picture, he manages to convey the sitter's individuality, and the portrait thus fulfills its traditional commemorative purpose. The presence of a single ring and the relative youth of the sitter may imply that the portrait was inspired by a marriage. There are no tangible clues to the sitter's identity, although in one of the sources attesting to the provenance of the panel there is an unconfirmed reference to its ownership by the Pazzi family in Florence.

David Franklin

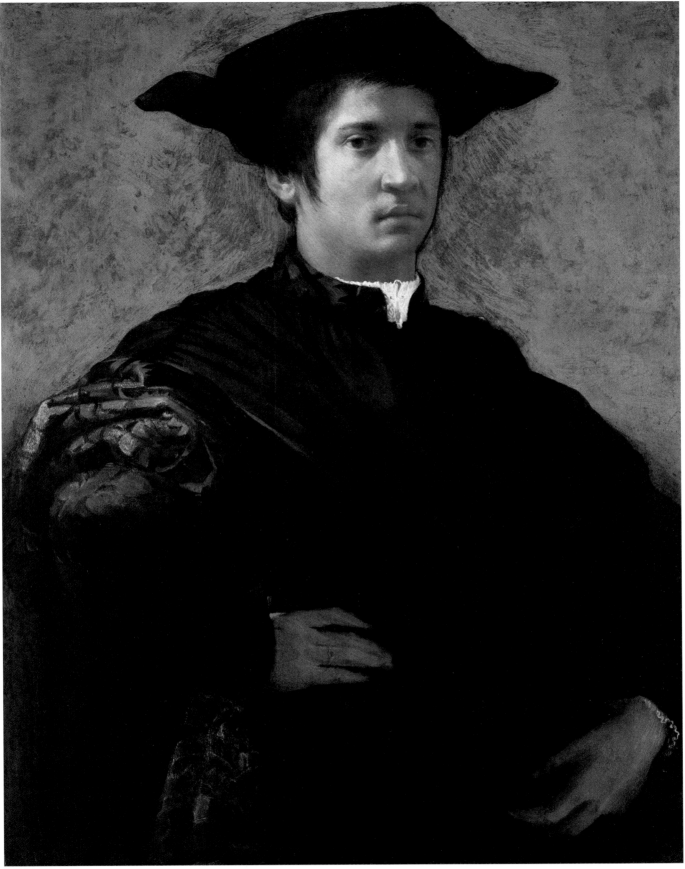

This painting of the *Virgin and Child with Saint Julian and a Donor* is neither signed nor dated, nor in any way documented. The oldest recorded attribution of the picture, to Andrea del Sarto, is clearly untenable. The attribution to Rosso Fiorentino can be defended only on stylistic grounds, but it has much to recommend it. The patchwork veneer of paint hatching is evident in almost every area of the surface – a personal expression so characteristic of Rosso as to be the main indicator of the autograph status of paintings attributed to him. His copyists tended to leave the picture surface in a more polished state, as in the *Rebecca and Eliezer at the Well* in Pisa (fig. 62.1). The swirling, almost alive draperies are also typical of Rosso's art. ¶ To judge by the intermediate scale of Rosso's painting, it was probably supplied informally for private devotion, not as an altarpiece for public display in a church. This would help to explain why it was overlooked in sources such as Vasari. The image is dominated by the kneeling figure in the foreground, who can be identified as Saint Julian wearing his canonical red. With some agitation he presents to the Virgin a man who is presumably his namesake (as was conventional then), while the Christ child, in the act of blessing, steps spiritedly across his mother toward them. The donor has a lively and intense expression as he looks heavenward and prays with open mouth and crossed thumbs – a specific gesture made also by Saint James in the *Dei* altarpiece signed and dated by Rosso in 1522, surviving in the Palazzo Pitti. Dressed in a dark suit with folded-back collar and a white shirt, he seems to be about thirty years of age. The saint, who holds the man firmly by the right arm, is the only figure in the picture with a halo, which would indicate his special status in the image. As for the relatively unusual subject matter and the scale of the panel, it is possible that the donor had died young and that the work was commissioned by his family as a votive image. More likely, the man may have commissioned it himself in honour of some vow for which he had invoked Saint Julian and the Virgin. In terms of the patronage of this rather small picture, it may be relevant that Julian was a nobleman who became the patron saint of travellers, as well as ferrymen and innkeepers. It must be admitted, however, that the custom of including such donors in paintings was somewhat outmoded by this date, occurring more commonly in religious commissions for provincial destinations. ¶ Despite its seeming intimacy, the composition of the painting is original and richly sophisticated, with a strong lateral emphasis and a mixture of figures in front, back, side, and three-quarter views. The evident difference in scale between the rather archaic, straight-backed Virgin and Saint Julian, who seems to rise in a sensitive, lilting movement, is an argument for the painting's attribution

to Rosso, as such an irrational juxtaposition is typically found in his work. The figures are placed in a shallow, natural setting painted in evocative patches of blue, green, and brown, and with the main pair elevated and set off by a dark green cloth of honour tied to a tree with a wide ribbon of vermilion. Julian's sword (an attribute stemming from the legend that he accidentally chopped off the heads of his sleeping parents) and his right knee rest on a conveniently placed rock form. ¶ The painting is closely related to Rosso's style of the mid- to late 1520s. The upright Virgin holding her arm at a sharp angle across her upper body to support the Christ child is reminiscent of her depiction in the *Adoration of the Magi* for Castel Rigone that Rosso helped to design for the Umbrian painter Domenico Alfani following the Sack of Rome in 1527.[1] One of Rosso's drawings for this altarpiece is preserved in an engraving by Cherubino Alberti (fig. 60.1). The Magus in the lower-right corner of the painting (not illustrated), is kneeling with one arm extended in mid-air; he more strikingly resembles the figure of Saint Julian in pose than the parallel figure in the engraving. This type of figure, seen from the back and, apparently inspired by the events of the moment, about to stand up, appears in several Rosso compositions in the later 1520s known from drawings, including the Bayonne *Throne of Solomon*. The drapery folds formed by animated pleats and Julian's tensile hair also have explicit parallels in passages in the *Deposition from the Cross* of 1527–1528, still in the church of San Lorenzo in Sansepolcro (fig. 60.2). In the previously unpublished painting, the Virgin's restraint, as well as her long, narrow nose, seem to anticipate the female saints in the upper part of the Città di Castello altarpiece, commissioned in 1528 and completed in 1530 on the eve of the artist's departure for France and the court of Francis I at Fontainebleau. Settling on a more precise date for the painting is a matter of guesswork, complicated by the rarity of paintings in Rosso's corpus, which contains fewer than two dozen autograph examples. Certainly, however, the painting has most in common with works of increasing stylistic refinement produced by Rosso in Italy, between about 1525 and 1530. This panel constitutes the most exciting addition in recent years to our knowledge of Rosso as a painter.

David Franklin

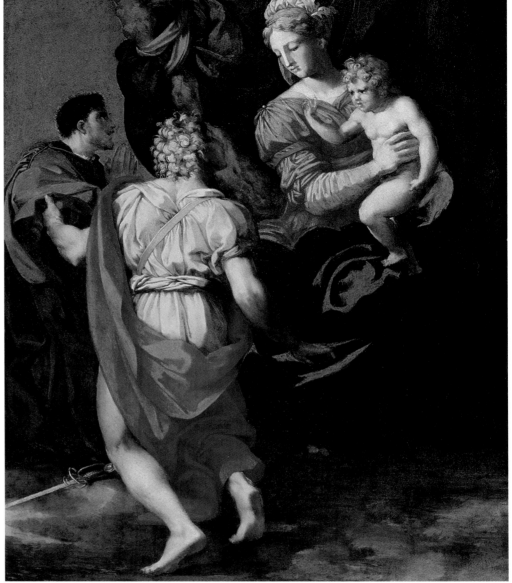

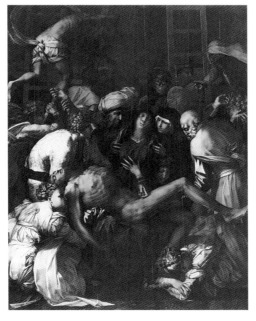

Fig. 60.1 Cherubino Alberti, *The Adoration of the Magi, after Rosso Fiorentino,* 1574, engraving, 37.8 x 26.6 cm British Museum, London (1874-8-8-487)

Fig. 60.2 Rosso Fiorentino, *The Deposition from the Cross,* 1527–1528, oil on panel, 270 x 201 cm. Church of San Lorenzo, Sansepolcro

This panel, which depicts a strange and fascinating Saint John the Baptist drinking at a spring, is being exhibited here publicly for the very first time. The work possesses all the stylistic characteristics of Florentine painting of the first third of the sixteenth century. Although from a formal point of view the figure calls to mind studies done by Pontormo while he was decorating the great hall of the Medici villa at Poggio a Caiano, as seen in a series of drawings on the same subject in the Uffizi,[1] the painting is definitely not by his hand. Rather, it must be unhesitatingly ascribed to Rosso Fiorentino. Both the general appearance and many details reflect the personality of this eccentric artist, and none of the painters who came under his influence ever attained this level of quality. All attempts to attribute the panel to one of the artists who might be suggested prove inconclusive. Jacone, who occasionally achieved a similar degree of strangeness in his drawings, is stylistically closer to Pontormo.[2] Giovanni Antonio Lappoli, Rosso's faithful friend, who worked from his drawings, never attained the level of refinement and light-handed execution that we see here. Alonso Berruguete, whose work is sometimes confused with Rosso's and who reflected his influence until he left Florence in 1518 to return to Spain, never reached this level of modelling or fine draftsmanship. Nor can the painting be linked to the pictorial practice of contemporaries with whom Rosso may have associated during his training, such as Baccio Bandinelli (who supposedly executed a rather mediocre painting on the same theme).[3] ¶ All of the evidence, then, points to Rosso Fiorentino. Stylistically the painting is comparable to other works by him, but it is especially close to the paintings done of his Roman period, from 1524 to 1527. The little panel recalls the *Dead Christ* belonging to the Museum of Fine Arts, Boston, painted in Rome shortly before the city was sacked. A comparison of the Baptist's face with the head of the angel located immediately to Christ's right reveals the same modelling of the cheeks and nose and the same manner of indicating the eyebrows. But the most striking point of similarity between the two paintings is their distinctive rendering of human anatomy, especially in the realism of the belly folds. Equally compelling is the fact that the Baptist's head is similar to one in the *Portrait of a Young Man* in the Gemäldegalerie in Berlin with respect to the facial modelling and the treatment of the hair.[4] The Berlin portrait and the *Saint John the Baptist* also both display a technique – notably in the hatching and cross-hatching – that is different from what we see in the artist's large-scale works. This characteristic technique is not found in all of Rosso's small pieces, which is no surprise considering the multiplicity of paths followed by the artist's inventive mind. What is surprising is that, technically and stylistically, the face in the small *Saint John the Baptist* shows remarkable similarities to faces in two unfinished but positively attributed works: that of the Christ child in the *Holy Family with the Young Saint John the Baptist* in the Walters Art Gallery in Baltimore, and that of the young man in a portrait in Naples (fig. 61.1), both of which were evidently begun in Rome and abandoned during the siege.[5] ¶ The *Saint John the Baptist* is noteworthy above all for its innovative features – the bubbles dancing on the water, for example, which are unique in sixteenth-century Italian painting, and the bizarre, almost surrealistic appearance of the feet and hands, whose devilish quality is fully consistent with the artist's personality. This spirit, typical of Rosso, is apparent in some of his rare surviving earlier drawings – witness the feet with pointed toe-nails in a preparatory study in the Uffizi (478F) for Saint Sebastian in the *Dei* altarpiece, done just prior to his departure for Rome, and the feet in the study of a seated male nude, also in the Uffizi (6489F), that he probably did after arriving in Rome and seeing Michelangelo's painted figures on the Sistine Chapel ceiling.[6] These sheets clearly show that Rosso developed his practice by following in Michelangelo's footsteps while at the same time giving play to a naturalistic bent that derived from his interest in Leonardo da Vinci. It is therefore not surprising to find the influence of the two great masters so manifest in the panel. ¶ Of all the works of this period, this *Saint John the Baptist* – who with other attributes could have been mistaken for Bacchus – stands out because of the eeriness, one could even say the perversity, that emanates from it. This determination to transcribe the extremeness of the subject argues emphatically (along with the stylistic evidence) in favour of the attribution to Rosso Fiorentino. The same perverse feeling is found in the artist's erotic works, such as the *Rape of Persephone*, engraved by Jacopo Caraglio from a drawing done by Rosso early on in Rome. The strangeness is pushed to an extreme in *Fury*, also engraved by Caraglio from a contemporary drawing by the artist.[7] ¶ This *Saint John the Baptist* was, in all likelihood, executed in the spring of 1524, after Rosso's arrival in Rome. It was certainly done quickly – as is suggested by the technique, and also by the error in the Latin inscription[8] – with the aim of advertising the artist's talent, the same motive that prompted Parmigianino to paint his *Self-portrait in a Convex Mirror* that same year.[9] By choosing to represent the patron saint of Florence, already the subject of numerous stunning paintings by his contemporaries, Fiorentino was hoping to attract the attention of the Florentine clientele that, under the rule of the Medici pope Clement VII, dominated the papal court.

Philippe Costamagna

Fig. 61.1 Rosso Fiorentino, *Portrait of a Young Man*, c. 1525, oil on panel, 120 x 86 cm. Galleria Nazionale di Capodimonte, Naples

This drawing was attributed to Rosso Fiorentino until Kusenberg ascribed it to Francesco Salviati, following the annotation "da Cecchino Salviati" at the lower margin.[1] It is convincingly datable to Salviati's stay in Florence in 1539, between his time in Rome and a sojourn in northern Italy. The previous attribution to Rosso derived from the fact that the drawing relates to one of his paintings – *Rebecca and Eliezer at the Well*, now preserved in a copy on panel in Pisa (fig. 62.1).[2] Rosso's painting had been executed in Florence, along with his *Moses Defending the Daughters of Jethro* (cat. no. 58), prior to the artist's move to Rome in the spring of 1524.[3] Rosso's patron Giovanni Cavalcanti, who was a dealer in luxury goods such as silk and gold cloth for Henry VIII, sent the original to England, where it was eventually destroyed. Given Cavalcanti's earlier involvement as an art dealer in England as well as the painting's neutral Old Testament subject matter, it can be assumed that Rosso's picture was commissioned directly for export, perhaps as a present for the king himself. Sicca speculates that it was ordered in 1522 by Cardinal Giulio de' Medici (later Pope Clement VII), through the diplomatic agency of Cavalcanti, as a royal wedding present, although the stylistic dating of the painting would not immediately support this theory.[4] ¶ In recording this design in Florence, Salviati must have worked either from a copy of the painting such as the one surviving in Pisa, which was explicitly executed to preserve the work of an illustrious Florentine painter in his native city, or from a Rosso drawing, now lost. As the highly precise drawing style appears indebted to Rosso's graphic technique, it is most likely that Salviati was working from a compositional drawing by Rosso rather than from the painted version or a copy after it. This would suggest that the differences in the design, rather than being the result of creative licence, may have occurred because Rosso's own drawing contained some of the same variations. Salviati's later drawing after Bronzino's *Allegory*, now in London (see cat. no. 120), also attests to his interest in producing versions of the work of illustrious local masters. ¶ The differences between Salviati's drawing of *Rebecca and Eliezer at the Well* and Rosso's design, at least as recorded in the Pisa copy, can be summarized as follows. Salviati reduced the scale of individual figures and provided the characters with more space. He also included an extra figure in the left foreground and others at the well in the background, while eliminating the camels at the right margin. Despite these alterations, Salviati's version offers a better notion of the sensuality and ornamental richness of Rosso's original design than the painted copy provides. The composition is equally compressed and fills up the entire field vertically, as Rosso intended. Salviati also retained the low viewpoint and reclining nudes at the base of the design and the telescoped placement of the two protagonists in the middle of the pictorial field. Although he altered some of the individual poses, he retained the nude boy at the left margin who holds a camel by the bridle – an obvious quotation from one of the so-called "horse tamers" on the Quirinal Hill in Rome that the young artist would have known well. The high finish of Salviati's drawing might suggest that it was intended for a painting, but the subject matter is so rare that this must surely be a highly resolved *ricordo* of Rosso's invention designed to be mined later for other purposes. ¶ Rosso's composition was also familiar to Vasari, who may have facilitated access to it for his friend and contemporary Salviati. Vasari describes the work at length in his Life of Rosso, first published in 1550, but, as with *Moses Defending the Daughters of Jethro*, he erred in his identification of the subject.[5] Vasari cites the story of Jacob at the well from Genesis 29:10, but the painting depicts the virgin Rebecca offering a drink at the well to Abraham's servant Eliezer, who had journeyed with ten camels, as related in Genesis 24. According to a common typology, this subject was seen as a prefiguration of the Annunciation because Abraham had sent his servant to find a virgin to marry his son Isaac, and the importance of the Annunciation for Florence (the Florentine year started on that feast day) may also have inspired the choice of this relatively unusual subject for the Florentine merchant and diplomat Cavalcanti. Like Salviati, Vasari was particularly infatuated with the supremely elegant women in the upper part of Rosso's design, with their profiled heads and elaborate headdresses, which in turn were derived from Michelangelo's drawings of "ideal heads" (*teste divine*) of the early 1520s.

David Franklin

Fig. 62.1 Attributed to Giovanni Antonio Lappoli, *Rebecca and Eliezer at the Well, after Rosso Fiorentino*, c. 1523–1524 (?), oil on panel, 165 x 117 cm. Museo Nazionale di San Matteo, Pisa

63 JACOPO DA PONTORMO (1494–1557) · The Baptism and Victory of the Nine Thousand
c. 1522 · Red chalk and red wash, heightened with white, with traces of stylus · 41.8 x 36.8 cm
Kunsthalle, Hamburg

64 PERINO DEL VAGA (1501–1547) · The Condemnation and Martyrdom of the Ten Thousand
c. 1522 · Pen and brown ink and brown wash, heightened with white, on brown prepared paper,
squared · 35.8 x 33.9 cm · Albertina, Vienna

Judging by the annotations, the Hamburg drawing was formerly attributed to Giorgio Vasari and Sebastiano del Piombo. However, it has been universally accepted as being by Jacopo da Pontormo since Berenson and Clapp suggested this attribution almost a century ago. The drawing needs to be discussed in relation to the one by Perino del Vaga in Vienna. Although Hermann Voss had earlier recognized that this sketch was related to Perino in style, Walter Vitzthum (in a written communication) was the first to ascribe it with confidence to the artist. ¶ Both designs relate to a commission to decorate the church of San Salvatore di Camaldoli, situated near the San Frediano Gate in Florence. It was commissioned by a confraternity devoted to the memory of Saint Achatius and the ten thousand martyrs who met their gruesome fate on Mount Ararat. Unfortunately, no documents survive for this major project, which was never completed because of the plague that devastated Florence in 1522–1523. Vasari is the main source, but he reveals only partial details about the commission and makes no reference at all to Pontormo's participation. The altarpiece in the chapel, Giovanni Antonio Sogliani's *Crucifixion with Saint Achatius* of 1521, now in the church of San Lorenzo in Florence, was already fully completed when the plague began, along with the predella painted by Bachiacca, now in the Uffizi. ¶ Given the likelihood that the confraternity, traditionally a fiscally conservative organization, would not have wished to pay for all these commissions at the same time, the drawings presumably date to after the completion of Sogliani's altarpiece. Cecchi has established a definite conclusion for the project prior to November 1522, when the Camaldolese monks were ordered to abandon their monastery because of the arrival of the plague in Florence.[1] Perino's sojourn in Florence lasted for perhaps six months starting in the summer of 1522, which allows his involvement to be dated fairly precisely.[2] It is less certain when Pontormo was given his commission, as he remained in Florence throughout his life, but he would have ceased work by the time he fled the city for the refuge of the Certosa del Galluzzo, where his presence is first documented with certainty in February 1523.[3] ¶ While Pontormo's large compositional drawing is executed in a relatively legible manner, it does not appear to be a finished *modello* of the type intended for the patron to approve. Perino's drawing, with its more elaborate technique and its use of prepared paper, is presumably such a *modello*. Indeed, it is probably the very drawing praised by Vasari in his *Lives of the Artists* as "a thing divine."[4] Vasari specifically mentions that Perino had sufficient time to move beyond the preparatory drawing stage and commence his final cartoon, which would certainly have brought to mind the events surrounding the production of the cartoons made by Michelangelo and Leonardo earlier in the century. There is no evidence that Pontormo, for his part, progressed further than the Hamburg drawing. ¶ It was Popham, in 1945, who first recognized that Perino and Pontormo were engaged on the same project in the Camaldoli, although his suggestion that their drawings were alternative ideas for the same subject is less acceptable.[5] As Merritt pointed out in a full discussion of their subject matter, the drawings represent a sequential narrative: Pontormo's sketch illustrates the earlier scene of the martyrs' triumph in battle under Achatius's leadership against a numerically superior rebel army, following their baptism by an angel who appeared to them and guaranteed them victory through Christ, while Perino's drawing depicts their later condemnation, torture, and ultimate martyrdom following their refusal to recant their new faith.[6] Pontormo's drawing depicts three monumental angels at the top surmounted by a Trinity, providing divine assistance to Achatius's army of nine thousand men. (Achatius's Christian army expanded to ten thousand with the addition of one thousand who were inspired to convert by what they had witnessed, which accounts for the common title of this subject in art.) The men's baptism by an angel prior to battle is shown in a band below these putti. The foreground is dominated by the battle itself, with horse-and-rider groups racing with extreme force and aggressivity across the space, parallel to the picture plane. This area includes two murders by soldiers whose poses echo those of the avenging angels. Perino's drawing, on the other hand, depicts the emperors Adrian and Antoninus in the foreground, ordering the martyrdom of Achatius and his army because they have refused to renounce Christ, and, following the sequence of the story, the condemned in the middle ground, being tortured and marched away and eventually crucified higher up the mountain. At the summit of this design there is an image of Christ or God apparently receiving the figures, along with the angels who had assisted them during their trials. ¶ Given that the designs by Pontormo and Perino are both lit from left to right, it can be assumed that they were intended either for the same wall within two Gothic-shaped arches in the chapel of the confraternity, or as parallel decorations in two adjacent chapels. Evidence for the latter possibility is provided by a reference in Vasari to the fact that Lorenzo di Bicci had previously worked for the same confraternity in the Camaldoli and had frescoed its story in "two chapels."[7] It is probable that Pontormo and Perino were replacing these early frescoes of about 1400, respecting the same subject matter as well as the sequence and division. The fact that the drawings represent two halves of the same legend suggests that

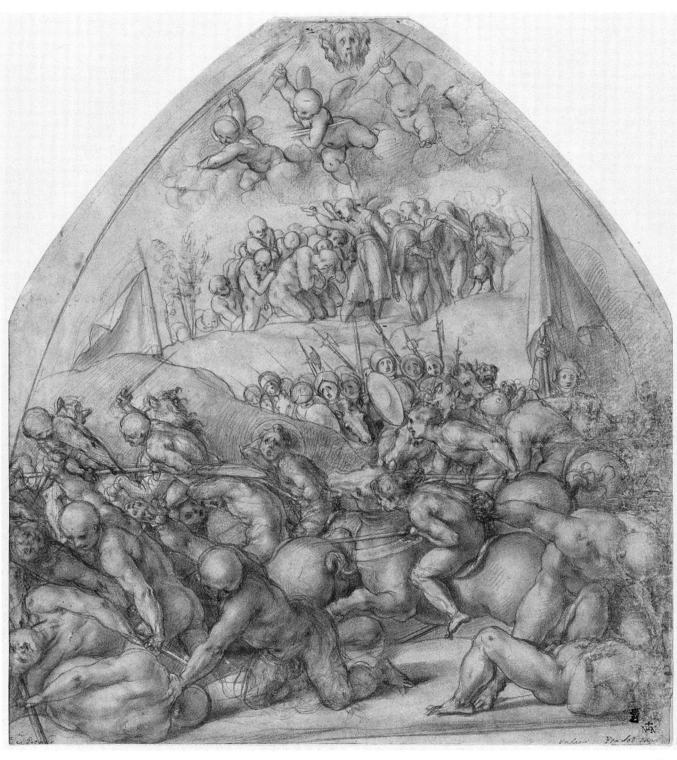

the artists were working, if not in tandem, at least toward a unified result.[8] This interpretation undermines one hypothesis – that Pontormo and Perino were in direct competition for the same commission and that it might be possible to identify a victor. Certainly, it is rather difficult to imagine that the members of the confraternity would have preferred Perino's design, given that their experience of art would have prepared them more for Pontormo's approach, which was based on the male nude in action and therefore rooted in the Florentine tradition. ¶ The two designs present an important stylistic confrontation at a particular moment in Florence in the early 1520s, contrasting Pontormo's local vernacular with Perino's Rome-based style derived from his training in Raphael's workshop. More explicitly than Perino's, Pontormo's intensely dynamic and powerfully emotional composition harks back to the battle cartoons for the Palazzo della Signoria produced by Michelangelo and Leonardo. Perino's drawing reveals instead a debt to the more elegant and restrained style of Raphael's *Battle of Ostia* fresco in the Stanza dell'Incendio in the Vatican and, ultimately, to the sculptural reliefs commonly found on ancient sarcophagi. The fierce controversies over the art produced specifically by Perino and by another Rome-based artist in Florence, Giovanni da Udine, in the Palazzo Medici – both, coincidentally, in the earlier 1520s, and both defended vehemently in retrospect by Vasari – are the most significant instances of the conflict of styles between Florentine and Roman painters. Vasari's general prejudice against Florentines who neglected Rome must also be taken into account in a consideration of how art of this period may be classified. Perino's method of synthesis was, like

Raphael's, so incompatible with the Florentine approach that it is unclear how profoundly he could have influenced the working method of any artist in the city of his birth, prior to Vasari. The biographer is the only source for Perino's visit to Florence, and also the person who copied Perino's drawing in a sketch identified with one surviving at Harvard (fig. 63.1). Yet even while exaggerating the significance of this sojourn (or perhaps totally fabricating it), Vasari makes a reference to the skepticism displayed by local artists toward Perino's promotion of a Roman style that rings absolutely true.[9] ¶ Of the two compositions, it was Pontormo's that would prove to have the most immediate impact in Florence, at least through his own later treatments of the same subject, despite the fact that the original commission in the Camaldoli was never completed. The design – one of the most complex the artist ever created – was developed in Pontormo's own painting of the *Martyrdom of the Ten Thousand*, formerly in the Ospedale degli Innocenti in Florence and now in the Palazzo Pitti (fig. 63.2). A reduced version of this work, executed for Carlo Neroni and now in the Uffizi, is usually ascribed to Bronzino. Both paintings were executed during the period of the last Florentine republic at the close of the 1520s.[10]

David Franklin

Fig. 63.1 Attributed to Giorgio Vasari, *The Martyrdom of the Ten Thousand, after Perino del Vaga*, pen and brown ink and brown wash, heightened with white, 37.1 x 34.5 cm. Fogg Art Museum, Harvard University Art Museums, Cambridge, Mass., Bequest of Charles A. Loesser (1932.265)

Fig. 63.2 Jacopo da Pontormo, *The Martyrdom of the Ten Thousand*, c. 1529–1530, oil on panel, 65 x 73 cm Galleria Palatina, Palazzo Pitti, Florence

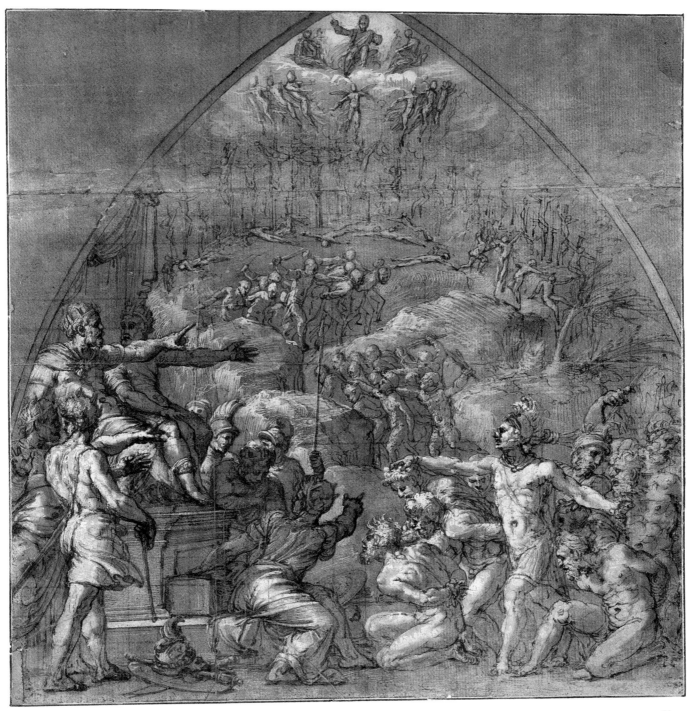

64

65 PERINO DEL VAGA (1501–1547) · **The Crossing of the Red Sea** · c. 1522 · Oil on canvas
118 x 201 cm · Pinacoteca di Brera, Milan

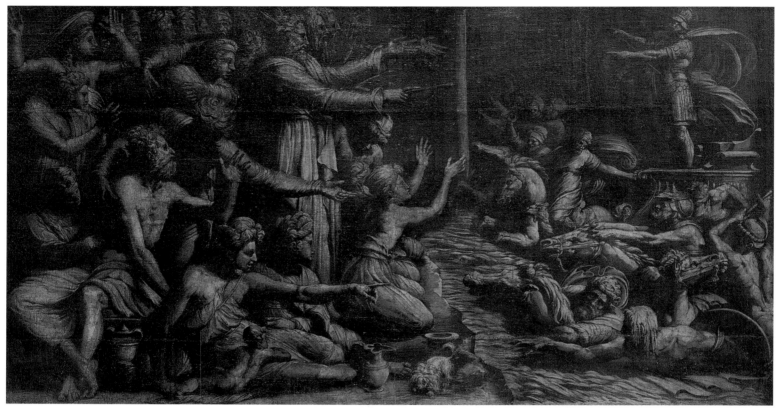

This painting was first recorded in 1825 just before the time of its sale to the Brera in Milan, with an attribution to a follower of Raphael named Polidoro da Caravaggio. It retained this ascription in successive catalogues in the nineteenth century, after which time the work was for all intents and purposes ignored.[1] It was Bernice Davidson who, in a written communication in 1987, first ascribed this neglected picture to Perino del Vaga on the basis of Vasari's extended description of a painting executed during the artist's brief sojourn in Florence in 1522. ¶ According to Vasari, Perino painted this work on a "coarse canvas" in a single day and night for Raffaello di Sandro, a chaplain at the church of San Lorenzo, in exchange for the cost of his lodgings, before the artist's departure from the city to escape the plague.[2] Vasari admired Perino's work, which he apparently knew first-hand, for the variety of poses and the beautiful costumes and hairstyles. In his Life of Giovanni Antonio Lappoli, Vasari also describes the residence of Raffaello di Sandro as a meeting place for the finest musicians and artists in Florence, including Rosso Fiorentino, and adds that Lappoli, who was a painter of minor talent from Arezzo, befriended Perino there. Lappoli has even been proposed as the author of the copy of the *Crossing of the Red Sea* in the Uffizi, which, before the discovery of the Milan picture, was considered to be the original.[3] Raffaello di Sandro's position as sacristan of San Lorenzo in this period would have brought him into official contact with a variety of painters as a commissioning patron. There is some circumstantial evidence that he was thinking of ordering a fuller cycle of paintings from Perino on the theme of Moses.[4] ¶ The image shown here, based on Exodus 14:21–30, depicts the dramatic moment when Moses, after the Israelites have crossed the Red Sea to escape Pharaoh's army, stretches out his hand as God has instructed him to do and the water flows back over the drowning soldiers. Presumably, this unusual subject for Florentine art attracted the patron and the painter equally – the patron for its relatively erudite theme and the painter for its potential to allow him considerable liberty in creating a memorable image. Its majesty, sensuality, and rather stylized, indeed almost ritualized, dramatic treatment make the painting an epitome of the most up-to-date style available in Rome just after the death of Raphael in 1520. The links between this particular type of monochrome technique, imitating a bronze relief, and various precedents in Raphael's art have been noted.[5] It was a painting technique evoking classical art that Raphael taught to the highest possible standard to all his students, above all to Polidoro, and for this reason the old attribution of the Milan painting is perfectly understandable. However, Cecchi has also related this particular technique of monochrome on canvas to the tradition of ephemeral decorations in Florentine painting.[6] ¶ Perino's painting can be compared to another work, probably done slightly later, based on another story in Exodus: Rosso's *Moses Defending the Daughters of Jethro*, now in the Uffizi, executed on a slightly smaller canvas (cat. no. 58). Like Rosso's painting, Perino's seems to have been undertaken in somewhat informal circumstances, which may account in part for the use of an inexpensive canvas. This in turn encouraged a broad and rapid handling, similar to what is seen in certain drawings by the artist (see cat. no. 64). Judging from Vasari's narrative, in the case of Perino's painting, speed and economy were even more of a consideration than in Rosso's. Perino's work is a pure grisaille, and so did not involve the purchase of any costly pigments. Neither artist would have been inclined to spend much time on these private commissions, which could not have earned them the fame or income of larger public works. In stylistic terms, however, the more elegant and decorative quality of Perino's painting contrasts with the sheer vitality and passion, as well as the greater overall coherence, of Rosso's image.

David Franklin

Fig. 66.1 Andrea del Brescianino, *The Virgin and Child with Saint Anne, after Leonardo da Vinci,* oil on panel, 129 x 96 cm. Formerly Kaiser-Friedrich Museum, Berlin (destroyed in the Second World War)

James Byam Shaw had some doubts about the attribution of this drawing to Jacone, but these misgivings were reflective of the relatively poor state of knowledge about the artist in 1976. Vasari's lack of interest in an artist, linked to Jacopo da Pontormo, whom he found slothful, argumentative, and disrespectful has only recently begun to be redressed.[1] This sheet was formerly attributed to Baccio Bandinelli and, subsequently, to Tribolo, but its ascription to Jacone is by now accepted, and indeed the sketch is eminently characteristic of the artist's work. Jacone's graphic style is distinguished by a handling of the pen in sharp, aggressive lines, inspired by a direct study of Michelangelo's drawings.[2] The figures are awkwardly proportioned, with oversized limbs and heads with staring eyes. There is concern, nevertheless, for the underlying structure of the body, and the treatment of even the Virgin Mary as partially nude at this stage of the design process was quite conventional in Florentine graphic practice. As superficially bizarre as the study seems, it should be recalled that sketches like this were preparatory and were not intended for public scrutiny or criticism. Yet, this drawing features some sophisticated elements, such as the treatment of the architecture as sharply recessed, allowing the full projection of the figures. ¶ In 1988 Pinelli compiled a list of about two dozen autograph drawings by Jacone. This list has since grown slightly (see cat. no. 67), but the artist's drawings are still rare.[3] The majority that survive are in pen and ink, and this drawing is among the more ambitious and complete examples of his draftsmanship. It also has an added interest: it contains the same core subject, featuring the Virgin sitting on the lap of her mother, Saint Anne, as the celebrated cartoon by Leonardo, exhibited, according to Vasari, in Santissima Annunziata in Florence around Easter 1501.[4] Although there are no explicit quotations in the drawing from what is assumed to have been Leonardo's design (see fig. 66.1), certain details, such as the Virgin's bent head and the child's upturned face, suggest direct knowledge of the work. The identity of the additional figure with hands clasped in prayer in the lower-right corner is less certain, although it most likely represents Saint John the Baptist's elderly mother, Saint Elizabeth. ¶ The purpose of this drawing, whether for an altarpiece or tabernacle fresco, or even as a study for a work of private devotion, must remain speculative, although Saint Anne had a popular cult following in Florence as a patron saint of the city. Indeed, as Saint Anne was a traditional symbol of communal liberty for Florentine republicans, it is tempting to link the image to the period of the last republic (1527–1530).[5]

David Franklin

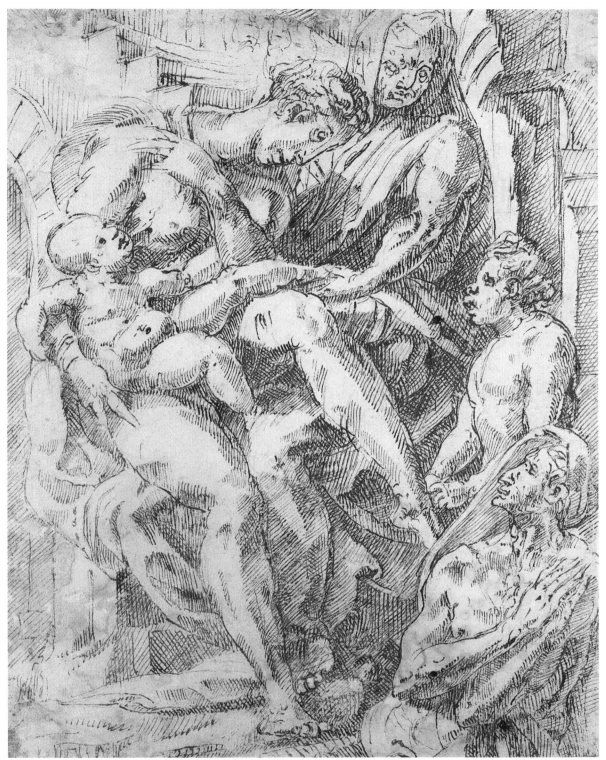

66

Previously ascribed to Francesco Salviati, Polidoro da Caravaggio, and Rosso Fiorentino (under whose name it is currently catalogued in the Villa Farnesina in Rome), this figure study of a seated woman with praying hands is in fact the work of Jacone, an attribution proposed here for the first time.[1] One reason why this drawing has proved difficult to attribute to Jacone with any confidence is because it is executed in red chalk, a medium that is relatively uncommon in his surviving studies. His known drawings are more typically in pen and ink, with long, scratchy lines and a charged, almost collapsed sense of form (see cat. no. 66). In contrast, this drawing is concentrated and almost analytical in its handling, with densely striated drapery folds. Nonetheless, the attribution to Jacone can be sustained by a comparison with his other drawings.

¶ Parallels for the ample, silhouetted form and the polished, roughly faceted drapery can be found in a sheet in the Ashmolean Museum (fig. 67.1). That sheet, which is now accepted as being by Jacone, has the reliable date of 1527 written in a fictive scroll at its base.[2] Although executed in pen and ink over a black-chalk underdrawing rather than in red chalk, the Oxford study shares many formal characteristics with the one in Rome. In the medium of red chalk, an apposite comparison is provided by a yet more tranquil, tempered drawing in the Uffizi of a *Standing Youth* (fig. 67.2), which carries a collector's inscription cancelling the name of Polidoro da Caravaggio ("Pulidoro") and attributing the work to Jacone ("Giacone") – an interesting alteration given that the Rome sheet too has been ascribed to the former artist.[3] The particular silhouetted quality typical of Jacone's drawn figures is more evident in this tidier *garzone* study, although it is also a characteristic of the *Seated Woman* sketch. ¶ The subject and purpose of the drawing are mysterious. It may represent the Virgin seated on the ground, as in depictions of the Adoration of the Child. The covered head and praying hands would fit such an interpretation, as would the orientation of the figure, who, in apparently acknowledging something to the viewer's right, could be looking at the Christ child. The one bizarre aspect of the drawing is the superimposition of two different studies for the same face on one body. In terms of style, the drawing is close to the altarpieces executed by Jacone in Cortona in the late 1520s.[4] Recognition of this particular type of more carefully calibrated drawing by Jacone, in addition to expanding the known range of his draftsmanship, helps to counter Vasari's colourful characterization of the artist as slothful and ill-mannered[5] – an analysis that modern scholarship is now starting to reject.

David Franklin

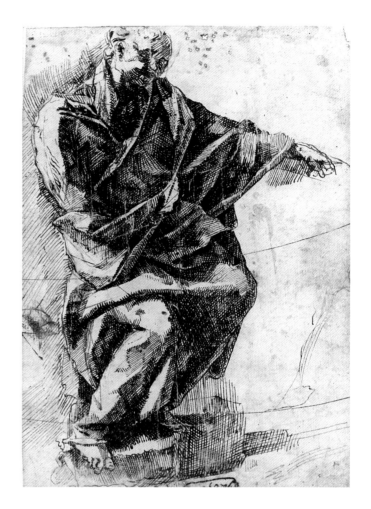

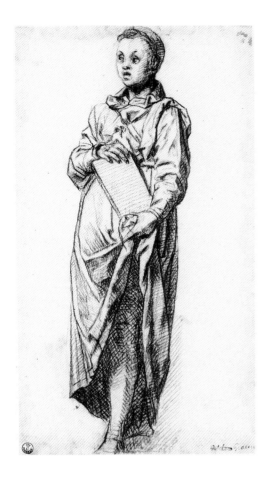

Fig. 67.1 Jacone, *Seated Man*, 1527,
pen and brown ink over black chalk,
29.1 x 19.9 cm. Ashmolean Museum,
Oxford (WA1946.353)

Fig. 67.2 Jacone, *Standing Youth*,
c. 1525, red chalk, 33.9 x 18.3 cm. Galleria
degli Uffizi, Florence (344F)

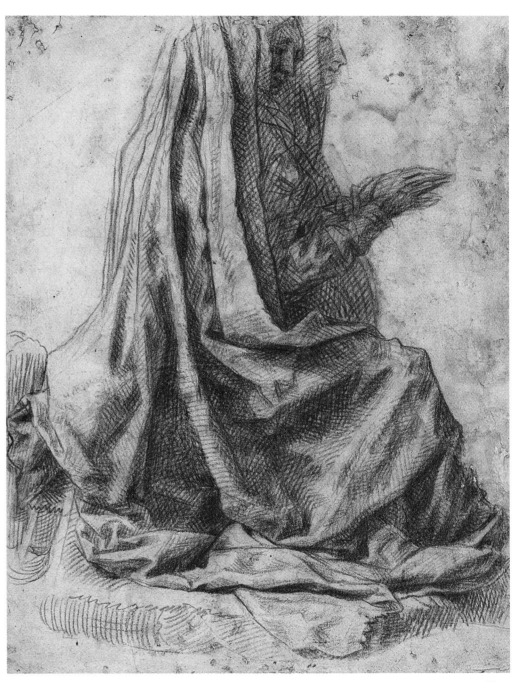

This powerful drawing is the earliest significant compositional study by Jacopo da Pontormo to survive. It was first attributed to him by Berenson, but it was Clapp who recognized it as one of the initial studies for the altarpiece, still in situ, in the church of San Michele Visdomini in Florence (fig. 68.1). The patron of the altarpiece, which was intended for a chapel dedicated to Saint Joseph, was Francesco di Giovanni Pucci, and it is apparent from documents that work on the painting was not begun before the summer of 1518.[1] The drawing is a page from the so-called "Corsini sketchbook," out of which some thirty-six sheets datable to the last years of the 1510s survive in Rome. The drawings reveal Pontormo's willingness to exploit an antiquated technique involving a ground coloured with a red wash, but to powerful and unexpected effect. The relatively soft charcoal in this drawing has two different consistencies, further contributing to the almost pictorial effect, as does the uneven application of the wash.[2] ¶ There are numerous differences between the drawing and the altarpiece surviving in the Visdomini church. In the drawing, for example, Saint John the Evangelist kneels at the centre, with his back to the viewer, but in the altarpiece he is in a sitting position, in the lower-left corner. Joseph holds the Christ child in both, but in the final picture his posture is different. In the drawing Saint Francis appears to be the figure blessing the Virgin and Child while standing at the centre behind Saint John the Evangelist, whereas in the altarpiece he is depicted in a more prominent position, kneeling before the Christ child in the lower-right corner. Saint James is in more or less the same place in both, standing at the right edge. The drawing also features one extra figure kneeling at the right margin, possibly an alternative idea for one of the saints or even for the donor, but not included in the finished work. ¶ The lateral aspect of the design is more prominent in the drawing than in the final painting, not least because the Christ child is positioned closer to the ground, which lowers the centre of gravity of the whole composition. The general arrangement of the drawing betrays the artist's source as pictorial representations of the Adoration of the Magi or Shepherds, in which a group of worshippers enters from the side to pay homage to the Virgin and Child. This tendency is sacrificed in the finished painting for a more structured composition befitting the requirements of a church altarpiece. Also, even more strongly than the painting, the drawing stresses the left half of the pictorial field, as the artist visually exploited the original placement of the altarpiece in a right-hand chapel in the nave in order to direct the attention of a viewer entering the church toward the high altar. The asymmetrical nature of the design, which has attracted some rather elaborate explanations, was in fact inspired by the unusual need to privilege Joseph as the dedicatory saint of the chapel for which the painting was intended, as well as by its placement on the side wall of a church with a relatively narrow nave. ¶ Pontormo's sketch is distinguished by the intense, almost grandiose power that the artist was able to concentrate with such rapidity on a small sheet of paper. The vortex of long, sharp lines that produces a not entirely legible result is present in other early drawings by the artist. The use of charcoal in this rather free, highly blended, and atmospheric style brings to mind drawings by Fra Bartolommeo and Leonardo rather than by Andrea del Sarto. Pontormo may have been exposed to drawings by Fra Bartolommeo while in the workshop of Leonardo as a youth, and equally to those of Mariotto Albertinelli, who had been Fra Bartolommeo's partner.[3] The verso (not shown) contains two nude studies, possibly early ideas for the figure of Saint Joseph.

David Franklin

Fig. 68.1 Jacopo da Pontormo, *The Virgin and Child with Saints*, 1518, oil on panel, 214 x 185 cm. Church of San Michele Visdomini, Florence

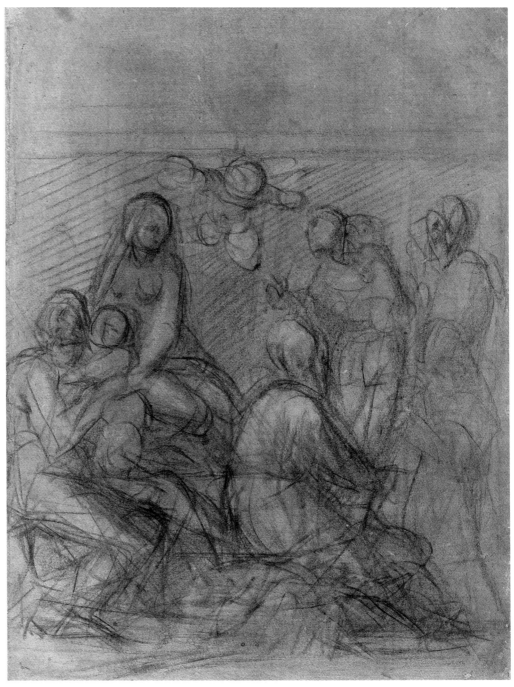

69 JACOPO DA PONTORMO (1494–1557) · **Saint Francis** (recto) · **Study of a Dead Christ** (verso)
c. 1517–1519 · Black chalk (recto), black and white chalks (verso) · 40.5 x 28.4 cm · The J. Paul Getty
Museum, Los Angeles

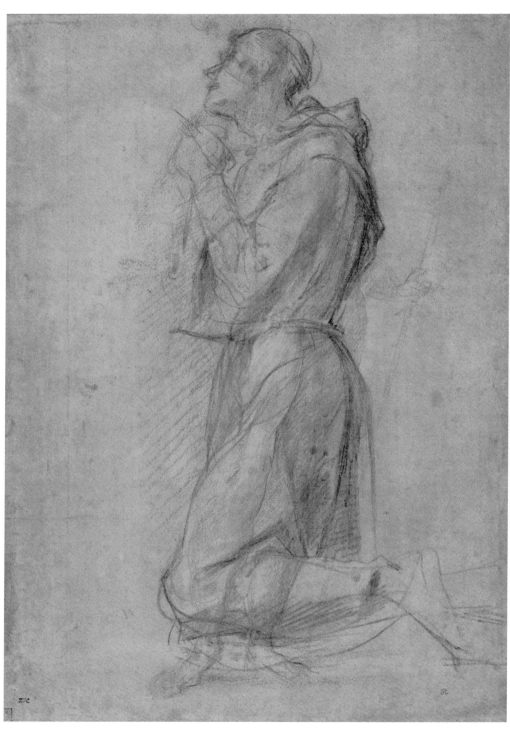

69 (recto)

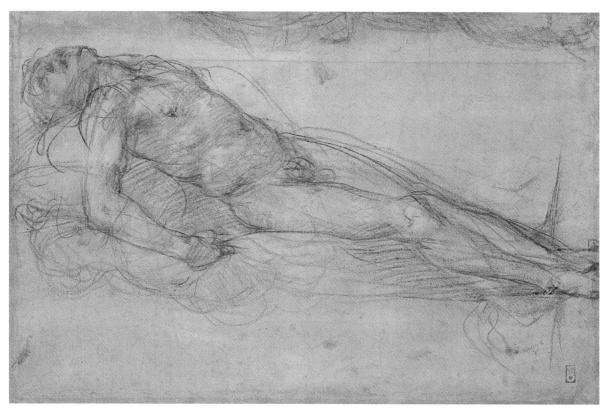

69 (verso)

The drawing on the recto of this sheet was first published by Forlani Tempesti in 1981, following its inclusion in an exhibition in Florence in 1980.[1] The attribution to Pontormo was apparently made prior to that date by Sylvie Béguin (verbal communication), when the work was still in a French private collection. The drawing is a study for the figure of Saint Francis, kneeling in the right foreground of an altarpiece by Pontormo, dated 1518, which survives in situ on a side altar in the church of San Michele Visdomini in Florence (see fig. 68.1). This was the funerary chapel of Francesco di Giovanni Pucci and, as the name saint of the original patron, Saint Francis was given a pivotal role in the image, kneeling before the Christ child. ¶ The main figure study is executed over a now almost obliterated drawing of a standing figure with an inclined head, holding a staff, that has been associated with the Saint James at the right margin of the altarpiece. Compared to other sketches for this Saint Francis in the Uffizi, one of which shows him in virtually the same pose but entirely nude, the present drawing appears to be from the conclusion of the design process. This can be inferred from the similarity of the pose in the finished painting and also from the artist's typical altering of the proportions to make the figure more attenuated and more bluntly expressive. At the same time, the handling is still intensely vigorous, with thick, almost splintered and imprecise lines used to create powerfully monumental forms. The sheer aggressiveness and virility of Pontormo's approach to drawing was always beyond that of Andrea del Sarto or Rosso Fiorentino in the 1510s, a formative period for all three artists. In his search for an atmospheric, dramatic range of light and dark, Pontormo reveals his indebtedness to Leonardo's particular contribution to the history of painting in Florence. To explore the contrast, he selected a black chalk with a particularly greasy texture. ¶ The verso features a nude Dead Christ lying on the ground and supported by cushions or bundles of drapery, his head arched back in a striking figuration of death. As with the recto, this image is drawn over another figure, more lightly sketched, perhaps again the standing Saint James from the Visdomini painting. Other drawings related to this figure survive in Rotterdam and in the Uffizi. Although they have in the past been related to a possible predella panel for the Pucci altarpiece, whose very existence is unconfirmed by any written source, Clapp's original suggestion that they are studies for a *Pietà* fresco for a chapel in the Augustinian church of San Gallo in Florence, which was destroyed in 1530, still seems the most plausible.[2] The presence of a drawing for this work on the same sheet as one for the Visdomini altarpiece, and the fact that the style of the two drawings is entirely compatible, would suggest that this lost painting dated from approximately the same time. Vasari's mention of the San Gallo fresco following that of the Visdomini painting fully supports this interpretation. ¶ It is apparent from other sketches roughly truncated at the margin of the verso that this sheet was originally much larger.

David Franklin

209

JACOPO DA PONTORMO (1494–1557) · **Portrait of a Man** · c. 1520 · Red chalk · 28 x 19.5 cm
Istituto Nazionale per la Grafica, Villa Farnesina, Rome

The present drawing, generally thought to be a depiction of Piero de' Medici il Gottoso (Piero the Gouty), the son of Cosimo de' Medici the Elder, relates to a painting formerly in the Chabaneau collection in Bordeaux (fig. 70.1).[1] If this is indeed Piero de' Medici, then it is ironic that in producing one of the very finest portrait drawings of the period Pontormo was representing someone who had lived long before it was made (Piero died in 1469). The identification of the sitter was arrived at on the basis of earlier images, which Pontormo could have studied, including a sculpture by Mino da Fiesole of 1453, now in the Bargello. It is possible that the painting was ordered as a pendant to the artist's portrait of Piero's father (fig. 70.2), for a commission featuring images of illustrious Medici. The commission would probably have been initiated by Ottaviano de' Medici for the family palace, only to be halted unexpectedly because of the death of Pope Leo X in 1521. Freedberg was the first to link the two retrospective portraits by Pontormo and identify the sitter in the Rome sheet.[2] The assumed connection to the Cosimo portrait provides a reasonably secure date for the drawing, which can also be supported on the basis of style. It does not appear, however, that Pontormo's portrait was taken beyond the design stage. The Bordeaux painting specifically would seem to be a pastiche by a Florentine artist, such as Andrea Boscoli, dating to much later in the sixteenth century, elaborated from relatively complete drawings such as the one in Rome.

¶ This is the most finished of the three surviving drawings for the portrait. The figure is portrayed as seated in a Savonarola chair and is viewed in profile from his right. In portraying a person he had never seen, Pontormo chose to introduce a severe expression with sharply delineated features, as befitting a distinguished member of the Medici dynasty. As in the painted version, the figure holds a closed letter in his left hand. The handling of the figure is impressive for its breadth and vigour. The form is described through a widely meandering contour with a sculptural solidity and relief, but with a more schematic, open approach to the generation of three-dimensionality than Pontormo would later favour.

¶ The verso (not shown) represents the same figure in an even more abbreviated form.

David Franklin

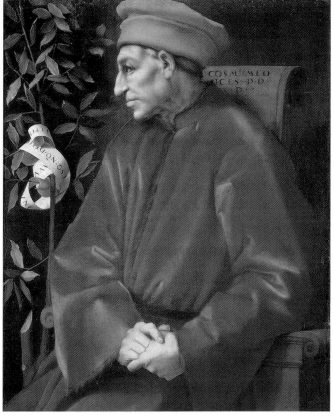

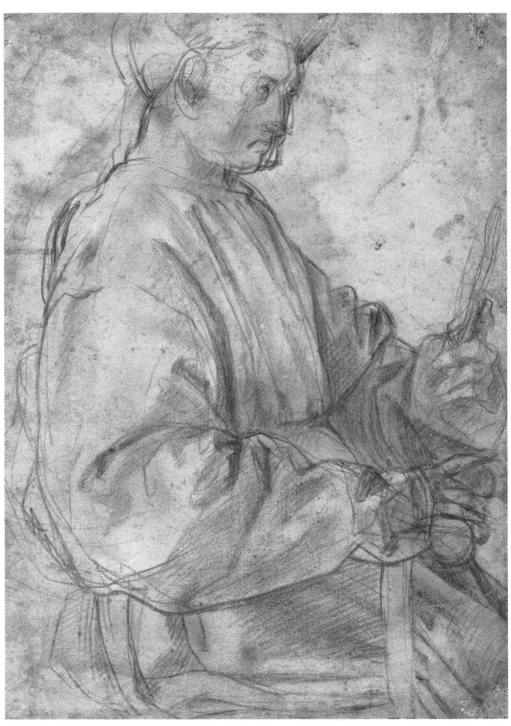

JACOPO DA PONTORMO (1494–1557) · **Study for Christ before Pilate** · c. 1523–1524 · Black and red chalks, heightened with traces of white chalk, over stylus · 27.4 x 28.3 cm · The Art Institute of Chicago · Restricted Gift of Anne Searle Meers, The Regenstein Foundation, and Dr. William D. Shorey

Fig. 71.1 Jacopo da Pontormo, *Christ before Pilate*, c. 1523–1524, lunette fresco, 300 x 290 cm. Museo della Certosa del Galluzzo, Florence

Pontormo's intense involvement with his subject matter is most strikingly illustrated in his drawings, most of which are individual figure studies in red and black chalks, many of them bearing only an approximate relationship to a particular painting or fresco. One of only forty compositional studies within Pontormo's large graphic corpus, this drawing from the Art Institute of Chicago has been identified as a preliminary design for *Christ before Pilate* (fig. 71.1), one of five lunette frescoes that the artist painted between 1523 and 1526 in the large cloister of the Certosa del Galluzzo, a Carthusian monastery outside Florence, to which he had fled to escape the plague in the fall of 1522.[1] Along with the decoration of the choir in the church of San Lorenzo, the Certosa fresco cycle has always been considered the most extreme of Pontormo's stylistic experiments. In this highly expressive and visually ambiguous drawing made for what is probably one of the first lunettes to be executed in the cycle, Pontormo devised an unusual illustration of this scene from the Passion, though a solution that he would not carry through to the fresco itself. As has long been recognized, this work contains elements derived from several of Albrecht Dürer's prints (for example, the *Small Passion* woodcuts of 1511) and from Donatello's late bronze relief (c. 1460–1466) of the same scene on the north pulpit in San Lorenzo.[2] ¶ In the Certosa fresco the bound Christ is clearly positioned at the centre, standing in profile with bowed head before the Roman governor Pilate, who is portrayed in the conventional manner, seated in judgement and about to wash his hands. In the Chicago drawing, Christ is identifiable as the tall figure placed off centre in the jumbled and blurred crowd on the left, standing with his hands tied behind his back. His head erect, he looks up at Pilate, the shrinking figure at the top of the stairs who glances back fearfully at Christ as he grasps the round handles of the doors. Despite these differences, both fresco and drawing share important compositional features, including the bound figure of Christ, the central axis, and the roughly symmetrical groups of figures crowded on either side. ¶ Pontormo's depiction of Pilate in the Chicago drawing, for which there is no known visual prototype, has a probable literary source in the apocryphal fourth-century Gospel of Nicodemus, or Acts of Pilate, as adapted in a late fifteenth-century Italian devotional work, *Meditatione sopra la passione del nostro signore iesu christo*. Attributed to a thirteenth-century Franciscan monk called pseudo-Bonaventura, this Passion tract was printed in at least twenty-eight editions between 1478 and 1500.[3] According to the relevant passage, when Christ entered the Roman governor's palace, twelve imperial standards held by ensigns lowered themselves of their own accord in homage to Christ, whereupon all of those assembled were compelled to kneel in worship. Beholding this spectacle, Pilate became frightened and fled the room.[4] In the Chicago drawing,

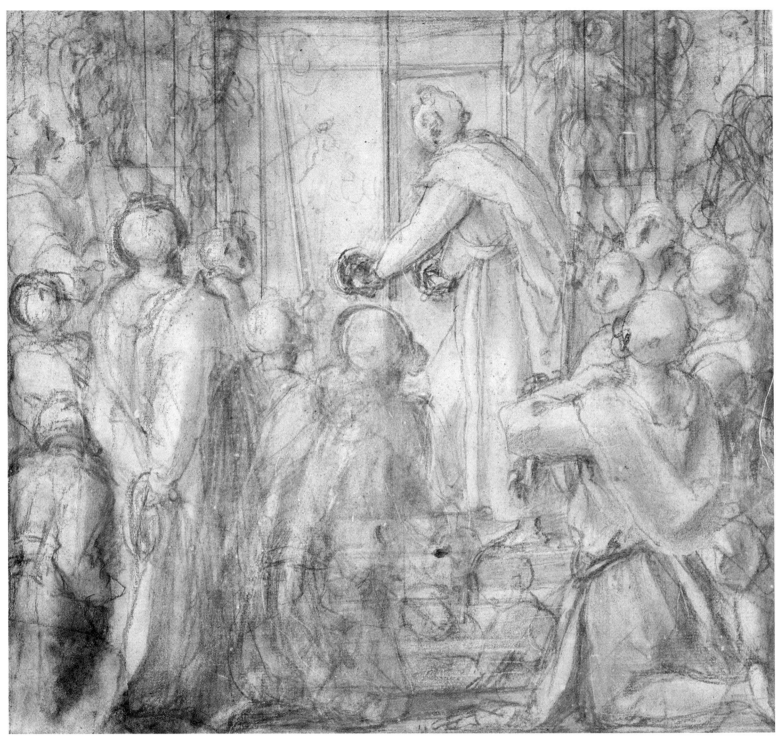

71

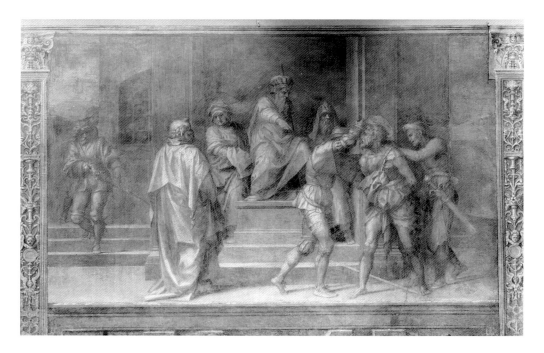

Fig. 71.2 Andrea del Sarto, *The Arrest of Saint John the Baptist*, 1517, fresco, 191 x 312 cm. Chiostro dello Scalzo, Florence

Pontormo makes Pilate's imminent exit the formal and psychological focus of the scene. He does so by placing Pilate near the centre of the composition and diminishing the size of his spooked and shrunken face in relation to his body – deviating from the larger size indicated by the stylus underdrawing, a network of heavily incised lines that parallel many of the forms articulated in black chalk.[5] This abrupt and unsettling change in scale is one of Pontormo's numerous revisions and reworkings throughout the composition, resulting in a palimpsest of shifting forms and spatial relationships.[6] Certain figures (most notably Christ, Pilate, and the kneeling figure in the right foreground) are distinguished by broader areas of light and shadow, the latter created by stumping or smudging the black chalk in such a way as to allow the tonality of the paper to filter through. As a result, the multi-layered surface has an overall transparent and luminous texture that is ultimately mysterious in nature and reinforces the enigmatic quality of the scene. ¶ Whatever external reasons might have led Pontormo to abandon his original conception of the scene of *Christ before Pilate* in the fresco itself, such a radical change between preliminary idea and final product is entirely characteristic of Pontormo's complex preparatory process. The numerous figure studies related to the final design of the *Vertumnus and Pomona* fresco in the villa at Poggio a Caiano (1520–1521) confirm Vasari's claim that Pontormo constantly revised his ideas even after beginning work on a fresco: "destroying and doing over again every day what he had done the day before, he racked his brains in such a manner that it was a tragedy; but all the time he was always making new discoveries, which brought credit to himself and beauty to the work."[7] A similar creative struggle is suggested in the Chicago sheet, with its multiple layers of fluctuating ideas. ¶ Whereas one can trace the complex evolution of *Vertumnus and Pomona* in over thirty extant preparatory

studies,[8] such documentation is lacking for the Certosa frescoes as a whole, to which only nineteen drawings have been related, including two compositional studies in the Uffizi for two unexecuted lunette frescoes.[9] In comparison to the Chicago drawing, these studies, which have been dated to between 1523 and 1524, display a flat and patterned effect that may be attributed to the influence of Dürer's prints. The more rounded and volumetric forms and deeper space of the Chicago drawing suggest that it belongs to a different and probably earlier stylistic moment, when Dürer's influence on Pontormo was less marked. Several elements in the drawing (notably the fairly rectangular format, the centralized and stage-like setting, and the columnar figure of Christ) indicate that at this preliminary stage of the Passion cycle Pontormo turned for inspiration to a contemporary Florentine source – Andrea del Sarto's grisaille fresco of the *Arrest of Saint John the Baptist* of 1517 in the Chiostro dello Scalzo (fig. 71.2) – which Pontormo then modified through his study of Dürer's prints, substituting eccentric shapes and abrupt shifts in scale for Sarto's classical forms and measured spatial intervals. In addition to documenting these conflicting and converging influences, this probing drawing dramatically reveals the evolving design of a deeply personal vision. It captures the essence of Pontormo's introspective approach to the given subject matter, combining the human and spiritual elements in a compelling and perplexing image that is both otherworldly and immediate.

Laura M. Giles

72 **JACOPO DA PONTORMO (1494–1557)** · **Pietà** · c. 1525–1527 · Black chalk and grey wash, heightened with white, squared; upper figures retouched with stylus · 44.3 x 27.6 cm · Christ Church Picture Gallery, Christ Church College, Oxford

This drawing is for Jacopo da Pontormo's altarpiece of the *Pietà* (fig. 72.1) surviving in situ in the Capponi chapel – the first in the right nave of the church of Santa Felicita in Florence.[1] The patron was Lodovico Capponi, who acquired the chapel in 1525 and rededicated the altar to the *Pietà*, supplementing the earlier dedication to the Annunciation. The purchase date has been assumed to be the date on which Pontormo began to paint the chapel, although he probably started slightly later than 1525. Vasari claims that the work took three years to complete.[2] The altarpiece, which survives in its original frame, was part of a larger ensemble that also included a fresco of the *Annunciation* on the interior facade of the church, four tondi on panel depicting the *Four Evangelists*, and a now destroyed fresco in the cupola featuring *God the Father with Four Patriarchs*. The altarpiece in particular was controversial even in the sixteenth century, and it remains one of the most discussed paintings of the Renaissance period in Florence. ¶ Although Jonathan Richardson apparently recognized that this was a Pontormo drawing, it was subsequently ascribed to Federico Barocci and languished in obscurity, unmounted, in the collection at Christ Church until it was noticed by James Byam Shaw.[3] While other drawings for this altarpiece survive, this one is especially significant as the only complete compositional study, containing all the main components that would appear in the finished altarpiece. The image features Christ at the moment when he is carried away from his mother, physically separated from her for the last time, after being placed on her lap by the followers who had been present with them both at the Crucifixion. At the core of the image, the Virgin holds up a tensed right hand that gestures toward Christ's receding body, giving her final farewell before his burial. The downward turn of her elongated body retains the trace of where her son had lain. That the Virgin is fully conscious emphasizes the respectful Marian aspect of the imagery and is a detail appropriate for the *Pietà*. This contrasts with depictions of her in the Deposition from the Cross, in which she frequently swoons with her eyes closed. ¶ The drawing thus concentrates on the rapport between Christ and the Virgin. To this degree, it is more accurately titled a *Pietà* than an *Entombment*, as has been the convention in the literature. As was usual with altarpieces, the rededication of the altar in Santa Felicita provided Pontormo with a starting point for the treatment of the subject matter that he was required to treat, but in this case he conceived of a variation on the topic. He even suppressed the identity of the other characters to focus attention on the essence of his theme. None of the other usual protagonists in the story, such as Mary Magdalen, John the Evangelist, Joseph of Arimathea, or Nicodemus, are readily identifiable. ¶ The complete squaring in chalk indicates a desire to transfer the design to another surface. This suggests that the artist was satisfied with the overall design and most of the details by this stage, although, as was conventional in Florentine graphic practice, he did not yet indicate all the costumes. There are, however, some noteworthy differences between the drawing and the painting. In formal terms, Pontormo significantly lengthened the proportions of the figures in the altarpiece to give them more elegance and buoyancy and also to reduce the overall density of the space. To this extent, he distanced the design from its principal source, Michelangelo's *Battle of Cascina*. To judge by the greater number of pentimenti in the area of the boy supporting Christ's back, the figure's action was still giving Pontormo trouble, as was the activity around Christ's head, which is turned with remarkable originality and sensitivity toward the viewer and away from the Virgin. Most of the changes were introduced to present the subject matter more as timeless icon than as temporal narrative in order to focus the attention of the devout on the critical moment when Christ is removed from the Virgin Mary's lap, at the point of their final farewell. The most obvious example of this is the elimination of any reference to Golgotha through the removal of the ladder in the upper background in the drawing and its replacement by a simple cloud in the painting. This shift from narrative to icon also occurs more subtly in the broader characterization and generally more extrovert treatment of the faces, not least that of the male figure behind the Virgin. This figure is sometimes considered to be a self-portrait, but it may, more plausibly, represent the wealthy Joseph of Arimathea, who relinquished his right to his own tomb for the Saviour.

David Franklin

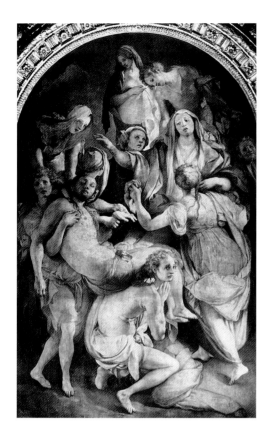

Fig. 72.1 Jacopo da Pontormo, *Pietà*,
c. 1525–1527, oil on panel, 313 x 192 cm
Church of Santa Felicita, Florence

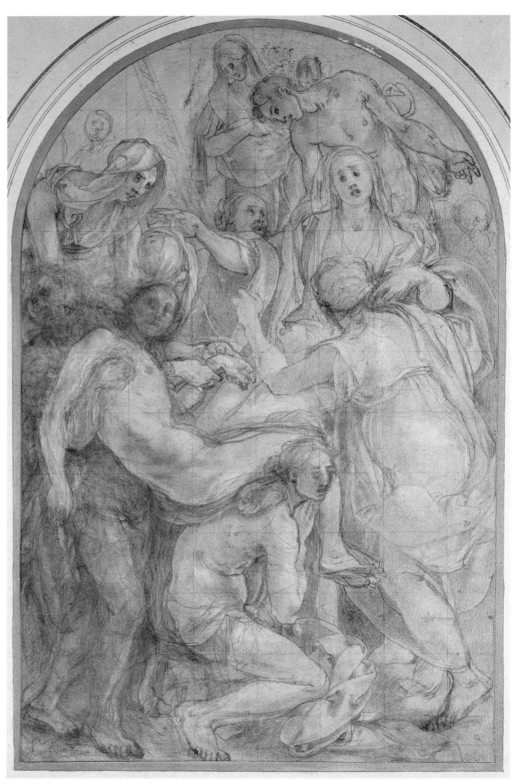

Catalogued in the celebrated 1836 exhibition of Michelangelo drawings from the Thomas Lawrence collection as the artist's study for the sleeping Adam in the fresco of the *Creation of Eve* on the Sistine Chapel ceiling, and, exceptionally, singled out for praise as "very capital," this figure study passed as a Michelangelo original for at least two centuries.[1] Except for the brief entry in the Lawrence catalogue, the drawing is unrecorded in published sources, despite its highly distinguished provenance: after Lawrence, it was owned by both the Dutch and German royal houses.[2] ¶ Rather than to Michelangelo, this double-sided drawing can be attributed to a younger Tuscan artist closely influenced by him – Jacopo da Pontormo. The recto of the drawing features a young, reclining male nude who sleeps with his face supported by his left arm, which in turn rests on a large cylindrical object, and with his right arm pulled behind his back. No other known drawings can be linked unequivocally to this design, although one sketch sometimes hesitantly associated with Pontormo's final commission for the frescoes in the choir of the church of San Lorenzo in Florence (fig. 73.1), depicts a male nude in a more summary fashion with his right arm covering his face in a comparable manner.[3] In the mature work presented here, the rather soft, exploratory handling of the black chalk and the elongated, almost segmented treatment of the human form evoke Pontormo's final drawings for the San Lorenzo choir project, left incomplete at his death. Settling on a more precise date for this drawing is a matter of guesswork, but its general balance and restraint suggest that it dates closer to 1530 than to 1550, after which Pontormo's style became yet more extreme and exaggerated, with a loss of some of the sculptural clarity and cooler emotional tenor that pervades this work. Indeed, the figure in this drawing perhaps most closely resembles those in isolated figure drawings related to Pontormo's fresco projects of the 1530s for the Medici villas at Poggio a Caiano, Careggi, and Castello, all of which remained incomplete or have since been destroyed. A black-chalk drawing of a male nude associated with the Castello loggia frescoes, now in the Uffizi (fig. 73.2), provides one such comparison.[4] ¶ Pontormo was not above distorting anatomical accuracy for decorative effect, and by this stage in the design process he was no longer working directly from a model, although details such as the left foot placed underneath the knee betray a direct observation from life. The soft surfaces of studies such as this one, in which lines are introduced in tightly controlled but flowing patterns with little cross-hatching, are also a feature of the drawings of his mature period and distinguish his graphic style from the more compact sketches of his pupil Bronzino (see cat. nos. 77 and 78). ¶ It was in the 1530s that Pontormo was closest to Michelangelo, artistically and personally, which makes the previous attribution of the drawing to the older master more understandable. On two occasions Pontormo produced monumental finished paintings from Michelangelo's cartoons – a *Noli me tangere* now in a private collection in Varese and the *Venus and Cupid* now in the Galleria dell'Accademia in Florence, both of

which were executed in Florence during the early 1530s.[5] The closest model in terms of a finished Michelangelo design is the painting of the Este *Leda* of about 1530, now lost but known from various accurate copies, which is comparable in its treatment of the body in strict profile with the raised outside leg and even the placement of an arm behind the back. Details of the pose, including the withdrawn arm, as well as the general tenor of the sleeping figure, with its accentuated musculature, can also be traced to the sculptures for the New Sacristy in the church of San Lorenzo, which were designed in the 1520s. At the same time, parallels for the accurate, intensely modulated, yet almost feathery handling of the black chalk can be found in Michelangelo's drawings for the New Sacristy marbles, as well as those for the *Leda*. Perhaps Pontormo had access to the artist's sketches, such as one in the British Museum, in developing this particular figure.[6] ¶ Compared to the majority of Pontormo's surviving drawings, this sheet is highly finished, with very few pentimenti (and no detectable underdrawing), suggesting that it was a resolved idea for a particular project. The study was perhaps executed for some part of the Medici commissions mentioned above, although they are not specifically described in the sources, or for an ephemeral decoration. The context for this rather tender, reflective, almost melancholic image does seem secular rather than ecclesiastical. The figure may represent a captive soldier who rests with an arm placed for support on a vessel containing some of the spoils of war. Another possibility not to be dismissed is that he is an allegorical figure. Certainly, Pontormo was frequently occupied with producing decorations of such a nature for the Medici family throughout his mature period. ¶ The verso of the drawing is less well preserved, but is certainly also by Pontormo. The image is equally remarkable and, if anything, more boldly expressive. It features a standing female nude in an active pose, as if captured in the process of throwing an object or in a state of extreme reaction. Were it not for the difference in gender, it would have been tempting to link this drawing to the studies, all now in the Uffizi, of nude soccer players that Pontormo commenced after 1531 by order of Pope Clement VII, which were to be included in another domestic fresco for the Medici at Poggio a Caiano but were never taken beyond the drawing stage. Nonetheless, the formal and stylistic proximity of those drawings to this sketch helps to confirm the attribution of the recto to Pontormo and also to support a dating to that particular decade. Close examination of the drawing on the verso reveals evidence of the hand of another figure gripping the right arm of the woman around the elbow, indicating that she is interacting with another person. The extreme pathos and powerful action embodied in this figure would be appropriate for an Expulsion from the Garden, but the identification of the subject, like that of the recto, remains elusive.

David Franklin

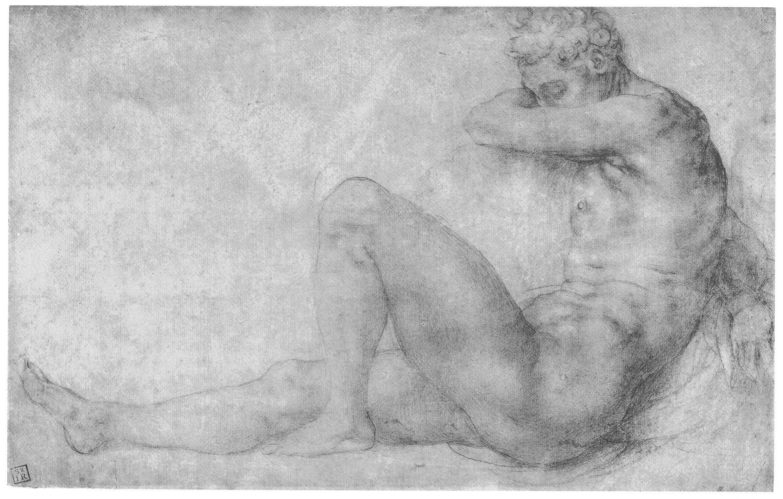

73 (recto)

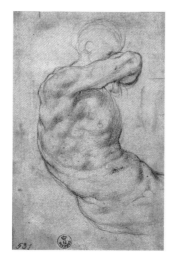

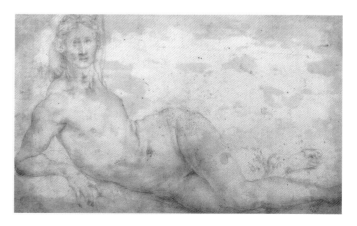

Fig. 73.1 Jacopo da Pontormo, *Seated Nude Hiding His Face*, 1530s (?), black chalk, 14.4 x 8.9 cm. Galleria degli Uffizi, Florence (6654F)

Fig. 73.2 Jacopo da Pontormo, *Reclining Male Nude*, c. 1537, black chalk, 19.9 x 31.8 cm. Galleria degli Uffizi, Florence (6683F)

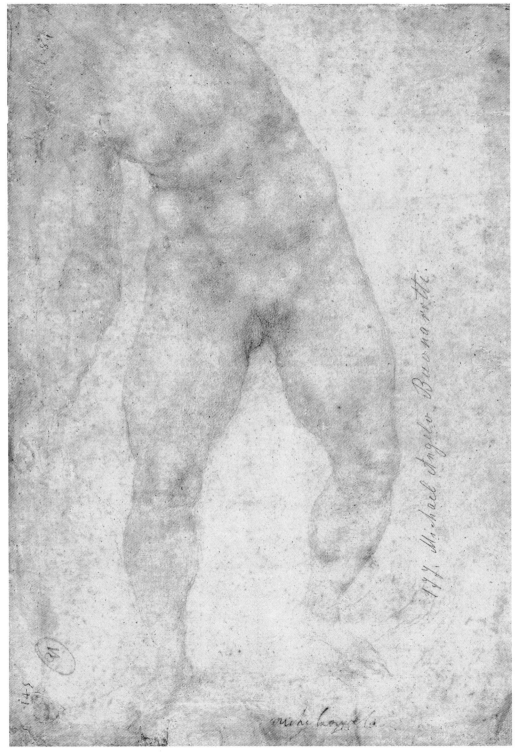

73 (verso)

74 **JACOPO DA PONTORMO (1494–1557)** · **Study of Three Nudes for the Castello Loggia** (recto)
Portrait of Maria Salviati (verso) · c. 1537 · Red chalk (recto), black chalk (verso) · 20.2 x 27.8 cm
British Museum, London

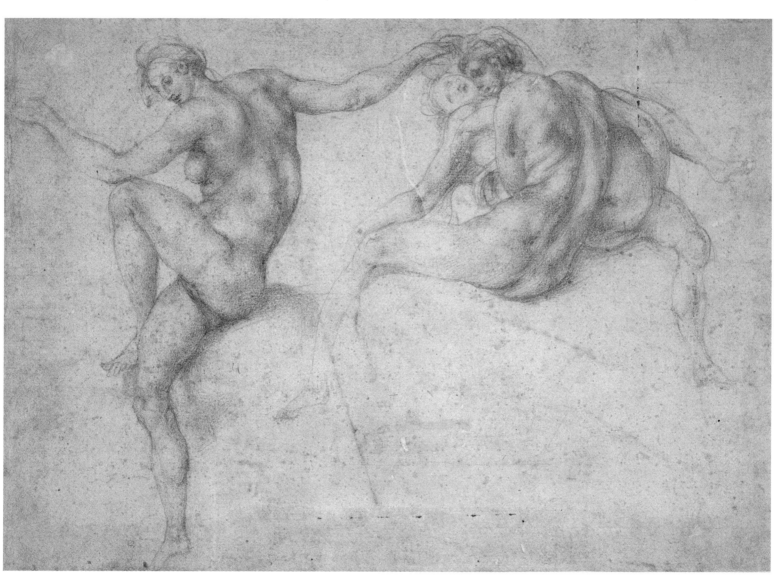

74 (recto)

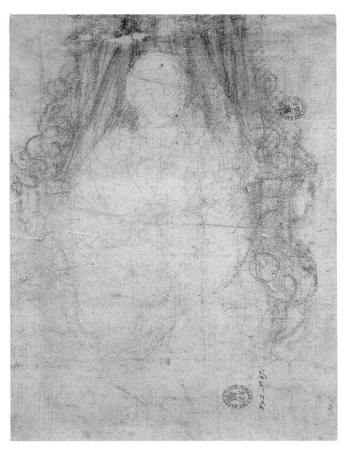

74 (verso)

Although he never published the drawing, A.E. Popham was the first to attribute this rather neglected sketch to Jacopo da Pontormo and relate it to the allegorical frescoes in the Medici villa at Castello.[1] The verso, as Popham further noted, contains a drawing for a portrait of Maria Salviati (1499–1543), the mother of Duke Cosimo I de' Medici. Vasari cites both commissions and mentions that Duke Cosimo, newly installed in 1537, commissioned Pontormo to fresco an outdoor loggia at Castello – a project that, according to Vasari, occupied him for five years and was eventually destroyed by the elements.[2] The portrait of Maria Salviati was executed in the same period, and it too no longer survives. ¶ The compositional drawing on the recto is an especially enchanting example of the artist's mature style, and is unusual in that it treats figures on a relatively small scale. It contains separate studies of a female nude and a pair of nudes of uncertain gender seated on tufts of ground that form natural pedestals. The drawing at the right features one figure holding another, rather like a bundle, who appears to be dying, but the subject matter remains obscure. The identity of the buoyant female nude in the other half of the drawing, who is wearing strange headgear and who is possibly balancing an object in her left hand, is equally uncertain. Both studies likely relate to some of the allegorical figures that Vasari describes as having been painted at Castello, along with the signs of the zodiac. It is tempting to believe that the figure on the left represents the Ceres specifically mentioned by Vasari, with fronds of wheat on her head as an attribute. ¶ Vasari's reference to the gigantic nude women that populated the frescoes at Castello is also an appropriate description of the bodies in this drawing. The attenuated, gawky proportions are a distinctive trait of the artist's later work, in which figures seem captured in a moment of transition, as are the patterning of the bodies and the sinuous, balletic rhythms. Some of the figural distortions, such as the elongation of the torsos and limbs and the emphasis on the silhouette, were natural choices in the creation of figures that had to be legible from the distant ground. Given the negative tenor of the scholarly literature on drawings of this type, traceable back to Vasari himself, it is important to recognize how Pontormo's decision to exaggerate these figures was a rational solution to a particular design problem. Also, by flattening the bodies to the picture plane and arranging the parts as distinct entities assembled into ensembles, the artist was following a modular method that was appropriate for frescoes that were intended to be painted in separate sections, or *giornate*, as the plaster dried during execution. ¶ The relatively tentative nature of the handling appears to reveal the artist caught in a moment of creative thinking as he developed a typically radical solution. The chalk is applied so minutely and evenly that it has a granular quality where it catches the surface of the paper. This soft, graduated finish recalls drawings by Michelangelo that Pontormo would have studied in Florence.

David Franklin

A black-chalk drawing of a female nude in a highly contorted and rather unbalanced pose dominates this sheet. A thumbnail sketch of an apparently unrelated full-length figure, balanced with crossed ankles, also appears in the lower-left corner. In the upper-right corner there is an even more lightly drawn figure. Despite its highly finished state, the drawing contains traces of stylus over the contours of the main figure – evidence for some process of transfer, thus indicating that it was not the final drawing in sequence in the production of this particular image. The drawing is very closely and obsessively worked, and contains numerous reinforcements and pentimenti of the contour lines. This towering nude with pliable body parts, seeming as if constructed from discrete segments, is characteristic of Jacopo da Pontormo's style. The figure appears to stand solely on one leg, with the left foot tucked behind the knee. The drapery billows and twists as it forms into rolls in a complex construction that echoes the agitated contortions of the form. ¶ As first pointed out by Pauli in 1927, the drawing can be associated with the allegorical frescoes painted by Pontormo in the pendentives of one of the two loggias at the Medici villa at Careggi, as described by Vasari.[1] The villa, earlier remodelled by Michelozzo for Cosimo de' Medici the Elder, was heavily restored by order of Alessandro de' Medici following the family's return to power after the end of the republic in Florence in 1530. The progress of Pontormo's partially completed commission was halted by the assassination of Duke Alessandro in 1536. We have no indication of the appearance of these frescoes, all of which were destroyed, other than from the very few surviving preliminary drawings. ¶ The figure in the Hamburg sketch balances a mirror on her bent leg, an attribute identifying her as Prudence – one of the figures that Vasari saw at Careggi. Despite this apparent link, Pilliod recently proposed a later dating for the drawing in light of the frescoes in the choir of the church of San Lorenzo in Florence, pointing out that the small study in the lower-left corner echoes the figure of Eve frescoed there for the *Labours of Adam and Eve*.[2] The link is undeniable. However, as the relatively tight and restrained drawing style, as well as the rather precious approach to the human figure, seem to confirm a dating in the 1530s for the Hamburg sheet, it seems likely that Pontormo reused, or simply

remembered, drawings such as this one (many more of which would have been made for the Careggi decorations) when starting the San Lorenzo project in the 1540s. Support for dating in the 1530s also comes from a previously unnoticed detail: the barely sketched figure in the upper-right corner appears to be a study for Bronzino's *Saint Sebastian* (cat. no. 83), which cannot be dated later than that decade. ¶ Even some of the scholars who accept the link to the Careggi *Prudence* have attributed the drawing to Bronzino, who was responsible for the execution of the final work in collaboration with Pontormo. Indeed, given that this type of contorted female nude had such a profound influence on the younger artist, the reattribution, first made by Forlani Tempesti in 1967, has much to recommend it.[3] The somewhat finicky, rather pneumatic approach to certain parts of the drawing would argue for Bronzino's authorship, although whether he could have achieved this level of overall quality and power in the mid-1530s remains open to question. Comparison can be made to another drawing that is certainly by Pontormo, related to the allegorical figures at Careggi and possibly representing *Justice*.[4] No authority has argued, however, that the invention of the Hamburg drawing should not be credited to Pontormo himself. ¶ The verso (not shown) contains an apparently unrelated figure study as well as a drawing of the *Virgin and Child*.

David Franklin

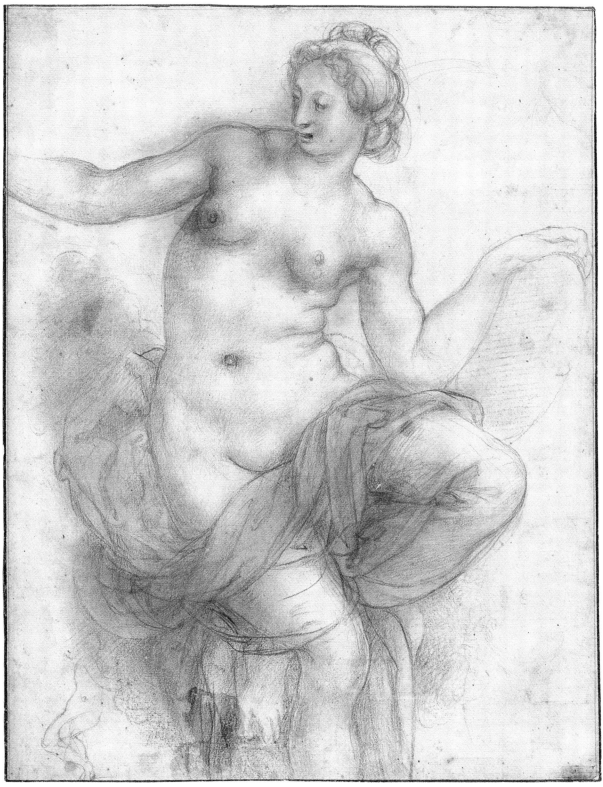

75

Painted on a single panel from which the corners have, unfortunately, been cut and remade, this imposing painting of the Virgin and Child can be safely attributed to Jacopo da Pontormo, as first suggested by Carl Strehlke (verbal communication). It was originally published with an attribution to Jacone.[1] Costamagna subsequently discovered the extensive provenance of this work, which once belonged to the Medici family and which was even publicly exhibited in the Uffizi for much of the eighteenth century.[2] The original patron is unknown, but not long after its completion the work was copied on several occasions, attesting to a certain renown and importance. The fact that the artist produced as few as a half-dozen devotional images of the Virgin and Child makes this painting all the more exceptional. ¶ While distilled and monumental, the image contains a particularly touching and intimate narrative in which the seated Virgin Mary protects the Christ child, who, while glancing upward, his eyes rolled back in his head, recoils with some agitation from her body as if with an awareness of his future Passion. The child is relatively large and robust for this type of image, indicating that he is perhaps of a more mature age than traditionally depicted. The Virgin's gesture of protective encirclement evokes the traditional iconography of the Madonna of Mercy. At the same time, the Virgin, who is treated in sharp profile, looks abstractedly outward in the manner of a sibyl, completely sharing the child's awareness of the future. Pontormo's subtle addition of layers of meaning to a standard type of devotional image is typical of his originality and intelligence. With the exception of the veil that seems to encircle her head, the Virgin is not especially richly dressed, as the artist intended to evoke a sense of humility. Indeed, the work is painted with a relatively restricted palette of broadly applied and segregated colours, relieved only by the *cangiante* of the Virgin's veil, which varies from yellow to lavender. ¶ The lack of a representational background concentrates attention on the subject and seems to accentuate its sculptural qualities. The image in fact derives from numerous venerable precedents in the domestic reliefs of Florentine sculptors from Donatello to Michelangelo.[3] The long, angular lines with deeply channelled drapery folds are especially suggestive of sculpture. At the same time, the surface is handled in a lively fashion (several pentimenti are detectable with the naked eye), with soft, almost translucent passages, as in the flesh tones. The dating of the work must be proposed on stylistic grounds alone, but the reference to traditional sculpture implies a relatively early date in the artist's career. More specifically, the sharply contrasting light and shade link the work to the Visdomini altarpiece of about 1518, while the robust quality of the forms compares well to the lunette fresco of *Vertumnus and Pomona* at Poggio a Caiano – a project suspended in 1521.

David Franklin

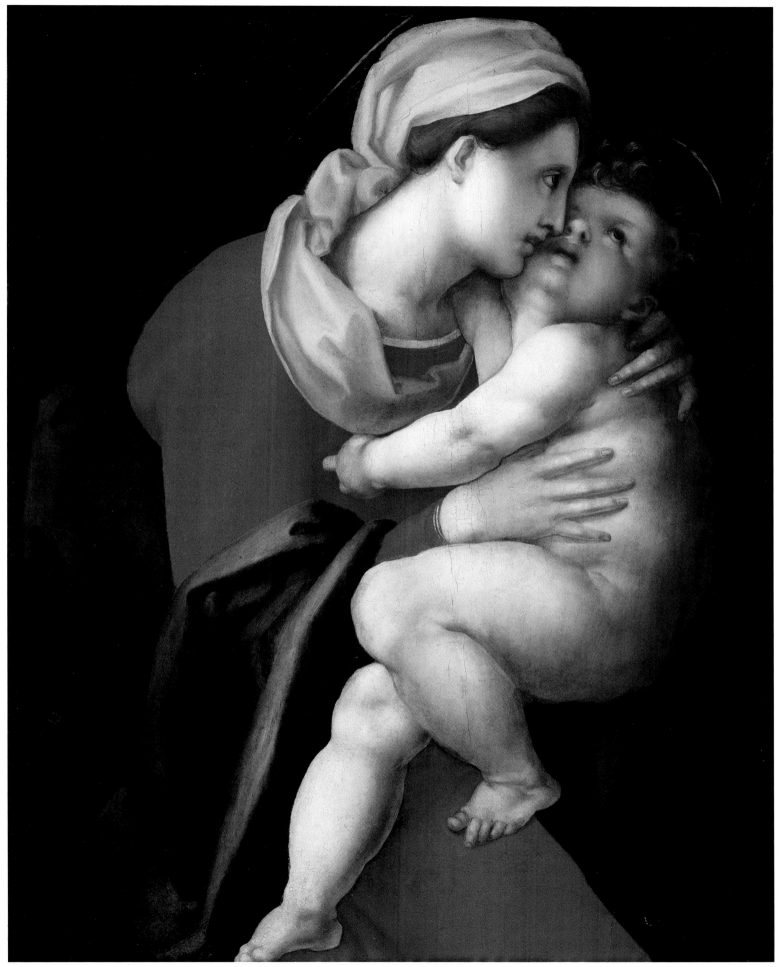

Notwithstanding Michael Jaffé's arguments in support of its previous attribution to Pontormo, this drawing is clearly the work of the master's pupil, Bronzino. It is typical of his graphic art, featuring the same painstaking, delicate use of black chalk found in other sheets of his from this period, such as the 1529 study for a *Dead Christ* (private collection, New York)[1] and the study for a *Portrait of a Man* in Florence (Uffizi, 6698F), once thought to be a likeness of Pontormo. The Chatsworth sheet is an autograph preparatory drawing for the *Young Man with a Lute* in the Uffizi (fig. 77.1), painted by Bronzino around 1533–1534. It is a final study for the sitter's pose, as is indicated by the squaring, but it renders the figure more legibly than does the finished work. Elements such as the folds of the garment and the position of the hands, just perceptible in the painting, become evident in the drawing. And here it is obvious that the young man's pose is a literal transposition of the statue of *Giuliano de' Medici*, executed by Michelangelo for the New Sacristy in the church of San Lorenzo. The painter has copied the sculptor's figure, positioning himself to the right in order to present the sitter full face. ¶ After his return from Pesaro in 1532, Bronzino was commissioned to paint several lunette decorations, including an *Allegorical Portrait of Dante*, in the home of the Florentine banker Bartolomeo Bettini – likely at the suggestion of Michelangelo, who had created the cartoon for Pontormo's *Venus and Cupid* for the same room. He replicated the pose of the San Lorenzo sculpture for this work,[2] adapted it for the *Young Man with a Lute*, and went on to use it in subtle variations in numerous portraits, including the Florence study for the *Portrait of a Man* and the *Portrait of Ugolino Martelli*, now in the Gemäldegalerie in Berlin. Bronzino had had occasion to study some of Titian's great portraits of power while north of the Apennines, but, back home in the Tuscan capital, rather than slavishly aping

the man held to be the finest portraitist of the day, he turned to the most esteemed artists of Tuscany for inspiration and developed a purely Florentine portrait style. The Chatsworth study is a prime example of how Florentine portraiture evolved, and it even appears, no doubt fortuitously, to be an adaptation of the *Portrait of a Young Man* painted by Andrea del Sarto in 1512 (now in the Duke of Northumberland Collection at Alnwick Castle).[3] The considerable influence of Michelangelo's statue on Florentine portraiture is also evident in works by Francesco Salviati (cat. nos. 121 and 122) and Michele Tosini (cat. no. 116). ¶ When Vasari, in 1534, adapted the Michelangelo pose for the *Portrait of Alessandro de' Medici* (now in the Uffizi) as the first official image of the duke of Florence, he intended thereby to underscore the new sovereign's legitimacy. Conversely, when Bronzino, in his *Allegorical Portrait of Dante* or his *Portrait of Ugolino Martelli*, chose a work by the most republican of Florentine artists as a model, he intended to suggest his sitters' opposition to Alessandro's despotic power. Although the identity of the sitter for the *Young Man with a Lute* remains unknown, the objects surrounding him[4] imply that he was a highly cultivated person, probably (as in the case of other portraits by Bronzino), a member of Benedetto Varchi's circle.[5]

Philippe Costamagna

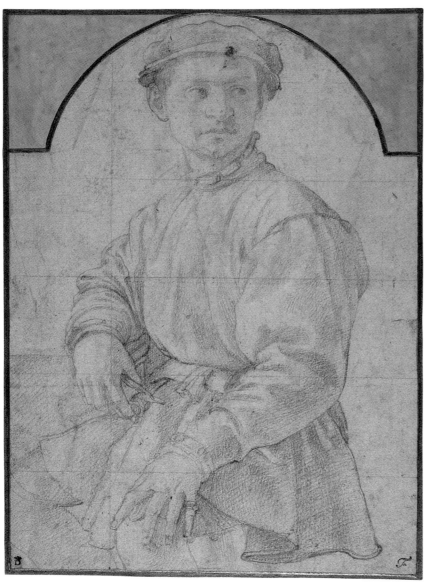

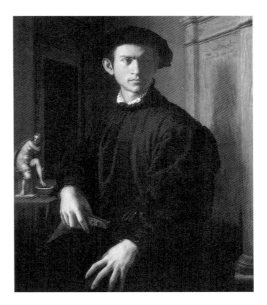

Fig. 77.1 Agnolo Bronzino, *Portrait of a Young Man with a Lute*, c. 1533–1534, oil on panel, 94 x 79 cm. Galleria degli Uffizi, Florence

In contrast to the production of his teacher, Pontormo, the author of hundreds of surviving drawings, Bronzino's entire graphic oeuvre consists of fewer than thirty sheets, so the recent appearance of the present sheet at a Paris auction is an event of the highest importance. The drawing has hitherto been universally regarded as a study for Bronzino's earliest known independent commission, the *Pietà with Saint Mary Magdalen* (fig. 78.1), for Lorenzo Cambi's altar in the Florentine church of Santa Trinita.[1] ¶ However, Bronzino's drawing differs in several important ways from the Cambi altarpiece. The first difference has to do with the poses of Christ and the other figures in the composition – who are here represented notionally by their disembodied hands on his body. In the New York drawing Christ's head falls gently forward and away from the viewer; in the Cambi *Pietà* it slumps sharply back and toward us. Christ's torso forms a straight diagonal line in the drawing, while in the altarpiece his back is curved, the line of his abdomen breaking with a heavily shadowed line just above the navel. The right hand behind Christ's nape (evidently Mary's) is absent from the painting, as is the other right hand (presumably Mary Magdalen's) supporting his left hand. The left hand faintly outlined on Christ's thigh in the New York drawing (and certainly belonging to the Magdalen) contrasts with the Magdalen's right hand in the Cambi altarpiece. If the New York drawing was for that painting, Bronzino must have made radical revisions to his overall composition quite late in the design process – after he had begun making detailed life studies for figures whose poses he would already have determined at an earlier stage. ¶ A second important difference involves the form of Christ's body, which is far more robust and idealized in the drawing.[2] If this drawing is indeed a preparatory study for the Cambi *Pietà*, it might be that the patron himself was responsible for the shift away from the staunchly built figure shown here toward the much more homely, less organic representation of the Dead Christ in the finished painting. Lorenzo Cambi's commercial empire was based on trade with northern Europe, and the markedly northern quality of his altarpiece – from its rather ungainly naturalism to its compositional borrowings from Dürer's *Large Passion* – may be related to a desire on his part to advertise his prestigious ultramontane connections.[3] ¶ A third notable difference between the drawing and the painting is the direction of the lighting; the drawing is lit from the left, while the figures in the Cambi *Pietà* are lit from the right. Lighting from the left was Bronzino's "default mode"; only four of his panel paintings are lit from the right, and in each case the artist's departure from standard practice seems related to the real lighting in which the painting was to be seen (or, as in his *Portrait of Andrea Doria*, to the lighting in the original design he was adapting). It would be quite unlikely for Bronzino to have made such a detailed study of a figure lit from one direction in preparation for a painting whose lighting scheme was dominated by illumination from the opposite direction. All these differences suggest that either Bronzino made extensive and extremely radical changes to the central Christ figure, the composition, and the lighting of the Cambi *Pietà* very late in its design process – at the stage of finished life studies – or else the New York drawing was not actually made for the Florentine banker's altarpiece.

¶ Within months of completing the Cambi altarpiece in 1529, Bronzino entered the service of the Duke of Urbino at Pesaro. Vasari relates that after his return in 1532, but before entering the Medici's service in 1539, the artist frescoed a *Pietà with Angels* in an outdoor tabernacle for Matteo Strozzi in Mercatale, San Casciano in Val di Pesa (fig. 78.2).[4] In this work – which was ruined and is now completely repainted – Bronzino followed the New York drawing with great fidelity; the pose of Christ is almost completely identical in both. The positions of the hands that support his nape and left arm in the drawing have been altered in the Mercatale fresco, but, as in the drawing, the hand on Christ's thigh is a left hand (and not a right hand, as in the Cambi *Pietà*). Significantly, the lighting of the frescoed *Pietà* comes from the left, as in the drawing. And, despite the best efforts of Bronzino's restorers to obscure his work, we can still see plainly that the figure of the Mercatale Christ is the same heroic, idealized, and muscular figure represented in the drawing – and not the gangly, limp, and disjointed body shown in the earlier Cambi *Pietà*. ¶ In view of the New York drawing's tenuous visual connection to the Cambi *Pietà*, and its close relation to the fresco in the Mercatale tabernacle, it therefore seems most likely that Bronzino created this study for the tabernacle. Its treatment of light and shadow, though more tentative and restrained, is reminiscent of his drawings for the chapel of Eleonora di Toledo (1541–1543) and other later works. Similarly, the closest formal parallel for the muscular figure of Christ in the New York sheet is the squarely proportioned protagonist of the *Lamentation* he painted for her chapel in 1543–1545. Thus, in its handling and in its formal elements, the New York drawing represents a crucial milestone between the powerful northern accents of Bronzino's earliest works and the towering achievements of his mature, idealizing *maniera*.

Louis A. Waldman

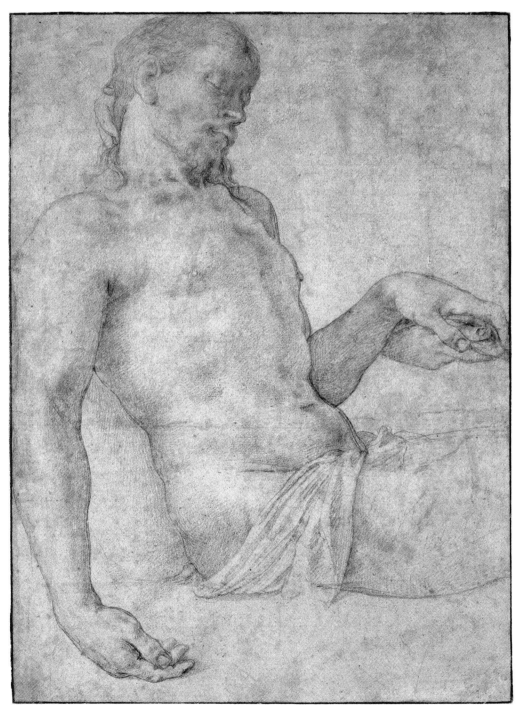

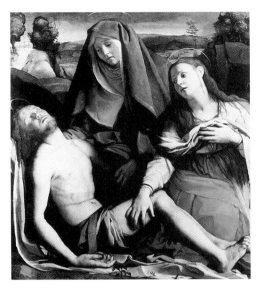

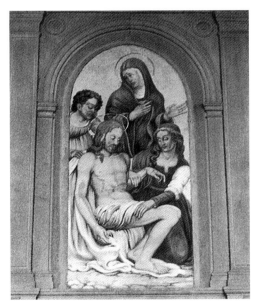

Fig. 78.1 Agnolo Bronzino, *Pietà with Saint Mary Magdalen*, 1529, oil on panel, 115 x 110 cm. Galleria degli Uffizi, Florence

Fig. 78.2 Agnolo Bronzino, *Pietà with Angels*, c. 1535, fresco (repainted) Mercatale, San Casciano in Val di Pesa

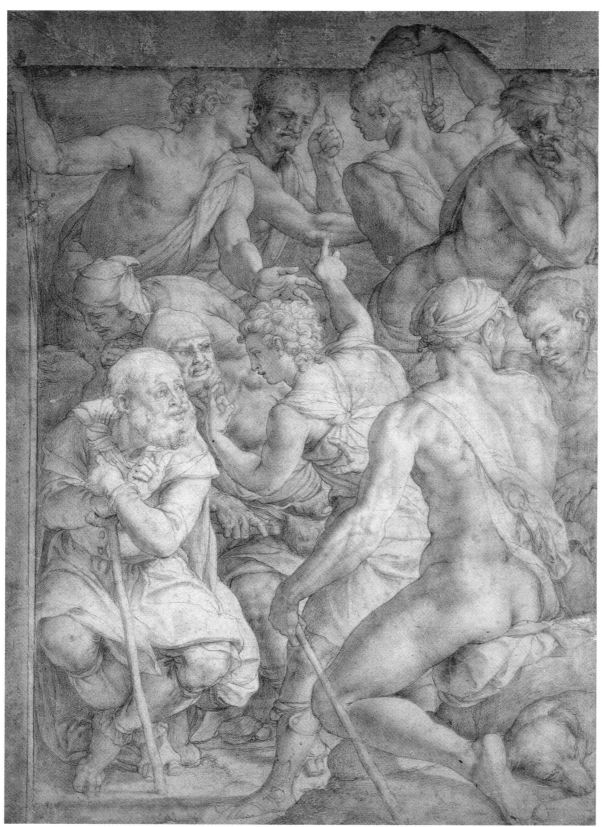

This drawing corresponds, in reverse, to the lower-left portion of a tapestry in the *Story of Joseph* series.[1] A far more schematic drawing for the upper portion is preserved in the Uffizi. Of all the drawings securely ascribed to Bronzino, it is the most highly finished and refined, and the control and facility displayed here in the handling of black chalk are rarely matched in sixteenth-century Italian drawing. ¶ The most obvious points of comparison, as noted by Smyth, are the presentation drawings of Michelangelo, which from the 1520s onward set a new standard of technical perfection in the art of *disegno*.[2] Some of those drawings were made for Florentine recipients such as Andrea Quaratesi or Gherardo Perini, while others Bronzino may have seen during a visit to Rome in 1548.[3] The idea of a relief-like composition of nude or semi-nude figures is also Michelangelesque. Pictorial space is created largely through the sculptural quality of the figures rather than through scale or perspective. As in the *Battle of Cascina* or several of the groups in the uppermost zone of the Sistine *Last Judgement*, a volume of space is defined through the depiction of foreground figures from behind, turned inward from the frontal plane. Despite these strong reminiscences of Michelangelo, Bronzino's figures possess a delicacy of surface anatomy and a consistency of proportion altogether different from the work of both the older artist and Bronzino's contemporary and teacher Pontormo. There is no conspicuous dependency on the recent treatments of the subject that Bronzino would have known – Andrea del Sarto's for the Borgherini bedchamber, now in the Palazzo Pitti, and Raphael's version in the Vatican Loggie. ¶ The cycle of twenty tapestries depicting the life of Joseph was one of the major artistic enterprises of the early reign of Duke Cosimo I de' Medici. The commission forms part of the duke's scheme to refashion a thirteenth-century building that symbolized the republican past of the city of Florence into a modern princely residence. At the same time, the luring away from the court of Ferrara of two eminent Flemish tapestry workshops (Rost and Karcher) was conceived, at least initially, as means of enhancing Florentine distinction in artistic manufacture. Until 1554, when Janni Rost's workshop was incorporated by the court, the workshops of Rost and Nicholas Karcher operated more as private mercantile enterprises than as court *botteghe*. The series thus presents itself not only as an instance of Medici image-making but also in terms of Florentine tradition and civic identity, and additionally as a demonstration of Florentine supremacy in the arts of *disegno*. The survival of this drawing (it is among the few that can be connected with the *Joseph* cycle) may owe something to its unique quality. If, as Smyth has proposed, it represents one of Bronzino's first-completed designs for the series, it may have been conceived as an exemplary work that set a standard in design for a craft new to Florence. ¶ The commission was given in 1545, when Rost and Karcher moved to Florence, and following the evaluation of two trial pieces of tapestry for which Bronzino also provided designs. By 1548 Bronzino was the sole artist at work on the *Joseph* series; Francesco Salviati had completed the design of one of the pieces but then departed for Rome. Pontormo designed three, but if Vasari is to be believed his efforts were found "unpleasing and difficult to weave." The tapestry produced by Janni Rost from the present design was delivered between 15 July and 3 August 1549, which suggests, given the length of time needed to weave such a tapestry, that the drawing was produced in 1548 or even earlier. The record in the ducal Guardaroba account documents Bronzino's authorship. ¶ The subject of

Joseph was a strategic choice reflecting the dual imperatives of Medici self-imaging and Florentine tradition. It had already appeared in two pre-eminent works of public art: the late thirteenth-century Baptistery mosaics and Lorenzo Ghiberti's *Gates of Paradise* (completed in 1452). Joseph is in many respects a counterpart to another biblical boy-hero, David, who was symbolic of republican Florence. David's political connotations became undesirable and possibly inflammatory after the violently contested re-establishment of the Medici principate in 1530, and Joseph could be seen as an effective substitute. His story combines the most favoured themes of Florentine narrative art adapted from the Old Testament: the young hero delivered from adversity, the genealogical succession of fathers and sons, and the sibling rivalry resulting from it. In addition, the story of Joseph combines the favourite Medici themes of exile and return.[4] ¶ In the drawing, the boy explains a dream to his doting father, gesturing to underline its portentous significance: the sun, moon, and eleven stars that in the dream pay homage to Joseph signify his supremacy over his parents and his eleven brothers. The brothers grimace in indignation, already planning to get rid of him. Smith has proposed that an allegorical treatment of the story by Philo Judaeus determined its particular appeal for the Medici regime. Joseph, according to Philo, is the type of the ideal statesman. Philo speaks of the identity between "state" and "household" in a manner that would have enhanced the subject's ideological possibilities; if citizens are "like brothers," Joseph's ascendancy signifies the necessity of hegemonic rule in the "household" of the state. Philo also glosses Joseph's later facility as an interpreter of dreams as an attribute of the ideal statesman: "the statesman must come forward and, like some wise expounder of dreams, interpret the day-time visions and phantoms of those who think themselves awake, and with suggestions commended by reason and probability show them the truth about each of these visions."[5] The study of Philo in Florence had acquired a certain prominence owing to an intellectual faction known as the "Aramei," which dominated the Accademia Fiorentina in the 1540s. The humanists Giambattista Gelli, Pierfrancesco Giambullari, and Cosimo Bartoli appropriated Jewish Scripture and philology to create a new foundation myth for Florence, according to which Noah appeared as the originator of Etruscan civilization and the Tuscan language itself evolved from Hebrew. Cox-Rearick has attributed the strong Medici predilection for Old Testament subjects in the 1540s to the hegemony of the Aramei.[6]

Stephen J. Campbell

Here we see a rare example of Bronzino as a designer of the festive apparati that transformed the city of Florence on the occasion of important dynastic marriages in the Medici family, in this case the marriage of Duke Cosimo's heir, Francesco de' Medici, to Princess Joanna of Austria in December 1565. This drawing is one of two surviving designs for a set of five vast paintings on the theme of matrimony that decorated a temporary wood-and-canvas facade on the Palazzo Ricasoli near the Ponte alla Carraia in Florence.[1] In scale, the works would have evoked the Sistine *Last Judgement*, to which Bronzino would pay homage also in his equally monumental *Martyrdom of Saint Lawrence* in the church of San Lorenzo in Florence, completed four years later; so too would the artistic effect of massive bodies vigorously moving against a featureless background, which in this case was probably also a brilliant field of blue. The design is an example of Bronzino's mature Michelangelesque mode, which he employed selectively for projects with a markedly ideological intent: the proclamation of "Florentineness" and the reappropriation of Michelangelo as a Medici cultural property.[2] This mature imitation of Michelangelo stands in contrast to Bronzino's late altarpieces, which respond to the post-Tridentine demand for a simpler and emotionally affecting religious art and constitute a departure from the more eclectic approach of Giorgio Vasari and other members of the Florentine Accademia del Disegno.[3] ¶ While strongly reminiscent of the battling angels and damned souls in the Sistine *Last Judgement*, the design reflects a close study of Michelangelo's *Archers Shooting at a Herm* (Windsor Castle, RL 12778), which may have been owned by the Florentine banker Andrea Quaratesi,[4] although Bronzino could also have known the invention from an engraving. The male figure advancing from the right is a variant of one of the figures in the *Archers*, while the falling nude to the left (with foreshortened torso) is a figure-type very characteristic of Pontormo (see Uffizi 6677F verso). ¶ The programs for the Ricasoli facade and for the entire decoration of the city for the 1565 ceremonial entry were devised by Vincenzo Borghini, a humanist closely involved with both the Accademia Fiorentina and the Accademia del Disegno. Borghini was a frequent collaborator with Giorgio Vasari, who coordinated the work of many Florentine painters and sculptors engaged to realize Borghini's elaborate allegorical tableaux. Borghini explained what he called his *finzione poetica* to Bronzino in a letter, but it is noteworthy that he deferred to the personal judgement of an artist who had also won distinction as a poet: "Do not regard what I am saying if it does not seem to you that it will turn out well; I am doing this only to express my general idea, not to lay down the law. If what I say does not satisfy, then do what you would judge to be best, which will all be approved by me, and I am certain that it will be better than anything I have said."[5] The entire program can be reconstructed from a thorough description in a 1566 pamphlet by Giambattista Cini.[6] ¶ Devoted to the rites of Hymen, the paintings depicted "all of those comforts, pleasures, and desirable things which one is accustomed to look for in a marriage, which gracefully put to flight the displeasing

things and the annoyances." One painting showed the Graces dancing while Youth, Delight, and Beauty embraced Contentment, Jocosity, Happiness, Fertility, and Repose. To the right of this painting appeared another depicting the subject shown in this design: "Love and Fidelity, and once again Happiness and Contentment with Pleasure and Repose, who with lighted torches in their hands were expelling from the world Jealousy, Strife, Care, Pain, Weeping, Deception, and Sterility, as well as other grievous and disagreeable entities that all too often perturb the human soul, and sending them back to the abyss." The painting to the left of the first, for which a design by Bronzino survives in the Louvre, showed the Graces with Juno, Venus, Concord, Cupid, Fecundity, and Sleep preparing the marriage bed along with Pasithea and Talassio, using torches, incense, and garlands, in accordance with the ancient custom. Above the entire group appeared other scenes devoted to Hymen, the marriage god, with an entourage of torch-bearing boys. ¶ Borghini's models were the famous classical epithalamia of Catullus, Statius, and Claudian, although the psychomachia theme of the present design is largely an independent invention by the humanist Borghini. While the term *psychomachia* is appropriate to an allegory in which personified human dispositions war with their opposites, the subject here is not a moralizing confrontation of Virtues and Vices, as is sometimes claimed. It is rather a depiction, unusual in Renaissance imagery, of the triumph of mental and sensual pleasures over the pains and anxieties of body and spirit, especially those that endanger marital harmony. Few of the personalities listed by Cini can be identified in this drawing, but those that can include Cupid, with his wings and arrow, and Deceit, who appears at the centre exposed beneath a fox-skin as it is torn from his head (by Fidelity?). Headdresses with the features of a fox formed part of the costume of the *Inganni* ("Deceptions") in an intermezzo performed following the wedding.[7]

Stephen J. Campbell

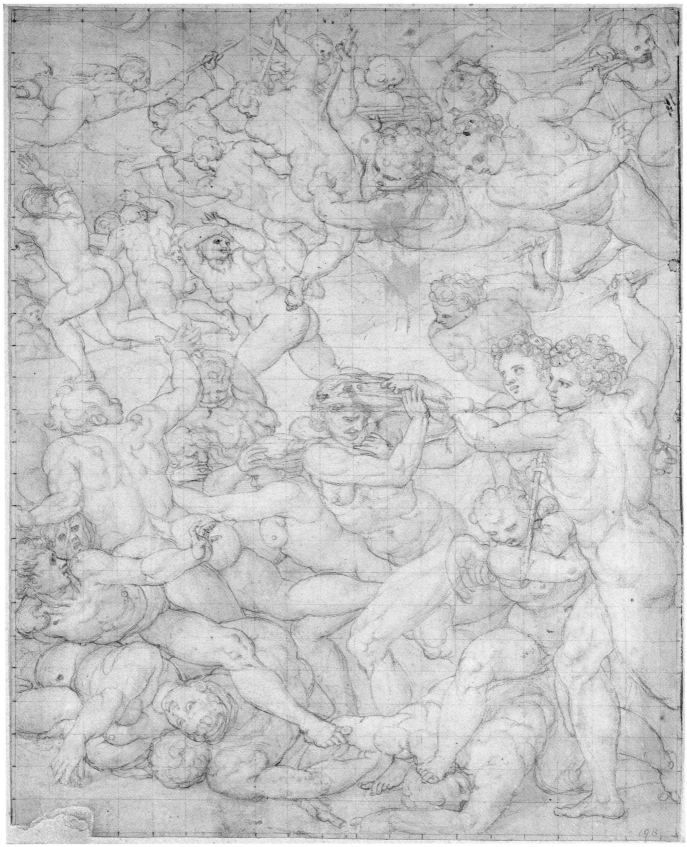

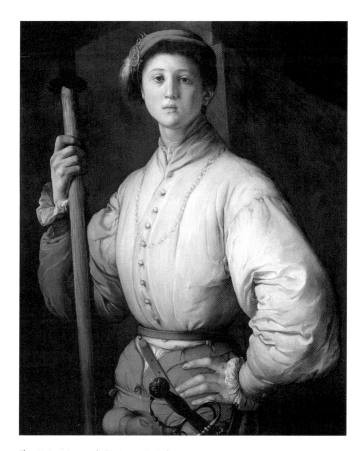

Fig. 81.1 Jacopo da Pontormo, *Portrait of a Halberdier*, 1529–1530, oil on panel, transferred to canvas, 92 x 72 cm
The J. Paul Getty Museum, Los Angeles

Vasari writes that Bronzino painted a cover for a portrait of Francesco Guardi by Jacopo da Pontormo (who was Bronzino's teacher). It showed "Pygmalion praying to Venus that his statue would receive the spirit of life, and, as happened according to the fables of the poets, become flesh and bone."[1] Without Vasari's notice Bronzino's panel might have been taken for an independent representation of this myth, for portrait-covers rarely survive together with the panels to which they were originally attached. By 1644 Bronzino's *Pygmalion and Galatea* was in the Barberini collection in Rome (only to be retrieved for Florence centuries later, after being seized by Hermann Goering), and all trace of the portrait of Francesco Guardi had been lost. In 1612 the *Portrait of a Halberdier*, now in the Getty Museum (fig. 81.1), was identified as a portrait of Duke Cosimo I de' Medici in an inventory of the Riccardi collection in Florence, but many scholars, including the present writer, have determined it to be the missing portrait of Francesco Guardi, a youth of some fifteen or sixteen years, painted at the time of the siege of Florence in 1529–1530. The *Pygmalion and Galatea* is slightly smaller than this portrait, but the difference of approximately 11 centimetres in height and 9 centimetres in width may have been compensated for by a frame. Bronzino's cover must have been for a work on the scale of the Getty portrait. ¶ The provision of portraits with covers, following the practice of framing and covering mirrors with hinged or sliding panels, was fashionable throughout Europe in the fifteenth and early sixteenth centuries. Sometimes covers bore coats of arms, but the connection between cover and portrait often resembled that between the two sides of a medal, in which an allegorical image on the reverse commented ingeniously on the appearance of the figure on the obverse. In this case, too, portrait and cover must have been thematically linked, yet the full implication of the relationship remains enigmatic. In Pontormo's portrait Francesco di Giovanni di Gherardo Guardi stands on guard before the angle of an earthwork fortification, looking out at the embattled territory around San Miniato al Monte that included part of his own inheritance, granted to his father by the republic in August 1529. In Bronzino's composition a bare landscape behind the main figures is punctuated by a handful of dead or dying trees.

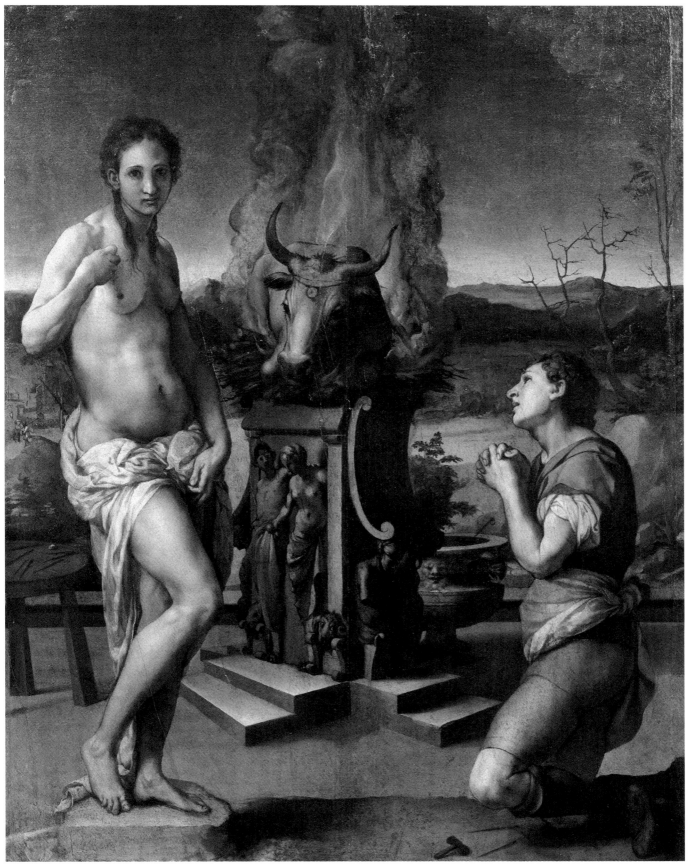

In the distance the sun rises behind the familiar hills surrounding Florence; a few huddled figures are seen to the left, close to a little church surrounded by a wall. In the foreground Pygmalion, whose figure is based on Pontormo's Saint Francis in the Pucci altarpiece in the church of San Michele Visdomini (derived in turn from Dürer), kneels in adoring prayer before the figure of Galatea, whose already living flesh contrasts sharply with the *pietra serena* of the altar behind. She too follows a Pontormo prototype, in this case the figure of Venus in a drawing of *Venus and Cupid*, which makes her apparent physical identification with Venus herself all the more compelling (Uffizi, 341F). ❡ According to Ovid (*Metamorphoses*, 10.238–297), Pygmalion remained celibate because he was disgusted by the carnality of the women of his day. Meanwhile he made of ivory a female figure more beautiful than any in nature, and so perfectly did his art conceal his art ("ars adeo latet arte sua") that the sculptor conceived a passionate desire for his creation. On the feast of Venus, therefore, when heifers with horns covered in gold were sacrificed on altars smoking with incense, Pygmalion prayed that the goddess would give him a virgin *like* his ivory one, although he did not dare request that his idol come alive. Venus made the flames burn brightly in response, and when Pygmalion returned home the ivory became warm flesh in his hands. The painting collapses these events, showing the eventual metamorphosis from idol to living flesh that Pygmalion fears to ask for in his prayer to Venus, as the flames on her altar flare upward around the sacrificial heifer. ❡ Bronzino ornamented the altar with terminal figures of Mars and Venus. Mars places his left arm around Venus's shoulder, thereby implying his embrace of the goddess of peace. Venus, however, proffers to Mars the apple of discord: it was the awarding of this to Venus by Paris that unleashed the Trojan war. In an inscription on the side of the altar that remained unnoticed for centuries Bronzino recorded the enigmatic, lyrical lament, "HEU VI[NCIT] VENUS" ("Alas, Venus conquered"). In this way Bronzino underlined, with great wit, the paradoxical relationship between Mars and Venus in war and peace: war originates in desire, and only ends through submission to that same desire, or, in mythological terms, in Mars's submission to Venus. No wonder the sculptured bucrania look so perplexed!

Pontormo presented the young Francesco Guardi as a new David guarding Florence (the desire for which by opposing forces brought about the siege). On the cover, instead of those weapons of war that have brought about the destruction of the landscape, Bronzino depicted Pygmalion's miniature ivory-carver's hammer. His fine chisels lie on the rough-hewn artist's stool to the left, which stands in sharp contrast to the intricately wrought bronze vessel ornamented with animal heads behind the altar. ❡ In Cinquecento Florence the myth of Pygmalion was inseparable from the theme of artistic *virtù*. In his reply to Benedetto Varchi's inquiry into the relative merits of painting and sculpture, Pontormo defended the superior naturalism and liveliness of figures painted on a plane surface. Varchi, by contrast, refers to Pygmalion's statue, and insists that the ancients worked in relief in order to deceive the viewer more completely. He recognized, nonetheless, that the *Venus and Cupid* drawn by Michelangelo and painted by Pontormo for Bartolomeo Bettini equalled the *Venus* of Praxiteles in its power to arouse physical desire. Varchi's inquiry into the relationship between the arts dates to 1547, but when Bronzino conceived his *Pygmalion and Galatea* he was already making a statement about the perfectly natural figure of Pontormo's portrait, and about the transformation of one kind of desire into another. Like Pygmalion, Bronzino was able to hide art with art itself, expressing the hope that Venus, whose victory in the Judgement of Paris led to war, would now bring peace to Florence. With peace, following Lucretius's invocation to the goddess in the opening lines of *De rerum natura*, comes the flourishing of the arts. Such dedication to the arts of peace, and to *alma Venus*, would be a cornerstone of Duke Cosimo I de' Medici's cultural policies, to which Bronzino contributed his considerable talents.

Elizabeth Cropper

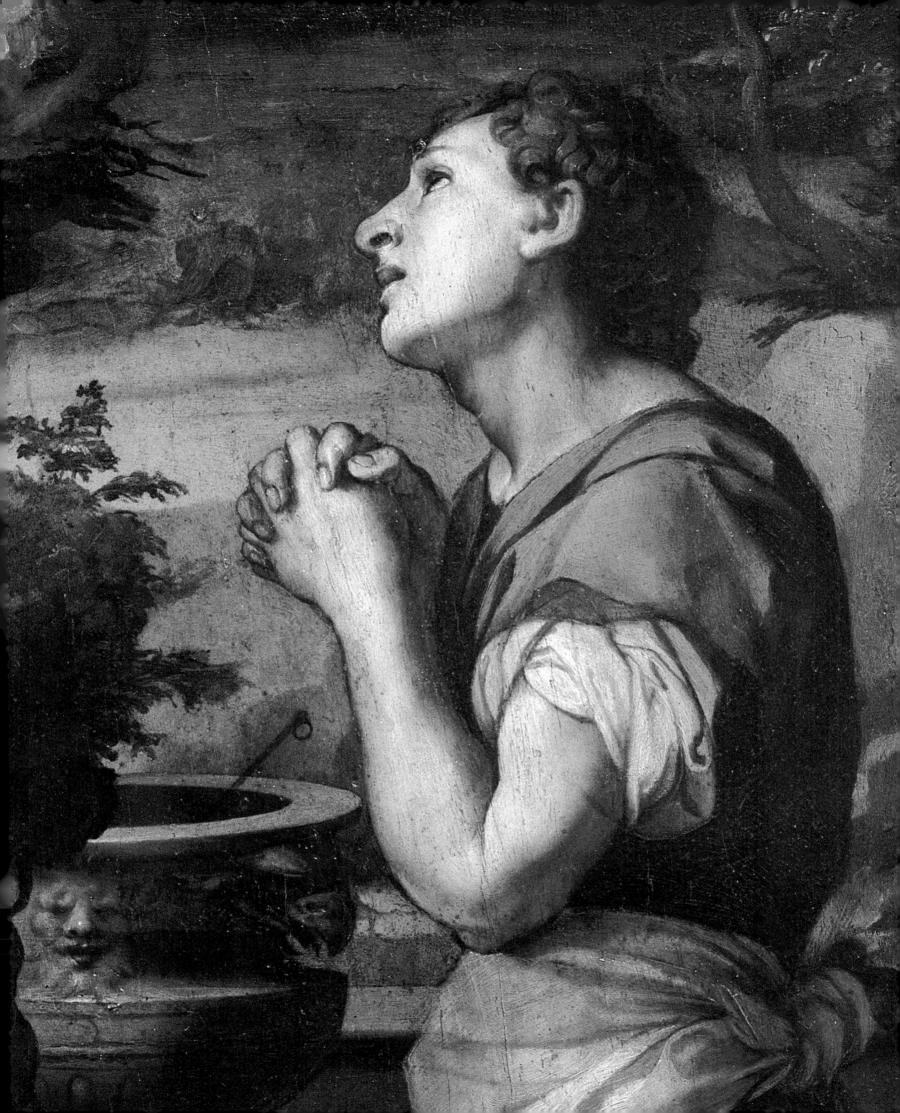

Andrea del Sarto joined the Confraternity of Saint Sebastian in Florence late in life, in February 1529. According to Vasari, he executed a painting of this subject for the confraternity perhaps as his very last work: he died in September of the following year. The painting was presumably made not long after Sarto joined the confraternity, possibly as a pious gesture and without a formal commission.[1] Vasari's account is not very specific, however, and one cannot be absolutely certain that the picture was completed. A version of the painting, which must be assumed to have been the original, is recorded as an altarpiece in the chapel of the confraternity, but by the nineteenth century that panel appears to have been lost.[2] It has been assumed that the painting shown here not only reflects Sarto's original image, but also is the highest-quality version of those that survive, of which nearly twenty have been identified along with numerous later derivations. ¶ This painting is composed in a half-length format and presents a frontal view of Saint Sebastian. With his right hand he holds out in front of his body two arrows tied together – his attribute – while with his left he grasps a palm of martyrdom. The saint was most commonly portrayed as pierced by arrows not to indicate that he was killed by archers but to emphasize his suffering. Glancing heavenward to the source of his inspiration, Saint Sebastian is depicted heroically and almost nude, without any wounds. The conception is notable for its elongated form, as well as for the reduction of colour. The painting is thus conceived more as an icon than as a narrative, as would have been appropriate for a work intended for private devotion or even as a small altarpiece. Saint Sebastian was commonly invoked as a defence against the plague, although he was unable to protect the artist, who apparently succumbed to an epidemic himself in 1530 during the siege of Florence. ¶ A technical examination of this version suggests that it was probably produced in the artist's workshop, and not necessarily after his death in 1530.[3] This reinforces the importance ascribed to this version in the scholarly literature to date. Ironically, considering that the original no longer appears to survive, the image was one of the artist's most popular, and it must have been relatively accessible on the premises of the Confraternity of Saint Sebastian, located near the church of Santissima Annunziata. It had particular appeal for Baroque painters in Florence because of the clarity of its representation and its evident piety. The painting of *Saint Sebastian* by another member of the confraternity, Bronzino, which survives in Madrid (cat. no. 83), pays direct homage to Sarto's picture. Not coincidentally, perhaps, the well-structured claw-like hands and the blue drapery with purple-hued shadows and sharply faceted folds that falls around the figure in the picture shown here clearly anticipate Bronzino's style.

David Franklin

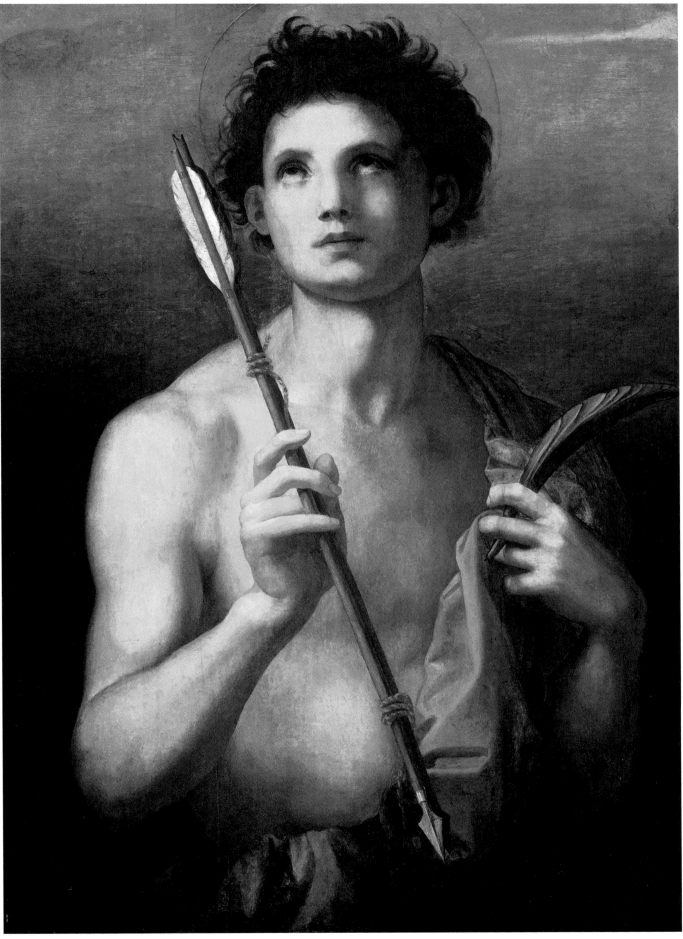

83 AGNOLO BRONZINO (1503–1572) · **Saint Sebastian** · c. 1535 · Oil on panel · 87 x 76.5 cm
Museo Thyssen-Bornemisza, Madrid

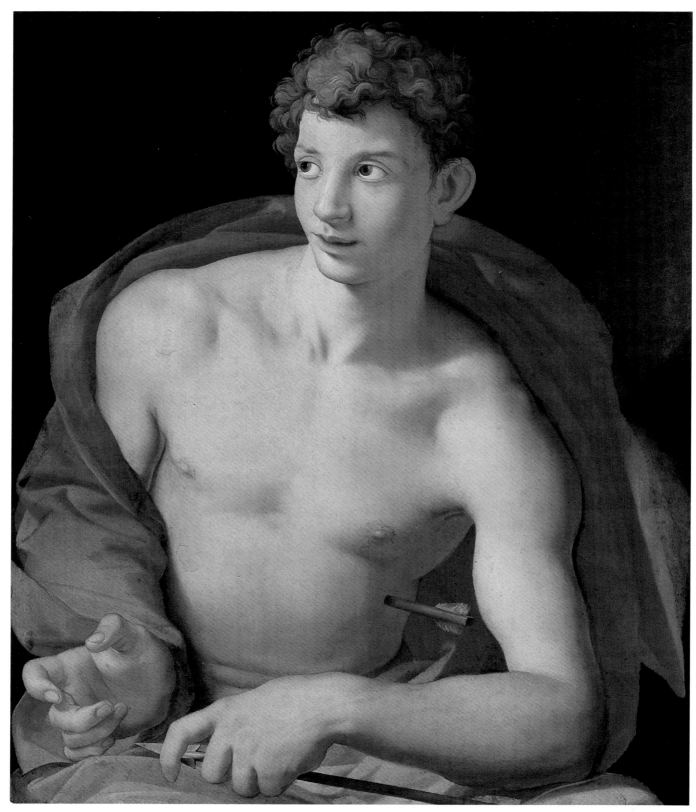

First attributed to Jacopino del Conte by Zeri when it was still in a private collection and in an unrestored state, this recently discovered painting is in fact by Bronzino. This attribution was first proposed by Cox-Rearick, who also noted a preliminary drawing for the work in the Uffizi (fig. 83.1).[1] Bronzino was Jacopo da Pontormo's most talented and devoted follower. Somewhat unusually for two painters of their ability, Bronzino and Pontormo maintained an informal partnership intermittently throughout their lives. There is no clear evidence that Pontormo was involved with the production of this painting, although this cannot be entirely ruled out. The style, interpretation, and pose of the image are developed from the paintings of the *Four Evangelists* in separate tondi in the Capponi chapel in the church of Santa Felicita in Florence, on which the young Bronzino collaborated with Pontormo toward the end of the 1520s. This link suggests that the painting is a relatively early work by Bronzino, although its style is sufficiently refined to allow for a date in the mid-1530s. This dating is supported by the evidence of a drawing in Hamburg (cat. no. 75) whose attribution has alternated between Bronzino and Pontormo. The drawing contains a schematic study of a figure possibly also relating to the Madrid painting and is securely datable to about 1535–1536.

¶ As in the Capponi tondi, the saint in this painting is represented in a compressed way as a seated, half-length figure, strongly projecting from a neutral background like a sculptural relief. He appears to be reacting to something outside the image while loosely holding an arrow in his left hand. Another arrow is visible piercing his naked side. The figure is mostly nude, but some drapery in a symbolic red appears to encircle his back and right arm and lie across his lap. The elegant, youthful figure type with blonde curls is reminiscent of the portrayal of the same saint in Pontormo's *Saint Anne* altarpiece, now in the Louvre, a work commenced during the years of the last Florentine republic (1527–1530).[2] ¶ The recent discovery by the present writer that Bronzino belonged to the Confraternity of Saint Sebastian in Florence is highly significant for an interpretation of this painting.[3] This group was one of the most sophisticated confraternities in Florence and counted several painters among its members in addition to Bronzino, including Andrea del Sarto (who joined late in life), Bartolomeo Ghetti, and Bastiano da Sangallo, the author of the *Cascina* copy now at Holkham Hall (cat. no. 13). Although the first record of Bronzino in the confraternity's account books appeared in 1541, it can be assumed that he had joined prior to that date. Perhaps this work is even connected to his admission as a member.[4] If it was not painted for the confraternity itself, this work was likely executed as an object of private devotion for one of its members. The latter included several prominent Florentine patricians, such as Bonaccorso Pinadori, Francesco da Montevarchi, and Matteo Sofferoni, for whom the painter worked on other occasions.[5] It is known that Sarto's painting of *Saint Sebastian* (see cat. no. 82) was on the high altar of the fraternal church, located behind Santissima Annunziata. Bronzino's painting can be viewed as a response to Sarto's iconic image, and it shares many of the same basic elements. Indeed, this link seems to refute the arguments that the painting may contain a disguised portrait and that it is also homoerotic in intention.[6] Saint Sebastian was invoked as a defence against the plague and was frequently represented in votive images, so one need not look far for inspiration for this commission.

David Franklin

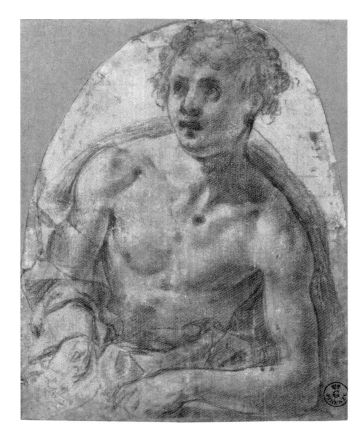

Fig. 83.1 Agnolo Bronzino, *Male Nude*, c. 1535, black chalk, 34.6 x 16.5 cm
Galleria degli Uffizi, Florence (6674F)

84 AGNOLO BRONZINO (1503–1572) · Portrait of Duke Cosimo I de' Medici as Orpheus

c. 1537–1539 · Oil on panel · 93.7 x 76.4 cm · Philadelphia Museum of Art · Gift of Mrs. John Wintersteen

In Bronzino's magnificent portrait, the mythological demigod Orpheus is shown resting the bow of his viol after having calmed Cerberus, the three-headed hound and gatekeeper of Hades. This is the second version of the composition on this panel. Originally Bronzino had painted Orpheus bowing the viol as he quieted the still-baying third head of Cerberus, which is now invisible. In that version Orpheus's cloak, held by a strap, covered more of his back and leg. By making the nudity more visible, Bronzino revealed the source he had employed for the body: the ancient marble fragment known as the *Torso Belvedere*, now in the Vatican. The reason for these alterations, which occurred well after most of the picture had been painted, is not known. ¶ The facial features of Orpheus resemble those of the young Duke Cosimo I de' Medici, although, curiously for a painting of such a famous personage, this work was never copied and seems never to have figured in the Medici collections. Assuming the painting is a portrait of Cosimo, its mythological theme needs to be related to Medici iconography. Cosimo often looked back to family precedents to give a sense of continuity and legitimacy to his regime, and Orpheus had a prominent place in Medici imagery: a statue by Baccio Bandinelli showing the musician after having calmed Cerberus stood in the courtyard of the Palazzo Medici. Commissioned around 1519 by Pope Leo X after the restoration of the exiled Medici to Florence, this work symbolized the peaceful age that the new generation of Medici rulers had hoped to usher in. Following a second exile in 1527, the Medici returned after a brutal siege to claim absolute rule in 1530. Alessandro de' Medici, the first of the Medici dukes, was assassinated in January 1537 and Cosimo became the new duke. His first months of rule were marked by conflict with the exiled republican opposition, and he was able to consolidate his position only after his victory at the battle of Montemurlo in August. If the iconography of the Bronzino painting relates to the Bandinelli statue and its patent affirmation of the Medici as peacemakers, this could explain why the composition was changed during its execution to show the new duke as a figure who had already secured peace. ¶ Forster proposed that Bronzino's painting was made for the July 1539 wedding of Cosimo to Eleonora di Toledo, for which Bronzino is known to have painted a series of celebratory pictures. Although there is no documentation to indicate that this painting served as one of the wedding's ephemeral decorations, it has been accepted in much art historical literature as a marriage portrait, in part because of its overt eroticism. However, the absence of any reference in the painting to Orpheus's wife Eurydice, whom he was to redeem from Hades, somewhat weakens the marriage argument. Moreover, the story is hardly appropriate for a wedding in that Orpheus's desire to look at Eurydice before the couple emerged from the fiery depths meant that he lost her. ¶ Orpheus was not only a peacemaker and devoted husband but also a renowned musician and poet. To depict Cosimo as Orpheus is to suggest that the duke promoted the arts. One of Cosimo's first official cultural acts was the founding in 1541 of the Accademia Fiorentina, an academy devoted to the promotion of Tuscan literature. Among its members was Bronzino, who also wrote poetry. A description of a painting of Orpheus of about this size is found in a house inventory (dating between 1647 and 1659) of Simone Berti, a member of a successor institution, the Accademia della Crusca. The inventory does not mention the name of the artist, nor does it refer to the picture as an allegorical portrait of Cosimo. The Bronzino in Philadelphia is, however, one of the rare examples of Orpheus in sixteenth- and seventeenth-century Florentine painting, and it is possible that Simone had inherited the painting from his father, Giovanni Berti, who was not only a patron of the arts but had in his possession a manuscript of Bronzino's own poetry.[1] Whether or not Simone Berti's painting was the Philadelphia Bronzino, his possession of an image of Orpheus, patron of poets, indicates that the subject appealed to literati. Had the painting been created in conjunction with the ceremonies surrounding either Cosimo's ascension to the dukedom or his marriage, or even the founding of the Accademia, it might, once it had served its original purpose, have become available as a collector's item.

Carl Brandon Strehlke

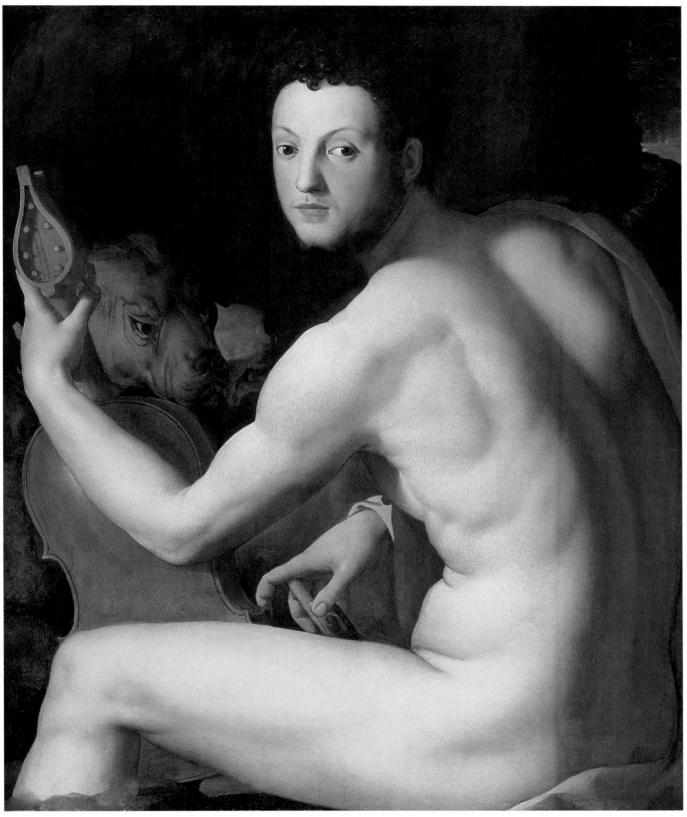

Bronzino, as court painter to the Medici, executed official portraits of Duke Cosimo I and Eleonora di Toledo, as well as more intimate portraits of their children. He also painted portraits of Florentine patricians and of the *virtuosi* favoured by Cosimo. When, in the early years of the twentieth century, this celebrated work by the artist was published while in the possession of the distinguished Berlin collector Eduard Simon, the identity of the sitter was unknown.[1] Some years later the Florentine art historian Luisa Becherucci made a compelling argument for pairing the portrait with one depicting a young woman in the Galleria Sabauda, Turin (fig. 85.1), with which it shares not only its dimensions and an undefined grey background, but also, most notably, the same damask design in the costume.[2] The fact that Eleonora di Toledo had already been named as the subject of that portrait[3] led to the identification of the male portrait as that of Duke Cosimo I de' Medici; this identification is not inconceivable, considering that Cosimo, like the figure in the portrait, had a broad forehead and protruding eyes, but there are valid arguments against it, and it has not found general acceptance.[4] ¶ Recently a document recording the sale of the Ottawa portrait from the Giugni palace in Florence to the dealer Elia Volpi, who in turn sold the painting to Simon, introduced new possibilities as to the identification of the sitter.[5] Simone da Firenzuola, who had commissioned the palace, bequeathed it to his daughter Virginia, the wife of Vincenzo Giugni, and it remained with Giugni descendants until it was sold in 1830.[6] In the early seventeenth century Virginia's son Niccolò Giugni inherited the palace. A senator, a member of the Tuscan order of Santo Stefano, and the first Marchese Giugni, Niccolò married Cassandra Bandini, and judging from the description in Bocchi-Cinelli's guidebook, the collection in the Giugni palace grew considerably through Cassandra's inheritance.[7] As the daughter of Giovanni Bandini, niece of Cardinal Ottavio Bandini, and granddaughter of Pierantonio Bandini and his wife Cassandra Cavalcanti, after whom she was named, Cassandra was principal heir of the Bandini family. Writing about Bronzino, Vasari specifically mentions portraits of Pierantonio Bandini and his wife.[8] Curiously, no previous attempt has been made to trace these portraits. It is proposed here that the Ottawa picture represents Pierantonio and that the one in Turin represents Cassandra. ¶ Following in the footsteps of his father, Francesco Bandini,[9] Pierantonio became one of the wealthiest and most prominent of Florentine bankers in Rome in the second half of the sixteenth century. He enjoyed a privileged position both within the Florentine mercantile community and at the papal court, where he was *depositario* for the College of Cardinals from 1559 to 1591.[10] In addition to the family palace in the banking district, in 1555 Pierantonio acquired a *vigna* with extensive gardens on Monte Cavallo, adjacent to the property that, under Gregory XIII, became the papal summer residence, and it is there the family lived after the 1588 financial crisis, in which the bank's Paris branch collapsed.[11] It was there also that Michelangelo's *Pietà* was kept,[12] and in the inventory of Pierantonio's effects mention is made of fragments of various antique statues in the gardens. The inventory also refers to a number of paintings dispersed throughout the house, including the usual devotional works in the bedrooms, five Flemish landscapes, several topographical views or maps, and numerous portraits, on wood and on canvas, framed and unframed and of various sizes, among which only those of Pierantonio's parents are identified, together with one of Pietro Strozzi.[13] Since names of artists are not quoted, it is impossible to discern whether Bronzino's portraits of Pierantonio and Cassandra were among these, although it is likely that they remained with the sitters until their deaths, at which time the heirs might have chosen to separate the two. It is also possible that the portraits never left Florence but were kept in the Bandini house there.[14] Both Giovanni and the youngest son, the future Cardinal Ottavio, were born in Florence, and on 28 August 1587 Caterina Giustiniani wrote a letter from Rome to her mother-in-law in Florence,[15] which suggests that dwellings may have been maintained in each city. ¶ The portraits are refined in execution, and the figures generously, even sumptuously, fill the space. The air of aristocratic aloofness that characterizes the male sitter is not inappropriate for Pierantonio, whose mother was a Salviati and who, on his father's side, was connected with the Baroncelli. While the portraits are left uncharacteristically empty of references to a city or a landscape with which to associate the subjects, there are enigmatic

elements in the background of each. In the portrait of Cassandra an extravagant curtain of transparent fabric, with green stripes and a fringe, billows out behind her, picking up the colour of the tablecloth in the portrait of Pierantonio, on which, in turn, the blue figure of a *Venus Pudica*, exceptional and striking in its colour, may well refer to Pierantonio's activity as a collector and to the antiquities recorded at his property at Monte Cavallo.[16] ¶ On stylistic grounds the portraits have been dated to a period from 1550 to 1555, which would put Pierantonio (born 1514), in his late thirties, whereas Cassandra, at least a decade younger (born sometime after 1523, the year her parents were married), would still have been in her twenties when she sat for the artist. Bronzino portrays her with unusual warmth, her eyes lively and a smile hovering on her lips, and we sense that, perhaps as a consequence of his own poetic gift, he had a particular sympathy for this descendant of the great Trecento poet Guido Cavalcanti. Further evidence concerning the physical appearance of Pierantonio and Cassandra can be gained by examining the busts on the family tombs in the Bandini chapel in the church of San Silvestro al Quirinale, in the immediate vicinity of their villa (fig. 85.2). In the busts of Pierantonio and his son Cardinal Bandini can be found high, broad foreheads like that of the sitter in the Ottawa portrait, while the distinctly rounded chin line of Cassandra compares well to that in the Sabauda portrait.[17]

Catherine Johnston

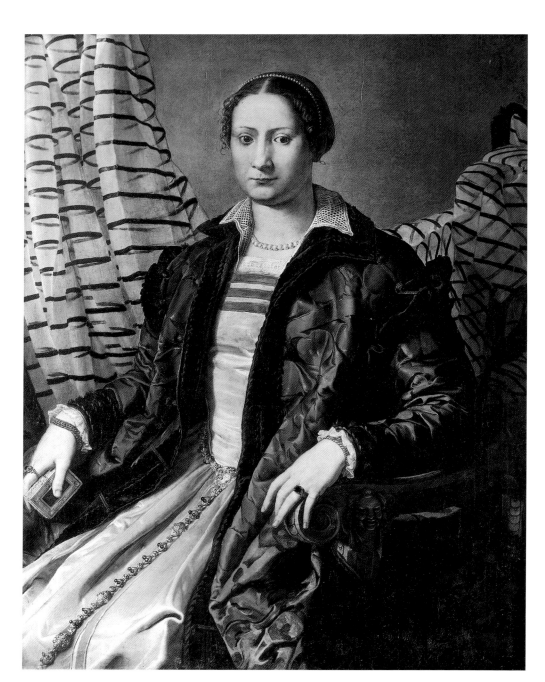

Fig. 85.1 Bronzino, *Portrait of a Woman* (here identified as Cassandra Cavalcanti), c. 1550–1555, oil on panel, 109 x 85 cm. Galleria Sabauda, Turin

Fig. 85.2 Giuliano Finelli, *Funerary Busts of Pierantonio Bandini and Cassandra Cavalcanti*, marble sculpture Church of San Silvestro al Quirinale, Rome

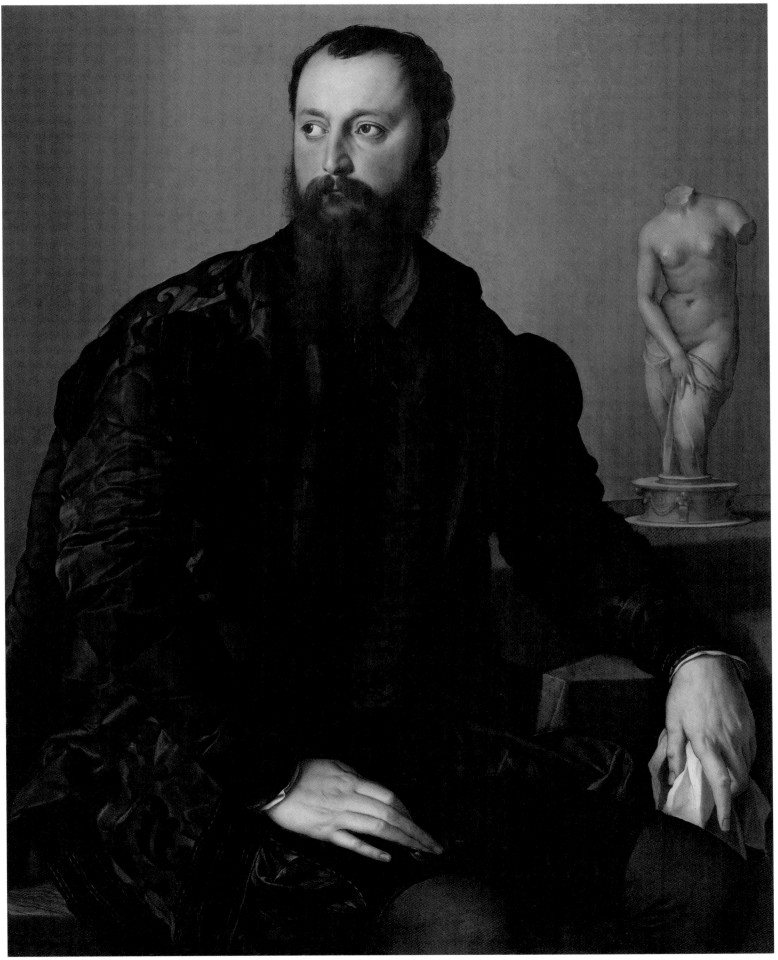

The *Young Man with a Lute* and its probable pendant, the *Old Man with a Skull* in the Staatliche Kunstsammlungen in Kassel (fig. 86.1), may well be allegories of youth and old age, as Scharf first proposed in the 1930s.[1] The connection between the two paintings is expressed through matching symbols and related inscriptions that form paired allegorical representations, one referring to youth and love, the other to senescence and death. Each displays a central personification before a landscape, a common portrait format in early sixteenth-century Italian art. This has prompted a few scholars to attempt identifications of the sitters.[2] However, while some allegorical paintings contain portraits, the faces of both the young man and the old one are schematic rather than highly individualized. Unfortunately, the original patron, function, and location of the two paintings remain unknown. ¶ The young man sits on a stone parapet, wearing Florentine garb first popular in the late fifteenth century: a small cap (*beretta*) and a long, red, beltless overgown (*cioppa* or *veste*) over a blue doublet (*farsetto*).[3] The blue sleeves of the doublet protrude from arm slits in the overgown and the white shirt (*camicia*) is pulled through the elbows of the doublet. The young man plays a lute with six courses of strings, presumably engaged in a Renaissance courting ritual.[4] Symbols of youth appear on either side: a vase of fresh cut flowers on the left and a full hourglass on the right. The edge of the parapet upon which the hourglass rests bears an inscription in gilt letters from Ovid's *Art of Love* (3.65): "Time flies on swift feet." This famous motto of fleeting youth and love accords with the lute player's nostalgic costume and melancholic air. The parapet in the Kassel *Old Man with a Skull* displays a spent hourglass and the preceding line from the *Art of Love*: "The hour passed cannot return."[5] ¶ At the left edge of the *Young Man with a Lute* a parade cart crowned by Cupid and drawn by rearing horses represents the triumphant power of love. The image is based on a fifteenth-century print of Petrarch's *Triumph of Love* (fig. 86.2). A quotation from another print in the same series, the *Triumph of Death*, appears in the identical position in the Kassel *Old Man with a Skull*.[6] The rest of the landscape in the *Young Man with a Lute* illustrates some of love's more troubling aspects. Beneath the Triumph of Love, at the left, Delilah shears Samson's hair – certainly a reference to love's ability to sap men's strength. In the right background, Apollo embraces Daphne as she turns into a laurel tree – a nod to unrequited love. Fortunately, the vase in the foreground offers a measure of symbolic relief. It contains jasmine (*Jasminum officinale*) and cornflowers (*Centaurea cyanus*), which represent divine love and the healing of wounds.[7] ¶ The principal background elements derive from sources in Florentine and Netherlandish art on the same theme.[8] Samson and Delilah are inspired by Lucas van Leyden's engraving of the subject. Nonetheless, the head of Delilah and her elaborate hat with ear flaps transcribes (in reverse) one of Michelangelo's drawings of a *testa divina*.[9] Apollo and Daphne derive from the same pair in the background of Perugino's *Triumph of Chastity* in the Louvre.[10] Finally, the distant peaks recall similar mountains in the background of Lucas van Leyden's engravings of the *Prodigal Son* and *Calvary*.[11] The expansive landscape background evokes the Netherlandish paintings popular in Italy since the mid-fifteenth century.[12] ¶ The saturated bright colours, wide landscape, and numerous quotations culled from paintings, prints, and drawings by both Italian and northern European artists are all hallmarks of Bachiacca's cosmopolitan style. Arthur McComb, Joan Caldwell, Lada Nikolenko, and others have dated the *Young Man with a Lute* to about 1522–1525. Its monumental appearance and elaboration upon the above-mentioned sources, however, belong to a slightly later stage of stylistic development than the *Saint Achatius* predella in the Uffizi (1521) and the Benintendi *spalliera* panels in Berlin and Dresden (1523). It therefore seems more reasonable to date the New Orleans painting, with its pendant in Kassel, to the second half of the decade, probably between the time Bachiacca joined the painter's confraternity (the Compagnia di San Luca) in 1525 and his matriculation in the painter's guild (the Arte de' Medici e Speziali) in 1529.[13]

Robert G. La France

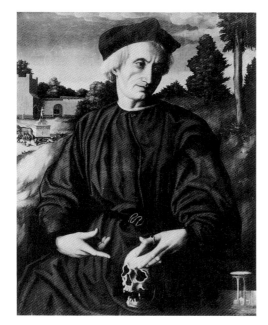

Fig. 86.1 Bachiacca, *Old Man with a Skull*, c. 1525–1529, oil on panel, 98.2 x 73.3 cm. Staatliche Kunstsammlungen, Kassel

Fig. 86.2 Florentine, 15th century (Francesco Rosselli?), *The Triumph of Love*, engraving, 26.2 x 17.2 cm. Hind 1938–1948, vol. 3, no. 191

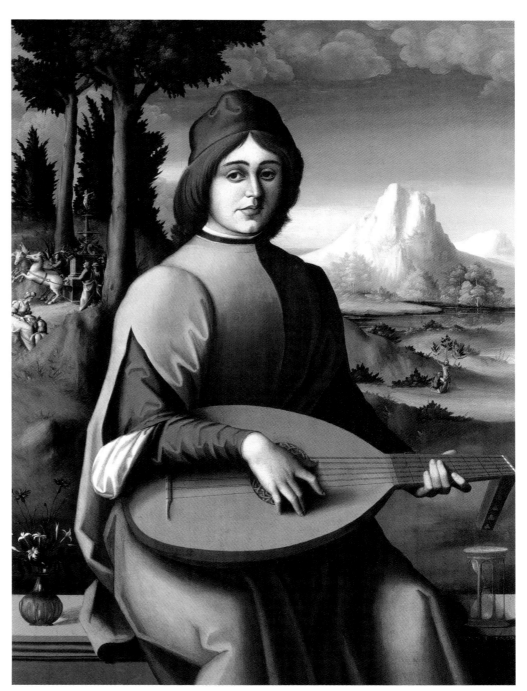

The *Woman with a Music Book* beautifully illustrates Bachiacca's role as painter, costume designer, and proto-scientific illustrator at the court of Duke Cosimo I de' Medici from about 1540 to 1557. Although once mistakenly thought to be by Bachiacca's younger friend and colleague Bronzino, Berenson identified Bachiacca as the author of this painting while it was still at Cornbury Park, Oxfordshire.[1] Indeed, the painting mimics elements of Bronzino's successful female portraits while demonstrating all the characteristics of Bachiacca's personal style and particular talents.
¶ Bachiacca's work draws upon a number of Bronzino's portraits, especially the acclaimed *Lucrezia Panciatichi* in the Uffizi (fig. 87.1), and quite likely the still unidentified *Woman and Child* in the National Gallery of Art in Washington. In comparison, the *Woman with a Music Book* shows Bachiacca's greater interest in subsidiary details, such as the headdress, sleeves, flowers, and tablecloth. Yet these were critical signifiers of class, status, and taste to Renaissance eyes. Bachiacca lavished his attention on the sitter's trappings, revealing his (and his family's) expertise in costume and tapestry design, embroidery, and zoological and botanical illustration. Francesco Bachiacca, "the court painter," and his younger brother Antonio, "the court embroiderer" (also called Bachiacca in documents), were actually multi-media artists and producers of a variety of luxury objects that enhanced the appearance of the Medici court.[2] ¶ Compare, for example, Lucrezia Panciatichi's dress, accoutrements, and setting with those of Bachiacca's *Woman with a Music Book*. Both ladies sit in armchairs and turn to our left (note how the dress of Bachiacca's sitter drapes over the chair arm); they wear similar red-pink silk dresses, cinched at the waist, with fine fabric partlets covering their otherwise exposed shoulders and fancy attached sleeves. Both hold books. As befitting the wife of a wealthy merchant, Bronzino's Lucrezia displays a jewelled belt, heavy gold necklaces, and fine silk clothes. Bachiacca's singer, certainly of lesser wealth and probably lower social status, is less expensively – if not less elaborately – outfitted. Whether the clothes were the sitter's own or studio props, the painter relished the pictorial challenges of her rich wardrobe. He embellished her overdress (*camora*) with an embroidered neckline and hemline and accented her modest

décolletage with a striped partlet. She sports a stylish blue sash with a gold pattern, knotted at the waist, and a pair of fine gold chains. She also wears the *balzo*, an elaborate rolled headdress.[3] Her most outstanding fashion accessories, however, are the puffed upper sleeves to which exquisite fur-lined and slashed lower sleeves are attached – garments often targeted by contemporary sumptuary laws.[4] Bachiacca's skill at painting elaborate and inventive costumes proved useful at court, as he and Antonio, joined by their *garzoni* (including his nephew "Baccino"), created masks and costumes for a Medici-sponsored carnival celebration in Piazza Santa Croce in 1546.[5] ¶ In addition, Bachiacca also served Duke Cosimo as an illustrator of plants and animals, a vocation also evident in the *Woman with a Songbook*. For example, the polished alabaster vase in the background displays carefully articulated pink roses (*Rosa centifolia*) and white dog roses (*Rosa canina*). An embroidered frieze of birds adorns the tablecloth in the painting's lower-left corner – an area often reserved for an artist's signature. In place of his name, Bachiacca painted each bird with a fidelity to nature that permits identification. On the left, the white, grey, and black bird with short beak and long tail is probably a great grey shrike (*Lanius excubitor*), a bird frequently found in Tuscany and commonly called in Italian the *averla maggiore*.[6] The next bird, predominantly blue in colour and depicted about to land, may be a blue tit (*Parus caeruleus*), called in Italian the *cinciarella*.[7] The third example, the brown bird with a short tail perpendicular to its body, is a common wren (*Troglodytes troglodytes*), or *scricciolo* in Italian.[8] Finally, a golden oriole (*Oriolus oriolus*), *rigogolo* in Italian, is folded into the tablecloth's corner.[9] These same birds appear in the borders of Bachiacca's tapestries, such as the *Grotesque Spalliere* and the series of *Months* (designed between 1545 and 1552), as well as in the fragments of Bachiacca's ruined murals for Duke Cosimo's *scrittoio* (c. 1542) on the mezzanine of the Palazzo Vecchio in Florence.[10] ¶ Despite his many skills, there is no clear indication that Bachiacca read music. The songbook appears to be of a format not produced after the 1520s, and the lines remain unidentified – partly because the artist obscured important elements of musical notation with the sitter's hands.[11] But the predominance of songbirds (passerines) in the tablecloth, given

their nature and habits, points to a love song. The blue tit is known for its varied, pleasant song, the wren for its fearlessness and affection for humans, the golden oriole for its love of sweet fruit, and the shrike for its gruesome practice of piercing its insect prey on thorns. As a group, the birds may represent aspects of love. ¶ The identity of the singer remains unclear. Burton Fredericksen traced the painting's provenance to the collection of the noble Frescobaldi family, noting that the sitter was associated with Lucrezia Frescobaldi, a poet and singer active at the Medici court after 1555.[12] The *Woman with a Music Book*, however, belongs to an earlier moment. The painting was probably painted in the early to mid-1540s, after Bronzino's *Lucrezia Panciatichi* and during the period in which Bachiacca imitated Bronzino's bright lighting and crisp contours, but before he began to employ darker backgrounds and less ostentatious dress. However, further investigation of the life and career of Lucrezia Frescobaldi could conceivably reveal a substantially more precocious career and corroborate the old association.

Robert G. La France

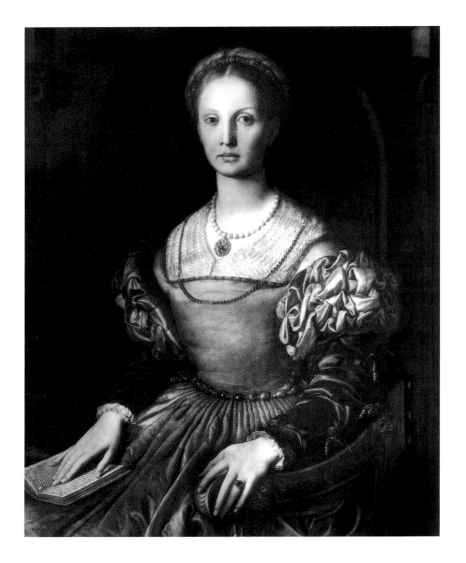

Fig. 87.1 Agnolo Bronzino, *Portrait of Lucrezia Panciatichi*, c. 1540, oil on panel, 102 x 85 cm. Galleria degli Uffizi, Florence

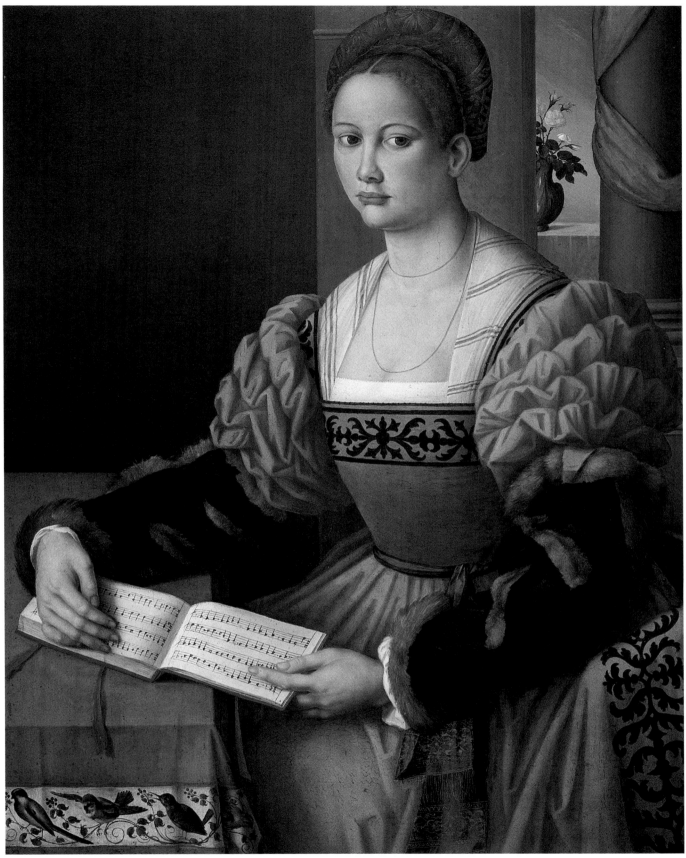

Although the precise circumstances of its commission are unknown, the Pittsburgh *Madonna* is a private devotional painting of a subject and type displayed in the homes of Italian patricians in the fifteenth and sixteenth centuries. The high polish, jewel-like colour, and flashes of gold contribute to the painting's rich appearance. It would easily have held its own amid the array of luxury items that decorated Florentine interiors – from gold and silver plate, gilt and painted furnishings, tapestries, embroideries, and majolica.[1] ¶ Owing to its fine state of preservation, the Pittsburgh panel may provide the clearest idea of the intensity and range of Bachiacca's palette. The artist layered transparent oil glazes to clothe the figures of the Virgin and Saint Elizabeth in saturated blue, pink-red, yellow, and violet. Oil glazes are also responsible for the diaphanous quality of Saint John's tunic. Bachiacca employed intense, contrasting hues, or shot colours, for the yellow-orange to chartreuse lining of the Virgin's mantle and the powder-blue to lavender veil tied around her neck. He further adorned the surface with gold-leaf haloes, a practice the artist maintained throughout his career. ¶ The Pittsburgh *Madonna* is the culmination of a series of similar paintings based on a composition by Fra Bartolommeo.[2] As Merritt observed, the figures of the Virgin and Child in Fra Bartolommeo's unfinished *Saint Anne* altarpiece, begun in 1510 for the Sala del Gran Consiglio of the Palazzo della Signoria and transferred by Duke Cosimo I de' Medici to the church of San Lorenzo in 1540, are probably the artist's immediate source.[3] Bachiacca first experimented with these same figures by Fra Bartolommeo in an early drawing in the Uffizi and a small painting formerly in Asolo.[4] As the son of a gold-smith, Bachiacca often relied on small designs that he expanded into larger works. Indeed, his small Uffizi drawing and his Asolo painting supplied the compositional pattern for four much larger paintings of the Virgin and Child with Saints Elizabeth and John the Baptist: one formerly owned by Count Niccolini in Florence; a second in the museum of the Arciconfraternità della Misericordia, also in Florence (fig. 88.1); a third, unpublished painting now in Moscow (fig. 88.2); and the fourth – the best-preserved – the present painting in Pittsburgh.[5] A comparison between Bachiacca's Uffizi drawing and the subsequent Florence, Moscow, and Pittsburgh paintings reveals an increasing monumentality of form, due probably to further study of Fra Bartolommeo's model and to close contact with Andrea del Sarto. ¶ Not all of Bachiacca's sources for the Pittsburgh *Madonna* are Florentine, or even Italian. Bachiacca collaborated with Andrea del Sarto from 1515 through the 1520s, when northern European prints – particularly those by Lucas van Leyden and Albrecht Dürer – circulated among Sarto's close colleagues, including Pontormo and Franciabigio.[6] While many Florentine artists adapted individual figures, poses, costumes, and landscape elements from foreign prints to enliven their work, few would continue to do so as liberally or as long as Bachiacca. In the case of the Pittsburgh painting, it is not surprising to observe that the background hill and trees derive from Lucas van Leyden's engraved landscapes, while two of the shepherds are more literally transcribed from Lucas's *Beggars* (Bartsch 143), one of Bachiacca's favourite print sources. ¶ A final comparison between the Pittsburgh panel and the Misericordia version reveals a significant alteration of style in addition to minor variations in clothing and a greater weightiness of form. The figures in the Pittsburgh work radiate light received from a powerful source of illumination emanating from the left, while the background is dimmed but visible through the crystalline air. These light and atmospheric effects combined with a more sensitive rendition of surface detail (ranging from Saint John's soft, spotted fur to the marble-like flesh and the Christ child's golden curls) recall Bronzino's portraits of the early to mid-1540s – particularly those of Bartolomeo and Lucrezia Panciatichi (fig. 87.1). Bachiacca and Bronzino, the younger of the two by nine years, were close friends and colleagues at the court of Duke Cosimo I de' Medici from 1540 until Bachiacca's death in 1557. As a demonstration of their friendship, Bronzino included a portrait of Bachiacca next to his own in the *Descent into Limbo* of 1551.[7] It appears likely that Bachiacca imitated Bronzino's extremely successful style of the 1540s in the Pittsburgh *Madonna*.

Robert G. La France

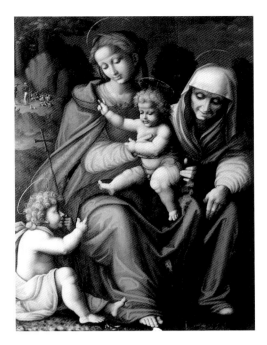

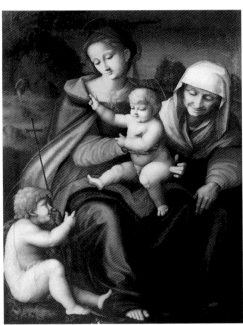

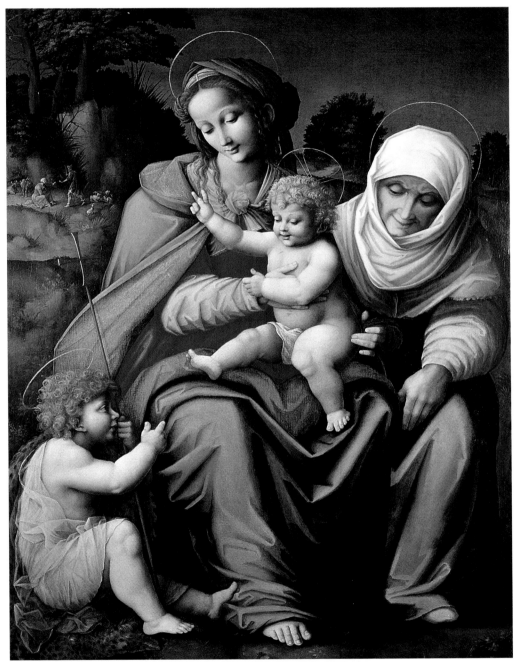

Fig. 88.1 Bachiacca, *The Virgin and Child with Saints Elizabeth and John the Baptist*, c. 1530, oil on panel, 119 x 90 cm Museo dell'Arciconfraternita della Misericordia, Florence

Fig. 88.2 Bachiacca, *The Virgin and Child with Saints Elizabeth and John the Baptist*, c. 1535, oil on panel, transferred to canvas, 120 x 87.5 cm. Private collection, Moscow

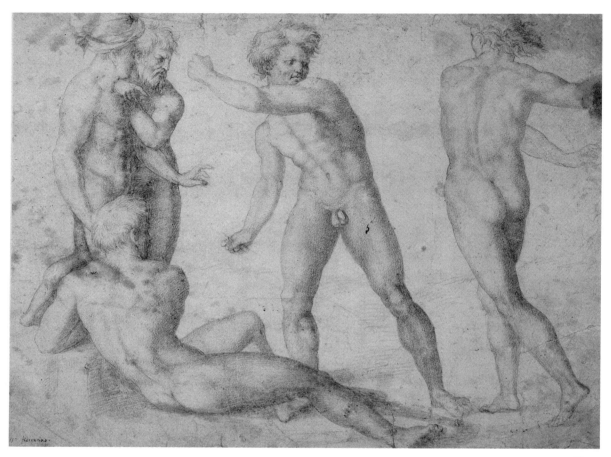

89

Fig. 89.1 Baccio Bandinelli, *Leda and the Swan*, c. 1510–1511, oil on panel, 128 x 101 cm. Collection du Rectorat, Université de Paris-Sorbonne, Paris

Fig. 89.2 Baccio Bandinelli, *Study for the Betrothal of the Virgin*, 1512, red chalk, 27.8 x 29.8 cm. British Museum, London (inv. Pp.1-60)

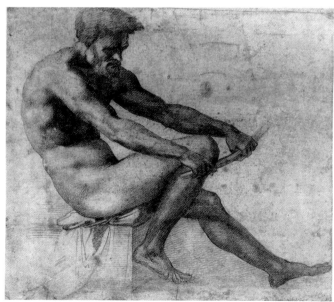

Vasari reports that even as a teenager Bandinelli was spurred by a desire to emulate Michelangelo's fame as a painter and sculptor, "convinced that he should not only compete with Buonarroti, but surpass him in both professions."[1] One of the earliest outgrowths of this interest in painting, we are told, was a cartoon depicting the Aetolian princess Leda embracing her twin sons Castor and Pollux as they emerged from their eggs. Although the original *Leda* cartoon mentioned by Vasari has not survived, a picture undoubtedly based on it – and quite probably painted by Bandinelli himself – was identified by Pouncey, on the basis of its similarities to autograph drawings by the artist. The whereabouts of the painting remained unknown from the time of its 1907 sale in Rome until its recent rediscovery in the Rectorat of the Sorbonne (fig. 89.1).[2] The present drawing – undoubtedly one of the earliest surviving sheets by Bandinelli – served as a model for the group of male nudes in the picture's middle ground at the right. ¶ The London study is a compendium of allusions to a variety of works both ancient and modern. The motif of the boxers – if not their precise poses – recalls Marco Dente's engraving of the pugilists Entellus and Dares, based on a design after Raphael or Giulio Romano, after an antique relief now in the Vatican.[3] More specifically, the pose of the combatant who faces us is clearly inspired by the antique *Horse Tamers* of Monte Cavallo in Rome,[4] while his companion seems to reproduce a lost figure drawing by Michelangelo, known from numerous copies, which was perhaps made as a preparatory study for a never-executed depiction of the *Martyrdom of the Ten Thousand*.[5] The reclining figure with his back to the viewer is based on antique river gods like the *Marforio*.[6] Bandinelli was obviously fascinated by the figures in the British Museum drawing, for he recycled at least two of them later in his career. The reclining figure was reused, with slight modifications, for an executioner in his *Martyrdom of Saint Lawrence* of 1526 (cat. no. 91), and the boxer on the right reappears in the marble *Flagellation* carved for Pope Clement VII (cat. no. 95). ¶ Evidence for dating the *Leda* and its related drawings depends, in part, on a number of clues from Vasari. In his biographies of Bandinelli and Andrea del Sarto, Vasari writes that in order to learn the technique of oil painting Bandinelli commissioned a portrait of himself from Sarto, with the idea that he would secretly observe the older master's technique and that Sarto, growing wise to the ruse, foiled his plan. Subsequently, we are told, Bandinelli turned to his contemporary, Rosso Fiorentino, for help in learning to paint. Beginning with a suggestion by Pouncey, scholars have inferred from this a dating of 1516–1517 for Bandinelli's attempt to learn painting from Sarto, and thus for the painted *Leda*. There is good reason, however, for dating the Sarto incident and the *Leda* several years earlier than usually supposed. ¶ Vasari's accounts of this period are chronologically vague and, apparently, contradictory. Both the 1550 and 1568 versions of the Life of Sarto relate that Bandinelli played his trick on Sarto "in quel tempo" ("in that time") when the latter was working on his second campaign of frescoes in the Chiostro dello Scalzo.[7] But the antecedent to "in quel tempo" is a paragraph that sweeps together about four years of Andrea's activity in the Scalzo, from the *Charity* (generally dated to about 1513) to the *Baptism of the Multitude* (paid for in July 1517). Because Vasari mentions the Bandinelli incident just after the end of this paragraph, Pouncey and most subsequent scholars have assumed that it took place around 1517; but the writer's vague phrase "at that time" could obviously apply just as well

to any part of the period discussed in the paragraph that leads up to it – that is, from about 1513 to the summer of 1517. ¶ In the Life of Bandinelli, on the other hand, Vasari's description of the *Leda* and his account of the artist's endeavours to learn from Sarto and Rosso are immediately preceded and followed by references to the Medici's return to Florence in September 1512.[8] Given the particularly erratic chronology in the Life of Bandinelli, the references to this watershed year may serve merely as a rough signpost for grouping a long sequence of works and events (of whose precise order the writer himself was sometimes less than certain). But a reading of Vasari's two biographies together does suggest an earlier alternative to the dating of 1516–1517 usually offered for the *Leda*. ¶ Comparison of the British Museum drawing with a touchstone of Bandinelli's graphic oeuvre – the beautiful red-chalk study made for his Santissima Annunziata *Betrothal of the Virgin*, commissioned around the beginning of 1512 (fig. 89.2) – seems to argue definitively for an earlier dating. While the two drawings share certain features characteristic of Bandinelli's early style – a fine, thin contour outline, the use of fine cross-hatchings to construct delicately modulated shadows, and a suffused treatment of light – in the drawing for the *Leda* the outlines are perceptibly more hesitant, rarely changing in thickness or tension, and the modelling lacks the three-dimensionality and the organic relationship with the outlines visible in the study for the *Betrothal*. In the latter one can clearly see the artist's more articulate handling of anatomy – apparent if one compares the torso of the boxer facing the viewer in the *Leda* group, with its listlessly meandering outline and stylized musculature, to the rhythmic, flowing forms of the *Betrothal* figure's abdomen, arms, and shoulders. In the *Leda* studies Bandinelli restricts himself to a fairly limited gamut of light and shade, and the cross-hatching does not follow the topography of the body, but in the study for the *Betrothal* the range of values is increased, and hatching begins to follow and define the planes of the figure. The degree of technical development separating the masterly study for the *Betrothal* of early 1512 from the more awkward and hesitant studies employed for the *Leda* seems to urge a dating of about 1510–1511 for the latter. The *Leda*'s boldly novel design, the eclectic aggregation of its figural borrowings, and the partially assimilated Leonardism combine all the merits and vices one might expect at this time from the work of Bandinelli, an ambitious young artist still searching for his own individual means of expression.

Louis A. Waldman

This magnificent pen-and-wash drawing records a fairly advanced stage in Bandinelli's process of designing his *Martyrdom of Saint Lawrence*, a composition that was originally planned as a fresco for the high altar of the church of San Lorenzo in Florence but was carried out instead as an engraving by Marcantonio Raimondi (cat. no. 91). Although the Louvre study is proportionally wider than the engraving, the essential form of the architectural "stage" – a raised central recess flanked by two-storeyed wings – has already been worked out. The treatment of the architecture in Bandinelli's drawing is characteristically simple and schematic, and marked by solecisms – such as the ionic pilasters on the ground floor that support no architrave – that must have struck contemporaries as bizarre.[1] One cannot help suspecting that the refined Bramantesque details of the architecture in the engraving may be largely due to the intervention of Raimondi himself. ¶ In the Louvre drawing, the general pose of Saint Lawrence has also been established – though in its early state the saint's gesture more literally reflects its source, Michelangelo's *Adam* on the Sistine Chapel ceiling. In the Louvre drawing, the saint reclines upon a kind of wide-mouthed oven; this was replaced in the final composition with the more traditional iron grate. Bandinelli has determined the general disposition of the rest of the figures, but their specific poses differ from those in the final print. As in the engraving, the executioners on either side stand erect, while those in the middle crouch, out of the way of the seated group on the level above. At the lower left we see a figure who has fallen while carrying a basket of coal or tinder; in the print, this motif has evolved into the reclining figure of a turbaned man (now at the lower right) who, apparently refusing to co-operate in the execution of the saint, is himself being killed by a Roman swordsman. The arrangement of the "upstairs" specta-tors in the drawing has an appearance of studied haphazardness, with figures climbing over the balustrade at the left and right in order to get a better view of the martyrdom; Bandinelli ultimately deleted these figures, giving the group of spectators a more restrained arrangement, which contrasts starkly with the violent postures of the executioners below them. ¶ The technique of the Louvre drawing is unusual in Bandinelli's oeuvre. Here the draftsman almost completely eschews the cross-hatching that is a hallmark of his style and instead lets his brush do the work of cre-ating shadow and modelling form. The broad areas of wash enable him to organize his large, proscenium-like space into individual zones demarcated by varying degrees of shadow. The use of pen and wash, employed often by Raphael for compositional studies but rarely by Bandinelli (and only during the first half of his career), can perhaps be linked to the fact that the artist was at work on a

painting commission. It also adds an element of finish to the image, which was likely a *modello* made for the patron's approval. ¶ The importance of the Louvre drawing is magnified by the fact that it is one of only two surviving studies for the *Saint Lawrence* composition. The only other extant autograph drawing postdates the Louvre sheet; it is a pen-and-ink study for the running nude executioner at the extreme left in the final print (fig. 90.1).[2] Ciardi Dupré identified several drawings as studies for the print, but none of these works has much claim to the autograph status she would grant them.[3] One of these, a faithful red-chalk drawing of the whole composition (fig. 90.2), has been accepted as an auto-graph study by most scholars, though it is demonstrably a copy.[4] Its literal reliance on Raimondi's print, along with its heavy outlines, blurred modelling, stringy drapery folds, and crude shorthand faces, reveals that it is certainly the work of a feeble copyist. Moreover, it is difficult to accept Ward's view that an "exact corre-spondence in technique and style" implies that the pen-and-wash drawing in the Louvre and the red-chalk drawing in Munich are "companion pieces." These doubts also militate against his corol-lary – and iconographically problematic – hypothesis that the actual subject of the Louvre sheet is *Lycias Condemning Cosmas and Damian to Death*.[5]

Louis A. Waldman

90

Vasari relates that shortly after Bandinelli completed his marble copy of the *Laocoön* in 1525 Pope Clement VII conceived a plan to have the artist fresco the side walls of the high altar of the church of San Lorenzo in Florence. These paintings were to depict the family's patron saints, Cosmas and Damian, on one side, and the Martyrdom of Saint Lawrence on the other.[1] Bandinelli's frescoes were never realized, but Vasari records that the artist produced a series of designs for them, culminating in the drawing (now lost) that is reproduced in Raimondi's engraving. ¶ According to accounts given by the early Church Fathers, Pope Sixtus II, before being executed during the persecution of the emperor Valerian in 258, had entrusted the Roman deacon Lawrence with the treasure of the Church. Lawrence refused to hand over the Church's treasure to the emperor, and as a result Valerian had him imprisoned, tortured on a grill, and finally beheaded.[2] Though Saint Lawrence had long been the patron of the Medici's family church in Florence, one cannot help suspecting that Clement's decision to commission a fresco of this subject was related to the political rivalries between the pope and Charles V, which would culminate in the Sack of Rome in the spring of 1527.[3] ¶ Although Raimondi's engraving is usually dated to about 1525 on the basis of its position immediately after the *Laocoön* in Vasari's chronology, there is good reason to assign it to the following year. As noted by Reiss, the fresco was probably connected to Clement's plan to commission tombs in the San Lorenzo presbytery for himself and Leo X from Michelangelo.[4] Around this period the pope also considered ordering Michelangelo to fresco the walls, as letters written in February 1526 by the pope's agent Giovanni Francesco Fattucci reveal.[5] ¶ It must have been within only a few months of this date that Clement decided to give the project not to the overburdened Michelangelo but to his rival. Vasari explicitly states that Bandinelli produced his designs for the *Martyrdom of Saint Lawrence* in Rome.[6] Since the artist's return to Florence can be dated to between late October 1526 and the end of the year,[7] Bandinelli's fresco commission, and the execution of Raimondi's engraving deriving from it, can be dated securely to between February 1526 and the end of the same year. ¶ Bandinelli never executed either of the San Lorenzo frescoes planned by Clement VII. It is likely that the project was abandoned by mutual consent, as around this period the pope ordered Bandinelli to begin carving the block that later became the *Hercules and Cacus*. But Vasari states that Bandinelli's finished preparatory drawing for the fresco depicting Saint Lawrence pleased the pope so much that he arranged for Raimondi to engrave it. ¶ According to Vasari, the engraver made several changes to the composition of Bandinelli's *Saint Lawrence*; when

the artist saw these he complained bitterly to the pope that the engraver had introduced errors into his work. Clement ignored these complaints, realizing "not only that Marcantonio, with great *giudizio*, had not committed errors, but that he had corrected many made by Bandinelli, and those of no small importance, and that he had demonstrated more skill in engraving than Baccio in drawing."[8] The basis of Vasari's story may lie in two differences between the rare first state of the print, exhibited here, and the final version (fig. 91.1). In the first state the turbaned executioner facing Saint Lawrence holds a forked staff in his right hand; Raimondi eliminated it in the second state and lengthened the handle of the fork in the left hand, with which the executioner jabs the expiring saint. ¶ In a letter of 1549 the Florentine writer Anton Francesco Doni described the *Martyrdom of Saint Lawrence* as one of the gems of his collection,[9] and it has been admired, ever since its creation, as one of the outstanding monuments in the history of Renaissance printmaking. The largest of all Raimondi's prints, it has been praised for the richness of its engraving technique; its hatches, flecks, and dots give it an astonishing subtlety of finish.[10] And the plate did much to establish Bandinelli's reputation as the pre-eminent draftsman of his time. ¶ The popularity of the image is attested by the numerous copies produced by later draftsmen, engravers, and painters.[11] The print continued to inspire artists throughout the centuries that followed. Inigo Jones, on his visit to Rome in 1614, was as captivated by it as by any of the city's ancient wonders; Jones's *Rome Sketchbook* contains numerous studies of heads, hands, and feet after Bandinelli's print, as well as a very beautiful copy of the swordsman at the far right.[12] But the most monumental later adaptation of Bandinelli's design is one that has hitherto escaped notice: the French neoclassical painter Pierre Guérin based the pose and features of the brooding protagonist in his *Return of Marcus Sextus* (exhibited in the Salon of 1799) on the rigidly upright figure seated on Valerian's left hand in Raimondi's print.[13]

Louis A. Waldman

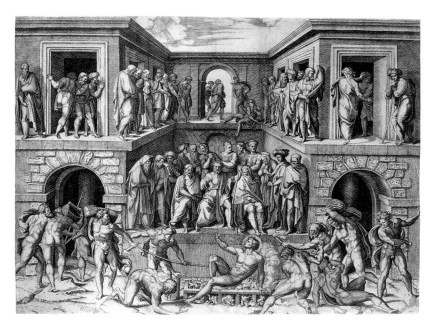

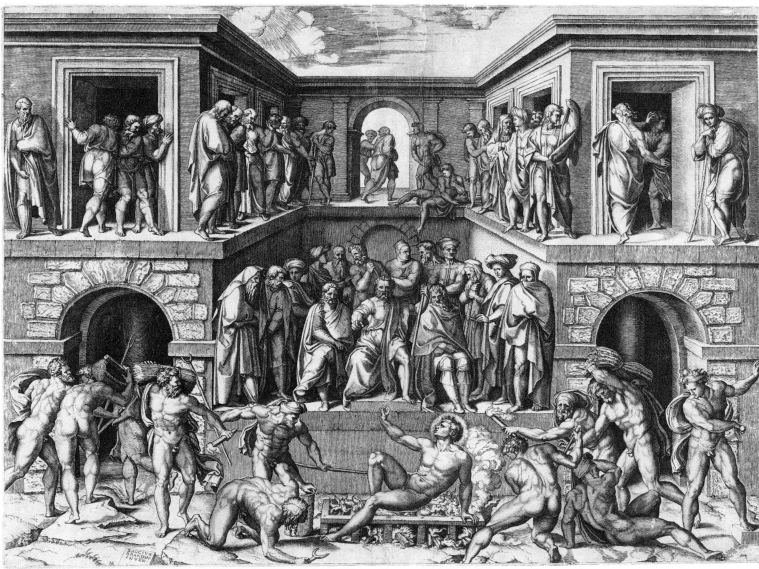

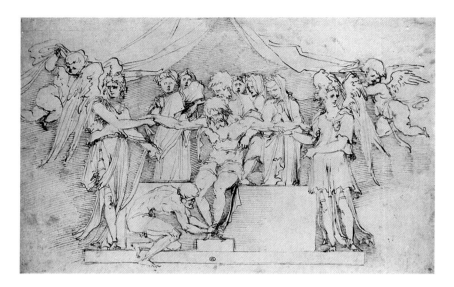

Fig. 92.1 Baccio Bandinelli, *The Lamentation*, c. 1526–1527, pen and brown ink, 28.4 x 38.5 cm. Musée du Louvre, Paris (117)

According to Vasari, shortly after Bandinelli's return to Florence from the papal court, in the final months of 1526 and through 1527, the thirty-three-year-old artist was inspired to resume the art of painting, which he had abandoned for some years. The most ambitious of the works he undertook during this period was an altarpiece of the *Lamentation*, commissioned for the Cistercian monastery of Cestello, now known as Santa Maria Maddalena dei Pazzi. The commission for the Cestello painting coincided with the final phase of a long and ambitious rebuilding of the church, carried out between 1480 and the late 1520s.[1] Bandinelli's painting, described by his biographer as "quite large" and "very beautiful," represented "Cristo morto e le Marie intorno e Niccodemo con altre figure."[2] Since some of his paintings had garnered negative reactions, Bandinelli decided to hire the painter Agnolo di Cristofano – brother of the recently deceased Franciabigio – to execute the cartoon in paint.[3] But the political unrest following the expulsion of the Medici in the spring of 1527, and the artist's subsequent flight from the city, prevented the completion of his Cestello *Lamentation*. ¶ This drawing is one of two compositional studies for a *Lamentation* by Bandinelli that have been identified as preliminary studies for the lost Cestello altarpiece; the other is in the Louvre (fig. 92.1).[4] The two drawings present variants on a planar, hieratic composition in which the Dead

Christ is held up in a frontal posture by three men or angels, with the Maries and other holy women disposed symmetrically about them. The visual prominence accorded the body of Christ – displayed like the consecrated Host upon an altar – is typical of the devotional art of this period, which was characterized by a growing emphasis on eucharistic themes.[5] ¶ Bandinelli's treatment of the *Lamentation* in the Uffizi drawing harks back to medieval representations of the Trinity. Apparition-like, the Dead Christ, his arms extended, is held up as though upon a human cross by a trio of male figures. The Saviour's stylized pose and exaggerated scale evoke a visionary emblem of the Catholic Mass, rather than a moment in the actual narrative of the Passion. While the central figure holding Christ's body seems almost to struggle under its weight, his bearded companions, probably Nicodemus and Joseph of Arimathea, support the Saviour's hands in a bizarre fashion upon their heads, while one displays the wound in Christ's side, and the other the nails and the crown of thorns, to the holy women below them. ¶ The size of Bandinelli's Cestello *Lamentation*, as attested by Vasari, implies that it was intended for a prominent place in the church. The church's titular saint was Saint Mary Magdalen, and the Lamentation and the related subject of the Pietà were favoured subjects in contexts dedicated to her.[6] But the high altar of the church seems an improbable site

92

for Bandinelli's altarpiece, not only because of the horizontal format of its composition but because a fairly recent altarpiece, most likely Francesco Botticini's *Virgin and Child in Glory with Saints Mary Magdalen and Bernard* of about 1485 (now in the Louvre), already stood there.[7] ¶ In all likelihood the intended site of Bandinelli's Cestello *Lamentation* was the new choir chapel that the monks constructed behind the high altar of the church around 1500.[8] In order to better observe the strict *clausura* dictated by their rule, the monks of Cestello took the remarkable step, in the final years of the Quattrocento, of replacing the Gothic choir in the nave of the church with a new choir chapel located behind the presbytery. This new choir was still perceived as too exposed to public view; as a result, in 1505 the prior was ordered to put up curtains "to the right and left of the altar of the cappella maggiore, so that the monks in the choir may not be seen and disturbed by the laity."[9] This expedient lasted until the 1520s, when a rood screen was erected to provide a permanent barrier between the choir chapel and the high altar.[10] Construction of the rood screen was evidently complete by April 1526 – around the time Bandinelli received the commission for his *Lamentation*.[11] A payment of 1503 records "the painting of a Saint Mary Magdalen painted behind the high altar,"[12] and in all probability Bandinelli's *Lamentation* was commissioned as a monumental replacement for that earlier image. The new painting's size would have suited such a space as the wall of the rood screen behind the high altar, which was 10 metres wide, or twice the breadth of the nave chapels.[13] The dimensions of the rood screen's rear wall probably would account for the oblong, mural-like dimensions of the surviving compositional studies.

Louis A. Waldman

This large and powerful compositional drawing belongs to a group of Passion studies by Bandinelli, all corresponding closely in style, technique, and format, and all evidently contemporary with one another. This Passion series (which includes some half-dozen sheets) was apparently done in preparation for a major cycle of reliefs, engravings, or paintings. The degree of detail and finish shown in the *Crucifixion* and its companions suggests that they were produced as *modelli*, finished drawings intended to be shown to a patron. Their exact purpose, however, and their date, have never been satisfactorily ascertained. ¶ It has been suggested that these drawings were made as studies for the high altar of Florence Cathedral, which Bandinelli planned for the centre of the richly decorated marble choir screen he designed on commission from Duke Cosimo I de' Medici in 1546, and on which he worked, with many interruptions, until his death in 1560.[1] As described by Vasari, Bandinelli's original plan for the high altar included a series of bronze reliefs of Passion scenes, which were to form a predella beneath the altar's crowning statue of God the Father. The bronze panels were never executed, but in the mid-1550s a series of gilt clay Passion scenes, identified by Vasari as the work of Bandinelli's assistant Vincenzo de' Rossi, were provisionally installed in their stead.[2] ¶ Stylistically, however, the Vienna *Crucifixion* and its companions have little in common with Bandinelli's drawings of the 1540s and 1550s. The ink washes boldly employed in the Passion scenes appear rarely, if ever, in drawings that can be assigned with confidence to the artist's last two decades; in his sheets from this period, such as the designs for the Old Testament reliefs on the parapet of the Florence Cathedral choir, he created a powerful style characterized by velvety shadows produced by means of a rich but precisely controlled vocabulary of hatch marks (see cat. no. 94). Moreover, the outlines in such late drawings are usually laid down with a magisterial precision that stands in marked contrast to the free-flowing and calligraphic lines that pulsate through the Albertina's *Crucifixion* and its related drawings, in which the pen's exploratory meanderings seem often to suggest form rather than define it. The stylistic characteristics of the *Crucifixion* evoke strong parallels with many of Bandinelli's pen and wash studies of the mid- to late 1520s, such as those for the *Martyrdom of Saint Lawrence* of 1526 (cat. nos. 90 and 91) and for the *Cestello Lamentation*, begun around 1526–1527 (cat. no. 92). ¶ Whatever medium it was designed for, the crowded and agitated composition of the *Crucifixion* harks back to Bandinelli's lifelong fascination with the art of the Quattrocento, and particularly with Donatello's Passion reliefs on the pulpits of San Lorenzo in Florence. But the composition is full of iconographic details that reflect Bandinelli's characteristically inventive approach to traditional themes. In order to maximize the scene's dramatic potential, the artist simultaneously portrays, or alludes to, several different moments in the biblical narrative, and at the same time adds peripheral incidents drawn from his own imagination. Christ hangs upon the cross, limp and apparently dead, while below him his mother swoons, the other Maries weep, and the tall, bareheaded Saint John the Evangelist hides his face in grief. To the right of the cross stands one of Christ's torturers, holding the pot of vinegar (or gall) and the sponge-tipped staff on which the bitter drink was lifted to his lips. To the left of the cross, a bearded man, apparently wearing a cuirass under his mantle, genuflects; given this highly rhetorical gesture of piety, he probably represents the Roman centurion who stood by Christ, and, at the moment of his death, cried, according to Mark's Gospel, "Truly this man was the Son of God!" (15:39) or, according to Luke, "Certainly this man was innocent" (23:47). ¶ It is difficult to interpret with certainty what the henchmen on either side of Christ are doing. It would seem at first glance that the good thief, on the left, is being nailed to his cross, while the bad thief, in a writhing, twisted pose, is being hoisted into place. If that is indeed the case, then these two groups of figures represent an earlier moment in the narrative than does the dead (or nearly dead) figure of Christ. Yet it may be, rather, that the bad thief is being lowered from his tree-like cross, and that the hammer-wielding henchman at the left is not nailing the good thief's feet but breaking his legs (as recorded in John 19:31–33). At the edges of the composition several men (including one of the ladder-bearing henchmen) are being attacked by soldiers on horseback; these incidents are not based on Scripture, nor, apparently, on iconographic tradition, but were probably invented by Bandinelli in order to dramatize the savage brutality of Christ's murderers. In the same spirit Bandinelli inserted a similar, equally fanciful incident into the margins of his design for Raimondi's *Martyrdom of Saint Lawrence* engraving (cat. no. 91); though reversed from left to right, the pose of the figure in the print on the lower right is almost precisely identical to that of the recumbent figure seen at the lower left in the Vienna *Crucifixion*. Indeed, many of the figures in the Albertina drawing reappear, variously transformed, in other works by Bandinelli, such as the magnificent *Deposition* relief made for the emperor Charles V around 1529 (known today from replicas in San Marino and the Louvre, as well as from a painted version in the Prado attributed to Allori).

Louis A. Waldman

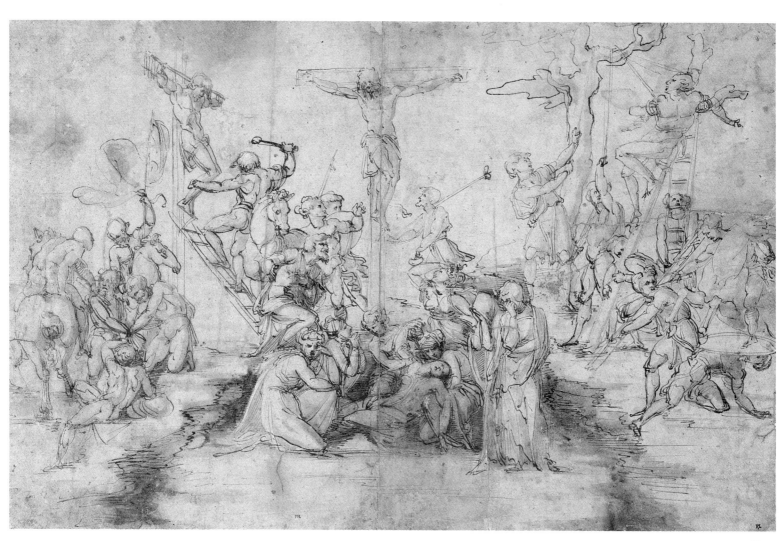

94 BACCIO BANDINELLI (1493–1560) · **The Drunkenness of Noah** · c. 1550 · Pen and brown ink
over black chalk · 36.1 x 28.6 cm · British Museum, London

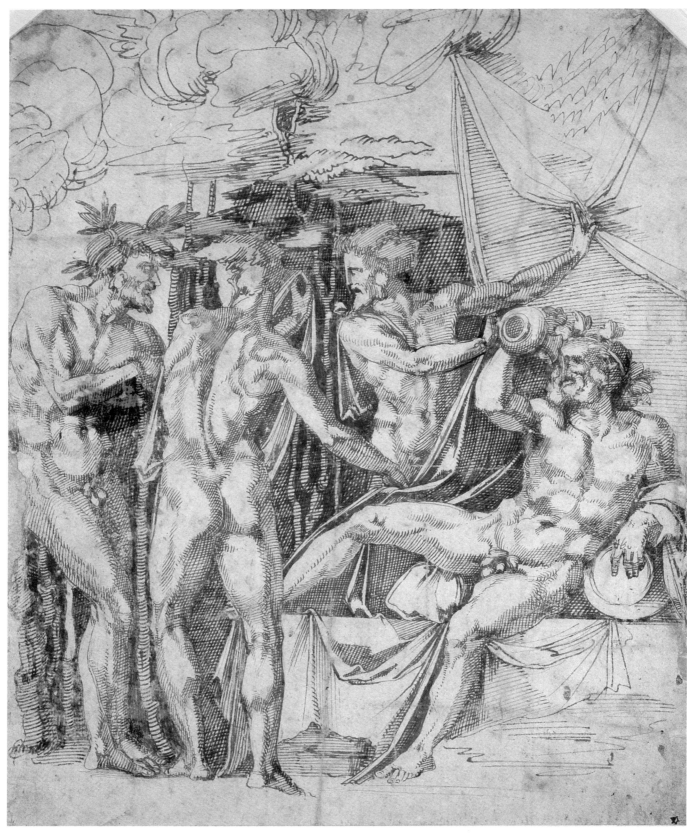

In 1546 Duke Cosimo I de' Medici began the rebuilding of the massive choir enclosure surrounding the high altar under Brunelleschi's dome in Florence Cathedral, entrusting the decoration to his court sculptor Bandinelli and the architecture to Giuliano di Baccio d'Agnolo Baglioni. For more than a century, plans for rebuilding the choir in materials worthy of its venerable site and function had gone unfulfilled; when Cosimo had received the Order of the Golden Fleece from the emperor Charles V's envoy in August 1546, he had been obliged to sit within a provisional wooden structure.[1] Vasari claims that Bandinelli himself persuaded the duke to undertake the massive project – the largest sculptural commission of Renaissance Florence – in order to distract Cosimo from the stagnation of his other commissions.[2]

¶ In order to win over the duke, Bandinelli and Baglioni created a scale model, based loosely on Brunelleschi's original design for the choir, but elaborated in a much richer and heavier architectural idiom (criticized by Vasari for its graceless excess) and adorned with a rich complement of statues and reliefs. In this model, the seven closed sides of the choir's parapet wall were each to be adorned with three reliefs of Old Testament scenes. According to Vasari, Bandinelli presented the duke with multiple drawings for each of these reliefs along with the wooden choir model, and with the combined eloquence of his words and his draftsmanship won the duke's final approval for the commission. ¶ The *Drunkenness of Noah* in the British Museum is one of a group of more than a dozen Old Testament studies by Bandinelli – some known only through copies – that appear to come from the group of presentation drawings for the parapet reliefs described by Vasari.[3] The figures in these drawings are very similar in scale, and the surviving autograph sheets are extremely consistent in technique, leaving little doubt that they belong to a single project. ¶ The choir parapet drawings, as a group, are among the most powerful and carefully wrought of all Bandinelli's graphic works – even Vasari grudgingly admired them in the *Lives*. Compared to a presentation made two decades earlier, the *Lamentation* in the Uffizi (cat. no. 92), Bandinelli's technique appears both more controlled and more economical. With breathtaking precision, he weaves a dense and varied network of hatchings – long and short, straight and curving, thick and thin – creating a powerful impression of sculptural relief while at the same time enveloping the composition's disparate elements within a unifying Leonardesque chiaroscuro.

¶ Like so many of Bandinelli's commissions, the choir project fell into dormancy, largely because of the artist's inability to concentrate on a single project. The history of the choir is a complicated saga of revisions and false starts, with Bandinelli restlessly abandoning existing plans and hatching new projects.[4] From a letter written in March 1548, for example, we learn that Bandinelli was turning anew to the problem of "the histories for the choir."[5] The following month he wrote to the ducal secretary Jacopo Guidi, "this is a project more fantastic and difficult than the previous one, and it needs to be more richly adorned, as the models will show you."[6] In 1549 Cosimo decided to give the commission for the reliefs of the parapet to Bandinelli's arch-rival, Benvenuto Cellini, but the plan came to naught; in early 1556 Cellini undertook the commission and began work on the first panel, depicting *Adam and Eve*, but abandoned the work within a few months.[7] When, a dozen years after Bandinelli's death, the choir was finally completed under the supervision of Francesco da Sangallo, Bartolomeo Ammanati, and Giovanni Bandini, the plan for a series of Old Testament reliefs had long since been abandoned, and the spaces they were meant to fill were given over to rectangular panels of purplish *marmo mistio* from Seravezza. The choir as it appeared then represented merely a fragment of the grandiose dreams and projects designed for it by Bandinelli; however, some trace of the sculptor's potent conception lives on in the magnificent drawings, such as this one, with which he ignited the imagination of his patron, Duke Cosimo I.

Louis A. Waldman

Vasari relates that when, in the winter of 1532–1533, Pope Clement VII went to Bologna for three months to meet with the emperor Charles V, Baccio Bandinelli left his work on his great marble group of *Hercules and Cacus* and travelled there "to kiss the feet of His Holiness, and brought with him a rectangular image one braccio high and one and a half braccia wide, of a Christ being beaten at the column by two nude men, which was in half-relief and very well executed. He gave this image to the pope, together with a medal portraying His Holiness, which he had commissioned from his close friend Francesco dal Prato; on the reverse of this medal was the flagellated Christ."[1] The depiction, in both the artist's gifts, of the Flagellation represents a transparent allusion to the afflictions suffered by the Vicar of Christ during the Sack of Rome by imperial troops in 1527 – and to his Christlike patience in enduring them. The medal by Francesco dal Prato has long been identified with a unique bronze piece now in the Staatliche Museen in Berlin;[2] the marble relief described by Vasari was considered lost until it was recently identified with this work at Orléans, whose dimensions correspond to those given by Vasari, and whose style is indisputably that of Bandinelli. ¶ The twisting pose of Christ's upper body, with one bent arm raised high above his head, is derived from the antique sculpture of the *Laocoön*, which since its discovery in 1506 had become a vastly influential model of emotional expressiveness in art. Bandinelli had been involved in the restoration of this statue,[3] which belonged to the papal collections, and during the early 1520s he sculpted a full-size copy for the Medici popes (now in the Uffizi). Bandinelli may have been aware of a bronze plaquette of the *Flagellation* by the northern Italian sculptor Moderno, in which Christ's pose is similarly based on that of the ancient marble.[4] Bandinelli had a predilection for repeating the same figures in different works, and the right-hand torturer is a translation into three dimensions of a nude pugilist shown in the background of his early painting of *Leda and the Swan* (c. 1510–1511) and in its preparatory drawing in the British Museum (cat. no. 89). ¶ The composition of Bandinelli's relief places it squarely within a tradition of three-figured Flagellation scenes in Florentine art. Parallels with the composition of the Orléans relief have been found in a Donatellesque plaquette of the early fifteenth century, in Michelangelo's preparatory drawings for Sebastiano del Piombo's *Flagellation* for San Pietro in Montorio in Rome (1516), and in a painted version attributed to Bachiacca from about 1512–1515 (National Gallery of Art, Washington). Except for certain minor details in the poses of the left-hand executioner and of Christ's legs, the composition of Bandinelli's relief corresponds closely to a crude sketch in the Ashmolean Museum (fig. 95.1) and another in the Willumsen collection, both of which were identified as studies for the *Flagellation* relief long before the recent rediscovery of the sculpture. These sheets are actually the work of two different pupils of Bandinelli rather than the master himself. Yet there is a good likelihood that the surviving drawings were made either from a version of Bandinelli's relief or after one of his lost preparatory studies for it. ¶ The fate of Bandinelli's relief, between its donation to Clement VII and its early nineteenth-century reappearance in a French château, remains a mystery. Yet, as the Ashmolean drawing suggests, tangible traces of the work's appearance must have remained in Florence. A plaster version of the work, almost identical in size with the original marble, exists to this day in the Palazzo Martelli in Florence; it shows what the raised arm of the left-hand executioner looked like before it was broken (an accident that may have occurred during a 1940 fire at the Musée Historique in Orléans). Although in the Martelli version Christ's left hand is replaced by a flaccid, neoclassical member, in a different position than in the marble in Orléans, it is definitely a cast rather than a freely modelled variant, as can be seen when photographs of the two works are superimposed on one another.[5] ¶ Bandinelli's relief style is remarkable for its austere, cold, linear perfection. In contrast to the work of his teacher Rustici, whose sculpture explored the possibilities of very low relief (*rilievo schiacciato*) for pictorial effect (see cat. no. 7), Bandinelli's relief presents figures that nearly detach themselves from the background, and the field against which they move is a featureless, abstract void. Bandinelli's lifelong involvement with relief sculpture may have been an attempt to outdo his great rival Michelangelo, who pointedly rejected the possibilities of the medium. ¶ Vasari informs us that after Bandinelli presented his relief and Francesco dal Prato's medal to the pope, the sculptor requested that Clement order the ruler of Florence, Duke Alessandro de' Medici, to give him the financial and material support he required in order to complete his Florentine *Hercules*. "He added that he was envied and hated in that city; and being of a fearsome tongue and wit, he persuaded the pope to see to it that Duke Alessandro should take care that Baccio's work should be completed, and that it should be installed in its proper place on the piazza [della Signoria]."[6] Bandinelli reiterated these requests in a letter to the pope of August 8, 1533, mentioning that he has also commissioned a medal of Duke Alessandro.[7] By dint of such gifts and protestations, Bandinelli finally received the support he needed from the treasury of the tight-fisted duke, and his completed *Hercules and Cacus* was unveiled to the hostile Florentine public on 1 May 1534.[8]

Louis A. Waldman

Fig. 95.1 Workshop of Baccio Bandinelli, *The Flagellation of Christ*, c. 1550–1560, pen and brown ink, 24.8 x 10.9 cm. Ashmolean Museum, Oxford (WA1863.634)

96 BACCIO BANDINELLI (1493–1560) · **Jason** · c. 1546 · Bronze · 39.8 cm high · Museo Nazionale del Bargello, Florence

Fig. 96.1 Baccio Bandinelli, *Ignudo della paura*, 1544–1545, bronze, 32 cm high. Museo Nazionale del Bargello, Florence

Fig. 96.2 Baccio Bandinelli, *Cleopatra*, 1544, bronze, 32.2 cm high Museo Nazionale del Bargello, Florence

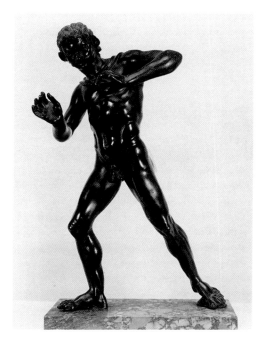

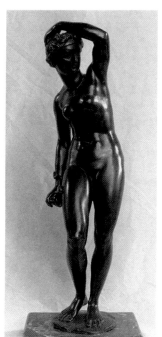

Small-scale bronzes represent an important but little-known aspect of Baccio Bandinelli's career. Like the countless small models that populate many contemporary portraits and self-portraits of Bandinelli, especially the Academy prints (see cat. no. 100), they are tangible, and portable, exemplars of the artist's fertile *invenzione*. Moreover, to an artist who liked to boast of his ability to surpass the ancients, *bronzetti* represented an opportunity to measure his work against the precious small bronzes that were a treasured part of every princely collection in the Renaissance. And small bronzes were ideally suited to the collaborative working methods Bandinelli favoured, much more so, in fact, than marble sculpture; if he wished, an artist could limit his involvement to the production of the initial model and delegate the casting and finishing to a skilled artisan. This indeed appears to have been Bandinelli's practice throughout his life when sculpting in bronze, in contrast to Cellini, who took a craftsmanlike interest in every phase of production. ¶ Vasari reports that in the early 1530s, while Bandinelli was preparing models for a never-completed colossal bronze sculpture group atop the fortress of Castel Sant'Angelo depicting the *Fall of the Rebel Angels*, the sculptor began making models for a series of bronze statuettes about two-thirds of a braccio (39 cm) high, including "Venuses, Apollos, Ledas, and other fantasies."[1] These works, made partly as trials of casting technique and partly "to pass the time," were cast by a Florentine named Jacopo della Barba. They were presented to the pope and other individuals, and some later made their way into the Guardaroba of Duke Cosimo I de' Medici in the Palazzo Vecchio. ¶ Although there is no reason to doubt Vasari's word that Bandinelli produced bronze statuettes during the 1530s in Rome, documentary evidence indicates that many of the *bronzetti* by him now in the Bargello (with provenances going back to Duke Cosimo I's collection) were actually made in the mid-1540s, principally in collaboration with the bronze-caster Teodoro da Ravenna (though there is evidence that the goldsmiths Domenico and Giovanni Paolo Poggini also collaborated in some cases).[2] The *Jason*, first documented as part of the ducal Guardaroba in inventories of 1553–1554,[3] probably belongs to the years of Bandinelli's collaboration with Teodoro and the Poggini brothers. ¶ Bandinelli's interest in the medium during the latter half of the 1540s was undoubtedly linked, in part, to a desire to compete with Cellini, whose dramatic displays of virtuoso casting after his arrival at the Medici court in 1545 made him Bandinelli's chief rival. Although most of Bandinelli's statuettes of the 1540s were made for Cosimo, the duke at least contemplated commissioning bronzes from the artist to be sent as gifts to other rulers.[4] ¶ The documentary evidence for Bandinelli's production of *bronzetti* for Cosimo is relevant to the historical and artistic context of the *Jason*. From May 1544 to September 1545 payments were made by the Opera di Santa Maria del Fiore for materials used by Teodoro da Ravenna in producing Bandinelli's small bronze portrait busts of *Cosimo I* and *Eleonora di Toledo* and "a mould of a *Satyr*."[5] In a letter of January 1545 Pier Francesco Riccio, ducal major-domo, wrote to the ducal secretary Cristiano Pagni urging that Cosimo provide payment to "Bandinelli's bronze-caster," an impoverished foreigner "who has cast two heads of the duke and one of the duchess, together with a satyr, which in truth appear to me to have come out quite cleanly." The duke responded by instructing Riccio to pay Teodoro the rest of what his work on these castings was worth, and ordering that a price should be set in advance for any future castings.[6] This letter suggests that Teodoro cast not only Bandinelli's small bronze busts of Cosimo and Eleonora now in the Bargello (inv. 1879:429, inv. 1879:437), but also the fine second specimen of the bust of Cosimo now in the Victoria and Albert Museum. ¶ The *Satyr* cast by Teodoro da Ravenna for Bandinelli is undoubtedly a version of the so-called *Ignudo della paura*, a common type of late fifteenth-century pseudo-antiquity, of which a version now in the Bargello (inv. 1879:82) had been in the Medici collections since the time of Lorenzo the Magnificent.[7] In July 1544 Bandinelli returned to the ducal Guardaroba "an antique called the *Ignudo della paura*," which he had undoubtedly borrowed in order to produce his own version, in collaboration with Teodoro.[8] The *Ignudo della paura* they created can probably be identified with another version now in the Bargello (inv. 1879:88, fig. 96.1), which is recorded in the ducal Guardaroba in 1553 alongside the late fifteenth-century version that served as its model.[9] This sixteenth-century copy of the *Ignudo della paura* has sometimes been attributed to Cellini, who borrowed a version of the work from the Guardaroba in 1546,[10] but there is no evidence that Cellini actually made a copy for the Medici. And there exist close parallels in anatomical modelling, surface, and patina between the *Ignudo* and other bronzes by Bandinelli made for the Medici, particularly the *Hercules* (Bargello, inv. 1879:281).[11] ¶ Although a 1549 payment from the Opera for wax given to Teodoro to cast "fighure" designed by Bandinelli seems to indicate that the two artists continued to collaborate on bronze sculpture for several years,[12] comparison with other documented bronzes suggests some hypotheses about the probable date of the *Jason*. In December 1544 another small bronze by Bandinelli, the *Cleopatra* (fig. 96.2), entered the Guardaroba; the record of its accession refers to it as "di getto finita" ("cast and finished"), a technical comment that could indicate that the statuette was a newly completed work from the foundry of Teodoro.[13] With its frontal pose, its reductive treatment of anatomy, its linear treatment of the hair, and the satin finish of its surface, the *Cleopatra*, among all of Bandinelli's surviving *bronzetti*, offers some of the closest stylistic parallels with the *Jason*. The similarities between the two bronzes are so compelling as to raise suspicions that the *Jason* too was cast by Teodoro during the period of his collaboration with Bandinelli, around 1544–1549. The subject of Jason carrying the Golden Fleece was undoubtedly intended as a compliment to Cosimo, who was invested by the command of the emperor Charles V with the prestigious Order of the Golden Fleece on 11 August 1546. Such an allusion to a watershed event in Cosimo's reign strongly implies that the *Jason* was cast not long after that date. ¶ As has often been noted, both the pose of the *Jason* and its notably long-legged physical type are closely based on that of the *Apollo Belvedere*, a celebrated antique displayed in the Belvedere Court of the Vatican, where Bandinelli could have seen it many times during his sojourns at the papal court. The *Apollo Belvedere* held an almost totemic fascination for Bandinelli: he adapted it decades earlier for his marble statue of *Orpheus* for the courtyard of the Palazzo Medici (c. 1519), and the figure was also copied or adapted in a number of drawings by Bandinelli and his circle.[14]

Louis A. Waldman

Adam von Bartsch, in the nineteenth century, intuited that this violent composition of heroic nude figures must reproduce a design by Baccio Bandinelli, but the print was largely ignored by scholars until the recent discovery that the work reproduces Bandinelli's original design for his 1534 *Hercules and Cacus*, as seen in a wax model now in the Skulpturensammlung in Berlin (fig. 97.1).[1] Although the Berlin wax corresponds precisely in its details and measurements to the description given by Vasari, who saw it when it was in the Guardaroba of Duke Cosimo I de' Medici, in recent years it has been published and exhibited as the work of the eighteenth-century sculptor Pierre Puget. But the print by Veneziano – an artist who collaborated with Bandinelli on other prints as well – offers definitive evidence that the Berlin model is indeed the artist's original *modello* from 1525, when he first received the commission. ¶ It was then, during the first years of his pontificate, that Pope Clement VII revived the idea, proposed decades earlier by Piero Soderini's government of Florence, to commission a companion to Michelangelo's *David* in front of the Palazzo della Signoria. In the summer of 1525 the pope had a massive block of marble, quarried perhaps as early as 1508, shipped from Carrara to Florence for the project. Initially the pope considered both Michelangelo and Bandinelli as candidates for the commission. It appears that as late as October 1525 Clement was considering allowing both Michelangelo and Bandinelli to produce competing models for a *Hercules* group. Michelangelo's plan to carve the block into a *Hercules and Antaeus* group had considerable popular support among the anti-Medici faction, but in the end Clement awarded the commission to Bandinelli, who began carving a group of *Hercules and Cacus*. After the expulsion of the Medici in 1527 the republican government returned the block to Michelangelo, who produced a *modello* for a group of *Samson and the Philistine*, but when the Medici came back to power in 1530 the block was returned to Bandinelli, who unveiled his finished *Hercules and Cacus* (fig. 97.2) in May 1534. ¶ Vasari reports that Bandinelli abandoned the design of the Berlin *modello* after his inspection of the block revealed that its dimensions were inappropriate; with Clement's permission, he produced several new models (lost today), from among which the pope selected the one that was

ultimately executed.[2] Given the group's obvious political symbolism – the virtuous Hercules as the Medici, Cacus as the rebellious Florentines – the shift from a design in which Hercules smashes Cacus's skull toward the less menacing treatment in the final statue was surely a conciliatory move on the part of the pope.[3] ¶ Several important differences can be noted between the poses of the figures in the Berlin *modello* and in Veneziano's engraving. In the print Hercules places his hand on Cacus's neck rather than on his upper arm, and the complex twisting pose of Cacus has been replaced with a simpler kneeling one. It may be that Veneziano simply took liberties in reproducing the model in order to avoid the anatomical challenges presented by the writhing, serpentine Cacus. But such discrepancies also suggest the possibility that he was working from a preparatory drawing that preserved a different phase of the composition, rather than from the surviving wax model itself. ¶ Be that as it may, Veneziano's print, like the quite atypical survival of Bandinelli's wax model, leaves little doubt that the innovative design was greatly admired by contemporaries – as Vasari attests.[4] The dynamic interweaving of figures, and the complex succession of views they present to the spectator, suggest that Bandinelli's rivalry with Michelangelo inspired him to emulate the older master's experiments with *figura serpentinata*. But the motif of Hercules's extended arm, stretching out into space with its club, could not be further removed from Michelangelo's famous insistence that a statue respect the shape of its block. Bandinelli's design, as preserved by Veneziano's engraving and the Berlin model, pushes the limits of marble sculpture in a way that profoundly affected later artists, from Vincenzo de' Rossi and Giambologna at the end of the sixteenth century to Bernini and Algardi in the seventeenth.

Louis A. Waldman

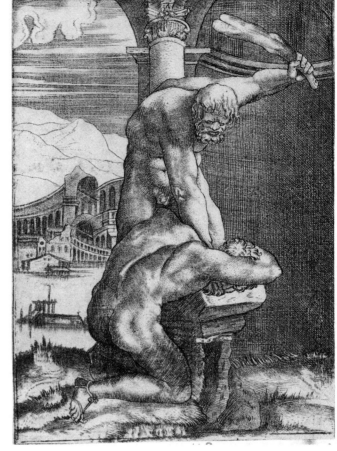

Fig. 97.1 Baccio Bandinelli, *Model for Hercules and Cacus*, 1525, wax, 73 cm high (without base). Staatliche Museen, Skulpturensammlung, Berlin

Fig. 97.2 Baccio Bandinelli, *Hercules and Cacus*, completed 1534, marble, 496 cm high. Piazza della Signoria, Florence

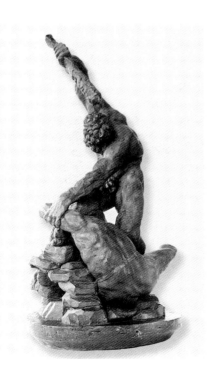

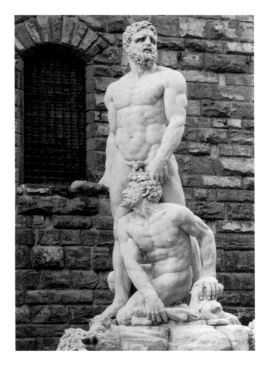

One of only five extant engravings by Niccolò della Casa, this print depicts the Florentine sculptor, painter, and draftsman Baccio Bandinelli. As is the case with many printmakers active in Italy in the mid-sixteenth century, little of a documentary nature is known about the French-born della Casa.[1] Although from the region of Lorraine, he was most notably active in Italy. In Rome he seems to have come into contact with Marcantonio Raimondi, one of the most influential of the earlier generation of printmakers. There he also met Antonio Salamanca and Antonio Lafrery, art dealers and printers who would later publish his engravings. At some point della Casa must have gone to Florence, where he encountered Bandinelli. The latter's workshop was known for its exchanges with printmakers, to whom drawings were sometimes provided. It is certain that all of the significant prints after Bandinelli's designs were based, as with this example, on drawings created exclusively for the engraver rather than composed as reproductions. ¶ Della Casa's oeuvre consists of only a few prints. Among these are eleven plates after Michelangelo's *Last Judgement* (completed in 1541) in the Sistine Chapel, produced between 1543 and 1545 for Salamanca.[2] In 1544 della Casa engraved and signed a related *Portrait of Duke Cosimo I de' Medici* (see cat. no. 99), also after a design by Bandinelli, which is his most detailed surviving work. Around the same time, he executed this *Portrait of Baccio Bandinelli*, based on a pen-and-ink self-portrait by Bandinelli now in the Uffizi (fig. 98.1).[3] Della Casa's print is known in two states, of which this is an example of the first. The second state includes, next to the engraver's name, the name of the publisher, A. Lafrery. ¶ The dimensions of the engraved portrait, as well as the size of the figure, are the same as those of the preparatory sketch made expressly for it. The shading lines introduced by della Casa are finer and more abundant than in the drawing, in keeping with the intrinsic nature of the engraving medium. Bandinelli's rather accessible expression in the drawing is hardened in della Casa's print by the deeper shadowing around the eyebrows, which gives the subject a more remote and severe gaze. ¶ Bandinelli's desire for printed self-portraits has been much discussed. They were part of one of the most audacious self-promotion campaigns ever waged by a Renaissance artist. Printmaking had particular value for Bandinelli in advertising not just his person but also his skills as a designer, and it enabled him to reach a wider audience than could have seen his original works. He presents himself here in an aristocratic knee-length format, attempting to elevate his social rank to that of a courtier and intellectual. This is accomplished, in part, through the prominent display of the shell-and-cross pendant of the Order of the Knights of Santiago, to which Bandinelli was elected by order of the emperor Charles V around 1529 or 1530. He stands among some of the precious statuettes and models that had contributed to his status and renown. These sculptures, which are in fact mostly imaginary, presumably also allude to his ability as a designer. ¶ Della Casa's print is a powerful and characteristic image of a sixteenth-century artist in the act of self-congratulation. This particular impression also carries an unusually complete provenance for a print, traceable back to the collection of Sir Joshua Reynolds himself. In his Discourse XII, Reynolds specifically praises a drawing of the *Descent from the Cross* by Bandinelli, which he also owned.[4]

David Franklin

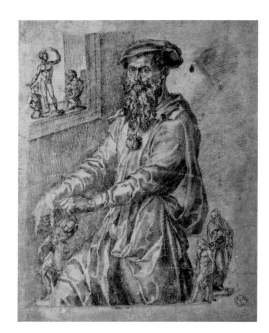

Fig. 98.1 Baccio Bandinelli, *Self-portrait*, pen and brown ink, 29 x 22 cm. Galleria degli Uffizi, Florence (14964F)

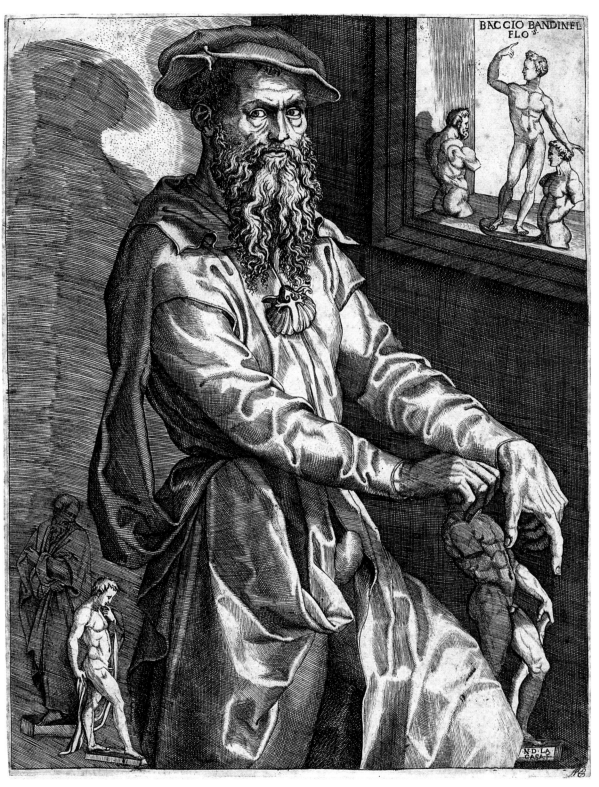

BACCIO BANDINEL
FLO S.

N·D·LA
CASA·

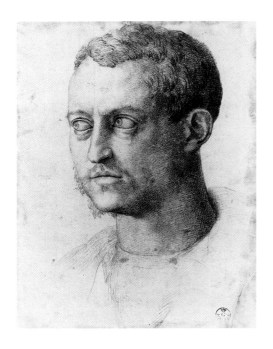

Fig. 99.1 Baccio Bandinelli, *Portrait of Duke Cosimo I de' Medici*, c. 1544, black chalk. Galleria degli Uffizi, Florence (15010F)

This strangely abstract, almost heraldic print, erroneously identified by Vasari as the work of the engraver Enea Vico, is one of the most remarkable portraits of Duke Cosimo I de' Medici. It shows the duke at three-quarter length, wearing a suit of elaborately decorated tournament armour and surrounded by attributes that display his warlike prowess. The head of Cosimo is based on a black-chalk drawing by Bandinelli in the Uffizi (fig. 99.1), which may have been produced originally as a study for his marble bust of the duke (whose armour shares many ornamental details with that shown in della Casa's print) and for a related small bronze portrait, both now in the Bargello. The tension between the naturalistic modelling of the head and the insistent flatness of the ornamental designs on Cosimo's armour gives the whole print a strangely wooden appearance. The visual confusion is compounded by the ambiguous spatial arrangement of the duke's emblematic weapon attributes, which hover behind him in a way that defies rational explanation. ¶ Della Casa's print is a unique fusion of three popular genres of engraving – the battle-print, the portrait, and the ornament print. Among the fifty-odd figures decorating his stunning garniture – to count only human and half-human creatures – many are engaged in some form of combat. On the upper part of his cuirass, a pair of marine centaurs engage in a sword fight. On his pauldrons, centaurs and humans (Lapiths?) appear in heated combat, with the centaurs decidedly carrying the day. Cosimo's cuisses represent Labours of Hercules: on the duke's right thigh, Hercules carries off the Nemean lion and the Erimanthean boar; on the left thigh, he battles the hydra, in a pose derived from the antique *Laocoön* – a statue that Bandinelli himself had copied for the Medici in the early 1520s and that he often imitated in his later works. Cosimo's helmet depicts a battle between two groups of nude men, together with other, unidentifiable scenes. Many of the figures on Cosimo's armour, however, are ornamental grotesques – such as the serpent-armed female herm in the centre of the cuirass or the full-length figures that adorn the pteryges hanging from the cuirass. ¶ The print is a veritable catalogue of symbols commonly associated with Duke Cosimo I and the Medici dynasty. The diamond ring at the upper right was a Medicean symbol dating back to the time of Piero the Gouty, its hardness connoting the durability of the dynasty.[1] The snaky-headed gorgon on Cosimo's shield alludes to another antique hero, Perseus – whose effigy the duke would commission from Bandinelli's arch-rival, Benvenuto Cellini, the year after this print was produced. The Hercules scenes, like the lion's skin on which Cosimo's name is inscribed, identify the duke with the great ancient paragon of virtue and strength; Cosimo's art commissions drove home this theme throughout his career.[2] The eagle, displayed across the lower part of Cosimo's cuirass, was a well-known symbol of Jove and of the Roman emperors; the decorative heads of beasts such as oxen, rams, and lions, also found on Bandinelli's sculpted busts of Cosimo, suggest the sitter's natural strength. On a more recondite level, the many goat-heads also allude to Capricorn, the zodiacal sign of Augustus, under which Cosimo was created duke and which he subsequently adopted as a personal emblem.[3]

Louis A. Waldman

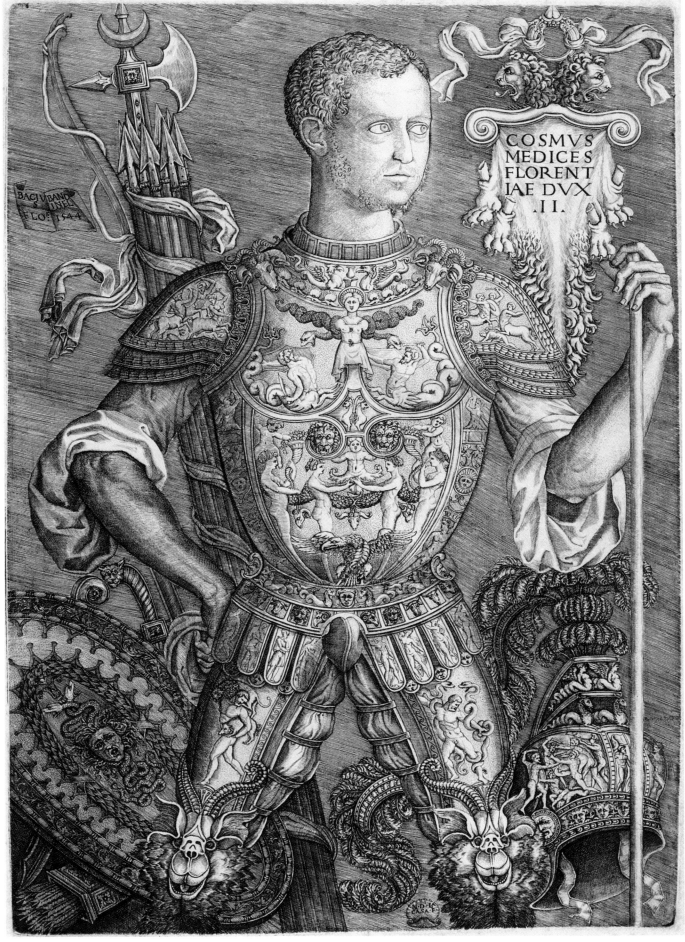

COSMVS
MEDICES
FLORENT
IAE DVX
. I I .

This engraving by Enea Vico of Parma provides an image of the art academy of the Florentine sculptor Baccio Bandinelli as a scene of reverent study quite different from a craftsman's workshop. In its subject and design it refers to an earlier engraving by Agostino Veneziano (fig. 100.1) that records the "ACADEMIA DI BACCHIO BRANDIN," which met at night in the Belvedere in Rome, but it enlarges on the constituent elements of the sophisticated identity Bandinelli fashioned for himself in that print by multiplying the number of books, statuettes, and apprentices and by adding anatomical material. It also corrects the name in the inscription from "Brandini" to the noble "Bandinelli" preferred by the artist – a status change also emphasized by the arms of the Order of Santiago over the fireplace, granted to the sculptor in 1530 by the emperor Charles V. In conveying the high social and intellectual status of the artist, the print shows Bandinelli as a worthy successor to his early artistic mentor Leonardo da Vinci. It also associates Bandinelli with progressive ideas about art education that would ultimately lead to the foundation of the Accademia del Disegno in 1563.[1] ¶ A comparison of the two prints reveals, however, that Vico's engraving lacks the theoretical coherence of its predecessor. In Veneziano's print Bandinelli's sculptural works are the focus of the drawing activity, thereby demonstrating practically and symbolically the derivation of *disegno* from *rilievo*, a key concept in Bandinelli's theory of art attested to by Anton Francesco Doni's dialogue *Disegno* (1549). In Vico's print, on the other hand, the attention of the draftsmen is directed inward and their efforts appear unconnected, while the statuettes are relegated to the status of peripheral attributes of the academy. Similarly, the good quality of the engraving technique cannot disguise the formal incoherence of the composition, with its inconsistent treatment of cast shadows, perspective, and scale. It is telling that Bandinelli himself, identifiable by the heraldic device on his tunic, appears uncomfortably squeezed into the composition at the far right.

¶ Three states of this engraving are known. The first (Bartsch XV, 305, 49-I) bears the inscription "Baccius Bandinellus invent." on the left-hand page of the open book at the upper right; then at the lower left, below the sleeping dog, a publisher is identified: "Romae Petrus Paulus Palumbus formis." In the second state, the name of the engraver is added on the right-hand page of the open book: "Enea vigo Parmegiano sculpsit." Finally, in the third state (Bartsch XV, 305, 49-II) the transfer of the plate from one publisher to another is recorded below the two skulls: "Gaspar Albertus successor Palumbi." While Passavant was correct in pointing out the existence of a second state with an inscription identifying the engraver, Bartsch was quite accurate in his description of the first state, notably with regard to the publisher's inscription. ¶ The Palumbi were a family of book and print sellers based from 1559 in the neighbourhood of Sant'Agostino in Rome; Pietro Paolo Palumbo is known to have flourished from 1563 to 1586.[2] This would suggest a significantly later date for a print that is usually dated on stylistic grounds to the 1540s or 1550s – in fact, it could place it later than Bandinelli's own death in 1560.

One possible explanation is that Vico might have engraved the plate earlier but that the print was not immediately published, emerging on the market only after the plate had entered the Roman publisher's stock. In this connection it is interesting to note that the engraver's "signature" was added only in the second state, in a different hand, and using a formulation otherwise unknown in Vico's oeuvre (the engraver usually signs "E.V.," "Enea Vico," or some variant of "AENEAS VICUS," but not "Enea vigo"). ¶ Several motifs in Vico's engraving can be linked to drawings and works by Bandinelli. A pen-and-ink drawing in Chicago of *Two Studies of the Head of a Youth*, which Ward has dated to about 1550 because the youth represented may be Bandinelli's son Clemente, can be compared to the depictions of the two apprentices in the right background of the print.[3] A black-chalk drawing in the British Museum represents Bandinelli in profile as he appears both in this print and in the relief portrait on his tomb in Santissima Annunziata in Florence.[4] Less directly, the Ashmolean's red-chalk drawing of a *Woman Reading by Lamplight* recalls the figures seated around the table.[5] Other drawings that have been identified as preparatory sketches for the print are more likely to be derivative from it.[6] ¶ The cross-legged poses of the youths standing and sitting around the fireplace are favoured motifs in Bandinelli's art. They can be found in the series of prophets carved for the choir screen in Florence Cathedral, some of which are signed and dated 1555. Bandinelli is represented in a similar pose in the portrait of the artist in the Isabella Stewart Gardner Museum in Boston, variously attributed to Bandinelli himself or (more recently) to Jacopino del Conte.[7] However, because these motifs that can be linked with other works by Bandinelli occur alongside borrowings from the prints of Albrecht Dürer – the meditating man derives from the pensive angel of *Melencolia I*, a print that is also the source for the sleeping dog, and the shadows cast by stools come from *Saint Jerome in His Study* (both dated 1514) – they read in this context more like quotations than authentic inventions created specifically for Vico's engraving. Waldman has recently demonstrated that Bandinelli's autobiographical *Memoriale* – a text that refers inaccurately to this print – is a posthumous forgery by the sculptor's grandson. Perhaps the idea for a new print, revising the design of Veneziano's, also emerged posthumously from within the Bandinelli circle through a comparable reworking of the artist's ideas, and the authorship ascribed to him in the inscription is similarly retrospective. In any case, the awkwardness of the composition and the eclectic referencing of different phases of Bandinelli's artistic development make the print a manifestation of a more prosaic method of *disegno* than the one it purports to represent.

Ben Thomas

Fig. 100.1 Agostino Veneziano, *The Academy of Baccio Bandinelli, after Baccio Bandinelli*, 1531, engraving, 27.4 x 29.8 cm British Museum, London (1879-7-12-287)

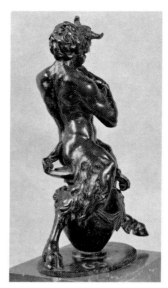

Fig. 101.1 Niccolò Tribolo, *Fountain Figures, Basins, and Architecture*, pen and brown ink over black chalk (verso of cat. no. 101)

Fig. 101.2 Niccolò Tribolo, *Satyr*, 1549, bronze, 26 cm high. Museo Nazionale del Bargello, Florence

This drawing documents an important element of one of the most ambitious garden plans of the Italian Renaissance: the complex of fountains and waterworks designed for Duke Cosimo I de' Medici's villa at Castello by the sculptor, architect, and engineer Niccolò Tribolo. Begun in 1537–1538, and not completed until a decade and a half after Tribolo's death, the complex united two monumental candelabrum-shaped fountains, a grotto, two fishponds, and a surprising fountain atop a live, ivy-covered tree. On a height at the north edge of the villa, Tribolo created a *giardino segreto*, given over to the cultivation of medicinal herbs. For this private garden he designed a fountain mounted in a wall niche, containing a figure of the god Aesculapius, at whose feet water flowed into a richly ornamented basin. The recto of this elegant presentation drawing represents Tribolo's design for the fountain, which was completed after his death by his pupil Antonio di Gino Lorenzi. Tribolo's drawing – which must represent very closely the form in which the fountain was executed – is rich in allusions to the salutiferous herbs growing within the *giardino segreto*'s walled enclave. As in the surviving statue of *Aesculapius* (completed by Lorenzi in 1555), the ancient god of medicine holds a snake-entwined caduceus; snakes surround a bundle of herbs in the spandrel of the arch above, while flanking reliefs of cornucopias hint at the abundance created by the water of the garden's aqueduct, flowing out of a grotesque mask into the dolphin-covered basin. Of the elegant complex documented in the Louvre drawing, only the marble statue of *Aesculapius* and the basin of variegated *marmo mistio* now survive, removed from their original setting, in the Palazzo Medici in Florence. ¶ As noted by Keutner, the satyr in the lower-left corner of the verso (fig. 101.1), seated on an urn and blowing a horn, closely resembles Tribolo's small bronze figure of a *Satyr* in the Bargello, cast in 1549 (fig. 101.2).[1] Although Keutner

believed the sketch was made specifically as a study for the statuette, and thus dated it to 1548–1549, it is equally possible that the satyr shown on the Louvre sheet was originally made as a study for some part of the decoration at Castello. There are significant differences of pose between the sketch and the statuette; moreover, the urn – an attribute not normally associated with satyrs – implies that this figure was originally planned in connection with a fountain. Other sketches appearing nearby on the same side of the sheet clearly relate to fountains – including a study of a cornucopia very similar to those shown on the recto as part of the Aesculapius fountain, and several designs for basins (with figures reclining on them). It seems quite possible, then, that Tribolo's bronze *Satyr* was originally conceived as a supporting figure for the Aesculapius fountain, and that the artist only later struck on the idea of "recycling" one of his discarded ideas into one of the most graceful and elegant small bronzes of the sixteenth century.

Louis A. Waldman

In 1542, at the request of Francis I, Cellini designed a model for the bronze decoration of the Porte Dorée, the ceremonial entrance to the château of Fontainebleau. Although the Porte Dorée was never completed, it is frequently noted that Cellini's description of the model in his autobiography exactly accords with the surviving figurative sculptures for it. He states that two female personifications of victory decorated the spandrels, framing a lunette with a reclining female nude representing the "genius of Fontainebleau," while two colossal satyr-caryatids supported the lunette on either side of the entrance:

I fashioned two satyrs, one upon each side. The first of these was in somewhat more than half-relief, lifting one hand to support the cornice, and holding a thick club in the other; his face was fiery and menacing, instilling fear into the beholders. The other had the same posture of support; but I varied his features and some other details; in his hands, for instance, he held a lash with three balls attached to chains. Though I call them satyrs, they showed nothing of the satyr except little horns and a goatish head; all the rest of their form was human.[1]

Before his return to Florence in 1545 Cellini had overseen the casting of the *Nymph of Fontainebleau* and *Victories* (both in the Louvre).[2] Only the satyrs were uncompleted. These Cellini left "in a state ready for casting," indicating that finished, full-size clay models had been made for each figure.[3] Cellini's designs for the satyrs are preserved by a recently discovered bronze *Satyr* holding a mace and by its counterpart, a *Satyr* holding a club (cat. no. 103), which Cellini also rendered in this magisterial drawing in the Woodner Collection of the National Gallery of Art.[4] The Woodner drawing and the Getty bronze, exhibited here for the first time together, depict the satyr intended for the doorway's left side. Cellini's inscription on the drawing records the measurement of the full-size model as seven braccia tall, a monumental scale somewhat more than twice life-size. The use of the past tense indicates that Cellini added the inscription later, which suggests that he took the drawing back with him to Florence.[5] There he could have presented it as an example of his first monumental work in bronze to his potential patron Duke Cosimo I de' Medici. The drawing's seen-from-below perspective, tawny colours, and nuanced detail suggest that Cellini executed it in France during the time he was at work on the full-size clay model, between 1543 and 1545.[6] ¶ Cellini's *Nymph of Fontainebleau* and the *Victories* were directly influenced by Rosso Fiorentino's designs for the North and South Cabinets in the Gallery of Francis I at Fontainebleau (1532–1539). The satyrs have no such specific precedents; they are

the doorway's most conceptually inventive sculptures. On the Porte Dorée, Cellini's satyrs would have presented novel, monumental versions of the numerous caryatids that Rosso Fiorentino (who headed the Fontainebleau workshop from 1530 to 1540) and his assistant Francesco Primaticcio (who took it over in 1540, upon Rosso's death) had developed into one of the château's most characteristic artistic motifs. As elements on a ceremonial entrance, the satyrs introduced the symbolic progress through the château that culminated in the Gallery of Francis I – a king who, like the armed Woodner *Satyr*, could be "fiery and menacing" in war but whose reign, like the "genius of Fontainebleau" itself, was a source of peace and harmony.[7] ¶ Two classical marble caryatid *Satyrs*, which Cellini would have known in the della Valle collection in Rome, are the most commonly cited antique sources for the Woodner *Satyr*,[8] while Michelangelo's colossal marble of a club-bearing *Hercules*, which stood in the gardens at Fontainebleau, is considered Cellini's immediate contemporary source.[9] The Woodner *Satyr*'s vivid naturalism, one of its most commented upon qualities, reflects Cellini's practice in both the Porte Dorée and the later *Perseus* (1545–1554), as described in his autobiography, of working after the nude model.[10] Cellini would have been quite familiar with this practice from his friendships with painters in Rome during the 1520s, especially his Florentine compatriot Rosso Fiorentino. Although Cellini's *Satyr* was not drawn directly after a live model, it is informed by earlier life studies, which might have been either drawn or modelled in wax or clay. These may have been similar in conception to Rosso's haunting life drawing of a *Female Nude* (c. 1520, Uffizi, 6478F), posed in an attitude reminiscent of caryatid sculpture.[11] ¶ The notion of placing paired, monumental guardians on a gateway derives initially from Cellini's previous experience in Rome and Florence. A Roman precedent is provided by Baccio Bandinelli's colossal stucco *all'antica* figures (1519–1520) flanking the entrance to the garden of the Villa Madama.[12] In Florence Bandinelli's club-bearing *Hercules and Cacus* (1525–1534) and Michelangelo's *David* (completed in 1504) – colossal marble giants standing before the doorway to the Palazzo Vecchio – were an even more probable inspiration.[13] The Royal Collection *Satyr*'s proportions and features pay homage to Michelangelo's *David*.[14] The Woodner *Satyr*, ferociously naturalistic, furthers Cellini's intention that the completed bronze carry an impact on a colossal scale, and, as such, may have been a corrective to Bandinelli's *Hercules*, a sculpture that Cellini later famously lampooned for its artificiality. Like the colossal *Fountain of Mars*, which Cellini designed concurrently with the Porte Dorée, the *Satyrs* foreshadow many of the artistic goals that he brought to the

design and execution of his monumental bronze of *Perseus* in Florence. ¶ The Woodner *Satyr* is an elaborately layered, labour-intensive drawing, consisting of underdrawing in black chalk, parallel hatching in brown ink applied with the tip of the brush, thinly brushed washes in white wash and brown ink, and reinforcement lines in pen and dark brown ink.[15] Although this type of complex, colouristic drawing was becoming rare by the mid-sixteenth century, Cellini describes the technique in his unfinished *Discourse on Drawing*, and his immediate sources for the practice should be considered.[16] The tremendously assured handling of the pen-and-ink reinforcements of contours and hatching, which impart incisive three-dimensionality to the *Satyr*'s features, recalls Cellini's practised goldsmith's technique of reinforcing designs he had incised on silver with pen-and-ink to guide his hammering out of the relief in repoussé.[17] Overall, however, the Woodner *Satyr*'s complex technique has most in common with Rosso Fiorentino's distinctive, elaborately executed drawn *modelli*, such as the *Venus and Mars* of 1530, owned by Francis I (now in the Louvre), and the *Gods in Niches* series of 1526.[18] The precision with which such drawings transcribe three-dimensional form made them ideal models for prints. Cellini probably emulated their elaborate technique so as to capture the nuances of light and shadow modelling the *Satyr*'s musculature and to emphasize the figure's believable projection in monumental relief. In his autobiography and in the *Treatises* Cellini stressed how difficult it was to maintain naturalistic credibility in colossal sculpture. The Woodner drawing may be one of the small-scale model solutions that Cellini employed to achieve that goal.

¶ Cellini resorted to drawn *modelli* instead of sculpted models when he was challenged by a novel project, like his first commission for large-scale bronzes on the Porte Dorée. A precedent for the Woodner *Satyr*, and the only drawn *modello* Cellini mentions having made, was the design for the chalice of Pope Clement VII (1531), his first commission for large, in-the-round figures in gold repoussé.[19] As Cellini states, the drawing for the chalice also served as a presentation design. He drew it for a pope who, like the French king, took an unusually active, personal interest in his work. Undoubtedly the Woodner *Satyr*, which is beautifully executed in a style reminiscent of Rosso's finest presentation drawings for Francis I, would have similarly engaged the king's interest during his visits to Cellini's workshop. Cellini may even have drawn the *Satyr* to persuade Francis that he was as gifted at drawing as his hated rival Primaticcio, who by that time had taken over Cellini's other commissions for colossal sculpture at Fontainebleau. ¶ Because the Woodner *Satyr* was drawn when

Cellini headed his first – indeed his largest – sculpture workshop, it may also have been one of many guides that Cellini produced for necessarily delegated work, such as the naturalistic chasing of the completed Porte Dorée bronzes.[20] The colourism and distinctly matte tonality of the Woodner *Satyr* evoke the gradual modulations of light and shadow natural to a clay model. Such an accurately drawn overview would have made a useful reference in the requisite toning-down of a bronze's reflective surface during chasing. Cellini's pragmatic adaptation of his drawing technique to the specific material requirements of his finished sculptures is also evinced in his drawing for the *Juno* (1540–1544, Louvre), a life-size silver candlestick figure commissioned by Francis I.[21] Unlike the *Satyr*, the *Juno* is executed solely in black chalk; its simple, abstract forms and distinctive, dense handling evoke the luminous surface effects of chased silver repoussé. The high degree of finish of the Woodner *Satyr* and the *Juno* drawing and at the same time the differences in their techniques suggest that both may have been drawn to serve as presentation designs and as workshop models.

Denise Allen

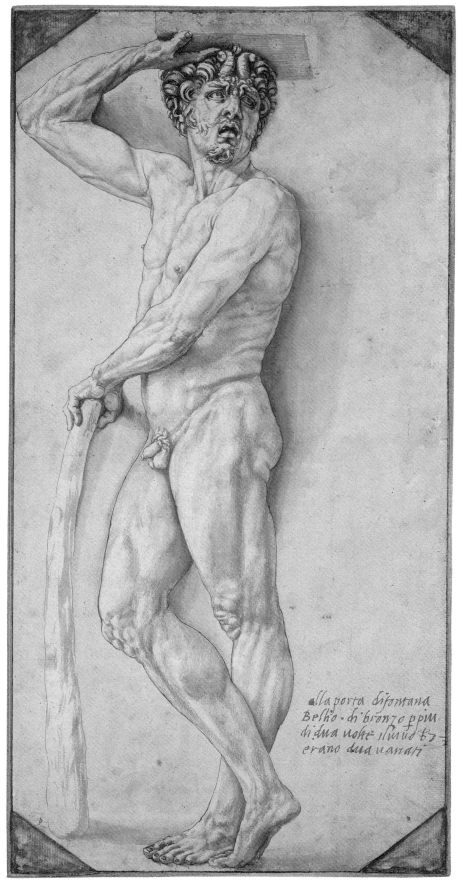

alla porta difontana
Belho · chi bronzo ppiu
di dua uolte il uiuo &7
erano dua uanati

102

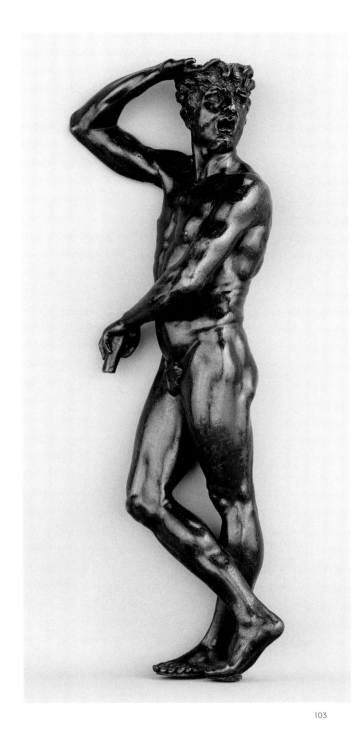

103

Between 1542 and 1545 Cellini designed and oversaw the execution of his first monumental bronzes for the relief decoration of the Porte Dorée, the ceremonial entrance to the royal château at Fontainebleau. The *Satyr* with a club in the Getty Museum, a model in high relief for the caryatid support at the left side of the doorway, was first published in 1982 by Pope-Hennessy. His attribution to Cellini was based on the bronze's exact resemblance to the autograph Woodner drawing (cat. no. 102); he suggested that the drawing recorded this bronze and that the bronze was cast by Cellini himself in Florence.[1] Subsequent authors have argued that it was unlikely Cellini cast the *Satyr*, which was instead a relic cast produced in his Paris workshop after his abrupt departure from France in 1545, made to replace and preserve his original wax model in the more permanent medium of bronze.[2] Marsden's discovery and publication in 2003 of the Royal Collection bronze *Satyr* (holding a mace), the caryatid support for the right side of the doorway, challenges these conclusions. Marsden's findings and Bassett's technical analysis of the Getty and Royal Collection *Satyrs* convincingly indicate that they were made as a pair and date to the years in which Cellini was at work on the Porte Dorée. Marsden has also proposed, less convincingly, that the *Satyrs* are the sole surviving elements of the presentation model for the doorway that Cellini presented to Francis I in 1542. ¶ Cellini's presentation model was probably wax or clay, not bronze. A model intended for a patron's approval had no need of permanence; moreover, there was simply not time for casting during the roughly twenty days that passed between Francis's commission and Cellini's presentation of the model – a length of time confirmed by Jestaz almost concurrently with Marsden's publication.[3] The Getty *Satyr*'s relatively large size and assured, precise forms also suggest that Cellini modelled the figure when he was well past the early stages of the design process. The Getty *Satyr* and its companion were more likely preceded by initial wax or clay sketch models that would have enabled Cellini to project these figures in the round with convincing naturalism. As composition models, the Getty and Royal Collection *Satyrs* could also have served as guides in the making of the full-scale, twice-life-size clay models of the satyrs that Cellini began sometime in the second half of 1543 and completed by June 1544.[4] It is the full-size clay model for the *Satyr* with a club that is probably recorded in the Woodner drawing, where the modelling of the musculature is rendered in more aggressive, distance-carrying detail than in the Getty bronze. The Woodner drawing also illustrates the orientation of the Satyr as it would have appeared on the front of the doorjamb on the Porte Dorée. Cellini had worked out this orientation in his composition model, for the pose is exactly duplicated by the Getty *Satyr* when it is photographed from the proper viewpoint.[5] But if Cellini intended the Getty and Royal Collection *Satyrs* to be solely composition models, why were they cast in bronze? ¶ Cellini himself tells us that he produced models in bronze for two reasons: to test the casting process and to serve as guides for chasing his finished bronzes. The Getty *Satyr* and its

companion may have been cast to serve the former purpose. In his autobiography and in the *Treatises* Cellini repeatedly emphasized that the successful execution of bronzes depends on understanding the skill of the bronze founders and the nature of local casting materials. At the turn of the sixteenth century, making small-scale trial casts for monumental bronzes was not unusual, especially for sculptors new to bronze founding. When Cellini was in Rome in the 1520s Baccio Bandinelli produced such casts in preparation for his first commission in monumental bronze for the Castel Sant'Angelo. In 1545, when Cellini was in Florence lobbying for the *Perseus* commission, he was required to prove his abilities at bronze casting by making a relatively small bronze trial relief (the *Saluki Dog* now in the Bargello).[6] In Paris in 1541, a few months before the Porte Dorée was commissioned and perhaps in anticipation of it, Cellini executed his first successful bronze sculptures: a bust of *Julius Caesar* and the *Head of a Nymph*. These life-size bronzes were made to test, Cellini said, his and his French founders' casting skills.[7] He also experimented with casting techniques, possessing knowledge of indirect casting, a casting method that he described in detail in the *Treatises*.[8] As the only bronze attributed to Cellini that is an indirect cast, the Royal Collection *Satyr* may be the sole surviving example of his hands-on experience with that technique. ¶ Unlike the Royal Collection *Satyr*, the Getty *Satyr* is a direct cast. That Cellini employed these different techniques reflects the experimental nature of his approach to bronze casting.[9] However, he used the more traditional method of direct casting for his completed monumental bronzes, such as the *Nymph of Fontainebleau* (the lunette for the Porte Dorée, now in the Louvre) and later for the *Perseus* in Florence. Cellini expressed regret that he had cast the *Perseus* using the direct method, for the indirect method would have preserved the sculpture's full-size model, which was destroyed in the direct procedure. Cellini noted that the laborious process of chasing the surface of the bronze *Perseus* would have been quicker and easier had the full-size model been preserved to serve as a guide for this last, essential stage of work, in which the bronze surface is meticulously tooled with files and details are both added and reinforced with hammers, punches, and chisels.[10] The intensely naturalistic effects characteristic of Cellini's finished bronzes depended largely on the successful execution of this chasing. In Paris, where bronze production was highly organized, Cellini separately contracted sculptors to execute the chasing of the Porte Dorée bronzes,[11] and because the detailed, full-scale models were destroyed during the direct-casting process, he provided these sculptors with other highly chased bronzes to serve as guides. Cellini's bronze *Bust of Julius Caesar* and *Head of a Nymph* are the documented chasing models offered for work on the finished Porte Dorée *Satyrs*.[12] The Woodner drawing's detail and meticulously rendered surface suggest that it may also have been intended to serve as a workshop reference for chasing the completed monumental bronze *Satyr*. However, as the Getty *Satyr* lacks the sharply incised detail and wire-brushing characteristic of the chased surfaces of Cellini's finished bronzes,[13] it is unlikely that it was ever intended to serve as a guide to chasing.

Denise Allen

The group of *Leda and the Swan* from the Bargello is perhaps the most erotic sculpture that has come down to us from the Italian Renaissance. It stands out from contemporary small bronzes, which show satyrs and nymphs in explicitly sexual situations, both for its larger size and on account of the material it is made of, white marble from Carrara, suggestive both of the colour of the swan's feathers and of the naked female's flesh. The sculpture is based on a lost painting made by Michelangelo for the duke of Ferrara, Alfonso d'Este, between November 1529 and October 1530, a work that was in turn indebted to an ancient Roman cameo.[1] The painting was never delivered to its original patron, but was taken to France by Michelangelo's pupil Antonio Mini shortly after completion. Among several copies that were derived from the painting before it was burned in the seventeenth century, an engraving by Cornelis Bos (fig. 104.1) seems particularly close to the lost original, judging from the interdependences and unique features of the various copies. The Bos version includes an egg and the twins Castor and Pollux, who sprang from Leda's union with Jupiter disguised as a swan. ¶ The sculpture differs from its two-dimensional model in many respects. For example, the bird's left wing is not raised behind Leda's leg but is only slightly opened, a change that confers a compact, block-like outline to the group, which better fits the requirements of sculpture. Also, in the marble, Leda's left leg rests on top of her lover's right wing rather than on his back, as in the engraving, so that she seems actively to temper the motion of the wing, which in the original had swept around her raised lower leg and foot. Here, however, the wing is reduced to a linear shape that in the main, frontal view is parallel to the other wing, to Leda's lower leg, and (at some distance) to her reclining back. This array of parallels lends optical support to the stable, compact appearance of the group, enhancing its sculptural character. ¶ This cluster of slanting lines, however, changes the general character of the composition. Where there was an animated equilibrium between the lovers, the bird's role is now diminished. The movement of the swan's body culminates in the queen's head, which in the marble is more upright. Correspondingly, the neck and head, which in the painting had gently rested on Leda's stomach and between her breasts, are now freely

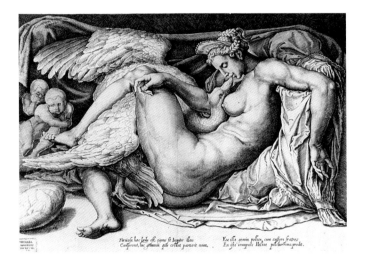

Fig. 104.1 Cornelis Bos, *Leda and the Swan*, 1540s, engraving, 30.5 x 40.7 cm British Museum, London (1874-8-8-332)

detached from the woman's body, permitting the beak to reach her lips. This alteration may have been motivated by the sculptor's desire to show off his technical skills. He also opened up a void between Leda's back and the backrest, where in the two-dimensional version there was drapery. With respect to the content, this change also serves to emphasize the kiss in which both lovers are absorbed. ¶ In the nineteenth century the sculpture was attributed to Bartolomeo Ammanati and identified with a statue by this sculptor that in 1584 Vincenzo Borghini said belonged to the Duke of Urbino.[2] But since the measurements given by Borghini do not tally with those of the Bargello work, Ammanati's authorship has in recent times been questioned, one scholar proposing an attribution to Daniele da Volterra instead.[3] However, the unbroken provenance of the sculpture proves that it came to Florence with the inheritance of the dukes of Urbino in 1631. In addition, a description of the statue when it was still in the della

Rovere palace in Pesaro clearly matches the present one ("a marble statuette of a reclining Leda with the swan between her legs").[4] Most importantly, however, the sculpture's style corresponds with that of Ammanati's other works. The figure of Leda bears a distinct similarity to the allegory of Victory from the tomb for Mario Nari (Bargello), notably in the shape of the eyes, the elaborate hairdo, and the articulation of the folds of cloth draped over the backrest. These similarities suggest a close date of execution for the two works, possibly in the early 1540s (Nari died in October 1539). Thus the figure of Leda may even be connected to Ammanati's earliest visits to Urbino, where he married the poetess Laura Battiferri in 1550. ¶ While in Renaissance and Baroque sculpture Leda is generally shown standing or seated, a reclining pose enjoyed new popularity from the eighteenth century on. Michelangelo's particular version was translated to the third dimension once again by Rodin's teacher Albert-Ernest Carrier-Belleuse in a terracotta (c. 1858) now in the Minneapolis Institute of Arts. In his version, the approaching swan is moved behind the lady's legs, which are covered by a thin veil in accordance with taste under Napoleon III. The Danish sculptor Kai Nielsen took the theme in the opposite direction (1918, Statens Museum, Copenhagen), showing Leda with her mouth open, throwing her head back, and pressing the back of one hand against her forehead. Ammanati would certainly not have approved of these later variations, and must have felt remorse for his own youthful transgression when in old age he fell under the influence of the Jesuits and in a public letter exhorted the members of the Accademia Fiorentina to forswear any representation of nudity at all.

Eike D. Schmidt

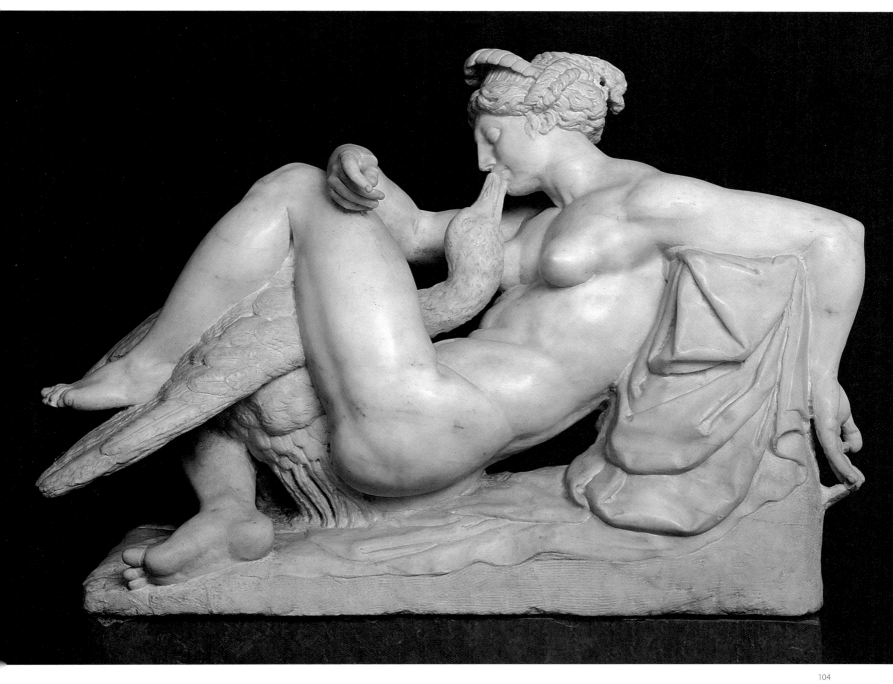

Vasari relates that while the Medici overseer of Pisa, Luca Martini, was writing his commentaries on Dante's *Inferno*, his friend and protégé Pierino da Vinci was inspired to sculpt a relief based on the poet's narrative of the death of Ugolino della Gherardesca, a count belonging to the Ghibelline faction. In canto 33 of the *Inferno*, Dante tells of his meeting with Ugolino in the lowest circle of Hell. The count describes how in 1289 Archbishop Ruggieri of Pisa locked him in a tower, together with his four sons, and allowed him to starve to death while watching his sons perish, one by one, before his eyes. ¶ The biographer writes that Pierino modelled the work in wax and subsequently cast it in bronze. As elsewhere in his Life of Pierino, Vasari's description (possibly based on the account of an inaccurate informant) does not correspond precisely to the actual work: the biographer reported that the relief showed not one but two of Ugolino's offspring already dead.[1] But he expressed an opinion shared by generations of later viewers when he noted that the young Pierino's work demonstrates the affective power of *disegno* just as effectively as Dante's displays the dramatic force of poetry. In some ways, Vasari even implies, Pierino's art rivals poetry's capacity for allusion and intertextuality. Thus, the sculptor's inclusion of the river god Arno reminds the viewer that the story took place in a tower near the river; the haggard personification of Hunger flying overhead introduces an allegory borrowed from Ovid into the world of the fourteenth-century poet. ¶ The allusive quality of Pierino's relief exists on another level: its style and the poses of most of the figures clearly show the inspiration of Michelangelo. The twisted head and bent right arm of the heroic old count derive from the *Moses*, which Vasari says Pierino copied in wax for Martini a year before modelling the *Ugolino*. The recumbent figure of Arno, nearly falling out of the frame, recalls works such as the *River Gods* planned for the Medici tombs in San Lorenzo, or the central figure in Michelangelo's *Conversion of Saint Paul* in the Pauline Chapel (1542–1550). The two youths seated at the left show the impact of the Sistine *ignudi*; the curved posture of the dead youth is a variation on the sleeping Adam in the *Creation of Eve*; and in *Hunger* we find the flying pose of God the Father in the *Creation of the Sun and the Moon*, rotated at a 180-degree angle

toward the spectator. Pierino's adaptations from Michelangelo should be understood as creative responses to a venerable tradition of artistic forms, much like Luca Martini's poetic allusions, which place him within a literary tradition that extends back to such figures as Dante and Petrarch. ¶ Pierino's original bronze version of the *Ugolino* has recently been identified by Avery with a lost-wax cast at Chatsworth. An equally fine version in wax in the Ashmolean Museum, though cast rather than modelled, may well have been finished by Pierino himself (either as an independent work or as insurance against a failure in casting). Of the various aftercasts in terracotta that survive, the version seen here – in a sixteenth-century frame, which appears to be original to the work – is particularly important on account of its provenance. From at least the eighteenth century through the latter part of the twentieth it was in the collection of the della Gherardesca – the family of Dante's hero – at Florence, where an engraving was made of it in 1782.[2] In Medicean Florence many patrician families commissioned works commemorating their ancestors – real or fictive – and the della Gherardesca family's version of Pierino's *Ugolino* undoubtedly played a significant role in the family's social and economic self-promotion as one of the most venerable families of the Tuscan patriciate.

Louis A. Waldman

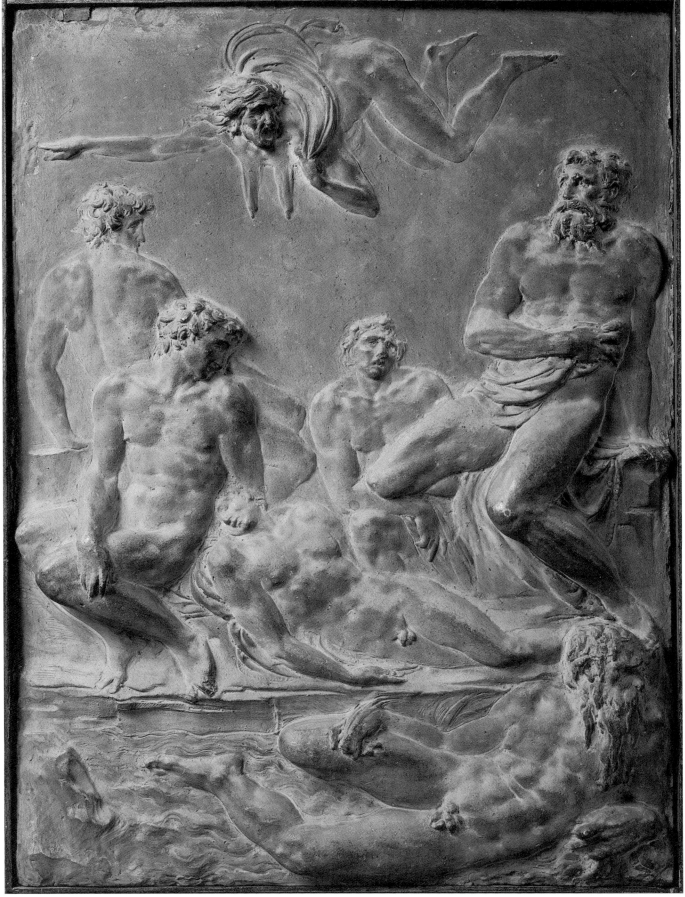

Inspired by the fame of the uncle he never met, Leonardo's nephew Pierino da Vinci developed into one of the most refined and technically accomplished heirs of Michelangelo's style – before the untimely end of his career at the age of only twenty-three. This virtuosic relief, carved near the end of his life, is his greatest masterpiece and deservedly one of the most celebrated works of sixteenth-century Italian sculpture. ¶ Vasari praised the work enthusiastically in the 1568 edition of the *Lives*, where he describes its subject as "Pisa restored by the duke [Cosimo I de' Medici], who in the work is present in the city and at its restoration, which is being urged on by his presence. Around the duke are portrayed his virtues, and particularly a Minerva representing Wisdom and the Arts revived by him in the city of Pisa; and she [Pisa] is surrounded by many ills and natural deficiencies of the place, which in the manner of enemies assail her all about and afflict her. From all of these [ills] she has now been liberated by the said virtues of the duke."¹ It seems likely that Vasari based his description on the testimony of others; this would explain, for example, why he believed, mistakenly, that the young woman with a basin on her head behind the duke was Minerva. ¶ Clad in a toga and extending a commander's baton in the manner of an ancient Roman emperor, Cosimo stands at the centre of the composition and literally raises the personification of Pisa (holding the city's coat of arms) from the ground. Pierino's preparatory drawings for the relief reveal how the figure of Pisa evolved from a seated pose, to a crouching pose, to the present attitude – midway between sitting and standing – with its unmistakable implication of movement. ¶ At the right a motley crew of vices – personified by fauns, satyrs, a centaur-hippocamp, and other ghastly personages – is routed by the approach, from the left, of a triumphant parade of figures representing classical virtues, accompanied by contemporary individuals. Most of these figures bear objects – a book, an armillary sphere, an astrolabe, and an array of weighty vessels (here probably representing *virtù*, as they do in Vasari's 1534 *Portrait of Lorenzo de' Medici*²) – which are emblematic of Cosimo's improvements to the city. In 1542 Cosimo had reopened the city's famous university, and in 1547 he established the office of canals, under the control of his secretary Luca Martini, who drained the city's insalubrious marshes, rebuilt its fleet, and acted as Cosimo's lieutenant in the administration of Tuscany's leading port. ¶ Martini gathered around himself a small coterie of scholars and artists, including Pierino, who became his protégé and "court artist." An unprecedented number of artworks, including two portraits from the workshop of Bronzino, celebrate his successful administration of Pisa's territory. There can be little

doubt that Martini was the patron of this pointed allegory; Pierino portrayed him at the left, holding a compass and astrolabe, which allude both to his engineering work in the Pisan countryside and to his research into the dimensions of Dante's *Inferno*.³ ¶ Pierino's relief includes several other contemporary portraits. Immediately above the secretary's head is a portrait of Michelangelo, the artist who most profoundly shaped Pierino's style – and, like Martini, a poet and amateur student of Dante. At the extreme left edge is a portrait of Pierino's teacher Tribolo, who had died in 1550; he clutches a *modello* of a reclining river god; the little figure alludes to Tribolo's ambitious designs for the fountains of the Medici villa at Castello (see cat. no. 101), and it forms a link with Pierino's own personification of the Arno, shown here at Cosimo's feet. Just above Tribolo is the head of a youth in low relief. The way he gazes at the viewer from the edge of the painting (as artists conventionally did when inserting self-portraits into a narrative), his turban (often worn by sculptors in this period), and his youthful appearance have led this figure to be identified as Pierino himself. ¶ Technically, Pierino's work is a masterful hybrid of the high relief practised by Bandinelli, with whom the young sculptor briefly studied, and the extremely low, pictorial technique of *rilievo schiacchiato* created by Donatello in the fifteenth century and revived in the early Cinquecento by Rustici (see cat. no. 7). Given the relief's exquisitely finished surface, it is remarkable that Vasari's 1568 Life of Pierino describes it as unfinished. The hypothesis that it was finished after 1568 by another hand is difficult to accept, given the exact correspondence of its surface finish to that in other works by Pierino, like the *Death of Count Ugolino della Gherardesca and His Sons* (cat. no. 105). In all likelihood, Vasari's informant mistakenly believed the figures in the background, faintly etched in *schiacchiato*, to be mere outlines, rather than finished figures in very shallow relief.

Louis A. Waldman

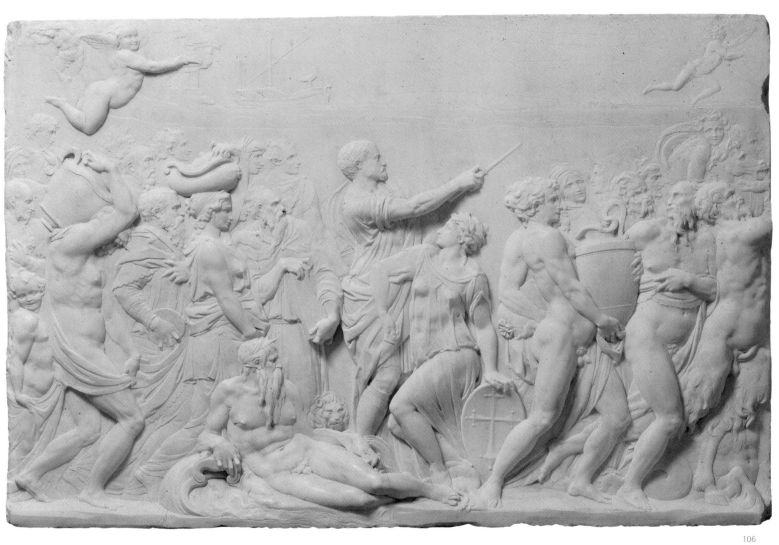

106

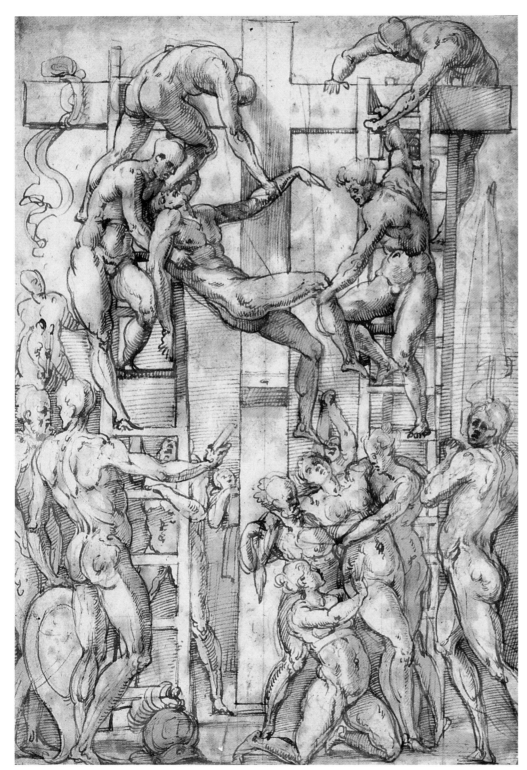

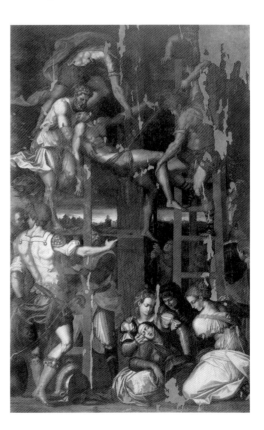

Fig. 107.1 Giorgio Vasari, *The Descent from the Cross*, 1536–1537, oil on panel, 327 x 197 cm. Church of Santissima Annunziata, Arezzo

On 3 January 1536 the twenty-five-year-old Vasari received his most ambitious religious commission to date.[1] The Confraternity of Corpus Domini in Arezzo asked him to paint a *Descent from the Cross* for the main altar of the church of San Domenico. In the 1790s this painting was transferred to Santissima Annunziata, where it survives in a much damaged state (fig. 107.1). The drawing exhibited here, one of Vasari's earliest known sheets, is a vigorous study for this painting. It was probably made shortly after the date of the commission and almost certainly before February 1537, when Vasari wrote to a friend in Florence, the physician Bartolommeo Rontini, offering a long description of the painting, whose execution must have been fairly advanced. However, the project had been giving Vasari some trouble; to avoid any distraction, he locked himself in his room to finish it, and he was confident that "if there were no interruptions" he would soon do so. In fact, according to his *Ricordanze* the altarpiece was finished in April 1537.[2] ¶ The present drawing and the Arezzo painting, both of which are fully characteristic of Vasari's early style, provide a glimpse into how he assembled his first major altarpiece. While the drawing's pen style betrays Vasari's early training with Bandinelli in the mid-1520s, the overall spirit and figure repertory points to Rosso Fiorentino, the single most important influence on the youthful artist in the early 1530s. After the Sack of Rome in 1527 Rosso worked for about three years in Sansepolcro and also in Arezzo, where he took Vasari under his wing. As the latter proudly records in the autobiographical description of his own works at the end of the 1568 edition of the *Lives*, Rosso gave him drawings, and even made one especially for him to help him with one of his earliest commissions, a *Resurrection of Christ*.[3] ¶ As Davidson's comprehensive analysis of the Hartford drawing and the painting shows, Vasari was struggling to come to grips with a complicated multi-figure composition. The overall design, including the figure of Christ, clearly owes a debt to Rosso's famous *Deposition* of 1527–1528 in Sansepolcro. But whereas Rosso's picture shows the slumped body of Christ positioned on the Virgin's lap (somehow ambiguous in its combination of *Deposition* and *Pietà*), Vasari's depicts an earlier moment in the sequence of events. ¶ The Hartford drawing, a swiftly made compositional study rather than a finished drawing, corresponds quite closely to the painting, except for the group of the fainting Virgin Mary and Saint John in the lower-right corner. In the drawing, this group recalls Raphael's Borghese *Deposition* of 1507. The figure of Mary Magdalen kneeling in the foreground corresponds exactly, but in reverse, to that in Raphael's picture. Vasari nonetheless must have been dissatisfied with this group, and he subsequently worked out a new solution more strongly indebted to Rosso. The figure of Saint John behind the Maries on the right side of the painting is quoted from Rosso's 1521 *Deposition* at Volterra, while the figure of the Magdalen in the lower-right corner is based on the female figure at the upper right of his 1530 *Risen Christ in Glory* at Città di Castello.[4] The elegant figure of the centurion on the left appears to conflate two other exemplary works of the period. It partly derives from the *repoussoir*

figure on the left in Perino del Vaga's famous *Martyrdom of the Ten Thousand* cartoon, designed during his brief stay in Florence in 1522–1523 for a fresco in the church of San Salvatore in Camaldoli. The fresco was never realized, but Vasari records that Perino had first made a small drawing, which was considered "divine" ("fu tenuta cosa divina"), before making the full-scale cartoon, with "admirable diligence," producing a work of such beauty and excellence in design as had not been seen in Florence since the cartoon drawn by Michelangelo for the Sala del Gran Consiglio (that is to say, his *Battle of Cascina*).[5] While the small drawing in this account is now commonly identified with a sheet in the Albertina (cat. no. 64),[6] a copy of it in the Fogg Art Museum (fig. 63.2) appears to be from Vasari's hand.[7] Perino's *repoussoir* figure, however, is itself a variation on a figure at the left in Raphael's fresco of the *Battle at Ostia* in the Stanza del Incendio in the Vatican, which Vasari had almost certainly copied during his brief study trip to Rome in 1532. As Vasari recalled in his autobiographical account of this sojourn, "there remained nothing of Raffaello, Polidoro, and Baldassare da Siena that I did not draw."[8]

¶ Despite this apparent awareness of Raphael's Roman works, Vasari's search for perfect figures focused mainly on central Italian models, mostly Tuscan, and Davidson has noted further quotations from works by Sodoma and Perugino. Yet Vasari was soon to look for inspiration elsewhere. Two years later, undoubtedly influenced by his second and more extensive study trip to Rome, in 1538, he would rid his work of most of its Bandinellian reminiscences and overcome his attempts to emulate Rosso's eccentric *maniera*. Instead, he would develop a lighter and more decorative style, based on Raphael and his school, primarily Perino del Vaga and Giulio Romano and, of course, Parmigianino, whose works Vasari studied intensively during his subsequent stay at Bologna in 1539–1540 (see cat. no. 109). The assimilation of these sources furnished the young painter with a modern style – less harsh and individualistic than his early efforts – that was much more likely to appeal precisely to those patrons in Rome, Florence, and Venice whom he was hoping to win.

Florian Härb

This drawing's subject matter has not yet been precisely identified, though the figure beaten before a Roman commander would appear to be Saint Sebastian, who was flogged to death at the order of the emperor Diocletian in 288 A.D. This subject was also suggested in the 1671 inventory of one of the drawing's previous owners, Everard Jabach. The drawing is mounted on a larger sheet that has an ornamental border commonly associated with Vasari's *Libro de' Disegni*. A cartouche on the mount identifies the draftsman as Lutio da Todi (Luzio Romano), a specialist in grotesque decoration and an assistant to Perino del Vaga in Rome in the 1540s. As Monbeig Goguel has correctly noted, however, the drawing's style is incompatible with Luzio's. While the drawing may well have been included in Vasari's *Libro*, the mount's ornamental decoration appears not to be from his hand, and the inscription was certainly added later, most likely when the drawing was in Jabach's collection.[1] Monbeig Goguel placed the drawing within the circle of Vasari, while Petrioli Tofani considered it to be from the same hand as the Hartford *Descent from the Cross* of about 1536–1537 (cat. no. 107), without, however, firmly attributing either of these to Vasari. ¶ Very few drawings from Vasari's early career survive, but the present sheet provides sufficient evidence of his authorship.[2] While the pen style is clearly indebted to that of Bandinelli, Vasari's teacher in the 1520s, Vasari's hand may be recognized in the facial types of the figures on the right watching the event and those of the smaller figures in the background. The oval or heart-shaped heads, like those peering over the balustrade in the upper register, are a trademark of his draftsmanship that can be traced throughout his career. The drawing's specific purpose has not yet been established, although its considerable size and thorough execution suggest it may have been made as an independent work of art, or possibly for a print, but it is less likely to have been a study for an altarpiece. No related work survives, nor is any documented in the artist's *Ricordanze* or in his extensive correspondence. ¶ As he did for the Hartford *Descent from the Cross*, Vasari drew on different models for this complex composition. The balustrade populated with onlookers derives from Marco Dente da Ravenna's engraving after Bandinelli's large drawing of the *Massacre of the Innocents*.[3] Vasari mentions this engraving in his Life of Bandinelli, particularly for the rich variety of the women's and soldiers' poses, and the skilful treatment of musculature, which earned the artist fame throughout Europe.[4] The Paris drawing strives to achieve a similar wealth of invention, or *copiosità*. The architectural backdrop and the ruler on the left are borrowed from Marcantonio Raimondi's engraving after Raphael's *Martyrdom of Saint Felicity*, as is the angel holding a martyr palm.[5] The figure with his back turned toward us leaning on a column at the far left could have been taken from that engraving, or, more likely, directly from Raphael's *Expulsion of Heliodorus* fresco in the Vatican Stanze, which Vasari would have seen and copied during his first trip to Rome, in 1532. While turning partly to Roman models, the drawing's style is essentially Florentine, close to that of the Hartford *Descent*. This combination of Florentine and Roman elements would suggest a date prior to, or perhaps during, the artist's second Roman sojourn, in 1538, after which the harshness of his early pen drawings gave way to a more elegant, fluid style based primarily on the works of Raphael and his school and of Parmigianino.

Florian Härb

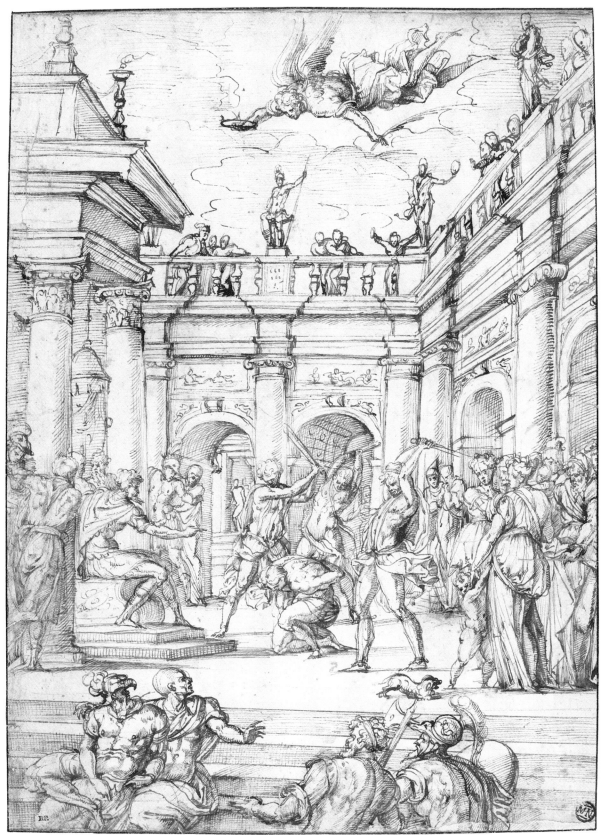

This carefully executed drawing relates to Vasari's tripartite altarpiece of the *Allegory of the Immaculate Conception*, painted in 1542–1543 for the family chapel of Biagio Mei in the church of San Pietro Cigoli in Lucca, and now in that town's Museo Nazionale di Villa Guinigi. It is a study for the figure of Saint Eustace in the right panel (fig. 109.1). The left panel is dedicated to Saint Blaise, the patron saint of the donor. According to the *Ricordanze*, Vasari received the commission on 20 July 1542 and completed the painting on 31 October 1543. He states that the patron wished his altarpiece to be similar to that of the same subject finished about a year earlier, in 1541, for the chapel of Vasari's friend and patron Bindo Altoviti, in the church of Santi Apostoli in Florence.[1] This was Vasari's first important altarpiece for a Florentine church and proved to be extremely popular. Several small-scale versions and large replicas by the artist and his workshop, and numerous variations by subsequent Florentine painters well into the seventeenth century, testify to the great success of Vasari's painting.[2] While the Lucca altarpiece is largely based on Altoviti's, Vasari made numerous changes to the positions and gestures of the figures. He also reduced their number by one and added two lateral panels with saints, thus repeating an altarpiece type that he had first employed in his *Descent from the Cross* at Camaldoli (1539–1540) and then used throughout his career.[3] ¶ A large drawing by Vasari in the Louvre shows the Lucca altarpiece set in its architecture, with the donor's coat of arms and additional grotesque decoration (fig. 109.2).[4] It is not known whether it was ever executed as such, for its original setting is now lost. The Louvre drawing matches the Lucca paintings in most details; even the figures in the side panels correspond closely. This is remarkable, for such finished drawings were usually made at an early stage in the design process and were almost always subject to change. Given that the Louvre drawing lacks virtually any pentimenti, it is quite conceivable that it was made as a *ricordo* of the altarpiece rather than as a preparatory design. ¶ The figure of Saint Eustace in the present drawing differs both from that in the Louvre sheet and from that in the painting. In the latter Vasari gave the figure a stronger twist, bringing it more in line with the Mannerist ideal of the *figura serpentinata*. By simultaneously showing the figure's front and back he achieved a highly artificial effect, for which, on another occasion, he was specifically praised by his early mentor, Pietro Aretino, in a letter of 15 December 1541.[5] The Lucca painting was executed a few years after Vasari's return from a prolonged stay in Bologna (from 1539 to 1540), where Parmigianino's Emilian works had a strong impact on his style, particularly notable in the fine cross-hatching and curved parallel hatching of this drawing.

Another source, as McTavish has noted, was Dürer's famous *Saint Eustace* engraving of 1501. The reclining dog and the deer's head in the drawing derive directly from this print. While Vasari ultimately did not use the dog in the painting, the foreshortened head of another at the lower left is clearly borrowed from the one at the centre right of Dürer's print. Dürer's engravings were greatly admired by Florentine artists – Pontormo quoted them in his Certosa del Galluzzo fresco cycle, and Vasari used them in his own compositions throughout his career. ¶ The fairly complex iconography of the *Immaculate Conception* is typical of the allegorical paintings Vasari made early in his career. Often their subject matter was devised with the help of humanists. According to his *Descrizione*, the autobiographical account of his own works at the end of the 1568 edition of the *Lives*, Vasari developed the iconography with his patron Altoviti and with the help of "molti comuni amici, uomini letterati," one of whom may have been Giovanni Pollastra, Vasari's advisor and early mentor in Arezzo.[6] As David Franklin has pointed out, the iconography is essentially based on a conflation of a passage from the Old Testament, Genesis 3:15 (pointing to the Virgin as the Second Eve, who will bring about the vanquishing of the serpent), and another from the New Testament, Revelation 12:1 (the Woman of the Apocalypse).[7] It has also been noted that Vasari had recourse to Rosso Fiorentino's now lost cartoon for one of the lunettes in the atrium of the church of Santissima Annunziata in Arezzo, depicting the Virgin as the Second Eve, a *concetto* that was devised by Pollastra. Vasari was familiar with Rosso's designs, which he described in his biography of the artist, and he also owned Rosso's small-scale model (probably wooden, with drawings) of the entire decoration.[8] The figures of Adam and Eve, bound to the Tree of Knowledge, and the serpent with a human upper body depend on Rosso's designs, known by several copies of now lost drawings by the artist.[9] ¶ Much of Vasari's extensive description of the Altoviti painting applies as well to the Lucca altarpiece. The upper register shows the Virgin, "clothed by the sun and crowned with twelve stars" and supported by angels. With her right foot she steps on the horns of the serpent, whose hands are bound behind his back and whose tail is wound around the trunk of the tree. Bound to the roots of the Tree of Knowledge at the centre are Adam and Eve ("the first transgressors of the commandment of God"). Then, Vasari writes, "bound to the other branches [are] Abraham, Isaac, Jacob, Moses, Aaron, Joshua, David, and the other kings in succession, according to the order of time; all, I say, bound by both arms, excepting Samuel and John the Baptist, who are bound by one arm only, because they were blessed in the womb."[10] ¶ A drawing of Saint

Eustace by Vasari is mentioned in a letter of 19 November 1657, written by Paolo del Sera to the great collector Cardinal Leopoldo de' Medici, regarding an exchange of drawings between the latter and another collector, Gualtiero van der Voort. According to this letter, Leopoldo received seventeen drawings from van der Voort, who in turn chose only seven, among them "quel Sant'Eustachio del Vasari." Apparently van der Voort did not aim at the highest-quality drawings, at least in del Sera's view, for he selected "not even the most exquisite ones" ("neanco de più esquisiti"). It is conceivable that the present drawing, which bears the stamp of the Dutch art dealer Jan P. Zoomer (1641–1724), is to be identified with the one formerly in the collection of Cardinal Leopoldo de' Medici.[11]

Florian Härb

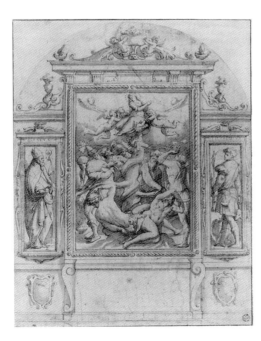

Fig. 109.1 Giorgio Vasari, *Allegory of the Immaculate Conception* (right panel), 1542–1543, oil on panel, 302 x 200 cm Museo Nazionale di Villa Guinigi, Lucca

Fig. 109.2 Giorgio Vasari, *Allegory of the Immaculate Conception*. c. 1542–1543, pen and brown ink and brown wash over black chalk, 41 x 31 cm. Musée du Louvre, Paris (2197)

In 1556, shortly after work began in the Quartiere degli Elementi of the Palazzo Vecchio in Florence, Vasari and his team embarked on the decoration of the Quartiere di Leone X. Named after the first Medici pope, Leo X, these quarters consisted of six rooms and a small chapel, which formed Duke Cosimo I de' Medici's private chambers. This drawing relates to the ceiling decoration in one of the rooms, known more specifically as the Sala di Cosimo il Vecchio (fig. 110.1). It is a study for one of eight spandrel paintings flanking the four tondi in the vault, depicting significant events in the life of the duke. Each spandrel shows Cosimo together with various allegories of Tuscan towns. In a letter to the duke dated 12 May 1558 Vasari refers to the room, except for the floor, as finished.[1] ¶ Devised by the humanist Cosimo Bartoli, the iconographic program for the ceiling paintings survives in a letter to Vasari written in 1556, which contains also the *invenzioni* for the room commemorating Cosimo il Vecchio and for the one commemorating Cosimo's father, Giovanni dalle Bande Nere.[2] This initial program for the Sala di Cosimo I, however, includes only one allegory of a Tuscan town (Pisa), while the other compartments were to show various virtues associated with the duke. These virtues were later abandoned in favour of a program emphasizing Cosimo's role as a reviver of the towns under his dominion and builder of fortifications in them. Here, as Rick Scorza has pointed out, Vasari and Bartoli drew on the classical motif of *Roma resurgens*, the reviving of towns by Roman emperors, frequently represented on Roman coins. The Tuscan towns are shown as either men or women, depending on their name's gender.[3] This program is also fully developed in a large and finished design for the entire ceiling decoration in the Louvre (fig. 110.2).[4] Subsequently, however, the individual scenes as shown in this drawing were rearranged.[5] ¶ The Ottawa drawing, in which Vasari thoroughly worked out the little sketch in the Louvre design, is a study for the spandrel to the right of *Cosimo Lending Assistance to Serravalle* (its counterpart to the left is *Cosimo Reviving Cortona*). Studies for two other spandrels, executed in the same technique on blue paper and squared for transfer, are in the Yale University Art Gallery in New Haven,[6] and in a private collection.[7] A finished study for the central ceiling painting is in the Uffizi,[8] and another

for one of the four tondi in the vault is in the Castello Sforzesco, Milan.[9] ¶ The present drawing shows Cosimo holding two nails (possibly relics from the True Cross) while handing an edict to the old man kneeling in front of him. In the painting, which otherwise follows the drawing quite closely, these items were not included, and Vasari added a male figure to the right of the old man. As Vasari explains in his *Ragionamenti*, a hypothetical dialogue in which he guides Cosimo's son, Francesco, through the newly decorated Palazzo Vecchio, the scene shows the two Spanish pilgrims of the tenth century, Egidio and Arcano, legendary founders of Sansepolcro.[10] On their return from Palestine, they had halted in this neighbourhood and built an oratory, in which they placed the relics they had brought from the holy places. Vasari further writes that Cosimo is shown putting a mural crown (*corona murale*) on the head of one of them, symbolizing its fortification by the duke. This, however, does not correspond with the painting. As Scorza has convincingly suggested, such discrepancies between the paintings on the one hand and their descriptions in the *Ragionamenti* on the other can be explained by the fact that when Vasari wrote his dialogue he looked for guidance to the finished drawings, such as that in the Louvre, rather than to the paintings on the ceiling.

Florian Härb

Fig. 110.1 Giorgio Vasari, detail from the ceiling of Sala di Cosimo il Vecchio, 1556–1558, oil on panel. Palazzo Vecchio, Florence

Fig. 110.2 Giorgio Vasari, *Design for the Ceiling of Sala di Cosimo I de' Medici*, 1556–1558, pen and brown ink and brown wash over black chalk, 35.5 x 41.5 cm. Musée du Louvre, Paris (2174)

111 GIORGIO VASARI (1511–1574) · The Crucifixion · 1560 · Pen and brown ink and brown wash over black chalk, heightened with white, on ochre prepared paper · 45.6 x 33.7 cm · Albertina, Vienna

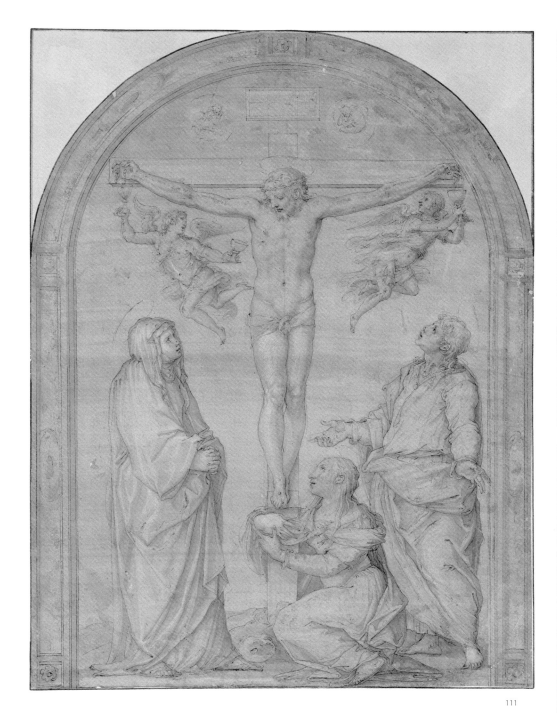

111

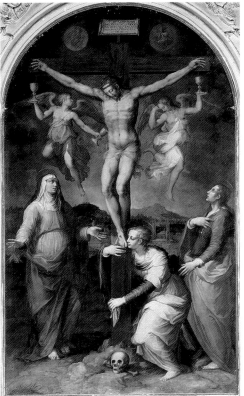

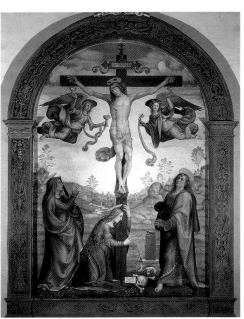

Fig. 111.1 Giorgio Vasari, *The Crucifixion*, 1560, oil on panel. Church of Santa Maria del Carmine, Florence

Fig. 111.2 Mariotto Albertinelli, *The Crucifixion*, 1506, fresco, 328 x 220 cm Certosa del Galluzzo, Florence

This is a highly finished drawing for the altarpiece painted in 1560 for the chapel of Vasari's friends Matteo and Simon Botti in the church of Santa Maria del Carmine in Florence (fig. 111.1). According to a draft of Vasari's *Ricordanze* preserved in the Beinecke Rare Book and Manuscript Library in New Haven, the painting was finished on 25 October 1560.[1] The final version of the *Ricordanze* mentions also a predella of the *Nativity* and an altar dossal, both of which were probably destroyed by fire in 1771.[2] Vasari was a close friend of his patrons, particularly of Simon Botti, a wealthy banker who may also have attended to the artist's financial affairs. Simon's younger brother Matteo was major-domo in Duke Cosimo I de' Medici's household. ¶ The drawing's considerable size and its high degree of finish, as well as the careful preparation of the paper in ochre, suggest that it was to be submitted to the patrons for approval. However, there are some differences between the Albertina drawing and the painting, particularly in the arrangement of the figures. The sweeping gesture of Saint John in the drawing was given to the Virgin in the painting, and the Magdalen is shown in a more upright position. Generally, the figures are more elongated in the painting. Despite its meticulous execution, the drawing shows several pentimenti in the black chalk underdrawing, and even some minor alternative solutions, for example in the right hand of Saint John, that Vasari did not erase. It is surprising that he did not seem to consider such pentimenti distracting in this finished work. ¶ When Vasari came to paint the Carmine *Crucifixion*, the commission that had occupied him most in Florence was the decoration and refurbishment of the Palazzo Vecchio. He had little time for other projects such as altarpieces, for which he had become famous in Florence ever since his highly successful *Immaculate Conception* of 1540 in the church of Santi Apostoli (see cat. no. 109). In fact, the Carmine *Crucifixion* was his first altarpiece for a Florentine church in about ten years, and it stood at the beginning of a series of altarpieces he and his workshop executed for Florentine churches in the 1560s, particularly for Santa Croce and Santa Maria Novella. Unlike most of these, however, the Carmine *Crucifixion* has a rather unassuming composition and expresses a simple monumentality that appears to reflect the new ideals of the contemporary Council of Trent. Yet no such new orientation may be detected in the artist's subsequent altarpieces, which are often based on complex theological *invenzioni*, and which usually ignore the rule of verisimilitude demanded by Counter-Reformation decorum. It is precisely for these qualities that they were subsequently criticized by Counter-Reformation texts such as Raffaele Borghini's *Il Riposo*, published in Florence in 1584. However, Borghini did not seem to have any objections to the Carmine painting, which he mentions only in passing.[3] ¶ Rather, the painting's somehow balanced appearance is the result of Vasari's assimilation of one of the great Florentine High Renaissance renderings of the subject. When designing the Carmine altarpiece, he revisited Mariotto Albertinelli's fresco in the Certosa del Galluzzo outside Florence (fig. 111.2). Painted in 1506, this was one of the artist's masterpieces, and Vasari praised it in the *Lives*, describing it as "extremely well executed with diligence and love."[4] From Albertinelli's painting derive not only the compact composition, including the two angels collecting the blood in chalices, but also the monumental figures and the archaic draperies, particularly evident in the Albertina drawing. Subsequently, to bring the composition more in line with late-*maniera* style, Vasari stretched the proportions of the figures and emphasized the composition's verticality. Even the ornamental border in the Albertina drawing is inspired by the stucco frame of Albertinelli's fresco. The latter must have particularly appealed to Vasari, for he employed such ornamental borders extensively as embellishments of the drawings in his collection, which he mounted in his *Libro de' Disegni*. The Albertina drawing is thus not only one of the most attractive drawings from Vasari's hand, but also highly characteristic of his retrospective approach, which involved frequent borrowing from the canonical works of the past (for an earlier example see cat. no. 107).

Florian Härb

One of Vasari's best-preserved easel paintings, the *Holy Family with Saint Francis in a Landscape* remained entirely hidden from public view until it was acquired by the Los Angeles County Museum of Art in 1987. Details about the canvas had long been known, however, from information provided by Vasari himself. In his *Ricordanze* Vasari states that in Venice he painted a large canvas for Francesco Leoni of a full-length Mary with the Christ child in her arms, together with a full-length seated Joseph and Saint Francis. He began the painting in December 1541 and was paid twenty scudi for it.[1] ¶ A Florentine banker and an associate of the Medici, Francesco Leoni had settled in Venice, where he befriended the artists Titian and Jacopo Sansovino and the writer Pietro Aretino. Leoni and Aretino corresponded from Venice with Vasari, who replied with his own news, and with requests, such as the 1540 letter written with Ottaviano de' Medici asking Leoni to send ultramarine blue at no more than four ducats an ounce, and thirty variously sized oil-paint brushes with blunt points.[2] Leoni and Aretino also urged Vasari to come to Venice. Although a visit had been planned from as early as November 1540, no doubt it was the commission to execute a stage set and other decorations for the 1542 Carnival production of Aretino's play *La Talanta* that finally precipitated Vasari's trip. Before leaving Florence, Vasari arranged to send Leoni his copies after Michelangelo's cartoons of *Venus and Cupid* and *Leda and the Swan* (for Diego di Mendoza, the emperor's ambassador in Venice), a bronze-coloured *Nativity* (for Aretino), and a half-length *Judith* with her handmaid holding the head of Holofernes.[3] Vasari arrived in Venice on 1 December 1541 and stayed with Leoni. He started the *Holy Family* now in Los Angeles without delay. ¶ The painting immediately became one of the most significant examples of up-to-date Florentine Mannerism in Venice. As a religious painting, though for a secular setting, its sole rival was the altarpiece of the *Lamentation* in the church of Corpus Domini, which Vasari's life-long friend Francesco Salviati had completed only the year before. However, as an object of emulation its effect on local painters seems to have been rather slight, perhaps because it was largely inaccessible (though surely known to at least Titian and Sansovino), and its style unsympathetic to conventional Venetian taste. ¶ Depictions of the Virgin and Child (often with other figures) in an ample landscape had long enjoyed favour, especially among cultivated private patrons commissioning works of art for domestic quarters. In the ambitious canvas for Francesco Leoni, Vasari elected to render the traditional subject in a highly ornate and self-conscious manner. By including the anachronistic figure of Saint Francis of Assisi at the left, he paid direct homage to the

patron himself, who shared the saint's given name. Saint Francis is offset on the right by the monumental figure of Saint Joseph, similarly gazing down diagonally and forward at the embracing Virgin and Child, who are centrally located and in the brightest light. In Florence, since at least the time of Donatello, there existed an intermittent fashion for showing the Virgin in strict profile, with her head tilted downward, in close proximity with that of her son. Often the Virgin also wears an elaborate headdress over plaited tresses. Michelangelo then proceeded to create a series of refined female heads in profile, adorned with exceptionally complex coiffures and headdresses – the influential *teste divine*. Hitherto in Venetian art it was rare to show the Virgin in profile and intricately coiffed, but Vasari made a point of highlighting these Florentine features. Significantly, Jacopo Sansovino also included some of the same Florentine traits in his Venetian sculptural reliefs of the Virgin and Child; none of these is precisely dated, but one belonged to Aretino in 1551.[4] Finally, Vasari rendered the drapery of his holy figures in crisp linear patterns, creating a taut network of diagonal lines and a shallow relief-like effect across the breadth of the canvas. ¶ Vasari further embellished his *Holy Family* by surrounding the principal figures with details evoking classical antiquity, such as the decorative mask and *putti* on the end of the cradle at the lower left, the marble corbel at the lower right, and the overgrown circular temple in the distance, suggesting the fall of the old pagan world. As a whole, the delicately painted landscape with its antique ruins and craggy mountains recalls not only the classical past but also more recent Roman models, such as the landscapes by Polidoro da Caravaggio. It seems, in fact, that Vasari was as anxious to convey a modish Roman tradition as he was to present venerable Florentine precedents. ¶ Rather curiously for a painting executed in Venice, Vasari has subdued the colour to a dusky range of warm neutrals, even muting the Virgin's conventional red and blue dress. Originally the foliage would have appeared green, but the copper resinate pigment has now turned brown.[5] Deep shadow further enhances the relief-like surface, in a manner reminiscent of the late paintings by Raphael and by members of his school such as Giulio Romano, whom Vasari had just visited in Mantua on his way to Venice. Vasari had also passed through Bologna, Modena, and Parma, and had looked appreciatively at the work of Correggio and Parmigianino, the memory of which may be detected in the soft and uncommonly delicate brushwork of the hair of the Holy Family. That the beautifully executed head of Joseph especially preoccupied Vasari is suggested by technical analysis, which indicates that the artist scraped out and entirely repainted this part.[6] ¶ For his overall

arrangement of the figures, Vasari resolutely stuck to distinguished formulae from Rome and Florence. His basic composition owes much to Raphael's *Holy Family* in the Louvre (fig. 112.1), commissioned by Lorenzo de' Medici, Duke of Urbino, and his uncle Pope Leo X, and sent to Francis I, as a gift for his queen.[7] Vasari had never seen the painting, but since Giulio Romano almost certainly participated in its execution, the two artists may have discussed this diplomatic gift (involving two Medici and Francis I) when they met in Mantua. Vasari also seems to have retained memories of one of Andrea del Sarto's last essays on the same theme, the *Medici Holy Family*, which of all Sarto's Madonnas shows her in the strictest profile. Vasari knew the painting well, because it belonged to his patron Ottaviano de' Medici, and he said it was painted with "incredible art, design, and diligence."[8] In 1541 he probably even made a copy of it,[9] possibly to be identified with a painting at Dulwich (fig. 112.2), with the addition of a Saint Joseph similar to Raphael's at the upper right. In a virtuoso demonstration of his newly matured skill and learning, Vasari thus conflated the Florentine and Roman traditions, and fashioned for a Florentine residing in Venice a work at once learned and tender.

David McTavish

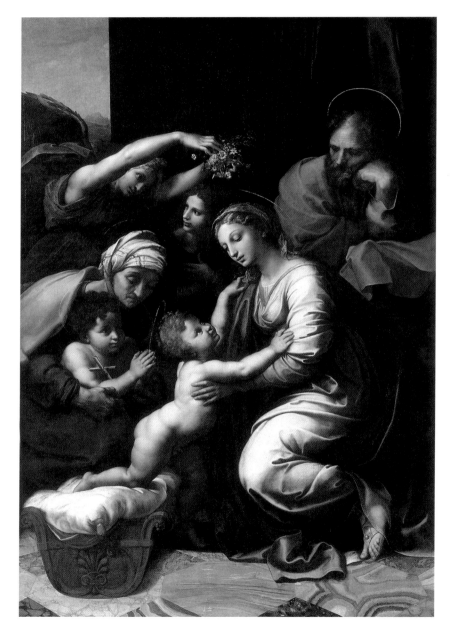

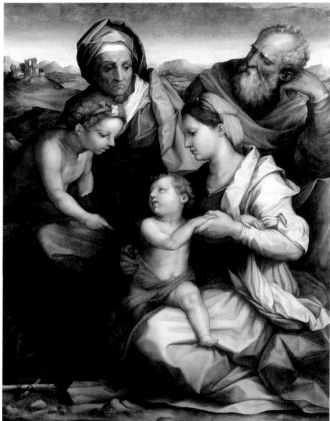

Fig. 112.1 Raphael, *The Holy Family of Francis I*, 1518, oil on canvas, 207 x 140 cm Musée du Louvre, Paris

Fig. 112.2 Giorgio Vasari, *The Medici Holy Family, after Andrea del Sarto*, c. 1541, oil on panel, 144.8 x 107.7 cm Dulwich Picture Gallery, London

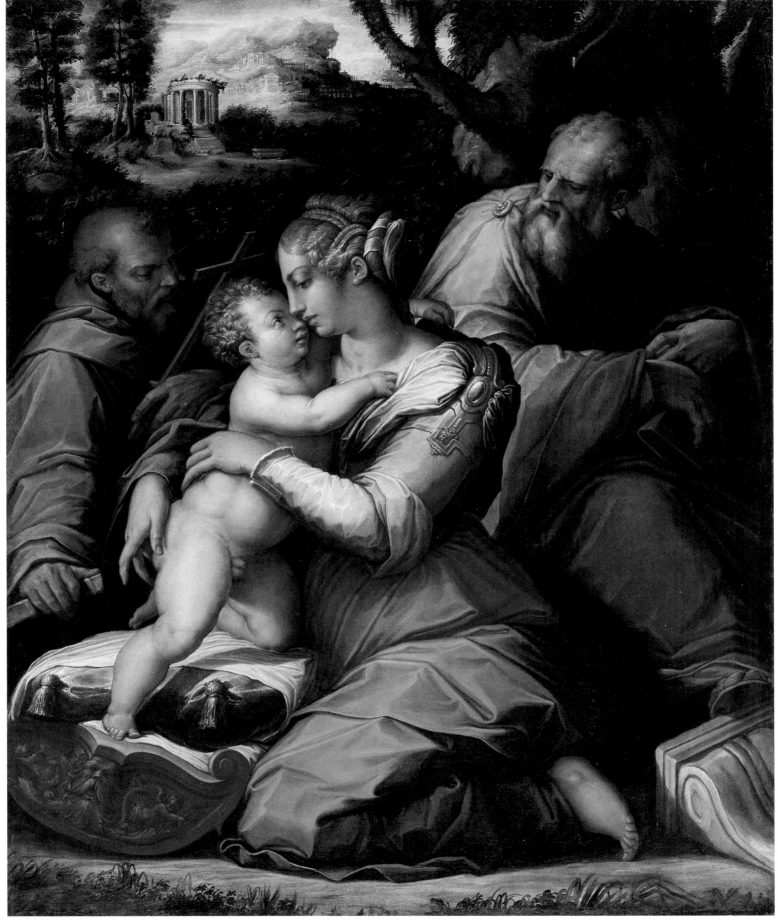

This rather enigmatic painting, completed in September 1544, probably represents the earliest work commissioned by Luca Martini, a highly accomplished and respected engineer in the service of Duke Cosimo I de' Medici. As a founding member of the Accademia Fiorentina, Martini counted artists and *letterati* among his friends, and the present work was doubtless inspired by his passion for Dante.[1] ¶ The title it is frequently given – *Six Tuscan Poets* – is a misnomer; it actually shows four poets and two humanists: from left, Cristofano Landino, Marsilio Ficino, Francesco Petrarca, Giovanni Boccaccio, Dante Alighieri, and Guido Cavalcanti.[2] Vasari did paint a group portrait of six poets, but four years later, for Paolo Giovio,[3] who wanted a variation on Martini's painting with portraits of Cino da Pistoia and Guittone d'Arezzo in place of the figures of Landino and Ficino, producing a more or less chronologically consistent celebration of early Tuscan poetry.[4] The confusion surrounding the subject of Martini's picture is partly attributable to Vasari himself, who in his descriptions of Martini's painting conflated the two works, completely omitting Landino and Ficino and claiming the work showed the same six poets painted for Giovio.[5] ¶ In his autobiography Vasari explained that he had sought authentic likenesses, and the heads to the left in Martini's painting replicate portraits of Landino and Ficino in Domenico Ghirlandaio's *Zechariah at the Temple* in Santa Maria Novella.[6] While the poets, garlanded with laurels, wear robes of bright colours and headgear typical of the Trecento, Landino's and Ficino's tight-fitting caps are characteristic of the fifteenth century.[7] Like the images of donors in a *sacra conversazione*, these humanists play no part in the narrative; the poets seem oblivious to their presence. ¶ This painting certainly won Vasari renown.[8] Its fame rested in part on the verisimilitude of the portraits, derived "dalle teste antiche loro accuratamente."[9] Moreover, it anticipated a surge of interest outside Italy in the iconography of Dante, Boccaccio, and Petrarch. In 1548–1549 Florentine communities resident abroad commissioned ephemeral images of Dante, Boccaccio, and Petrarch to adorn the theatre constructed in Lyons for the marriage of Henry II and Catherine de' Medici and the Arch of the Florentines erected in Antwerp for the triumphal entry of Philip II.[10] ¶ Martini's painting was doubtless highly fashionable, but Giovio harboured a particular fascination for authentic portraits.[11] Though Vasari, in the 1550 edition of the *Lives*, later wrote that a fresco by Taddeo Gaddi in Santa Croce included Dante and Cavalcanti as bystanders, that work was clearly not his source.[12] His point of departure was Raphael's *Parnassus* in the Stanza della Segnatura (fig. 113.1), which shows both Dante – his distinctive profile visible just to the left of

a bearded Homer, upper left – and Boccaccio (the small head to the left of the tree on right), whom Vasari transposed in reverse into Martini's painting. The poet to the immediate right of Homer appears to have inspired Vasari's Cavalcanti; though far from exact, their features are broadly similar, with Vasari adopting the sharp turn of the head and the gesture of the poet's right hand.[13] Indeed, the expressive heads and gestures of Vasari's tight-knit group of overlapping figures also appear indebted to Raphael's inventions, "emphasizing their argument with their hands and particular movements, all attention with their ears, wrinkling their eyebrows, showing their astonishment in many different ways."[14] ¶ The *Parnassus* was an obvious repertory for "authentic" portraits of poets, since, as Vasari came to explain, not only were they derived from reliable sources but they were "vivi vivi" – they appeared to live and breathe.[15] Though Cavalcanti, Dante's "primo amico," is not mentioned in Vasari's description of Raphael's fresco, it would have been logical to identify him with the figure to the right of Homer, as the one who makes eye contact with Dante. Vasari derived his models for historical portraits principally from figures in famous monumental paintings; his reliance on the *Parnassus* is therefore entirely consistent with his working method.[16] Vasari's Petrarch (third from left in cat. no. 113), however, bears only a general resemblance to Raphael's portrait[17] and was instead surely modelled on Andrea del Castagno's fresco in the Villa Pandolfini in Legnaia. Vasari reversed the head, rotating it slightly, so that the tip of the nose extends just beyond the left cheek. The delicate features share much with the fresco: the angle of the narrow aquiline nose and the pitch of the nostrils, the slim pursed lips, the profile of the double chin, and especially the elongated curve of the eyebrows (the one furthest from the viewer rising in an accentuated arc).[18] ¶ The Villa Pandolfini was easily accessible from Florence, and Vasari relates that when he had been in Rome as a young man in the early 1530s he had drawn all the works of Raphael that he could find.[19] Two such drawings survive – one of them showing Boccaccio – and similar studies probably included Dante and Cavalcanti.[20] Like Vasari's other drawings after figures in the Stanze, these are large, carefully executed, and detailed enough to have served as points of reference for Martini's picture. Naturally, some of the heads in the drawings are sketchily indicated, which may explain the lack of precise correspondence between Vasari's Cavalcanti and its prototype in the fresco. Perhaps he did not copy that particular head in great detail; if so, twelve years later he would have been compelled to improvise. ¶ Evidence suggests that Vasari also made use of a drawing by Bronzino, who around 1532–1533 executed portraits of

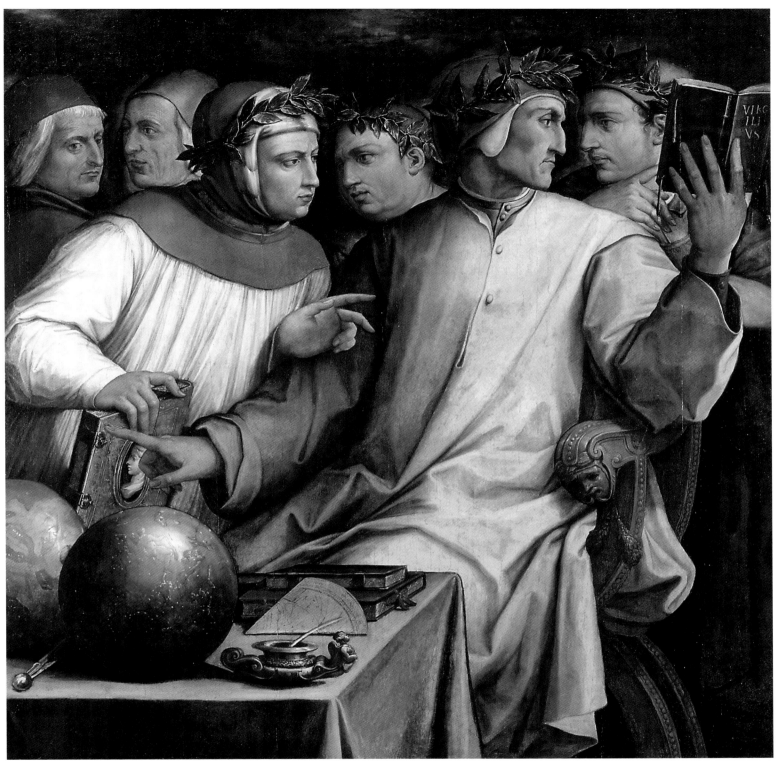

113

Fig. 113.1 Raphael, *Parnassus*, c. 1508–1511, fresco. Stanza della Segnatura, Vatican City

Fig. 113.2 Agnolo Bronzino, *Portrait of Dante*, c. 1532–1533, black chalk over red chalk, 29.1 x 21.8 cm. Staatliche Graphische Sammlungen, Munich (2147)

poets in lunettes for Bartolomeo Bettini.[21] Dante's portrait has survived along with the study for it, in black chalk (fig. 113.2). Though the drawing reflects neither the angle nor the orientation of the painted head, it would doubtless have helped Bronzino transcribe Dante's features precisely into his painting.[22] Bronzino's drawing is also reminiscent of Raphael, though the profile shows a flatter nose and a less pronounced chin. The *cognoscenti* – Bettini and Martini among them – might have considered this a more "authentic" likeness, created by an artist whose admiration for Dante was well known. Though the head of Vasari's Dante is rotated marginally more toward the viewer, the angle of the mouth and nose and the modelling and fall of light are so similar as to suggest that Bronzino's drawing was indeed his immediate model. Bronzino, who had negotiated the price for Martini's picture, may therefore have helped Vasari in more ways than one.[23] Since his drawing did not mirror the representation of Dante exactly as depicted in the lunette, Bronzino may have felt that there was little conflict of interest in allowing Vasari to use it.[24] Their respective patrons were, after all, close friends. ¶ The *significato* of Martini's painting was doubtless connected with the *Questione della lingua*, in which the Accademia Fiorentina contested non-Tuscan attempts to dictate linguistic and poetic standards.[25] Aiming in part to disseminate learning to a wider public that lacked knowledge of Latin and Greek, the Accademia organized public readings and lectures on Dante and Petrarch and published both original works and Tuscan translations of classical texts. In this respect Dante was a pivotal figure, especially as the discovery in 1514 of the *De vulgari eloquentia* had rendered him a pre-eminent authority on the vernacular. The 1540s witnessed his revival in Florence, after a decline suffered in the previous century. For a core of its members, Dante represented the guiding spirit, even personification, of the Accademia, which made him immune to the criticisms of Pietro Bembo and his followers.[26] In his *De imitatione* of 1512, Bembo upheld Petrarch as the ultimate model for verse, a standard that many Florentines still recognized.[27] ¶ For Benedetto Varchi, Dante came to represent the supreme model for literature in the vernacular. Moreover, two prominent academicians, Giovambattista Gelli and Carlo Lenzoni, praised Dante's ability to expound complex material in the vernacular (astrology, geography, theology, philosophy, and cosmography) while expressing the highest concepts with a lexical precision exceptional for his time.[28] The arguments presented in support of Dante within the context of this linguistic and literary dispute are crucial for an understanding of Vasari's picture, the iconography of which was doubtless devised by Martini himself.[29] ¶ Luca Martini was particularly

fascinated by Dante.[30] In Vasari's painting, Dante seems to orchestrate a *disputa* on literary matters. Gesticulating with his right hand, he appears to have stopped Petrarch in mid-speech, turning aside to reflect on a passage from Virgil, whose name is inscribed on the cover of his book. Cavalcanti, a figure known to have held Virgil in contempt, also points to the volume, perhaps conceding a point as he glances over at Petrarch.[31] Boccaccio's apparent lack of involvement may result from his portrait being a literal transcription of Raphael's, uncomfortably grafted onto the composition. This exchange is observed by Landino and Ficino at the left, who came to express great admiration for Dante's encyclopedic knowledge (most notably in Landino's commentary on the *Divina Commedia*, published in Florence 1481 and prefaced by Ficino).[32]

¶ The objects on the table – particularly the celestial and terrestrial globes, the dividers, and the quadrant – allude to the complex structures around which the *Divina Commedia* is built, "la mondana Fabrica" or universal fabric, as Vincenzo Borghini came to describe it.[33] It is hardly surprising that this aspect of Dante's epic was of particular interest to Martini, who was an engineer. Martini had studied the work's topography with Varchi and was among those who attempted to calculate the precise dimensions of the *Inferno* and *Purgatorio*, not only producing drawings of astronomical descriptions in the *Divina Commedia* but even constructing a model of the site of the *Inferno*.[34] Martini and his colleagues were heirs to the fifteenth-century tradition of subjecting Dante to scrutiny and interpretation, as exemplified by Landino and Ficino, the silent observers in Vasari's unprecedented poetic *disputa*. ¶ Martini's painting celebrates Dante's knowledge of science, but there appears to be a further theme. Upon first encountering Virgil, Dante addressed him as "my master and my author … from whom my writing drew the noble style [*lo bello stilo*] which has brought me honour."[35] Dante defined that style as the tragic or epic genre, which he ranked far above the comic and elegiac modes, the latter commonly associated since antiquity with love poetry.[36] Hence with Petrarch stand both "lo amoroso Boccaccio," as Vasari described him, and Cavalcanti, famed for his *Sonnette* and his *Canzone d'amore*, with its analysis of love as a passion that leads to self-destruction.[37] Vasari's painting for Martini thus surely proclaims the superiority of epic over love poetry. The text of Virgil in Dante's hand and the attributes of epic poetry scattered on the table contrast starkly with the cameo portrait of Laura, Petrarch's love, displayed on the volume he holds. The picture's narrative appears to present the poets of love conceding to Dante, in which respect the underlying meaning of Martini's painting would be diametrically opposed to that of the pictorial ensemble painted by Bronzino for Bartolomeo Bettini. Though both were members of the Accademia, Martini and Bettini apparently aligned themselves with different camps, as reflected in their respective commissions from Vasari and Bronzino. Vasari himself confirmed that Bettini's commission was an overt celebration of love poets, a theme complemented by the display in the same chamber of Pontormo's *Venus and Cupid*, executed after a design by Michelangelo.[38] The picture commissioned by Luca Martini, on the other hand, appears to leave no room for doubt as to the supremacy of both Dante and his medium, epic poetry.

Rick Scorza

This canvas is half of a processional banner executed by Giorgio Vasari for the Confraternity of Saint John the Baptist in Arezzo, whose members were known as the Peducci (the diminutive for *feet*, referring to their habit of going barefoot in procession).[1] The other half of the banner, which was originally of double-sided construction, features the *Preaching of Saint John the Baptist* and also survives in the Museo Diocesano in Arezzo (fig. 114.1). From an entry in the artist's *Ricordanze*, it can be established that the banner was ordered on 12 December 1548, the subjects were *Saint John the Baptist Preaching* and *Saint John the Baptist Baptizing Christ*, and the cost was estimated at forty scudi. From other sources, the completion date can be surmised to have been the summer of 1549, which Vasari spent in Florence.[2] ¶ Vasari also describes the work at length in his autobiography, published in the 1568 edition of the *Lives of the Artists*, which incorporates these facts into a narrative.[3] The passage indicates that the work was fully completed in Florence and sent to the artist's house in Arezzo, where it was seen by chance by Cardinal Georges d'Armagnac, who offered the painter a large sum in order to acquire it for the French king. Archival documents discovered by the present writer offer yet more information about the painting's completion. It is known that Vasari received his final payment as late as October 1550. This may have been the only money he obtained for the picture, as suggested by the content of a document of January 1550 stating that when the work was completed the confraternity lacked the necessary funds to pay for it, and that as a consequence they sold some farmland and allotted thirty-eight scudi from this sale to Vasari's brother Piero, acting as the agent for the painter, who was then in Rome. Taken together with the evidence from the autobiography, this would appear to indicate that, unusually, Vasari's work was not dispatched to the patron immediately following its completion. Hence we find the reference to the canvas having been kept in the artist's house in Arezzo, even though it was painted in Florence: it remained there until payment was settled. ¶ Vasari's rich autobiographical description of this commission for his native town demonstrates its significance for him. In this case, he singled it out because of the flattering attention it received from a visiting French cardinal, who thought the banner of sufficient quality for a royal collection. Cardinal Georges d'Armagnac was one of the most distinguished diplomats of the period.[4] His visit, which can be dated to about 10 September 1549, is mentioned in an amusing letter written by Vincenzo Borghini in Arezzo and sent to Vasari in Florence. The letter indicates that the cardinal excitedly contemplated other works by the artist, in particular the *Marriage of Esther and Ahasuerus* in the Badia di

Sante Flora e Lucilla.[5] In attempting to purchase Vasari's painting, the French cardinal was acting as a broker in Italian art for Henry II. Such brokering was by then an established practice, and d'Armagnac had earlier taken on this role for Francis I. ¶ In comparison to the *Preaching of Saint John the Baptist*, the *Baptism of Christ* features a more novel approach, with the three tenderly portrayed kneeling angels set for reasons of space in the middle of the design instead of toward the edge, as was conventional. Indeed, the preliminary drawing for this design, which survives in the Louvre (fig. 114.2), includes one of the angels at the side – the most obvious difference between the drawing and the finished painting. The design is not overly balanced, but nonetheless is kept close to the picture plane for maximum legibility, since the banner was to be carried out-doors. Because they were partly functional objects, taken out for regular public processions, old canvases wore out and new banners were generally required to replace them. In this case, Vasari was replacing a standard commissioned in 1473 from Pietro di Galeotto of Perugia, a pupil of Piero della Francesca.[6] With the loss of Vasari's major work of this period, the Martelli altarpiece for the church of San Lorenzo in Florence, the Peducci banner assumes a greater importance in providing an example of the painter's style from this critical moment in his career, just before the publication of the first edition of the *Lives*.

David Franklin

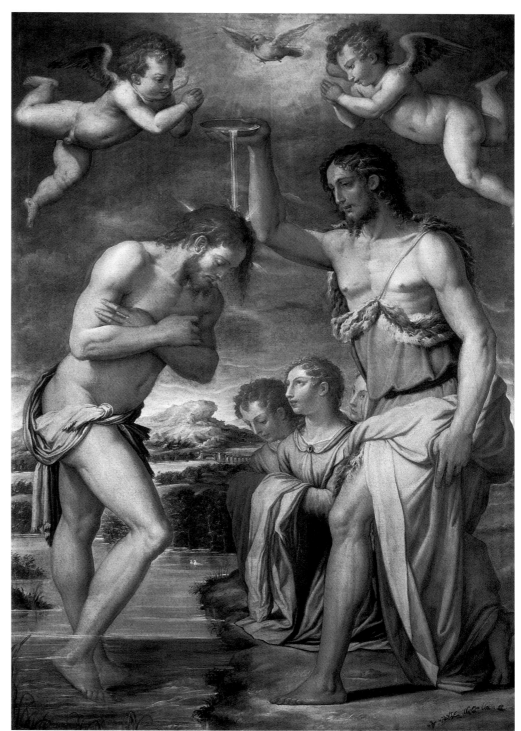

Fig. 114.1 Giorgio Vasari, *The Preaching of Saint John the Baptist*, c. 1548–1549, oil on canvas, 190 x 128 cm. Museo Diocesano, Arezzo

Fig. 114.2 Giorgio Vasari, *The Baptism of Christ*, c. 1548–1549, pen and brown ink and brown wash over black chalk, 20.3 x 14.7 cm. Musée du Louvre, Paris (2093)

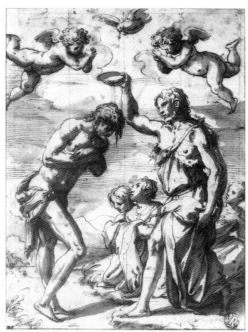

This recently rediscovered *quadretto* is one of several small paintings that Vasari executed as replicas of altarpieces and other large-scale autograph works for his close friend and long-term iconographic advisor Vincenzo Borghini. From 1552 Borghini, a member of the Benedictine order, served Duke Cosimo I de' Medici as *spedalingo* or prior of the foundling hospital, the Ospedale degli Innocenti. The painting was probably a gift from Vasari, which would explain its high standard of finish. The artist has taken care to reproduce accurately in reduced scale the rich colours of the original, along with its intricate figures and compositional detail. This is particularly evident in the rendering of costume and ornament, notably the containers of precious metal, the earrings, turban, and headdress of the black Magus and his attendant, and the exotic creatures (camel, elephant, and parrot) that inhabit the upper left of the picture. Vasari and Borghini shared a liking for elaborate iconographic detail and invention, and Vasari's highly animated colouring ("colorito molto fiero") – a notable characteristic of this particular work – was especially to Borghini's taste, no less than the detailed rendering of figures on a small scale.[1] ¶ Borghini's *quadretto* is a replica of the altarpiece of 1566–1567 (fig. 115.1) that was Vasari's first commission from Pius V, a work destined for the burial chapel planned for the pope in the church of Santa Croce in his native Bosco Marengo.[2] Vasari executed the altarpiece in Florence, starting work in the summer of 1566, and delivered the picture on 25 February 1567, personally seeing to its transportation to Rome in accordance with the pope's instructions.[3] Such was Borghini's interest in Vasari's various projects for Pius V that the artist had promised him his large preparatory chiaroscuro drawing for the altarpiece.[4] However, the replica is so faithful in every respect that it must have been executed in Florence with the original painting as a reference. ¶ Two recently discovered documents recording the works of art that Borghini possessed at the time of his death confirm that he owned the present replica. The first is an inventory that the notary Raffaello Eschini began to compile on 24 August 1580, nine days after Borghini's death. His annotations reveal that numerous works had been promised to a certain "Livo" – the painter Ventura di Vincenzo Ulivieri, himself a foundling and Borghini's last artistic protégé.[5] These are accounted for in the second document of May 1581, when Livo loaned them to Borghini's successor as *spedalingo*.[6] There the present painting is recorded as "Uno quadro de' Magi colorito a olio con suo ornamento di noce intagliato et messo d'oro, con sua cortina di taffettà verde, di altezza di uno braccio et 1/8 et di lunghezza di 7/8." Borghini so treasured his *quadretto* that he displayed it in a carved walnut frame with gilded ornamentation and a protective curtain of green taffeta. ¶ According to Livo, Borghini's picture measured 65.7 by 51 centimetres – dimensions marginally higher and slightly wider but close enough to those of the present replica as to leave little doubt that it was Borghini's picture. Both it and the altarpiece have evidently been trimmed in each dimension – the altarpiece, most notably, at both top and bottom.[7] ¶ The subject of Vasari's altarpiece was perfectly suited to its destination, since the chapel in question was dedicated to the Feast of the Name of Jesus and the Epiphany, in celebration of the manifestation of Christ to the Gentiles as personified by the Magi.[8] The main compositional elements established in a large, rapidly executed preliminary study now in the Uffizi (fig. 115.2) were carried over, for the most part, into both the altarpiece and Borghini's replica.[9] Following Matthew's Gospel, it shows the star that "came and stood over where the young child was" and the Magi who "fell down, and worshipped him" (Matthew 2:9–11). The king on the right grasps Christ's ankle to kiss his leg, and in the paintings extends his other hand to receive from a servant an elaborately chased silver vessel. The poses of Christ and the Virgin, her arm encircling the child's waist, were carried into the altarpiece and its replica with minimal change. Christ, his head turned more to his right in the two paintings, is seated with his arms and legs apart as he reaches forward to the kneeling Magi, touching the forehead of the one on his left. The area to the viewer's left in the drawing underwent extensive revision, with the introduction into the scene of the magnificent black Magus and his attendant, resplendent in their colourful oriental costumes adorned with jewels and precious threads, their physiognomies acutely observed. ¶ Surprisingly, even with such a straightforward subject Vasari encountered problems. In the late spring of 1566 he produced a drawing for his patron's approval; the pope's response came back via the papal treasurer, Guiglielmo Sangalletti, in a letter of 12 July. The pope liked Vasari's drawing but had raised two objections. First, Christ was born in a stable (*capanna*), not in the palace that Vasari seemed to have drawn. Second, Vasari had omitted the ox and the ass; Sangalletti communicated the pope's wish that they be included.[10] ¶ Sangalletti specifically described Vasari's drawing as a *schizzo* – a sketch – as opposed to a finished drawing or *disegno*. This suggests that the pope may have examined the aforementioned study in the Uffizi (fig. 115.2), showing the main wall of the chapel in elevation. In this drawing the *Adoration* is shown in an elaborate carved frame, its top arched to correspond with the vaulting of the chapel. The areas between the frame and the upper corners of the chapel walls are adorned with grotesques, and auxiliary compositions may have been planned for the carved rectangular fields on either side of the

altarpiece. The altar, evidently intended to contain the pope's remains, projects outward adorned with large volutes. Finally, the floor-level compartments on either side were to display the pope's arms in oval shields. There is no doubt that this drawing shows the project in its earliest stages, since the arched top of the altarpiece was ultimately squared off to make for a rectangular format into which the angels and the Star of Bethlehem were accordingly reintegrated. There is further evidence that this was the *schizzo* to which Sangalletti referred: not only are the ox and the ass missing, but the background shows the continuous facade of a stone palace articulated with pilasters and pierced by a doorway to the right.

¶ Vasari made one concession to the pope. To the left of the altarpiece and its replica is a stone arch, evidently part of the house in which there was no room for the Holy Family to lodge. To the right are roughly hewn tree trunks supporting the thatched roof of the requested *capanna* or stable. Yet there is no sign of either ox or ass. ¶ By the mid-1560s it was becoming increasingly common for morally minded individuals, whether clerics or secular writers, to express disagreement with religious pictorial narratives. Since the 1540s nudity in church art had been an obvious target, and the twenty-fifth session of the Council of Trent, which closed on 4 December 1563, formalized the guidelines for church decoration by declaring that "all lasciviousness be avoided; in such wise that figures shall not be painted or adorned with a beauty exciting to lust."[11] The same session also declared that any "abuses" that had crept into ecclesiastical art should be abolished, "in such wise that no images suggestive of false doctrine, and furnishing occasion of dangerous error to the uneducated, be set up." For some, that decree constituted grounds for insistence upon absolute fidelity to the Bible and other canonical texts. Many of the views expressed in Raffaello Borghini's *Riposo*, published in Florence in 1584, illustrate this. For Bernardo Vecchietti, one of the interlocutors in a dialogue in the *Riposo*, the scene of the Flood in Pontormo's San Lorenzo frescoes had strayed so far from the Bible that it could potentially mislead: "painting illustrates for the unlettered [*gli idioti*] exactly what the Bible teaches those who study the sacred word, since the uneducated [*gli ignoranti*] look to paintings for what they should follow, taking from them what they do not know from Scripture."[12] In true Counter-Reformation spirit, Pius V, a zealous reformer, had long been conspicuous for his austerity and asceticism; moreover, as a Dominican he had served as Commissary General of the Inquisition in 1551 and, six years later, as Inquisitor General of Christendom.[13] His concern for the fidelity to Scripture of Vasari's design therefore comes as no surprise. ¶ Vasari would never have blatantly ignored the wishes of a patron, let alone those of the most important individual in Christendom. He must have presented a satisfying defence of his depiction of the *Adoration*. The ox and the ass, though an integral part of the story of Christ's birth, are not mentioned in the Bible. Their origins lie in the Gospel of Pseudo-Matthew, an apocryphal sixth-century Latin work on Christ's infancy, of enormous influence in the Middle Ages, that relates how the ox and the ass came to worship the newborn Christ.[14] Vasari might well have argued not only that the source for these creatures fell outside the New Testament canon but that they were more closely associated with Christ's Nativity than with the Adoration of the Magi, a defence in which he would surely have relied on Borghini's considerable knowledge of sacred literature. Indeed, further evidence of Borghini's involvement in the project comes in the *epitaffio* from the apocryphal book of Judith (15:9) that in his preparatory drawing Vasari inscribed on the altar: "TV GLORIA HIERVSALEM / TV LAETITIA / ISRAEL / T.O.P.N." It seems unlikely that Vasari, who was largely reliant on others for inscriptions, would have come up with this invention, while Borghini was expert in devising *epitaffi*. It is surely significant that this highly apposite inscription, celebrating the newborn Christ as the glory of Jerusalem and the joy of Israel, comes from the book of Judith, a heroine Borghini especially revered.[15] ¶ If Vasari's *quadretto* of the *Adoration of the Magi* was a gift to Borghini it would have been an extremely precious one, since the subject was intimately connected with his friend's guardianship of abandoned children. The Ospedale degli Innocenti had long been associated with images of the Adoration. The parallel between the infant Christ, himself in peril and needing refuge, and abandoned children is self-evident. In Florence abandoned children or *innocenti* were commonly identified with the Innocents massacred by Herod. Both the Adoration and the Massacre were recurrent themes in the works of art commissioned by the institution.[16] After all, it was Herod's fury with the Magi that provoked his order to slay all children under the age of two. It would therefore have been especially pleasing for Borghini, who already owned both a drawing by Rosso of the *Adoration of the Magi* and Vasari's large preparatory chiaroscuro drawing for the Bosco Marengo altarpiece, to have yet another autograph rendering of this subject by Vasari himself, but this time a beautifully painted version.[17]

Rick Scorza

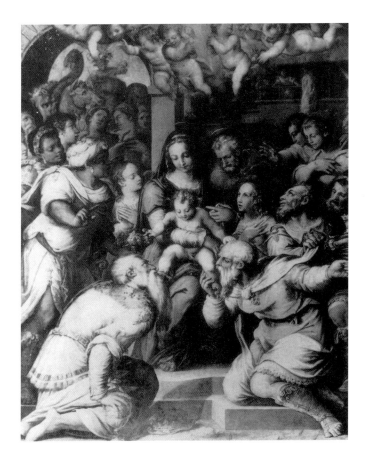

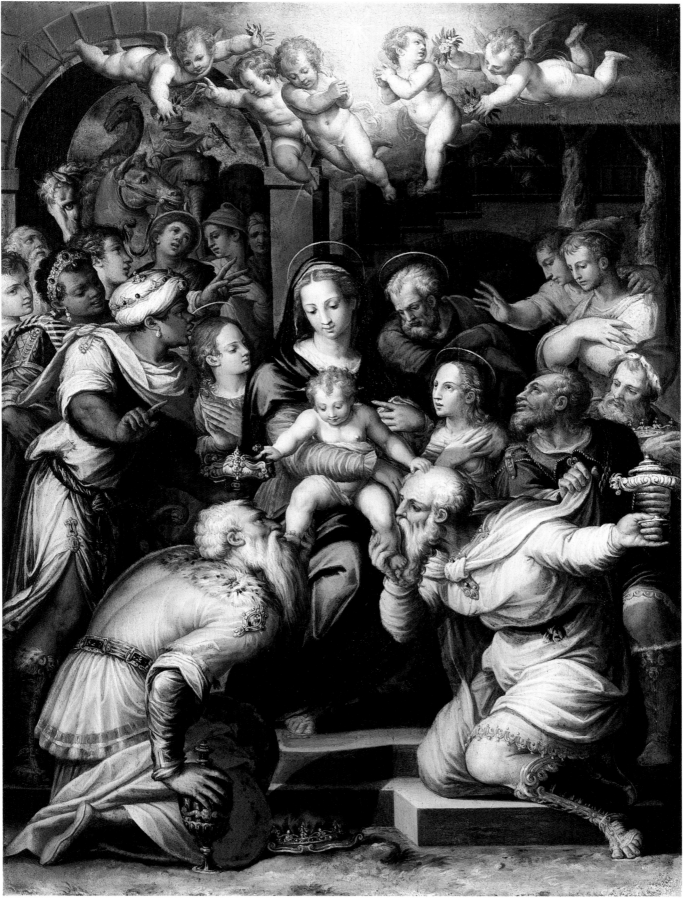

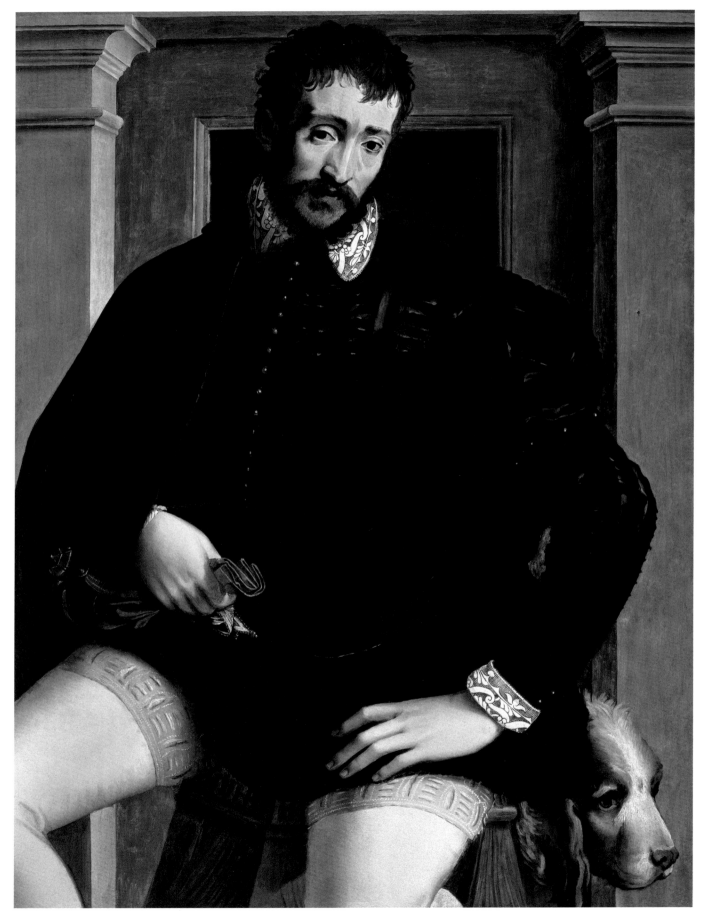

Although traditionally ascribed to Francesco Salviati, this portrait is unquestionably the work of Michele Tosini. The alternation of attribution is hardly surprising, given that the portraiture of the two artists has often been confused. Salviati's production is now becoming more clearly defined, while Tosini's is still poorly known. However, the only portrait unanimously credited to Tosini – the *Portrait of a Hunter*, formerly in the Antinori collection – attests to his outstanding skills in this domain.[1] The difficulty in establishing the corpus of his portraits, and the resulting confusion, arise from the fact that a large number of artists worked in his studio: minor painters such as Francesco and Giovanni Brina, Francesco and Bartolomeo Trabalesi, and Niccolò Betti, but also painters of repute, such as Girolamo Macchietti and Mirabello Cavalori, all of whom produced portraits closely imitative of the master's style during their training. On the other hand, it was no doubt the existence of this large stable of talent that prompted Giorgio Vasari to call on Tosini for assistance at the Palazzo Vecchio construction site, where he commissioned him to do numerous portraits.[2] ¶ The swift brushstrokes and powerful modelling of the *Portrait of a Man with a Dog* call to mind the figures in such positively attributed works as the *Baptism of Christ* in the Pinacoteca Nazionale in Ferrara and the *Martyrdom of the Ten Thousand* in the Museo di San Salvi in Florence, both of which date to about 1555. A similar date seems appropriate for this portrait. The sitter's garments, a lace shirt with standing collar and a slit doublet with bouffant sleeves, are typical of mid-sixteenth-century fashion. And typical of Tosini is the remarkably light handling, which leaves the brushstrokes visible in the background. ¶ This man posing with his dog – casually seated on a stool, legs spread and cape drawn up over his thighs – is a familiar arrangement in Mannerist portraiture. As in the Bronzino drawing (cat. no. 77) and the Salviati portrait (cat. no. 122), the pose echoes the one developed by Michelangelo for the statue of *Giuliano de' Medici* in the New Sacristy, but in reverse. All of Michelangelo's sculptures in the church of San Lorenzo served repeatedly as a repertory of forms for Tosini, notably for the figures of the San Salvi *Martyrdom of the Ten Thousand*, and also, more literally, for the two allegories of *Dawn* and *Night* (Galleria Colonna, Rome). The systematic reference to

the work of Michelangelo by Florentine artists of the mid-sixteenth century, a central feature of Mannerist art, was driven not only by the artists but also by the wishes of their patrons; this was surely the case for Tosini's two allegories commissioned by the Salviati family.[3] ¶ The dog and the sword are emblematic of the person portrayed. As chivalrous attributes, they may suggest that the man was of noble lineage. In this respect, the depiction is comparable to the *Portrait of a Hunter* formerly in the Antinori collection, where the sitter is posed with his pack of dogs and his footman. However, the traditional codes were not always applicable in the sixteenth century. Francesco Salviati, for example, represented his primary patrons, members of the Salviati family, with similar attributes – Giovan Battista with a helmet and Cardinal Giovanni with his pack of dogs[4] – which, in this instance, symbolized the banking family's aspiration to be recognized as nobility. In the mid-sixteenth century, after the restoration of the Medici dynasty, and with the emperor's encouragement, many Florentine merchant-class families laid claim to aristocratic status, and had recourse to portraits as a means of personal promotion. In Mannerist portraits, emblems could have a number of different, but not incompatible, meanings. Dogs, which additionally symbolized fidelity,[5] underscored the subject's vigilance, vigour, and sexual endowment (exaggerated here by the unusual pose).[6]

Philippe Costamagna

117 **FRANCESCO SALVIATI (1510–1563)** · **David** · c. 1526–1530 · Pen and brown ink over black chalk
41.1 x 27.5 cm · National Gallery of Canada, Ottawa · Gift of the National Gallery of Canada
Foundation Renaissance Ball Patrons, for the Gallery's 125th Anniversary, 2005

It was Monbeig Goguel who first recognized that a number of ambitious pen-and-ink drawings attributed to Baccio Bandinelli, including this example of a standing male nude, were in fact by his student Francesco Salviati.[1] The drawing makes reference to a specific type of Bandinelli drawing that featured a solitary male nude treated in a dynamic pose on a large scale, but it demonstrates a looser, livelier, and more daring technique, which supports the attribution to the younger artist on stylistic grounds. It is conceivable that drawings such as this one were executed as virtuoso exercises, without a specific purpose, as the artist sought to develop his technique. ¶ The drawing is of additional interest because it relates to Michelangelo's sculpture of *David*, as viewed from the back (fig. 117.1) – with some elements reversed. The most obvious differences between the drawing and the surviving sculpture, now in the Galleria dell'Accademia in Florence, are found in the extension of the right arm with the hand pointing heavenward in a gesture of defiance, and in the greater torsion of the legs.[2] ¶ Michelangelo's sculpture was publicly installed on the Piazza della Signoria and so was readily accessible to all. Salviati's particular obsession with this sculpture is revealed in one of the more charming anecdotes in Vasari's *Lives of the Artists*.[3] During the troubles in Florence following the Sack of Rome in 1527, when the Medici were expelled from the city, a bench thrown from the Palazzo della Signoria struck the *David* and shattered the left arm into three pieces. The fragments lay on the ground for a few days until Salviati and Vasari, who was also then a student in Bandinelli's workshop, took the risk of intermingling with the soldiers stationed in Florence's main piazza in order to retrieve the pieces of marble, which they then brought to the house of Salviati's father. Duke Cosimo I de' Medici later had the sculpture repaired. This story gives the drawing an added dimension in explicitly documenting Salviati's attraction to the great sculpture. ¶ As Salviati was in Bandinelli's studio around 1526–1527, Monbeig Goguel logically assigned this date to the sketch shown here. However, it is also possible that some of these youthful drawings by Salviati were executed slightly later. In this particular instance, for example, the same basic pose recurs, in reverse, in a drawing in black chalk in the Louvre (fig. 117.2), unquestionably of a Saint John the Baptist, that is too accomplished to be the work of an apprentice. The Louvre sheet has been linked to a project to decorate the chapel in the Palazzo dei Penitenzieri in Rome, commissioned by Cardinal Giovanni Salviati.[4] As the Rome project was probably initiated around 1530, prudence is required in suggesting a date for the Ottawa drawing, given that the two poses are so similar. While the inclusion of the sling in the left hand and the military reference provided by the body armour on the ground seem to confirm that the pen-and-ink sketch is earlier in date and depicts David rather than John the Baptist, it nevertheless appears to have served as the starting point for the figure in the Louvre drawing. ¶ The Ottawa sheet contains a second sketch at the right margin, presumably for the same youthful figure, which concentrates more explicitly on the underlying anatomy of the back. There is also a separate study of a foot, as well as another study of part of the body now truncated at the right margin of the sheet. Such reworking of different parts of a nude figure was a traditional practice among Florentine draftsmen. ¶ The drawing is distinguished by its confident handling of pen and ink, with aggressively applied, rhythmic hatching lines and a total lack of wash or white heightening. This technique is almost unparalleled in the period for its sheer assurance and purity, bordering on the decorative or calligraphic.

David Franklin

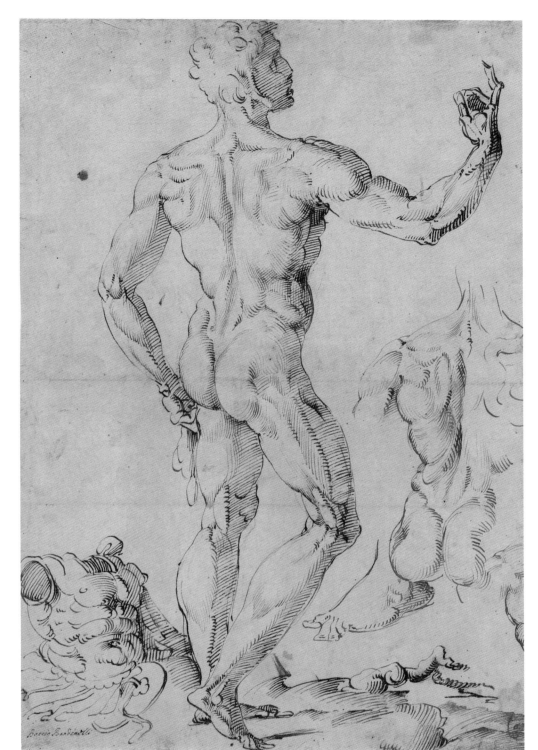

Fig. 117.1 Michelangelo, *David* (back view), c. 1504, marble, 410 cm high. Galleria dell'Accademia, Florence

Fig. 117.2 Francesco Salviati, *Saint John the Baptist*, c. 1530, black chalk, 40.5 x 21.5 cm. Musée du Louvre, Paris (1662)

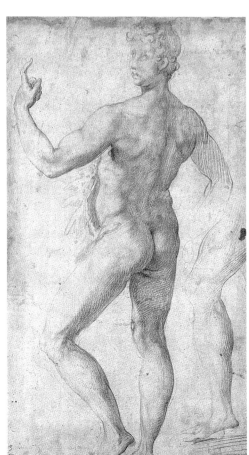

"He mastered [*possedeva*] the nude as well as any other painter of his time," wrote Giorgio Vasari about his close friend Francesco Salviati.[1] Although Vasari also claimed that Salviati was a universal painter, there can be no doubt that the human figure – particularly the nude figure – took pride of place for him, and constituted, in an astonishing array of poses and attitudes, the essential component of his art. During much of his professional career Salviati continued to draw the nude figure, mostly male but occasionally female, either from a posed model or from his very fertile imagination. Even in Salviati's draped figures, the underlying body and its musculature are often visible through the clothing, as Vasari himself remarked.[2] ¶ While the initial function of this impressive though largely neglected double-sided sheet remains obscure, a number of former attributions suggest the likely context in which it was created. In the seventeenth century the drawing belonged to Sir Peter Lely, the Dutch artist and avid collector of drawings, who was court painter to Charles II of England. Lely's stamp appears at the lower right of the verso, which implies that at that time this side of the sheet was considered the more important. On the recto at the lower right, the drawing bears an old ascription to Michelangelo, which has long since been discredited but points to the Renaissance artist who unassailably set the standard for images of the male nude. Since Salviati had spent the first twenty years of his life in Florence, he knew most of the local works by Michelangelo very well. Vasari even claims that he and Salviati, while still teenagers, had together salvaged the three pieces of the left arm of Michelangelo's *David*, shattered during the republican seizure of the Palazzo della Signoria in 1527.[3] Michelangelo's *Battle of Cascina* would have provided enduring inspiration for an artist such as Salviati – and an inescapable challenge. The *Battle*'s apparently definitive depiction of the vigorously active male figure supplied Salviati with models for a lifetime,[4] and simultaneously provoked the invention of his own audacious variations, such as the present examples. ¶ In the last century the drawing was assigned to two artists who were younger than Michelangelo but much obsessed with him. In 1937, when it was evidently in the collection of Walter Gernsheim in London, the drawing was considered to be by Battista Franco, an artist from Venice who was smitten by Michelangelo's work in every medium.[5] Then in 1955 the drawing appeared on the London art market as by Baccio Bandinelli, the attribution it retained until recently. Significantly, Vasari relates that Bandinelli's copies after Michelangelo's nudes in the *Battle of Cascina* surpassed those by all of his contemporaries.[6] Throughout his life, Bandinelli himself executed large and emphatic pen-and-ink studies of the male nude, which Francesco Salviati certainly knew, because for a short period around 1526–1527 he was a student, along with Vasari, in Bandinelli's workshop.[7] ¶ Salviati's early pen-and-ink drawings, like those of Vasari, betray the period of training with Bandinelli, though only recently have those by Salviati been convincingly identified.[8] Following a format often adopted by Bandinelli, on both sides of this drawing there is a single full-length, muscular

nude in dynamic action, executed entirely in vigorous pen and brown ink, with no trace of brush or tonal wash. As in Bandinelli's drawings, the pen line, which appears exceptionally rapid, models the muscles with energetic hatching and cross-hatching. But here the hatching is more varied and rhythmically curvilinear than is usual for Bandinelli, which supports an attribution to Salviati.[9] The loop of foliage along the ground is a particularly telling detail, one that exemplifies the artist's calligraphic virtuosity, even at what must have been a relatively early date. With masterful assurance, Salviati's incisive line operates as an effective means of imitating the figure's three-dimensional surface, and also as an exhilarating aesthetic refinement in itself. Salviati's draftsmanship, more spontaneously ornate than his teacher's, still remains urgent and descriptive, a brilliant amalgam of artifice and observation. ¶ The figures themselves, with their poses that flex the limbs and tighten the muscles, typify Salviati's restless search for novelty. In turn, the implied movement is dramatically amplified by encircling draperies, as in classical sculpture and some of the nudes in the *Battle of Cascina*. The swirling drapery of the man seen from behind is even reminiscent of that in northern European drawings by such artists as Urs Graf and Albrecht Altdorfer. Although Salviati's broad-shouldered figures suggest that he was less obsessed than Michelangelo with precise anatomical description, they also attest to Vasari's comment that in Rome during the late winter of 1532 both he and Salviati studied nudes from life at a nearby bath-house (*stufa*) and then did anatomical studies in the cemetery.[10] As a large, double-sided, pen-and-ink sheet devoted exclusively to the male nude, this drawing resembles most closely a sheet owned by Michael Hall in New York that was also reclaimed for Salviati only recently.[11] None of these figures relates directly to other known works by the artist, but since much of his oeuvre from the 1530s is lost, comparisons are difficult. It might be noted, however, that the upper part of the man seen from the back is roughly analogous to the foreground figure in Salviati's *Death of the Children of Niobe* (fig. 118.1), a drawing directly connected with an anonymous engraving dated 1541. The sheet in Montreal typically indicates that although Francesco Salviati profited from his esteemed Florentine mentors he was intimidated by none of them.

David McTavish

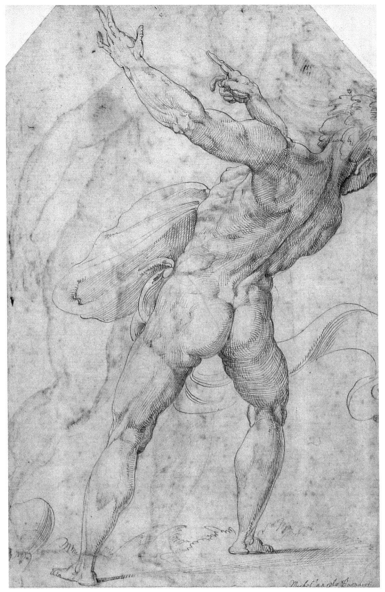

118 (recto)

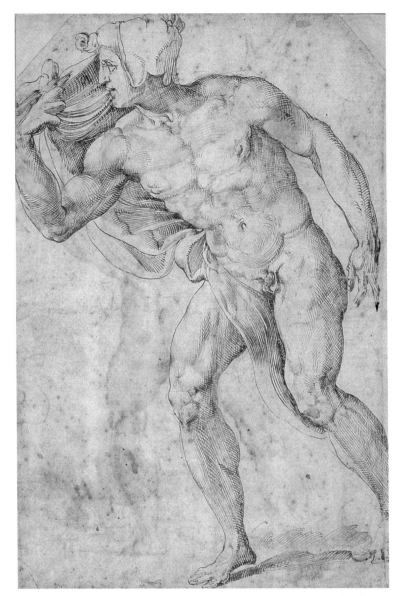

118 (verso)

Fig. 118.1 Francesco Salviati, *The Death of the Children of Niobe*, c. 1541, brown ink, heightened with white, 30.9 x 45 cm Ashmolean Museum, Oxford (WA1863.674)

119 FRANCESCO SALVIATI (1510–1563) · **Portrait of a Boy** · c. 1535–1538 · Red chalk · 16.8 x 12.4 cm
Private collection, Chicago

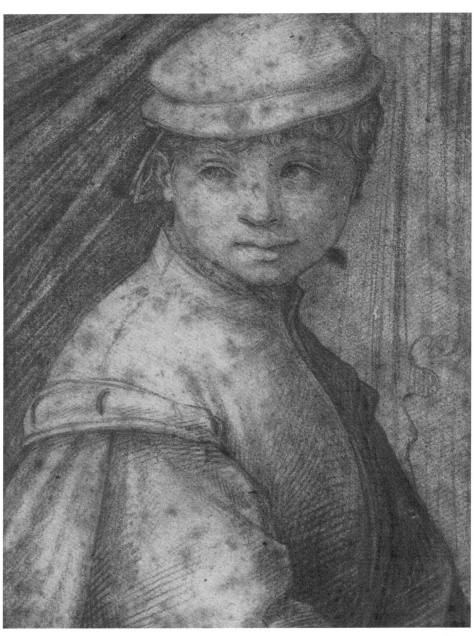

This highly finished likeness of a young man in a cap belongs to Salviati's early efforts in portraiture, a genre in which he was to become the foremost Florentine exponent of his generation, second perhaps only to the slightly older Bronzino. It shows the sitter placed before a curtain, part of which is pulled to the left, as if to support the direction of his gaze. Salviati would have known such use of the curtain – which ultimately derived from Raphael's Madonnas[1] – from paintings by his last teacher, Andrea del Sarto, such as his *Virgin and Child* of 1528–1530 in the Palazzo Pitti, painted at approximately the time of Salviati's apprenticeship in Sarto's workshop.[2] Yet the present drawing owes much more to that master. More specifically, it is the handling of the red chalk that Salviati learned from Sarto, the precise use of parallel hatching and cross-hatching to build up areas of different size and density in order to lend volume to the figure and to define the tonal values. While Salviati's training with Sarto lasted only from the spring of 1529 to the latter's death on 29 September 1530, he had been familiar with his drawings much earlier. In the mid-1520s he was apprenticed only to the lesser Florentine painter Giuliano Bugiardini, but thanks to his friendship with Giorgio Vasari, a pupil of Sarto at the time, he secretly received drawings by the master, which, according to Vasari, Salviati studied and copied day and night.[3]

¶ Although no corresponding painting has yet come to light, the present drawing was almost certainly made with a painted portrait in mind. It is comparable in style and technique to a red-chalk drawing of the *Virgin and Child* in the Louvre,[4] where the Christ child, as Costamagna has pointed out, is a variation on that in Sarto's Barberini *Holy Family* of 1528–1529.[5] This was another work that the young trainee may have seen, and probably copied, in Sarto's studio, or that he may have known from preparatory drawings. A red-chalk drawing of the Christ child in the Ashmolean Museum in Oxford, copied from a now lost painting by Sarto (known by a copy at Hampton Court recently attributed to Jacopino del Conte), further testifies to Salviati's meticulous study of this master's paintings.[6] To this early period belong a red-chalk drawing of a young man, at Chatsworth, traditionally attributed to Salviati, and another in the Louvre, which is preparatory to his *Portrait of a Young Lute Player* in the Musée Jacquemart-André in Paris.[7] In these, perhaps the earliest of Salviati's known portrait drawings, the realistic rendering of the sitters' appearance successfully emulates the powerful directness of Sarto's life studies.[8]

¶ Compared to the latter drawings, however, the Chicago portrait is more advanced; it is perhaps less immediate, but it is more subtle in capturing the boy's personality, showing less interest in the extrinsic features than in the character of his sitter. The slight twist in the young man's pose may also reflect Salviati's growing interest in Parmigianino, whose work he discovered following his move to Rome in 1531. Costamagna has therefore dated this drawing convincingly to about 1535–1538, during Salviati's prolonged stay in Rome, which lasted until 1539, the year he left for Bologna and Venice. In more general terms, the drawing oscillates between the Sartesque Chatsworth portrait on one hand and the black-chalk portrait drawing of a young man in the Victoria and Albert Museum on the other.[9] The latter belongs to a slightly later moment in the development of Salviati's style, which had already assimilated the smoothness of Bronzino's portraits.

Florian Härb

120 FRANCESCO SALVIATI (1510–1563) · **Allegory of the Triumph of Venus, after Bronzino** (recto)
Architectural Study (verso) · c. 1545 · Pen and brown ink and brown wash over black chalk
11.4 x 9.8 cm · National Gallery of Canada, Ottawa

This drawing was published recently for the first time by Monbeig Goguel, who attributed it to Francesco Salviati on the basis of style.[1] The fluid handling with the rather dry, striated application of wash has parallels in previously accepted drawings by Salviati.[2] In addition, the lively, exquisite treatment of the contour lines is evidence of the supremely refined touch of this artist. Although small in scale, the drawing illustrates well the delicate, refined sensibility of Salviati's art. After its acquisition by the National Gallery of Canada, the drawing was lifted from its mount to reveal a verso for the first time – a study by the artist for an unidentified doorway. ¶ The sketch on the recto does not represent an original composition, but, remarkably, records Bronzino's celebrated *Allegory of the Triumph of Venus* in London (fig. 120.1). Indeed, both the painting and this drawing were once together in the Spencer collection, at which time the sketch was considered a preparatory study for the painting. Bronzino's picture was painted in Florence around 1540 to 1545, when the artist was occupied with various Medici commissions, but was sent to the French king Francis I (who died in 1547).[3] Salviati was also working in Florence during this period, when he and Bronzino, together with Jacopo da Pontormo, formed part of a team to design twenty tapestries illustrating the story of the Old Testament Joseph for Duke Cosimo I de' Medici, in a new workshop established by the duke in 1545.[4] Salviati later travelled to France around 1556 and stayed for almost two years, and he would have seen the panel there a second time.[5] The style of the sketch is more consonant, however, with drawings associated with his Florentine period, suggesting that he made it prior to the departure of the panel to Paris, in part to record a composition that he had no reason to believe he would see again.

¶ There are some significant differences, however, between the drawing and the surviving painting, which raises the question of what precisely Salviati was copying. For example, Venus's legs overlap more tightly in the drawing than in the painting, and in the latter her left arm reaches down much farther. Cupid's pose is also different, and in the sketch his right hand clasps the opposite breast (though in the underdrawing it is in fact the correct one), while his left hand does not hold Venus's crown. Overall, Salviati has rendered the figures smaller in relation to the pictorial field and has given them more space in which to move. There seem to be two possible explanations for these discrepancies. Salviati may have executed his copy not after the London painting but after a compositional drawing by Bronzino, now lost, that also contained some or all of these variations. Alternatively, Salviati made his drawing from memory because, for whatever reason, it was not convenient for him to make a sketch in front of the original, and

as a result some changes crept into his version. One other hypothesis can definitely be refuted: it is clear that Salviati did not produce his copy while Bronzino's picture was in progress, because these differences do not correspond to an earlier version of the painting revealed by technical examination.[6] ¶ For Salviati to replicate a Bronzino design in Florence at this time was not an innocent undertaking, given that the two were rivals – Salviati the Florentine, who had spent his formative years in Rome, returning to usurp commissions from Bronzino, who had stayed in Florence in the distinguished company of Pontormo. It is not known for certain whether Bronzino was one of those who criticized Salviati's vast Sala dell'Udienza frescoes in the Palazzo Vecchio, but one can imagine that he must have been implicated. The fullest evidence for a rivalry between Salviati and Bronzino actually comes from the period after the making of this drawing. Salviati's only public altarpiece in Florence, executed toward the end of his stay in the city around 1548, for the Dini family chapel in the church of Santa Croce, was produced in unofficial competition with a Bronzino altarpiece of *Christ in Limbo*, signed and dated 1552, for the Zanchini chapel in the same church. Both were placed on altars on the inner facade of Santa Croce, where they could easily be compared. Letters written in 1552 from correspondents in Florence to Vasari in Rome, where he was collecting gossip about the event, reveal that Bronzino's work was widely judged to be superior to Salviati's.[7] Although the reasons for this assessment are not explicitly recorded in these sources, it would partly have stemmed from pure chauvinism among the Florentines, as they attempted to secure their dominance in artistic matters against interlopers from Rome, Venice, or elsewhere. In this context, it is possible to view Salviati's drawing not only as a record but also as a critique of Bronzino's invention, providing further evidence for the controversy overshadowing his sojourn in Florence in the 1540s.

David Franklin

120 (recto)

120 (verso)

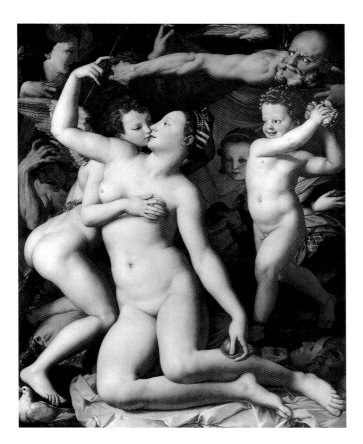

Fig. 120.1 Agnolo Bronzino, *Allegory of the Triumph of Venus*, c. 1540–1545, oil on panel, 146.5 x 116.8 cm. National Gallery, London

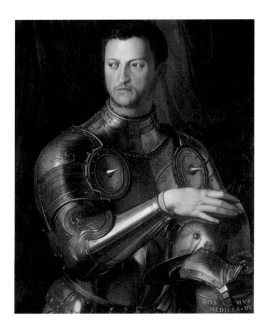

Fig. 121.1 Agnolo Bronzino, *Portrait of Duke Cosimo I de' Medici in Armour*, 1540s, oil on panel, 86 x 67 cm. Art Gallery of New South Wales, Sydney (78.1996)

This important portrait, traditionally ascribed to Francesco Salviati, has been neglected by scholars until recently.[1] In the catalogue of the 1998 Salviati exhibition, Cox-Rearick and the present writer include the work in his corpus, while Cecchi sees in it the hand of Michele Tosini. This disagreement, which might surprise the attentive reader of the catalogue,[2] may be explained not so much by any difficulty in appreciating the range of Salviati's portraiture as by the painting's state of preservation. Having been transferred from panel to canvas, and having undergone a number of different restorations, the painting shows signs of general wear (particularly in the landscape), which gives it a rather mechanical appearance that is sometimes found in the work of certain artists from Michele Tosini's studio. However, the stylistic characteristics are clearly those of Salviati. The modelling of the face, the drawing of the hands, the treatment of the draperies, and the way the light catches in the sitter's curls are all typical of the artist. ¶ By virtue of its subject, its author, and its format, this painting occupies a central place in the evolution of Florentine portraiture in the sixteenth century. It was probably one of the first *portraits d'apparat* painted in Florence. The subject is Duke Cosimo I de' Medici, sumptuously arrayed and splendidly posed, standing before a red drape that opens onto a view of the city of Florence, toward which his hand is gesturing. This gesture masks the insignia of the Golden Fleece (whose presence is suggested by the chain), which serves to date the work to between 1544, when the duke received the decoration, and 1546, the year of his official investiture. It was during this same period that Bronzino developed the prototype for the state portraits of the ducal couple. ¶ In the fall of 1545, in an effort to impose Bronzino as portraitist to the new regime, Pier Francesco Riccio, the duke's major-domo, concealed Titian's *Portrait of Pietro Aretino* (Palazzo Pitti, Florence), which the poet had recently sent to Cosimo. For Riccio, who knew how powerfully persuasive Aretino could be in promoting the Venetian artist's skills as official portrait painter to the emperor and to Italian sovereigns,[3] it was unthinkable that Cosimo should commission his likeness from a non-Tuscan, even if – as the likeness of Aretino could attest – he was the greatest portraitist of the day.[4] The portrait that

Bronzino painted in 1545 is identified with *Portrait of Duke Cosimo I de' Medici in Armour* in Sydney (fig. 121.1).[5] However, to create the duke of Florence's official image, Bronzino sought inspiration in Titian's *Portrait of Charles V in Armour* (present whereabouts unknown), made famous throughout the peninsula by means of the woodcut done by Giovanni Britto in the early 1540s. Salviati, who was aware of the major-domo's stratagem, clearly imitated the Bronzino pose when he portrayed the duke, so much so that his painting might be thought to be after Bronzino rather than from life. However, using his knowledge of Titian's portraits that he saw during his stay in Venice, and others that were held in the ducal collection, notably the *Portrait of Pietro Aretino* (which, as he told the poet, he saw in January 1546), the artist adapted Bronzino's prototype in a manner that is even closer to the official portrait formula developed by Titian. By this means he evidently hoped to surpass his predecessor and, backed by Riccio, to be named portrait painter to the duke. To this end, Salviati played his best cards, his Titianesque talent for portraiture and his ability to render landscape, already widely known through his frescoes depicting the story of Furius Camillus in the Palazzo Vecchio. ¶ The competition for the duke's favour waged by Salviati and Bronzino may be compared to the earlier rivalry between Benvenuto Cellini and Baccio Bandinelli. Although Salviati painted some portraits of members of the duke's family,[6] he was not awarded the commissions he had hoped for, namely more cartoons for the *Joseph* tapestries, the decoration of the choir in the church of San Lorenzo, and the *Allegory with Mars and Venus* for the king of France (cat. no. 120), plums that went to Pontormo and Bronzino. After vainly submitting drawing after drawing for the duke's construction projects, by 1546 Salviati was beginning to encounter strong opposition at the Medici court. The prestigious commission for this portrait, executed between the fall of 1545 (when Bronzino's portrait of the duke was completed) and 11 August 1546 (the date of the ceremonial bestowal of the Golden Fleece), would appear to be Cosimo's final gesture of trust in an artist too closely linked to his uncle Cardinal Giovanni Salviati, with whom the sovereign began severing all ties in 1546.[7]

Philippe Costamagna

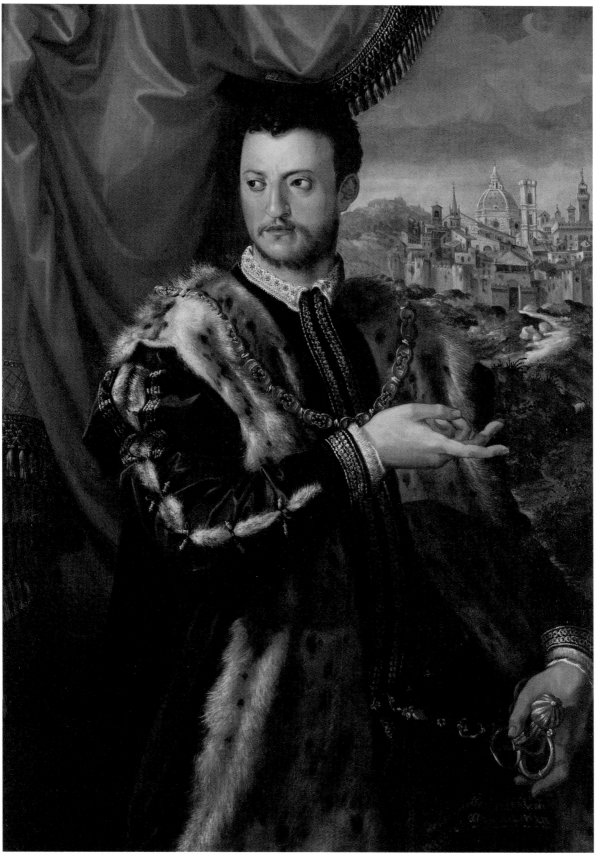

This painting is an example of the confusion that has existed between portraits by Francesco Salviati and those by Michele Tosini.[1] The portrait has been attributed just as often to one as to the other artist, occasionally even resulting in heated debate. The work at one point underwent radical restoration treatment that involved the removal of the original glazes, accentuating details such as the sunset effect, and this may have influenced some opinions. The portrait was presented under Salviati's name in the Paris showing of the 1998 exhibition, and this attribution now appears to have been generally accepted, although there are those who still ascribe it to Tosini (Pilliod), and some who even consider it the work of an artist of an earlier generation (Robertson). However, the painting clearly displays the stylistic characteristics of Francesco Salviati: the modelling of the face and hands cannot be confused with that of any other artist, and he alone in Florence was capable of rendering the landscape in this manner, emphasizing the details with white highlights. The work was no doubt painted around 1547–1548, at the end of the artist's long stay in Florence; stylistically, it is comparable to the *Deposition from the Cross* in the Dini chapel in Santa Croce, completed in 1548, to the Uffizi *Christ Carrying the Cross*, and, as portraiture, to the *Portrait of a Young Man* in the Liechtenstein Museum in Vienna. ¶ The sitter, although unidentified, is unquestionably Florentine, as is indicated by the presence of the *marzocco*, the Florentine lion, and, in the left background, the river god, a personification of the Arno. Salviati had previously executed a fresco of the *Allegory of the Arno*, between the two windows of the Sala dell'Udienza in the Palazzo Vecchio,[2] and a grisaille of the same subject in the Palazzo Valori, as described in 1591 by Francesco Bocchi.[3] In the portrait, the river god's reclining, spread-legged pose – recurrent in the artist's work, notably, and incongruously, behind Saint Elizabeth in the *Birth of*

Saint John the Baptist in the oratory of San Giovanni Decollato in Rome[4] – is yet another element that serves to confirm the Salviati attribution. An allegorical presence of this sort could imply that the subject of the portrait was a member of the Accademia Fiorentina, founded in 1542 by Duke Cosimo I de' Medici. And such a supposition could be confirmed by the young man's pose, which derives from that of Michelangelo's sculpted *Giuliano de' Medici* in the New Sacristy in San Lorenzo – a choice that was not fortuitous. Salviati was very familiar with Michelangelo's influence on portraiture, as exemplified in Sebastiano del Piombo's depictions of Pope Clement VII and of his own patron, Cardinal Giovanni Salviati,[5] but this was the first time that he borrowed the sculptor's pose. It thus can be assumed that the pose was chosen by the sitter, who no doubt wanted to underscore his affiliation with the Accademia Fiorentina by emulating the cultural leaders portrayed by Bronzino some years earlier, who had probably become members as well. The allusion to Michelangelo was highly symbolic, not only culturally, but also politically, given the Florentine sculptor's allegiances. While Michelangelo may not have practised portrait painting, his impact on this field was significant.

Philippe Costamagna

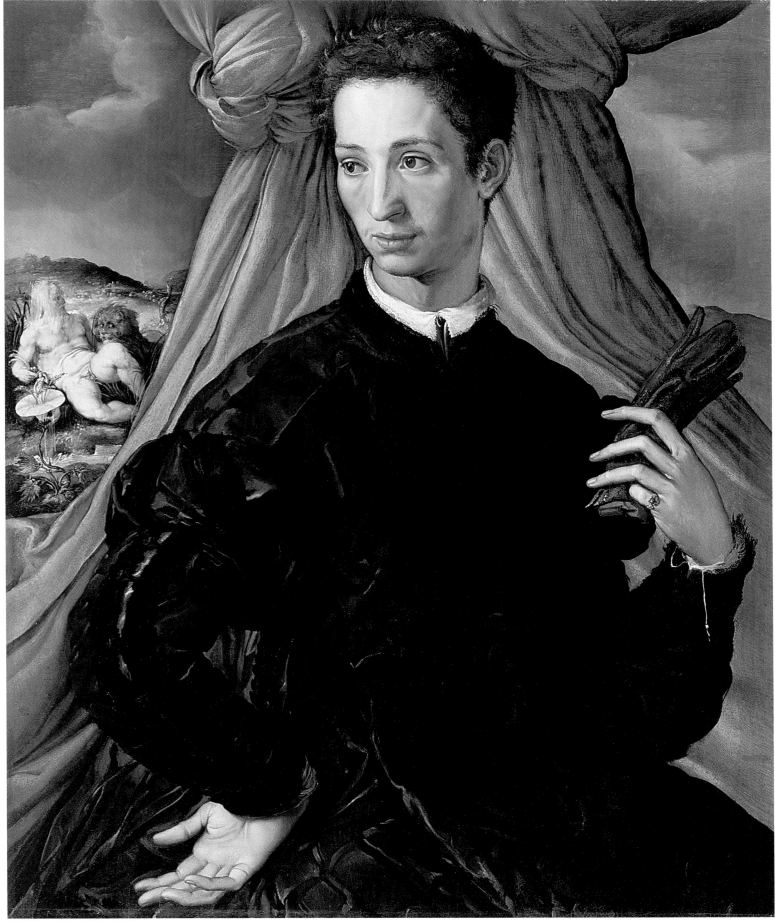

After the departure of Girolamo and Luca della Robbia the Younger for France in the 1520s, Santi Buglioni became the primary exponent of glazed terracotta sculpture in Tuscany. Indeed, Vasari stated that "only Santi Buglioni today knows how to make this kind of statuary."[1] Buglioni's most famous work is the large relief of the *Seven Acts of Mercy* for the frieze of the portico of the hospital of the Ceppo in Pistoia, commissioned by Lorenzo Buonafede in 1526. ¶ The present sculpture was originally published as a work of Giovanni della Robbia, but was correctly identified by Gentilini as an autograph sculpture of Santi Buglioni, and published by Fiamma Domestici in 1998. This attribution is confirmed by the vigorous modelling of the face and hands, the fiery intensity of the expression, the energetic disposition of the drapery, and the characteristic palette of the glazing, with its combination of deep Naples yellow, purplish-brown, and pale blue. ¶ The figure was incorrectly identified by Gentilini and Domestici as Duns Scotus, the thirteenth-century Franciscan philosopher. In fact, the statue represents San Giovanni di Capistrano (1385–1456), as was first suggested by Fernando de Quinta Alegre (verbal communication). A leader of the Observant Franciscans, San Giovanni was the principal lieutenant to San Bernardino of Siena, the head of the Order. A photograph from the 1950s or 1960s shows the present work in conjunction with a figure of San Bernardino, identical in colour and size (present whereabouts unknown). Certainly these two sculptures must originally have formed a pair and must have been made for a prominent Franciscan monastery. A third figure, representing Saint Francis, possibly also formed part of this group (Siviero Collection, Palazzo Vecchio, Florence). Life-size free-standing statues in glazed terracotta are exceedingly rare, and the commission that led to the making of this group must have been of exceptional prestige and importance. ¶ San Giovanni di Capistrano is here represented in the guise of a preacher. Stepping forward, he pulls his robe up with his left hand, and points upward with his right hand. His mouth is open, as if speaking, and the forward motion of the figure adds a sense of compelling urgency. He seems to be in the middle of passionate oratory or preaching. Unmistakably, Santi Buglioni borrowed this pose from the figure of Plato in Raphael's *School of Athens*. Buglioni, however, has transformed the aspect of the figure, making him into a personification of Counter-Reformation zeal. ¶ The figure was modelled and fired in at least four sections – the head, the right hand, the upper body, and the lower body – which were then joined after firing. The unglazed areas of terracotta in the hands, head, and feet were originally painted after firing, as is demonstrated by the traces of gesso and paint found there.

Andrew Butterfield

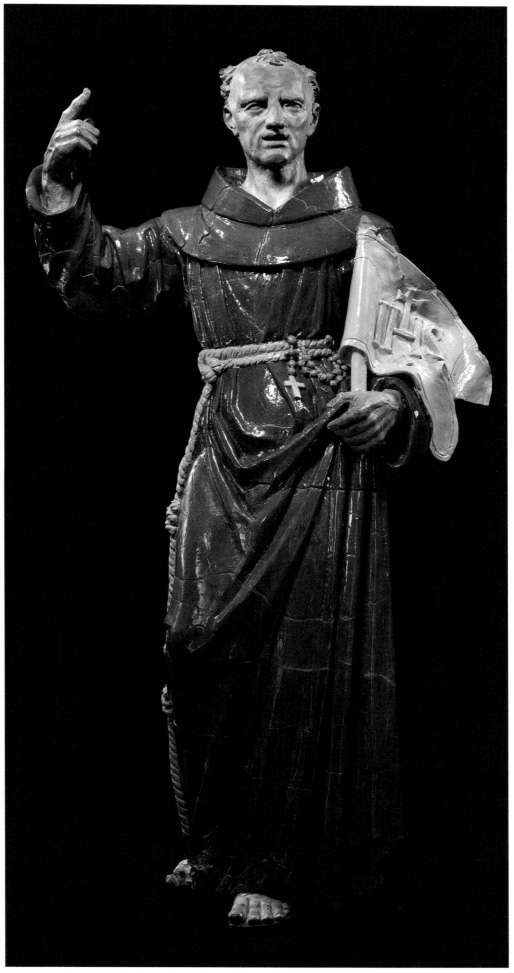

Cat. no. 1
LEONARDO DA VINCI (1452–1519)
Sheet of Studies
c. 1503–1504
Black chalk and pen and brown ink
21 x 28.3 cm
Royal Library, Windsor Castle (12328)

Provenance: bequeathed to Francesco Melzi; purchased from his heirs by Pompeo Leoni, c. 1582–1590; Thomas Howard, 2nd Earl of Arundel, by 1630; probably acquired by Charles II; Royal Collection by 1690.

References: Popham 1946, no. 202; Clark and Pedretti 1968–1969, pp. 27–28; Pedretti 1987, no. 119.

Cat. no. 2
LEONARDO DA VINCI (1452–1519)
Leda and the Swan
c. 1505
Pen and brown ink and brown wash over black chalk
16 x 13.9 cm
Annotations: in pen and brown ink, *Leonardo da Vinci*
Devonshire Collection, Chatsworth (717)

Provenance: possibly William Cavendish, 2nd Duke of Devonshire (L. 718); by descent to the 12th Duke of Devonshire.

References: Jaffé 1994, no. 880; Bambach 2003, no. 99 (with bibliography).

Cat. no. 3
RAPHAEL (1483–1520)
Leda and the Swan, after Leonardo da Vinci
c. 1507
Pen and brown ink over black chalk
31 x 19.2 cm
Watermark: three hills
Royal Library, Windsor Castle (12759)

Provenance: Royal Collection by c. 1810.

References: Fischel 1913–1941, vol. 2, no. 79; Popham and Wilde 1949, no. 789; Joannides 1983, no. 98; Oberhuber and Ferino Pagden 1983, no. 114; Clayton 1999, no. 12 (with bibliography).

Notes
1 Joannides 1983, no. 286.
2 Ibid., no. 139.

Cat. no. 4
RAPHAEL (1483–1520)
Studies of the Virgin and Child
c. 1506–1507
Pen and brown ink and red chalk
26.2 x 19.3 cm
Albertina, Vienna (SR 250, R 53, inv. 209v)

Provenance: Timoteo Viti; Marchese Antaldi; Pierre Crozat; Marquis de Gouvernet; Julien de Parme; Prince de Ligne; Herzog Albert von Sachsen-Teschen.

References: Knab et al. 1983, nos. 162, 163; Joannides 1983, no. 181; Birke and Kertész 1992–1997, vol. 1, p. 121ff.; Teckningar 1992, no. 24; Pedretti 1992, no. 3; Penny 1992, fig. 7; Edinburgh 1994, no. 21; Meyer zur Capellen 1996, p. 166ff., nos. 106, 107, 109; New York 1997, no. 12; Oberhuber 1999, p. 58, nos. 51, 52; Venice, Vienna, and Bilbao 2004–2005, no. 12.

Notes
1 Knab et al. 1983, no. 161.
2 Popham 1946, plate 16.

Cat. no. 5
FOLLOWER OF ANDREA DEL VERROCCHIO (ACTIVE C. 1500–1520)
Saint Jerome
c. 1500–1520
Stucco
59.1 cm high
Victoria and Albert Museum, London (65-1882)

Provenance: purchased in Florence, 1882 (vendor not recorded).

References: Pope-Hennessy 1964, vol. 2, p. 403, no. 420; Ost 1975, pp. 54–58, 63–65; Marani 2000, pp. 95–96.

Notes
1 See Pope-Hennessy 1964, vol. 2, pp. 403–404, nos. 421, 422.
2 See Pope-Hennessy 1996, pp. 181–197; I. Lavin, "On the Sources and Meaning of the Renaissance Portrait Bust," in *Looking at Renaissance Sculpture*, ed. S.B. McHam (Cambridge, 1998), pp. 60–78.
3 There is little comparative data by which to assess the significance of this analysis. The bust appears to have a modelled back made of similar material – therefore most likely contemporary although it could be a later addition. Plaster has been added to areas of the interior, probably in the nineteenth century, with sculptors' tools inserted as support struts. On stucco see Bassett and Fogelman 1997, pp. 87–88; for a stricter definition of stucco as a lime plaster see N. Penny, *The Materials of Sculpture* (New Haven, 1993), p. 311.
4 Vasari 1996, vol. 1, p. 557; Maclagan and Longhurst 1932, p. 63.
5 For a more detailed discussion see Bellosi 1990; Ost 1975.
6 Clark and Pedretti 1968–1969, p. 2, no. 19001; Clayton 1992, p. 95.
7 Suida 1929, pp. 110–111.
8 Marani 2000, p. 95, attributing the various busts to Verrocchio's circle.

Cat. no. 6

GIOVANNI FRANCESCO RUSTICI (1474–1554)
Mercury Taking Flight
c. 1515
Copper alloy, probably bronze, on a weathered green and red breccia marble ball
47.9 cm high
The Fitzwilliam Museum, University of Cambridge (M.2-1997)

Provenance: commissioned by Cardinal Giulio de' Medici for the Palazzo Medici, Florence, 1515; Sir Francis Cook, Richmond, Surrey; bequeathed to Wyndham Francis Cook, London, 1901; bequeathed to Humphrey Wyndham Cook, London, 1905; his sale, Christie's, London, 8 July 1925, lot 242 (as "Italian, 16th century"), purchased by Frank Partridge; sold to Henry Harris, London; his sale, Sotheby's, London, 24 October 1950, lot 106, purchased by Sylvia Adams against the N.A.C.F. on behalf of Lt. Col. the Hon. Mildmay Thomas Boscawen, D.S.O., M.C., Mtotochovu, Tanganyika; bequeathed to his sister, the Hon. Mrs. Pamela Sherek, Geneva, 1958; bequeathed to the Fitzwilliam Museum in her brother's memory, 1995.

References: Skinner 1904, p. 136, no. 610; Loeser 1928; Wiles 1933, pp. 9, 83–84; Middeldorf 1935, pp. 71, 72, 76; Ciardi Dupré 1963, pp. 38, 48 note 21; Pope-Hennessy 1963, vol. 3, p. 43; Pope-Hennessy 1974; Avery and Dillon 2002, pp. 36, 45 note 106, 56–68 (entry by A. Radcliffe), 242–244.

Notes

1 This entry is based on that of A. Radcliffe and the technical report by J. Dillon in Avery and Dillon 2002, pp. 56–68, 242–244.
2 Loeser (1928, p. 266) stated that Henry Harris "nearly a year" after his acquisition of the bronze (8 July 1925), while reading Vasari, "came on a description in the Life of Rustici which answered in all particulars the bronze in his possession."
3 "Onde nella venuta, l'anno mille cinquecento e quindici, di papa Leone a Firenza, a richiesta d'Andrea del Sarto suo amicissimo fece alcune statue, che furono tenute bellissime; le quali, perchè piacquero a Giulio cardinale de' Medici, furono cagione che gli fece fare sopra il finimento della fontana che è nel cortile grande del palazzo de' Medici, il Mercurio di bronzo alto circa un braccio, che è nudo sopra una palla in atto di volare: al quale mise fra le mani un instrumento che è fatto, dall'acqua che egli versa in alto, girare. Imperochè, essendo bucata una gamba, passa la canna per quella e per il torso; onde, giunta l'acqua alla bocca della figura, percuote in quello strumento bilicato con quattro piastre sottili saldate a uso di farfalla, e lo fa girare. Questa figura, dico, per cosa piccola, fu molto lodata." Vasari-Milanesi 1878–1885, vol. 6, p. 602; the English translation is based on that by Radcliffe in Avery and Dillon 2002, p. 58.
4 Wiles 1933, pp. 9, 83–84; Pope-Hennessy 1961, no. 21; Pope-Hennessy 1963, p. 43; Radcliffe in Avery and Dillon 2002, pp. 56–68.
5 Radcliffe in Avery and Dillon 2002, pp. 58–59.
6 Skinner catalogued the bronze as follows: "Statue in bronze of a herald, balancing himself on his right leg on a marble ball; his right arm is upraised and his left is pressed against his side. In his right hand he probably held a trumpet, now missing … By the addition of four small wings and a caduceus with a windmill, the figure has been converted into a *Mercury*." Skinner 1904, p. 136, no. 610.

7 "By the addition of small wings and a caduceus with windmill in his hand the figure has been transformed into a Mercury." Humphrey Wyndham Cook sale, Christie's, London, 8 July 1925, p. 54, lot 242.
8 Avery and Dillon 2002, pp. 243–44 note 5.
9 One serious objection to identifying it as the Rustici work described by Vasari is the fact that when inventoried in 1609, among the effects of the Guardaroba of the Palazzo Medici, it was described as gilt ("un merchurio di Bronzo indorato che serviva per la fontana del cortile grande"), while no trace of gilding has been detected on the present bronze. However, Radcliffe has proposed several reasons why any original gilding may not have survived; see Avery and Dillon 2002, p. 67.
10 Ciardi Dupré 1963, pp. 38, 48 note 21.
11 Middeldorf 1935, pp. 71, 72, 76; Pope-Hennessy 1974, pp. 23–29, 31–35; Radcliffe in Avery and Dillon 2002, p. 61.
12 Radcliffe in Avery and Dillon 2002, p. 67; see also note 9 above.

Cat. no. 7

GIOVANNI FRANCESCO RUSTICI (1474–1554)
Saint George and the Dragon
c. 1520–1528 (?)
Marble relief
29 x 48 cm
Szépművészeti Múzeum, Budapest (1138)

Provenance: purchased from E. Costantini, Florence, 1894 (as Leonardo da Vinci, with an alleged provenance from the Piccolomini family of Siena).

References: Middeldorf 1935, pp. 71, 76; Valentiner 1959, pp. 206, 208; Balogh 1975, vol. 1, no. 144; Ciardi Dupré dal Poggetto 1977, p. 65; Pope-Hennessy 1996, pp. 447–448; Gentilini 1992, vol. 2, p. 456; M. Maccherini in Barocchi 1992, no. 35; Davis 1995, pp. 93–94, 102–107.

Notes

1 Gauricus 1969, p. 256.
2 And for an artist as varied as Rustici – whose stylistic changes must have been made possible by the reflective leisure he enjoyed as an independently wealthy artist (see Vasari-Milanesi 1878–1885, vol. 6, pp. 600–601) – the example of Donatello's protean transformations of *maniera* must also have played a formative role in the creation of his own creative identity.
3 On the Villa Salviati *Annunciation* see Davis 1995, pp. 108–111.
4 For the text of Michelangelo's letter on the *paragone* between painting and sculpture see Barocchi 1971, vol. 1, pp. 522–523.
5 Vasari-Milanesi 1878–1885, vol. 6, p. 601.
6 For a useful overview of Leonardo's engagement with the subject of the horse see Pedretti 1985–1986.
7 See, for example, Clark and Pedretti 1968–1969, nos. 12331, 12370. On Leonardo's dragons see also Blass-Simmen 1991.
8 Clark and Pedretti 1968–1969.
9 See Ciardi Dupré 1963, figs. 48a, 48b, 50a.
10 For an example involving the dating of Rustici's *Holy Family* in the Bargello see Waldman 1997b.

Cat. no. 8

GIOVANNI FRANCESCO RUSTICI (1474–1554)
Saint John the Baptist
c. 1510–1520
Glazed terracotta
100.3 x 33 x 26.7 cm
Museum of Fine Arts, Boston, Gift of Mrs. Solomon R. Guggenheim (50.2624)

Provenance: Irene Rothschild (Mrs. Solomon R.) Guggenheim, Long Island, N.Y., by 1950; gift to the museum, 1950.

Notes

1 Letter in Museum of Fine Arts, Boston, curatorial file.
2 Vasari 1967, vol. 6, pp. 449–450; Vasari 1996, vol. 2, p. 519; J. Pope-Hennessy, *Italian High Renaissance and Baroque Sculpture* (New York, 1970), pp. 39–41, 340–342; Kemp 1988, especially pp. 18–23.
3 Gentilini 1992, vol. 2, pp. 452–456; A. Bellandi in Gentilini 1998, pp. 365–367. Recent discussions focusing on attributions include A. Radcliffe in *Renaissance and Baroque Bronzes from the Fitzwilliam Museum, Cambridge* (London, 2002), pp. 56–69; F. Caglioti, "Il perduto 'David mediceo' di Giovanfrancesco Rustici e il 'David' Pulszky del Louvre," *Prospettiva* 83/84 (1996), pp. 80–101; Davis 1995, pp. 92–133.
4 K. Weil-Garris Posner, *Leonardo and Central Italian Art 1515–1550* (New York, 1974), pp. 38–39.
5 For a summary of Leonardo's whereabouts in these years, including the period 1507–1508, when he shared a house with Rustici, see *Leonardo da Vinci Master Draftsman*, exh. cat. (New Haven and London, 2003), pp. 236–237.
6 Kemp (1988) stresses this aspect of Leonardo's work and sees reflections of it in Rustici's Baptistery group. See also K. Weil-Garris Brandt, *Leonardo e la scultura* (Vinci, 1999), including bibliography.
7 The index finger of the right hand is a modern replacement.
8 F. Viatte in *Leonardo da Vinci Master Draftsman*, pp. 111–119; P.L. Rubin and A. Wright, *Renaissance Florence: The Art of the 1470s*, exh. cat. (London, 1999), pp. 93–106; A. Butterfield, *The Sculptures of Andrea del Verrocchio* (New Haven and London, 1997), pp. 185–198.
9 I thank my MFA colleagues Richard Newman, Head of Scientific Research, and, especially, Abigail Hykin, Associate Conservator, Objects Conservation, for their work on this object and for the ongoing discussion about its facture and condition. Thermoluminescence testing was carried out by C. Goedicke and S. Schwerdtfeger, Rathgen-Forschungslabor, Staatliche Museen zu Berlin, May 2004.
10 Vasari says that Rustici would not show his unfinished works to anyone "in order to be able to change them as often and in as many ways as he wished" ("per poter mutarle quante volte et in quanti modi altri vuole"). Vasari 1967, vol. 6, p. 446.
11 A. Cecchi, "Profili di amici e committenti" in Florence 1986, pp. 42–58.

Cat. no. 9
LUCA DELLA ROBBIA THE YOUNGER (1475–1548)
Adoring Angel
c. 1510–1515
Partially glazed terracotta
60 x 45 cm
Private collection

Provenance: Carlo de Carlo, Florence.

References: G. Gentilini in Butterfield 2001, pp. 52–61; Gentilini 1992, vol. 2, pp. 332, 347; Radcliffe 1992, pp. 100–105; A. Bellandi in Gentilini 1998, p. 283; F. Petrucci in Gentilini 1998, p. 301.

Cat. no. 10
PIERO DI COSIMO (1462–1522)
Prometheus Stealing the Celestial Fire
c. 1515
Oil on panel
64 x 116 cm
Musée des Beaux-Arts, Strasbourg (354)

Provenance: acquired by the Musée des Beaux-Arts from the collection of Sir Charles Robinson, London, 1896.

References: Loeser 1896, p. 286; Schubring 1915, p. 317, nos. 412, 413; Panofsky 1937; Florence 1949, no. 6; Paris 1956, no. 110; Raggio 1958, pp. 44–62; Bacci 1966, p. 100, nos. 47, 48; Fermor 1993, pp. 86–88; Moench 1993, pp. 58–61; Forlani Tempesti and Capretti 1996, pp. 138–140, no. 46a–b; Cieri Via 2002, pp. 95–109.

Notes
1 In addition to the pathbreaking studies of Panofsky and Raggio, valuable insights on the recondite iconography of both panels may be found in Cieri Via 2002, pp. 95–109; D. Geronimus, "The Painting Career of Piero di Cosimo (1462–1522)" (Ph.D. diss., Oxford University, 2001), pp. 95–99; R. Steiner, *Prometheus: Ikonologische und anthropologische Aspekte der bildenden Kunst von 14. bis zum 17. Jahrhundert* (Munich, 1991), pp. 103–165; R. Oertel, *Italienische Malerei bis zum Ausgang der Renaissance* (Munich, 1960), p. 52; K. Borinski, "Die Deutung der Piero di Cosimo zugeschriebenen Prometheus-Bilder," *Sitzungsberichte der Bayerischen Akademie der Wissenschaften* (1921), pp. 3–21; Georg Habich, "Über zwei Prometheus-Bilder angeblich von Piero di Cosimo: Ein Deutungsversuch," *Sitzungsberichte der Bayerischen Akademie der Wissenschaften* (1920), pp. 3–18.
2 See Barriault 1994. Piero's Prometheus scenes are addressed, specifically, on pp. 157–158.
3 Berenson 1909b, pp. 163, 166. One year later S. Reinach, in *Répertoire des peintures du moyen âge et de la Renaissance (1280–1580)*, vol. 3 (Paris, 1910), p. 758, identified the Strasbourg scene as either the myth of Prometheus or that of Daedalus.
4 Plato dramatically underscores the variance in intellect and skill between the two Titan brothers in the *Protagoras*, 320d–322a.
5 D. Arasse ("Après Panofsky: Piero di Cosimo, peintre," in *Pour un temps: Erwin Panofsky* [Paris, 1983], pp. 135–150), noting a similarity between Piero's clay athlete and Michelangelo's *David*, advanced on that basis a politicized, anti-Medicean reading of the former. Only a very superficial formal agreement, however, recommends such a link between the two figures.

6 Piero's airborne pair of Prometheus and Athena is paralleled in the splendid Ptolemaic cameo-cup of sardonyx known as the "Tazza Farnese," once in the possession of Alfonso II of Naples, Pope Paul II, and later Lorenzo the Magnificent. This formal echo is noted in T.E.S. Yuen, "The Tazza Farnese as a Source for Botticelli's *Birth of Venus* and Piero di Cosimo's *Myth of Prometheus*," *Gazette des Beaux-Arts* (ser. 6) 74 (1969), pp. 175–178.
7 Most tellingly, Erasmus once referred to stupidity with the term "fungus." Although at times associated with hermits and their virtuous hardships, mushrooms acquired generally unfavourable meanings in the Renaissance, becoming associated with sin, obstinacy, lust, and death; see Levi D'Ancona 1977, pp. 234–236. As regards Piero's crushed figure, Cieri Via (2002, p. 103) has also proposed a connection to the Deucalion and Pyrrha myth and the formation of man, "children of the earth," from their cast stones (Ovid, *Metamorphoses*, I, 398–415). Ultimately, the most convincing reading of the pinned man remains allegorical, the heavy stone suggesting mankind's oppressed, uncultivated beginnings.
8 Alternatively, the mysterious central group may illustrate the Olympian gods' attempts to soften the mind of Jove in his torment of Prometheus (and, by extension, the punishment of mankind, in the form of Pandora). The two standing figures could, therefore, refer to Mars and Venus. Schubring (1915, p. 317, nos. 412, 413) identified the group's members as Pandora, Epimetheus, Hephaestus, Aphrodite, Athena, and Hermes. (The present writer, however, distinguishes only two female figures among the group.) The three pairs of figures have also been interpreted allegorically, as love and the *vita attiva e contemplativa* (Loeser 1896, p. 286) or, along the same lines, as the contemplative, active, and "median" aspects of mankind (Cieri Via 2002, p. 108), or as the three ages of man (L. Ragghianti Collobi, *Catalogo della mostra d'arte antica: Lorenzo il Magnifico e le arti*, exh. cat. [Florence, 1949], no. 6).

Cat. no. 11
MICHELANGELO BUONARROTI (1475–1564)
Male Nude Seen from the Back
c. 1504
Black chalk, heightened with white
18.8 x 26.2 cm
Annotations: in pen and brown ink, *impossible de trouver plus beau*; in black pencil, partly effaced, *Collezione di P.P. Rubens*
Albertina, Vienna (SR 157, R 130, inv. 123v)

Provenance: Peter Paul Rubens; Pierre Jean Mariette (L. 2097); Prince de Ligne; Herzog Albert von Sachsen-Teschen.

References: Birke and Kertész 1992–1997, vol. 1, p. 68ff.; Hirst 1993, pp. 35, 61; Martínez Bielsa 1999, p. 193, no. 121; Joannides 2003, pp. 65, 68, 78ff.; Venice, Vienna, and Bilbao 2004–2005, no. 5.

Notes
1 De Tolnay 1947–1960, vol. 1, fig. 232.
2 Vasari 1996, vol. 2, p. 657.
3 Joannides 2003, nos. 2v, 6r.
4 De Tolnay 1975–1980, vol. 1, no. 51.
5 Thausing 1878, p. 109.

Cat. no. 12
MARCANTONIO RAIMONDI (C. 1470/1482–1527/1534)
Copy after the Cartoon for the Battle of Cascina by Michelangelo (The Climbers)
1510
Engraving
28.4 x 22.8 cm
Inscriptions: *1510*
Bartsch XIV.487
British Museum, London (1895-9-15-135)

Provenance: purchased by the British Museum as part of the John Malcolm collection, 1895.

References: Hind 1913, pp. 252–253; Gould 1966, pp. 3–4; Oberhuber 1978, no. 487; Shoemaker and Broun 1981, p. 7, no. 19; Faietti and Oberhuber 1988, no. 35; Landau and Parshall 1994, pp. 143–144.

Cat. no. 13
BASTIANO DA SANGALLO (1481–1551)
Copy after the Cartoon for the Battle of Cascina by Michelangelo (The Climbers)
c. 1542
Oil on panel
78.7 x 129 cm
The Earl of Leicester and Trustees of the Holkham Estate, Norfolk

Provenance: possibly Francis I; Barberini collection; recorded at Holkham Hall by 1773.

References: Hirst 1988, pp. 42–46; M. Kemp in Washington 1991, no. 167; A. Cecchi in Florence 1996, no. 20.

Notes
1 For the project in general see especially Hirst 1988, pp. 42–46; A. Cecchi in Florence 1996, no. 20.
2 Concerning the date see L. Morozzi, "La 'Battiglia di Cascina' di Michelangelo: Nuova ipotesi sulla data di commissione," *Prospettiva* 57/60 (1988–1989), pp. 320–324. The documentation relating to the whole commission is reviewed in N. Rubinstein, *The Palazzo Vecchio 1298–1532* (Oxford, 1995), pp. 73–75, 114–115. The original location of both frescoes is still a matter of debate.
3 Vasari-Milanesi 1878–1885, vol. 6, p. 294; Vasari 1996, vol. 2, p. 429.
4 On the history of the cartoons see Hirst 1988, pp. 19–20.

Cat. no. 14
GIOVANNI FRANCESCO RUSTICI (1474–1554)
The Conversion of Saint Paul
c. 1525
Oil on panel
111.5 x 194 cm
Victoria and Albert Museum, London (1562-1904)

Provenance: probably acquired in Florence by Lord Carmichael; gift to the museum, 1904.

References: Barocchi 1992, p. 129; Davis 1995, p. 107.

Notes
1 The documentation is reviewed in N. Rubinstein, *The Palazzo Vecchio 1298–1532* (Oxford, 1995), pp. 73–74.
2 Vasari-Milanesi 1878–1885, vol. 5, p. 247; Vasari 1996, vol. 2, p. 520. Concerning Rustici, who lacks a monograph, see C. Avery in Turner 1996/2000, vol. 27, pp. 447–449. For further documentation of his life and work see Waldman 1997b.

3 A. Radcliffe in *Italian Renaissance Sculpture in the Time of Donatello*, exh. cat. (Detroit, 1985), p. 242. The old attributions are reviewed in C.M. Kauffmann, *Catalogue of Foreign Paintings. Victoria and Albert Museum* (London, 1973), pp. 24–25; see, more recently, G. Agosti in Barocchi 1992, p. 129; Davis 1995, pp. 107, 121–122 note 49; Franklin 2001, p. 35.

4 A. Civai, *Dipinti e sculture in casa Martelli: Storia di una collezione patrizia fiorentina dal Quattrocento all'Ottocento* (Florence, 1990), pp. 40–41. It is noted here that Leonardo himself had lived in the Martelli palace in Rome in 1508.

5 Vasari-Milanesi 1878–1885, vol. 6, pp. 147–148; Vasari 1996, vol. 2, p. 274.

Cat. no. 15
FRANCESCO D'UBERTINO VERDI, CALLED BACHIACCA (1494–1557)
The Conversion of Saint Paul
c. 1540
Oil on panel
96.5 x 78.7 cm
Memorial Art Gallery, University of Rochester (54.2)

Provenance: private collection, England; Julius Weitzner, New York; Caesar B. Diorio, New York; acquired by the Memorial Art Gallery of the University of Rochester with the Marion Stratton Gould Fund, 1954.

References: Indianapolis 1954, no. 5; Merritt 1955, pp. 1–2; Merritt 1958, pp. 103–115; University of Kansas 1958, p. 70; Merritt 1961, p. 30; Baltimore 1961, p. 42, no. 17; Marlier 1962, pp. 82–91; Berenson 1963, vol. 1, p. 20; Faison 1964, p. 58; Nikolenko 1966, pp. 23, 60; Fredericksen and Zeri 1972, p. 629; Sutton 1977, p. 26; Colbert 1978, p. 103; Merritt 1988, p. 67; La France 2002, no. 55.

Notes
1 Vasari (1996, vol. 2, pp. 444–445) placed an eleven-sentence biography of Bachiacca within the Life of Bastiano da Sangallo, clearly stating that Bachiacca and Sangallo were friends – although not particularly friendly with Vasari. For more on Vasari's friends and enemies see P. Barocchi, "Palazzo Vecchio: Committenza e collezionismo medicei e la storiografia artistica contemporanea," in *Studi vasariani*, ed. P. Barocchi (Turin, 1984), pp. 120–121; A. Cecchi, "Il maggiordomo ducale Pierfrancesco Riccio e gli artisti della corte medicea," *Mitteilungen des Kunsthistorischen Institutes in Florenz* 42:1 (1998), pp. 115–143; E. Pilliod, "Representation, Misrepresentation, and Non-Representation: Vasari and His Competitors," in Jacks 1998, pp. 30–52.

2 Louvre, Paris (2249). This face is also associated with the *Battle of Anghiari*. See F. Viatte, "Leonardo da Vinci, *Head of an Old Man*," in Bambach 2003, pp. 465–467, no. 76.

3 On the renovations of the ducal palace see Allegri and Cecchi 1980. Bachiacca's major documented contributions to the Medici household include a painted *scrittoio* for the duke, two sets of tapestry cartoons, a painted terrace for the enjoyment of the duchess and her children, and the designs for a set of royal bed-curtains. See La France 2002; La France 2003, pp. 242–243.

4 The verb *abbacchiare* and its common aphaeretic form *bacchiare* are commonly used in this sense in sixteenth-century literature. Accademia della Crusca, *Vocabolario degli Accademici della Crusca con tre indici delle voci, locuzioni, e proverbi Latini e Greci posti per entro l'opera* (Florence, 1974), p. 113, under "Batacchio"; N. Tommaseo and B. Bellini, *Dizionario della lingua italiana*, 3rd ed. (Milan, 1977), vol. 3, p. 432, under "Bacchiare." See the discussion of other possible interpretations of the nickname in La France 2002, p. 109ff.

5 The nickname only appears in documents after 1540 (La France 2002, p. 70ff.). The artist's only signed work, the duchess's terrace of 1552–1553, gives his Christian name and nickname: "FRANC. BACHI. FACI."

Cat. no. 16
MICHELANGELO BUONARROTI (1475–1564)
Three Labours of Hercules
c. 1530
Red chalk
27.2 x 42.2 cm
Inscriptions: *questo e il seco*[n]*do leone ch*[e] *ercole am*[m]*azzo*
Royal Library, Windsor Castle (12770)

Provenance: Royal Collection by c. 1810.

References: Popham and Wilde 1949, no. 423; Dussler 1959, no. 363a; Hartt 1971, no. 360; De Tolnay 1975–1980, vol. 2, no. 335; Joannides 1996, no. 18.

Cat. no. 17
FRA BARTOLOMMEO (1472–1517)
The Temptation of Saint Anthony
c. 1499
Pen and brown ink and brown wash, heightened with white, on yellow tinted paer
23.3 x 16.6 cm
Annotations: in pen and brown ink, *N. dell Frate*
Watermark: six-pointed star in a circle
Royal Library, Windsor Castle (12784)

References: Knapp 1903, p. 315, nos. 6, 7; Von der Gabelentz 1922, vol. 2, pp. 305–306, no. 875; Berenson 1938, vol. 2, p. 46, no. 522; Popham and Wilde 1949, pp. 193–194, no. 115; Fischer 1990a, pp. 315–340; Fischer 1990b, pp. 77–80, 104 note 79, no. 19 (recto), pp. 175, 176 (verso); C. Trepesch in Güse and Perrig 1997, p. 82.

Notes
1 Vasari 1986, pp. 579–586; Vasari-Milanesi 1878–1885, vol. 4, pp. 175–212; Vasari 1996, vol. 1, pp. 670–681; W. Kallab, *Vasaristudien: Herausgegeben aus dessen Nachlasse von J. Schlosser* (Vienna and Leipzig, 1908), p. 277.

2 C. von Holst, "Fra Bartolommeo und Albertinelli: Beobachtungen zu ihrer zusammenarbeit am Jüngsten Gericht aus Santa Maria Nuova und in der Werkstatt von San Marco," *Mitteilungen des Kunsthistorischen Institutes in Florenz* 23 (1974), pp. 274–318; G. Damiani in Padovani 1996, pp. 163–172.

3 Royal Library, Windsor Castle (12788). See Fischer 1990a, p. 321, figs. 5, 6; the painting is reproduced on p. 319, fig. 3.

4 Codex Escurialensis, Escorial, fol. 59 verso; see H. Egger, *Codex Escurialensis* (Vienna, 1906).

5 E. Fahy, "The Beginnings of Fra Bartolommeo," *The Burlington Magazine* 108 (1966), pp. 450–463; E. Fahy, "The Earliest Work of Fra Bartolommeo," *The Art Bulletin* 51 (1969), pp. 142–154; E. Fahy, *Some Followers of Domenico Ghirlandaio* (New York and London, 1976, pp. 450–463); *Pittura a Rimini tra gotico e manierismo*, exh. cat. (Rimini, 1979), pp. 50–52. See also C. Fischer, *Fra Bartolommeo et son atelier: Dessins et peintures des collections françaises*, exh. cat. (Paris, 1994–1995), pp. 1–23.

6 W. Kallab, *Vasaristudien*, p. 277.

7 Vasari 1986, p. 822 (where he mistakes Schongauer for Dürer); Vasari-Milanesi 1878–1885, vol. 7, p. 140; Vasari 1996, vol. 2, p. 646; A. Condivi, *Vita di Michelangelo Buonaroti* (Florence, 1553), pp. 14–15; B. Varchi, *Orazione funerale fatta e recitata da lui pubblicamente nell'essequie di M. Buonarroti in Firenze, in chiesa di S. Lorenzo* (Florence, 1564), p. 13.

8 Vols. M48, N96; see Fischer 1990b, pp. 79–80, no. 19.

9 Galleria degli Uffizi, Florence (1244E); see Fischer 1990a, p. 324.

10 Pierpont Morgan Library, New York (I.28); see Fischer 1990a, p. 326.

11 Kupferstich-Kabinett, Berlin (KdZ 5190); see Fischer 1990a, pp. 330–331.

12 Kupferstich-Kabinett, Dresden (inv. C.1860-96).

13 See note 3 above. The painting was sold at Sotheby's, London, 19 March 1975, lot 95; it was published by L. Borgo, "Fra Bartolommeo's Beginnings – Once More with Berenson," *The Burlington Magazine* 119 (1977), pp. 89–93.

Cat. no. 18
FRA BARTOLOMMEO (1472–1517)
Three Studies for Dominican Friars
c. 1504–1508
Black chalk, heightened with white chalk, on brown prepared paper
26.2 x 27 cm
Szépmüvészeti Múzeum, Budapest (1766)

Provenance: Giorgio Vasari; Pierre Crozat, Paris; Pierre Jean Mariette, Paris (L. 1852); Antonio Cesare Poggi; Nicolaus Esterházy (L. 1965).

References: Von der Gabelentz 1922, vol. 2, p. 28, no. 24; Berenson 1938, vol. 2, p. 24, no. 212; Vayer 1957; Zentai 1998a; Zentai 1998b, pp. 48–49, no. 16.

Notes
1 Kupferstich-Kabinett, Berlin (KdZ 482); Gilhofer & Ranschburg, Lucerne, 28 June 1934, lot 21; private collection. See Zentai 1998a, p. 100, figs. 44–46.

2 W. Hood, *Fra Angelico at San Marco* (New Haven and London, 1993), pp. 199–207.

3 W. Hood, "Fra Angelico at San Marco: Art and Liturgy of Cloistered Life," in *Christianity and the Renaissance: Image and Religious Imagination in the Quattrocento*, ed. T. Verdon and J. Henderson (New York: Syracuse, 1990), pp. 115–117.

4 Fischer 1990b, pp. 144–147.

5 Vol. M 199 recto; see Fischer 1990b, pp. 148–149, no. 38.

6 Vol. M 171 recto; see Zentai 1998a, p. 105.

7 Fischer 1990b, pp. 12–18.

Cat. no. 19
GIOVANNI ANTONIO SOGLIANI (1492–1544)
Young Woman Kneeling
c. 1520
Black and white chalks and pen and black ink
30.6 x 21.5 cm
National Gallery of Canada, Ottawa (41080)

Provenance: unidentified collector's mark "VLV" detectable under ultraviolet light; Hugh Squire; sale, Sotheby's, London, 28 June 1979, lot 53; sale, Christie's, London, 19 April 1988, lot 30; Pierre de Charmont, Geneva; sale, Christie's, Paris, 21 March 2002, lot 6; purchased from Flavia Ormond Fine Arts Ltd., London, 2002.

Notes
1 Vasari 1986, pp. 759–761; Vasari 1996, vol. 1, pp. 880–881. For Sogliani's drawings in particular see the seminal article by R. Bacou, "A Group of Drawings by Sogliani," *Master Drawings* 1 (1963), pp. 41–43.
2 For this school of artists see especially Padovani 1996; *Fra Paolino e la Pittura a Pistoia nel Primo '500*, exh. cat., ed. C. d'Afflitto, F. Falletti, and A. Muzzi (Pistoia, 1996).

Cat. no. 20
MARIOTTO ALBERTINELLI (1474–1515)
The Creation and Fall of Man
c. 1514–1515
Oil on panel
56.2 x 165.3 cm
Courtauld Institute of Art Gallery, Gambier-Parry Collection, London (P.1966.GP.6)

Provenance: Buonacorsi Perini, Florence; purchased in Italy by Irvine; William Buchanan; sale, Christie's, London, 12 May 1804, lot 6 (as Raphael); possibly Duke of Lucca sale, Phillips, London, 5 June 1841, lot 49; William Coningham sale, Christie's, London, 9 June 1849, lot 44 (as Albertinelli); acquired in 1849 by Gambier-Parry through P. and D. Colnaghi, London.

References: Shearman 1967, no. 23; Borgo 1976, no. 28.

Notes
1 I am following the interpretation of J. Shearman, *Provisional Catalogue: Gambier-Parry Collection* (London, 1967), pp. 8–10. See also Borgo 1976, I.28a, where the work is dated slightly too early. Borgo discusses a third painting by Albertinelli, a *Cain and Abel* now in the Accademia Carrara in Bergamo, as another component in this decorative scheme (pp. 165–166), although Shearman has rejected this possibility.
2 Vasari 1986, p. 589; Vasari 1996, vol. 1, p. 684. While the Courtauld and Strossmayer panels, taken together, undoubtedly constitute one of these three works, the other two have yet to be securely identified.
3 Bober and Rubinstein 1986, p. 184, no. 149. L. Freedman ("Falling Gaul as Used by Cinquecento Painters in Rome and Venice," *Acta Historiae Artium* 39 [1997], p. 122) doubted the connection between the sculpture and Albertinelli's painting, claiming Albertinelli's source was Michelangelo's *Adam* from the *Creation* on the Sistine Chapel ceiling, though this seems unconvincing.
4 See A. Cecchi in Florence 1986, pp. 126–128.
5 For this project see Barriault 1994, no. 19.

Cat. no. 21
RIDOLFO GHIRLANDAIO (1483–1561)
Portrait of a Man
c. 1503–1510
Tempera (?) and oil on panel, transferred to canvas
68.2 x 49.2 cm
The Art Institute of Chicago, Mr. and Mrs. Martin A. Ryerson Collection (1933.1009)

Provenance: Prince Brancaccio, Rome; William Beattie, Glasgow, by 1901; Arthur T. Sulley, London, by 1910; Scott and Fowles, New York; acquired by Martin A. Ryerson, 1912; bequeathed in 1933.

References: Lloyd 1993, pp. 103–106; Franklin 2001, pp. 108–110.

Notes
1 See Franklin 2001, chapter 6.
2 For a full account of its condition and past treatments see Lloyd 1993, p. 106.
3 First pointed out by Linda Klinger in Lloyd 1993, pp. 104–106. According to Cecchi (1994, p. 18), the image was rendered for the anonymous engraver by no less an artist than Francesco Salviati.
4 See A. Gherardi, "Priormi e Gonfaloniere," in *Miscellanea Fiorentina* (Florence, 1902), vol. 1, p. 44.
5 C. Gamba, "Ridolfo e Michele di Ridolfo del Ghirlandaio," *Dedalo* 9 (1928–1929), p. 465.

Cat. no. 22
RIDOLFO GHIRLANDAIO (1483–1561)
Portrait of a Man (The Goldsmith)
c. 1515
Tempera and oil on panel
44 x 32 cm
Galleria Palatina, Palazzo Pitti, Florence (1912:207)

Provenance: Paolo del Sera, Venice, 1668; Cardinal Leopoldo de' Medici, 1675; Tribuna degli Uffizi, 1704; Palazzo Pitti, from 1716.

References: Inghirami 1828, p. 44; Inghirami 1834, p. 40; Bardi 1839, vol. 2; Chiavacci 1859, p. 102; Lermolieff 1880, pp. 383–384; Giglioli 1910; Venturi 1924; Suida 1929, pp. 151–152 (2001 edition, p. 203 note 54); Rudolph and Biancalani 1970, p. 36; Costamagna and Fabre 1985, pp. 31–33; Fileti Mazza 1987, pp. 212–213; S. Padovani in Chiarini and Padovani 2003, vol. 2, p. 332.

Notes
1 Giglioli 1910, pp. 168–170; Fileti Mazza 1987, pp. 212–213.
2 Rudolph and Biancalani 1970, p. 36.
3 Biblioteca Riccardiana, Florence, Ms. 4211, c. 9v.
4 Inghirami 1828, p. 44; Inghirami 1834, p. 40; Bardi 1839, vol. 2; Chiavacci 1859, p. 102.
5 Lermolieff 1880, pp. 383–386.
6 Venturi 1924, pp. 197–199; Suida 1929, pp. 151–152.
7 Costamagna and Fabre 1985.
8 See Franklin 2001, pp. 103–125.
9 S. Padovani in Chiarini and Padovani 2003, p. 332.

Cat. no. 23
RIDOLFO GHIRLANDAIO (1483–1561)
The Nativity, with Saints (portable tabernacle)
c. 1509–1515
Tempera (?) and oil with gold on panel
35.6 x 22.9 cm (central panel), 31 x 10 cm (left wing), 31 x 9.9 cm (right wing)
The Metropolitan Museum of Art, New York, The Michael Friedsam Collection, Bequest of Michael Friedsam, 1931 (32.100.80)

Provenance: Genolini, Milan; Cristoforo Benigno Crespi, Milan (as Albertinelli); his sale, Galerie Georges Petit, Paris, 4 June 1914, no. 24 (as Ridolfo Ghirlandaio); Thomas Agnew & Sons, London, 1914; Oswald Sirén, Stockholm, 1914; F. Kleinberger & Co., New York, 1914–1916; Michael Friedsam, New York, 1916–1931.

References: Berenson 1909b, p. 139; Freedberg 1961, p. 210; Zeri 1971, pp. 191–193; McTavish et al. *Annunciation*.

Notes
1 Zeri 1971, pp. 192–193.
2 Concerning yet another version see Vasari-Milanesi 1878–1885, vol. 6, p. 536; Vasari 1996, vol. 2, p. 479.
3 Berenson as cited in Zeri 1971, p. 193; Freedberg 1961, p. 210.
4 See Franklin 1993, pp. 4–5.
5 Vasari-Milanesi 1878–1885, vol. 2, pp. 416–417, vol. 5, pp. 176–177; Vasari 1996, vol. 1, pp. 670–671; E. Fahy in Padovani 1996, pp. 66–69.
6 P. Zambrano and J.K. Nelson, *Filippino Lippi* (Milan: Electa, 2004), no. 57.
7 Horne 1915; Gamba 1936, p. 165; J.K. Nelson in Milan and Florence 2004, pp. 282–284.
8 Borgo 1976, pp. 41–46, 204–206.

Cat. no. 24
RIDOLFO GHIRLANDAIO (1483–1561)
The Annunciation
c. 1509–1515
Tempera (?) and oil with gold on panel
31.1 x 10 cm each
Agnes Etherington Art Centre, Queen's University, Kingston, Purchased with the assistance of the Government of Canada through the Cultural Property Export and Import Act, 1984 (27-032)

Provenance: private collection, England; A. Roy Thomas, Ottawa.

References: McTavish et al. *Annunciation*.

Notes
1 McTavish et al. *Annunciation*.
2 Berenson 1909b, p. 139.
3 Vasari-Milanesi 1878–1885, vol. 6, p. 534; Vasari 1996, vol. 2, p. 478.
4 Vasari-Milanesi 1878–1885, vol. 4, p. 224; Vasari 1996, vol. 1, pp. 684–685.
5 Franklin 1993, pp. 11–12.
6 Franklin 2001, pp. 105, 112–113.
7 Smith 1959.

Cat. no. 25
MASTER OF SERUMIDO (ACTIVE C. 1505–1540)
The Annunciation
c. 1505–1510
Tempera (?) and oil on panel
50.5 x 65.5 cm
National Gallery of Canada, Ottawa (14708)

Provenance: with Annesley Gore, London, 1929 (as Albertinelli); Frederick J. Perry, Montreal, 1929; bequeathed by Mrs. Jeanne Taschereau Perry, Montreal, 1965.

References: Laskin and Pantazzi 1987, pp. 184–185.

Notes
1 Laskin and Pantazzi 1987, p. 185.
2 It was not even considered among the "Rejected Attributions" in the monograph by Borgo (1976).
3 F. Zeri, "Eccentrici fiorentini," *Bollettino d'Arte* 47:2 (1962), pp. 318–326.
4 "Filologia e Ghiribizzi: Pittori eccentrici, piste impraticate," in *La Piscina di Betsaida* (Florence and Siena, 1995), pp. 139–182.
5 "The Rank and File of Renaissance Painting: Giovanni Larciani and the 'Florentine Eccentrics,'" in *Italian Renaissance Masters*, exh. cat. (Milwaukee, 2001), pp. 30–33.
6 L. Aquino, "La camera di Lodovico de Nobili, opera di Francesco del Tasso, e qualche precisazione sulla cornice del Tondo Doni," *Paragone*, 59:659 (2005), pp. 86–111.
7 S. Padovani, "I ritratti Doni: Raffaello e il suo misterioso collaboratore, il 'Maestro di Serumido,'" forthcoming in *Paragone* 61:663 (2005).
8 Laskin and Pantazzi 1987.

Cat. no. 26
GIROLAMO DELLA ROBBIA (1488–1566)
The Virgin and Child with Saint John the Baptist, after Raphael
c. 1510–1515
Glazed terracotta
130 x 70 cm
Biblioteca Nazionale Centrale, Florence

Provenance: Vieri Giugni Canigiani, Florence; Jenny Finaly, 1922; Horace Finaly; bequeathed to the City of Florence, 1945; Biblioteca Nazionale by 1947.

References: Marquand 1919, pp. 169–170; Mondolfo 1948, p. 272; Gentilini 1992, vol. 2, p. 336; A. Bellandi in Gentilini 1998, pp. 296–297.

Notes
1 G. Lazzi and M. Rolih Scarlino, *I manoscritti Landau Finaly della Biblioteca Nazionale Centrale di Firenze*, vol. 1 (Milan, 1994), pp. xviii–xix.
2 *Atto di consegna degli oggetti della raccolta Landau Finaly*, B.N.F., file 41, p. 42.
3 Levi D'Ancona 1977, p. 193.
4 See Vasari 1996, vol. 1, pp. 279–280.
5 Both quotations are from Vasari-Milanesi 1878–1885, vol. 2, p. 183.

Cat. no. 27
GIULIANO BUGIARDINI (1475–1554)
The Birth of Saint John the Baptist
c. 1515
Oil on panel
113 x 118 cm
Galleria Estense, Modena (223)

Provenance: Cardinal Alessandro d'Este, Rome, 1624; entered the Galleria Estense collection between 1814 and 1821.

References: Sricchia Santoro 1963, p. 22 note 26; Pagnotta 1987, pp. 50, 200, 206, 207 (with bibliography); C. Cremonini in Modena 1998, pp. 264–266 (with bibliography); Cremonini 1998, p. 123.

Notes
1 Pagnotta 1987, pp. 18–19, 46–47, 50, 200, 206.
2 See O. Sirén, "Alcuni quadri sconosciuti di Giuliano Bugiardini," *Dedalo* 6 (1925/1926), p. 778.
3 Pagnotta 1987, p. 200.
4 Berenson 1909b, p. 134; Venturi 1925, p. 452. A detailed account of the collections to which this work belonged has recently been compiled. See C. Cremonini in Modena 1998, pp. 264–266. Cremonini (1998) also gives a new transcription of the inventory of Cardinal Alessandro d'Este's collection (previously published by Giuseppe Campori in 1870), which included the Modena panel.
5 See Sricchia Santoro 1963, p. 22 note 26.

Cat. no. 28
GIULIANO BUGIARDINI (1475–1554)
Saint Sebastian
c. 1518
Oil on canvas
166 x 106.6 cm
New Orleans Museum of Art, Gift of the Samuel H. Kress Collection (61.89)

Provenance: Grand-Duc d'Oldenburg; sale, Muller's, Amsterdam, 25 June 1924, lot 114; Contini Bonacossi, Florence; S.H. Kress, New York, by 1939; gift to the museum, 1961.

References: Pagnotta 1987, no. 36.

Notes
1 Vasari-Milanesi 1878–1885, vol. 6, pp. 201–211; Vasari 1996, vol. 2, pp. 309–315.
2 J. Cox-Rearick, "Fra Bartolomeo's Saint Mark Evangelist and Saint Sebastian with an Angel," *Mitteilungen des Kunsthistorischen Institutes in Florenz* 18 (1974), pp. 329–354.
3 Cox-Rearick 1974, pp. 168–171.
4 Vasari 1986, p. 553; Vasari-Milanesi 1878–1885, vol. 4, pp. 188–189.

Cat. no. 29
ANDREA DELLA ROBBIA (1435–1525)
Saint Sebastian
c. 1500–1510
Glazed terracotta
130 cm high
Museo Civico e Diocesano d'Arte Sacra, Montalcino

Provenance: formerly church of San Francesco, Montalcino.

References: Marquand 1922, vol. 2, p. 133; Carli 1972, p. 30; Gentilini 1992, vol. 1, p. 263; F. Petrucci in Florence 1996, p. 100; A. Sigillo in Gentilini 1998, pp. 221–222.

Notes
1 J. Darriulat, *Sébastien, le renaissant: Sur le martyre de saint Sébastien dans la deuxième moitié du Quattrocento* (Paris, 1998), pp. 151–152.
2 Levi D'Ancona 1977, p. 173.
3 Vasari 1996, vol. 1, p. 279.

Cat. no. 30
ANDREA DEL SARTO (1486–1530)
The Angel of the Annunciation
c. 1513
Red chalk over black chalk
34.5 x 29.3 cm
Annotations: in black chalk, 33; *Andrea del Sarto*
Watermark: similar to Briquet 5641
Galleria degli Uffizi, Florence (273F)

Provenance: Medici collections; first catalogued in 1849.

References: Shearman 1965, vol. 2, p. 328; Florence 1986, no. 9; Petrioli Tofani 1991, p. 122.

Notes
1 For Sarto's painting see Florence 1996, no. 48. For the dating see Franklin 1994, pp. 5–6.
2 See A. Cecchi in Florence 1986, pp. 43–44.
3 Vasari-Milanesi 1878–1885, vol. 6, p. 247; Vasari 1996, vol. 1, p. 83.
4 Natali and Cecchi 1989, p. 42.
5 J.K. Lydecker, "The Patron, Date, and Original Location of Andrea del Sarto's Tobias Altar-piece," *The Burlington Magazine* 127 (1985), pp. 349–355.
6 The drawing in Rotterdam was originally catalogued under Sarto, but it has been attributed to Pontormo by the present writer.

Cat. no. 31
ANDREA DEL SARTO (1486–1530)
Two Studies of a Man Carrying a Load (recto)
Study of a Dirk (verso)
c. 1520
Red chalk
23.7 x 14.7 cm
Ashmolean Museum, Oxford (WA1949.303)

Provenance: Lionel Lucas (L.II 1733a); sale, Christie's, London, 9 December 1949, part of lot 98; purchased by the Ashmolean Museum, 1949.

References: Parker 1956, no. 693; Berenson 1961, p. 413, no. 1764B** (as Naldini, after Sarto); Freedberg 1963, vol. 2, pp. 102–103; Shearman 1965, vol. 2, p. 367, vol. 1, p. 87; Macandrew 1980, p. 285; A. Forlani Tempesti in Florence 1980a, no. 34; Monti 1965, p. 162; Monti 1981, p. 154; Kliemann 1986, no. 2.

Notes
1 See Paris 1986, no. 28.
2 See the discussion by A. Petrioli Tofani in *Sixteenth-Century Tuscan Drawings from the Uffizi*, exh. cat. (New York, 1988), no. 5.
3 Joannides 2003, no. 13, excluding any connection with the putto in the Giardino Cesi and suggesting a link with the tomb of Julius II, c. 1505–1506.

Cat. no. 32
ANDREA DEL SARTO (1486–1530)
Study of a Kneeling Figure and Sketch of a
Face (recto)
Study of a Standing Figure and Two Faces
(verso)
c. 1522–1523
Red and black chalks (recto), red chalk (verso)
27.2 x 19.8 cm
Annotations: on recto, in black chalk, *39'* (cancelling *95* in
red chalk)
The J. Paul Getty Museum, Los Angeles (84.GB.7)

Provenance: art market, Lausanne; purchased by the
J. Paul Getty Museum, 1984.

References: Shearman 1959, p. 129; Shearman 1965,
vol. 2, p. 386; Goldner 1988, no. 1.

Notes
1 For the authoritative stylistic dating of the
painting and a full discussion of the drawings see
J. Shearman, "Andrea del Sarto's Two Paintings
of the Assumption," *The Burlington Magazine* 101
(1959), p. 129.
2 For the history of the painting see L.A.
Waldman, "A Document for Andrea del Sarto's
'Panciatichi Assumption,'" *The Burlington*
Magazine 139 (1997), pp. 469–470.

Cat. no. 33
ANDREA DEL SARTO (1486–1530)
Five Studies for a Lunette with the Virgin and
Child (The Madonna del Sacco)
c. 1525
Red chalk
28.9 x 26.2 cm
British Museum, London (1912-12-14-2)

Provenance: G.W. Reid; J.P. Heseltine (L. 1507).

References: Shearman 1965, vol. 2, p. 363; Turner 1986,
no. 55.

Notes
1 On the painting see Shearman 1965, vol. 2,
pp. 264–265.
2 See Franklin 2001, p. 130.
3 P. Rubin, "London: Drawings at Buckingham
Palace and the British Museum," *The Burlington*
Magazine 127 (1986), p. 524.

Cat. no. 34
ANDREA DEL SARTO (1486–1530)
Study for a Portrait of a Young Woman
c. 1525
Red chalk over traces of black chalk on partly red prepared
paper
27.4 x 20.6 cm
Annotations: *big[i]o; naso ango; verde;* on verso, *bigio;*
cholor bigiastre [?]; *verde* [?]; [...]*acho / dibianch*[...]
École Nationale Supérieure des Beaux-Arts, Paris (289)

Provenance: Pierre Jean Mariette; J. Dupan, Geneva;
bequeathed by Alfred Armand and Prosper Valton, 1908.

References: D. Cordellier in Paris 1986, pp. 71–72 (with
bibliography).

Notes
1 See C. Caneva in Florence 1986, pp. 157–158
(with bibliography).
2 Only Shearman (1965, vol. 2, pp. 367–368)
disassociates the present drawing from the other
sheets, contending that the artist would not have
worked the physical features of a familiar model
on the sheet. Nonetheless, this is clearly the *naso*
ango (angular nose) that differentiates the model
for these drawings from Lucrezia del Fede and
Maria de Berrettaio.
3 See D. Cordellier in Paris 1986, pp. 80–81;
A. Petrioli Tofani in Florence 1986, pp. 280, 307–309.
4 Vasari-Milanesi 1878–1885, vol. 5, p. 38.
5 Freedberg (1963, vol. 2, pp. 125 note 7, 128),
who saw Maria del Berrettaio's features in the
Uffizi portrait and in the Saint Catherine of the
Luco *Pietà*, believed that the Mary Magdalen of
the altarpiece represented Maria del Fede.
6 The poems visible in the book are sonnets 153
and 154, which means that the young woman is
pointing to sonnet 152; see Natali 1998, p. 77.
7 Shearman (1965, vol. 2, p. 394) reproduces a
document dated 19 April 1518, concerning commit-
ments made by Sarto in regard to his wife's
younger sister, including the obligation to finance
her stay at a convent until her marriage.

Cat. no. 35
ANDREA DEL SARTO (1486–1530)
Two Studies of a Man Suspended by
His Left Leg
c. 1530
Red chalk
20.6 x 19.2 cm
Devonshire Collection, Chatsworth (710)

Provenance: N.A. Flinck (L. 959); William Cavendish,
2nd Duke of Devonshire (L. 718).

References: Shearman 1965, vol. 1, pp. 161–162, vol. 2,
pp. 320–321; Edgerton 1985, pp. 114–119; Jaffé 1994,
no. 71.

Notes
1 The best early account, from the mid-sixteenth
century, is by Benedetto Varchi (*Storia Fiorentina*,
ed. L. Arbib [Florence, 1838–1841], vol. 2, pp. 315–316),
who names the captains as Cecco Orsino, Jacopo
Antonio Orsino, and Giovanni da Sessa, and the
three citizen-traitors as Alessandro Corsini, Taddeo
Guiducci, and Pier Francesco Ridolfi. See also
Shearman 1965 for a full discussion of the sources.
2 Edgerton 1985, p. 76.
3 Vasari-Milanesi 1878–1885, vol. 5, p. 54 note 1;
Vasari 1996, vol. 1, p. 852.
4 B. Varchi, *Storia Fiorentina*, vol. 2, pp. 315–316.

Cat. no. 36
ANDREA DEL SARTO (1486–1530)
The Virgin and Child
c. 1510–1512
Tempera (?) and oil on panel
82.5 x 65.4 cm
Museum of Fine Arts, Boston, Bequest of William A.
Coolidge (1993.43)

Provenance: possibly Joseph Strutt, Derby, by 1827;
by descent to Lord Belper; sold to Thomas Agnew & Sons,
London, 1960; acquired from Thomas Agnew & Sons
by William A. Coolidge, 19 July 1971; bequeathed to the
museum, 1993.

References: E. Zafran in Sutton 1995, no. 4, p. 36.

Notes
1 According to E. Zafran in Sutton 1995, p. 38
note 1. I thank Ronni Baer for the additional
information related to provenance.
2 J.K. Lydecker, "The Patron, Date, and Original
Location of Andrea del Sarto's Tobias Altar-piece,"
The Burlington Magazine 127 (1985), pp. 349–355.
3 Vasari-Milanesi 1878–1885, vol. 5, pp. 9, 14;
Vasari 1996, vol. 1, pp. 825, 829.
4 Franklin 2001, p. 159.

Cat. no. 37
ANDREA DEL SARTO (1486–1530)
The Virgin and Child
c. 1515–1517
Tempera and oil on panel
85.6 x 62.5 cm
National Gallery of Canada, Ottawa (4352)

Provenance: Robert Lawley, 6th Baronet and 1st Baron
Wenlock, Escrick, Yorkshire, and Florence, from before
1834; by descent to Barons Wenlock, Escrick, Yorkshire,
from before 1853 to 1932; by descent to the Hon. Mrs.
Eustace Vesey, sister of the 6th Baron Wenlock; by
descent to her granddaughter Mrs. Margaret Peyton-Jones,
Wendover, Buckinghamshire; purchased 1938.

References: Freedberg 1963, vol. 2, pp. 229–230; Monti
1981, pp. 117–118; Shearman 1965, vol. 2, pp. 289–290
(studio) 385–386; Natali and Cecchi 1989, no. 27, repr.
p. 67 (under Andrea); Natali 1998, pp. 100–101; London
2001a, pp. 19–20; London 2001b, pp. 15,17–21, 24;
Canberra 2002, under no. 5; Spear 2002, p. 28.

Notes
1 Three of these are cancelled. The fourth one
includes an Italian ducal crown above what may be
an escutcheon containing indecipherable symbols
with a cross of Malta or Santo Stefano appended
at the bottom. The fifth seal, in black wax, is
attached to the top end of the panel and shows a
lion, griffin, or bull *passant regardant* surmounted
by a closed crown. Neither of these two seals
relates to any for families catalogued in the Bargello,
nor to the *stemme* reproduced in Ginori Lisci 1972,
vol. 2, pp. 835–845. The sixth seal, which shows
intertwined *W*s, likely refers to the Wenlock family,
in whose possession the picture was recorded
from 1853 to 1932.
2 See Laskin and Pantazzi 1987, p. 4.
3 *The Complete Peerage* (1959), vol. 12, part 2,
pp. 485–487. Before his death near Florence in 1834,
Robert Lawley had acquired from the Capponi a
number of paintings by Salvator Rosa and Carlo
Dolci, inherited from the Rossi collection.
4 Alessandro Cecchi examined the work in the
National Gallery of Canada's conservation labora-
tory in 1987, deemed it an autograph painting by
the artist, and later published it as such (Natali
and Cecchi 1989, no. 27). It was subsequently seen
by John Shearman, who also accepted it as an
autograph work.
5 Today it is generally thought to be the picture
Vasari (1967, vol. 4, p. 299; 1996, vol. 1, p. 831) men-
tions as having been painted for Giovanni Gaddi.
There the Virgin's robe is already a cool plum
colour, but her mantle and head scarf are blue, and
a transparent veil covers her bodice, which opens
in a V-shape to reveal a yellow underblouse, then is
fastened with a button. The Virgin is placed asym-
metrically at the left of the composition and sil-
houetted against a sheer rock face, which contributes
to an overall impression of more sober colouring.

6 The drawing was published simultaneously by Shearman and Monti in their respective catalogues raisonnés.
7 Galleria degli Uffizi, Florence (1890.N.1577). For a good reproduction of this detail see Natali 1998, plate 57. Dr. Natali has kindly indicated that this figure measures 60 centimetres from the toes to the tip of the nose, whereas in the Ottawa example the measurement is 55.5 centimetres.
8 Stephen Gritt, chief of the National Gallery of Canada's conservation laboratory, has generously shared with me his experience of cleaning Andrea del Sarto's Botti *Madonna*. It became clear that one or more cartoons were employed in the transfer of the design from the underdrawing of the version in the Royal Collection to this picture and to the replica at Alnwick. See the discussions by both Shearman and Gritt in London 2001b, pp. 15–21 and 25–41 respectively. Earlier, Shearman (1965, vol. 2, p. 258) cited fragments of the artist's only known surviving cartoon, reproducing two of them (vol. 1, plates 122c, 123c). David Franklin points out that the one for the head of Saint Joseph is now in the Norman MacKenzie Art Gallery, Regina (PC-ROW 6-4 35-3).
9 See also the section on this question in Florence 1986, pp. 330–357, and note 11 below.
10 See, for example, the underdrawing for Andrea del Sarto's Passerini *Assumption of the Virgin* in the Palazzo Pitti (Florence 1986, p. 336).
11 London 2001a, plate 3; B.L. Brown in Canberra 2002, no. 5.
12 There the colours revert to the traditional red and blue for the Virgin's dress and mantle, her head is less inclined than in the Ottawa painting, and the Christ child's left hand does not project beyond his own right arm. In London 2001a, p. 30 note 35, Shearman is quoted as saying, "I would restrict Andrea's personal intervention on this version to the cartoon, its transfer, and supplementary drawing – all of it – and at the level of painting in the Christ child" (the present writer's own opinion, incidentally, quoted on p. 23, was meant to be restricted to the underdrawing). In a note in his essay in London 2001b, Shearman elaborates further: "Very possibly the pictures were painted side by side, with the master contributing more to the drawing of one, and for that reason, perhaps, more to the painting of the other" (p. 20). Although he implies that the cartoon for the Ottawa painting came first, the contrary seems to be the case.

Cat. no. 38
ANDREA DEL SARTO (1486–1530)
Portrait of a Man
c. 1517–1520
Oil on canvas
72 x 57 cm
Inscriptions: signed with the artist's monogram
National Gallery, London (690)

Provenance: Palazzo Puccini, Pistoia, by 1821; purchased from the Puccini estate by Eastlake for the National Gallery, 1862.

References: Freedberg 1963, vol. 2, pp. 79–80, no. 39; Shearman 1965, vol. 2, pp. 237–238, no. 47; Natali and Cecchi 1989, p. 78, no. 33.

Notes
1 For the tentative identification of the sitter as Giovanni Battista Puccini, and a thorough review of earlier opinions, see Shearman 1965.
2 Natali and Cecchi 1989, p. 78.

Cat. no. 39
ANDREA DEL SARTO (1486–1530)
Portrait of Becuccio Bicchieraio
c. 1528
Oil on panel
86 x 67 cm
National Gallery of Scotland, Edinburgh (2297)

Provenance: Ricci Collection, Florence; Galleria Dini, Piazza di San Gaetano, Florence, by 1829; purchased in Florence as from the Ricci collection by the Rev. John Sanford, c. 1832; by descent to his daughter Anna, later married to Frederick, 2nd Lord Methuen, Corsham Court; Methuen sale, Christie's, 13 May 1899, lot 88, purchased by Waring; Vernon Watney collection, Cornbury Park, by 1915; by descent to Oliver Watney; Cornbury Park sale, Christie's, 23 June 1967, lot 38, purchased by the National Gallery of Scotland.

References: Freedberg 1963, vol. 2, p. 221; Shearman 1965, vol. 2, pp. 282–283; Brigstocke 1978, pp. 127–129; Conti 1983–1984; Florence 1986, p. 55; A. Cecchi in Natali and Cecchi 1989, p. 123; Natali 1998, p. 171.

Notes
1 Vasari 1966–1987, vol. 4, p. 350; Vasari 1996, vol. 1, p. 828.
2 Conti 1983–1984.
3 Vasari 1966–1987, vol. 4, p. 377; Vasari 1996, vol. 1, p. 843.
4 See Freedberg 1963, vol. 2, p. 221; Brigstocke 1978, pp. 127–129 (with bibliography).
5 This was further expanded in Florence 1986, p. 55 note 14.
6 Vasari 1966–1987, vol. 5, p. 316; Vasari 1996, vol. 2, p. 350.

Cat. no. 40
ANDREA DEL SARTO (1486–1530)
The Sacrifice of Isaac
c. 1528–1529
Oil on panel
178.2 x 138.1 cm
The Cleveland Museum of Art, Delia E. Holden and L.E. Holden Funds (37.577)

Provenance: possibly Cardinal Carlo de' Medici, Florence, 1649; Montalvi, Florence; Peruzzi, Florence; Zondadari, Florence; William Cave, Bentry House, until 1854; Peters; George Cornwall-Legh, Chester; Thomas Harris, London; Durlacher Brothers, New York; Holden Collection, Cleveland.

References: Freedberg 1963, vol. 2, no. 66, pp. 146–151; Shearman 1965, vol. 2, pp. 269–270.

Cat. no. 41
ANDREA DEL SARTO (1486–1530)
The Sacrifice of Isaac
c. 1529
Oil on panel
98 x 69 cm
Museo Nacional del Prado, Madrid (336)

Provenance: Escorial, collection of Charles IV (recorded there in an 1814 inventory).

References: Freedberg 1963, vol. 2, no. 66, pp. 146–151; Shearman 1965, vol. 2, pp. 281–282.

Notes
1 On the Dresden version see Freedberg 1963, vol. 2, no. 66, pp. 147–148; Shearman 1965, vol. 2, pp. 280–281.
2 A. Cecchi in Florence 1986, pp. 53–54; see also Elam 1993, pp. 62–63.
3 J.L. De Jong, "Three Italian Sacrifices: Lorenzo Ghiberti, Andrea del Sarto, Michelangelo Merisi da Caravaggio," in *The Sacrifice of Isaac*, ed. E. Noort and E. Tigchelaar (Leiden, 2002), pp. 158–161.
4 Though according to Cecchi (Natali and Cecchi 1989, p. 130), Shearman's theory (1965, p. 269) that the Medici owned the Cleveland version is not unquestionable.
5 Vasari 1986, p. 724; Vasari 1996, vol. 1, p. 851.
6 Foschi's copy is reproduced in *The Cleveland Museum of Art Catalogue of Paintings: European Paintings of the 16th, 17th, and 18th Centuries*, vol. 3 (Cleveland, 1982), p. 408.

Cat. no. 42
ANONYMOUS
Beato Filippo Benizzi Healing a Beggar, after Andrea del Sarto
c. 1510
Engraving
33.1 x 22.5 cm
National Gallery of Art, Washington, Rosenwald Collection (1964.8.37)

Provenance: Friedrich Quiring (L. supp. 1041c); Lessing J. Rosenwald.

References: Hind 1938–1948, vol. 1, p. 218; Levenson et al. 1973, no. 189; Landau and Parshall 1994, p. 163.

Notes
1 Shearman 1965, vol. 1, p. 15, vol. 2, p. 200.
2 Ibid., p. 200.
3 It could also relate to the cultic significance of this story at Santissima Annunziata. A seventeenth-century writer, Vincenzo Giustiniani, informs us that "a very ancient panel painting" of this same story was then visible in the chapel dedicated to Filippo Benizzi in the church itself (Shearman 1965, vol. 2, p. 200).
4 See, for example, Hind 1938–1948, vol. 2, plates 8–14, 44, 50, 62, 64, 65; vol. 4, plate 439.
5 Hind (1938–1948, vol. 1, p. 218) believed he could see certain stylistic similarities between this print and engravings by Veneziano, including the *Pietà with Angels* after Sarto. However, the marked difference in quality between this print and Veneziano's securely attributable works casts doubt on Hind's hypothesis.
6 Shearman 1965, vol. 1, pp. 24–25.

Cat. no. 43
AGOSTINO VENEZIANO (C. 1490–AFTER 1536)
Pietà with Angels, after Andrea del Sarto
1516
Engraving
28.7 x 21.9 cm
Inscriptions: *1516 / AV*
Bartsch XIV.40
The Metropolitan Museum of Art, New York, Whittelsey Fund, 1949 (49.97.13)

Provenance: purchased from the Albertina, 1948.

References: Freedberg 1963, vol. 1, pp. 33–34; Shearman 1965, vol. 2, pp. 229–230; Shearman 1966, pp. 152–153; Oberhuber 1978, vol. 26, p. 58; Minonzio 1980, p. 275; A. Cecchi in Florence 1986, pp. 50–51; Massari and Prosperi Valenti Rodinò 1989, p. 39; Landau and Parshall 1994, p. 120; Natali 1998, pp. 100, 157, 201; Franklin 2001, p. 128.

Notes
1 Vasari-Milanesi 1878–1885, vol. 5, p. 23.
2 Ibid., p. 420.
3 Ibid., p. 23.
4 Shearman 1965, vol. 2, pp. 229–230; Nagel 2000, p. 263 note 28.
5 Verdon 2003, p. 132.

Cat. no. 44
JACOPO SANSOVINO (1486–1570)
Saint Paul
c. 1506–1508 or 1511–1513
Terracotta
59 cm high
Musée Jacquemart-André, Paris (1890:872)

Provenance: acquired by Edouard André from the Florentine dealer Pestelli, 1886 (as Baccio da Montelupo).

References: Weihrauch 1935, pp. 18–20; Middeldorf 1936; Mariacher 1962, pp. 18, 21; Garrard 1970, pp. 250–258; Jacquemart-André 1975, no. 136; Boucher 1991, vol. 2, pp. 319–320, no. 9; Myssok 1999, pp. 202–209, 351–352, no. 10; Boston 2003–2004, nos. 11,11a.

Notes
1 Despite these similarities, the recent proposal (Myssok 1999) that the Paris model was produced as a study for the *Saint James* is difficult to accept, given the differences in the draperies and, above all, in the heads of the two figures.
2 A. Schiavo, "La Badia di San Michele Arcangelo a Passignano in Val di Pesa," *Benedettina* 8 (1954), pp. 257–287; 9 (1955), pp. 31–92.
3 T. Mozatti in Boston 2003–2004, nos. 11, 11a.

Cat. no. 45
FRANCIABIGIO (1484–1525)
Male Nude
c. 1516
Red chalk over black chalk
38.8 x 14.6 cm
Galleria degli Uffizi, Florence (312F)

Provenance: first recorded in the Uffizi in 1849.

References: McKillop 1974, p. 175; E. Capretti in Florence 1996, no. 51a.

Notes
1 On the painting see E. Capretti in Florence 1996, no. 51.
2 F. di Pietro, *I disegni d'Andrea del Sarto negli Uffizi* (Siena, 1910), pp. 10–11.
3 D. Franklin, review of Florence 1996, *The Burlington Magazine* 139 (1997), p. 140.
4 Vasari 1986, p. 787; Vasari-Milanesi 1878–1885, vol. 5, p. 190; Vasari 1996, vol. 1, p. 919.

Cat. no. 46
FRANCIABIGIO (1484–1525)
The Calumny of Apelles
c. 1513–1515
Oil on panel
37 x 48 cm
Inscriptions: signed with the artist's monogram; *CLAUDITE QUI REGITIS POPULOS HIS VOCIBUS AURES / SIC MANIBUS LAPSUS NOSTRIS PINXIT APELLES*
Galleria Palatina, Palazzo Pitti, Florence (1912:427)

Provenance: Medici collections by 1588; Galleria degli Uffizi; Grand Duke Ferdinando, Poggio a Caiano, 1710–1713; Galleria Palatina by 1828.

References: McKillop 1974, pp. 42–44, 135–137 (with bibliography); A. Conti in Florence 1980b, pp. 258–259, no. 482; Faedo 1985, p. 18; Massing 1990, pp. 286–289 (with bibliography); Franklin 2001, p. 161; S. Padovani in Chiarini and Padovani 2003, vol. 1, no. 288 (with bibliography).

Notes
1 See A. Conti in Florence 1980b; S. Padovani in Chiarini and Padovani 2003.
2 Sricchia Santoro 1993.
3 See A. Cecchi in Florence 1996, p. 180.
4 D. Cast, *The Calumny of Apelles: A Study of the Humanist Tradition* (New Haven and London, 1981); Faedo 1985; Massing 1990.
5 Kupferstich-Kabinett, Berlin, Cod. 78, c. 2v; see Faedo 1985, fig. 1.
6 See McKillop 1974, pp. 36–137.
7 Massing 1990.
8 *Libro d'Inventario dei beni di Lorenzo il Magnifico* (1492), ed. M. Spallanzani and G. Gaeta Bertelà (Florence, 1992), c. 55v.
9 See N. Pons in Milan and Florence 2004, pp. 244–246.
10 Massing 1990.

Cat. no. 47
FRANCIABIGIO (1484–1525)
Portrait of a Jeweller (Michelangelo di Viviano?)
1516
Oil on panel
70 x 52 cm
Inscriptions: signed with the artist's monogram; *A.S. M.DXVI*
Princeton University Art Museum

Provenance: Worsley Collection by 1848; Earl of Yarborough by 1857; sold, with the Yarborough Collection, Christie's, 12 July 1929, lot 74 (as a portrait of Caradosso by Raphael); purchased by a dealer (?) named Abraham; acquired by Viscount Sulley; sold, with the Sulley Collection, Christie's, 1 June 1934, lot 19, to Bett (?); London dealer Arthur Kauffmann, 1955; sold to Mr. Rosenberg; thence to Mrs. Trude Rosenberg, Stoneroyd, Simonstone, near Burnley, Lancashire; sale, Sotheby's, 8 April 1981; purchased for the Princeton University Art Museum from Piero Corsini, New York, 1983.

References: Waagen 1857, p. 68; Crowe and Cavalcaselle 1903–1914, vol. 6, p. 128; "Notable Works" 1955, plate 10; McKillop 1974, pp. 146–147, no. 20; Princeton 1984; Princeton 1986, p. 77; Sricchia Santoro 1993, p. 36.

Notes
1 A sheet of *Studies of Hands* in black chalk (Staatliche Graphische Sammlungen, Munich, 12867v) has been identified as a preparatory drawing for the hands of the jeweller in this portrait (McKillop 1974, pp. 147, 178), but there is actually no visible connection between the drawing and the painting.
2 For an up-to-date survey of Caradosso's career (with bibliography) see M. Collareta in Turner 1996/2000, vol. 5, pp. 696–697.
3 For example, in the revised edition of S.J. Freedberg's survey (1985, vol. 1, p. 482).
4 Vasari-Milanesi 1878–1885, vol. 9, p. 142. For the identification of the figures see also the diagram in Allegri and Cecchi 1980, p. 122; for a more legible illustration of the portion of the fresco that includes Caradosso's portrait see U. Muccini and A. Cecchi, *The Apartments of Cosimo in Palazzo Vecchio* (Florence, 1991), p. 115.
5 C. Gilbert, Review of S.J. Freedberg, *Painting of the High Renaissance in Rome and Florence*, *The Art Journal* 21:4 (Summer 1962), p. 289. Equally problematic is Gilbert's attempt to reattribute that paradigmatically Venetian painting in the Getty Museum (Berenson 1956, plate 108), with its atmospheric treatment of light, to Franciabigio himself.
6 On Michelangelo di Viviano's birth and death dates see Waldman 2004, no. 1, pp. xi, xiv note 7. His date of death is given incorrectly (for very tendentious reasons) as 1528 in the purportedly autobiographical *Memoriale* of Baccio Bandinelli, which the present writer has identified as a seventeenth-century pastiche (ibid., pp. x–xii). Franciabigio's sitter, with his beady eyes, beetling brows, saturnine expression, lined face, and thin-pressed lips demonstrates at least a passing resemblance to Bandinelli; compare the latter's *Self-portrait* in the Isabella Stewart Gardner Museum in Boston (J. Woods-Marsden, *Renaissance Self-Portraiture: The Visual Construction of Identity and the Social Status of the Artist* [New Haven and London, 1998], pp. 138–147).
7 B. Cellini, *I trattati dell'oreficeria e della scultura di Benvenuto Cellini*, ed. C. Milanesi (Florence, 1857), p. 8.
8 Waldman 2004, no. 55.
9 Ibid., nos. 13, 17, 19.
10 Ibid., nos. 89–91.

Cat. no. 48
FRANCIABIGIO (1484–1525)
Noli me tangere
c. 1520–1525
Detached fresco
162 x 145 cm
Museo di San Salvi, Florence (1890:3242)

Provenance: fresco detached in 1890; purchased by the Gallerie Fiorentine, 1894; on deposit with the Horne Museum, Florence, 1930–1980, and then restored to the Museo di San Salvi.

References: McKillop 1974, pp. 172–173; S. Meloni Trkulja in Padovani and Meloni Trkulja 1982, p. 65, no. 44; Sricchia Santoro 1993, p. 41; E. Capretti in Florence 1996, pp. 278–279, no. 95; Franklin 2001, pp. 167–168.

Notes
1 "Arcangelo tessitore di drappi in Porta Rossa, sopra una torre che serve per terrazzo." Vasari-Milanesi 1878–1885, vol. 5, p. 198; Vasari 1996, vol. 1, p. 923.
2 See A. Natali in Florence 1996, pp. 262–263.

Cat. no. 49
DOMENICO PULIGO (1492–1527)
Cleopatra
c. 1515
Oil on panel
71.5 x 55 cm
Szépmüvészeti Múzeum, Budapest (71.23)

Provenance: Sándor Lederer, Budapest, who purchased it in Rome, 1891; purchased at the twenty-sixth auction of paintings of the Commission Stores, Budapest, 1971.

References: Capretti 2002, p. 38; E. Capretti in Capretti and Padovani 2002, pp. 76–77, no. 6 (with bibliography).

Notes
1 Berenson 1963, vol. 1, p. 183.
2 Tàtrai 1983, p. 20 note 8.
3 For these paintings see Capretti and Padovani 2002, pp. 44–51.
4 See Oberhuber 1978, vol. 26, pp. 181–183, no. 187, pp. 188–189, no. 192; Shoemaker 1981, pp. 88–89, no. 18, pp. 94–95, no. 20.
5 Vasari-Milanesi 1878–1885, vol. 4, p. 467; Vasari 1996, vol. 1, p. 770.
6 Vasari-Milanesi 1878–1885, vol. 4, p. 467; Vasari 1996, vol. 1, p. 771.
7 Vasari-Milanesi 1878–1885, vol. 4, p. 465; Vasari 1996, vol. 1, p. 770.
8 Waldman 1999.
9 Vasari-Milanesi 1878–1885, vol. 4, p. 465 note 3.
10 Sotheby's, Florence, 25–26 March 1985, lot 189.
11 See E. Capretti in Capretti and Padovani 2002, p. 77.
12 Sotheby's, New York, 7 April 1988, lot 35.
13 La Porta 1992, p. 36; E. Capretti in Capretti and Padovani 2002, pp. 86–87.
14 D.A. Brown, *Andrea Solario* (Milan, 1987), p. 227.
15 See Urbini 1993.
16 F. Sricchia Santoro in Siena 1990, pp. 266–269 (with bibliography).
17 Finarte, Milan, 21 April 1986, no. 12.

Cat. no. 50
DOMENICO PULIGO (1492–1527)
Portrait of a Woman as the Magdalen
c. 1520–1525
Oil on panel, transferred to canvas
91 x 68.5 cm
National Gallery of Canada, Ottawa (567)

Provenance: Dukes of Hamilton, Hamilton Palace, near Glasgow, from the early nineteenth century; sale, Christie's, London, 1 July 1882, lot 761 (as Sarto); Charles Butler, London; sale, Christie's, London, 25–26 May 1911, lot 79; A.J. Sulley; Cottier & Co., New York; purchased 1912.

References: Waagen 1854, vol. 3, p. 300; Crowe and Cavalcaselle 1864–1866, vol. 3, p. 585; Ffoulkes 1894, p. 170; Berenson 1903, vol. 1, p. 298; Crowe and Cavalcaselle 1903–1914, vol. 6, p. 202; Freedberg 1963, vol. 2, p. 229; Costamagna and Fabre 1986, vol. 1, pp. 242–244, no. 52; Gardner 1986, pp. 278–280; Laskin and Pantazzi 1987, pp. 237–238 (with bibliography); Capretti 1988–1989, pp. 402–405; La Porta 1992, pp. 39, 41; Capretti 1993, pp. 6–7; E. Capretti in Capretti and Padovani 2002, p. 41; Costamagna 2002, p. 199.

Notes
1 M. Mosco in Florence 1986, pp. 67–72.
2 F. Cardini, *I magi: Storia e leggende* (Venice, 2000).
3 See Costamagna 1994, p. 195, no. 55.
4 Florence 1986, pp. 76–78, no. 17.
5 Ibid., p. 71.
6 See Capretti and Padovani 2002, pp. 44–51.
7 For this painting see Padovani 2004.
8 Capretti and Padovani 2002, p. 82.
9 See Capretti 1993.
10 Vasari-Milanesi 1878–1885, vol. 4, p. 465; Vasari 1996, vol. 1, p. 769.
11 Costamagna 2002, p. 200.

Cat. no. 51
ANTONIO DI DONNINO DEL MAZZIERE (1497–1547)
The Myth of Apollo and Daphne and the Myth of Narcissus
early 1520s
Oil on panel
30 x 44.5 cm
Galleria Corsini, Florence (70)

Provenance: entered the Corsini collection in the middle of the eighteenth century.

References: see cat. no. 52.

Cat. no. 52
WORKSHOP OF ANTONIO DI DONNINO DEL MAZZIERE
The Myth of Narcissus
early 1520s (?)
Oil on panel
30 x 41.5 cm
Private collection, Milan

Provenance: Casa Rosini, Pisa; R.H. Benson Collection, London; W.M.H. Pollen Collection, Norton Hall, Gloucestershire.

References: Cust 1907, p. 208; London 1914, p. 69, no. 36; Crowe and Cavalcaselle 1903–1914, vol. 6, p. 132 note 5; Sinibaldi 1925, p. 27 note 1; Venturi 1925, pp. 471–472; Berenson 1932, p. 17; Berenson 1936, p. 408; Freedberg 1961, vol. 1, p. 499; Shearman 1962, p. 479 note 22; Zeri 1962, p. 235; Berenson 1963, vol. 1, p. 184; Freedberg 1972, pp. 499, 600; McKillop 1974, pp. 192–193; Zeri 1994, p. 36; V. Silvani in Capretti and Padovani 2002, pp. 146–147, no. 37, with bibliography.

Notes
1 V. Silvani in Capretti and Padovani 2002.
2 Ibid., pp. 148–149.
3 Vasari-Milanesi 1878–1885, vol. 5, p. 200; Vasari 1996, vol. 1, p. 923.

Cat. no. 53
ANTONIO DI DONNINO DEL MAZZIERE (1497–1547)
Diana and Actaeon
early 1520s
Oil on panel
32.6 x 26.3 cm
Inscriptions: *PROCUL HINC PROCUL ESTE PROPHANI*
Private collection

Notes
1 Zeri 1962. Concerning this artist see the entries by V. Silvani in Capretti and Padovani 2002, pp. 146–149. More recent studies include P. Costamagna, "Nouvelles considérations sur Baccio Bandinelli peintre: La redécouverte de la Léda et le cygne," *Les Cahiers d'histoire de l'art* 1 (2003), pp. 7–18; A. Cecchi, "Aggiunte per Antonio di Donnino del Mazziere," in *Arte, Collezionismo, Conservazione: Scritti in onore di Marco Chiarini*, ed. M.L. Chappell, M. di Giampaolo, and S. Padovani (Florence, 2004), pp. 194–199.
2 Ovid, *Metamorphoses*, F.J. Miller, trans. (Cambridge, Mass.: Harvard University Press, 1984), 3.180ff.
3 Ovid 3.230ff.
4 For the attribution to Antonio di Donnino of a miniature on a codex dedicated to Leo X see A. Cecchi, "Aggiunte."
5 For the derivation of some drawings by Antonio di Donnino from prints by Dürer see M. Sframeli in Florence 1996, pp. 272–275.
6 Inv. 1313–1318E, 1355–1360E. See A. Cecchi, "Aggiunte"; Florence 1996, pp. 272–275 (with bibliography).
7 The green could be mistaken for blue if compared with the oxidized green of the land-scape, but a comparison with the bright blue, obtained with lapis lazuli or azurite, in Actaeon's collar or the distant mountains shows it to be unquestionably green, similar in colour to the meadow in the middle ground.

8 The device of the three feathers, even when not connected with the Medicean diamond ring, appears in several Medici manuscripts from the age of Lorenzo and later, though with no precise order in the sequence of colours, as was pointed out in *All'ombra del Lauro*, exh. cat., ed. A. Lenzuni (Florence, 1992). In the frontispiece for the Proemio to Marsilio Ficino's translation of Plotinus, the three feathers appear in the order white, green, and red (p. 132); in the frontispiece of the *De optimo cive* by Platina, the sequence is red, white, and green (p. 104); and in another miniature it is green, red, and white (p. 157). On the frequency of Medicean emblems in manuscripts from the age of Lorenzo see pp. 140–143. See also F. Ames-Lewis, "Early Medicean Devices," *Journal of the Warburg and Courtauld Institutes* 13 (1979), pp. 122–143; A. Cecchi in *Sandro Botticelli: The Drawings for Dante's Divine Comedy*, exh. cat., ed. Hein-Th. Schultze Altcappenberg (London, 2000), vol. 1, pp. 128–129. The three feathers appear also in the pope's chapel in the church of Santa Maria Novella, in the ceiling decorated by Cosimo Feltrini, and in the coat of arms carved by Baccio d'Agnolo, commissioned by Alessandro de' Medici, possibly for the great hall in the palace of the Mercanzia Vecchia and now in the Bargello; see A. Cecchi in Florence 1996, pp. 396–397.
9 See P. Giovio, *Ragionamento sopra i motti, et disegni d'arme, et d'amore, che comunemente chiamano imprese* (Venice, 1556), p. 63.
10 Ovid 3.191–193.
11 Virgil *Aeneid* 6.258 in H.R. Fairclough, trans., G.P. Goold, ed., *Virgil: Eclogues; Georgics; Aeneid, Books 1–6* (Cambridge, Mass.: Harvard University Press, 1999).
12 Compare Virgil 6.257–258 with Ovid 3.230–235.

Cat. no. 54
PIER FRANCESCO FOSCHI (1502–1567)
The Virgin and Child Enthroned with Saints
c. 1525
Black chalk, pen and brown ink, and brown wash, heightened with white, on greyish-blue prepared paper, some auxiliary lines incised with stylus
30.9 x 26.8 cm
Inscriptions: in pen and brown ink, *S*; *B*; *T*
Annotations: in pen and brown ink, *Timoteo da Urbino*
Ashmolean Museum, Oxford (WA1950.57)

Provenance: Earls of Pembroke, Wilton House (from a volume of drawings bearing the date 23 November 1772); sale, Sotheby's, 9 July 1917, lot 320; L.D. Cunliffe; P. and D. Colnaghi, London; purchased by the Ashmolean Museum, 1950.

References: Parker 1956, no. 495 (as attributed to Puligo); Berenson 1961, p. 520, no. 2376A** (as Puligo); Pouncey 1957, p. 159 (as Foschi); Shearman 1965, vol. 2, p. 226; Macandrew 1980, p. 274; A. Forlani Tempesti in Florence 1980a, no. 218; Forlani Tempesti 1991, under no. 90.

Notes
1 L.A. Waldman, "Three Altarpieces by Pier Francesco Foschi: Patronage, Context and Function," *Gazette des Beaux-Arts* 137 (2001), pp. 17–18.
2 The martyr Saint Thomas Becket is sometimes depicted wearing a Benedictine habit (although he is more commonly represented as a bishop saint). If the name Thomas had significance for the patron of the altarpiece, then a second saint bearing that name would have been appropriate, differentiated at the planning stages by the letter "B." However, Saint Thomas Becket is often known in Italy as San Tommaso Cantauriense.

Cat. no. 55
PIER FRANCESCO FOSCHI (1502–1567)
The Virgin and Child with the Young Saint John the Baptist
c. 1545
Oil on panel
104 x 84 cm
Moretti, Florence–London

Provenance: sale, Christie's, New York, 30 May 2003, lot 25.

Notes
1 See Franklin 2001, pp. 147–148. Pinelli (1967) is fundamental to a reconstruction of the artist's oeuvre.
2 G. Tátrai, "Tableau inconnu de Pier Francesco Foschi d'après Andrea del Sarto," *Bulletin du Musée hongrois des beaux-arts* 51 (1978), pp. 87–93. The Christ child reappears in Foschi's painting of the *Holy Family* in the Palazzo Pitti (Pinelli 1967, p. 89). The artist also made a copy of Sarto's *Sacrifice of Isaac*, now in the villa at Poggio Imperiale in Florence.
3 O. Giglioli, "Affreschi inediti di Pier Francesco di Jacopo di Domenico Toschi," *Bollettino d'Arte* 32 (1938), pp. 25–31.
4 L.A. Waldman, "Three Altarpieces by Pier Francesco Foschi: Patronage, Context and Function," *Gazette des Beaux-Arts* 137 (2001), pp. 17–18.

Cat. no. 56
JACOPINO DEL CONTE (C. 1515–1598)
Portrait of a Man
c. 1530–1537
Oil on panel
66 x 46.7 cm
Philadelphia Museum of Art, John G. Johnson Collection (cat. 81)

Provenance: purchased by John G. Johnson from Dowdeswell, London, 1911.

References: Venturi 1932, p. 105; Freedberg 1963, vol. 2, p. 231; Shearman 1965, vol. 1, p. 170 note 4; Cheney 1970, p. 39 note 51; Zeri 1978, pp. 118–119; Costamagna and Fabre 1991, p. 24.

Notes
1 Berenson to Johnson, from Settignano, 21 November 1911, Philadelphia Museum of Art, John G. Johnson Collection Archives.
2 L. Bellosi made the attribution in an article on Jacopino's portraits ("Intorno a un ritratto fiorentino di Jacopino del Conte," in *Kunst des Cinquecento in der Toskana*, ed. M. Cämmerer, [Munich, 1992], pp. 213–218) without commenting on the Johnson painting.

Cat. no. 57
MASTER OF THE UNRULY CHILDREN (ACTIVE C. 1515–1530)
Charity
c. 1515–1530
Terracotta
59.1 cm high
Victoria and Albert Museum, London (A.56-1920)

Provenance: purchased by August Zeiss in Florence before 1869; bought from his widow, Mrs. Best (through Lady Helena Best), formerly August Zeiss Collection.

References: Bode 1890–1908, pp. 160–161; Stites 1931, p. 206; Pope-Hennessy 1964, vol. 2, pp. 406–407, no. 425; Avery 1981, pp. 46–49, no. 9; Ferretti 1992, p. 47; C. Avery in Turner 1996/2000, vol. 20, pp. 778–779; Bellandi 2004, pp. 242–251.

Notes
1 Bode 1890–1908, pp. 160–161.
2 Stites 1931. For bibliography see Ferretti 1992; C. Avery in Turner 1996/2000; Bellandi 2004.
3 Ferretti 1992, pp. 47–48.
4 C. Avery in Turner 1996/2000; Bellandi 2004, p. 246, crediting G. Gentilini with the attribution.
5 On replicated images and their significance see G.A. Johnson, "Art or Artefact? Madonna and Child Reliefs in the Early Renaissance," in *The Sculpted Object, 1400–1700*, ed. S. Currie and P. Motture (Aldershot, 1997), pp. 1–24; C. Klapisch-Zuber, "Holy Dolls: Play and Piety in Florence in the Quattrocento," in *Looking at Renaissance Sculpture*, ed. S.B. McHam (Cambridge, 1998), pp. 111–127; P. Motture, "Making and Viewing: Donatello and the Treatment of Relief," in *Depth of Field: The Place of Relief in the Time of Donatello*, exh. cat., ed. P. Curtis (Leeds, 2004), pp. 18–29.
6 See Ferretti 1992, pp. 35–42; J.M. Musacchio, *The Art and Ritual of Childbirth in Renaissance Italy* (New Haven and London, 1999), pp. 126–134.
7 See Ferretti 1992, p. 41.
8 Pope-Hennessy 1964, vol. 1, pp. 126–127, no. 104; recently reattributed to the young Leonardo in F. Caglioti, "Su Matteo Civitali scultore," in *Matteo Civitali e il suo tempo: Pittori, scultori e orafi a Lucca nel tardo Quattrocento*, exh. cat. (Milan, 2004), p. 72.
9 For comparisons see Butterfield and Franklin 1999, p. 823; Franklin 2001, plate 118; Bellandi 2004, p. 248.

Cat. no. 58
ROSSO FIORENTINO (1494–1540)
Moses Defending the Daughters of Jethro
c. 1523–1524
Oil on canvas
160 x 117 cm
Galleria degli Uffizi, Florence (1890:2151)

Provenance: Giovanni Bandini, Florence; donated to the Uffizi by the heirs of Don Antonio de' Medici, 1632.

References: Elam 1993; Franklin 1994, pp. 109–117; Natali 1995, p. 92; Falciani 1996, pp. 46–49.

Notes
1 Vasari 1986, p. 751; Vasari-Milanesi 1878–1885, vol. 5, p. 159; Vasari 1996, vol. 1, p. 902.
2 Elam 1993.
3 Ibid., p. 64.
4 See P. Barocchi, "La Galleria e la Storiografia Artistica," in *Gli Uffizi: Quattro Secoli di una Galleria* (Florence, 1983), vol. 1, p. 54 note 21.
5 Natali (1995, p. 92) in particular has doubted that the work is autograph.

6 See, for example, V. Gaston, "The Prophet Armed," *Journal of the Warburg and Courtauld Institutes* 51 (1988), pp. 220–225 (with a summary of other opinions). Gaston tried to find a source for Rosso's violent interpretation of the subject in the sermons of Savonarola, who particularly praised Moses among all the prophets because of his willingness to use violence to achieve his ends. According to this view, Rosso's painting is a politicized allegory about the spiritual depravity of the Florentine clergy, symbolized by the shepherds. See also Falciani 1996, pp. 46–49.
7 The dossier in the Ufficio Ricerche of the Uffizi lists all its inventory numbers with descriptions.
8 Franklin 1994, p. 114.

Cat. no. 59
ROSSO FIORENTINO (1494–1540)
Portrait of a Man
c. 1524
Oil on panel
88.7 x 67.9 cm
National Gallery of Art, Washington, Samuel H. Kress Collection (K1735, 1961.9.59, 1611)

Provenance: Thomas Sebright, Beechwood, near Boxmoor; sold by Giles Sebright, Christie's, London, 2 July 1937, lot 128 (as Sarto), apparently purchased by Marshall; Eugenio Ventura, Rome; Contini Bonacossi, Florence (according to Contini Bonacossi records, the portrait was once owned by the Pazzi family, Florence); purchased from the Contini Bonacossi by the Samuel H. Kress Foundation, New York, 1950; donated to the National Gallery of Art, 1961.

References: Franklin 1994, p. 211; C. Falciani in Florence 1996, no. 133.

Notes
1 G.F. Waagen, *Works of Art and Artists in England*, trans. H.E. Lloyd (London, 1838), vol. 3, p. 86 (1857, p. 329). Freedberg (1963, vol. 2, pp. 237, 242) did not connect the painting at Beechwood mentioned by Waagen with this portrait. McKillop (1974, p. 217) perpetuated the oversight.
2 Expertise written on the back of a photograph in the National Gallery file, dated 1950.
3 H. Keutner ("Zu einigen Bildnissen des frühen Florentiner Manierismus," *Mitteilungen des Kunsthistorischen Institutes in Florenz* 8 [1959], pp. 141–144) considered it to be from Sarto's circle, c. 1517–1519, and Berenson (1963, vol. 1, p. 195) was simply not convinced of the attribution.
4 S. Béguin, "Pontormo et Rosso," in *Pontormo e Rosso: Atti del convegno di Empoli e Volterra* (Venice, 1996), p. 93.

Cat. no. 60
ROSSO FIORENTINO (1494–1540)
The Virgin and Child with Saint Julian and a Donor
c. 1525–1530
Oil on panel
63.5 x 53.3 cm
Private collection, New York City

Provenance: European private collection.

Notes
1 See Franklin 1994, pp. 157–161.

Cat. no. 61
ROSSO FIORENTINO (1494–1540)
Saint John the Baptist Drinking at the Spring
c. 1524
Oil on panel
47 x 37.5 cm
Inscriptions: *ECE.AGNVS.DEI*
Private collection, London

Provenance: Charles Loeser Collection, Florence; R. Bruscoli, Florence; private collection, London.

Notes
1 The first of these studies for a *Saint John the Baptist in the Desert* shows a young man from the studio posing on a rock (6595F, 6740F recto), then the figure is set in motion (6645F verso, 6726F recto, 6740F verso), and finally, in a contorted pose, he raises a cup to his mouth (6597F, 6654F); see Cox-Rearick 1981, pp. 190–192.
2 Jacone, a pupil of Andrea del Sarto, began with a style that was influenced by his master (see the Santa Lucia dei Magnolia altarpiece in Florence), then joined Pontormo's studio in 1530. His major work, the altarpiece in the church of Santa Maria del Calcinaio in Cortona, is not as finely handled as this small panel, and his own small paintings, though more polished in execution, are decidedly Pontormesque in nature and not stylistically comparable to the present work.
3 A comparison of the London painting with the *Leda and the Swan* in the Rectorat of the Sorbonne (fig. 89.1), for which Bandinelli had Rosso's assistance, shows that the two works cannot be by the same artist; see Béguin and Costamagna 2003, pp. 7–18.
4 The attribution of the Berlin portrait, regarded as one of Rosso's major works (Falciani 1996, p. 50), has been questioned nonetheless by Franklin (1994, p. 290 note 14). Whereas Franklin classified the portrait among those by anonymous sixteenth-century Florentines, my proposal as an alternative to Rosso – which still seemed to be the most logical attribution – was Berruguete (Costamagna 1994, p. 95 note 26). Today the tendency is toward a definitive ascription of the painting to Rosso. While Falciani (Florence 1996, p. 358) places the Berlin portrait among the artist's early works, it more likely dates to his arrival in Rome, where he reprised the pose that he had used around 1522 for the *Portrait of a Man* in the National Gallery of Art in Washington.
5 See Franklin 1994, pp. 73–76, 224–227.
6 See R.P. Ciardi in Florence 1996, pp. 354, 362.
7 See Franklin 1994, pp. 135–38.
8 *Ecce* is written with a single "c." In his brief biography of Rosso, Vasari points out that the artist was obliged to perfect his Latin before going to work for Francis I (Vasari-Milanesi 1878–1885, vol. 5, p. 166; Vasari 1996, vol. 1, p. 906).
9 On Parmigianino's painting, now in Vienna, see S. Ferino Pagden, "L'autoritratto del Parmigianino: La consistenza (im)materiale dell' autoritratto di Vienna," in *Parmigianino e il manierismo europeo: Atti del Convegno Internazionale di studi (Parma, 13–15 giugno 2002)*, ed. L. Fornari Schianchi (Parma, 2002), pp. 67–82.

Cat. no. 62
FRANCESCO SALVIATI (1510–1563)
Rebecca and Eliezer at the Well
c. 1539
Red chalk
32.7 x 23 cm
Annotations: in pen and brown ink, *da Cecchino Salviati*
Galleria degli Uffizi, Florence (14610F)

Provenance: Medici collections.

References: P. Joannides in Rome and Paris 1998, no. 4.

Notes
1 K. Kusenberg in *Le Rosso* (Paris, 1931), p. 153, no. 10.
2 The attribution to Lappoli, first proposed by Joannides (Rome and Paris 1998), seems entirely plausible.
3 On both paintings see Franklin 1994, pp. 109–117.
4 C. Sicca, "Rosso e l'Inghilterra," in Ciardi and Natali 1996, pp. 147–156.
5 Vasari 1986, p. 751; Vasari 1996, vol. 1, p. 902.

Cat. no. 63
JACOPO DA PONTORMO (1494–1557)
The Baptism and Victory of the Nine Thousand
c. 1522
Red chalk and red wash, heightened with white, with traces of stylus
41.8 x 36.8 cm
Annotations: in pen and brown ink, *Del Piombo; Vasari, Fra Sebastiano*
Kunsthalle, Hamburg (21253)

Provenance: possibly Giorgio Vasari; unidentified collectors (L. 2798 and L. 1976); bequeathed by E.G. Harzen, 1863 (L. 1244).

References: Merritt 1963; Cox-Rearick 1964, no. 195; Hamburg 1997, no. 43; Hamburg 2001, no. 8.

Cat. no. 64
PERINO DEL VAGA (1501–1547)
The Condemnation and Martyrdom of the Ten Thousand
c. 1522
Pen and brown ink and brown wash, heightened with white, on brown prepared paper, squared
35.8 x 33.9 cm
Albertina, Vienna (2933, SL384)

Provenance: Pierre Jean Mariette; Le Noir; Herzog Albert von Sachsen-Teschen (L. 174).

References: Clapp 1914, p. 140; Merritt 1963; Parma Armani 1986, no. C.II; Mantua 1999, no. 224; Mantua 2001, no. 20.

Notes
1 A. Cecchi in Mantua 2001, pp. 115, 327.
2 Ibid., p. 327.
3 Costamagna 1994, p. 168.
4 Vasari 1986, p. 861; Vasari 1996, vol. 2, p. 166.
5 Popham 1945, p. 59 note 3.
6 Merritt 1963, p. 261.
7 Vasari 1986, pp. 203–204; Vasari 1996, vol. 1, p. 238.

8 There is considerable debate on this point, hampered by a total lack of primary evidence. Two other views, still in need of further support, have been expressed. Cox-Rearick has suggested that Pontormo never executed the fresco and that the project was given entirely to Perino (1964, pp. 211–212), a view supported by A. Cecchi (Mantua 2001, no. 6). L. Wolk-Simon ("Fame, *Paragone*, and the Cartoon: The Case of Perino del Vaga," *Master Drawings* 30 [Spring 1992], p. 74) has put forward the opposite view, namely that Pontormo made his drawing only after Perino left Florence.

9 As pointed out by Wolk-Simon in her review of *Perino del Vaga, tra Raffaello e Michelangelo* (*Master Drawings* 41 [2003], p. 49), the copies after Perino's drawing are not by contemporary Florentine artists and his cartoon was probably not even accessible.

10 For these paintings see Costamagna 1994, nos. 65, 65a. Another related version but with a nominal subject related to the Constantine legend, plausibly attributed to Jacone, has recently appeared on the art market, further attesting to the relatively strong appeal of Pontormo's composition in Florence.

Cat. no. 65
PERINO DEL VAGA (1501–1547)
The Crossing of the Red Sea
c. 1522
Oil on canvas
118 x 201 cm
Pinacoteca di Brera, Milan (Nap. 964; Inv. Gen. 282; Reg. Con. 450)

Provenance: acquired from Gaspare Porta, 1826.

References: Venturini 1992, pp. 242–243, no. 104; Ceriana 1997, pp. 295–300; A. Cecchi in Mantua 2001, pp. 118–119, no. 22.

Notes

1 Venturini 1992, pp. 242–243, no. 104.
2 Vasari 1986, pp. 862–863; Vasari 1996, vol. 2, p. 168.
3 Vasari-Milanesi 1878–1885, vol. 6, p. 8; Vasari 1996, vol. 2, pp. 205–206. For the Uffizi version see Parma Armani 1986, pp. 338–340, D.1. Natali (Florence 1996, p. 286) doubted the attribution of the Uffizi painting to Perino. Ceriana (1997, p. 299) has suggested Lappoli as the possible author of the Uffizi copy, although this is very much a hypothesis. On Lappoli in general see D. Franklin, "Documents for Giovanni Antonio Lappoli's Visitation in Sante Flora e Lucilla in Arezzo," *Mitteilungen des Kunsthistorischen Institutes in Florenz* 41 (1997), pp. 197–205.
4 A. Cecchi (Mantua 2001, p. 118) draws attention to a drawing by Perino in Vienna of the same approximate date that appears to depict the earlier episode of the baby Moses being removed from the bulrushes.
5 B. Davidson, "Early Drawings by Perino del Vaga: Part Two," *Master Drawings* 1 (1963), pp. 21–22; Parma Armani 1986, pp. 53–54, 338–340. Ceriana (1997) also relates the pose of the figure in the lower-left corner to one in the now destroyed lunette by Michelangelo featuring *Phares, Esron, and Aram* in the Sistine Chapel. However, this same pose was used for the figure of Lazarus in Sebastiano's altarpiece of the *Raising of Lazarus*, now in the National Gallery in London, a more obvious source.
6 A. Cecchi in Mantua 2001, p. 47.

Cat. no. 66
JACOPO DI GIOVANNI DI FRANCESCO, CALLED JACONE (1495–1554)
The Virgin and Child with Saints Anne and Elizabeth and the Young Saint John the Baptist
c. 1527–1530
Pen and brown ink over black chalk
26.7 x 20.3 cm
Christ Church Picture Gallery, Christ Church College, Oxford (0089)

Provenance: General Guise.

References: Byam Shaw 1976, no. 103; Pinelli 1988, pp. 19, 32 note 33.

Notes

1 See Franklin 2001, p. 206.
2 On this relationship see C. Davis, "Michelangelo, Jacone and the Confraternity of the Virgin Annunciate called 'dell'Orciuolo,'" *Apollo*, no. 487 (2002), pp. 22–28.
3 See Pinelli 1988, p. 33.
4 Franklin 1994, pp. 12–13.
5 A painter called Jacopo di Giovanni, whom we can assume to be Jacone, witnessed a document in Florence on 10 November 1527, so it appears that he was in the city following the departure of the Medici family the previous May (Archivio di Stato, Florence, Notarile Antecosimiano, 3349, fol. 360 recto). I thank Louis A. Waldman for sharing this document with me. Whether Jacone remained any longer in Florence is still uncertain; other evidence suggests that he went to Cortona soon after in order to escape the political and military turmoil.

Cat. no. 67
JACOPO DI GIOVANNI DI FRANCESCO, CALLED JACONE (1495–1554)
Seated Woman
c. 1525–1530
Red chalk
29.1 x 21.6 cm
Istituto Nazionale per la Grafica, Villa Farnesina, Rome (Fondo Corsini 125028)

Provenance: Corsini collection.

References: Carroll 1976, pp. 515–517, F55.

Notes

1 G. Sinibaldi (*Italian Drawings: Masterpieces of Five Centuries*, exh. cat. [Washington, 1960], p. 34, no. 50, published the traditional attribution to Rosso for the first time and related the drawing to the upper part of the *Risen Christ in Glory* in the cathedral of Città di Castello. Carroll (1976, vol. 2, pp. 515–517, F55) rejected the attribution to Rosso and suggested instead Francesco Salviati. Polidoro's name with a question mark was attached to the drawing by Philip Pouncey, on the mount.
2 See Parker 1956, p. 388, no. 725, where it was attributed to Tribolo.
3 Petrioli Tofani 1991, p. 152, inv. 344F.
4 For the surviving Cortona altarpiece see S. Casciu, *La maniera moderna nell'Aretino: Dal Rosso a Santi di Tito, guida alle opere* (Venice, 1994), p. 20, no. 3.
5 Vasari-Milanesi 1878–1885, vol. 6, pp. 452–453; Vasari 1996, vol. 2, pp. 441–443.

Cat. no. 68
JACOPO DA PONTORMO (1494–1557)
The Virgin and Child with Saints
c. 1518
Charcoal, heightened with white, on red prepared paper
21.8 x 16 cm
Istituto Nazionale per la Grafica, Villa Farnesina, Rome (Fondo Corsini 124229)

Provenance: Corsini collection.

References: Clapp 1914, p. 335; Cox-Rearick 1964, nos. 29, 120; Prosperi Valenti Rodinò 1994, no. 13.

Notes

1 For the relevant documents see Franklin 1990, pp. 488–489.
2 Prosperi Valenti Rodinò (1994, no. 13) describes the medium as "charcoal" as opposed to black chalk.
3 On this point see Cox-Rearick 1964, vol. 1, p. 124.

Cat. no. 69
JACOPO DA PONTORMO (1494–1557)
Saint Francis (recto)
Study of a Dead Christ (verso)
c. 1517–1519
Black chalk (recto), black and white chalks (verso)
40.5 x 28.4 cm
Watermark: cross with two circles and three triangles
The J. Paul Getty Museum, Los Angeles (83.GG.379)

Provenance: Jonathan Richardson, Sr. (L. 2183); Sir Joshua Reynolds (L. 2364); Thomas Hudson (L. 2432); Michel Gaud.

References: Forlani Tempesti 1981, pp. 117–122; Goldner 1988, no. 35.

Notes

1 Forlani Tempesti 1981, pp. 117–122; Florence 1980a, no. 404.
2 Clapp 1914, p. 222; see also Costamagna 1994, p. 139, no. 26, p. 276, no. A17.

Cat. no. 70
JACOPO DA PONTORMO (1494–1557)
Portrait of a Man
c. 1520
Red chalk
28 x 19.5 cm
Annotations: in pen and brown ink, *19*
Istituto Nazionale per la Grafica, Villa Farnesina, Rome (Fondo Corsini 124162)

Provenance: Corsini collection.

References: Cox-Rearick 1964, no. 85; Costamagna 1994, p. 151.

Notes

1 Costamagna 1994, no. A12. The painting was sold at Sotheby's, London, 5 March 1969, lot 83.
2 Freedberg 1961, p. 529. Freedberg's theory was rejected by L. Berti (*Pontormo e il suo tempo* [Florence, 1993], pp. 44–47).

Cat. no. 71
JACOPO DA PONTORMO (1494–1557)
Study for Christ before Pilate
c. 1523–1524
Black and red chalks, heightened with traces of white
chalk, over stylus
27.4 x 28.3 cm
The Art Institute of Chicago, Restricted Gift of Anne Searle
Meers, The Regenstein Foundation, and Dr. William D.
Shorey (1989.187)

Provenance: private collection, England; British Rail Pension
Fund; purchased by the Art Institute of Chicago, 1989.

References: Giles 1991; Stratis 1991; Costamagna 1994,
pp. 11, 54, 60–61, 175–176; Conti 1995, pp. 33–34, 78;
McCullagh and Giles 1997, no. 255, pp. 197–198.

Notes
1 This identification, first proposed by the
present writer (Giles 1991), has been generally
accepted. Conti (1995) suggested that the drawing
represents a scene from Roman history and could
be a study for a lost or unexecuted wall fresco in
the villa at Poggio a Caiano.
2 See I. Lavin, "An Observation on 'Medievalism'
in Early 16th-Century Style," *Gazette des Beaux-Arts*
50, ser. 6 (1950), pp. 113–118.
3 These are listed in *Gesamtkatalog der Wiegendrucke*
vol. 4 (Leipzig, 1930), nos. 4769–4797.
4 "& intrando iesu in nel palacio se inclinavano
insino a terra gli dodece standardi liquali guarda-
vano el pretorio & non per la sua volutate ma per
paura forono costreti ingenochiarse & adorare:
la qualcosa vede[n]do pilato tutto impaurito usci
di fora." As transcribed from *Meditatione sopra la
passione del nostro iesu christo* (Venice, 1492), sig. ci.
5 For an extensive discussion of Pontormo's sty-
lus underdrawing in this drawing see Stratis 1991.
6 For two similarly reworked chalk composi-
tional studies from the early and mid-1520s, both
in the Uffizi (436S and 6675F), see Giles 1991,
figs. 8, 9; Cox-Rearick 1981, nos. 194, 224.
7 "Perciocchè guastando e rifacendo oggi quello
che aveva fatto ieri, si travagliava di maniera il
cervello, che era una compassione; ma tuttavia
andava sempre facendo nuovi trovati, con onor suo
e bellezza dell'opera." Vasari-Milanesi 1878–1885,
vol. 6, pp. 264–265; Vasari 1996, vol. 2, p. 353.
8 For most of these see Cox-Rearick 1981,
nos. 131–160.
9 Inv. 6622F and 2271F; Cox-Rearick 1981,
nos. 207, 212.

Cat. no. 72
JACOPO DA PONTORMO (1494–1557)
Pietà
c. 1525–1527
Black chalk and grey wash, heightened with white, squared;
upper figures retouched with stylus
44.3 x 27.6 cm
Christ Church Picture Gallery, Christ Church College, Oxford
(1336)

Provenance: Jonathan Richardson, Sr. (L. 2184); General
Guise bequest, 1765.

References: Cox-Rearick 1964, no. 272; Byam Shaw 1976,
no. 119.

Notes
1 For the painting in general and its bibliography
see Franklin 2001, pp. 192–194. J. Shearman's
Pontormo's Altarpiece in Santa Felicita (Newcastle,
1971) remains the classic study.
2 Vasari 1996, vol. 2, p. 358.
3 According to P. Pouncey in his review of
Berenson 1961 (*Master Drawings* 2 [1964], p. 290).

Cat. no. 73
JACOPO DA PONTORMO (1494–1557)
Reclining Male Nude (recto)
Standing Female Figure (verso)
1530s
Black chalk
25.1 x 38.3 cm
Annotations: on verso, in pen and brown ink, *Michelangelo*,
and in graphite, *177. Michael Angelo Buonarotti*
National Gallery of Canada, Ottawa (41370)

Provenance: Sir Joshua Reynolds; Thomas Lawrence;
Samuel Woodburn, sold to Willem II of the Netherlands,
1838; his sale, Het Paleis, The Hague, 12–20 August
1850, possibly lot 104; purchased by Grand Duke Charles
Alexander of Sachsen-Weimar-Eisenach, Thuringia;
Grand-ducal collection, Weimar; European private collection;
purchased 2004.

References: Franklin 2005, pp. 180–182.

Notes
1 *One Hundred Original Drawings by Michael
Angelo collected by Sir Thomas Lawrence*, London,
July 1836, no. 44: "A NOBLE STUDY FOR THE
ADAM – in the Sistine Chapel; this drawing is
executed in black chalk. *Very Capital. Size, 15 inches
by 10 inches. From the Collection of Sir Joshua Reynolds.*"
2 See Franklin 2005.
3 Cox-Rearick 1981, p. 343, no. 382.
4 C. Falciani, *Pontormo: Disegni degli Uffizi*, exh. cat.
(Florence, 1996), no. VIII.5.
5 For each of these paintings see M. Hirst and
G. Mayr, "Michelangelo, Pontormo und das
Noli Me Tangere fur Vittoria Colonna," in *Vittoria
Colonna: Dichterin und Muse Michelangelos*, ed. S.
Ferino-Pagden, exh. cat. (Vienna, 1997), pp. 335–344;
Florence 2002.
6 J. Wilde, *Michelangelo and His Studio* (London,
1953), p. 83, no. 48 verso.

Cat. no. 74
JACOPO DA PONTORMO (1494–1557)
Study of Three Nudes for the Castello Loggia
(recto)
Portrait of Maria Salviati (verso)
c. 1537
Red chalk (recto), black chalk (verso)
20.2 x 27.8 cm
British Museum, London (Pp.1-57)

Provenance: bequeathed by Richard Payne Knight, 1824.

References: Cox-Rearick 1981, no. A212, p. 395; Pilliod
2001, p. 17.

Notes
1 Pilliod 2001, pp. 17, 236 note 13. For the verso
see also E. Pilliod in Jacks 1998, pp. 44–45. Cox-
Rearick (1981, no. A212, p. 395) had considered the
drawing on the recto to be by an unnamed assis-
tant of Pontormo.
2 Vasari-Milanesi 1878–1885, vol. 6, pp. 282–283;
Vasari 1996, vol. 2, pp. 366–367.

Cat. no. 75
JACOPO DA PONTORMO (1494–1557)
Allegorical Female Nude
c. 1535–1536
Black chalk, heightened with white, with traces of stylus
35.5 x 26.2 cm
Kunsthalle, Hamburg (21173)

Provenance: E.G. Harzen (L. 1244); museum stamp
(L. 1328).

References: Cox-Rearick 1964, nos. 314, 333; Hamburg
1997, no. 44; Hamburg 2001, no. 9.

Notes
1 G. Pauli, *Zeichnungen Alter Meister in der
Kunsthalle zu Hamburg* (Frankfurt am Main,
1924–1927), vol. 1, no. 19.
2 Pilliod 2001, p. 39.
3 Forlani Tempesti 1967, p. 81. The attribution
to Bronzino was also proposed by Smyth (1971,
p. 50 note 18), and more recently by Costamagna
(1994, p. 232).
4 Cox-Rearick 1964, no. 316.

Cat. no. 76
JACOPO DA PONTORMO (1494–1557)
The Virgin and Child
c. 1520
Oil on panel
82.3 x 64.2 cm
Private collection, New York City

Provenance: Carlo de' Medici; Cosimo III de' Medici;
Medici collections (displayed in the Uffizi 1704–1769 and
possibly until 1784); art market, New York; acquired by
the present owner in 1992.

References: Costamagna 1994, no. 39; P. Costamagna in
Florence 1996, no. 103.

Notes
1 L. Berti, "Fortuna del Pontormo," in *Quaderni
Pontormeschi* 2 (Florence, 1956), p. 23.
2 Costamagna 1994, pp. 163–164.
3 Ibid., p. 165.

Cat. no. 77
AGNOLO BRONZINO (1503–1572)
Portrait of a Young Man
c. 1533–1534
Black chalk, squared
26.4 x 18.7 cm
Devonshire Collection, Chatsworth (714)

Provenance: N.A. Flinck; William Cavendish, 2nd Duke of
Devonshire (L. 718).

References: Jaffé 1994, no. 51 (with bibliography);
Costamagna 1994, p. 212; Brock 2002, p. 112.

Notes
1 See Monbeig Goguel 2001b, pp. 259–264;
J. Cox-Rearick in Florence, Chicago, and Detroit
2002–2003, no. 157.
2 See P. Costamagna in Florence 2002, pp. 184–185.
3 A similar observation was made by Shearman
(1965, vol. 1, p. 130 note 1) concerning the study for
the *Portrait of a Man* in the Uffizi (6698F).
4 See J. Cox-Rearick in Florence, Chicago, and
Detroit 2002–2003, no. 14.
5 See A. Cecchi, *Agnolo Bronzino* (Florence,
1996), p. 20.

Cat. no. 78
AGNOLO BRONZINO (1503–1572)
Study for the Pietà of Mercatale
c. 1535
Black chalk, squared on verso
31.4 x 21.9 cm
Private collection, New York City

Provenance: sale, Drouot, Paris, 20 November 2000, lot 21; P. and D. Colnaghi, London, 2001.

References: Monbeig Goguel 2001b; Brock 2002, pp. 39–40; J. Cox-Rearick in Florence, Chicago, and Detroit 2002–2003, no. 157.

Notes
1 On the Cambi altarpiece see Waldman 1997a.
2 This discrepancy has been behind the supposition – quite unnecessary, I believe – that the drawing was not made from a live model, but patched together from other drawings, or else drawn from a clay figure (Monbeig Goguel 2001b).
3 Waldman 1997a, p. 100.
4 On the Mercatale tabernacle see Vasari-Milanesi 1878–1885, vol. 7, pp. 595–596 (Vasari calls it an "opera bellissima"); Cox-Rearick 1993, p. 96.

Cat. no. 79
AGNOLO BRONZINO (1503–1572)
Joseph Recounting His Dream of the Sun, Moon, and Eleven Stars
c. 1545–1548
Black chalk, traces of squaring
43.4 x 33.1 cm
Ashmolean Museum, Oxford (WA1961.11)

Provenance: possibly Filippo Baldinucci Collection; purchased by the Ashmolean Museum, 1961.

References: McComb 1928, p. 166; Parker 1961, p. 58; Andrews 1964, p. 160; Heikamp 1969, p. 35; Smyth 1971, pp. 21, 35–39; Smith 1979, pp. 1–13; A. Petrioli Tofani in Florence 1980a, p. 88; MacAndrew 1980, pp. 15–17, no. 128-1; Adelson 1980, p. 79; McCorquodale 1981, pp. 103, 113; Adelson 1990, pp. 75, 175, 176, 188, 365–367; Forti Grazzini 1994, pp. 1, 16–18; Meoni 1998, p. 130.

Notes
1 The tapestry is one of the group of ten presently housed in the Sala del Dugento in the Palazzo Vecchio, Florence. The remaining ten from the series are in the Palazzo del Quirinale, Rome.
2 Smyth 1971, pp. 35–39.
3 Joannides (1996, p. 68), following a suggestion by E. Pilliod, identifies the version of Michelangelo's *Tityus* at Windsor Castle (RL 0471) as by Bronzino, c. 1550.
4 Smith 1979; Cox-Rearick 1993, pp. 291–292.
5 Philo, *On Joseph*, XXIV; in *Philo*, trans. F.H. Colson (London, 1935), vol. 6, p. 209.
6 Cox-Rearick 1993; on the Aramei see also d'Alessandro 1980 and Pozzi 1990.

Cat. no. 80
AGNOLO BRONZINO (1503–1572)
The Pleasures and Blessings of Matrimony Expelling the Vices and Ills
c. 1565
Black chalk, pen and brown ink, and brown wash, squared
39.9 x 30.8 cm
Annotations: in red chalk, *198*
Christ Church Picture Gallery, Christ Church College, Oxford (1340)

Provenance: General Guise.

References: Smyth 1955, pp. 58–59; Pillsbury 1970, pp. 74–83; Smyth 1971, pp. 78–79; Byam Shaw 1976, no. 132; A. Petrioli Tofani in Florence 1980a, p. 88; McCorquodale 1981, p. 149; Scorza 1981; Brock 2002, p. 235.

Notes
1 The companion drawing, showing Juno, Cupid, and the Graces, is in the Louvre (953); for the correct identification of its subject see Scorza 1981, p. 70 note 105.
2 On the *Martyrdom of Saint Lawrence* and the emulation of Michelangelo see S.J. Campbell, "Counter-Reformation Polemic and Mannerist Counter-Aesthetics: Bronzino's *Martyrdom of Saint Lawrence* in San Lorenzo," *Res: Anthropology and Aesthetics* 46 (2004), pp. 99–120.
3 Late altarpieces in which Bronzino pursues a clear, decorous, and affecting presentation of sacred history include the *Noli me tangere* for Santo Spirito (1561–1565, now in the Louvre), the *Lamentation* for Santissima Annunziata (1565, now in the Galleria dell'Accademia, Florence), the *Pietà* in Santa Croce (1570), and the *Resurrection of the Daughter of Jairus* for Santa Maria Novella (1570).
4 Joannides 1996, p. 77.
5 Bottari and Ticozzi 1822, vol. 1, pp. 216–219.
6 Vasari-Milanesi 1878–1885, vol. 8, pp. 531–535, the source of the quotations in the paragraph that follows.
7 Scorza 1981, p. 70.

Cat. no. 81
AGNOLO BRONZINO (1503–1572)
Pygmalion and Galatea
c. 1530–1532
Oil on panel
81 x 63 cm
Inscriptions: *HEU VI*[NCIT] *VENUS*
Galleria degli Uffizi, Florence

Provenance: Barberini collection; seized by Hermann Goering during the Second World War (part of a group of paintings intended for the art museum to have been dedicated to Hitler in Linz); hidden during the war in the salt mines of Altaussee, Austria; transferred to a collecting point in Monaco, 1946; recovered by Rodolfo Siviero, 16 November 1954, and exhibited at the Palazzo Vecchio, Florence; restituted to the Galleria degli Uffizi shortly after.

References: Cropper 1997, pp. 92–98; Cox-Rearick 1964, vol. 1, pp. 123–137, 163–164; Falciani 1996, pp. 21–22; Brock 2002, pp. 52–58.

Notes
1 For what follows see Cropper 1997. The case against the identification of the portrait has been made by A. Pinelli, among others, for which see Philadelphia 2004, p. 92. What is not in doubt is that the *Pygmalion and Galatea* was the cover for a portrait by Pontormo of Francesco Guardi in the costume of a soldier at the time of the siege.

Cat. no. 82
WORKSHOP OF ANDREA DEL SARTO (1486–1530)
Saint Sebastian
c. 1529–1530 (?)
Oil on panel
84.6 x 60.9 cm
Bob Jones University Museum and Gallery, Greenville, South Carolina (P.70.483)

Provenance: Cook Collection, Richmond, Surrey; sale, Christie's, London, 1 June 1956, lot 90; acquired from Central Picture Galleries, 1970.

References: Freedberg 1963, vol. 2, no. 87; Shearman 1965, vol. 2, no. 100; Nolan 2001, no. 13.

Notes
1 Vasari 1986, p. 725.
2 Shearman 1965, vol. 2, p. 285.
3 According to Stephen Gritt, Chief Conservator at the National Gallery of Canada, who has restored the painting: "In its materials and construction, the painting is entirely consistent with one from Sarto's workshop. The complete absence of any change in the design from the drawing stage on the panel through to the painting would indicate perhaps that the design had reached a point of satisfactory refinement by the time this version was produced. While this may mean that some artist other than Sarto could have painted the work, it does not exclude his participation in its production as a supervisor."

Cat. no. 83
AGNOLO BRONZINO (1503–1572)
Saint Sebastian
c. 1535
Oil on panel
87 x 76.5 cm
Museo Thyssen-Bornemisza, Madrid (1985.2)

Provenance: private collection, Rieti; acquired by the Thyssen collection, 1985.

References: Cox-Rearick 1987, pp. 155–162; Pilliod 2001, p. 94.

Notes
1 Cox-Rearick 1987, p. 155.
2 D. Franklin, "Pontormo's Saint Anne Altarpiece and the Last Florentine Republic," *Revue du Louvre: La revue des musées de France* 51:1 (2001), pp. 76–87.
3 See Pilliod 2001, pp. 91–94.
4 Ibid., p. 251 note 54.
5 Ibid., pp. 91–92.
6 Cox-Rearick 1987, pp. 160–162; see also Brock 2002, p. 166.

Cat. no. 84
AGNOLO BRONZINO (1503–1572)
Portrait of Duke Cosimo I de' Medici as Orpheus
c. 1537–1539
Oil on panel
93.7 x 76.4 cm
Philadelphia Museum of Art, Gift of Mrs. John Wintersteen
(1950-86-1)

Provenance: possibly Simone Berti, Florence, 1650; property of Lun; sale, Christie's, London, 14–15 March 1777 (as *Orpheus* by Bronzino), purchased by Serafini; Maj. Eric Knight, Kidderminster, Worcestershire, by 1939; Roland, Browse, and Delbanco, London, 1948; purchased by Mrs. John (Bernice McIlhenny) Wintersteen for the Philadelphia Museum of Art's seventy-fifth anniversary, 1950.

References: Simon 1985; Tucker 1985; Cox-Rearick 1987, pp. 158–159; Plazzotta 1989; Cox-Rearick 1993, p. 33; Brock 2002, pp. 171–174; J. Cox-Rearick in Florence, Chicago, and Detroit 2002–2003, pp. 153–154; Tazartes 2003, pp. 108–109; Florence, Chicago, and Detroit 2002–2003, no. 17; Philadelphia 2004, no. 38; E. Cropper in Philadelphia 2004, pp. 28–30; C.B. Strehlke in Philadelphia 2004, pp. 130–133.

Notes

1 P. Innocenti, "Formazione cinquecentesca e dispersione seicentesca di una biblioteca laica: I libri di Giovanni e Simone Berti," in *Il bosco e gli alberi: Storie di libre, storie di biblioteche, storie di idee* (Florence, 1984), vol. 1, pp. 105–257. I thank Elizabeth Cropper for this reference.

Cat. no. 85
AGNOLO BRONZINO (1503–1572)
Portrait of a Man (Pierantonio Bandini)
c. 1550–1555
Oil on panel
106.7 x 82.5 cm
National Gallery of Canada, Ottawa (3717)

Provenance: Vincenzo Fraschetti, Palazzo Guigni, Florence; Volpi, Florence; Eduard Simon, Berlin, before 1906; sale, Cassirer, Berlin, 10–11 October 1929, lot 11; with Knoedler, London; purchased from Knoedler 1930.

References: Laskin and Pantazzi 1987, pp. 44–45 (with bibliography); Costamagna 1988, p. 23; M. Pantazzi in Franklin 2003, p. 86; Cox-Rearick and Westerman Bulgarella 2004, pp. 101–159; Calafati 2004.

Notes

1 See the correspondence between Elia Volpi, a Florentine dealer, and Wilhelm von Bode, director of the Berlin museums, who must have recommended its purchase to Simon (Zentralarchiv, SMPK, Nachlass Bode 5672/2 Volpi, 31 October 1904). For the early literature on the painting see Laskin and Pantazzi 1987, vol. 1, pp. 51–52.
2 Like the Ottawa work, the Sabauda painting is supported on three vertical panels. As well, the red silk coat, or *zimarra*, has the same leaf pattern as in the coat worn by the sitter in the Ottawa portrait, and it is similarly edged with velvet. This pattern also occurs in two northern paintings dating somewhat earlier in the century – on the green backdrop curtain in Holbein's *Ambassadors* (c. 1520, National Gallery, London) and on the black sleeve of Bartel Beham's *Bavarian Prince* (1531, National Gallery of Canada), as well as in a number of Italian pictures. Most notably it was identified with the burial garments of the young Don Garcia de' Medici

and thus was likely of Florentine manufacture; see M. Westerman Bulgarella, "Un Damasco Mediceo: Ricerche sulla origine, significato e uso nella pittura fiorentina del cinque e seicento," *Jacquard* 30 (1996–1997), pp. 2–6, 13. The Sabauda portrait by Bronzino was acquired in Genoa by Carlo Felice, king of Sardinia, together with the Durazzo palace, in 1824. No early trace of the picture has come to light in the Durazzo collection; see L. Leoncini, *Da Tintoretto a Rubens: Capolavori della Collezione Durazzo*, exh. cat. (Genoa, 2004), pp. 45, 68 note 3.
3 R. D'Azeglio, *La Reale Galleria di Torino illustrata* (Turin, 1836), vol. 1, p. 219. Cosimo and Eleonora, second daughter of Don Pedro da Toledo, the Spanish viceroy of Naples, were married in 1539.
4 Apart from the facts that no such portraits are recorded in the Medici archives and that Cosimo was never portrayed with a long forked beard, the Turin portrait bears little resemblance to other portraits of Eleonora. Cox-Rearick and Westerman Bulgarella, however, have recently revived this identification.
5 In the course of writing his doctoral thesis for the University of Florence (2004) on the palace that the renowned architect Bartolomeo Ammanati built for Simone da Firenzuola, Marco Calafati came across this document and generously shared his findings with the present writer. Calafati concludes that the sitter was Firenzuola himself.
6 See Ginori Lisci 1972, vol. 1, pp. 457–461.
7 F. Bocchi, *Le bellezze della Città di Firenze*, ed. G. Cinelli (Florence, 1677), pp. 489–492. Bocchi's guide of 1591 describes only the palace and its garden (p. 202), whereas in the 1677 edition sculptures from the garden of Cardinal Ottavio Bandini are singled out. A number of paintings are mentioned, including an untraced *Santa Maria Maddalena* by Bronzino, but it is not said how they were acquired. Although no reference is made to Bronzino's portrait of Pierantonio, and no record from before 1904 is yet known of the painting in the palace, it is logical to assume that it may have entered as part of Cassandra's inheritance from her father, Giovanni, who predeceased Cardinal Ottavio, or from other descendants of the Bandini family. The Bandini and Giugni papers, preserved at the Archivio Niccolini da Camugliano in Florence, are currently inaccessible.
8 Vasari 1967, vol. 8, p. 16; Vasari 1996, vol. 2, p. 870.
9 Francesco served at times as Michelangelo's banker, and they were distantly related through the Baroncelli family. Sometime before Michelangelo died he gave Francesco his late *Pietà* group, today in Florence Cathedral but for many years at the Bandini villa at Monte Cavallo. For Michelangelo's Florentine obsequies, Vasari corresponded with the artist's nephew suggesting he approach the Bandini to see if they might relinquish the piece so that it could be placed on the artist's tomb; see Frey 1941, pp. 67, 71.
10 See *Dizionario Biografico degli Italiani*, entry on Pierantonio Bandini; J. Delumeau, *Vie économique et sociale de Rome dans la seconde moitié du XVIᵉ siècle* (Paris, 1957), vol. 2, pp. 884, 911–912. Pierantonio pursued various banking partnerships, first with his brother Alemanno, then with his sons Orazio and Mario. He also judiciously arranged marriages for members of his family. One daughter married a son of the Corsi family, and another, Dianora, married a Strozzi – both were Florentine families with banking ties. Orazio wed Caterina Giustiniani, daughter of Giuseppe Giustiniani of the powerful Genoese banking family in Rome; she was sister to the noted patrons Cardinal Benedetto and Marchese Vincenzo Giustiniani (*Caravaggio e I Giustiniani*, exh. cat., ed. S. Danesi Squarzina [Rome, 2001]). Pierantonio's eldest son, Francesco, was an ecclesiastic closely linked with the Camera Apostolica.

11 In 1589, when Henry III was assassinated, considerable funds lent to him remained unrecovered, and Mario Bandini, who had previously enjoyed a position at the Valois court, was imprisoned until 1594. In Rome the Bandini bank was saved through loans from, among others, the Giustiniani, to whom they conceded part of their palace. At the time of Pierantonio's death (Archivio di Stato, Rome, Notai Auditor Camerae, Notaio Petrus Catalonius, vol. 1552, p. 769) two other Genoese banking families, the Herrera and Costa, rented the remainder.
12 See F. Trinchieri Camiz, "The *Pietà* in Rome," *Michelangelo's Florence Pietà*, ed. J. Wasserman (Princeton, 2003), pp. 99–107, 161–163.
13 Cited in note 11 above. Of the portraits, there is, on p. 756, line 31, "un alto quadro senza cornice d'un retratto"; on p. 756v, line 5, "un quadretto con doi ritratti di donna"; line 21, "quattro quadri di ritratti diversi"; on p. 758v, line 1, "Doi ritratti di Cardinali"; line 2, "un altro a Piant..."; line 3, "quattordici quadri diversi d'Euomini et donne"; line 5, "Un retratto de Pietro Stozzi"; p. 761, "Dui quadretti di tele dipinti à olio un retratto de padre e, madre di Pier Antonio secondo dicono"; p. 764v, line 3, "Un retratto de Pio V"; line 4, "un retratto di Gr[egorio XIII?]"; line 6, "un quadro del ritratto della C ... Foirenza tela."
14 In Francesco's will of 29 September 1562 (Archivio di Stato, Rome, Notai Auditor Camerae, Notaio Caesar Quintius Lottus, vol. 3920, pp. 287–289), Pierantonio was bequeathed a house "al canto de' Pazzi e del Proconsolo."
15 Fondazione Caetani, Rome, Archivio Giustiniani-Bandini, Busta 3, fasc. 42.
16 In both the inventory made following Cardinal Ottavio's death in 1629 and in Bocchi-Cinelli's reference to works inherited by Cassandra Bandini in the Giugni palace there is mention of a marble Venus. In the inventory two "*amorini*" were included, whereas in the guide there is only one: "Venere di marmo, e maniera Greca con un Amorino da parte, figure piccola ma di pregio" (1677, p. 490). No *amorino* is present here and the colour itself is likely a conceit typical of the artist, perhaps inspired by Cosimo and Francesco de' Medici's current interest in carving lapus lazuli. That the statue is antique is evident from the missing head and truncated arm, yet the figure is mounted on a distinctly Florentine Mannerist base, with garlands and masks that must be of the artist's own invention. This feature cannot be taken to represent an existing base, for infrared reflectography reveals that Bronzino changed the design from a stepped base to the one we see in the picture.
17 Cardinal Bandini's bust was made by Giuliano Finelli before his death in 1629, whereas those of Pierantonio and Cassandra were not only posthumous but executed some forty or more years after their deaths. See D. Dombrowski, *Giuliano Finelli: Bildhauer zwischen Neapel und Rom* (Frankfurt, 1997), pp. 96–98, 323.

Cat. no. 86
FRANCESCO D'UBERTINO VERDI, CALLED BACHIACCA (1494–1557)
Portrait of a Young Man with a Lute (Allegory of Youth and Love)
c. 1525–1529
Oil on panel
97.5 x 72 cm
Inscriptions: *CITO PEDE LABITUR* [A]*ETAS*
New Orleans Museum of Art (61.75)

Provenance: Alexander Barker, London and Hatfield, South Yorkshire; Barker sale, Christie's, London, 6 June 1874, lot 43, and 21 June 1879, lot 512; P. and D. Colnaghi, London, 1879; Charles Butler, London and Warren Wood, Hatfield, Hertfordshire, by 1893–1894; Sir Alfred Beit, London and Tewin Water, Welwyn, Hertfordshire; Sir Otto John Beit, London and Tewin Water, Welwyn, Hertfordshire; Mrs. Arthur Bull (Alice Angela Beit), Tewin Water and Bryndewen, Gwent, 1930–1946; Bull sale, Christie's, London, 25 October 1946, lot 4; Contini Bonacossi, Florence; Samuel H. Kress collection, 1950–1953; National Gallery of Art, Washington, Kress loan, 1951; Isaac Delgado Museum of Art, New Orleans Museum of Art, from 1953.

References: Ffoulkes 1894, p. 172; Venturi 1925, vol. 9, pp. 463–464; McComb 1926, pp. 157–158; Scharf 1937, pp. 65–66; Salvini 1939, p. 522; Merritt 1961, p. 32 note 9; Baltimore 1961, pp. 37–38, no. 9; Berenson 1963, vol. 1, p. 20; Nikolenko 1966, pp. 14–15, 48; Shapley 1966–1973, vol. 3, pp. 7–8; De Mirimonde 1967, p. 322; Caldwell 1975, pp. 297–309; Colbert 1978, pp. 64–67; La France 2002, no. 38.

Notes
1 A. Scharf, "Neues zu Bacchiacca," in *Festschrift für Walter Friedländer zum 60. Geburtstag am 10. März 1933*, ed. D. Sauer (Florence: Kunsthistorisches Institut, 1933), pp. 527–537; published in English in 1937.
2 Caldwell unconvincingly identified the young man as the Ferrarese poet Matteo Maria Boiardo and the old man as Cardinal Pietro Bembo, based on circumstantial evidence and perceived similarities with later engraved and stamped portraits. Shapley offered that the young man may be the Florentine humanist Agnolo Poliziano. F. Schmidt-Degener ("An Unidentified Portrait of an Old Man," *The Burlington Magazine* 74 [1939], pp. 234–239) identified the old man as Pope Hadrian VI on equally questionable evidence. Berenson (1963) first proposed that a painting of the *Triumph of Time* (formerly David M. Koetser Gallery, Zurich) was a fragment of a possible third portrait, an idea later developed by Caldwell (1975). But the *Triumph of Time* does not appear to have been cut down and, as Colbert (1978) noted, its elongated figures and simplified forms are by Bachiacca's studio.
3 See J. Herald, *Renaissance Dress in Italy 1400–1500* (London, 1981), p. 53ff.; R. Levi Pisetzky, *Storia del costume in Italia* (Milan, 1964–1969), vol. 2, pp. 323, 326. The costume is similar to that worn by Poliziano in Domenico Ghirlandaio's frescoes of the *Confirmation of the Rule* in the Sassetti chapel in Santa Trinita, Florence, and in the lower-left corner of the *Annunciation to Zacharias* in Santa Maria Novella, Florence.
4 The fretted six-course lute, with five pairs of strings and one single string, appears in Italian paintings from about 1475 (for example, Giovanni Bellini's San Giobbe altarpiece of about 1487, in which the central angel at the foot of the throne holds a similar lute, also plucked with the thumb). See D. Alton Smith, *A History of the Lute from Antiquity to the Renaissance* (Lute Society of America, 2003), p. 53. Lutes of this type were produced throughout the sixteenth century; an example is the six-course lute by Friedrich Pryffer, of about 1546,

in the Warburg-Stiftung, Eisenach (illustrated by Smith between pages 94 and 95). On the lute as a symbol of both eros and death see Smith, pp. 95–96 notes 1 and 2.
5 "NEC QUE PRAETERIT HORA REDIRE POSTEST."
6 See Hind 1938–1948, vol. 3, p. 191 (Love), p. 193 (Death).
7 Levi D'Ancona 1977, pp. 193–195, no. 81 (jasmine), pp. 113–114, no. 45 (cornflower).
8 Bartsch 25, v. 1507.
9 Gabinetto Disegni e Stampe degli Uffizi, 599E verso.
10 Bachiacca (with his elder brother Baccio d'Ubertino) trained in Perugino's studio around 1505–1515, where he may have had direct contact with the *Triumph of Chastity*. Bachiacca relied on drawings after Perugino's works throughout his long career.
11 Bartsch 78, c. 1510, and Bartsch 74, c. 1517, respectively. The city gate in the left distance of the Kassel *Old Man with a Skull* also derives from Lucas van Leyden's *Prodigal Son*.
12 On the Italian reception of northern European art see P. Nuttall, *From Flanders to Florence: The Impact of Netherlandish Painting 1400–1500* (New Haven, 2004).
13 Archivio di Stato, Florence, Accademia del Disegno, 1 (*Compagnia di San Luca*), fol. 8v, and Medici e Speziali, 11 (*[Matricole] Libro Verde per Firenze da 1523 a 1546*), fol. 53v.

Cat. no. 87
FRANCESCO D'UBERTINO VERDI, CALLED BACHIACCA (1494–1557)
Portrait of a Woman with a Music Book
c. 1540–1545
Oil and gold leaf on panel
103 x 80 cm
The J. Paul Getty Museum, Los Angeles (78.PB.227)

Provenance: Marchese Lamberto Frescobaldi, Florence, by 1746, and at least until 1801 (as Bronzino); Vernon James Watney by 1925–1928; Oliver Vernon Watney, Cornbury Park, Oxfordshire, 1928–1967; Watney sale, Christie's, London, 23 June 1967, lot 24; J. Paul Getty, Sutton Place, Surrey, 1967–1978; purchased by the Getty Museum, 1978

References: Berenson 1963, vol. 1, p. 19; Schissler 1972, no. 51; Colbert 1978, p. 78; Tongiorgi Tomasi 1984, p. 41; McIver 1992, no. 15; Jaffé 1997, p. 4; La France 2002, no. 62.

Notes
1 The attribution to Bachiacca is supported by Schissler, Colbert, and others. According to letters in the painting's file at the Getty Museum, a few scholars, such as Ellis Waterhouse (1981) and John Shearman (1996), doubted the attribution, perhaps influencing David Jaffé to add a question mark after the artist's name in the 1997 summary catalogue.
2 In documents, at least three Verdi family artists employed the nickname Bachiacca: Francesco d'Ubertino Verdi, his brother Antonio d'Ubertino Verdi, and Francesco's eldest son, Ubertino di Francesco Verdi. See La France 2002, p. 65ff.
3 R. Levi Pisetzky, *Storia del costume in Italia* (Milan, 1964–1969), vol. 3, pp. 90–91.
4 See C. Kovesi Killerby, *Sumptuary Law in Italy 1200–1500* (Oxford, 2000).
5 See La France 2002, pp. 183–184, docs. 76–81 (Archivio di Stato, Florence, GM 101, insert 1, fol. 16r, 28r, 40r–41r, 43r–44v, 63r, 67r–v, 68r). Only one of these documents has been previously published; see Adelson 1990, p. 524, doc. 54.
6 See L. Jonsson, *Birds of Europe* (London, 1992), p. 480; P. Savi, *Ornitologia Toscana* (Pisa, 1827), vol. 1, p. 93ff.

7 The blue tit also has a bright yellow breast (Jonsson, *Birds of Europe*, p. 466; Savi, *Ornitologia Toscana*, vol. 2, pp. 15–16). Unfortunately, the painted surface of the *Woman with a Songbook* is mildly abraded. In my opinion, traces of a yellow glaze remain on this bird's breast, an observation that has yet to be confirmed through scientific analysis.
8 Jonsson, *Birds of Europe*, p. 380; Savi, *Ornitologia Toscana*, vol. 1, pp. 296–297.
9 Jonsson, *Birds of Europe*, p. 486; Savi, *Ornitologia Toscana*, vol. 1, p. 190.
10 On the *scrittoio* see F. Vossilla, "Cosimo I, lo scrittoio del Bachiacca, una carcassa di capodoglio e la filosofia naturale," *Mitteilungen des Kunsthistorischen Institutes in Florenz* 37:2/3 (1993); for the tapestries see Meoni 1998, pp. 142–147, nos. 11–14, pp. 72–85, nos. 24–33.
11 I thank Professors Stanley Boorman and Wendy Heller for these observations.
12 Notes in the Getty Museum file.

Cat. no. 88
FRANCESCO D'UBERTINO VERDI, CALLED BACHIACCA (1494–1557)
The Virgin and Child with Saints Elizabeth and John the Baptist
c. 1545
Oil on panel
120.7 x 90.8 cm
Frick Art and Historical Center, Pittsburgh (1970.051)

Provenance: Count Ruberto Serristori, Florence; sale, Salecchi, 1956; Wildenstein Galleries, New York, 1958; Helen Clay Frick Foundation, Pittsburgh, since 1969.

References: Poggi 1908, p. 279; Berenson 1909a, pp. 108–110; Venturi 1925, vol. 9, p. 474; McComb 1926; Berenson 1932, p. 35; Salvini 1939, p. 522; Marcucci 1958, p. 26; Merritt 1961, pp. 22–23; Baltimore 1961, p. 40, no. 12; Berenson 1963, vol. 1, p. 20; Nikolenko 1966, pp. 25, 53; Hovey 1972, p. 6; Hovey 1975, pp. 57–58; Colbert 1978, p. 68; La France 2002, no. 50; La France 2003, p. 241.

Notes
1 On the Florentine domestic interior see A. Schiaparelli, *La casa fiorentina e i suoi arredi nei secoli XIV e XV*, 2 vols. (Florence, 1983); J.K. Lydecker, *The Domestic Setting of the Arts in Renaissance Florence* (Baltimore, 1987); P. Thornton, *The Italian Renaissance Interior: 1400–1600* (New York, 1991).
2 C. von Holst, "Florentiner Gemälde und Zeichnungen aus der Zeit von 1480 bis 1580, Kleine Beobachtungen und Ergänzungen," *Mitteilungen des Kunsthistorischen Institutes in Florenz* 15 (1971), pp. 19–20.
3 The painting is now in the Museo di San Marco, on loan from the Uffizi (inv. 1574); see Padovani 1996.
4 La France 2002, nos. 90 and 18 respectively.
5 La France 2002, nos. 48 (ex Niccolini, Florence), 49 (Misericordia, Florence).
6 Shearman 1965, vol. 1, pp. 66–67; Natali 1998.
7 Bronzino depicted himself in the guise of David (with a harp) and Bachiacca as Isaiah (with a saw); see R. Gaston, "Iconography and Portraiture in Bronzino's *Christ in Limbo*," *Mitteilungen des Kunsthistorischen Institutes in Florenz* 27:1 (1983), pp. 51–52, 54.

Cat. no. 89
BACCIO BANDINELLI (1493–1560)
Two Male Nudes Fighting, Watched by Three Others
c. 1510–1511
Black chalk
27.5 x 35.9 cm
Annotations: in pen and brown ink, [Ro]*sso Fiorentino*
British Museum, London (1895-9-15-562)

Provenance: Sir John Charles Robinson; John Malcolm.

References: Robinson 1876, no. 125; Kusenberg 1931, no. 49; Barocchi 1950, p. 223 note 3; Berenson 1961, no. 992; Pouncey 1961, p. 324; Stillman 1961, p. 38; Stewart 1963, no. 410; Ciardi Dupré 1966, p. 168 note 14; Providence 1973, no. 98; Brandt 1974, p. 79 note 236; Carroll 1976, pp. 529–530; Ward 1978, no. 6; Florence 1980a, no. 6; Ward 1982, no. 201; E.D. Schmidt in Vinci 2001, no. II.10; Béguin and Costamagna 2003, p. 9.

Notes
1 Vasari-Milanesi 1878–1885, vol. 6, p. 138.
2 For the literature on the painting since its rediscovery in 1996 see Béguin and Costamagna 2003, especially p. 7.
3 On the *Entellus and Dares* (Bartsch XIV.159.195) see J.V. Quarrier in Providence 1973, no. 89; the impact of this motif on Bandinelli's drawing was first noted in Brandt 1974, p. 79 note 235. Stillman (1961) has also suggested that the left-hand boxer figure derived from one of the sons in Michelangelo's Sistine *Drunkenness of Noah*. Stewart (1963, p. 410) related the poses to Michelangelo's *Flagellation* drawings of 1516.
4 For the Roman *Horse Tamers* on the Quirinal Hill see Bober and Rubinstein 1986, no. 125.
5 For the copies of Michelangelo's lost figure drawing (Uffizi 6469F, Louvre 685 recto) see Joannides 1994, p. 12 (who first noted Bandinelli's use of the figure); see also P. Joannides. "'… Non volevo pigliar quella maniera': Rosso and Michelangelo," in Ciardi and Natali 1996, pp. 136–139; Joannides 2003, no. 64. Stewart (1963, p. 410) and Ward (1988, no. 13) suggested that the figure derived from Michelangelo's preparatory drawings for Sebastiano del Piombo's *Flagellation*, produced in the spring and summer of 1516, but the resemblance is rather general.
6 For the *Marforio* see Bober and Rubinstein 1986, no. 64. Vasari reports that Bandinelli's fascination with the *Marforio* went back to his boyhood, when he supposedly carved a version of the ancient figure out of snow (Vasari-Milanesi 1878–1885, vol. 6, p. 135).
7 Vasari-Milanesi 1878–1885, vol. 5, pp. 22–23; Vasari 1966–1987, vol. 4, p. 360.
8 Vasari-Milanesi 1878–1885, vol. 6, pp. 138–139.

Cat. no. 90
BACCIO BANDINELLI (1493–1560)
The Martyrdom of Saint Lawrence
1526
Pen and brown ink and brown wash
35.5 x 56.9 cm
Musée du Louvre, Paris (99)

Provenance: Everhard Jabach (L. 2961).

References: Jabach 1671, no. 82; Davidson 1961, no. 6; Ciardi Dupré 1966, p. 155; D. Heikamp in Vasari 1967, vol. 6, p. 29 note 1; Harprath 1977, no. 5; Monbeig Goguel 1979, no. 10a; Ward 1982, no. 327.

Notes
1 Vasari remarked often about Bandinelli's incompetence or lack of interest in the finer points of architecture: "Bandinelli … did not appreciate architecture or did not know anything about it" (Vasari-Milanesi 1878–1885, vol. 5, p. 358); "Baccio never cared about the art of architecture" (vol. 6, p. 144); "in architecture Baccio was worth little" (vol. 6, p. 163); "Baccio, who never took any account of architecture" (vol. 6, p. 174).
2 Ward 1982, no. 63; A. Gnann in Mantua 1999, no. 270.
3 Ciardi Dupré 1966, pp. 155–156, 169 note 30.
4 As observed by Davidson (1961, no. 6) and echoed by Oberhuber (1966, no. 142). The work is accepted as autograph by all other writers: Delaborde 1888, no. 85; Ciardi Dupré 1966, p. 169 note 30; Harprath 1977, no. 5; Cox-Rearick 1989, p. 78 note 32; Ward 1982, no. 249; A. Gnann in Mantua 1999, no. 268.
5 Ward 1982, no. 327.

Cat. no. 91
MARCANTONIO RAIMONDI
(C. 1470/1482–1527/1534)
The Martyrdom of Saint Lawrence, after Baccio Bandinelli
1526
Engraving, first state
43.6 x 57.5 cm
Inscriptions: *Baccius Brandin. inven.*; engraver's monogram *MAF*
Bartsch XIV.104-1
Albertina, Vienna (DG1970/325)

Provenance: Imperial Library.

References: Oberhuber 1978, vol. 26, p. 135; Ward 1982, no. 249; Los Angeles 1988–1989, no. 38; Cox-Rearick 1989, p. 43; A. Gnann in Mantua 1999, no. 269.

Notes
1 Vasari-Milanesi 1878–1885, vol. 6, p. 147.
2 For the legend and iconography of Saint Lawrence see Kaftal 1952, cols. 614–622; Farmer 1978, pp. 237–238; L. Petzoldt in *Lexikon der Christlichen Ikonographie* (Rome, 1974), vol. 7, cols. 374–380. In his account of the *Saint Lawrence*, Vasari confuses the persecution of Valerian, in which Saint Lawrence died, with the better-known campaign of his predecessor Decius, who reigned from 249 to 251 (Vasari-Milanesi 1878–1885, vol. 6, p. 147).
3 On the use of sacred imagery to allude to the political vicissitudes see also cat. no. 95.
4 Michelangelo had been intensely preoccupied by this commission, producing finished designs and quarrying blocks, between 1524 and late 1526, when the impending arrival of the imperial armies put a temporary halt to this and all other papal commissions; see Reiss 1992, pp. 45–46, 53.
5 Poggi 1965–1983, p. 210; Reiss 1992, p. 48.
6 Immediately following his account of the *Saint Lawrence* (Vasari-Milanesi 1878–1885, vol. 6, p. 147), Vasari writes, "Dopo questo, tornatosene a Firenze …" ("After this, having returned to Florence …").
7 Bandinelli is documented in Rome between 24 April and 23 October 1526, when he personally collected a number of disbursements from the Benintendi bank there (Waldman 2004, no. 150). He evidently had been back in Florence for some weeks – long enough to reorganize his workshop – by 12 January 1527, when he sent a recently hired assistant, the fifteen-year-old Giorgio Vasari, to collect the interest on his *Monte* account (ibid., no. 114).
8 Vasari-Milanesi 1878–1885, vol. 5, p. 419.

9 See Waldman 2004, no. 680.
10 On the complexity, range, and variety of strokes employed in Raimondi's engraving see Davidson (1961, p. 5).
11 The best known of the drawn copies is a full-size red chalk rendition in Munich, by an anonymous draftsman (fig. 90.2), which has often been misidentified as Bandinelli's original drawing.
12 Smith 1952, pp. 204–205.
13 On the use of Raimondi's engravings by nineteenth-century artists see E. Broun, "The Portable Raphael," in Shoemaker and Broun 1981, pp. 36–46.

Cat. no. 92
BACCIO BANDINELLI (1493–1560)
The Lamentation
c. 1526–1527
Pen and brown ink and brown wash
25.3 x 40.3 cm
Galleria degli Uffizi, Florence (539F)

References: Ferri 1890, p. 31; Antal 1956, pp. 20, 48; Forlani 1962, no. 40; Petrioli Tofani 1972, no. 49; Carroll 1976, p. 537; Ward 1982, no. 68; Cox-Rearick 1989, p. 80 note 60; Petrioli Tofani 1991, p. 229; Cox-Rearick 1993, pp. 177, 379 note 47; Costamagna 1994, pp. 68, 97 note 113.

Notes
1 On the early history and Renaissance rebuilding of Cestello see Luchs 1977.
2 Vasari-Milanesi 1878–1885, vol. 6, p. 151.
3 Ibid., p. 152.
4 See Ward 1982, no. 341.
5 On the representation of Christ in the changing devotional climate of the early sixteenth century see Cox-Rearick 1993, pp. 190–194; Nagel 2000 (with bibliography).
6 An example is Bronzino's *Pietà* in the Uffizi, painted for the Cambi chapel in Santa Trinita in 1529, which functioned for well over a century as the backdrop for celebrations of the Magdalen's feast day. On the liturgical functioning of Bronzino's *Pietà with Saint Mary Magdalen* (which the *ricordi* of the patron, Lorenzo Cambi, refer to simply as the "quadro di Santa Maria Madelena") see Waldman 1997a.
7 On Botticini's altarpiece see Luchs 1977, pp. 77–79.
8 On the choir chapel of Cestello see Luchs 1977, pp. 28–30.
9 Luchs 1977, pp. 29, 374.
10 Ibid., p. 30.
11 Ibid., p. 278, citing Archivio di Stato, Florence, Compagnie Religiose Soppresse, 428, no. 96, fol. 30v.
12 Luchs 1977, pp. 79, 308.
13 For the dimensions of the *tramezzo* see Luchs 1977, fig. 8.

Cat. no. 93
BACCIO BANDINELLI (1493–1560)
The Crucifixion
c. 1520–1529
Pen and brown ink and brown wash
38 x 55.2 cm
Albertina, Vienna (14181)

Provenance: Sir Peter Lely (L. 2092); P.H. Lankrink (L. 2090); Charles, Prince de Ligne.

References: Florence 1980a, no. 72; Ward 1982, no. 409; Ward 1988; Birke and Kertész 1992–1997, vol. 3, pp. 1830–1831.

Notes
1 Ward 1982, no. 409; Ward 1988, p. 76. On the commission for the choir of Florence Cathedral see Waldman 1997c and Waldman 1999.
2 Waldman 1999, pp. 202–203.

Cat. no. 94
BACCIO BANDINELLI (1493–1560)
The Drunkenness of Noah
c. 1550
Pen and brown ink over black chalk
36.1 x 28.6 cm
British Museum, London (1895-9-15-549)

Provenance: Sir Peter Lely (L. 2092); Sir Thomas Lawrence (L. 2445); Samuel Woodburn; his sale, Christie's, 4 June 1860, no. 42; John Malcolm.

References: Robinson 1876, no. 112; Bean 1960, under no. 3; Stillman 1961, p. 8; D. Heikamp in Vasari 1967, vol. 6, p. 20 note 1; Ward 1982, no. 195; Turner 1986, no. 92; Ward 1988, no. 40; Waldman 1999.

Notes
1 On the history of the choir prior to Cosimo's rebuilding see Waldman 1997c; Waldman 1999, pp. 1–68.
2 Vasari-Milanesi 1878–1885, vol. 6, pp. 175–177.
3 For a discussion of the entire series see Ward 1988, no. 39. Ward here enumerates fourteen sheets, but one of these, *The Blind Lamech Slaying His Grandfather* (formerly in the Woodner Collection, New York), is, in my opinion, nothing other than a crude modern pastiche.
4 On the troubled vicissitudes of the choir commission see Waldman 1999.
5 Waldman 2004, no. 603.
6 Ibid., no. 606.
7 Waldman 1999, pp. 126–128, 192–198.

Cat. no. 95
BACCIO BANDINELLI (1493–1560)
The Flagellation of Christ
1532–1533
Marble
63 x 81 cm
Musée des Beaux-Arts, Orléans (A.202 MII)

Provenance: Château de Dampierre-en-Burly (Loiret), 1829; donated by the château's owner, M. de Béhague, to the Musée des Beaux-Arts, Orléans, 1829; transferred to the Musée Historique, Orléans, between 1855 and 1882; believed missing after 1946; rediscovered in the storerooms of the Musée Historique et Archéologique, Orléans, 1992; transferred to the Musée des Beaux-Arts, 1994.

References: Gaborit 1994; É. Moinet in Tours 1996–1997, pp. 272–275, no. 80; Schmidt 2000, pp. 251, 253; E.D. Schmidt in Vinci 2001, no. II.10; E.D. Schmidt in Florence, Chicago, and Detroit 2002–2003, no. 50.

Notes
1 Vasari-Milanesi 1878–1885, vol. 6, p. 156: "a baciare i piedi di Sua Santità, e portò seco un quadro, alto un braccio e largo uno e mezzo, d'un Cristo battuto alla colonna da due ignudi, il quale era di mezzo rilievo e molto ben lavorato. Donò questo quadro al Papa, insieme con una medaglia del ritratto di Sua Santità, la quale aveva fatta fare a Francesco dal Prato suo amicissimo, il rovescio della quale era Cristo flagellato."
2 For the medal by Francesco dal Prato see Habich 1922–1923, p. 118, plate 80, no. 1; Attwood 2003, vol. 1, pp. 328–329.
3 Laschke 1998.
4 See Leithe-Jasper 1986, no. 125.
5 The variation in Christ's hand is typical of the kind of liberties that were taken with casts of sculpture before the second half of the nineteenth century. The alteration of Christ's left hand in the Martelli cast was in all likelihood due to the difficulty of rendering the undercutting of the original, deeply modelled hand in a plaster mould.
6 Vasari-Milanesi 1878–1885, vol. 6, p. 156: "espose Baccio gl'impedimenti e le noie avute nel finire il suo Ercole, pregandola che col Duca operasse di dargli commodità di condurlo al fine; ed aggiugneva che era invidiato e odiato in quella città: e essendo terribile di lingua e d'ingegno, persuase il papa a fare che 'l Duca Alessandro si pigliasse cura che l'opera di Baccio si conducesse a fine, e si ponesse al luogo suo in piazza."
7 Waldman 2004, no. 227.
8 On the date of the unveiling see Waldman 2004, no. 237.

Cat. no. 96
BACCIO BANDINELLI (1493–1560)
Jason
c. 1546
Bronze
39.8 cm high
Inscriptions: on the support of the left foot, *BACCIVS BAN. FACIEBAT*
Museo Nazionale del Bargello, Florence (1879:423)

Provenance: Guardaroba of Duke Cosimo I de' Medici.

References: Florence 1980b, no. 652; Massinelli 1991, pp. 57–62.

Notes
1 Vasari-Milanesi 1878–1885, vol. 6, p. 153.
2 On the Poggini and Bandinelli see M. Chiarini in Florence 1980b, p. 320.

3 The work also appears in inventories of 1555 and 1560; see Waldman 2004, nos. 977, 1041, 1067, 1362. It was not among the four statuettes by Bandinelli (*Hercules, Cleopatra,* and two figures of *Venus*) that were chosen for display in the Tribuna of the Uffizi by 1589 (Waldman 2004, no. 1573).
4 A memorandum by ducal major-domo Pier Francesco Riccio dated 23 September 1545 indicates that Bandinelli had offered to cast a group of the *Laocoön* for the duke to give to Francis I, though whether this was meant to be a statuette or a monumental group on the scale of Bandinelli's earlier marble *Laocoön* is uncertain (Waldman 2004, no. 500).
5 Waldman 2004, nos. 455, 461, 476.
6 Ibid., no. 475.
7 For the surviving examples see G. Agosti and V. Farinella in Barocchi 1992, pp. 38–39. Based on an ancient prototype representing a flute-playing satyr, these small bronzes sometimes passed as genuine antiquities in the Renaissance. According to Massinelli (1991, pp. 31–35), the specimen of the *Ignudo della paura* that belonged to the Medici at the time of Lorenzo the Magnificent can be identified with inv. 82 in the Bargello.
8 Waldman 2004, no. 463.
9 Massinelli 1991, p. 35.
10 E. Plon, *Benvenuto Cellini, orfèvre, médailleur, sculpteur: Recherches sur sa vie, sur son œuvre et sur les pièces qui lui sont attribuées* (Paris, 1883), p. 385; Massinelli 1991, p. 35.
11 Massinelli 1991, p. 51.
12 Waldman 2004, no. 704. It is also known that in 1549 Bandinelli borrowed a small bronze statuette of *Hercules* sculpted by him from the Guardaroba of Duke Cosimo I, perhaps with the intention of producing a replica; the borrowed work may be identical to one that the artist brought to the Guardaroba in 1555 (Waldman 2004, nos. 653, 1076).
13 Waldman 2004, no. 473.
14 See, for example, Massinelli 1991, pp. 58, 60; Bober and Rubinstein 1986, p. 72.

Cat. no. 97
AGOSTINO VENEZIANO (C. 1490–AFTER 1536)
Hercules and Cacus, after Baccio Bandinelli
c. 1525
Engraving
12 x 8.4 cm
Bartsch XIV.455
Albertina, Vienna (DG2003/28)

References: Oberhuber 1978, vol. 27, p. 125, no. 455; Schmidt 1996, pp. 101–103; Myssok 1999, p. 246.

Notes
1 Schmidt 1996, pp. 101–103.
2 Vasari-Milanesi 1878–1885, vol. 6, pp. 149–150.
3 V.L. Bush, "Hercules and Cacus and Florentine Traditions," *Memoirs of the American Academy in Rome* 35 (1980), pp. 181–182.
4 Vasari's lengthy and admiring description of the model concludes: "Baccio's aforesaid model is today in the Guardaroba of Duke Cosimo; it is considered a very precious thing by him, and by artists it is considered a rare thing" (Vasari-Milanesi 1878–1885, vol. 6, p. 150).

Cat. no. 98
NICCOLÒ DELLA CASA (ACTIVE C. 1543–1550)
Portrait of Baccio Bandinelli
c. 1544
Engraving, first state
29.7 x 21.9 cm
Inscriptions: *ANT.LARERI.R.; N.D.LA / CASA.; BACCIO BANDINEL / FLO.s*
Passavant VI.4
National Gallery of Canada, Ottawa (41343)

Provenance: Sir Joshua Reynolds (L. 2364); William Esdaile (L. 2617); sale, Sotheby's, London, 20 November 1980, lot 59; David Tunick, Inc., New York, 1988; private collection, United States; David Tunick, Inc., New York, 2003; purchased 2004.

References: Fiorentini and Rosenberg 2002, pp. 42–44.

Notes
1 A.P.F. Robert-Dumesnil, *Le peintre-graveur français* (Paris, 1865), vol. 9, pp. 180–183. See, most recently, A. Ferri in *Dizionario Biografico degli Italiani* (Rome, 1988), vol. 36, pp. 720–721.
2 E. Borea, "Stampe da modelli fiorentini nel Cinquecento," in Florence 1980a, p. 276.
3 See Fiorentini and Rosenberg 2002, pp. 42–44. Eight other impressions of the print are listed at p. 35 note 9. The authors discuss a later engraved portrait after Bandinelli that was started by della Casa, but completed in a copy by Béatrizet.
4 *Discourses on Art*, ed. R. Wark (New Haven and London, 1959), p. 221; see also E. Wind, "The Maenad under the Cross: Comments on an Observation by Reynolds," *Journal of the Warburg and Courtauld Institutes* 1 (1939), pp. 70–71.

Cat. no. 99
NICCOLÒ DELLA CASA (ACTIVE C. 1543–1550)
Portrait of Duke Cosimo I de' Medici, after Baccio Bandinelli
1544
Engraving
43 x 29.5 cm
Inscriptions: *COSMVS MEDICES FLORENTIAE DUX .II.; BACIVS BANDINEL FLO.S 1544; N.D.LA CASA.F.*
Bartsch XV
The Minneapolis Institute of Arts, Gift of Herschel V. Jones, 1926

References: Forster 1971, p. 78; Florence 1980a, no. 691; Ward 1982, no. 424; Ward 1988, no. 36; Choux 1975, p. 177; Irle 1997, p. 65; Vossilla 1997, pp. 264–276; Fiorentini and Rosenberg 2002, p. 35.

Notes
1 As noted by a contemporary, Paolo Giovio (*Dialogo delle imprese militari e amorose* [1551], ed. M.L. Doglio [Rome, 1978]). Giovio adds that the *diamante* "signifies indomitable strength."
2 On Cosimo and Hercules see Forster 1971, pp. 72–82; Cox-Rearick 1984. Ward (1988, no. 36) believed that the print was actually meant to portray Cosimo in the guise of Hercules. But to see the work simply as a Cosimo-Hercules is, I think, to simplify its complex layers of symbolism, which operate in a more polysemously allusive fashion.
3 On Cosimo's adoption of the Augustan zodiacal sign of Capricorn see Forster 1971, p. 86; Cox-Rearick 1984.

Cat. no. 100
ENEA VICO (1523–1567)
The Academy of Baccio Bandinelli, after Baccio Bandinelli
c. 1561–1562
Engraving, third state
30.4 x 47.3 cm
Inscriptions: *Baccius Bandinellus invent. / Enea vigo Parmegiano sculpsit / Romae Petrus Paulus Palumbus formis*
Albertina, Vienna (DG2003/847)

References: Bartsch XV, 305, 49-I, 49-II; Passavant, vol. 16, p. 122 note 49; Colasanti 1905; Pevsner 1940; Parker 1956; Ciardi Dupré 1966; Ward 1978; E. Borea in Florence 1980a, p. 264, no. 688; Olszewski 1981, p. 99, no. 74; Weil-Garris Brandt 1981; Olszewski 1985; Waźbiński 1987; Wiebel 1994, pp. 108–109, no. 57; Cazort et al. 1996, pp. 142–143, no. 35; McCullagh and Giles 1997; Ward 1993; Landau and Parshall 1994, p. 286; Fiorentini 1999, p. 146, no. 30; Barzman 2000; Bury 2001; Béguin and Costamagna 2003; Waldman *Rewriting the Past* (forthcoming).

Notes
1 Pevsner 1940, pp. 39–42; Weil-Garris Brandt 1981, pp. 227–233; Waźbiński 1987, vol. 1, pp. 53–69; Barzman 2000, pp. 4–6.
2 Bury 2001, p. 230.
3 Ward 1993; McCullagh and Giles 1997, p. 398, no. 703.
4 Ward 1978, p. 45, no. 23.
5 Parker 1956, no. 79.
6 Ciardi Dupré 1966, pp. 162–165; Olszewski 1985.
7 Béguin and Costamagna 2003.

Cat. no. 101
NICCOLÒ TRIBOLO (1500–1550)
Design for a Fountain
c. 1540–1549
Pen and brown ink over black chalk
30 x 22.6 cm
Musée du Louvre, Paris (49)

Provenance: Baldinucci (II, 24; Ammanati); purchased by the Louvre, 1806 (L. 1886).

References: Rome 1959, no. 17 (under Ammanati); Keutner 1965, pp. 240–242, note 24; Aschoff 1967, p. 46 note 7; Lloyd 1968, p. 245; Monbeig Goguel 1972, no. 184.

Notes
1 Keutner 1965, p. 241.

Cat. no. 102
BENVENUTO CELLINI (1500–1571)
Satyr
c. 1543–1545
Pen and brown ink and brown and white washes over black chalk
41.6 x 20.3 cm
Inscriptions: in pen and brown ink, *alla porta di fontana / bellio di bronzo p[er] piu / di dua volta il vio b[raccie] 7 / erano dua variati*
National Gallery of Art, Washington, Woodner Collection, Patron's Permanent Fund (1991.190.2)

Provenance: John Barnard (L. 1419), London; Sir Thomas Lawrence (L. 2445), London; Samuel Woodburn; Hans M. Calmann, London; William H. Schab Gallery, New York; purchased by Ian Woodner, New York, 1959; by inheritance to his daughters, Andrea and Dian Woodner, New York, 1990; gift to the National Gallery of Art, 1991.

References: see cat. no. 103.

Notes
1 B. Cellini, *The Life of Benvenuto Cellini Written by Himself*, trans. J.A. Symonds, 3rd ed. (London, 1889), pp. 327–328; B. Cellini, *La Vita*, ed. G.D. Bonino (Turin, 1973), pp. 330–331. For an overview and illustrations of the surviving sculptures for the Porte Dorée see Cox-Rearick 1996, pp. 288–294; Pope-Hennessy 1985, pp. 132–161; Marsden and Basset 2003, pp. 552–563.
2 For the chronology of the Porte Dorée see, most recently, Jestaz 2003, pp. 99–119 (with bibliography).
3 B. Cellini, *The Treatises of Benvenuto Cellini on Goldsmithing and Sculpture*, trans. C.R. Ashbee (London, 1888; New York, 1967), p. 111; B. Cellini, *I trattati dell'orificeria e della scultura*, ed. G. Milanesi (1887), p. 232; Grodecki 1971, pp. 50–51, documents IV, V, VI, pp. 70–72.
4 Marsden and Bassett 2003. Before Marsden's discovery, a bronze satyr's head had been associated with Cellini's mace-bearing satyr for the Porte Dorée; see Bliss 2003, pp. 40–41; Fogelman et al. 2002, pp. 40–41.
5 Today the Woodner *Satyr* is generally accepted as a *modello* executed in France and not a *ricordo* drawn after Cellini's return to Florence. See Marsden and Bassett 2003, pp. 557, 559; Zerner 1996, p. 392 note 4; M. Grasselli, ed., *The Touch of the Artist: Master Drawings from the Woodner Collection* (New York, 1995), pp. 194–197.
6 Marsden and Bassett 2003, p. 559.
7 M. Cole in Nova and Schreurs 2003, pp. 45–47; Herrig 1992, pp. 142–173; Cox-Rearick 1996, pp. 291–292.
8 Marsden and Bassett 2003, p. 555; Fogelman et al. 2002, p. 41. Although the della Valle *Satyrs* were among the famous Roman marble antiquities cast in bronze under the direction of Primaticcio at Fontainebleau, it should be noted that they were not displayed in the Gallery of Francis I and were cast after Cellini's departure from France. See, most recently, G. Bresc-Bautier in *Primatice: Maître de Fontainebleau*, exh. cat. (Paris, 2004), p. 141.
9 On Michelangelo's lost Hercules see S. Frommel in *Primatice*, pp. 213–214; Cox-Rearick 1996, pp. 302–313.
10 Jestaz 2003, pp. 117–119; Bliss 2003, pp. 77–78.
11 Illustrated in Franklin 1994, pp. 65–66.
12 Heikamp 1966, pp. 53–54.
13 Heikamp 1966, p. 54; M. Cole in Nova and Schreurs 2003, p. 47.
14 Marsden and Bassett 2003, p. 555.
15 The presence of white wash has been hitherto unrecorded. I thank Margaret Grasselli for confirming this observation and discussing the technique of the drawing with me.
16 B. Cellini, "Discorso sopra l'arte del Disegno," pp. 1929–1930, in Barocchi 1971.
17 Cellini, *I trattati*, p. 133.
18 On the *Venus and Mars* see Franklin 1994, pp. 263–264; E. Carroll, *Rosso Fiorentino: Drawings, Prints and Decorative Arts* (Washington, 1987), pp. 170–175. On the *Gods in Niches* series see Franklin 1994, pp. 133–137; Carroll, *Rosso Fiorentino*, pp. 96–126.
19 Cellini, *La Vita*, p. 123.
20 See cat. no. 103 below, on the Getty *Satyr*; this drawing's use as a chasing model was first suggested in *Meisterzeichnungen aus sechs Jahrhunderten: Die Sammlung Ian Woodner* (Cologne, 1986), p. 50.
21 On this drawing see Cox-Rearick 1996, pp. 298–302.

Cat. no. 103
BENVENUTO CELLINI (1500–1571)
Satyr
Perhaps modelled c. 1542–1543, cast 1543–1544
Bronze
56.8 cm high
The J. Paul Getty Museum, Los Angeles (85.SB.69)

Provenance: Drey Gallery, Munich, sold to August Lederer, Vienna, 1918; by inheritance to his widow, Serena Lederer, Vienna, 1936; seized by the Nazis, 1938; restituted by the Allied forces to the Austrian government, 1947; restituted by the Austrian government to Erich Lederer, Geneva, 1947; by inheritance to his widow, Elisabeth Lederer, Geneva, 1985; purchased by the Getty Museum, 1985.

References: Pope-Hennessy 1982, pp. 406–412; Goldner 1983, p. 52; Pope-Hennessy 1985, pp. 135–136, 141; Avery 1986; Radcliffe 1988, p. 930; Cox-Rearick 1996, pp. 290–293, 300, 360; Poeschke 1996, p. 211; A. Nova in Turner 1996/2000, vol. 6, pp. 141–142; Bassett and Fogelman 1997, p. 77; Fusco 1997, p. 16; P. Fogelman in Getty Museum 1998, pp. 26–27; P. Fogelman in Fogelman et al. 2002, pp. 38–42; Bliss 2003, pp. 72–93; Marsden and Bassett 2003, pp. 552–563; Jestaz 2003, pp. 105–119, 132.

Notes
1 On the Woodner drawing see cat. no. 102 above; Pope-Hennessy 1982, pp. 406–412; Pope-Hennessy 1985, p. 136.
2 Fogelman et al. 2002, pp. 40–41.
3 Jestaz 2003, p. 99.
4 Bliss 2003, p. 81; Grodecki 1971, pp. 50–51, documents IV, V, VI, pp. 70–72.
5 As in Marsden and Bassett 2003, p. 553, and not as in Jestaz's reconstruction (2003, p. 132).
6 Pope-Hennessy 1985, pp. 225–226.
7 B. Cellini, *The Life of Benvenuto Cellini Written by Himself*, trans. J.A. Symonds, vol. 2 (New York, 1906), pp. 132–135; B. Cellini, *La Vita*, ed. G.D. Bonino (Turin, 1973).
8 For a description of Cellini's indirect casting method see R. Stone, "Antico and the Development of Bronze Casting in Italy at the End of the Quattrocento," *Metropolitan Museum Journal* 16 (1981), pp. 108–109.
9 Marsden and Bassett 2003, pp. 562–563.
10 B. Cellini, *The Treatises of Benvenuto Cellini on Goldsmithing and Sculpture*, trans. C.R. Ashbee (London, 1888; New York, 1967), p. 114; B. Cellini, *I trattati dell'orificeria e della scultura*, ed. G. Milanesi (1887), p. 241.
11 Grodecki 1971, pp. 49–55; G. Bresc-Bautier, "Parisian Casters in the Sixteenth Century" in *Large Bronzes in the Renaissance*, Studies in the History of Art, no. 64 (Washington, 2003), pp. 95–113.
12 Grodecki 1971, p. 53, document VIII, pp. 73–74.
13 Marsden and Bassett 2003, p. 559.

Cat. no. 104
BARTOLOMEO AMMANATI (1511–1592)
Leda and the Swan
c. 1540
Marble
49.5 x 68 cm
Museo Nazionale del Bargello, Florence (73S)

Provenance: collection of the della Rovere dukes of Urbino; collection of the Medici dukes of Florence (acquired in 1631 with the inheritance of Vittoria della Rovere); Florentine State Museums; Museo Nazionale del Bargello since second half of the nineteenth century.

References: Campani 1884, p. 152; Supino 1898, p. 59; Kinney 1976, pp. 25–33; Davis 1977, p. 71; Roethlisberger 1987, p. 67; Poeschke 1992, pp. 196–197; Joannides 1993, p. 818 note 5; E.D. Schmidt in Vinci 2001, no. IV.6, pp. 166–167; Dalli Regoli 2001.

Notes
1 Concerning the fortunes of Michelangelo's painting and the copies made from it see Cox-Rearick 1996, no. VII-4, pp. 237–241; Vinci 2001, pp. 155–167. On Rabelais's likely response to Michelangelo's painting when it was in Lyons see F. Rigolot, "Leda and the Swan: Rabelais's Parody of Michelangelo," *Renaissance Quarterly* 38 (1985), pp. 688–700.
2 See Campani 1884, p. 152; Supino 1898, p. 59.
3 Kinney and Davis, taking up a suggestion by Middeldorf, have rejected Ammanati's authorship. For the attribution to Daniele da Volterra see Joannides 1993, p. 818 note 5.
4 For a more detailed reconstruction of the sculpture's provenance and analysis of its style see E.D. Schmidt, "Bartolomeo Ammannati, Leda col cigno," in Vinci 2001.

Cat. no. 105
PIERINO DA VINCI (C. 1529–1553)
The Death of Count Ugolino della Gherardesca and His Sons
c. 1548
Terracotta
63 x 46.2 cm
Private collection, Paris

Provenance: della Gherardesca collection, Florence, by 1782; private collection, Geneva (by descent); private collection, United States (by descent).

References: Yates 1951, plate 17b; Florence 1960, no. 172; Avery 1995, especially pp. 57, 61 note 13; M. Cianchi in Cianchi 1995, pp. 47–55; Collareta 1995; Nelson 1995a, p. 292; Nelson 1995b; M. Cianchi in Turner 1996/2000, vol. 24, pp. 756–757; Boudon 1998; J.K. Nelson in Florence, Chicago, and Detroit 2002–2003, no. 95.

Notes
1 Vasari-Milanesi 1878–1885, vol. 6, pp. 126–127. Vasari misdescribed two other works made by Pierino for Luca Martini, the *Pisa Restored* (cat. no. 106) and the *River God*, now in the Louvre (see L.A. Waldman in Florence, Chicago, and Detroit 2002–2003, no. 94).
2 Reproduced in Yates 1951, plate 17b (reprinted in Yates 1983, plate 1b).

Cat. no. 106
PIERINO DA VINCI (C. 1529–1553)
Pisa Restored
c. 1552
Marble
74 x 108 cm
Vatican Museums, Vatican City (742)

Provenance: Salviati family; Bartolomeo Cavaceppi, Rome, by 1772; purchased from him by Giovanni Battista Visconti, 1792, on behalf of the Museo Clementino Vaticano.

References: F. Mancinelli in New York 1983, no. 65; M. Cianchi in Cianchi 1995, pp. 47–55; Collareta 1995; Nelson 1995a; M. Cianchi in Turner 1996/2000, vol. 24, p. 757; J.K. Nelson in Florence, Chicago, and Detroit 2002–2003, no. 95.

Notes
1 Vasari-Milanesi 1878–1885, vol. 6, p. 129.
2 On Vasari's portrait, which includes a metal vase inscribed "VIRTUTUM OMNIUM VAS" ("the vessel of all virtues"), see Corti 1989 (with bibliography).
3 For Martini's Dante studies see Nelson 1995b.

Cat. no. 107
GIORGIO VASARI (1511–1574)
The Descent from the Cross
1536–1537
Pen and brown ink and brown wash over black chalk
32.7 x 23.8 cm
Wadsworth Atheneum, Hartford (1951.225)

Provenance: P. and D. Colnaghi, London, 1951; James Junius Goodwin, Hartford.

References: Davidson 1954, pp. 228–231; Barocchi 1964b, pp. 12, 123; Notre Dame 1970, p. 82, no. D30; Petrioli Tofani 1985, pp. 418–419; Jacks 1998, no. 13; Härb 1998, p. 84.

Notes
1 Frey 1923–1930, vol. 2, p. 853, no. 76.
2 Ibid., p. 855, no. 89.
3 Vasari-Milanesi 1878–1885, vol. 7, pp. 651–652; Vasari 1996, vol. 2, p. 1020.
4 A study by Vasari for the head of the Magdalen is in the Uffizi (1214E); see Petrioli Tofani 1985, pp. 417–420.
5 Vasari-Milanesi 1878–1885, vol. 5, pp. 606–607; Vasari 1996, vol. 2, pp. 166–167.
6 See A. Cecchi in Mantua 2001, no. 20.
7 Inv. 1932.265; see Mongan and Sachs 1946, vol. 1, p. 101.
8 Vasari-Milanesi 1878–1885, vol. 7, p. 654; Vasari 1996, vol. 2, p. 1022.

Cat. no. 108
GIORGIO VASARI (1511–1574)
The Martyrdom of a Saint
c. 1538
Pen and brown ink over black chalk
40.7 x 28 cm
Musée du Louvre, Paris (1963)

Provenance: Everard Jabach (L. 2959), his mount and number on verso in red chalk: 309; paraphe J. Prioult (L. 2953), with Jabach's number spelled out; Musée du Louvre (L. 1899 and 2207).

References: Jabach 1671, vol. 1, no. 309 (as Luzio da Todi, *Un empereur qui fait assommer saint Sébastien*); Monbeig Goguel 1972, no. 327 (as circle of Vasari); Ragghianti Collobi 1974, vol. 1, p. 173 (as Luzio da Todi); Petrioli Tofani 1985, pp. 421–422; Härb 1998, pp. 91–93.

Notes
1 It was probably an artist working for Jabach who completed the missing parts at the lower right of the drawing, a treatment suffered by many sheets from his collection prior to their sale to the king of France in 1671.
2 For a detailed discussion of Vasari's early drawings see Härb 1998.
3 Oberhuber 1978, vol. 26, p. 33.
4 Vasari-Milanesi 1878–1885, vol. 6, p. 144; Vasari 1996, vol. 2, p. 272.
5 Oberhuber 1978, vol. 26, p. 153.

Cat. no. 109
GIORGIO VASARI (1511–1574)
Saint Eustace
c. 1542–1543
Pen and brown ink and brown wash over black chalk
25.8 x 9.9 cm
Annotations: in pen and brown ink, *Geo: Vasari*
Private collection, Montreal

Provenance: possibly Cardinal Leopoldo de' Medici; possibly Gualtiero van der Voort, by 1657; J.P. Zoomer (L. 1511); Mely Ehrensberger, Berne; her sale, Christie's, London, 29 June 1971, lot 121; Charles E. Slatkin Galleries, New York; private collection, Montreal.

References: D. McTavish in Ottawa 1976, no. 3.

Notes
1 Frey 1923–1930, vol. 2, p. 860, no. 135.
2 For a full discussion of Vasari's Altoviti *Immaculate Conception* see F. Härb in A. Chong et al., *Raphael, Cellini, and a Renaissance Banker: The Patronage of Bindo Altoviti*, exh. cat. (Boston and Florence, 2003–2004), no. 21.
3 For example, in his *Adoration of the Magi* painted for Rimini in 1547 (side panels now lost), or the *Coronation of the Virgin* in the Badia, Florence (1566–1568).
4 See Monbeig Goguel 1972, no. 193.
5 Härb 1998, p. 88; Frey 1923–1930, vol. 1, p. 107.
6 See J. Kliemann in Arezzo 1981, pp. 103–108.
7 Franklin 1994, pp. 236–246.
8 Vasari-Milanesi 1878–1885, vol. 5, p. 164.
9 Franklin 1994, pp. 242–243.
10 Vasari-Milanesi 1878–1885, vol. 7, p. 668.
11 Gaeta Bertelà 1987, p. 477.

Cat. no. 110
GIORGIO VASARI (1511–1574)
Duke Cosimo I de' Medici Reviving Sansepolcro
c. 1556–1558
Pen and brown ink and brown wash over black chalk, heightened with white, squared, on blue paper
16.1 x 18.3 cm
National Gallery of Canada, Ottawa (9838)

Provenance: Lämmle; John Manning Fine Art, London, November 1961, no. 80; purchased 1962.

References: Popham and Fenwick 1965, p. 18, no. 23; Allegri and Cecchi 1980, p. 152, no. 9; Jacks 1998, no. 37; Scorza 1995–1996, p. 65.

Notes
1 Frey 1923–1930, vol. 1, pp. 501–504, no. 266. In the *Ricordanze* he lists the room under the year 1559, between the Sala di Lorenzo il Magnifico and the Sala di Giovanni dalle Bande Nere (Frey 1923–1930, vol. 2, p. 874, no. 256).
2 Frey 1923–1930, vol. 1, pp. 439–442, no. 234.
3 The exception is Fivizzano, which is depicted as an old woman.
4 See Monbeig Goguel 1972, no. 210.
5 One of the scenes in the Louvre design, *Cosimo Reviving Empoli*, was ultimately replaced by *Cosimo Reviving Prato*.
6 *Cosimo Reviving Fivizzano* (1982.17.19); see Scorza 1995–1996, pp. 64–74.
7 *Cosimo Reviving Volterra*; see Newcastle 1982, no. 8.
8 Inv. 1186E; this shows Cosimo I de' Medici triumphant at the battle of Montemurlo following the defeat of the *Fuorusciti* under Piero Strozzi in 1537.
9 *Cosimo among His Artists, Sculptors, and Engineers* (B 2646-6876); a copy of this drawing, executed in the same technique but better preserved, is in the Metropolitan Museum of Art in New York (58.104).
10 Vasari-Milanesi 1878–1885, vol. 8, p. 194.

Cat. no. 111
GIORGIO VASARI (1511–1574)
The Crucifixion
1560
Pen and brown ink and brown wash over black chalk, heightened with white, on ochre prepared paper
45.6 x 33.7 cm
Albertina, Vienna (13146)

Provenance: Herzog Albert von Sachsen-Teschen (L. 174).

References: Koschatzky et al. 1971, no. 45; Birke and Kertész 1992–1997, p. 1771; Härb 1997, p. 59.

Notes
1 Jacks 1992, p. 777: "A di 25 di Ottobre 1560 fu finita la Tavola di M. Matteo Botti."
2 Frey 1923–1930, vol. 2, p. 875, no. 267. In the autobiographical description of his works at the end of his 1568 edition of the *Lives*, Vasari records the commission as contemporary ("ne' medesimi giorni") with his *Coronation of the Virgin* at Città di Castello and the *Pietà* for the chapel at Poggio a Caiano (Vasari-Milanesi 1878–1885, vol. 7, pp. 707–708).
3 R. Borghini, *Il Riposo* (Florence, 1584), p. 548.
4 Vasari-Milanesi 1878–1885, vol. 4, pp. 107–108.

Cat. no. 112
GIORGIO VASARI (1511–1574)
The Holy Family with Saint Francis in a Landscape
1541–1542
Oil on canvas
184.2 x 125.1 cm
Los Angeles County Museum of Art, Gift of The Ahmanson Foundation (M.87.87)

Provenance: Francesco Leoni, Venice; private collection, Vienna, by 1975; Somerville and Simpson, London and New York.

References: Fronek 1987, pp. 7–9; Corti 1989, pp. 40–41, no. 23; Conisbee 1991, pp. 173–176, no. 45; F. Härb in Florence, Chicago, and Detroit 2002–2003, pp. 177–178, no. 42; Hochmann 2004, pp. 271, 283.

Notes
1 Frey 1923–1930, vol. 2, pp. 858–859.
2 Frey 1923–1930, vol. 1, pp. 104–105.
3 Frey 1923–1930, vol. 2, p. 858; Shearman 1983, pp. 277–278.
4 Boucher 1991, nos. 28, 43, 70.
5 Fronek 1987, p. 8.
6 Ibid., p. 7.
7 Conisbee 1991, p. 175.
8 Vasari-Milanesi 1878–1885, vol. 5, p. 52.
9 Frey 1923–1930, vol. 2, p. 857, no. 108. See also Florence 1986, p. 164 note 15. Florian Härb has identified another panel (129.8 x 102.8 cm), sold at auction in London (Christie's, 16 December 1998, lot 47) and subsequently on the art market in Florence, as a copy by Vasari after Andrea del Sarto's *Medici Holy Family*.

Cat. no. 113
GIORGIO VASARI (1511–1574)
Disputa between Dante and the Tuscan Love Poets
1544
Oil on panel
132.1 x 131.1 cm
Inscriptions: on cover of book in Dante's left hand, *VIRG / ILI / VS*
The Minneapolis Institute of Arts, John R. Van Derlip and William Hood Dunwoody Funds (71.24)

Provenance: Cardinal Mazarin; Philippe d'Orléans; the Belgian banker Walkuers, 1792; Laborde de Méréville; Jeremiah Harman; a syndicate formed by the Duke of Bridgewater, Lord Carlisle, and Lord Gower; Bryan (by whom exhibited at the Lyceum and at his gallery, Pall Mall, London, 1798–1799); Thomas Henry Hope or Henry Philip Hope; bequeathed by the latter to their nephew, Henry Thomas Hope, of Deepdene; Mrs. Henry Thomas Hope; bequeathed to her grandson, Lord Francis Pelham Clinton Hope; sale, Christie's, 20 July 1917, lot 126; E.D. Winkworth; sale, Sotheby's, 17 May 1961, lot 34; Wildenstein & Co., New York.

References: Holbrook 1911, pp. 154–158; Peters Bowron 1971–1973, pp. 42–53; J. Kliemann in Arezzo 1981, p. 123, no. 21; Lawall Lipshultz 1988, p. 78; Corti 1989, p. 49, no. 30; Nelson 1992, pp. 59–71; Baldini 1994, pp. 69, 77, 170; Franklin 1994, p. 4; Nelson 1995a, pp. 284–285, 300 note 8; Rubin 1995, pp. 290–291; Leporatti 2002, p. 66; J.K. Nelson in Florence 2002, pp. 191–192, no. 24.

Notes
1 The painting was begun in July 1543. Nelson (1995, pp. 289–296) summarizes Martini's major undertakings for Cosimo.
2 To my knowledge, Baldini (1994, pp. 69, 170) was the first to accord the painting its correct title: *Quattro poeti toscani e due umanisti*. As

Kliemann (Arezzo 1981, p. 123, no. 21) observed, the measurements given by Vasari, approximately 136 by 175 centimetres, are slightly higher and considerably wider than the Minneapolis picture. A comparison with prints after the composition (see note 6 below) reveals that it has been marginally cut at the right, since more of the book in Dante's left hand is visible in the engravings than in the painting. More than likely, as Nelson (1992, p. 72 note 1) indicated, the dimensions given in the *Ricordanze* are not entirely reliable, as was sometimes the case.

3 Martini's painting is on panel, while we know from Vasari's *Ricordanze* that Giovio's was on canvas (Frey 1923–1930, vol. 2, p. 867, no. 178). Giovio's painting was not entrusted in its entirety to an anonymous "todesco" or "fiamingo"; see J. Kliemann in Arezzo 1981, p. 123. On 2 September 1547, anxious to receive the picture, Giovio urged Vasari to "bare his arms" – roll up his sleeves and get to work – with respect to the unfinished heads: "lassando li busti et veste da fare come cosa mechanica a qualche pittor' della seconda buffola" (Frey 1923–1930, vol. 1, p. 200, no. 97).

4 See Giovio's letter to Vasari of 27 November 1546 (Frey 1923–1930, vol. 1, pp. 174–175, no. 87), mistakenly requesting Cavalcanti – who already features in Martini's painting – instead of Cino da Pistoia. He corrected this oversight in a letter of 18 December (p. 176, no. 88), though Frey read "circa" for "Cino." See Ferrero's transcript (P. Giovio, *Lettere*, ed. G.G. Ferrero, vol. 2 [Rome, 1956–1958], p. 61).

5 Kliemann (Arezzo 1981, p. 123) first made this observation, which has since been universally accepted. See Corti 1989, p. 49, no. 30; Nelson 1992, pp. 60–61; J.K. Nelson in Florence, Chicago, and Detroit 2002–2003, pp. 191–192, no. 24; Leporatti 2002, p. 66. Compare Vasari's description in his *Ricordanze* (Frey 1923–1930, vol. 2, p. 861, no. 144) with that in the *Lives* (Vasari 1967, vol. 8, p. 226). Vasari wrote the *Ricordanze* shortly before his autobiography, but long after he had completed the paintings for Martini and Giovio.

6 Vasari 1967, vol. 3, pp. 163–164. As Hope (1985, p. 324) observed, it appears to have been common knowledge that they were represented in the fresco, which is in the Tornabuoni chapel. Possibly following Holbrook (1911, p. 158), who wrote, "it may perhaps mean that Vasari possibly portrayed the two humanists under fanciful names," Peters Bowron (1971–1973, p. 45) suggested that the painting shows Guittone and Cino in the guises of Ficino and Landino (subsequently accepted by Lawall Lipshultz 1988, p. 78). But Giovio's instructions to Vasari confirm that this was not the case, and it is highly unlikely that Vasari would have represented famous poets in the guises of others. Ficino is also identified by the inscription in two sixteenth-century engravings showing the composition in reverse, one anonymous and the other by Hieronymus Cock. In both versions, however, Poliziano's name is inscribed above Landino's likeness (T.A. Riggs, *Hieronymus Cock: Printmaker and Publisher* [New York and London, 1977], p. 361, no. 195; Peters Bowron 1971–1973, p. 52 note 22), an anomaly that has yet to be explained.

7 See Peters Bowron 1971–1973, p. 45.

8 He refers to the many copies that were made, the following of which have survived: Oriel College, Oxford; Palazzo Albani, Rome; Aldo Gonelli, Florence; Galleria Vangelisti, Lucca (a small replica on parchment); Sale, Sotheby's, 23 April 1998, lot 29.

9 Vasari 1967, vol. 8, p. 226.

10 Lyons 1549, sigs. M3v-M4r; Antwerp 1550, sigs. G2v-H3v. On each occasion these portraits were displayed alongside those of other famous Florentines.

11 In his museum on Lake Como, Giovio displayed several hundred portraits of *uomini illustri*; see also Peters Bowron 1971–1973, p. 43.

12 The fresco, since lost, showed Saint Francis resuscitating a boy who had fallen from a balcony (Vasari 1966–1987, vol. 2, p. 205). Hope (1985, p. 322) points out that both Ghiberti in his *Commentaries* and the author of the *Anonimo Magliabechiano* had described Gaddi in the fresco instead of Cavalcanti, a discrepancy accounted for by Vasari in the 1568 edition of the *Lives* (Vasari 1967, vol. 1, p. 449). Vasari made reference to a portrait of Cino in a relief sculpture on the latter's tomb in Pistoia Cathedral (ibid., I, p. 382), but there is no mention of a portrait of Guittone in the *Lives*.

13 M. Franklin ("A Note on Boccaccio in Hiding," *Source* 14:1 [1994], pp. 1–5) recognized that Vasari's "Boccaccio" was derived from the *Parnassus*. In both editions of the *Lives*, Vasari lists Boccaccio among the poets depicted in the fresco (Vasari 1966–1987, vol. 4, p. 171), but without indicating his placement. Many have since concluded that Vasari's "Cavalcanti" is Virgil; see the concordance of identifications proposed from Bellori to the present day in D. Cordellier and B. Py, *Musée du Louvre, Musée d'Orsay: Département des art graphiques. Inventaire général des dessins italiens. Raphaël: Son atelier, ses copistes* (Paris, 1992), pp. 127–128.

14 "Faccendone segno co 'l disputar con le mani e co 'l far certi atti con la persona, con attenzione degli orecchi, con lo increspare delle ciglia e con lo stupire in molte diverse maniere" (Vasari 1967, vol. 4, pp. 75–76).

15 "I quali furono cavati parte da statue, parte da medaglie e molti da pitture vecchie, et ancora di naturale mentre che erano vivi" (Vasari 1966–1987, vol. 4, p. 171). The passage recurs with slight modifications in the 1568 edition (Vasari 1967, vol. 4, p. 74). For a detailed discussion of how Vasari sourced and used historical portraits see Hope 1985, especially pp. 333–334.

16 See Hope 1985, pp. 334–335. Hope also observes that Vasari frequently selected figures from frescoes and altarpieces without seeking any kind of comparative evidence for his proposed identifications. His adoption of Raphael's figure as the model for Cavalcanti, which may have been an informed guess, further demonstrates how absolute historical accuracy could take second place when Vasari required a likeness for a particular purpose.

17 Petrarch is third from the left in the *Parnassus*. See R. Jones and N. Penny, *Raphael* (New Haven and London, 1983), p. 69. Peters Bowron (1971–1973, p. 45) proposed that Vasari's source was probably a fifteenth-century manuscript miniature in the Laurenziana showing the poet in profile. That seems unlikely, especially in the light of Hope's analysis. Moreover, the image bears little detailed resemblance to Vasari's animated likeness. Nelson (1992, pp. 63–64) observed that another miniature of the same period in the Biblioteca Riccardiana represents a generic type of Dante in profile.

18 The rest of the figure departs radically from Castagno, though the fresco could have inspired the rhetorical gesture of Vasari's poet. The frescoes are mentioned in both editions of the *Lives* (Vasari 1966–1987, vol. 3, p. 354; Vasari 1967, vol. 2, p. 502).

19 Together with Salviati he copied the entire length of the Sistine Chapel ceiling, after which "non restò cosa di Raffaello … che similmente io non disegnassi" (Vasari 1967, vol. 8, p. 204). Moreover, between receiving the commission from Martini and delivering the picture, Vasari spent several months in Rome (ibid., pp. 225–226), and his contacts with the Farnese court would presumably have made access to the Stanze relatively simple. I owe this observation to Charles Hope.

20 Cordellier and Py (cited in note 13 above), p. 135, no. 164. The other (pp. 130–131, no. 148), showing the poets at the lower left, includes Sappho holding the scroll inscribed with her name. These drawings were not made after Raimondi's engraving (see Shoemaker and Broun 1981, pp. 155–157, nos. 48a, 48b), since neither figure is shown there. Vasari's claimed access to the Stanze is often questioned. The errors in his account of the *Parnassus* certainly result from his reliance on Raimondi's print; see T.S.R. Boase, *Giorgio Vasari: The Man and the Book* (Princeton, 1979), pp. 240–241; Rubin 1995, pp. 365–368. However, the inclusion of Sappho and Boccaccio confirms that Vasari also relied on his early drawings made *in situ* when composing his description – hence its correspondence with specific details of the fresco; see also J. Wood, "Cannibalized Prints and Early Art History: Vasari, Bellori and Fréart de Chambray on Raphael," *Journal of the Warburg and Courtauld Institutes* 51 (1988), pp. 210–212. M. Winner ("Il giudizio di Vasari sulle prime tre stanze di Raffaello in Vaticano," in *Raffaello in Vaticano*, exh. cat. [Rome, 1984–1985], pp. 180–181) suggests that Vasari was invited to Rome in 1531 by Cardinal Ippolito de' Medici. As a relative of the pope, Ippolito would certainly have been influential enough to give Vasari access to restricted areas; also, whenever Clement VII left the Vatican for the papal villa at Magliana, Vasari and Salviati would enter the Vatican "per mezzo d'amici in dette stanze a disegnare" (Vasari 1967, vol. 6, p. 516).

21 The cycle included Boccaccio and Petrarch; see Vasari 1967, vol. 6, pp. 174–175; vol. 8, p. 16. For further discussion, including observations on Bettini and his circle, see Leporatti 2002, pp. 65–66, 70–82.

22 See H. Bevers, R. Harprath, et al., *Zeichnungen aus der Sammlung des Kurfürsten Carl Theodor*, exh. cat. (Munich, 1983–1984), p. 23, no. 9. Costamagna (Florence 2002, p. 193, no. 25) points out that the drawing differs significantly from the head in the lunette, which is turned more obliquely away from the viewer and tilted up and back. He also discusses the lunette itself, in a private collection in Florence, and its replica, in the National Gallery of Art in Washington (Florence 2002, pp. 184–186, no. 22).

23 Vasari himself confirms Bronzino's assistance: "per prezzo di pagamento se nebbe scudi dieci, che il Bronzino pittor fece lacordo" (Frey 1923–1930, vol. 2, p. 861, no. 144).

24 Since Bronzino's cycle of poets has not survived, the precise extent to which he may or may not have helped Vasari to achieve his particularly incisive likenesses remains a matter of speculation. Nelson (1992, pp. 65–67) suggests that Bronzino's figures probably served as prototypes for Vasari, pointing out that Martini, as Bettini's friend, would certainly have known the lunettes. Though Vasari could conceivably have relied on Bronzino for the finer details of one or possibly more of the poets' features, it is extremely unlikely that he would have assigned them identical poses. In fact, the "Dante" painted for Martini is quite different from the figure in Bettini's lunette.

25 The state-sponsored Accademia grew out of the more informal and independent Accademia degli Umidi, created in 1540, which Martini had joined soon after its establishment. See Nelson 1995a, p. 300 note 9.

26 The standard bibliography on the Accademia Fiorentina is well known; see, for example, the studies cited by Nelson (1995a, p. 300 note 2). For more recent contributions see A. Ricci, "Lorenzo Torrentino and the Cultural Programme of Cosimo I de' Medici," in *The Cultural Politics of Duke Cosimo I de' Medici*, ed. K. Eisenbichler (Aldershot 2001), pp. 112–116; M.A. Watt, "The Reception of Dante in the Time of Cosimo I," ibid., pp. 121–124. Carlo Lenzoni published a counter-attack on Bembo (*In difesa della lingua fiorentina, et di Dante*) and, like Giovambattista Gelli, argued that only natives of Tuscany should judge and teach Tuscan, since foreigners were largely insensitive to the language's natural beauty. On Cosimo's interest and involvement see A.L. De Gaetano, *Giambattista Gelli and the Florentine Academy: The Rebellion against Latin* (Florence, 1976), pp. 107–110.
27 By far the majority of the Accademia's lectures were on Petrarch: between 1541 and 1545 there were 61, compared to 29 on Dante (Nelson 1992, pp. 61, 73 note 19). See also Leporatti 2002, pp. 67–68, with reference to Bembo's *Prose*, published in 1525.
28 Likewise another academician, Pierfrancesco Giambullari, Canon of San Lorenzo, saw in Dante an extraordinary competence in every field of human thought and learning; see also M.A. Watt, "The Reception of Dante" (cited in note 26 above), pp. 124–125; Peters Bowron 1971–1973, p. 50. Varchi's positive appraisal of Dante's language was presented in his *Ercolano*, published posthumously in 1570. For a discussion of his earlier views, which were rather more pro-Bembo, see Leporatti 2002, pp. 73–74. In stark contrast to the Accademia, Bembo held that Dante would have been more worthy of praise had he chosen themes less elevated than those which were the province of theologians and philosophers (ibid., pp. 67–68).
29 As has been plausibly suggested by Nelson (1992, p. 59; 1995a, p. 284).
30 An active academician, Martini recorded ancient Tuscan proverbs, composed poems in the vernacular, and in 1545 assisted Varchi and others in collating textual references from seven manuscripts of the *Divina Commedia*. See also Nelson 1992, p. 61; V. Borghini, *Lettera intorno a' manoscritti antichi*, ed. G. Belloni (Rome, 1995), p. xxi.
31 "Colui ch'attende là, per qui mi mena, forse cui Guido vostro ebbe a disdegno" (Dante *Inferno* 10.62–63, cited in Vandelli 1929, p. 78, see note 36, following); see also Peters Bowron 1971–1973, p. 43; Nelson 1992, p. 59.
32 Nelson 1992, p. 62; Nelson 1995a, p. 285. See also Leporatti (2002, pp. 67–70) for further discussion of Landino's edition of the *Divina Commedia*, which included in its preface the mathematician Antonio di Tuccio Manetti's investigation into the topography of the *Inferno*. Leporatti points out that Ficino was largely responsible for the rediscovery of the *Stilnovisti*, whose poetry, like Dante's, was rich in scientific and philosophical allusions.
33 Such attributes were conventional to Dante iconography. In Borghini's scheme of 1565 for the ephemeral monument erected at the Porta al Prato, Dante was depicted resting his hand on a terrestrial globe, "tutto con la mente in se stesso raccolto, di contemplare o l'ordine, o 'l moto, o la mondana Fabrica." The attribute was highly appropriate, since "col suo divino ingegno … penetrò la natura di tutte le cose … ricercando ogni cosa insino al centro della Terra … al Trono, et seggio di Dio." See R.A. Scorza, "A New Drawing for the Florentine *Apparato* of 1565: Borghini, Butteri and the Tuscan Poets," *The Burlington Magazine* 127 (1985), pp. 889 (with bibliography); R.A. Scorza,

"A Florentine Sketchbook: Architecture, *Apparati* and the Accademia del Disegno," *Journal of the Warburg and Courtauld Institutes* 54 (1991), plate 43b.
34 Nelson 1992, p. 61; Nelson 1995a, p. 285. The symbolism of the objects in the painting is discussed by Peters Bowron (1971–1973, pp. 47–50), who also identified the constellations and the countries depicted on the celestial and terrestrial globes.
35 "Tu se' lo mio maestro e 'l mio autore; tu se' solo colui da cu' io tolsi lo bello stilo che m'ha fatto onore" (*Inferno* 1.85–87, in Vandelli 1929, p. 8, see note 36, following).
36 "Per tragoediam superiorem stilum induimus, per comoediam inferiorem, per elegiam stilum intelligimus miserorum. Si tragice canenda videntur, tunc adsumendum est vulgare illustre … Si vero comice, tunc quandoque mediocre … Si autem elegiace, solum humile nos oportet sumere … Stilo equidem tragico tunc uti videmur, quando cum gravitate sententiae tam superbia carminum, quam constructionis elatio, et excellentia vocabulorum concordat" (Dante *De vulgari eloquentia* 2.4). See Vandelli's observations in *La Divina Commedia: Testo critico della Società Dantesca Italiana riveduto, col commento scartazziniano*, ed. G. Vandelli (Milan, 1929), pp. 8–9 note 87; also E.R. Curtius, *European Literature and the Latin Middle Ages* (London, 1979), pp. 168–182, 441. In antiquity the elegiac couplet was associated with a wide range of subjects – not just mourning but also erotic themes such as laments of unrequited or lost love; see P. Wilson, "The *Aulos* in Athens," in *Performance Culture and Athenian Democracy*, ed. S. Goldhill and R. Osborne (Cambridge, 1999), pp. 96–122.
37 Vasari 1967, vol. 4, p. 74; see also Leporatti 2002, pp. 68–69.
38 "Con animo di farvi gl'altri poeti che hanno con versi e prose toscane cantato d'amore" (Vasari 1967, vol. 6, p. 175). See also Nelson 1992, pp. 69–71; P. Costamagna in Florence 2002, p. 185. The scheme was never completed as envisaged, since only three of the lunettes were finished in 1536, when Bettini left Florence for Rome. Pontormo was also forced to sell the *Venus and Cupid* by the supporters of Alessandro de' Medici, whereupon it entered the Medici collection.

Cat. no. 114
GIORGIO VASARI (1511–1574)
The Baptism of Christ
1548–1549
Oil on canvas
190 x 128 cm
Museo Diocesano, Arezzo

Provenance: Confraternity of San Giovanni de' Peducci, Arezzo.

References: Franklin 1997 (with bibliography).

Notes

1 The archival documents upon which the following discussion is based are cited in full in Franklin 1997.
2 Frey 1923–1930, vol. 2, p. 868.
3 Vasari-Milanesi 1878–1885, vol. 7, p. 689; Vasari 1996, vol. 2, p. 1048.
4 See D. Potter, *A History of France 1460–1560: The Emergence of a Nation State* (London, 1995), p. 174; N. Lemaitre, *Le Rouergue flamboyant: Le clergé et les fidèles du diocèse de Rodez, 1417–1563* (Paris, 1988), p. 416.
5 Franklin 1997, p. 243.
6 See D. Franklin, "The Identity of a Perugian Follower of Piero della Francesca," *The Burlington Magazine* 135 (1993), pp. 625–627.

Cat. no. 115
GIORGIO VASARI (1511–1574)
The Adoration of the Magi
1567
Oil on panel
65 x 48 cm
Richard L. Feigen, New York

Provenance: Vincenzo Borghini, prior of the Ospedale degli Innocenti, Florence; bequeathed by Borghini to Venturi di Vincenzo Ulivieri, "pittore di casa" of the Ospedale degli Innocenti; consigned by Ulivieri to Fra Niccolò da Cortona, prior of the Ospedale degli Innocenti; possibly one of three works attributed to Vasari sold in December 1833 to the Marchese Panciatichi; Bertha Tilly, New York; sale, Sotheby's, New York, 5 November 1986, lot 30; R.L. Feigen & Co., New York.

References: Scorza 2003, pp. 99–101.

Notes

1 See, for example, Borghini's letter of 15 February 1571 on Vasari's *Perseus and Andromeda* for Francesco de' Medici's *studiolo*: "ha un colorito molto fiero et e fra quelle d'Andrea et del frate. In somma a mio gusto" (Frey 1923–1930, vol. 2, p. 567, no. 781).
2 This is confirmed in Vasari's letter to Borghini of 1 March 1567: "va n'una sua capella, dove vol fare la sua sepoltura" (Frey 1923–1930, vol. 2, p. 303, no. 568). On the altarpiece see also Viale Ferrero 1959, p. 19; Barocchi 1964b, p. 63; J. Kliemann in Arezzo 1981, pp. 94–95, nos. 36a, 36b; Ieni 1985, p. 50; Spantigati and Ieni 1985, p. 106; Corti 1989, p. 121, no. 99. The pope was ultimately buried in the Roman basilica of Santa Maria Maggiore.
3 He was awarded the project when he went to Rome to pay his respects to the recently elected pope (Vasari 1967, vol. 8, pp. 264–265). See also Vasari's letter to Borghini of 18 August 1566 (Frey 1923–1930, vol. 2, p. 272, no. 544), in which he comments: "Domattina la comincio a colorire," and also p. 879, nos. 324, 325.
4 See Borghini's letter to Vasari, in Rome, 8 March 1567: "Se voi poteste ripescare quel disegno della tavola che mandasti costi, ricordatevi, che me lo promettesti" (Frey 1923–1930, vol. 2, p. 310, no. 570). Borghini's "ripescare" may suggest that the drawing was still with the patron; it has since been lost.
5 Livo was successor to Borghini's earlier protégés, the painters Giovanni Battista Naldini and Francesco Morandini.
6 Archivio Innocenti, Florence, Filza d'Archivio 17, fol. 346r; see Scorza 2003, Appendix III.
7 The upper part of the replica shows the star that guided the Magi to Bethlehem, which is only partially visible in the altarpiece. Comparison with the replica also reveals that the bottom and the sides of the altarpiece have been substantially cut, which presumably occurred when it was restored in the seventeenth century.
8 This was the penultimate chapel on the right of the nave, the altar of which was remodelled in stucco in the eighteenth century (Ieni 1985, p. 50).
9 The drawing is inscribed by the artist: "TV GLORIA HIERVSALEM / TV LAETITIA / ISRAEL / T.O. P.N." The meaning of the abbreviations is not immediately apparent. A small rectangular sheet showing the *Adoration* has been pasted within the borders of the ornamental frame, leaving the angels and the radiance from the Star of Bethlehem of the original composition visible. See Barocchi 1964a, p. 42, no. 38; J. Kliemann in Arezzo 1981, p. 94, no. 36a; Petrioli Tofani 1986–1987, vol. 2, p. 493.

10 "Mostrai lo schizzo mandatomi del quadro per farsi per Nostro Signore la storia: Li piacque, ma mi disse, che la Nostra Donna non stava in un palazzo quando partorí N. Signore, come quello adornamento par sia, ma si bene in una capanna, et che questa ci voleva essere. In similitudine oltre non ci era nel bove ne lasino, che queste ancora ci deve essere" (Frey 1923–1930, vol. 2, p. 262, no. 539). Sangalletti added that Vasari should make the painting large enough to serve as an altarpiece and, once having seen to the pope's wishes, proceed with the commission.

11 J. Waterworth, ed. and trans., *The Council of Trent, The Twenty-Fifth Session: The Canons and Decrees of the Sacred and Oecumenical Council of Trent* (London, 1848), pp. 235–236; M. Firpo, *Gli affreschi di Pontormo a San Lorenzo: Eresia, politica e cultura nella Firenze di Cosimo I* (Turin, 1997), pp. 21–63. On 5 December 1569 Sangalletti informed Vasari that the pope wanted the figures on the predella panels for the monumental high altar of Santa Croce to be fully clothed ("quei bracci et gambe nude non le vole") because their naked limbs smacked more of paganism than devotion (Frey 1923–1930, vol. 2, p. 470, no. 694). See also Scorza 2001, p. 53.

12 Borghini 1584, p. 77 (present writer's translation). Vecchietti continues that Pontormo "non ha fedelmente rappresentata l'inventione della sacra historia, e quello che vi ha messo di suo non vi può stare in alcun modo, e d'honestà, e di riverenza non accade parlarne, anzi disonestà grandissima si vede." Nudes apart, he comments that there is no sacrificial altar in the scene showing the aftermath of the flood, nor is there any sign of the animals that had travelled in the ark. Noah, moreover, is naked, and figures that should by then have been dead are struggling in the water (ibid., pp. 78–80).

13 See B. Platina, *Historia delle vite de' sommi Pontefici…* (Venice, 1608), fols. 327v–328r. Prior to his elevation to the papacy, Michele Ghislieri had also been confessor to Alfonso D'Avalos, Marchese del Vasto.

14 *Liber de ortu beatae Mariae et infantia Salvatoris* (14.1): "Tertia autem die nativitatis domini … Maria … ingressa est stabulum et posuit puerum in praesepio, et bos et asinus adoraverunt eum."

15 Judith was, of course, a popular Florentine icon, but for Borghini she epitomized the triumph of humility over arrogance. Several works in his collection commemorated her heroic act, and he employed another biblical inscription to adorn his *quadretto* of the *Triumph of Judith*, executed by Naldini in 1564; see Cecchi 1977. A wax statuette of *Judith* by Vincenzo Danti that he owned was more than likely displayed alongside this picture; see also Scorza 2003, pp. 108–109.

16 Images of massacred Innocents appear in the lunette at the entrance to the Ospedale's *chiesa publica* (Vasari 1967, vol. 2, p. 454). For further discussion of the Ospedale and the theme of the Adoration see Scorza 2003, pp. 101–104.

17 Rosso's "bellissimo disegno," another gift from Vasari, was a preparatory drawing for the high altarpiece of the church of San Francesco in Arezzo, executed by Giovanni Antonio Lappoli (Vasari 1967, vol. 5, pp. 412–413; see also Franklin 1994, p. 177).

Cat. no. 116
MICHELE TOSINI (1503–1577)
Portrait of a Man with a Dog
c. 1555
Oil on panel
116 x 86 cm
Galerie Sarti, Paris

Provenance: private collection, Vienna; private collection, London.

References: Costamagna 2002, pp. 211–212.

Notes
1 On a first attempt to reconstitute a corpus of the portraits painted by Michele Tosini see K. Forster, "Probleme um Pontormos Porträtmalerei (III): Ein beitrag zum Porträtwerk Michele Tosinis," *Pantheon* 25 (1967), pp. 27–34.
2 Particularly the portraits inserted in the frescoes of Pope Leo X's apartments; see Allegri and Cecchi 1980, pp. 154, 157; A. Baroni Vannucci, *Jan Van Der Straet detto Giovanni Stradano, flandrus pictor et inventor* (Milan and Rome, 1997), pp. 31–33.
3 See P. Costamagna, "Le mécénat et la politique culturelle du cardinal Giovanni Salviati," in Monbeig Goguel et al. 2001, pp. 227–228.
4 The portrait of Giovan Battista Salviati is at the John and Mable Ringling Museum in Sarasota, but the present location of the cardinal's portrait (recorded in documents) is unknown; see P. Costamagna in Rome and Paris 1998, pp. 47, 51 note 2, 234, no. 89.
5 See A. Dallaj, "La funzione simbolica del piccolo cane nel ritratto," in *Antonio da Pordenone: Il gentilumo con cagnolino, Castello Sforzesco: Quaderni della Pinacoteca*, ed. M. Garberi (Milan, 1990), pp. 64–76.
6 See P. Simons, "Alert and Erect," in *Gender Rhetorics: Postures of Dominance and Submission in History*, ed. R. Trexler (New York, 1994), p. 172.

Cat. no. 117
FRANCESCO SALVIATI (1510–1563)
David
c. 1526–1530
Pen and brown ink over black chalk
41.1 x 27.5 cm
Annotations: in pen and brown ink, *Baccio Bandinelli*; on verso, in pen and brown ink, *Di Bacchio di detto Michelangelo*; in graphite, *baccio*
National Gallery of Canada, Ottawa, Gift of the National Gallery of Canada Foundation Renaissance Ball Patrons, for the Gallery's 125th Anniversary, 2005 (41486)

Provenance: Sagredo-Borghese collection (associated number on the mount, *S.F. no. 31*, and on the verso, *S.F. no 74*); sale, Drouot, Paris, 13 November 1986, lot 180; Katrin Bellinger Kunsthandel, Munich.

References: Monbeig Goguel 1989, p. 713; C. Monbeig Goguel in Turin 1990, under no. 49a; London 1992, no. 8; C. Monbeig Goguel in Rome and Paris 1998, under no. 14.

Notes
1 C. Monbeig Goguel in Turin 1990, under no. 49a. Monbeig Goguel had previously maintained the attribution to Bandinelli; see Monbeig Goguel 1989, p. 713.
2 Salviati also studied a model of a nude male youth by Michelangelo, now in the Casa Buonarroti in Florence, which is sometimes associated with the bronze *David* that the sculptor sent to France. However, details such as the specific treatment of the musculature and of the hair, as well as the raised chin, indicate that this drawing makes deliberate reference to the famous marble.

3 Vasari-Milanesi 1878–1885, vol. 7, pp. 8–9; Vasari 1996, vol. 2, p. 557.
4 A. Coliva, ed., *Francesco Salviati: Affreschi romani* (Milan, 1998), pp. 55–57. M. Hirst (Paris and Rome 1998, no. 13) has challenged this potential link between the Louvre drawing and the Rome commission and discusses the sketch in relation to a painting of a seated John the Baptist mentioned by Vasari.

Cat. no. 118
FRANCESCO SALVIATI (1510–1563)
Male Nude Seen from the Back, Pointing Upward (recto)
Male Nude in Profile to the Left (verso)
c. 1530s
Pen and brown ink
41.9 x 26 cm
Private collection, Montreal

Provenance: Sir Peter Lely (L. 2090); probably Walter Gernsheim, London, 1937 (as Battista Franco, according to a photograph in the Witt Library, London); P. and D. Colnaghi, London; Charles E. Slatkin Galleries, New York; acquired by the present owner in 1956.

References: McTavish 2000, p. 67; Monbeig Goguel 2001a, pp. 6, 54–55.

Notes
1 Vasari-Milanesi 1878–1885, vol. 7, p. 41; Vasari 1996, vol. 2, p. 581.
2 Ibid.
3 Vasari-Milanesi 1878–1885, vol. 7, pp. 8–9; Vasari 1996, vol. 2, p. 557.
4 P. Joannides in Rome and Paris 1998, p. 55.
5 Vasari-Milanesi 1878–1885, vol. 6, p. 571; Vasari 1996, vol. 2, p. 498.
6 Vasari-Milanesi 1878–1885, vol. 6, p. 137; Vasari 1996, vol. 2, p. 267.
7 Vasari-Milanesi 1878–1885, vol. 7, p. 8; Vasari 1996, vol. 2, p. 556.
8 Monbeig Goguel 1989, p. 713; Monbeig Goguel in Turin 1990, p. 126; Monbeig Goguel 2001a, pp. 53–58.
9 McTavish 2000, p. 67.
10 Vasari-Milanesi 1878–1885, vol. 7, p. 13; Vasari 1996, vol. 2, p. 560.
11 Rome and Paris 1998, no. 15.

Cat. no. 119
FRANCESCO SALVIATI (1510–1563)
Portrait of a Boy
c. 1535–1538
Red chalk
16.8 x 12.4 cm
Private collection, Chicago

Provenance: William Cavendish, 2nd Duke of Devonshire (L. 718), by descent to the 11th Duke of Devonshire; his sale, Christie's, London, 3 July 1984, lot 42, purchased by Duca Roberto Ferretti di Castelferretto, Montreal; his sale, Christie's, New York, 11 January 1994, lot 171; private collection, Chicago.

References: D. McTavish in Toronto and New York 1985, no. 1C; Jaffé 1994, no. 64; P. Costamagna in Rome and Paris 1998, no. 85.

Notes

1 The curtain as a compositional device to underscore the gaze of the protagonist is used in a similar fashion in Raphael's *Madonna of the Fish* (c. 1513) in the Prado, Madrid.
2 Freedberg 1963, vol. 1, no. 476.
3 Vasari-Milanesi 1878–1885, vol. 7, p. 8; Vasari 1996, vol. 2, p. 556.
4 Inv. 2727; see Rome and Paris 1998, no. 6.
5 Freedberg 1963, vol. 1, no. 79.
6 Parker 1956, no. 681; see also P. Costamagna in Rome and Paris 1998, under no. 6.
7 P. Costamagna, ibid., nos. 78, 79.
8 Ibid., no. 82.
9 P.W. Ward-Jackson, *Italian Drawings*, Victoria and Albert Museum Catalogues (London, 1979), vol. 1, p. 136, no. 280.

Cat. no. 120
FRANCESCO SALVIATI (1510–1563)
Allegory of the Triumph of Venus, after Bronzino (recto)
Architectural Study (verso)
c. 1545
Pen and brown ink and brown wash over black chalk
11.4 x 9.8 cm
Annotations: on verso, in graphite, *Bronzino / 1590*
National Gallery of Canada, Ottawa (41430)

Provenance: Earl Spencer (L. 1530); Spencer sale, London, 10 June 1811, lot 60; Thomas Lawrence (L. 2445); F. Abbott (L. 970); sale, Christie's, New York, 28 January 1999, lot 55; private collection, New York; purchased 2004.

References: Monbeig Goguel 2001a, pp. 62–65.

Notes

1 Monbeig Goguel 2001a, pp. 62–65.
2 Monbeig Goguel points explicitly to a securely attributed drawing of the Florentine period in *Francesco Salviati o la Bella Maniera*, exh. cat. (Paris and Rome, 1998), no. 119. See also no. 76 in that catalogue for a drawing dated to about 1545 with a comparable use of hatching in pen and ink.
3 On Bronzino's painting and its much-debated meaning see the summary in Cox-Rearick 1996, no. VII-1.
4 Panofsky's suggestion (*Studies in Iconology*, Oxford, 1939, p. 91) that Bronzino's design for the London painting first existed as a tapestry cartoon and was intended to serve as a companion to another tapestry has never been supported by any material evidence.
5 I. Cheney, "Comment: The Date of Francesco Salviati's French Journey," *The Art Bulletin* 74 (1992), pp. 157–158.
6 C. Plazzotta and L. Keith, "Bronzino's 'Allegory': New Evidence of the Artist's Revisions," *The Burlington Magazine* 141 (1999), pp. 89–99.
7 Franklin 2001, pp. 221–222.

Cat. no. 121
FRANCESCO SALVIATI (1510–1563)
Portrait of Duke Cosimo I de' Medici
c. 1545–1546
Oil on panel, transferred to canvas
124 x 85 cm
Private collection, Milan

Provenance: A.S. Drey, Munich; Vogel collection, Lucerne; Fischer sale, Lucerne, 1967, no. 81; acquired by the present owner on the Italian art market, 1994.

References: J. Cox-Rearick in Rome and Paris 1998, p. 26; P. Costamagna in Rome and Paris 1998, p. 51 note 12; A. Cecchi in Rome and Paris 1998, p. 65 note 23; F. Moro in Milan 1998–1999, no. 100 (with bibliography).

Notes

1 See S. Lecchini Giovannoni, "Francesco Salviati ritrattista alla corte Medicea," in *Scritti in onore di Mina Gregori* (Cinesello Balsamo, 1994), pp. 126–129.
2 See E. Cropper in Monbeig Goguel et al. 2001, p. 692.
3 On the importance of the role of Pietro Aretino in promoting Titian's portraits see L. Freedman, *Titian's Portraits through Aretino's Lens* (University Park, Pa., 1995).
4 In this regard see F. Mozzetti, *Tiziano: Ritratto di Pietro Aretino* (Modena, 1996).
5 See R. Simon, "Bronzino's Portrait of Cosimo I in Armour," *The Burlington Magazine* 125 (1983), pp. 527–539; R. Simon, "'Blessed be the Hand of Bronzino': The Portrait of Cosimo I in Armour," *The Burlington Magazine* 129 (1987), pp. 387–388. With this portrait of the duke made for Paolo Giovio's museum of portraits of famous men (where it was installed in July 1546), Riccio was seeking the benefits of publicizing a symbolic image of power.
6 Vasari-Milanesi 1878–1885, vol. 7, p. 27; Vasari 1996, vol. 2, p. 570.
7 See P. Hurtubise, *Une famille-témoin, les Salviati* (Vatican City, 1985), pp. 202, 243–245.

Cat. no. 122
FRANCESCO SALVIATI (1510–1563)
Portrait of a Man
c. 1547–1548
Oil on panel
102.1 x 82.5 cm
The Saint Louis Art Museum (415:1943)

Provenance: acquired by the museum from Arnold Seligman & Co., New York, 1943.

References: P. Costamagna in Rome and Paris 1998, p. 240 (with bibliography); Wolk-Simon 1998, p. 53; Robertson 1999, p. 77; Pilliod 2001, p. 207.

Notes

1 See Costamagna 2002, pp. 211–222, 216 note 109.
2 A preparatory drawing is in the Louvre (38407); see C. Monbeig Goguel in Rome and Paris 1998, pp. 16, 40.
3 See F. Bocchi, *Le bellezze della città di Firenze …* (Florence, 1591), pp. 178–79.
4 On the origin and ambiguity of this figure by Salviati see Monbeig Goguel 2001a, pp. 20–22.
5 See P. Costamagna, "Entre Raphaël, Titien et Michel-Ange: Les portraits d'Andrea Doria par Sebastiano del Piombo et Bronzino," in *Les portraits du pouvoir*, ed. O. Bonfait and B. Marin (Rome and Paris, 2003), pp. 27–29.

Cat. no. 123
SANTI BUGLIONI (1494–1576)
San Giovanni di Capistrano
c. 1550
Glazed terracotta
154.9 x 76.2 x 35.6 cm
Private collection, New York City

Provenance: Banti collection, Florence; Luigi Bellini, Florence.

References: Venice 1962, p. 34, no. 209; Galleria Luigi Bellini 1965; Gentilini 1998, p. 359, no. VI.13; Butterfield and Radcliffe 2002, pp. 136–139; Glueck 2003.

Notes

1 Vasari 1996, vol. 1, p. 557.

ADELSON 1980 C. Adelson et al. *Le arti del principato mediceo*. Florence, 1980.

ADELSON 1990 C. Adelson. "The Tapestry Patronage of Cosimo I de' Medici, 1543–1553." Ph.D. diss., New York University, 1990.

ALLEGRI AND CECCHI 1980 E. Allegri and A. Cecchi. *Palazzo Vecchio e i Medici, guida storica*. Florence, 1980.

ANDREWS 1964 K. Andrews. "A Note on Bronzino as a Draughtsman." *Master Drawings* 2 (1964), pp. 157–160.

ANTAL 1956 F. Antal. *Fuseli Studies*. London, 1956.

AREZZO 1981 L. Corti et al. *Giorgio Vasari, principi, letterati e artisti nelle carte di Giorgio Vasari: Pittura vasariana dal 1532 al 1554* (exh. cat.). Florence, 1981.

ASCHOFF 1967 W. Aschoff. "Tribolo disegnatore." *Paragone* 18:209/29 (July 1967), pp. 45–47.

ATTWOOD 2003 P. Attwood. *Italian Medals c. 1530–1600 in British Public Collections*. 2 vols. London, 2003.

AVERY 1981 C. Avery. *Fingerprints of the Artist: European Terra-cotta Sculpture from the Arthur M. Sackler Collections*. Washington, D.C., and Cambridge, Mass., 1981.

AVERY 1986 C. Avery. "The Pope's Goldsmith." *Apollo* 124 (July 1986), pp. 61–62.

AVERY 1995 C. Avery. "Pierino da Vinci's 'Lost' Bronze Relief of 'The Death by Starvation of Count Ugolino della Gherardesca and His Sons' Rediscovered at Chatsworth." In Cianchi 1995, pp. 57–61.

AVERY AND DILLON 2002 V. Avery and J. Dillon. *Renaissance and Baroque Bronzes from the Fitzwilliam Museum, Cambridge* (exh. cat.). London, 2002.

BACCI 1966 M. Bacci. *Piero di Cosimo*. Milan, 1966.

BALDINI 1994 U. Baldini. *Giorgio Vasari pittore*. Florence, 1994.

BALOGH 1975 J. Balogh. *Katalog der ausländischen Bildwerke des Museums der Bildenden Künste in Budapest, IV–XVIII Jahrhundert*. Budapest, 1975.

BALTIMORE 1961 Baltimore Museum of Art. *Bacchiacca and His Friends: Florentine Paintings and Drawings of the Sixteenth Century* (exh. cat.). Baltimore, 1961.

BAMBACH 2003 C.C. Bambach, ed. *Leonardo da Vinci: Master Draftsman*. New York and London, 2003.

BARDI 1839 L. Bardi. *L'imperiale e reale Galleria Pitti illustrata*. Florence, 1839.

BAROCCHI 1950 P. Barocchi. *Il Rosso*. Rome, 1950.

BAROCCHI 1964a P. Barocchi. *Mostra di disegni del Vasari e della sua cerchia*. Florence, 1964.

BAROCCHI 1964b P. Barocchi. *Vasari pittore*. Milan, 1964.

BAROCCHI 1971 P. Barocchi, ed. *Scritti d'arte del Cinquecento*. 3 vols. Milan and Naples, 1971.

BAROCCHI 1992 P. Barocchi, ed. *Il giardino di San Marco: Maestri e compagni del giovane Michelangelo* (exh. cat.). Florence, 1992.

BARRIAULT 1994 A. Barriault. *Spalliera Paintings of Renaissance Tuscany: Fables of Poets for Patrician Homes*. University Park, Pa., 1994.

BARTSCH A. von Bartsch. *Le peintre graveur*. 21 vols. Vienna, 1803–1821.

BARZMAN 2000 K. Barzman. *The Florentine Academy and the Early Modern State: The Discipline of Disegno*. Cambridge and New York, 2000.

BASSETT AND FOGELMAN 1997 J. Bassett and P. Fogelman. *Looking at European Sculpture: A Guide to Technical Terms*. Los Angeles, 1997.

BEAN 1960 J. Bean. *Inventaire général des dessins des Musées de Province, IV, Bayonne, Musée Bonnat: Les dessins italiens de la collection Bonnat*. Paris, 1960.

BÉGUIN AND COSTAMAGNA 2003 S. Béguin and P. Costamagna. "Nouvelles considérations sur Baccio Bandinelli peintre: La redécouverte de la *Léda et le cygne*." *Les Cahiers d'Histoire de l'Art* 1 (2003), pp. 7–18.

BELLANDI 2004 A. Bellandi. "Madonna adorante (da un presepe a figure mobili)." In *Altomani and Sons 2004*, pp. 242–251. Milan, 2004.

BELLOSI 1990 L. Bellosi. "Andrea del Verrocchio." In *Pittura di luce: Giovanni di Francesco e l'arte fiorentina di metà Quattrocento* (exh. cat.), pp. 180–183. Florence, 1990.

BERENSON 1903 B. Berenson. *The Drawings of the Florentine Painters, Classified, Criticised and Studied as Documents in the History and Appreciation of Tuscan Art: With a Copious Catalogue Raisonné*. 2 vols. London, 1903.

BERENSON 1909a B. Berenson. *The Central Italian Painters of the Renaissance*. New York and London, 1909.

BERENSON 1909b B. Berenson. *The Florentine Painters of the Renaissance*. 3rd ed. New York and London, 1909.

BERENSON 1932 B. Berenson. *Italian Pictures of the Renaissance*. Oxford, 1932.

BERENSON 1936 B. Berenson. *Pitture italiane del Rinascimento*. Milan, 1936.

BERENSON 1938 B. Berenson. *The Drawings of the Florentine Painters*. 3 vols. Chicago, 1938.

BERENSON 1956 B. Berenson. *Lorenzo Lotto*. London, 1956.

BERENSON 1961 B. Berenson. *I disegni dei pittori fiorentini*. 3 vols. Milan, 1961.

BERENSON 1963 B. Berenson. *Italian Pictures of the Renaissance: Florentine School*. 2 vols. London, 1963.

BIRKE AND KERTÉSZ 1992–1997 V. Birke and J. Kertész. *Die Italienischen Zeichnungen der Albertina: Generalverzeichnis.* 4 vols. Vienna and Cologne, 1992–1997.

BLASS-SIMMEN 1991 B. Blass-Simmen. *Sankt Georg, Drachenkampf in der Renaissance: Carpaccio, Raffael, Leonardo.* Berlin, 1991.

BLISS 2003 J.R. Bliss. "Benvenuto Cellini's Satyrs for the Porte Dorée at Fontainebleau." In *Large Bronzes in the Renaissance*, Studies in the History of Art, no. 64, ed. P. Motture, pp. 72–93. Washington, D.C., 2003.

BOBER AND RUBINSTEIN 1986 P.P. Bober and R. Rubinstein. *Renaissance Artists and Antique Sculpture: A Handbook of Sources.* New York and London, 1986.

BODE 1890–1908 W. Bode. "Versuche der Ausbildung des Genre in der Florentiner Plastik des Quattrocento." *Jahrbuch der Königlich Preussischen Kunstsammlungen* 11 (1890), pp. 95–107. Reprinted in *Florentiner Bildhauer der Renaissance*, pp. 253–279, Berlin, 1902, and *Florentine Sculptors of the Renaissance*, pp. 157–164, London, 1908.

BORGHINI 1584 R. Borghini. *Il riposo.* Florence, 1584.

BORGO 1976 L. Borgo. *The Works of Mariotto Albertinelli.* New York and London, 1976.

BOSTON 2003–2004 A. Chong, D. Pegazzano, and D. Zikos, eds. *Raphael, Cellini, and a Renaissance Banker: The Patronage of Bindo Altoviti* (exh. cat.). Boston 2003–2004.

BOTTARI AND TICOZZI 1822 G. Bottari and S. Ticozzi. *Raccolta di lettere sulla pittura, scultura ed architettura.* Milan, 1822.

BOUCHER 1991 B. Boucher. *The Sculpture of Jacopo Sansovino.* 2 vols. New Haven and London, 1991.

BOUDON 1998 M. Boudon. "Le relief d'*Ugolin* de Pierino da Vinci: Une réponse sculptée au problème du *paragone*." *Gazette des Beaux-Arts* 132 (July–August 1998), pp. 1–18.

BRANDT 1974 K.W.-G. Posner [Brandt]. *Leonardo and Central Italian Art, 1515–1550.* New York, 1974.

BRIGSTOCKE 1978 H. Brigstocke. *Italian and Spanish Paintings in the National Gallery of Scotland.* Edinburgh, 1978.

BROCK 2002 M. Brock. *Bronzino.* Paris, 2002.

BURY 2001 M. Bury. *The Print in Italy, 1550–1620* (exh. cat.). London, 2001.

BUTTERFIELD 2001 A. Butterfield, ed. *Masterpieces of Renaissance Art: Eight Rediscoveries* (exh. cat.). New York, 2001.

BUTTERFIELD AND FRANKLIN 1998 A. Butterfield and D. Franklin. "A Documented Episode in the History of Renaissance 'Terracruda' Sculpture." *The Burlington Magazine* 140 (December 1998), pp. 819–824.

BUTTERFIELD AND RADCLIFFE 2002 A. Butterfield and A. Radcliffe, eds. *Italian Sculpture: From the Gothic to the Baroque* (exh. cat.). New York, 2002.

BYAM SHAW 1976 J. Byam Shaw. *Drawings by Old Masters at Christ Church Oxford.* 2 vols. Oxford, 1976.

CALAFATI 2004 M. Calafati. "Sulle orme di un Bronzino: Firenze, Berlino, Ottawa: Ritratto di Simone da Firenzuola?" *Mitteilungen des Kunsthistorischen Institutes in Florenz* 48 (2004) (forthcoming).

CALDWELL 1975 J. Caldwell. "Two Portraits of Poets by Bachiacca." *Commentari* 26 (1975), pp. 297–309.

CAMPANI 1884 A. Campani. *Guide du visiteur au Musée Royal National dans l'ancien Palais du Podestat de Florence.* Florence, 1884.

CANBERRA 2002 G. Algranti, ed. *Titian to Tiepolo: Three Centuries of Italian Art* (exh. cat.). London and Milan, 2002.

CAPRETTI 1988–1989 E. Capretti. "I dipinti di Domenico Puligo." 2 vols. Ph.D diss., Università degli Studi di Firenze, 1988–1989.

CAPRETTI 1993 E. Capretti. "Ritratti e alcune 'teste' del Puligo." *Antichità Viva* 32 (1993), pp. 5–14.

CAPRETTI 2002 E. Capretti. "Domenico Puligo, un protagonista 'ritrovato' dell'arte fiorentina del Cinquecento." In Capretti and Padovani 2002, pp. 24–53.

CAPRETTI AND PADOVANI 2002 E. Capretti and S. Padovani, eds. *Domenico Puligo (1492–1527): Un protagonista dimenticato della pittura fiorentina* (exh. cat.). Livorno, 2002.

CARLI 1972 E. Carli. *Montalcino, Museo Civico, Museo Diocesano d'Arte Sacra.* Bologna, 1972.

CARROLL 1976 E. Carroll. *The Drawings of Rosso Fiorentino.* 2 vols. New York and London, 1976.

CAZORT ET AL. 1996 M. Cazort, M. Kornell, and K.B. Roberts. *The Ingenious Machine of Nature: Four Centuries of Art and Anatomy* (exh. cat.). Ottawa, 1996.

CECCHI 1977 A. Cecchi. "Borghini, Vasari, Naldini e la *Giudetta* del 1564." *Paragone* 28:323 (1977), pp. 100–107.

CERIANA 1997 M. Ceriana. "Un Perino del Vaga ritrovato." In *Scritti per l'Istituto Germanico di Storia dell'Arte di Firenze.* Florence, 1997.

CHENEY 1970 I.H. Cheney. "Notes on Jacopino del Conte." *The Art Bulletin* 52:1 (March 1970), pp. 32–40.

CHIARINI AND PADOVANI 2003 M. Chiarini and S. Padovani, eds. *La Galleria Palatina e gli Appartamenti Reali di Palazzo Pitti: Catalogo dei dipinti.* 2 vols. Florence, 2003.

CHIAVACCI 1859 E. Chiavacci. *Guida della R. Galleria del Palazzo Pitti.* Florence, 1859.

CHOUX 1975 J. Choux, "Nicolas de la Case, graveur lorrain du XVIe siècle." *Pays Lorrain* 55 (1975), pp. 175–180.

CIANCHI 1995 M. Cianchi, ed. *Pierino da Vinci: Atti della giornata di studio, Vinci, Biblioteca Leonardiana, 26 maggio 1990.* Florence, 1995.

CIARDI AND NATALI 1996 R.P. Ciardi and A. Natali, eds. *Pontormo e Rosso: Atti del convegno di Empoli e Volterra projetto Appiani di Piombino.* Venice, 1996.

CIARDI DUPRÉ 1963 M.G. Ciardi Dupré. "Giovan Francesco Rustici." *Paragone* 14:157 (1963), pp. 29–50.

CIARDI DUPRÉ 1966 M.G. Ciardi Dupré. "Per la cronologia dei disegni di Baccio Bandinelli fino al 1540." *Commentari* 17 (1966), pp. 146–170.

CIARDI DUPRÉ DAL POGGETTO 1977 M.G. Ciardi Dupré dal Poggetto. Review of J. Balogh, *Katalog der ausländischen Bildwerke des Museums der Bildenden Künste in Budapest, IV–XVIII Jahrbundert* (Budapest, 1975). *Prospettiva*, no. 8 (January 1977), pp. 63–67.

CIERI VIA 2002 C. Cieri Via. "Un artista intellectuale: Piero di Cosimo e il mito di Prometeo." In *Metamorphosen, Wandlungen und Verwandlungen in Literatur, Sprache und Kunst von der Antike bis zur Gegenwart: Festschrift für Bodo Guthmüller zum 65. Geburtstag*, ed. H. Marek, A. Neuschäfer, and S. Tichy, pp. 95–109. Wiesbaden, 2002.

CLAPP 1914 F.M. Clapp. *Les dessins de Pontormo.* Paris, 1914.

CLARK AND PEDRETTI 1968–1969 K. Clark and C. Pedretti. *The Drawings of Leonardo da Vinci in the Collection of Her Majesty The Queen at Windsor Castle.* 3 vols. 1935. London, 1968–1969.

CLAYTON 1992 M. Clayton. *Leonardo da Vinci: The Anatomy of Man: Drawings from the Collection of Her Majesty Queen Elizabeth II* (exh. cat.). Boston, Toronto, and London, 1992.

CLAYTON 1999 M. Clayton. *Raphael and His Circle: Drawings from Windsor Castle.* London, 1999.

COLASANTI 1905 A. Colasanti. "Il memoriale di Baccio Bandinelli." *Repertorium für Kunstwissenschaft* 28 (1905), pp. 406–446.

COLBERT 1978 C.D. Colbert. "Bacchiacca in the Context of Florentine Art." Ph.D. diss., Harvard University, 1978.

COLLARETA 1995 M. Collareta. "Pierino da Vinci e Pisa." In Cianchi 1995, pp. 35–37.

CONISBEE 1991 P. Conisbee et al. *The Ahmanson Gifts: European Masterpieces in the Collection of the Los Angeles County Museum of Art.* Los Angeles, 1991.

CONTI 1983–1984 A. Conti. "Andrea del Sarto e Becuccio Bicchieraio." *Prospettiva*, nos. 33–36 (April 1983–January 1984), pp. 161–165.

CONTI 1995 A. Conti. *Pontormo.* Milan, 1995.

CORTI 1989 L. Corti. *Vasari: Catalogo completo dei dipinti.* Florence, 1989.

COSTAMAGNA 1988 P. Costamagna. "Osservazione sull'attività giovanile di Alessandro Allori. Seconda parte – Les Portraits." *Antichità Viva* 27:1 (1988), p. 23.

COSTAMAGNA 1994 P. Costamagna. *Pontormo: Catalogue raisonné de l'œuvre peint.* Milan and Paris, 1994.

COSTAMAGNA 2002 P. Costamagna. "De l'idéal de beauté aux problèmes d'attribution: Vingt ans de recherche sur le portrait florentin au XVIᵉ siècle." *Studiolo: Revue d'histoire de l'art de l'Académie de France à Rome* 1 (2002), pp. 193–220.

COSTAMAGNA AND FABRE 1985 P. Costamagna and A. Fabre. "À propos de 'L'Orfèvre' du Pitti." *Antichità Viva* 24 (1985), pp. 31–33.

COSTAMAGNA AND FABRE 1986 P. Costamagna and A. Fabre. *Les portraits florentins du début du XVIᵉ siècle à l'avènement de Cosimo I: Catalogue raisonné d'Albertinelli à Pontormo.* 2 vols. Paris, 1986.

COSTAMAGNA AND FABRE 1991 P. Costagmagna and A. Fabre. "Di alcuni problemi della bottega di Andrea del Sarto." *Paragone* 42:491 (1991), pp. 15–28.

COX-REARICK 1964 J. Cox-Rearick. *The Drawings of Pontormo.* Cambridge, Mass., 1964.

COX-REARICK 1981 J. Cox-Rearick. *The Drawings of Pontormo: A Catalogue Raisonné with Notes on the Paintings.*2 vols. Rev. ed. New York, 1981.

COX-REARICK 1984 J Cox-Rearick. *Dynasty and Destiny in Medici Art: Pontormo, Leo X and the Two Cosimos.* Princeton, 1984.

COX-REARICK 1987 J. Cox-Rearick. "A 'St Sebastian' by Bronzino." *The Burlington Magazine* 129 (March 1987), pp. 155–162.

COX-REARICK 1989 J. Cox-Rearick. "From Bandinelli to Bronzino: The Genesis of the Lamentation for the Chapel of Eleonora di Toledo." *Mitteilungen des Kunsthistorischen Institutes in Florenz* 33 (1989), pp. 37–84.

COX-REARICK 1993 J. Cox-Rearick. *Bronzino's Chapel of Eleonora in the Palazzo Vecchio.* Berkeley, 1993.

COX-REARICK 1996 J. Cox-Rearick. *The Collection of Francis I: Royal Treasures.* Antwerp, 1995; New York, 1996.

COX-REARICK AND WESTERMAN BULGARELLA 2004 J. Cox-Rearick and M. Westerman Bulgarella. "Public and Private Portraits of Cosimo de' Medici and Eleonora da Toledo: Bronzino's Paintings of his Ducal Patrons in Ottawa and Turin." *Artibus et Historiae,* no. 49 (2004), pp. 101–159.

CREMONINI 1998 C. Cremonini. "Le raccolte d'arte del cardinale Alessandro d'Este: Vicende collezionistiche tra Modena e Roma." In Modena 1998, pp. 91–137.

CROPPER 1997 E. Cropper. *Pontormo: Portrait of a Halberdier.* Los Angeles, 1997.

CROWE AND CAVALCASELLE 1864–1866 J.A. Crowe and G.B. Cavalcaselle. *A New History of Painting in Italy from the Second to the Sixteenth Century.* London, 1864–1866.

CROWE AND CAVALCASELLE 1903–1914 J.A. Crowe and G.B. Cavalcaselle. *A History of Painting in Italy, Umbria, Florence and Siena from the Second to the Sixteenth Century.* 6 vols. London, 1903–1914.

CUST 1907 L. Cust. "La Collection de M.R.-H. Benson." *Les Arts* 70 (October 1907), pp. 2–32.

D'ALESSANDRO 1980 A. D'Alessandro. "Il mito dell'origine 'aramea' di Firenze in un trattatello di Giambattista Gelli." *Archivio storico italiano* 138 (1980), pp. 339–389.

DALLI REGOLI 2001 G. Dalli Regoli. "Michelangelo e l'altra Leda." *Artista* 13 (2001), pp. 142–147.

DAVIDSON 1954 B.F. Davidson. "Vasari's *Deposition* in Arezzo." *The Art Bulletin* 36:3 (September 1954), pp. 228–231.

DAVIDSON 1961 B.F. Davidson. "Marcantonio's Martyrdom of San Lorenzo." *Bulletin of the Rhode Island School of Design* 47 (1961), pp. 1–6.

DAVIS 1977 C. Davis. "The Tomb of Mario Nari for the SS. Annunziata in Florence: The Sculptor Bartolomeo Ammannati until 1544." *Mitteilungen des Kunsthistorischen Institutes in Florenz* 21 (1977), pp. 69–94.

DAVIS 1995 C. Davis. "I Bassorilievi di Gianfrancesco Rustici." *Mitteilungen des Kunsthistorischen Institutes in Florenz* 39 (1995), pp. 93–107.

DELABORDE 1888 H. Delaborde. *Marc-Antoine Raimondi: Étude historique et critique.* Paris, 1888.

DE MIRIMONDE 1967 A.P. de Mirimonde. "La musique dans les allégories de l'amour: 2. Eros." *Gazette des Beaux-Arts* 69 (May–June 1967), pp. 319–346.

DE TOLNAY 1943 C. de Tolnay. *The Youth of Michelangelo.* Princeton, 1943.

DE TOLNAY 1947–1960 C. de Tolnay. *Michelangelo.* 5 vols. Princeton, 1947–1960.

DE TOLNAY 1975–1980 C. de Tolnay. *Corpus dei disegni di Michelangelo.* 4 vols. Novara, 1975–1980.

DUSSLER 1959 L. Dussler. *Die Zeichnungen des Michelangelo: Kritische Katalog.* Berlin, 1959.

EDGERTON 1985 S.Y. Edgerton. *Pictures and Punishment.* Ithaca, 1985.

EDINBURGH 1994 *Raphael: The Pursuit of Perfection* (exh. cat.). Edinburgh, 1994.

ELAM 1993 C. Elam. "Art in the Service of Liberty: Battista della Palla, Art Agent for Francis I." *I Tatti Studies* 5 (1993), pp. 62–69.

FAEDO 1985 L. Faedo. "L'impronta delle parole: Due momenti della pittura di ricostruzione." In *Memoria dell'antico nell'arte italiana,* ed. S. Settis. Vol. 2, *Generi ritrovati,* pp. 8–42. Turin, 1985.

FAIETTI AND OBERHUBER 1988 M. Faietti and K. Oberhuber, eds. *Humanismus in Bologna, 1490–1510* (exh. cat.). Vienna, 1998.

FAISON 1964 S.L. Faison, Jr. *Art Tours and Detours in New York State.* New York, 1964.

FALCIANI 1996 C. Falciani. *Il Rosso Fiorentino.* Florence, 1996.

FARMER 1978 D.H. Farmer. *The Oxford Dictionary of Saints.* Oxford, 1978.

FERMOR 1993 S. Fermor. *Piero di Cosimo: Fiction, Invention and Fantasìa.* London, 1993.

FERRETTI 1992 M. Ferretti. "Maestro dei bambini irrequieti: Due putti in lotta." In *Per la Storia della Scultura: Materiali inediti e poco noti,* ed. M. Ferretti, pp. 33–49. Turin, 1992.

FERRI 1890 P.N. Ferri. *Catalogo raissuntivo della raccolta di disegni antichi e moderni posseduta dalla R. Galleria degli Uffizi di Firenze.* Rome, 1890.

FFOULKES 1894 C.J. Ffoulkes. "Le esposizioni d'arte italiana a Londra." *Archivio Storico dell'Arte* 7 (1894), pp. 153–176.

FILETI MAZZA 1987 M. Fileti Mazza, ed. *Archivio del Collezionismo Mediceo: Il Cardinal Leopoldo, I.* Milan and Naples, 1987.

FIORENTINI 1999 E. Fiorentini. *Ikonographie eines Wandels: Form und Intention von Selbstbildnis und Porträt des Bildhauers im Italien des 16. Jahrhunderts.* Bonn, 1999.

FIORENTINI AND ROSENBERG 2002 E. Fiorentini and R. Rosenberg. "Baccio Bandinelli's Self-Portrait." *Print Quarterly* 19 (2002), pp. 34–44.

FISCHEL 1913–1941 O. Fischel. *Raphaels Zeichnungen.* 8 vols. Berlin, 1913–1941.

FISCHER 1990a C. Fischer. "The Young Fra Bartolommeo and *The Temptation of St. Antony.*" In *European Drawings from Six Centuries: Festschrift to Erik Fischer,* pp. 315–340. Copenhagen, 1990.

FISCHER 1990b C. Fischer. *Fra Bartolommeo, Master Draughtsman of the High Renaissance: A Selection from the Rotterdam Albums and Landscape Drawings from Various Collections* (exh. cat.). Rotterdam, 1990.

FLORENCE 1949 *Lorenzo il Magnifico e le arti: Mostra d'arte antica.* Florence, 1949.

FLORENCE 1960 M. Gregori, M. Bacci, and C. Donzelli, eds. *Mostra dei tesori segreti delle case fiorentine* (exh. cat.). Florence, 1960.

FLORENCE 1980a *Il primato del disegno: Firenze e la Toscana dei Medici nell'Europa del Cinquecento* (exh. cat.). Florence, 1980.

FLORENCE 1980b *Palazzo Vecchio: Committenza e collezionismo medicei / Firenze e la Toscana dei Medici nell'Europa del 500* (exh. cat.). Florence, 1980.

FLORENCE 1986 M. Chiarini, ed. *Andrea del Sarto, 1486–1530: Dipinti e disegni a Firenze* (exh. cat.). Milan, 1986.

FLORENCE 1996 A. Cecchi, A. Natali, and C. Sisi, eds. *L'officina della maniera: Varietà e fierezza nell'arte fiorentina del Cinquecento fra le due repubbliche (1494–1530)* (exh. cat.). Florence, 1996.

FLORENCE 2002 F. Falletti and J.K. Nelson, eds. *Venus and Love: Michelangelo and the New Ideal of Beauty / Venere e Amore: Michelangelo e la nuova bellezze ideale* (exh. cat.). Florence, 2002.

FLORENCE, CHICAGO, AND DETROIT 2002–2003 M. Chiarini, A. Darr, and C. Giannini, eds. *The Medici, Michelangelo, and the Art of Late Renaissance Florence / L'ombra del genio: Michelangelo e l'arte a Firenze, 1537–1631* (exh. cat.). New Haven and Milan, 2002.

FOGELMAN ET AL. 2002 P. Fogelman, P. Fusco, and M. Cambareri. *Italian and Spanish Sculpture: Catalogue of the J. Paul Getty Museum Collection.* Los Angeles, 2002.

FORLANI 1962 A. Forlani. *I disegni italiani del Cinquecento.* Venice, 1962.

FORLANI TEMPESTI 1967 A. Forlani Tempesti. "Note al Pontormo disegnatore." *Paragone* 18:207/27 (1967), pp. 70–86.

FORLANI TEMPESTI 1981 A. Forlani Tempesti. "Un foglio del Pontormo." *Bolletino d'Arte* 66 (January–March 1981), pp. 117–122.

FORLANI TEMPESTI 1991 A. Forlani Tempesti. *The Robert Lehman Collection.* Vol. 5, *Italian Fifteenth- to Seventeenth-Century Drawings.* New York and Princeton, 1991.

FORLANI TEMPESTI AND CAPRETTI 1996 A. Forlani Tempesti and E. Capretti. *Piero di Cosimo: Catalogo completo.* Florence, 1996.

FORSTER 1971 K.W. Forster. "Metaphors of Rule: Political Ideology and History in the Portraits of Cosimo I de' Medici." *Mitteilungen des Kunsthistorischen Institutes in Florenz* 15 (1971), pp. 65–103.

FORTI GRAZZINI 1994 N. Forti Grazzini. *Gli arazzi.* 2 vols. Rome and Milan, 1994.

FRANKLIN 1990 D. Franklin. "A Document for Pontormo's S. Michele Visdomini Altar-piece." *The Burlington Magazine* 132 (July 1990), pp. 487–489.

FRANKLIN 1993 D. Franklin. "Ridolfo Ghirlandaio's Altar-pieces for Leonardo Buonafé and the Hospital of S. Maria Nuova in Florence." *The Burlington Magazine* 135 (January 1993), pp. 4–16.

FRANKLIN 1994 D. Franklin. *Rosso in Italy: The Italian Career of Rosso Fiorentino.* New Haven and London, 1994.

FRANKLIN 1997 D. Franklin. "Vasari as a Source for Himself: The Case of the Peducci Banner in Arezzo." *Studi di Storia dell'Arte* 8 (1997), pp. 307–317.

FRANKLIN 2001 D. Franklin. *Painting in Renaissance Florence, 1500–1550.* New Haven and London, 2001.

FRANKLIN 2003 D. Franklin. *Treasures of the National Gallery of Canada.* Ottawa, 2003.

FRANKLIN 2005 D. Franklin. "A Newly Discovered Drawing by Pontormo." *The Burlington Magazine* 147 (2005) (forthcoming).

FREDERICKSEN AND ZERI 1972 B. Fredericksen and F. Zeri. *Census of Pre-Nineteenth-Century Italian Paintings in North American Public Collections.* Cambridge, Mass., 1972.

FREEDBERG 1961 S.J. Freedberg. *Painting of the High Renaissance in Rome and Florence.* Cambridge, Mass., 1961.

FREEDBERG 1963 S.J. Freedberg. *Andrea del Sarto: Catalogue Raisonné.* 2 vols. Cambridge, Mass., 1963.

FREEDBERG 1972 S.J. Freedberg. *Painting of the High Renaissance in Rome and Florence.* New York, 1972.

FREEDBERG 1985 S.J. Freedberg. *Painting of the High Renaissance in Rome and Florence.* 2 vols. Rev. ed. Cambridge, Mass., 1985.

FREY 1923–1930 K. and H.-W. Frey, eds. *Der literarische Nachlass: Giorgio Vasaris.* 2 vols. Munich, 1923–1930.

FREY 1941 K. Frey. *Il carteggio di Giorgio Vasari dal 1563 al 1565.* Arezzo, 1941.

FRONEK 1987 J. Fronek. "The Restoration of a Master Painting." *Members' Calendar, Los Angeles County Museum of Art* 25:11 (November 1987), pp. 7–9.

FUSCO 1997 P. Fusco. *Summary Catalogue of European Sculpture in the J. Paul Getty Museum.* Los Angeles, 1997.

GABORIT 1994 J.-R. Gaborit. "Un relief du musée des Beaux-Arts d'Orléans: La Flagellation par Baccio Bandinelli." *Bulletin de la Societé Nationale des Antiquaires de France* (1994), pp. 146–152.

GAETA BERTELÀ 1987 G. Gaeta Bertelà. *Archivio del collezionismo Mediceo: Il Cardinal Leopoldo de' Medici, I: Rapporti con il mercato veneto, vol. 2 (catalogo storico dei disegni).* Milan and Naples, 1987.

GALLERIA LUIGI BELLINI 1965 *Galleria "Luigi Bellini" di Giuseppe e Mario Bellini.* Florence, 1965.

GAMBA 1936 C. Gamba. *Botticelli.* Milan, 1936.

GARDNER 1986 G.A. Gardner. "The Paintings of Domenico Puligo." Ph.D. diss., Ohio State University, 1986.

GARRARD 1970 M. Garrard. "The Early Sculpture of Jacopo Sansovino: Florence and Rome." Ph.D. diss., The Johns Hopkins University, 1970.

GAURICUS 1969 P. Gauricus. *De sculptura (1504).* Ed. and trans. A. Chastel and R. Klein. Geneva and Paris, 1969.

GENTILINI 1992 G. Gentilini. *I Della Robbia: La scultura invetriata nel Rinascimento.* 2 vols. Florence, 1992.

GENTILINI 1998 G. Gentilini, ed. *I Della Robbia e "l'arte nuova" della scultura invetriata* (exh. cat.). Florence, 1998.

GETTY MUSEUM 1998 *Masterpieces of the J. Paul Getty Museum: European Sculpture.* Los Angeles, 1998.

GIGLIOLI 1910 O.H. Giglioli. "Notiziario: R.Galleria Palatina." *Rivista d'Arte* 7 (1910), pp. 168–170.

GILES 1991 L.M.Giles. "*Christ before Pilate*: A Major Composition Study by Pontormo." *The Art Institute of Chicago Museum Studies* 17 (1991), pp. 22–40.

GINORI LISCI 1972 L. Ginori Lisci. *I palazzi di Firenze nella storia e nell'arte.* 2 vols. Florence, 1972.

GLUECK 2003 G. Glueck. Review of the exhibition *Italian Sculpture: From the Gothic to the Baroque.* *New York Times,* 10 January 2003, p. E47.

GOLDNER 1983 G.R. Goldner. *Master Drawings from the Woodner Collection.* Malibu, 1983.

GOLDNER 1988 G.R. Goldner. *European Drawings: Catalogue of the Collections,* vol. 1. Malibu, 1988.

GOULD 1966 C. Gould. *Michelangelo: Battle of Cascina.* Newcastle-upon-Tyne, 1966.

GRODECKI 1971 C. Grodecki. "Le séjour de Benvenuto Cellini à l'Hôtel de Nesle et la Fonte de la Nymphe de Fontainebleau d'après les Actes Notaires Parisiens." *Bulletin de la Société de L'Histoire de Paris et de L'Île-de-France* (1971).

GÜSE AND PERRIG 1997 E.-G.Güse and A. Perrig, eds. *Zeichnungen aus der Toskana: Das Zeitalter Michelangelos* (exh. cat.). Munich and New York, 1997.

HABICH 1922–1923 G. Habich. *Die Medaillen der italienischen Renaissance.* Stuttgart and Berlin, 1922–1923.

HÄRB 1997 F. Härb. "Theorie und Praxis der Zeichnung bei Giorgio Vasari." In Güse and Perrig 1997, pp. 54–63.

HÄRB 1998 F. Härb. "Modes and Models in Vasari's Early Drawing Oeuvre." In Cambridge 1998, pp. 83–110.

HAMBURG 1997 E. Schaar. *Italienische Zeichnungen der Renaissance aus dem Kupferstichkabinett der Hamburger Kunsthalle* (exh. cat.). Hamburg, 1997.

HAMBURG 2001 *Von Dürer bis Goya: 100 Meisterzeichnungen aus dem Kupferstichkabinett der Hamburger Kunsthalle* (exh. cat.). Hamburg, 2001.

HARPRATH 1977 R. Harprath. *Italienische Zeichnungen des 16. Jahrhunderts aus eigenem Besitz* (exh. cat.). Munich, 1977.

HARTT 1971 F. Hartt. *The Drawings of Michelangelo.* London, 1971.

HEIKAMP 1966 D. Heikamp. "In margine alla 'Vita di Baccio Bandinelli' del Vasari." *Paragone* 17:191 (1966), pp. 51–62.

HEIKAMP 1969 D. Heikamp. "Die Arazzeria Medicea im 16 Jahrhundert: Neue Studien." *Münchner Jahrbuch der Bildenen Kunst* 20 (1969), pp. 33–37.

HERRIG 1992 D. Herrig. *Fontainebleau: Geschichte und Ikonologie der Schlossanlage Franz I.* Munich, 1992.

HIND 1913 A.M. Hind. "Marcantonio Raimondi," *Print Collector's Quarterly* 3 (1913), pp. 243–276.

HIND 1938–1948 A.M. Hind. *Early Italian Engraving: A Critical Catalogue with Complete Reproduction of the Prints Described.* 7 vols. London, 1938–1948.

HIRST 1988 M. Hirst. *Michelangelo and His Drawings.* New Haven and London, 1988.

HIRST 1993 M. Hirst. *Michelangelo: I disegni.* Turin, 1993.

HOCHMANN 2004 M. Hochmann. *Venise et Rome, 1500–1600: Deux écoles de peinture et leurs échanges.* Geneva, 2004.

HOLBROOK 1911 R.T. Holbrook. *Portraits of Dante from Giotto to Raffael: A Critical Study with a Concise Iconography.* London and New York, 1911.

HOPE 1985 C. Hope. "Historical Portraits in the *Lives* and in the Frescoes of Giorgio Vasari." In *Giorgio Vasari tra decorazione ambientale e storiografia artistica* (Convegno di studi, Arezzo, 1981), ed. G.C. Garfagnini, pp. 321–338. Florence, 1985.

HORNE 1915 H.P. Horne. "Botticelli's *Last Communion of S. Jerome.*" *The Burlington Magazine* 28 (November 1915), pp. 45–47.

HOVEY 1972 W.R. Hovey. *The Arts in Changing Societies: Reflections Inspired by Works of Art in the Frick Art Museum, Pittsburgh.* Pittsburgh, 1972.

HOVEY 1975 W.R. Hovey. *Treasures of the Frick Art Museum.* Pittsburgh, 1975.

IENI 1985 G. Ieni. "*Una machina grandissima quasi a guisa d'arco trionfale*: L'altare vasariano." In Spantigati and Ieni 1985, pp. 49–62.

INDIANAPOLIS 1954 *Pontormo to Greco: The Age of Mannerism: A Loan Exhibition of Paintings and Drawings of the Century 1520–1620* (exh. cat.). Indianapolis, 1954.

INGHIRAMI 1828 F. Inghirami. *L'Imp. e Reale Palazzo Pitti.* Fiesole, 1828.

INGHIRAMI 1834 F. Inghirami. *La Galleria dei Quadri esistente nell'Imp. e Reale Palazzo Pitti.* Fiesole, 1834.

IRLE 1997 K. Irle. "Herkules im Spiegel der Herrscher." In *Herkules: Tugendheld und Herrscherideal*, ed. C. Lukatis and H. Ottomeyer, pp. 61–77. Eurasburg, 1997.

JABACH 1671 *Dessins de la collection Everard Jabach acquis en 1671 pour la collection royale*, Musée du Louvre, Cabinet des dessins. 5 vols. Paris, 1978.

JACKS 1992 P. Jacks. "Giorgio Vasari's *Ricordanze*: Evidence from an Unknown Draft." *Renaissance Quarterly* 45:4 (1992) pp. 739–784.

JACKS 1998 P. Jacks, ed. *Vasari's Florence: Artists and Literati at the Medicean Court.* Cambridge, 1998.

JACQUEMART-ANDRÉ 1975 F. de la Moureyre-Gavoty. *Sculpture italienne.* Paris, 1975.

JAFFÉ 1994 M. Jaffé. *The Devonshire Collection of Italian Drawings.* 4 vols. London, 1994.

JAFFÉ 1997 D. Jaffé. *Summary Catalogue of European Paintings in the J. Paul Getty Museum.* Los Angeles, 1997.

JESTAZ 2003 B. Jestaz. "Benvenuto Cellini et la Cour de France (1540–1545)." In *Art et Artistes en France de la Renaissance à la Révolution: Études réunies par Bertrand Jestaz*, Bibliothèque de l'École des chartes, vol. 161, ed. B. Jestaz, pp. 105–119, 132. Geneva, 2003.

JOANNIDES 1983 P. Joannides. *The Drawings of Raphael, with a Complete Catalogue.* Oxford, 1983.

JOANNIDES 1993 P. Joannides. "Daniele da Volterra's 'Dido.'" *The Burlington Magazine* 135 (December 1993), pp. 818–819.

JOANNIDES 1994 P. Joannides. "Bodies in the Trees: A Mass-Martyrdom by Michelangelo." *Apollo* 140 (November 1994), pp. 3–14.

JOANNIDES 1996 P. Joannides. *Michelangelo and His Influence: Drawings from Windsor Castle* (exh. cat.). Washington, D.C., 1996.

JOANNIDES 2003 P. Joannides. *Inventaire général des dessins italiens.* Vol. 6, *Michel-Ange: Élèves et copistes.* Paris, 2003.

KAFTAL 1952 G. Kaftal. *Iconography of the Saints in Tuscan Painting.* Florence, 1952.

KEMP 1988 M. Kemp. *Leonardo e lo spazio dello scultore (XXVII Lettura Vinciana).* Vinci, 1988.

KEMP 1989 M. Kemp, ed. *Leonardo on Painting: An Anthology of Writings by Leonardo da Vinci with a Selection of Documents Relating to His Career as an Artist.* New Haven and London, 1989.

KEUTNER 1965 H. Keutner. "Niccolò Tribolo und Antonio Lorenzi: Der Äskulapbrunnen im Heilkräutergarten der Villa Castello bei Florenz." In *Studien zur Geschichte der Europäischen Plastik: Festschrift Theodor Müller.* Munich, 1965.

KINNEY 1976 P. Kinney. "The Early Sculpture of Bartolomeo Ammanati." Ph.D. diss., New York University, 1976.

KLIEMANN 1986 J. Kliemann. *Andrea del Sarto: Il tributo a Cesare (1519–1521).* Poggio a Caiano, 1986.

KNAB ET AL. 1983 E. Knab, E. Mitsch, and K. Oberhuber. *Raphael: Die Zeichnungen.* Stuttgart, 1983.

KNAPP 1903 F. Knapp. *Fra Bartolommeo della Porta und die Schule von San Marco.* Halle, 1903.

KOSCHATZKY ET AL. 1971 W. Koschatzky, K. Oberhuber, and E. Knab. *The Famous Italian Drawings of the Albertina Collection.* Milan, 1971.

KUSENBERG 1931 K. Kusenberg. *Le Rosso.* Paris, 1931.

LA FRANCE 2002 R.G. La France. "Francesco d'Ubertino Verdi, il Bachiacca (1494–1557): 'Diligente Dipintore.'" Ph.D. diss., Institute of Fine Arts, New York University, 2002.

LA FRANCE 2003 R.G. La France. "Bachiacca's Formula for Success." In *The Art Market in Italy, 15th–17th Centuries / Il mercato dell'arte in Italia, secc. XV–XVII*, ed. M. Fantoni, L.C. Matthew, and S.F. Matthews-Grieco, pp. 237–252. Modena, 2003.

LANDAU AND PARSHALL 1994 D. Landau and P. Parshall. *The Renaissance Print, 1470–1550.* New Haven and London, 1994.

LA PORTA 1992 P. La Porta. "Ritratto di Domenico Puligo." *Prospettiva*, no. 68 (1992), pp. 30–44.

LASCHKE 1998 B. Laschke. "Die Arme des Laokoön." In *Il cortile delle statue*, ed. B. Andreae, C. Pietrangeli, and M. Winner, pp. 175–186. Mainz, 1998.

LASKIN AND PANTAZZI 1987 M. Laskin, Jr., and M. Pantazzi. *Catalogue of the National Gallery of Canada: European and American Painting, Sculpture, and Decorative Arts.* 2 vols. Ottawa, 1987.

LAWALL LIPSHULTZ 1988 S. Lawall Lipshultz. *Selected Works: The Minneapolis Institute of Arts.* Minneapolis, 1988.

LEITHE-JASPER 1986 M. Leithe-Jasper. *Renaissance Master Bronzes from the Collection of the Kunsthistorisches Museum, Vienna.* Washington, D.C., 1986.

LEPORATTI 2002 R. Leporatti. "Venere, Cupido e i poeti d'amore / Venus, Cupid and the Poets of Love." In Florence 2002, pp. 64–89.

LERMOLIEFF 1880 I. Lermolieff. *Die Werke italienischer Meister in den Galerien von Muenchen, Dresden und Berlin.* Leipzig, 1880.

LEVENSON ET AL. 1973 J.A. Levenson, K. Oberhuber, and J.L. Sheehan. *Early Italian Engravings from the National Gallery of Art.* Washington, D.C., 1973.

LEVI D'ANCONA 1977 M. Levi D'Ancona. *The Garden of the Renaissance: Botanical Symbolism in Italian Painting.* Florence, 1977.

LLOYD 1968 C. Lloyd. "Drawings Attributable to Niccolo Tribolò." *Master Drawings* 1:3 (Autumn 1968), pp. 243–245.

LLOYD 1993 C. Lloyd. *Italian Paintings before 1600 in the Art Institute of Chicago: A Catalogue of the Collection.* Chicago, 1993.

LOESER 1896 C. Loeser. "Quadri italiani nella Galleria di Strasborgo." *Archivio Storico dell'Arte* 9, ser. 2 (1896), pp. 277–287.

LOESER 1928 C. Loeser. "Gianfrancesco Rustici." *The Burlington Magazine* 52 (June 1928), pp. 260–272.

LONDON 1914 *Catalogue of Italian Pictures at 16, South Street, Park Lane, London, and Buckhurst in Sussex Collected by Robert and Evelyn Benson.* London, 1914.

LONDON 1992 *Drawings Related to Sculpture 1520–1620.* London, 1992.

LONDON 2001a *A Del Sarto Rediscovered* (exh. cat.). London, 2001.

LONDON 2001b *Andrea del Sarto: The Botti Madonna* (exh. cat.). London, 2001.

LOS ANGELES 1988–1989 B. Davis, ed. *Mannerist Prints: International Style in the Sixteenth Century* (exh. cat.). Los Angeles, 1988–1989.

LUCHS 1977 A. Luchs. *Cestello, a Cistercian Church of the Florentine Renaissance.* New York, 1977.

LYONS 1549 *La magnifica et triumphale entrata del Christianiss: Re di Francia Henrico II ... fatta nella nobile et antiqua citta di Lyone ... colla particolare descritione della Comedia che fece recitare la Natione Fiorentina.* Lyons, 1549.

MACANDREW 1980 H. Macandrew. *Catalogue of the Collection of Drawings in the Ashmolean Museum.* Vol. 3, *Italian Schools: Supplement.* Oxford, 1980.

MACLAGAN AND LONGHURST 1932 E. Maclagan and M.H. Longhurst. *Catalogue of Italian Sculpture.* London, 1932.

MANTUA 1999 K. Oberhuber, ed. *Roma e lo stile classico di Raffaello* (exh. cat.). Entries by A.Gnann. Mantua, 1999.

MANTUA 2001 E. Parma, ed. *Perino del Vaga tra Raffaello e Michelangelo* (exh. cat.). Mantua, 2001.

MARANI 2000 P.C. Marani. *Leonardo da Vinci: The Complete Paintings.* Trans. A.L. Jenkens. New York, 2000.

MARCUCCI 1958 L. Marcucci. "Contributo al Bachiacca." *Bollettino d'Arte* 43 (1958), pp. 26–39.

MARIACHER 1962 G. Mariacher. *Il Sansovino*. Milan, 1962.

MARLIER 1962 G. Marlier. "Pourquoi ces rochers à visages humains? Le paysage anthropomorphe se situe au point de rencontre de l'inquiétude religieuse et de l'hallucination païenne." *Connaissance des Arts* 124 (1962), pp. 82–91.

MARQUAND 1919 A. Marquand. *Della Robbia Heraldry*. Princeton, 1919; New York, 1972.

MARQUAND 1922 A. Marquand. *Andrea della Robbia and His Atelier*. 2 vols. Princeton, 1922.

MARSDEN AND BASSETT 2003 J. Marsden and J. Bassett. "Cellini's Other Satyr for the Porte Dorée at Fontainebleau." *The Burlington Magazine* 145 (August 2003), pp. 552–563.

MARTÍNEZ BIELSA 1999 A. Martínez Bielsa. *La expresión del dibujo del desnudo en el Renasciemiento italiano*. Valencia, 1999.

MASSARI AND PROSPERI VALENTI RODINÒ 1989 S. Massari and S. Prosperi Valenti Rodinò. *Tra mito e allegoria: Immagini a stampa nel '500 e '600*. Rome, 1989.

MASSINELLI 1991 A.M. Massinelli. *Bronzetti e anticaglie dalla Guardaroba di Cosimo I*. Florence, 1991.

MASSING 1990 J.M. Massing. *Du texte à l'image: La Calomnie d'Apelle et son iconographie*. Strasbourg, 1990.

MCCOMB 1926 A. McComb. "Francesco Ubertini (Bacchiacca)." *The Art Bulletin* 8:3 (March 1926), pp. 140–167.

MCCOMB 1928 A. McComb. *Agnolo Bronzino: His Life and Works*. Cambridge, 1928.

MCCORQUODALE 1981 C. McCorquodale. *Bronzino*. New York and London, 1981.

MCCULLAGH AND GILES 1997 S.F. McCullagh and L.M. Giles. *Italian Drawings before 1600 in The Art Institute of Chicago: A Catalogue of the Collection*. Chicago, 1997.

MCIVER 1992 K.A. McIver. "Music in Italian Renaissance Painting, 1480–1580: A Study in Iconology." Ph.D. diss., University of California, Santa Barbara, 1992.

MCKILLOP 1974 S.R. McKillop. *Franciabigio*. Berkeley, Los Angeles, and London, 1974.

MCTAVISH 2000 D. McTavish. Review of *Francesco Salviati o la Bella Maniera*. *Master Drawings* 38 (2000), pp. 66–70.

MCTAVISH ET AL. *ANNUNCIATION* D. McTavish, A. Murray, and E. Forest. "Ridolfo Ghirlandaio's Grisaille *Annunciation* Re-discovered" (forthcoming).

MEONI 1998 L. Meoni. *Gli arazzi nei musei fiorentini: La collezione medicea: Catalogo completo*. Vol. 1, *La manifattura da Cosimo I a Cosimo II (1545–1621)*. Livorno, 1998.

MERRITT 1955 H.S. Merritt. "A New Accession." *Gallery Notes: Memorial Art Gallery of the University of Rochester* 20:3 (January 1955), pp. 1–2.

MERRITT 1958 H.S. Merritt. *Bacchiacca Studies: The Uses of Imitation*. Princeton, 1958.

MERRITT 1961 H.S. Merritt. "Francesco Ubertini: Called Il Bacchiacca, 1494–1557." In *Bacchiacca and His Friends*, pp. 19–34. Baltimore, 1961.

MERRITT 1963 H.S. Merritt. "The Legend of St. Achatius: Bachiacca, Perino, Pontormo." *The Art Bulletin* 45 (September 1963), pp. 258–263.

MERRITT 1988 H.S. Merritt. "Francesco Ubertini, called il Bachiacca: *The Conversion of St. Paul*." In *The Memorial Art Gallery of the University of Rochester: An Introduction to the Collection*, ed. S.D. Peters, pp. 66–67. New York, 1988.

MEYER ZUR CAPELLEN 1996 J. Meyer zur Capellen. *Raffael in Florenz*. Munich and London, 1996.

MIDDELDORF 1935 U. Middeldorf. "New Attributions to G.F. Rustici." *The Burlington Magazine* 66 (February 1935), pp. 71–81.

MIDDELDORF 1936 U. Middeldorf. "Sull'attività della bottega di Jacopo Sansovino." *Rivista d'Arte* 18, ser. 2 (1936), pp. 245–263.

MILAN 1998–1999 *L'anima e il volto: Ritratto e fisiognomica da Leonardo a Bacon* (exh. cat.), ed. F. Caroli. Milan, 1998–1999.

MILAN AND FLORENCE 2004 *Botticelli e Filippino: L'inquietudine e la grazia nella pittura fiorentina del Quattrocento / Botticelli and Filippino: Passion and Grace in Fifteenth-Century Painting* (exh. cat.). Milan and Florence, 2004.

MINONZIO 1980 D. Minonzio. "Novità e apporti per Agostino Veneziano." *Rassegna di Studi e di Notizie* 8 (1980), pp. 273–320.

MODENA 1998 J. Bentini, ed. *Sovrane passioni: Le raccolte d'arte della Ducale Galleria Estense*. Milan, 1998.

MOENCH 1993 E. Moench. *Les primitifs italiens du Musée des Beaux-Arts de Strasbourg*. Strasbourg, 1993.

MONBEIG GOGUEL 1972 C. Monbeig Goguel. *Vasari et son temps: Maîtres toscans nés après 1500, morts avant 1600*. Paris, 1972.

MONBEIG GOGUEL 1979 C. Monbeig Goguel. *Roman Drawings of the Sixteenth Century from the Musée du Louvre, Paris* (exh. cat.). Chicago, 1979.

MONBEIG GOGUEL 1989 C. Monbeig Goguel. Review of R. Ward, *Baccio Bandinelli 1493–1560* (Cambridge, 1988). *The Burlington Magazine* 131 (October 1989), pp. 712–714.

MONBEIG GOGUEL 2001a C. Monbeig Goguel. "Francesco Salviati et la *Bella Maniera*: Quelques points à revoir: Interprétation, chronologie, attributions." In Monbeig Goguel et al. 2001, pp. 15–68. Rome, 2001.

MONBEIG GOGUEL 2001b C. Monbeig Goguel. "Per Bronzino: Un nuovo modello di 'Cristo morto' tra Pontormo e Allori." In *L'intelligenza della passione: Scritti in onore di Andrea Emiliani*, ed. M. Scolaro and F.P. Di Teodoro, pp. 259–267. Bologna, 2001.

MONBEIG GOGUEL ET AL. 2001 C. Monbeig Goguel, P. Costamagna, and M. Hochmann, eds. *Francesco Salviati et la Bella Maniera: Actes des colloques de Rome et de Paris (1998)*. Rome, 2001.

MONDOLFO 1948 A. Mondolfo. *La Biblioteca Landau Finaly*. Florence, 1948.

MONGAN AND SACHS 1946 A. Mongan and P. Sachs. *Drawings in the Fogg Museum of Art*. 2 vols. Cambridge, Mass., 1946.

MONTI 1965 R. Monti. *Andrea del Sarto*. Milan, 1965.

MONTI 1981 R. Monti. *Andrea del Sarto*. Milan, 1981.

MYSSOK 1999 J. Myssok. *Bildhauerische Konzeption und plastisches Modell in der Renaissance*. Münster, 1999.

NAGEL 2000 A. Nagel. *Michelangelo and the Reform of Art*. Cambridge, 2000.

NATALI 1995 A. Natali. *La Piscina di Betsaida: Movimenti nell'arte fiorentina del Cinquecento*. Florence, 1995.

NATALI 1998 A. Natali. *Andrea del Sarto: Maestro della "maniera moderna."* Milan, 1998.

NATALI AND CECCHI 1989 A. Natali and A. Cecchi. *Andrea del Sarto: Catalogo completo dei dipinti*. Florence, 1989.

NELSON 1992 J.K. Nelson. "Dante Portraits in Sixteenth-Century Florence." *Gazette des Beaux-Arts* 120 (September 1992), pp. 59–77.

NELSON 1995a J.K. Nelson. "Creative Patronage: Luca Martini and the Renaissance Portrait." *Mitteilungen des Kunsthistorischen Institutes in Florenz* 39 (1995), pp. 283–305.

NELSON 1995b J.K. Nelson. "Luca Martini, Dantista, and Pierino da Vinci's Relief of the Death of Count Ugolino della Gherardesca and His Sons." In Cianchi 1995, pp. 39–46.

NELSON AND WALDMAN 2004 J.K. Nelson and L.A. Waldman. "La questione dei dipinti postumi di Filippino Lippi: Fra Girolamo da Brescia, il 'Maestro di Memphis,' e la pala d'altare a Fabbrica di Peccioli." In *Filippino Lippi e Pietro Perugino: La deposizione della Santissima Annunziata e il suo restauro*, ed. F. Falletti and J.K. Nelson, pp. 120–147. Florence, 2004.

NEWCASTLE 1982 R. Holland. *Italian Drawings 1525–1570 from the Collection of Ralph Holland* (exh. cat.). Newcastle-upon-Tyne, 1982.

NEW YORK 1983 *The Vatican Collections: The Papacy and Art* (exh. cat.). New York, 1983.

NEW YORK 1997 *A Quintessence of Drawing: Masterworks from the Albertina* (exh. cat.). New York, 1997.

NIKOLENKO 1966 L. Nikolenko. *Francesco Ubertini Called Il Bacchiacca*. Locust Valley, N.Y., 1966.

NOLAN 2001 J. Nolan. *Selected Masterworks from the Bob Jones University Museum and Gallery*. Greenville, S.C., 2001.

"NOTABLE WORKS" 1955 "Notable Works of Art Now on the Market." *The Burlington Magazine* 97 (December 1955), plate X.

NOTRE DAME 1970 M. Milkovich and D. Porter. *The Age of Vasari* (exh. cat.). Binghamton, N.Y., 1970.

NOVA AND SCHREURS 2003 A. Nova and A. Schreurs, eds. *Benvenuto Cellini: Kunst und Kunsttheorie im 16. Jahrundert*. Frankfurt, 2003.

OBERHUBER 1966 K. Oberhuber. *Graphische Sammlung Albertina, Die Kunst der Graphik III, Renaissance in Italien, 16. Jahrhundert, Werke aus dem Besitz der Albertina* (exh. cat.). Vienna, 1966.

OBERHUBER 1978 K. Oberhuber, ed. *The Illustrated Bartsch*, ed. W. Strauss. Vols. 26 [14–1] and 27 [14–2], *The Works of Marcantonio Raimondi and of His School*. New York, 1978.

OBERHUBER 1999 K. Oberhuber. *Raffael: Das malerische Werk*. Munich, London, and New York, 1999.

OBERHUBER AND FERINO PAGDEN 1983 K. Oberhuber, S. Ferino Pagden, et al. *Raphael: Die Zeichnungen*. Stuttgart, 1983.

OLSZEWSKI 1981 E.J. Olszewski. *The Draftsman's Eye* (exh. cat.). Cleveland, 1981.

OLSZEWSKI 1985 E.J. Olszewski. "Distortions, Shadows and Conventions in Sixteenth-Century Italian Art." *Artibus et Historiae* 11:6 (1985), pp. 101–124.

OST 1975 H. Ost. *Leonardo-Studien*. Berlin and New York, 1975.

OTTAWA 1976 M. Cazort-Taylor. *European Drawings from Canadian Collections, 1500–1900* (exh. cat.). Ottawa, 1976.

PADOVANI 1996 S. Padovani, ed. *L'età di Savonarola: Fra' Bartolomeo e la scuola di San Marco* (exh. cat.). Florence, 1996.

PADOVANI 2004 S. Padovani. "Domenico Puligo's *Portrait of a Lady* and Its Copy." *Arte Cristiana* 92 (2004), pp. 11–16.

PADOVANI AND MELONI TRKULJA 1982 S. Padovani and S. Meloni Trkulja. *Il cenacolo di Andrea del Sarto a San Salvi: Guida del museo*. Florence, 1982.

PAGNOTTA 1987 L. Pagnotta. *Giuliano Bugiardini*. Turin and Milan, 1987.

PANOFSKY 1937 E. Panofsky. "The Early History of Man in a Cycle of Paintings by Piero di Cosimo." *Journal of the Warburg and Courtauld Institutes* 1:1 (July 1937), pp. 12–30; "The Early History of Man in Two Cycles of Paintings by Piero di Cosimo." In *Studies in Iconology: Humanistic Themes in the Art of the Renaissance*, pp. 33–67. New York, 1939. Reprint, 1972.

PARIS 1956 *De Giotto à Bellini: Les Primitifs Italiens dans les Musées de France* (exh. cat.). Paris, 1956.

PARIS 1986 D. Cordellier, ed. *Hommage à Andrea del Sarto* (exh. cat.). Paris, 1986.

PARKER 1956 K.T. Parker. *Catalogue of the Collection of Drawings in the Ashmolean Museum*. Vol. 2, *Italian Schools*. Oxford, 1956.

PARKER 1961 K.T. Parker. *Ashmolean Museum: Report of the Visitors*. Oxford, 1961.

PARMA ARMANI 1986 E. Parma Armani. *Perin del Vaga: L'anello mancante: Studi sul manierismo*. Genoa, 1986.

PASSAVANT 1864 J.D. Passavant. *Le peintre-graveur*. Leipzig, 1864.

PEDRETTI 1985–1986 C. Pedretti. *Leonardo da Vinci: Drawings of Horses from the Royal Library at Windsor Castle* (exh. cat.). Washington, D.C., 1985–1986.

PEDRETTI 1987 C. Pedretti. *The Drawings and Miscellaneous Papers of Leonardo da Vinci in the Collection of Her Majesty The Queen at Windsor Castle*. London and New York, 1987.

PEDRETTI 1992 C. Pedretti. "L'origine dei disegni a pennello di Raffaello." In *Kunst des Cinquecento in der Toskana*, ed. M. Cämmerer, pp. 37–42. Munich, 1992.

PENNY 1992 N. Penny. "Raphael's 'Madonna dei Garofani' rediscovered." *The Burlington Magazine* 134 (February 1992), pp. 67–81.

PETERS BOWRON 1971–1973 E. Peters Bowron. "Giorgio Vasari's *Portrait of Six Tuscan Poets*." *The Minneapolis Institute of Arts Bulletin* 60 (1971–1973), pp. 42–53.

PETRIOLI TOFANI 1972 A. Petrioli Tofani. *I grandi disegni italiani degli Uffizi di Firenze* (exh. cat.). Milan, 1972.

PETRIOLI TOFANI 1985 A. Petrioli Tofani. "Due nuovi disegni del Vasari agli Uffizi." In *Giorgio Vasari tra decorazione ambientale e storiografia artistica*, ed. G. Gafargnini, pp. 417–422. Florence, 1985.

PETRIOLI TOFANI 1986–1987 A. Petrioli Tofani. *Gabinetto disegni e stampe degli Uffizi: Inventario I–II: Disegni esposti*. 2 vols. Florence, 1986–1987.

PETRIOLI TOFANI 1991 A. Petrioli Tofani. *Gabinetto disegni e stampe degli Uffizi: Inventario: Disegni di figura*. Florence, 1991.

PEVSNER 1940 N. Pevsner. *Academies of Art, Past and Present*. Cambridge, 1940.

PHILADELPHIA 2004 C.B. Strehlke. *Pontormo, Bronzino, and the Medici: The Transformation of the Renaissance Portrait in Florence* (exh. cat.). Philadelphia, 2004.

PILLIOD 2001 E. Pilliod. *Pontormo, Bronzino, Allori: A Genealogy of Florentine Art*. New Haven and London, 2001.

PILLSBURY 1970 E. Pillsbury. "The Temporary Facade on the Palazzo Ricasoli: Borghini, Vasari, and Bronzino." *Studies in the History of Art* 3 (1970), pp. 75–83.

PINELLI 1967 A. Pinelli. "Pier Francesco di Jacopo Foschi." *Gazette des Beaux-Arts* 69 (February 1967), pp. 87–108.

PINELLI 1988 A. Pinelli. "Vivere 'alla filosofica' o vestire di velluto? Storia di Jacone fiorentino e della sua 'masnada' antivasariana." *Ricerche di Storia dell'arte* 34 (1988), pp. 5–34.

PLAZZOTTA 1989 C. Plazzotta. Review of *Agnolo Bronzino, Rime in burla*, ed. F.P. Nardelli (Rome, 1988). *The Burlington Magazine* 131 (October 1989), p. 715.

POESCHKE 1992 J. Poeschke. *Die Skulptur der Renaissance in Italien*. Vol. 1, *Michelangelo und seine Zeit*. Munich, 1992.

POESCHKE 1996 J. Poeschke. *Michelangelo and His World: Sculpture of the Italian Renaissance*. New York, 1996.

POGGI 1908 G. Poggi. "Di una Madonna del Bachiacca attribuita a Raffaello." *Monatshefte für Kunstwissenschaft* 1 (1908), pp. 275–280.

POGGI 1965–1983 G. Poggi, ed. *Il carteggio di Michelangelo*. Posthumous ed., P. Barocchi and R. Ristori. 6 vols. Florence, 1965–1983.

POPE-HENNESSY 1961 J. Pope-Hennessy, ed. *Italian Bronze Statuettes* (exh. cat.). London, 1961.

POPE-HENNESSY 1963 J. Pope-Hennessy. *Italian High Renaissance and Baroque Sculpture*. 3 vols. London, 1963; 2nd ed. 1970.

POPE-HENNESSY 1964 J. Pope-Hennessy, assisted by R. Lightbown. *Catalogue of Italian Sculpture in the Victoria and Albert Museum*. 3 vols. London, 1964.

POPE-HENNESSY 1974 J. Pope-Hennessy. "A Fountain by Rustici." *Victoria and Albert Museum Yearbook* 4 (1974), pp. 23–29, 31–35.

POPE-HENNESSY 1982 J. Pope-Hennessy. "A Bronze Satyr by Cellini." *The Burlington Magazine* 124 (July 1982), pp. 406–412.

POPE-HENNESSY 1985 J. Pope-Hennessy. *Cellini*. New York, 1985.

POPE-HENNESSY 1996 J. Pope-Hennessy. *Italian High Renaissance and Baroque Sculpture*. 4th ed. London, 1996.

POPHAM 1945 A.E. Popham. "On Some Works by Perino del Vaga." *The Burlington Magazine* 86 (January 1945), pp. 56–66.

POPHAM 1946 A.E. Popham. *The Drawings of Leonardo da Vinci*. London, 1946.

POPHAM AND FENWICK 1965 A.E. Popham and K.M. Fenwick, *European Drawings (and Two Asian Drawings) in the Collection of the National Gallery of Canada*. Toronto, 1965.

POPHAM AND WILDE 1949 A.E. Popham and J. Wilde. *The Italian Drawings of the XV and XVI Centuries in the Collection of His Majesty the King at Windsor Castle*. London, 1949.

POUNCEY 1957 M. Pouncey. "Five Drawings by Pierfrancesco di Jacopo di Domenico Toschi." *The Burlington Magazine* 99 (May 1957), p. 159.

POUNCEY 1961 P. Pouncey. "Di alcuni disegni del Bandinelli e di un suo dipinto smarrito." *Bollettino d'Arte* 46 (1961), pp. 323–326.

POZZI 1990 M. Pozzi. "Mito aramaico-etrusco e potere assoluto a Firenze al tempo di Cosimo I." In *Le pouvoir monarchique et les supports idéologiques aux XIVᵉᵐᵉ–XVIIᵉᵐᵉ siècles*, ed. J. Dufournet et al., pp. 65–76. Paris, 1990.

PRINCETON 1984 *Record of the Art Museum, Princeton University* 43:1 (1984), pp. 18–19.

PRINCETON 1986 *Selections from the Art Museum, Princeton University*. Princeton, 1986.

PROSPERI VALENTI RODINÒ 1994 S. Prosperi Valenti Rodinò. *Da Leonardo a Volterrano: Disegni fiorentini dal XV al XVII secolo*. Rome, 1994.

PROVIDENCE 1973 *Drawings and Prints of the First Maniera, 1515–35* (exh. cat.). Providence, 1973.

RADCLIFFE 1988 A. Radcliffe. Review of *Cellini* by John Pope-Hennessy. *The Burlington Magazine* 130 (December 1988), p. 930.

RADCLIFFE 1992 A. Radcliffe. "Two Adoring Angels, Workshop of Andrea della Robbia, c. 1510." In *The Thyssen-Bornemisza Collection: Renaissance and Later Sculpture*, pp. 100–105. London, 1992.

RAGGHIANTI COLLOBI 1974 L. Ragghianti Collobi. *Il Libro de' disegni del Vasari*. 2 vols. Florence, 1974.

RAGGIO 1958 O. Raggio. "The Myth of Prometheus." *Journal of the Warburg and Courtauld Institutes* 21 (1958), pp. 44–62.

REISS 1992 S.E. Reiss. "Cardinal Giulio de' Medici as a Patron of Art, 1513–1523." Ph.D. diss., Princeton University, 1992.

ROBERTSON 1999 C. Robertson. Reviews of Exhibitions: *Francesco Salviati o la Bella Maniera*, Rome, Villa Medici, Paris, Musée du Louvre. *Renaissance Studies*, no. 13 (1999), pp. 73–79.

ROBINSON 1876 J.C. Robinson. *Descriptive Catalogue of Drawings by the Old Masters, Forming the Collection of John Malcolm of Poltalloch, Esq.* London, 1876.

ROETHLISBERGER 1987 M.G. Roethlisberger. "Le thème de Léda en sculpture." *Genava*, n.s. 35 (1987), pp. 65–89.

ROME 1959 R. Bacou and J. Bean. *Disegni fiorentini del Museo del Louvre dalla collezione di Filippo Baldinucci* (exh. cat.). Rome, 1959.

ROME AND PARIS 1998 C. Monbeig Goguel, ed. *Francesco Salviati (1510–1563), o la bella maniera* (exh. cat.). Rome and Paris, 1998.

RUBIN 1995 P.L. Rubin. *Giorgio Vasari: Art and Art History*. New Haven and London, 1995.

RUDOLPH AND BIANCALANI 1970 S. Rudolph and A. Biancalani, eds. "Quaderni degli Uffizi-1." In *Mostra storica della Tribuna degli Uffizi*. Florence, 1970.

SALVINI 1939 R. Salvini. "Ubertini, Francesco." In *Allgemeines Lexikon der Bildenden Künstler von der Antike bis zur Gegenwart*, ed. U. Thieme and F. Becker, pp. 522–523. Leipzig, 1939.

SCHARF 1937 A. Scharf. "Bacchiacca: A New Contribution." *The Burlington Magazine* 70 (February 1937), pp. 60–66.

SCHISSLER 1972 B. Schissler. *The J. Paul Getty Collection* (exh. cat.). Minneapolis, 1972.

SCHMIDT 1996 E.D. Schmidt. "Die Überlieferung von Michelangelos verlorenem Samson-Modell." *Mitteilungen des Kunsthistorischen Institutes in Florenz* 40 (1996), pp. 78–147.

SCHMIDT 2000 E.D. Schmidt. "Scultura sacra nella Toscana del Cinquecento." In *Storia delle arti in Toscana: Il Cinquecento*, ed. R.P. Ciardi and A. Natali, pp. 231–254. Florence, 2000.

SCHUBRING 1915 P. Schubring. *Cassoni: Truhen und Truhenbilder der italienische Frührenaissance*. Leipzig, 1915.

SCORZA 1981 R.A. Scorza. "Borghini and *Invenzione*: The Florentine *apparato* of 1565." *Journal of the Warburg and Courtauld Institutes* 44 (1981), pp. 57–75.

SCORZA 1995–1996 R.A. Scorza. "Vasari and Gender: A New Drawing for the Sala di Cosimo I." *Yale University Art Gallery Bulletin* (1995–1996), pp. 65–74.

SCORZA 2001 R.A. Scorza. "Un nouveau dessin de Vasari pour l'autel de l'église Santa Croce à Bosco Marengo." *Revue du Louvre: La revue des musées de France* 51:2 (2001), pp. 51–55.

SCORZA 2003 R.A. Scorza. "Vincenzo Borghini's Collection of Paintings, Drawings and Wax Models: New Evidence From Manuscript Sources." *Journal of the Warburg and Courtauld Institutes* 66 (2003), pp. 63–122.

SHAPLEY 1966–1973 F.R. Shapley. *Paintings from the Samuel H. Kress Collection: Italian Schools*. 3 vols. London, 1966–1973.

SHEARMAN 1962 J. Shearman. "Pontormo and Andrea del Sarto, 1513." *The Burlington Magazine* 104 (November 1962), pp. 478–483.

SHEARMAN 1965 J. Shearman. *Andrea del Sarto*. 2 vols. Oxford, 1965.

SHEARMAN 1966 J. Shearman. "The 'Dead Christ' by Rosso Fiorentino." *Bulletin: Museum of Fine Arts, Boston* 64:338 (1966), pp. 148–172.

SHEARMAN 1967 J. Shearman. *Provisional Catalogue: Gambier-Parry Collection*. London, 1967.

SHEARMAN 1983 J. Shearman. *The Early Italian Pictures in the Collection of Her Majesty the Queen*. Cambridge, 1983.

SHOEMAKER AND BROUN 1981 I.H. Shoemaker and E. Broun. *The Engravings of Marcantonio Raimondi* (exh. cat.). Lawrence, Kans., 1981.

SIENA 1990 *Domenico Beccafumi e il suo tempo* (exh. cat.). Milan, 1990.

SIMON 1985 R.B. Simon. "Bronzino's *Cosimo I de' Medici as Orpheus*." *Bulletin Philadelphia Museum of Art* 81:348 (Fall 1985), pp. 17–27.

SINIBALDI 1925 G. Sinibaldi. "Le opere di Andrea del Sarto che si conservano a Firenze." *L'Arte* 28 (1925), pp. 5–27.

SKINNER 1904 A.B. Skinner. *Catalogue of the Art Collection, 8 Cadogan Square, S.W.1*. London, 1904.

SMITH 1952 J.S. Smith. "The Italian Sources of Inigo Jones's Style." *The Burlington Magazine* 94 (July 1952), pp. 200–207.

SMITH 1959 M.T. Smith. "The Use of Grisaille as a Lenten Observance." *Marsyas* 8 (1959), pp. 43–54.

SMITH 1979 G. Smith. "Cosimo I and the Joseph Tapestries for the Palazzo Vecchio." *Discussion Papers in Western European Studies*, Ann Arbor, 1979. Reprinted in *Renaissance and Reformation*, n.s., 6:3 (August 1982), pp. 183–196.

SMYTH 1955 C.H. Smyth. "Bronzino Studies," Ph.D. diss., Princeton University, 1955.

SMYTH 1971 C.H. Smyth. *Bronzino as Draughtsman: An Introduction*. New York, 1971.

SPANTIGATI AND IENI 1985 C. Spantigati and G. Ieni, eds. *Pio V e Santa Croce di Bosco: Aspetti di una committenza papale*. Bosco Marengo, 1985.

SRICCHIA SANTORO 1963 F. Sricchia Santoro. "Per il Franciabigio." *Paragone* 14:163 (July 1963), pp. 3–23.

SRICCHIA SANTORO 1993 F. Sricchia Santoro. "Del Franciabigio, dell'Indaco e di una vecchia questione. I." *Prospettiva*, no. 70 (April 1993), pp. 22–49.

STEWART 1963 J.D. Stewart. "Bandinelli's Relief of the Flagellation." *The Burlington Magazine* 105 (September 1963), p. 410.

STILLMAN 1961 D.B. Stillman. "Drawings by Baccio Bandinelli: Their Style and Sources." M.A. thesis, Columbia University, 1961.

STITES 1931 R.S. Stites. "Leonardo da Vinci, Sculptor: Part III." *Art Studies: Medieval, Renaissance and Modern* 8:2 (1931), pp. 289–300.

STRATIS 1991 H.K. Stratis. "The Technical Aspects of Pontormo's *Christ before Pilate*." *The Art Institute of Chicago Museum Studies* 17 (1991), pp. 47–51.

SUIDA 1929 W. Suida. *Leonardo und sein Kreis*. Munich, 1929; Italian edition, ed. M.T. Fiorio, Venice, 2001.

SUPINO 1898 I.B. Supino. *Catalogo del R. Museo Nazionale di Firenze (Palazzo del Potestà)*. Rome, 1898.

SUTTON 1977 D. Sutton. *Treasures from Rochester*. Rochester, N.Y, 1977.

SUTTON 1995 P.C. Sutton. *The William Appleton Coolidge Collection*. Boston, 1995.

TÁTRAI 1983 V. Tátrai. *Mittelitalienische Cinquecento-Gemälde*. Budapest, 1983.

TAZARTES 2003 M. Tazartes. *Bronzino*. Milan, 2003.

TECKNINGAR 1992 R. Teckningar. *En utställning ingående i Nationalmuseums 200-årsjubileum*. Stockholm, 1992.

THAUSING 1878 M. Thausing. "Michelangelo's Entwurf zu dem Karton der Schlacht bei Cascina." *Zeitschrift für Bildende Kunst* (1878), Part 1, pp. 107–112; Part 2, pp. 129–142.

TONGIORGI TOMASI 1984 L. Tongiorgi Tomasi. "L'immagine naturalistica a Firenze tra XVI e XVII secolo: Contributo al rapporto 'arte-natura' tra manierismo e prima età barrocca." In *Immagini anatomiche e naturalistiche nei disegni degli Uffizi, sec. XVI, XVII*, ed. R.P. Ciardi and L. Tongiorgi Tomasi, pp. 37–67. Florence, 1984.

TORONTO AND NEW YORK 1985 D. McTavish. *Italian Drawings from the Collection of Duke Roberto Ferretti* (exh. cat.). Toronto and New York, 1985.

TOURS 1996–1997 *Italies: Peintures des musées de la région Centre* (exh. cat.). Tours, 1996–1997.

TUCKER 1985 M.S. Tucker. "Discoveries Made during the Treatment of Bronzino's *Cosimo de' Medici as Orpheus*." *Bulletin Philadelphia Museum of Art* 81:348 (Fall 1985), pp. 28–32.

TURIN 1990 G.C. Sciolla, ed. *From Leonardo to Rembrandt: Drawings from the Royal Library of Turin / Da Leonardo a Rembrandt: Disegni della Biblioteca Reale di Torino* (exh. cat.). Turin, 1990.

TURNER 1986 N. Turner. *Florentine Drawings of the Sixteenth Century*. London, 1986.

TURNER 1996/2000 J. Turner. *The Dictionary of Art*. 34 vols. London and New York, 1996. Online edition, revised, 2000.

UNIVERSITY OF KANSAS 1958 University of Kansas Museum of Art. *Masterworks from University and College Collections* (exh. cat.). Lawrence, Kans., 1958.

URBINI 1993 S. Urbini. "Il mito di Cleopatra: Motivi ed esiti della sua rinnovata fortuna fra Rinascimento e Barocco." *Xenia Antiqua* 2 (1993), pp. 181–222.

VALENTINER 1959 W.R. Valentiner. "Rustici in France." In *Studies in the History of Art Presented to William E. Suida*, pp. 205–217. London, 1959.

VASARI 1966–1987 G. Vasari. *Le vite de' più eccellenti pittori, scultori e architettori nelle redazioni del 1550 e 1568*, ed. R. Bettarini and P. Barocchi. 6 vols. Florence, 1966–1987.

VASARI 1967 G. Vasari. *Le vite de' più eccellenti pittori, scultori e architettori* [Florence, 1568], ed. P. della Pergola, L. Grassi, and G. Previtali. 9 vols. Novara, 1967.

VASARI 1986 G. Vasari. *Le vite de' più eccellenti architetti, pittori, et scultori italiani, da Cimabue insino a' tempi nostri* [Florence, 1550], ed. L. Bellosi and A. Rossi. 2 vols. Turin, 1986.

VASARI 1996 G. Vasari. *Lives of the Painters, Sculptors and Architects*. Trans. G. du C. de Vere; intro. D. Ekserdjian. New York and Toronto, 1996.

VASARI-MILANESI 1878–1885 G. Vasari. *Le vite de' più eccellenti pittori, scultori ed architettori* [Florence, 1568], ed. G. Milanesi. 9 vols. Florence, 1878–1885.

VAYER 1957 L. Vayer. *Master Drawings from the Collection of the Budapest Museum of Fine Arts*. New York, 1957.

VENICE 1962 *Tesori d'arte italiana mostra-mercato dell'antiquariato* (exh. cat.). Venice, 1962.

VENICE, VIENNA, AND BILBAO 2004–2005 A. Gnann, ed. *Michelangelo und seine Zeit: Meisterwerke der Albertina / The Era of Michelangelo: Masterpieces from the Albertina* (exh. cat.). Milan, 2004–2005.

VENTURI 1924 A. Venturi. "Un rivendicato Leonardo nella Galleria Pitti a Firenze." *L'Arte* 27 (1924), pp. 197–199.

VENTURI 1925 A. Venturi. *Storia dell'arte italiana*. Vol. 9, part 1, *La Pittura del Cinquecento*. Milan, 1925.

VENTURI 1932 A. Venturi. *Storia dell'arte italiana*. Vol. 9, part 5, *La Pittura del Cinquecento*. Milan, 1932.

VENTURINI 1992 L. Venturini. *Pinacoteca di Brera: Scuola dell'Italia centrale e meridonale*. Milan, 1992.

VERDON 2003 T. Verdon. "Michelangelo and the Body of Christ: Religious Meaning in the Florence *Pietà*." In J. Wasserman, *Michelangelo's Florence Pietà*, pp. 127–148. Princeton and Oxford, 2003.

VIALE FERRERO 1959 M. Viale Ferrero. *La chiesa di Santa Croce a Bosco Marengo*. Turin, 1959.

VINCI 2001 G. Dalli Regoli, R. Nanni, and A. Natali, eds. *Leonardo e il mito di Leda: Modelli, memorie e metamorfosi di un'invenzione* (exh. cat.). Vinci, 2001.

VON DER GABELENTZ 1922 H. Von der Gabelentz. *Fra Bartolommeo und die florentiner Renaissance*. 2 vols. Leipzig, 1922.

VOSSILLA 1997 F. Vossilla. "Baccio Bandinelli e Benvenuto Cellini tra il 1540 e il 1560: Disputa su Firenze e su Roma." *Mitteilungen des Kunsthistorischen Institutes in Florenz* 41 (1997), pp. 254–313.

WAAGEN 1854 G.F. Waagen. *Treasures of Art in Great Britain: Being an Account of the Chief Collections of Paintings, Drawings, Sculptures, Illuminated Mss., etc*. 3 vols. London, 1854.

WAAGEN 1857 G.F. Waagen. *Galleries and Cabinets of Art in Great Britain*. London, 1857.

WALDMAN 1997a L.A. Waldman. "Bronzino's Uffizi 'Pietà' and the Cambi Chapel in S. Trinita, Florence." *The Burlington Magazine* 139 (February 1997), pp. 94–102.

WALDMAN 1997b L.A. Waldman. "The Date of Rustici's 'Madonna' Relief for the Florentine Silk Guild." *The Burlington Magazine* 139 (December 1997), pp. 869–872.

WALDMAN 1997c L.A. Waldman. "Dal Medioevo alla Controriforma: I Cori di Santa Maria del Fiore." In *Sotto il cielo della Cupola: Il Coro di Santa Maria del Fiore* (exh. cat.), pp. 37–68. Florence, 1997.

WALDMAN 1999 L.A. Waldman. "The Choir of Florence Cathedral: Transformations of Sacred Space, 1334–1572." Ph.D. diss., New York University, 1999.

WALDMAN 2001 L.A. Waldman. "Bandinelli and the Opera di Santa Maria del Fiore: Privilege, Patronage and Pedagogy." In *Santa Maria del Fiore: The Cathedral and Its Sculpture*, ed. M. Haines, pp. 217–252. Fiesole, 2001.

WALDMAN 2004 L.A. Waldman. *Baccio Bandinelli and Art at the Medici Court: A Corpus of Early Modern Sources*. Philadelphia, 2004.

WALDMAN REWRITING THE PAST L.A. Waldman. *Rewriting the Past: The Memoriale Attributed to Baccio Bandinelli and the Culture of Forgery in Early Modern Europe* (forthcoming).

WARD 1978 R. Ward. *A Catalogue of the Drawings by Baccio Bandinelli in the Department of Prints and Drawings in the British Museum*. MA Report, Courtauld Institute, University of London, 1978.

WARD 1982 R. Ward. "Baccio Bandinelli as a Draughtsman." Ph.D. diss., Courtauld Institute, University of London, 1982.

WARD 1988 R. Ward. *Baccio Bandinelli, 1493–1560: Drawings from British Collections* (exh. cat.). Cambridge, 1988.

WARD 1993 R. Ward. "New Drawings by Bandinelli and Cellini." *Master Drawings* 31 (1993), pp. 395–398.

WASHINGTON 1991 J.A. Levenson, ed. *Circa 1492: Art in the Age of Exploration* (exh. cat.). New Haven and Washington, D.C., 1991.

WAŹBIŃSKI 1987 Z. Waźbiński. *L'Accademia Medicea del Disegno a Firenze nel Cinquecento: Idea e istituzione*. 2 vols. Florence, 1987.

WEIHRAUCH 1935 H.R. Weihrauch. *Studien zum bildnerischen Werke des Jacopo Sansovino*. Strasbourg, 1935.

WEIL-GARRIS BRANDT 1981 K. Weil-Garris Brandt. "Bandinelli and Michelangelo: A Problem of Artistic Identity." In *Art the Ape of Nature: Studies in Honor of H.W. Janson*, ed. M. Barasch and L.F. Sandler. New York, 1981.

WIEBEL 1994 C. Wiebel. *Italienische Druckgraphik des 15. bis 18. Jahrhunderts: Kupferstiche und Radierungen aus eigenen Besitz* (exh. cat.). Coburg, 1994.

WILES 1933 B. Wiles. *The Fountains of Florentine Sculptors and Their Followers from Donatello to Bernini*. Cambridge, Mass., 1933.

WOLK-SIMON 1998 L. Wolk-Simon. Reviews of Exhibitions: *Francesco Salviati o la Bella Maniera*, Rome, Villa Medici, Paris, Musée du Louvre. *Apollo* 148 (1998), pp. 53–54.

YATES 1951 F. Yates. "Transformations of Dante's Ugolino." *Journal of the Warburg and Courtauld Institutes* 14:1/2 (1951), pp. 92–117.

YATES 1983 F. Yates. *Renaissance and Reform: The Italian Contribution*. London, 1983.

ZENTAI 1998a L. Zentai. "Quelques remarques sur un (deux) dessin(s) de Fra Bartolommeo." *Bulletin du Musée hongrois des Beaux-Arts (A Szépművészeti Múzeum Közleményei)* 88–89 (1998), pp. 99–114.

ZENTAI 1998b L. Zentai. *Sixteenth-Century Central Italian Drawings: An Exhibition from the Museum's Collection*. Budapest, 1998.

ZERI 1962 F. Zeri. "Eccentrici fiorentini." *Bollettino d'Arte* 47, ser. 4 (April 1962), pp. 216–236, 314–326.

ZERI 1971 F. Zeri, with the assistance of E.E. Gardner. *Italian Paintings, Florentine School: A Catalogue of the Collection of the Metropolitan Museum of Art*. New York, 1971.

ZERI 1978 F. Zeri. "Rivedendo Jacopino Del Conte." *Antologia di belle arti* 2:6 (May 1978), pp. 114–120.

ZERI 1994 F. Zeri. *Giorno per giorno nella pittura: Scritti sull'arte italiana del Cinquecento*. Turin, 1994.

ZERNER 1996 H. Zerner. *L'Art de la Renaissance en France: L'invention du classicisme*. Paris, 1996.

INDEX OF ARTISTS AND WORKS

This index lists artists and objects in the exhibition; comparatives and illustrations are not included. Artists are alphabetized by common name (e.g., "Leonardo" not "da Vinci", but "Cellini" not "Benvenuto"). Numerals refer to catalogue numbers.